The Crafts Supply Sourcebook

A Comprehensive Shop-By-Mail Guide

Revised Second Edition

Margaret A. Boyd

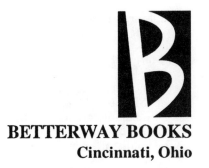

BETTERWAY BOOKS

Cincinnati, Ohio

Cover design and photograph by Susan Riley
Typography by Park Lane Associates

The Crafts Supply Sourcebook, 2nd Edition. Copyright © 1989, 1992 by
Margaret Boyd. Printed and bound in the United States of America.
All rights reserved. No part of this book may be reproduced in any
form or by any electronic or mechanical means including information
storage and retrieval systems without permission in writing from the
publisher, except by a reviewer, who may quote brief passages in a re-
view. Published by Betterway Books, an imprint of F&W Publications,
Inc., 1507 Dana Avenue, Cincinnati, Ohio 45207. 1-800-289-0963.
Second edition.

97 96 95 94 93 5 4 3 2 1

Library of Congress Cataloging-in-Publication Data

Boyd, Margaret Ann.
 The crafts supply sourcebook : a comprehensive shop-by-mail
guide
 / Margaret Boyd.
 p. cm.
 Includes bibliographical references and index.
 ISBN 1-55870-262-8 (pbk.) : $16.95
 1. Handicraft--United States--Equipment and supplies--
 Directories.
 2. Handicraft--Canada--Equipment and supplies--Directories.
 I. Title.
TT12.B683 1992
680'.28--dc20
 92-14964
 CIP

In memory of my grandmothers,
Johanna Pribyl and Elizabeth Jane Munnerlyn.

Contents

SECTION II: NEEDLECRAFTS, SEWING & FIBER ARTS

SECTION III: RESOURCES

Introduction

This sourcebook has over 2,600 listings. How I have enjoyed researching through catalogs and brochures! There is so much to be excited about—the supplies, the videos, and most of all, opportunity for instruction, wherever you are. The wonderful new books and state-of-the art materials motivate and inspire. What an enriching experience!

What is so grand about these listings is that at the heart of them is the people—dedicated and active professionals, many of them. Many include instructions or technical hints in their catalogs, along with details on the materials they carry.

They are enthused about helping us. It is their commitment to aid us, to share their expertise, and with that, to foster and preserve their craft. There it is for us—a treasure trove of experience, information, and inspiration (and yes, materials), ours for the ordering.

Join me and enjoy!

Margaret A. Boyd

Acknowledgements

My thanks to all who responded with time and materials for this book, especially to those who provided valuable data and offered more. Because of their help, I could give greater detail to many listings and present their valuable hints and expertise throughout the book.

My appreciation also to Dover Publications, Inc. for their contributions of artwork for this book. All designs without a credit or copyright line are from the Dover Pictorial Archive Series and are copyright free. These particular designs may be used by readers in any manner desired without further payment, permission, or acknowledgment.

To one David McCarty, wiz of the highest order, my gratitude for his technical programming assistance and teaching.

A special appreciation to my husband, Frank A. Boyd, for his constant loving support. My thanks to Patti DeLette Boyd, my daughter-in-law, for her valuable aid in the early preparation of the book. And thank you, family, for your understanding.

Guide to the Listings in this Book

This book is organized into broad Categories (as shown in the Table of Contents), depending on what products companies carry (sometimes several crafts from one company). Check the index when shopping—supplies can be found in unlikely places.

In listings, reference to SASE means self-addressed, stamped envelope; large SASE refers to a #10 envelope. Include an SASE with every inquiry you make to any company (unless directed otherwise) or you may be disappointed.

Listings include information on materials, services, price breaks, wholesalers (indicate directly or with reference to "Contact a dealer" or "Manufacturer").

Manufacturers are listed in this book because consumers may want the address; some manufacturers will send information to consumers; or to aid those contacting for wholesale and/or distributor information.

Some company listings are less comprehensive than others. Even with scant information a listing might be an important source for some people. Listings are current as of publication, and updates are available.

Many mail order companies now have toll free numbers for orders.

An Invitation to Readers:
I welcome your comments and contribution of information for future editions and for the updating newsletter. Write to:

> Margaret A. Boyd
> P.O. Box 6232-X
> Augusta, GA 30906

Section I
General Arts, Crafts & Hobbies

Craft Supplies—Variety of Crafts

🐦🐦🐦🐦🐦🐦🐦🐦🐦🐦🐦🐦🐦🐦🐦🐦

See also specific craft categories and BOOKS & BOOK-SELLERS, PUBLICATIONS, and ASSOCIATIONS.

Discovering a craft while browsing through a catalog can lead to unexpected (and rewarding!) avenues of personal expression.

🐦🐦🐦🐦🐦🐦🐦🐦🐦🐦🐦🐦🐦🐦🐦🐦

Aleen's (Div. Artis)
Box 68
Temple City, CA 91780

Contact dealer, or send SASE for information.

Deco-Art Americana Paints. Finishes: Satin, Right-On (matte, satin, gloss) coating for wood, tile, plaster, ceramic, paper, and tightly woven fabric. Shrink Art Clear and Opake plastic sheets and projects. Hot Stitch™ fusible web. Adhesives: no-sew and sticky glues, white glue, tacky glue and designer tacky, school, Hot Stitch™ glue powder for fabrics. Fabric stiffener. Fine line syringe glue applicator. Fabric dyes/paints. 39 Idea Sheets/pamphlets: tole, 5 bread dough titles, basket projects, fabric stiffened designs, super scrap crafts, fabric covered boxes, bridal accessories, kitchen foil projects, party flags, pom poms.

Alpel Publishing
P.O. Box 203-CSS
Chambly, Quebec, Canada J3L 4B3

Free brochure—specify area of interest.

Book: *Catalogue of Canadian Catalogues* (Shop at Home From Hundreds of Mail Order Sources) by Leila Albala. This is a directory of Canadian sources including scores of listing for arts, crafts, graphic supplies, books and publications (some on crafts and needlecrafts), knitting and crochet, jewelry making and lapidary, embroidery, quilting, sewing, tole, dollhouses, doll patterns, miniatures, electronics, paints, woodworking. Indexed.

American Art Clay Co., Inc.
4717 W. 16th St.
Indianapolis, IN 46222
317-244-6871

Free information packet.

Craft supplies: instant paper mache, Sculptamold, Super dough, others. Friendly Plastic™ modeling material—plastic strips can be melted, molded, and cooled to harden; in 6 colors; set. Design stiks™ with fluorescents and metallics. Jewelry accessories, findings. Sun Burst opaque metallic acrylics; sets, sprays. Translucent and glitter colors, Glow-in-the-dark phosphorescent paints. Batik It™ cold water fabric dyes; Rub'N Buff and Brush 'N Leaf metallics, Stain 'N Buff wood finishes. (See CERAMICS, METALWORKING, and MOLD CRAFTS.)

Art & Craft Supply
P.O. Box 5070
Slidell, LA 70469

Free catalog.

Supplies including hard-to-find items. "Low prices."

Art Video Library
1389 Saratoga Way
Grants Pass, OR 97526
503-479-4071

Brochure $1.00.

Craft instructional videos—for sale to anyone, sale or rent to members. On payment of yearly fee, members may rent up to 3 videos at a time for 7 days at low cost (rental may apply to purchase). Videos are on VHS or Beta, cover acrylics and other paints; on color. Craft and needlecraft subjects include: candy making, stenciling, theorem and bronzing, soft sculpture dolls, cake decorating, tole painting, stained glass windows, sculpting and modeling, plaster casting, waste molds, latex and RTV molds, bas relief, bronze casting, etching and engraving. Sewing (basics, techniques, knits, lingerie, designer jeans, slipping patterns, machine embroidery, jointed teddy bears. (See ARTIST'S SUPPLIES.)

Arts America
12 Havemeyer Pl.
Greenwich, CT 06830
203-869-4693

Free catalog.

Over 300 videos on art: exhibitions, artists, museum collections, art/craft techniques, architecture, others.

Boin Arts and Crafts
87 Morris St.
Morristown, NJ 07960
201-539-0600

Catalog $2.00 (refundable).

Arts and crafts materials, tools, and equipment for: ceramics (with firing and non-firing clays), enameling, metal crafts (copper, aluminum, nickel, brass), leather crafts, plaster casting, wood ware, wood burning, sand painting, mosaics, basketry, weaving, rug making, felt, candle making, silkscreen, etching, airbrushing; tools. Macramé.

General supplies: jewelry findings, beads, shells, Styrofoam, magnets, cork wood sticks, music box movements, plastic canvas, embroidery threads/items. Burlap, feathers; artist's materials. Group packs for adults and children in variety of crafts. Has large order discounts.

Bolek's Craft Supplies, Inc.
P.O. Box 465
Dover, OH 44622

Catalog $1.50.

Craft supplies: Music boxes, chenille, ribbons, beads, pompoms, satin roses, moveable eyes, floral parts, others. Has quantity prices.

Brians Crafts Unlimited
1421 South Dixie Freeway
New Smyrna Beach, FL 32168

Catalog $1.00 (refundable).

Variety of crafts: wooden ware—shelf rack, towel bar, caddy, door harp kits, candle cups, shadow boxes, easels, others. Artist's stretched canvas, Loew-Cornell brushes. Plaid and Delta paints/sprays. T-shirt paints, stamps and inks, stamp tints. Beads: plastic facet, starflake, pony, spacers, assortments, pearls, metallics.

Basketry—reeds, hoops, cording, tools (awls, reed cutter, tuck tool). Floral—wires, pins, foam, moss, excelsior, grapevine wreaths, twist-paper. Macramé and plastic needlepoint supplies. Hoops, fabrics, waste canvas, DMC floss. Doll parts. Dollhouse kits. Light-up village kits. Kids' craft kits. How-to books. MasterCard, Visa. (See MACRAME.)

Caldwell Ceramics
P.O. Box 533
Bermuda Run, NC 27006

Catalog $1.00.

Craft supplies: Laces, baskets, jewelry parts and supplies, ribbon, brushes, paints, bisque, wood turnings, canvas, others. "Discounted."

Craft King
P.O. Box 90637
Lakeland, FL 33804
813-686-9600

Catalog $2.00.

Over 6,000 craft supply items: artist's supplies—paints, acrylics, aqua stains, Shiva oils, Delta glass stains, aerosol. Papers—transfer, tracing, others. Canvas board. Ceram tole kits, wood shapes. Naturals: raffia, wreaths, excelsior.

Supplies for rag basketry, plastic canvas, needlework, hoops. Beads—plastic, pearls, metallic, kits. Bandanas, conchos, jewelry findings. Macramé and lampshade frames, rings. Music boxes/movements. Rotating base plate. Glues, epoxy. Sequins, buttons, bells, felt, pompoms. Styrofoam. Glue guns, magnets. Sculpey sets. Floral supplies. Ribbons, trims. Doll parts and dolls.

Miniatures (wood and others) including baskets, clothespins, broom, sports items, figures, teddies, animals, trees, vehicles, toys, hats, tools, holiday items, birds, flowers. Naturals: wreaths, baskets, raffia, excelsior, moss, potpourri.

Wooden ware: "Hug A Bodies" punch out and other wood shapes, wreaths, barrel lids, clothespins, mini chalkboards, skateboard, blackboards, apples, eggs, washboards, calendar, string-along jointed figures, slogans, boxes, door harps, tool caddy, others. Wide array of books. Has discounted prices, no minimum.

Craft Supplies 4 Less
13001 Las Vegas Blvd. So.
Las Vegas, NV 89124

Catalog $4.00.

Supplies for many crafts: laces, appliques, ribbons, cords, beads, wood items; silk painting, others. "Discounted."

Creative Craft House
Box 2567
Bullhead City, AZ 86430
602-754-3300

Catalog $2.00.

Full line of pine cone and seashell projects, other natural materials. Floral supplies, lapel vases, leaves, parts. Fiberform (pulp forms). Doll parts: faces, hands, heads, arms, feet, eyes, eyelashes. Shoes. Doll bodies. Animal noses. Wide array of miniatures: animals, sea ornaments, figures, stork, holiday figures, lace bell, heart, bottles, bells, fans, flags, thermometers; dollhouse furniture. Novelties: birds, figures, Christmas, wedding. Beads: glass seed, others; plastic, bamboo, wood, metallic, bone. Conchos, metal filigrees, findings. Gold foil, mirrors, Styrofoam and cutter. Quantity prices. (Also sells wholesale.)

Design Originals
2425 Cullen St.
Ft. Worth, TX 76107
817-877-0067

Catalog $2.00.

200 craft/needlecraft project books: 5 tie and dye, marbleizing, dye dresses, 4 fabric painting, tube paints, 3 appliques. Jewelry making, "hot" belts, 3 button projects, 4 paper and clay jewelry. Feed sack fabric projects (and fabrics), 3 fabric cord titles (braid, knot, wrap, and wood buckle shapes). Wreaths, plant hangers, braided rugs. 11 ragpoint rag coil basket titles, 7 rag rugs, seagrass door mats, 6 friendship bracelets, and 6 cross-stitch titles. Rag rug supplies. 7 printed canvas packages, blank canvas. Ragpoint needles. Wood handles, wire shapes, coiling—by spools, wood bottoms. Fabric cord spools.

Dick Blick
P.O. Box 1267
Galesburg, IL 61402

Catalog $3.00.

Complete artist's supplies. Crafts: paints, markers, papers (crepe, origami, fluorescent, colors, Dippity Dye, construction, tissue, honeycomb, mural, rice, others). T-shirt printing set, screen printing machine, printer, supplies. Block printing supplies, 2 printing kits. Modeling and other clays, plaster, molds, Styrofoam shapes, hot wire cutters. Woodburning pens, balsa, pine plaques, basswood signs. Button machine, presses, die sets, circle cutters. EnviroTex Lite™ resin cover. Wood cutouts.

Group/value packs: trims, ribbons, sand painting, others. Cork, clothespins, mini-thermometers, suction cups. Wood house shapes, boxes, chenille. Stencils. Glass stains, leading. Feathers, pyrolace, etching kit, crushed pebbles, dried flowers, formafilm, wire wreaths. Colored sands. Shrink Art kits. Transfer Magic™ film.

Basket kits, reed, coiling, raffia, rush. Leather kits, lacing, sides and remnants, tools. Adhesives, hot glue gun. Magic™ batik, tjanting, wax melter kits, beeswax.

Tooling metals, plaques, molds, punches. Jewelry findings. Stitch canvases (and plastic), hooks, iron-ons. Beads and small looms. Threads/yarns—wide array; packs, economy assortments. Trims, burlap, felt, muslin, paper capers (twist). String art, wood and tile kits, casting resin, Paint 'N Swirl, Spin-A-Patch. Selected kits for 6 to 100 projects per kit: felt, plastic mesh, chenille, wood, jumping jacks, string, thread art, Popsicle sticks, magnets, glass stain, sun catchers, pom poms, leather, glow in the dark sheeting, window boxes, metal punch, others. Sand painting, stitchery, yarn, sewing cards, foils, pencil puppets, others. Books. Quantity prices. (See ARTIST'S SUPPLIES and SCULPTURE & MODELING.)

Dover Publications, Inc.
31 East 2nd St.
Mineola, NY 11501

Free catalog.

Craft and needlecraft books: copyright-free design books —clip art (holiday, borders, layout grids, old-fashioned animals, transportation, romantic cuts, children, patriotic, silhouettes, sports, Gibson Girls, teddies, wedding, men, women, children, sports, humorous, office, and nautical motifs, alphabets). Copyright free design books: Japanese, Chinese, Art Nouveau and Deco, Scandinavian, Early American, Arabic, Mayan; illustrations from many other eras; 1920s, 1930s; 16-20th centuries, American Indian, Indian, Egyptian; historic ornaments, florals, textiles, geometrics, patchwork. Stencils: traditional, floral, Japanese.

Folk designs, lettering, calligraphy, stained glass, historic costumes, art. Needlecraft books: 38+ quilting titles, applique, knitting and crochet, lacemaking, 14+ embroidery, iron-on transfer patterns, needlepoint, 54+ charted designs, doll/toy making; needlework designs.

Other craft and design books: silkscreen, bookbinding, paper crafts, beading, jewelry, stained glass, basketry, marionettes, sculpture, decoupage, tole, leather, boomerangs, sundials, miniatures, dollhouses, 30+ cut/use stencil books. (And other non-craft titles.)

Earth Guild
33 Haywood St.
Asheville, NC 28801

Write for catalog.

Tools/materials for: knitting — Brother knitting machines; accessories. Netting—twines, cords, sticks, rings, shuttles. Candle making — waxes, stearic acid, colors, scents, wicks. Clays, Sculpey, Kemper tools/kit. Leather tools, woodworking tools, sets, rasps; carving, others. Indian bead loom and seed beads. Hardwood dowels. Rattail cords. Dyes (natural, Deka, Lanaset, Procion), fabric paints, marbling kit, silk fabric. Batik wax, tjanting tools. Basketry fibers, handles, hoops, tools. Woodburners. Yarns — cottons, wools, rug types, weaving. Spinning fibers. Spinning, weaving, and rug making equipment. Has quantity prices; allows discounts to teachers, institutions, and professionals. MasterCard, Visa. (See SPINNING & WEAVING.)

Enterprise Art
P.O. Box 2918
Largo, FL 34639

Free catalog.

Beads, bead patterns, and bead ornament kits. Bead basket, hangers, and other kits. Stitchery ornament kits. Bulk supplies: doll parts, plastic canvas, beads—full line of plastic types. Clock kits. Wood items. Snow paint. Others. "Buy bulk and save." DonJer Products.

Guildcraft Inc.
3158 Main St.
Buffalo, NY 14214
716-837-9346

Catalog $1.00 (refundable).

Craft supplies, projects and kits (for individuals, camps, etc.): art sand, felt, pompoms, tissue, leather, wood shapes, beads, others. Art supplies, papers.

Heartland Craft Discounters
P.O. Box 65, Rt. 6 East
Geneseo, IL 61254
309-944-6411

Catalog $2.00 (includes monthly flyers).

Products for arts, crafts, needlecrafts, including artist's supplies—brushes, calligraphy pens and inks, stretcher bars, Sculpey compound, canvas, paints (Ceramcoat dyes/paints, Paint Writers, puffy pens, spatter paint, hiva oils, Folk Art colors; finishes). Jewelry findings. Naturals: moss, wreath forms and wire, excelsior. Floral supplies, potpourri, flowers. Musical movements. Beading wires and threads. Plastic beads.

Frames — wood, shadowbox, shell, metallic, sectional. Resin figures (holiday and others). Wood novelties, figures, cutouts, plaques. Balsa, dowels, blackboards, letters, shapes, woodburning pens. Clock parts and movements. Products for arts, crafts, needlecrafts, stencils and kits.

Wedding supplies—flower sprays, leaves, rosebuds, ribbon roses, bouquet holders, tulle circles, wedding sprays, bridal headpieces. Bride and groom figures. Glues, cements, glue gun. Magnets. Novelties, Miniatures. Toy parts: animal noses, joints, paws, eyes. Model kits: balsa planes, Hobbycraft cars, Testor paints, glues.

Has quantity prices, allows discount to institutions. (Also sells wholesale to businesses.) (See NEEDLECRAFT SUPPLIES section for embroidery, knitting, crochet, plastic canvas, sewing, and others.)

Jiffy Foam, Inc.
221 Third St.
Newport, RI 02830
401-846-7870

Contact dealer or send SASE for information.

Balsa Foam plastic foam: paintable, easy to carve with wood tools or cookie cutters; use for stamping of fabrics and other materials, also block printing. Manufacturer.

Joe Kubert Art & Graphic Supply
37A Myrtle Ave.
Dover, NJ 07801
201-328-3266

Catalog $3.00.

Crafts, artist's, and graphics supplies (major brands): boards—scratch foam core, others. Papers: stencil, 3 parchments, origami, graph, 15 rice papers. Markers, paints, sets, adhesives, 15+ airbrushes/compressor. Pantographs. Silkscreen supplies, kits, equipment. Magnifiers, lamps. Tools: Moto-Tool, Moto Lathe, Moto Flex Shaft, Moto Shop. 3 potter's wheels, turntable, 3 clays. Wire, modeling and sculpting tools. 6 modeling compounds. Casting plaster, mold rubber, Celluclay, plaster/gauze. Batik, cold water dyes. Textile and fabric paints, colors, metallics, ballpoint. Stained glass colors. Stripper sets, stencils, vinyl letters. Books. (See ARTIST'S SUPPLIES.)

Kemper Mfg. Co.
13595 12th St.
Box 696
Chino, CA 91710

Contact dealer or write for literature.

Darwi modeling compound (non-toxic, air dries, attaches easily to anything) can be modeled by hand and/or using Kemper modeling tools; carved, sanded, painted; used to cover household items, even primed (painted or sealed) Styrofoam; can make molds for metal or other casting as it is heatproof. (See TOOLS & EQUIPMENT.)

Kirchen Bros.
Box 1016
Skokie, IL 60076
312-676-2692

Catalog $2.00 (refundable).

Doll Baby™ parts (heads, bodies, tiny heads/bodies, hands, feet, faces, eyes); animal noses, eyes; fashion dolls and crochet patterns, doll fashions, shoes, socks—all for a variety of doll sizes. Pre-painted wood, tin products, baskets, wreaths, paints and brushes, quality craft kits (holiday, ornaments, others), burlap, felt, craft furs, art foam, trims (bells, feathers, ribbons, sequins).

Shrink Art, magnets, miniatures, holiday novelties, small mirrors, butterflies. Quilling papers, tool. Naturals: cones, brooms, mats, wreaths, corn husks, wheat, feathers, baskets. Books. Others. Has quantity prices. May run sales. Discover, MasterCard, Visa.

Lou Davis Wholesale
1490 Elkhorn Rd.
Lake Geneva, WI 64640
414-248-2000

Free catalog.

Doll accessories, jewelry findings, music boxes, quartz clock movements, electrical items. Major credit cards.

Nancy Neale Typecraft
Box 40
Roslyn, NY 11576
516-621-7130
Summer address: Bernard, ME 04612, 207-244-5192.

Send SASE for list.

Antique and old wood printing type (letters, numbers, punctuation), in 1" to 5" sizes, variety of styles, in English, and some in German and Hebrew (inquire); by 100+ lots. (Type can be used to print, as ornaments, for collages, nameplates, door knockers, inlay wood pattern, etc.) Old copper and zinc engravings assortments (20+ lots); metal dingbats (flowers and decorative ornaments in 25+ lots—engravings and dingbats can be used as rubber stamps). Wood printer's galleys, rare brass galleys. Fancy initials, type specimen books, quoins. California type trays. Price breaks on very large orders.

MICRO-DRY: *Place a cup of water in the microwave and you can use your microwave to dry watercolors on paper (bend paper to fit), papier maché (without metal armature or trims), flowers, and other items. Set timer for very short periods at a time and check often. Courtesy of MAB.*

National Artcraft Co.
23456 Mercantile Rd.
Beachwood, OH 44122
216-292-4944

Catalog $4.00 (refundable).

Musical movements (Save-play, light-play, blink-play; 200 wind-up tunes, tune-medley) and accessories; glass domes, cigarette lighter inserts, doll/animal eyes and lashes. Clock movements (battery, electric), electrical parts. Magnets: clip type, bar, disc, flexible strips, 5" X 8" sheets (adhesive backed). Brushes, craft finishes. Rhinestones. Ceramic decals. Kraftkits.

Planmaster, Inc.
P.O. Box 45
South Holland, IL 60473

Product listing $1.00.

Grit sheets—to scale designs up or down, on paper or heavy weight cards, ¼" to 1" grid sizes.

Polyform Products Co.
9420 W. Byron St.
Schiller Park, IL 60176
312-678-4836

Contact your dealer or write for details.

Super Sculpey ceramic-like sculpturing compound for miniatures, plaques, jewelry, sculpture; workable until baked in home oven at 300 degrees; can be molded by hand, later sanded, drilled, painted, engraved, carved, antiqued, glazed, or bronzed; in 30 colors.

Ridge Handcrafts, Inc.
Box 6013
Oak Ridge, TN 37831

Catalog $3.00 (refundable).

Craft supplies, "thousands" for: wood, basketry, jewelry, artists, needlecrafts; miniatures, tools, accessories, books.

Saral Paper Co.
322 W. 57th St., Suite 30
New York, NY 10019

Contact dealer or send SASE for details.

Saral™ wax-free transfer paper (pencil-erases, non-skip with ink or paint); 5 colors in sampler and tole kit packages, or by roll.

Sax Arts & Crafts
P.O. Box 51710
New Berlin, WI 53151

Catalog $4.00 (with coupon off purchase).

Arts and crafts supplies: 7 enameling kilns, enamels, tools, aids, master class pack, copper forms. Low temperature enameling supplies. Tooling metals. Weaving looms and aids; yarn remnant assortments, weaving kits, rug and craft yarns. Embroidery/crewel threads.

Rug-making hooks, frame, aids. Canvases, hoops, needles, burlap (and colors), felt. Soft sculpture and string art supplies. Indian beading, wood and tile beads. Feathers. Macramé and basketry supplies. Batik/waxes, fabrics. 3 dyes, 7 fabric paints, 3-D paints, sets. Airbrush kits and inks. Stenciling, films. Country crafts, trims, Styrofoam, mosaics. Stained glass and kits. Bevel and fusion glass, etching.

Candlemaking, plastic, and wood items. Decoupage and leathercraft supplies. Clays and stands. Sculpture compounds. Carving materials. Mask making (ceramic, papier mache, bisque) kits. Plaster casting, moulage, others. Plastics and Plexiglas, heat gun and strip, balsa and assortments, carving blocks, X-acto sets. Tools for wood carving. Cement and plaster supplies.

Torches. Wires, rolling mills, pin vises. Metals: Nugold, sterling wires and sheets, brass, copper, pewter, nickel silver; casting metals. Art metal equipment, bench vises, buffers, grinders. Foredom and Dremel power tools, mini tools. Jewelry findings. Lost wax and other casting equipment and investments, waxes, supplies. 3 third hands. Jewelry making kits, tools, magnifiers.

Quantity prices; discounts to teachers and institutions. American Express, MasterCard, Visa. (Also sells wholesale to businesses.) (See ARTIST'S SUPPLIES.)

Schrock's
1527 E. Amherst Rd., Box 1136
Massillon, OH 44646
216-837-8845

Catalog $2.00.

Wood items: natural ladders (8" to 24" long), small crates (3 sizes), 2" bucket, 3" milk can. Heart basket kits. Full line of basket supplies. Magnet strip. Others.

Scott Plastics Co.
P.O. Box 1047
Tallevast, FL 34270
813-351-1787

Send SASE with specific inquiry.

Unfinished high-density foam in 3 thicknesses (³/4", 1", 2") and in several package sizes (by the cut sheet, or 4' X 8' sheet, by half skid or skid). (See SIGN MAKING.)

Seams Sew Easy
P.O. Box 2189
Manassas, VA 22110

Send large SASE for Ornaments brochure.

Holiday—38 Christmas ornament patterns: lace angel, pine log reindeer, Victorian motifs, treetop angel, others.

The Cracker Box
Solebury, PA 18963

Catalog $3.98.

Over 200 Christmas ornament kits—rounds, ovals, teardrop, and other shapes; up to about 8" in diameter; to decorate with rhinestones, jewels, metallic braids and trims, ribbons, sequins, and others; to pin or glue onto satin or other ornaments, or fashion decoratives inside transparent balls; with directions.

The Fimo Factory
525 N. Andreasen #G
Escondido, CA 92029
619-741-3242

Send SASE for full information.

Fimo modeling compound (bulk form); hardens in 275 degree oven, can be lacquered; suitable for small and miniature items; 3-D decoratives for picture frames, metal and wood boxes; Christmas ornaments, others.

© Sax Arts & Crafts

Traditions, Ltd.
5702 Industry Lane #15
Frederick, MD 21701
301-695-1321

Catalog $3.00.

Country crafts supplies for stenciling, scherenschnitte (paper cutting), fabric painting, others.

Unicorn Studios

P.O. Box 370
Seymour, TN 37865

Catalog $1.00 (refundable).

Musical movements and voices (full line of tunes, electronic types, windup types): music, animal and doll voices (12), accessories, mini-light sets, kits, wooden boxes (28), toy parts. Wyndo cards. Instructions, books.

Woodsmiths

128 Henry Rd.
Enola, PA 17025

Send SASE for list.

Music boxes: see-through plastic, 2½" diameter, 1½" high, with brass cover ring and acetate protective disc; tilt stops, Swiss musical movements in 30 tunes (Lullaby, Blue Danube, Irish Lullaby, Teddy Bear's Picnic, Sound of Music, Edelweiss, A Time for Us, Danny Boy, It's A Small World; others). MasterCard, Visa.

Zimmerman's

2884 35th St. N.
St. Petersburg, FL 33713
813-526-4880

Catalog $2.00.

Craft supplies: beads, ribbons, doll making items, yarns and crochet threads, plastic canvas, knitting and crochet needles and aids, miniatures, wood products, macramé cords, sewing aids, flowers and flower parts. Paints, finishes, glues, others. "Discount." MasterCard, Visa.

The Fluid Writer Pen (for drawing, fabric painting, etc.) can be used with acrylic paints, watercolors, oils, or ink. © Kemper Mfg., Inc.

Artist's Supplies, Graphics & Printing

🐛🐛🐛🐛🐛🐛🐛🐛🐛🐛🐛🐛🐛🐛🐛🐛

This section includes Airbrushing and Calligraphy. See PAINTS, FINISHES & ADHESIVES; TOLE & DECORATIVE CRAFTS; and other specific categories; BOOKS & BOOKSELLERS, PUBLICATIONS, and ASSOCIATIONS.

🐛🐛🐛🐛🐛🐛🐛🐛🐛🐛🐛🐛🐛🐛🐛🐛

ACP Inc.
P.O. Box 1426
Salisbury, NC 28145
704-636-3034

Catalog $1.00.

Artist's supplies: Staff pens and nibs; Brause, Speedball, Mitchell (and carded pens). Platinum Silverline, Osmiroid, and Shaeffer pens. Pen sets, markers, metallics. Inks—calligraphy, colored, drawing, fountain pen, sepia, calligraphy types. 25 Winsor & Newton drawing inks and 65+ gouache colors. Gesso primer. Practice pads and guidelines. Papers: fine papers, tracing and parchment types. Acrylic folk art paints, brushes. Calligraphy books. Line of basketry supplies and books. Allows discount to teachers, institutions, and professionals. (Also sells wholesale to businesses.) (See BASKETRY.)

Aiko's Art Materials Import
3347 N. Clark St.
Chicago, IL 60657

Catalog $1.50.

Oriental art supplies including brushes, inks, papers. Japanese handmade paper (for printing, painting, collage, restoration, crafts, bookbinding); homespun (Kizuki), solid colors, textured with fiber, Masa.Hsho.Torinoko papers, designed (paper on paper), stencil designed, metallics, Gossamer types. Fabric dyes and equipment.

Aldy Graphic Supply, Inc.
1115 Hennepin Ave.
Minneapolis, MN 55403

Send SASE for list.

Staedtler technical pen set (7), tabletop Speedcote and Procote handwaxer, Portage artwaxer. Safco vertical art rack, Iwata airbrushes, Alvin folding table. Projectors (Artograph AG 100 and DB400 types). Others.

Alexander Art Corporation
P.O. Box 20250
Salem, OR 97307

Free supply catalog.

Supplies: specially formulated oil paints (extra thick), and personally designed brushes (by Bill Alexander, as seen on TV). Instructional videos (techniques, hints, and tips) and books; bimonthly newsletter. Credit cards.

American Airbrush Academy
14144 Central Ave.
Chino, CA 91710
714-591-4573

Send SASE for videos list.

Videos on airbrushing — may include wall murals, graphics, T-shirts, ceramics, other; techniques and hints.

American Artist Book Club
P.O. Box 2012
Lakewood, NJ 08701

Send SASE for full information.

Members are entitled to purchase an introductory selection at substantial savings, and agree to purchase an additional two books in the next year at discounts from 20% to 50%. Members receive a club bulletin 15 times yearly. Among the art instruction books may be: all aspects of painting and painting techniques, pastels, impasto, colored pencils, drawing, perspective, methods of impressionism, wildlife artists, faces and figures, others.

American Tombow, Inc.
3115 Via Calinas
Westlake Village, CA 91361
818-889-3440

Contact dealer or send SASE for details.

Tombow ABT brush-pen (pen on one end, brush on the other — either tip can be used to create subtle water washes) with waterbase ink, in 72 colors and in sets.

Art Box
Van Alstyne, TX 75095

Catalog $2.00 (refundable).

Artist's supplies: acrylics, oils, canvases, brushes, easels, mediums, watercolor sets, charcoal, oil pastels, paper palettes, paint sets, other supplies.

Art Express
1561 Broad River Rd.
Columbia, SC 29210

Free catalog.

Art supplies "at discount" — known brands including Holbein, Grumbacher, Canton, Artograph, Badger, LeCornell, others; paints, papers, canvas, inks, pastels, equipment and accessories; others.

Art Supply Warehouse
360 Main Ave.
Norwalk, CT 06851
203-846-2279
800-243-5038 (orders only)

Write for catalog.

Artist's supplies: full line of paints (watercolors, oils, acrylics), markers, brushes, papers, canvas, equipment and

tools; others, at "savings up to 60% off suggested retail prices." MasterCard, Visa.

Art Video Library
1389 Saratoga Way
Grants Pass, OR 97526
503-479-4071

Brochure $1.00.

Art instructional videos for sale to anyone, sale or rent to members. For a yearly fee, members may rent up to 3 videos at a time at low cost (rental may apply to purchase). Videos (VHS/Beta) cover acrylics, oil and watercolor painting, pastels, drawing, color, perspective, anatomy, still life, landscapes, portraits; with noted instructors (John Michael Carter, Dolores Demeres, Margaret Holland Sargent, Kendra Burton, Julie Kelly, Gary and Kathwren Jenkins, William Palluth, William Blackman, Rick Graham, Linda Flannery, Joyce Pike, Uni Martchenko, Neil Boyle, Glen Vilppu, Jake Lee, Lynn Pittard, Brenda Harris, others. (See CRAFT SUPPLIES.)

ArtCadi Products
Box 5591
Lincoln, NE 68505

Contact dealer or send SASE for information.

Accessories for drawing desks: tool holder plus piggyback for felt markers, "drop lock" airbrush holder.

Arthur Brown & Bro., Inc.
P.O. Box 7820
Maspeth, NY 11378
718-628-0600

Catalog $3.75.

Art supplies of a wide array of known brands, others: colors, media, and finishes—known brands. Papers including watercolor, tracing, rice, fluorescent, printing types, others. Supplies, equipment, and tools for lithography, calligraphy, graphic arts, dry mounting, framing, airbrush, silkscreen, wood carving, textile painting, engraving, block printing, etching, others. Adhesives.

Equipment: lettering guides, brushes, easels, scaleograph, lighting, magnifiers, paper cutters, furniture, tracing units; tools by Dremel, X-acto, Paasche, Badger, Burgess, Thayer & Chandler, Koh-I-Noor, Ultrasonic, others. Drafting items. Books.

Artists' Connection
20 Constance Ct.
P.O. Box 13007
Hauppauge, NY 11788

Free catalog.

Art supplies: name brand brushes, paints (watercolors, gouache, oils, acrylics, others), easels and accessories; other supplies "from 20% to 70% off retail."

Artists' Video Productions
97 Windward Lane
Bristol, RI 02809

Free catalog.

Arts America
12 Havemeyer Pl.
Greenwich, CT 06830
203-869-4693

Free catalog.

Over 300 arts/crafts videos on techniques, exhibitions, artists, museum collections, architecture, others.

Assn. of Television Artists
P.O. Box 2746
Reston, VA 22090
703-450-7666

Send SASE for complete information.

A membership in this painting association allows discounts on supplies, videos, and books; a subscription to "Brush Strokes" newsletter, craft projects; notification of artists' seminars, demonstrations, classes, etc. Among the artists mentioned: Bob Ross, Priscilla Hauser, Dorothy Dent, Gary Jenkins.

Badger Air-Brush Co.
9128 W. Belmont Ave.
Franklin Park, IL 60131

Project information sheet & catalog $1.50.

Airbrushes (large cup gravity feed) for painting and finishing, in sets/outfits. Air-Opaque paints in 35 non-toxic colors and 8 pearlescents that are intermixable; lightfast, waterproof, non-bleed paints for air-brushes, paint brushes, or technical pens.

Beebe Hopper
731 Beech Ave.
Chula Vista, CA 92010
619-420-8766

Send SASE for list.

Decorative art instruction books (with Featherstroke technique): Painting Wild Geese, Wildfowl Painting of variety of ducks, and instructions for detailed painting of waterfowl scene; Mallards, and Canvasback duck books.

Berol USA
Brentwood, TN 37024

Contact dealer or send SASE for information.

Berol™ Prismacolor™ color pencils (and in sets of 12, 24, 36, and 48 colors); and Art Stix™ (and in sets of 12, 24, 36 and 48 colors); can be used with cold press 100% cotton papers with watercolors and other techniques.

C & L Productions
Suite 2001, Brown & Williamson Tower
Louisville, KY 40202

Free brochure.

Paint-Along instructional videos (2 hrs.) with John Michael Carter, as one-on-one workshops — painting demonstrations/instructions; color mixing; in oils; on still life, landscape, waterfront, portraiture.

Camelot Productions
2750 Glendower Ave., Suite 20
Los Angeles, CA 90027

Send SASE for list and information.

Oil painting instructional videos (1-2 hours, VHS or Beta), by Margaret Holland Sargent, A.P.S.C.: Getting Started, Basic Techniques, Intermediate Oil Painting Techniques, How to Succeed in Portraiture, Portraits: Painting the Head, Sample Promotion Portfolio. Has price break on order of 4+ videos.

Candlelight Studios
P.O. Box 627
Littleriver, CA 95456

Send SASE for list.

Art instructional videos (40 min. to 82 min. long; VHS, Beta) by E. John Robinson: oils — seascapes (surf, breakers, rocks/surf, sea at sunset, moonlit sea) and landscapes (mountain/lake, sunset, cascading stream, autumn vineyards). Watercolor seascape.

Canson-Talens (formerly Morilla, Inc.)
21 Industrial Drive
South Hadley, MA 01075

Contact dealer or send SASE with inquiry.

Canson French watercolor papers: Moulin du Roy—an archival, 100% cotton, acid-free paper for all wet techniques; Montval — delicate surface, acid-free, for wet techniques. Bristol 100% rag graphic papers, also tracing, bond layout, ledger, cross section, others. Rembrandt™ soft pastels in 203 colors (42 pure tones, 40 dark shades, 121 pale tints).

Charles Brand Machinery Inc.
45 York St.
Brooklyn, NY 11201
718-797-1887

Send SASE or call for full information.

Line of etching presses, lithography presses, inking rollers, electric hot plates, others.

Cheap Joe's Art Stuff
300A Industrial Park Rd.
Boone, NC 28607

Free catalog.

Artist's supplies: Arches papers — 140# CP or rough, 300# CP or rough; 25 sheets and up. Winsor & Newton brushes (flat, flat wash, and others). Line of supplies at reduced cost. Professional oils, watercolors.

Co-Op Artists' Materials
P.O. Box 53097
Atlanta, GA 30355

Free catalog.

Artist's supplies/equipment (known brands): oils, acrylics, watercolors, gouache, dry pigments; sets. Modeling paste. Drawing inks, calligraphy pens/sets, markers, 5 pastels sets, oil pastels, iridescents. 4 colored and other pencils/sets. Brush-pans. Paper and mat cutters. Sumi kit, ink sticks, pigments, grindstone, watercolors, brushes. Paint items: 9 palettes, 7 easels, stretcher strips, pre-stretched canvas, tools. 11 pages of brushes.

73 art papers (handmade, others): watercolor, print, mardi gras colored, pastel, parchment, Oriental, tracing; acid free types; pads, boards. Acetate and films. 15 tapes, pens, erasers and electric erasers, 5 sharpeners. Wax. Spray adhesives, cements, glues. Art waxers. Burnishers.

Drafting—rules, triangles; sets; technical and plotter pens, T-squares. Letraset, templates. Ultrasonic cleaner. Frames. 7 drafting tables, boards. Magnifier lamps, lamps, tracing box, projector. Airbrushing: 30+ airbrushes, sets. Compressors, regulators, accessories. Airbrush parts. Colors — 12+ types; Deka fabric paints, metallics, fluorescents. Stencil burner, material. Bronze powders (metallic golds). Treasure gold wax. Sign painting brushes and enamels. Modeling clay, Permoplast, Marblex; tools. Books. All at discount. Runs sales.

Conrad Machine Co.
1525 S. Warner
Whitehall, MI 49461
616-893-7455

Free catalog. Request trade-ins list.

Etching and lithography presses: etching presses in 12" X 24" size equipped with steel rolls, Benelex Bed & y to 1 Drive. Etching presses — 18" X 36" and 24" X 53" equipped with Benelex Bed & Deluxe Twin-Torque drive. Convertible Press (27" X 48") hand drive model, equipped with Benelex Bed, Delux Twin-Torque drive. Lithographic press. Options: steel stand, micrometer gauges, extra long bed plates. Heavy duty floor model etching presses and lithographic presses. Accessories: Levigators, mezzotint rocker, muller, others. Remanufactured presses, in 12" to 36" size. Quantity prices. (Sells wholesale to businesses.)

Coyote Film Productions
P.O. Box 16004
Santa Fe, NM 87506

Send SASE for details.

Instructional video (VHS) — Santa Fe Art Class with M.A. Nibbelink, Becoming a 'Colorist' with Watercolor: teaches basic skills of watercolor — drawing, composition, value, color, technique, then creates a watercolor with the viewer.

DAD Publishing Co.
701 Lee St.
Des Plaines, IL 60016

Send SASE for details.

Instructional videos — Learn to Paint (for oil painting) by Sherry C. Nelson. How to Paint a Hummingbird, and How to Paint a Pintail Duck, with packets. By Buck Paulson: Dancing Lights, Seascape Canvas, How to Paint Skies (different skies), Basic Principles of Seascapes.

David A. Leffel
P.O. Box 278
Sanbornton, NH 03269
603-934-3222

Send SASE for details.

Art video tapes: Painting the Portrait, Painting the Still Life—complete palette and brush techniques (18 years at Art Student's League), 120 minute lengths. Master-Card, Visa.

Dember Arts
P.O. Box 8093
Van Nuys, CA 91409

Send SASE for listing.

Instructional videos (2½ to 5½ hour step-by-step art courses): basic, advanced airbrush techniques and photo retouching; watercolor Hi-Tech, and Scientific Render-ing. Renderings and techniques in various media; and Hi-tech and Industrial Rendering — cutaway illustrations, conceptual and finished professional renderings. Painting Techniques for Murals — covers materials, paints, brushes, airbrushes, masking devices, scaffolding, mall stick aids, tapes, transferring color comprehensives to wall surfaces. Instruction books. MasterCard, Visa.

Dick Blick
Box 1267
Galesburg, IL 61402

Catalog $3.00.

Art supplies: paints—acrylics, watercolors, oils, egg tem-pera, alkyds, water miscible oils, paintstiks, quick-dry oils, others; brushes, holders. Sets. Canvases, stretcher strips. Pastels, pencils. Etching benches, press. Picture frames. Shrink wrap machines, mat cutters, mat boards, and pre-cuts. Portfolios, boxes, totes. Airbrushes, pens. Phantom Line drawing aid (reflective viewer). Easels, sketchboard, art projectors, lightbox. Magnifiers, draft-ing tables. Books. Quantity prices. (See CRAFT SUP-PLIES and SCULPTURE & MODELING.)

Educational Art Materials
6180 Atlantic Blvd.
Norcross, GA 30071

Catalog $2.00.

Artist's supplies (bulk and other): paints—tempera, fin-ger paints, acrylics—in pint and up sizes; others, sets. Watercolor sets. Palettes, Spin-A-Patch™, boxes. Boxes of illustrated modern art and other cards. Easels, can-vas, stretcher strips, calligraphy kit, pens, papers. Mark-ers, pens, crayons, chalks, pastels, pencils. Boards, scratch board, drawing inks. Papers — drawing, newsprint, watercolor, rice, others. Paper cutters. Pre-cut mats. Presses, laminating film, tacking iron; 11 pages of brushes. Block and screen printing kits, supplies — presses, inks, others. Has quantity prices. American Ex-press, MasterCard, Visa. (See CRAFT SUPPLIES.)

Embry Publications
#8 Dogwood Court
Dothan, AL 36303
205-794-5712

Send SASE for full information.

"Scratch It and Paint It" kits (pattern comes applied to black scratch board. Scratch off pattern with knife blade, and apply color to white scratches). Designs in-clude: full carousel, cat, rooster, carousel head, dog, rabbit.

Famous Artists School
19 Newtown Tpke.
Westport, CT 06880

Send SASE for details.

Art instruction books using methods developed by Nor-man Rockwell, Ben Stahl, Robert Fawcett, and others), each with self-correcting overlay sheets; each title bought is a free art lesson from a school instructor. Titles in-clude: How to—Draw and Paint Landscapes, Draw and Paint Portraits and Draw the Human Figure, Draw Ani-mals. American Express, MasterCard, Visa.

Graphic Chemical & Ink Co.
728 North Yale Ave., Box 27
Villa Park, IL 60181

Write for catalog.

Printmaking supplies: block printing — linoleum and wood blocks, brayers, cutting tools. Lithographic—gums, asphaltum, tusche, rollers (rubber, NuClear). Litho stones in many sizes. KU Leather and composition. Inks, variety of papers. Other supplies.

Graphic Media Co.
13916 Cordary Ave.
Hawthorne, CA 90250

Catalog $5.00 (refundable).

Art supplies, wide range at "20%-60% off" — name brands including Grumbacher, Winsor & Newton, Liqui-tex, Parker, Pelikan, 3M, Letraset, Lamy, K&E and others.

Grumbacher
30 Englehard Dr.
Cranbury, NJ 08512

Contact dealer or send SASE for information.

Brushes for artists and signpainters. Other artists' sup-plies. Artists' supplies, including Golden Edge synthetic brushes (with resilience/strength of sable) for oils, acry-lics, watercolors; in 8 shapes and 47 sizes. Others.

HK Holbein, Inc.
Box 555
Williston, VT 05495

Catalog and color charts $3.50.

Soft and oil pastels, including sample sets with pastel blending brushes and stumps. Watercolors—84 colors (tubes), pocket travel set. Brushes, including for oils in pure Chinese bristle types, water and Oriental writing brushes with natural and synthetic hair, sable blend, and "Hake" goat hair, in wide range of styles, sizes, and sets.

Artist's oils in 142 colors including transparents, whites, foundations, and sets. Ecolse oils; artists' acrylic colors—transparent, opaque, pearl, and luminous, De-signer acrylic Aeroflash permanent inks in transparent, opaque, and luminous colors. Acrylic gouache.

HW Productions
Box 4273
Burlingame, CA 94011

Free brochure.

Video: Classical Life Drawing, with Fred Holle—lecture demonstration home-study for watercolorists and oil painters. Draw from live model, enhance perception and sensitivity. (From the Artist in Residence™ Series.)

Jerry's Artorama
P.O. Box 1105
New Hyde Park, NY 11040
516-328-6633

Catalog $2.00 (refundable).

Artist's supplies. Opaque projectors, reducing lens.

Joe Kubert Art & Graphic Supply
37A Myrtle Ave.
Dover, NJ 07801
201-328-3266

Catalog $4.00.

Artist's, cartoonist's, and graphic materials: illustration boards, papers (art, parchments, drawing, watercolor, others). Markers, paint colors and sets (oils, acrylics, finger paints, gouache, watercolors, Sumi), finishes. Palettes, brushes—all kinds. Watercolor pastels, tempera, art pens, casein, crayons, chalk. Colored/drawing pencils, pastels. Metallics, gilding. Airbrushes, sets. Calligraphy pens/inks. Drafting materials. Pantographs. Mat and paper cutters. drawing tables, boards. projectors. easels, canvas, stretcher strips. Cartoon and animation instruction books. Graphic and printing products.

Papers (drafting, etching, flint, parchment, printmaking, rag, rice, sign, tracing, others. Contrast-O™ graphic medium (white vinyl over black polyester base). Paints and sets. Metallized polyester. Frisket materials, perspective grids, films. Letraset letters, tapes, film. Markers. Hand/art waxers. Fixatives. Boards.

Drafting/drawing—templates, technical pens, others. Dry mounting presses. Drawing tables, light boxes, projectors. Etching tools, presses, supplies. Block printing presses, papers, brayers, inks. airbrushes. Silkscreen supplies, kits, colors, units, frames, film, fabrics, solvents, film cutting tools, knives. Books. Allows discount to professionals, teachers, and institutions.

John Pike Art Products
P.O. Box 171
Endicott, NY 13760

Send SASE for full information.

Kerry Specialties
P.O. Box 5129
Deltona, FL 32728
407-474-6209

Send SASE for list.

Brushes: artists' and tole types, "golden sable" (feel/handle like real sable)—shaders, sets, others.

John Pike watercolor palette, perspective machine, and book *Watercolor*. "Dealer inquiries welcome."

Koh-I-Noor Rapidograph, Inc.
100 North St., P.O. Box 68
Bloomsbury, NJ 08804
201-479-4124

Send SASE for details and nearest dealer.

Colors/art instruments/accessories: Pelikan opaque and transparent watercolors (pan sets). Gouache—concentrated designer colors (60, 4 metallics) for all surfaces including glass. Master Color (water soluble oils)—18 colors; sets. Casein colors (Plaka) similiar effects to oils. Enamels (thin with water) for models, glass, bisque, tole.

Drawing inks: India, gold, 26 colors; drawing "Z" for drawing/tracing papers; waterproof Ultradraw™. Artist-Color™ transparents for pen, brush; as glaze over acrylics, etc.; 12 color sets. Pens: technical—Rotring Rapidograph™ in colors with dry/seal; and sets; and with disposable capillary cartridges (no-leak, instant ink flow).

Calligraphy and lettering pens, sketch ArtPen™ and ArtPencil™. Water box, Goldstar brushes, art pencil sharpener, pen holders, and cartridges. Accessories: portable white plastic drawing board with locking straight edge, perimeter guide rail; carry case. Drawing instruments. Templates, triangles.

La Papeterie St. Armand
950 Rue Ottawa
Montreal, Quebec, Canada H3C 1S4
514-874-4089

Contact dealer or send SASE for information.

Dominion handmade watercolor papers of 100% linen rag, with deckle edges, a pH of 7.5, in 4 finishes, 3 colors, 3 weights, 5 dimensions; termed "elegant and strong" with no machine direction, identical on both sides.

Langnickel
229 W. 28th St.
New York, NY 10001
212-563-9440

Contact dealer, or send SASE for information.
Nocturna watercolor brushes—synthetic fibers and natural squirrel hair (for soft-strength), black brush area; 21 sizes/styles.

rotring ArtistColor set.
© *Koh-i-noor Rapidograph™*

M-M Videos
Box 158
Freehold, NY 12431

Send SASE for details.

Drawing instructional video, by Stanley Maltzman — step-by-step creation of landscape drawing from choice of location through finished picture—demonstration of techniques, materials, rendering, composition; for beginners and intermediates (56 minutes). MasterCard, Visa.

Magic of Maine
P.O. Box 8000
Lewiston, ME 04243
207-782-5650

Free brochure.

Instructional videos: painting wildlife into landscapes, others — sales and rentals. Video art tape production service for artists.

Masterson Enterprises, Inc.
Box 60243
Phoenix, AZ 85082

Contact your dealer or send SASE for details.

Painter's Pal artist's palette (9" X 12")—stay-wet palette for oils and acrylics, with airtight paint cups and cover, brush storage (keeps paints fresh for days). Paint cups hold primary colors and solvent.

Napa Valley Art Store
1041 Lincoln Ave.
Napa, CA 94558
707-247-1111

Free catalog.

Artist's supplies: Winsor & Newton watercolor papers and blocks, water color series, others. Has MasterCard, Visa.

New York Central Art Supply
62 Third Ave.
New York, NY 10003

Free catalog.

Fine arts supplies: colors (oils, watercolors, acrylics, sets), markers, pens, pastels, brushes, pencils. Over 150 types of canvas (in widths up to 197"), supplies, tools, and accessories for silkscreen, woodcut, etching, lithography. Handmade papers by Fabriano, Arches, and others; other types of papers. Marbling supplies. Other fine art supplies and equipment. "All at discount prices."

North Light Art School
1507 Dana Ave.
Cincinnati, OH 45207

Write for full information.

Home-study art course—instruction (and individual attention) from professional artists; series of basic studies, to advanced; on use of materials, composition, perspective, techniques for pencil, color painting; more.

Ott's Discount Art Supply
714 Greenville Blvd.
Greenville, NC 27858
919-756-9565

Free catalog.

Full range of pencils, charcoal and artist's papers. Others.

Paasche Airbrush Co.
7440 W. Lawrence Ave.
Harwood Hts., IL 60656
312-867-9191

Contact your dealer or send SASE for details.

Airbrushes (including the new gravity feed double action internal mix model, sprays fluid requiring gravity feed and makes color changes with interchangeable color cups); with double action control (air/fluid feed) in set; others; for paints, varnish, lacquers, other. Airbrush accessories, portable air painting kit (for oils, inks, watercolors). Air paint sprayers. Others. Manufacturer.

Painter's Corner, Inc.
108 W. Hwy. 174
Republic, MO 65738
417-732-2076

Send SASE for brochure.

Videos (painting instruction, by Dorothy Dent): 12 titles, 1 hour in length, including landscapes, others. Painting packets, books.

Pearl
308 Canal St.
New York, NY 10013
212-431-7932

Send SASE for list.

Full line of artist's supplies—known brands. May run specials. Has major credit cards.

Pentel of America, Ltd.
2805 Columbia St.
Torrance, CA 90503

Contact your dealer or send SASE for details.

Line of watercolors, artist's oil pastels (36 colors; sets); plastic crayons (non-smear, in sets of 8, 12, and 16 colors). Pastel dye sticks in 15 permanent colors. Has quantity prices, large order discounts. Manufacturer.

Perma Colors
226 E. Treemont
Charlotte, NC 28203
704-333-9201

Send SASE for price list.

Art supplies: dry pigments, rabbit skin glue gesso primed panels, resin/acrylic gesso primed panels. Kolkinsky sable brushes (factory direct). "Dealers needed."

PGO
208 Harris Rd.
Bedford Hills, NY 10507

Send SASE for details.

Portrait guide and overlay: creates true likenesses in any medium or scale with transparent overlay; as complete workshop for students and artists (with instructions).

Rex Graphic Supply
P.O. Box 6226
Edison, NJ 08818
201-613-8777

Send SASE or call for full information.

"The Creator" table for graphic artists, draftsman, etc.: with white melamine top and heavy gauge tubular steel base (enamel finish), dual position foot rest, rear stabilizing bar, built-in floor levelers; adjustable for height and angle; in 2 size models.

Robert Simmons, Inc.
45 W. 18th St.
New York, NY 10011

Contact dealer or write for information.

Brushes for: watercolors, oils, acrylics; crafts, artwork, ceramics, hobbies, lettering. Priscilla Hauser tole decorative brushes. Ceramic brushes — Mary Gilbertson, Marc Bellaire, Helen Altieri types. Fabric Master™ brushes: design book, base coaters (flat, round), scrubbers (nylon). Bamboo brushes, brushes for plaster crafts and china painting. Brush roll pack sets—most sizes and styles. Books. Manufacturer.

Savoir Faire
P.O. Box 2021
Sausalito, CA 94966
415-332-4660

Contact dealer or send SASE for information.

Lana French watercolor papers, including 100% rag Lanaquarelle that is pH neutral, resilient, with surface consistency. Sennelier (French) extra soft pastels, in over 550 colors, each derived from one of 80 pure tones.

Sax Arts & Crafts
P.O. Box 51710
New Berlin, WI 53151

Catalog $4.00 (refundable).

Artist's supplies (known brands): colors — tempera (liquid, powder, cakes, budget), finger paints, crayons, watercolors (and concentrated), acrylics, oils, casein, pastels, oil pastels, and sets. Media, palettes, brushes, palette knives. Boxes, organizers, trays. Markers, pens. Sumi supplies.

Airbrush kits, accessories, compressors, paints, inks, fabric paint, books. Canvases, stretchers, tools. Easels, boards. Papers: drawing, sulphite, construction, backgrounds, corrugated, fluorescent, cellophanes, watercolors, print-making, silkscreen, block printing. Rice papers. Boards: mounting, mats, pre-cut mats. Mat cutters.

Frames, framing tools and supplies. Knives, scissors. Seta fabric paint. Pastes, epoxy, glues, cements. paper trimmers. Electric waxer, glue guns, tapes, punches, pencils. Drawing aids: mannequins, models. Drafting instruments and supplies, calligraphy pens and papers. Let-

tering, mounting presses, film, light boxes, projectors.

Photography supplies. Magnifier lamps, others. Art furniture. Block printing inks, brayers, cutter sets, blocks. Offset printing kit, printing presses. Etching papers, tools, plates, grounds, inks. Paper lithography supplies. Screen printing kits, supplies, frames, fabrics. T-shirt printing machine. Photo and speed screen supplies.

Art instructional videos: painting, airbrush, calligraphy, print making, tissue art, weaving, others. Sound film strips. Books. Has quantity prices. American Express, MasterCard, Visa. (See CRAFT SUPPLIES.)

Seeba Film Productions
American Artist
1515 Broadway
New York, NY 10036

Send SASE for list; $12 for preview tape.

Art instruction videos from England: (1) Watercolour, with Ray Campbell Smith, FRSA (2 hours instruction, all aspects, and outdoor demo), (2) Watercolour Demonstrations, Ray Campbell Smith, FRSA (paints four landscapes). (3) Painting Miniatures, with Elizabeth Davys Wood on materials, methods; comes with sample to paint. (4) Drawing in Pastel Pencils, with Colin Bradley (draws still life and family pets). Airbrushing, with Jim Dunford (choose, care for, and create unique pictures). Preview tape is refundable. VHS or Beta.

Selwyn Textile Co. Inc.
134 W. 29th St.
New York, NY 10001
212-564-7992

Send SASE for samples and price list.

Artist's linen and cotton canvas in widths up to 144", large variety of weights and textures, primed or unprimed. Also has framing fabrics: silks, suedes, velveteens, and burlaps. No minimum requirement. Has discounts for quantity. Credit cards.

Shapiro Art, Inc.
1335 Astor
Chicago, IL 60610

Send SASE for full details.

Instructional one-hour videos (VHS, Beta) with Irving Shapiro, teacher/painter in watercolors: Mountain Stream, and Harbor Scene. (Savings in cost when both tapes are ordered.) MasterCard, Visa.

St. Cuthberts Mill

Contact through distributors.

From England, art papers: Saunders Waterford Series—watercolor, mold made, 100% rag, acid free, gelatine sized, deckle edged; 3 finishes, 4 weights. Bockingford—watercolor, mold made, non-rag, acid free, cold press, 5 weights, "economy." Somerset print-making paper, 100% rag, acid free, deckle edges, 2 colors/ weights/finishes. Distributors: Crestwood Paper Co. 212-989-2700; Steiner Paper Corp. 212-675-0245; Wynstone Papers 312-943-3916; Andrews Nelson Whitehead 718-937-7100; Bienfang (Bockingford only) 215-732-7700.

Stackpole Books
P.O. Box 1831
Harrisburg, PA 17105

Send SASE for details.

Books: *How to Paint Shorebirds, How to Paint Songbirds,* both by David Mohrhardt—gouache and acrylic techniques, step-by-step instructions, overview of painting media and surfaces; practice sketches, color photos, anatomical reference drawings. "Dealer inquiries invited."

Stan Brown's Arts & Crafts, Inc.
13435 N.E. Whitaker Way
Portland, OR 97230
503-257-0559

Catalog $2.50.

Artists' supplies: full lines of paints, brushes, papers, canvas, other materials including known brands; books.

The Artist's Club
4900 SW Griffith Dr., Suite 249
Beaverton, OR 97005

Free catalog.

Pecan shell resin figures, ready to paint—rabbits, figures, children. Master Stripper. Other items. Has major credit cards.

The Italian Art Store
40 W. Ray Burn
P.O. Box 300
Millington, NJ 07946

Free catalog.

European artist's supplies: colors, oils, acrylics, watercolors, others at "savings of 35% off list."

Utrecht Manufacturing Corp.
33 Thirty-Fifth St.
Brooklyn, NY 11232
718-768-2525

Free catalog.

Professional artists' colors, stretchers, paper converters; other major brand art supplies: papers, colors, brushes, canvases, others. "At impressive savings." Outlets in New York, Boston, Chicago, Philadelphia, Washington, DC.

Winsor & Newton
P.O. Box 1396
Piscataway, NJ 08855

Contact dealer or send SASE for information.

Artist's brushes, including the Sceptre™ 6-brush series that blends synthetic fibers with genuine sable — has spring/touch of sable at lower cost; for any medium. Other brushes for variety of media.

Wm. Blackman Productions
2369 Magda Circle
Thousand Oaks, CA 91360

Free brochure.

Over 25 art instruction video tapes (methods and techniques for oils, step-by-step painting): animals, clowns, florals, seascapes, landscapes, barns, exotic birds, others.

Workshops—The Artist's Studio
North Light Art School
1507 Dana Ave.
Cincinnati, OH 45207

Free details.

Artist's painting workshops: professional contact and instruction, aid—in a guided workshop approach; for oil, acrylics, or watercolors.

World Art & Picture Frames, Inc.
626 N. Great Southwest Pkwy.
Arlington, TX 76011

Catalog $5.00 (refundable on $50 order).

Wide range of art supplies—acrylics, watercolors, oils, markers, pens, papers, canvas, others; and picture frames and framing materials; "up to 60% savings."

Ziegler
P.O. Box 50037
Tulsa, OK 74150

Catalog $2.00 (refundable).

Artists' supplies: paints, brushes, variety of papers, miniature easels (brass or wood), picture frames (miniature, shadowbox, others; variety of sizes).

Basketry & Seat Weaving

🐚🐚🐚🐚🐚🐚🐚🐚🐚🐚🐚🐚🐚🐚🐚🐚🐚
See also BATIK & DYEING, INDIAN & FRONTIER CRAFTS, NATURE CRAFTS, KNITTING & CROCHET, and other related categories; BOOKS & BOOKSELLERS, PUBLICATIONS, and ASSOCIATIONS.

Some of the catalogs below also show directions and/or have helpful hints for basketmaking and seat weaving.
🐚🐚🐚🐚🐚🐚🐚🐚🐚🐚🐚🐚🐚🐚🐚🐚🐚

ACP Inc.
P.O. Box 1426
Salisbury, NC 28145
704-636-3034

Catalog $1.00.

Basketry supplies: reeds (8 sizes flat, 4 oval, 11 round). Raffia, cane (7 sizes), and cane binder. Spline, seagrass, fiber rush, prewoven cane. Basket hoops — 5 shapes. handmade handles, birch basket bases. Basket kits: egg, berry, square bottomed, gathering (round bottom, square handle), wall (flat side), purse, homestead, mini (lattice-work base), wine (tall and narrow), colonial (shallow round), carriage, Sunday Go To Meeting, friendship. Tools: awl, reed cutters. Thread. Reed dyes (10 subtle colors). Decorative acrylic paints, aids, brushes. 50+ books on basketry. Allows discount to teachers, institutions, and professionals. (Also sells wholesale to businesses.) (See ARTIST'S SUPPLIES.)

Adirondack Seatweavers
Box 177
Fonda, NY 12068

Send SASE for list.

Basketry/seatweaving items: hoops, hadles, frames, splints (oak, ash, reed), cane, Shaker tape, fiber rush. Dyes, kits, books. "Low prices."

Allen's Basketworks
8624 S.E. 13th
Portland, OR 97202
503-238-6384

Send large SASE ($.45 postage) for catalog.

Basketry supplies (domestic and imported): 3 basic basket kits — Cajun garlic, Cherokee berry, Appalachian melon. Reeds—round, flat, oval, half round—8 sizes. Pullit rattan, and poles. Binding cane. Raffia, pine needles, seagrass, fiber rush (twist paper—6 colors). Corn husks (and colors). "Richard's bean twine" by roll or case. Generic paper-twist in 12 colors, by 10 yard pack or 20 lb. spools. Fiber core. Basket feet. Hoops in variety of shapes and sizes. Handles—market, lock, swing, spear, bushel—many sizes. Wood strips (poplar, black walnut, cherry). Wood bases—rounds, ovals, rectangles, and for paper twist. Paper covered wire. Hearts. Tools:

cutting pliers, awl, splint lifters, basket scissors. Dyes: Comcraft and Napier. Pamphlet: In The Beginning, by Allen Keeney (basic basketry projects for a group); $1.50. 60+ books. Quantity prices, large order discounts; discounts to professionals. (Also sells wholesale to businesses.)

Butcher Block Shop, Etc.
P.O. Box 146
Wrightsville, PA 17368
717-252-2800

Free brochure.

Basket and caning supplies: reed, hoops, Nantucket Lightship supplies. Kits, books.

Carol's Canery
Rt. 1, Box 68
P.O. Box 237
Palmyra, VA 22963
804-589-4001

Catalog $1.00.

Basketry supplies: 70+ basket kits by Carol's Canery, ACP, Blue Ridge, Finestkind, Burgundy Hill, Folk Art, Snaggy Hollow, Nepier, Crooked-River. Dyes: Comcraft, ACP, Cushing, Napier (and stains), Basket Tree. Twist paper—13 colors. Grapevine hoops. Nantucket Lightship molds (oak, walnut, cherry). Naturals: reed (9 sizes), flat, oval, half round, 13 round, smoked round/flat. Rush, seagrass, white pulut, coir, cattail rush, raffia, philodendron leaves. Ash and oak splint, poplar strips, spline (6 sizes). Precut ribs for melon baskets. Cane—14 sizes, binder, cane webbing. Tools: pegs, awls, rush shuttle, caning chisel, clamps, clippers, tip tools, gauge, Weave-Rite tools. Basket feet, waxed thread, hide glue. Wreath forms, hoops, key frames, variety of handles. Books. Has quantity prices, large order discounts. Allows discounts to teachers, institutions, and professionals.

Connecticut Cane & Reed Co.
134 Pine St., Box 762
Manchester, CT 06040
203-646-6586

Free catalog.

Basketry supplies: full line of Nantucket basket molds (purse ovals, fruit basket, Shaker style, bushel, pushbottom—all in solid hardwood with undercut grips), Nantucket accessories (rims, rivets, bolts, pins, ears, handles, bases, ribs, weavers). Basket kits, variety of types. Materials: seagrass, oval hoops, reeds (11/64" to 1"), handles (D, hickory, ash swing, square, others). Reeds (round, flat oval, split), round and square hoops, ash and oak splints. Basket dyes. "Largest selection" of basket books.

Country Seat
Box 24
Kempton, PA 19529
215-756-6124

Send large SASE ($.65 postage) for list.

Basketry and chair seating supplies: oval and other reeds, hoops, handles, basket kits, over 100 instruction books. "Lowest prices." MasterCard, Visa.

Crooked-River Crafts, Inc.
P.O. Box 129
La Farge, WI 54639
608-625-4460

Free brochure.

Basket-Tree Rattan™ floral rattan (to weave or curl, swirl), in basket kits: melon, heart, tulip, lattice, egg, biscuit, country egg, country key; in rainbow, natural. Floral kits: flair, wreath, viney round, and heart wreaths. Supplies: rattan reed (8 kinds; 1 oz. or 4 oz. packs, 1 lb. coil) in 31 colors, natural; in 3 color mixes, Christmas patterns. Assortments: beginner country kits, flair assortments, wreath collection, floral assortments. Hoops. Basketry dyes—24 colors. Natural rattan vine wreath (ready to trim). Jewelry supplies. Quantity prices. Discount to teachers, institutions, professionals. (Also sells wholesale to businesses.)

Frank's Cane & Rush Supply
7252 Heil Ave.
Huntington Beach, CA 92647
714-847-0707

Free catalog.

Basket and seatweaving supplies: 5 rattans and shredded rattan, poles. Canes — 6 sizes, 3 binder canes (and Sadori). 13 cane webbings. Reed spline, fiber rush, wire rush, Danish cord, flat fibre, fibre wicker (paper twist), fibre braids, braided round reeds. Oriental seagrass, coir, sugar palm, rice straw, raffias, sisal cord. 4 reeds, tissue flex. Wood hoops and handles. Basket bases, oak dowels, chair braces, plugs, pins, candle cups, Shaker mugs and pegs, wooden hearts, wheels, parts—spindles, finials, gallery rails. Kits: Nantucket Lightship basket, seat weaving, hand carving. Furniture kits.

Upholstery: welt cords, blind tacking strip, edgings. Polyfilament. Nails. Tools—caning needles, awl, spline and wood chisels, cane cutters, staple gun and lifter, calipers, templates. Books. Brass hardware — drawer handles, roll-top desk lock, ice box hinges, card frame pull, hall tree hook (double), cupboard latch; plated candle cup insert. Quantity prices. MasterCard, Visa.

GH Productions
521 E. Walnut St.
Scottsville, KY 42164

Catalog $1.00 (refundable).

Basket kits. Supplies: handcrafted white oak basket handles and splints, reed, cane; waxed linen thread, tools, books.

Gratiot Lake Basketry
Star Rt., Box 16
Mohawk, MI 49950
906-337-5116

Free catalog.

Complete line of basketry supplies: reeds—round, half round, flat splint, flat oval, smoked, multi-color mixes. White pulute, maple, black walnut, and cherry. Ash splint (1/3" to 3", coils); and red oak, poplar, seagrass. Cane bindings—from mini-fine chair type to wide hanks. Slab and chair rattan. Cane webbing. Hardwood hoops (for egg, rump, or melon baskets) in 9 sizes. Oak rims/hoops—square, oval, round, market. Poplar hoops. Spline, swing handles (5 sizes). Bushel basket handles. D-shaped handles, ash, and oak notched handles; others —round swing, round double notched, oak handles/ears, oak hinged, and hearts, others.

Florida basketry materials: wild grapevine rings, palm inflorescence, philodendron sheath. Basketmaking patterns, by Grace Kabel, Mary Wiseman, Joan Moore, J. Griffin and Elda Nye, Barb Klann, Joyce Gardner, Sharon Wright, Kathy Cook, Sue Kurginski. Books. Quantity discounts; discount to teachers and institutions. (Sells wholesale, with very large minimum order.)

Great Aunt Victoria's Wicker
Box 99
Waubaushene, Ontario L0K 2C0
Canada

Send SASE with inquiry.

Basket kits, round and flat reed, seagrass, dyes. Books.

H. H. Perkins Co.
10 South Bradley Rd.
Woodbridge, CT 96525
203-389-9501

Seat/basket weaving booklet & catalog $1.00.

Caning: strands (over 5 widths) by bunch. Plastic cane (3 widths) by coils. Fiber splint and rush, Hong Kong grass, reed—flat, ash, flat oval. Kits for bench, barstool, ladder back chairs, rocker, others. Reed kits: doll cradle, stools, others. Reeds. Raffia (colors). Basket bases, hoops, books. MasterCard, Visa.

Jam Creations
P.O. Box 31024
Highland, MI 48031

Send SASE for price list.

Books: *Friendship Baskets* (patterns for beginner to advanced), *Tribute* (23 patterns for all levels, as tribute to basketmakers who added "sparkle" to weaving), *Tole Sampler* (weaving patterns, painting instructions).

John McGuire
398 South Main
Geneva, NY 14456
315-781-1251

Send large SASE for information.

Basketry supplies: Nantucket items, handles, molds. Custom-made tools. Book: *Basketry, The Shaker Tradition*, by John McGuire (autographed).

Judy Mulford
2098 Mandeville Cyn. Rd.
Los Angeles, CA 90049

Send SASE for price information.

Book: *Basic Pine Needle Basketry*, by Judy Mulford (with 200 drawings and 118 photos); includes weaving basics, stitches, making lids, dyeing and embellishments, designs, other.

Made in the Shade
4842 Flamingo Rd.
Tampa, FL 33611
813-837-5243

Send $1.00 for samples and prices.

Basket weaving materials: multi-reed, handspun yarns, philodendron sheaths, palm sprays, others.

Mary E. Lewis
4411 Bee Ridge Rd., Suite 239
Sarasota, FL 34233

Samples $1.00 (refundable).

Tropical basket weaving materials: philodendron sheaths (by doz. lots), palm inflorescence (by the pound). (Also sells wholesale.)

Misti Washington
521 Canyon Dr.
Solana Beach, CA 92075
619-481-9548

Send SASE for price list.

Books: *Appalachian Beginnings* (techniques and designs for five styles of rib constructed baskets), *The Grandmother Basket* (how-to booklet on Appalachian four-quadrant melon basket).

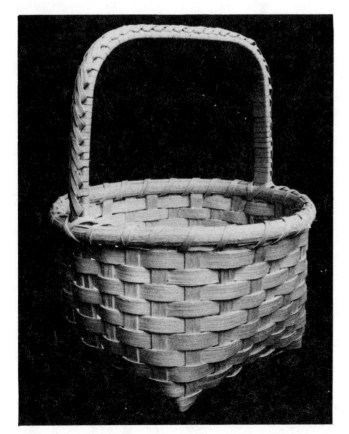

Sunday Go-to-Meeting basket made from a kit. © *ACP. Inc.*

North Carolina Basket Works
1808 Phillips Dr.
Sanford, NC 27330

Send $.45 stamp for price list.

Distinctive selection of basketry kits; complete line of supplies including reeds, other naturals, large selection of handmade white oak handles. Nantucket and Shaker hardwood molds—accurate reproductions; rental available on selected molds. (Also sells wholesale.)

North Star Wood Products
247 N. Ash St.
Gwinn, MI 49841
906-346-6195

Send large SASE for list.

North Star oak basket handles; variety of types, styles, and sizes; "remarkable prices." (Also sells wholesale.)

Ozark Basketry Supply
599 FA
Fayetteville, AR 72702

Catalog $4.00.

Supplies: basketry kits, tools, chair cane, handles, hoops, materials, chair seating supplies, dyes — "low priced." 100+ books. MasterCard, Visa. (Also sells wholesale.)

Plymouth Reed & Cane Supply
1200 W. Ann Arbor Rd.
Plymouth, MI 48170
313-455-2150

Price list and brochure $1.00

Basketmaking supplies: natural weaving products, handles, hoops, tools, kits (variety of styles and sizes); chair caning materials, others. Dyes, tools. Instruction books. Discover, MasterCard, Visa. (Also sells wholesale.)

Quist Co.
16484 Hwy. 202
Rocky Ford, CT 81067

Send SASE for details.

Rope making machine (for swings, jump ropes, etc.).

Reed & Cane
Rt. 1, Box 960
Eureka Springs, AR 72632
501-789-2639

Catalog $1.00.

Basketry supplies including reed: flat or round, variety of sizes; 10 pound minimum. Other items. Has MasterCard, Visa.

Royalwood Ltd.
517 Woodville Rd.
Mansfield, OH 44907
419-526-1630

Catalog $1.00 (refundable).

Basketry supplies: large selection of reed and other natural weaving materials; hoops, handles, dyes, accessories,

basketry kits. Martha Wetherbee's brown ash, tools, molds. (Also sells wholesale.)

The Basket Works
77 Mellor Ave.
Baltimore, MD 21228

Catalog $1.00 (refundable).

Basketmaking items: reed, ash, oak, pine needles, raffia, oak hoops, handles; kits, dyes, books. (Also sells wholesale.)

The Caning Shop
926 Gillman St.
Berkeley, CA 94710
415-527-5010

Catalog $1.00 (refundable).

Basketry and chair caning supplies: cane webbing, canes, binder cane, spline, Danish seat cord, rawhide and rubber webbing, Shaker tapes (colors). Reed splint, fiber rush, Hong Kong grass, ash splint, braided raffia, willow sticks. Reeds (whole and split). Rattan poles, Kooboo and whole rattans. Pine needles, hickory and palm bark, paper rush, jute roving, date palm stalks. pressed fiber seats. basket kits, hoops. Tools: awls, chisels, clamp, knife, clippers, shears, sliver gripper, cutters. Instructional videos for rent. Books. Quantity prices, discounts to professionals. (Also sells wholesale to businesses.)

The Handle Works
8400 Old Hartsville Rd.
Adolphus, KY 42120

Catalog $1.00 (refundable).

Basket handles—handcrafted of white oak (swing handles with ears). Basket rims; tools, books.

The NorEsta
320 Western Ave.
Allegan, MI 49010
616-673-3249

Send SASE for price catalog.

Basketry supplies: press cane, hank cane, rush, splint, wicker, flat and round reeds, hoops, handles, dyes; basketry tools, others. Books. (Also sells wholesale.)

The Reed Dyepot
P.O. Box 1432
Southwest Harbor, ME 04656

Send SASE for full information.

Book: *The Reed Dyepot*, by Kay MacQuaid (dyeing reed with natural dyes such as logwood, madder, indigo, cochineal, others). "Wholesale inquiries welcome."

The Wool Room
Laurelton Rd.
Mt. Kisco, NY 10549
914-241-1910

Send $1.00 and SASE for catalog.

Line of basketry supplies. (Also weaving and knitting equipment and yarns.) Has quantity prices. Allows discount to teachers and institutions.

Tint & Splint Basketry
P.O. Box 123
Dearborn Heights, MI 48127
313-565-5320

Send SASE for catalog.

Complete line of basket-making supplies: natural materials, handles, hoops, tools, dyes, books, others.

Victorian Video Productions
P.O. Box 1540
Colfax, CA 95713
707-762-3362

Free catalog.

Instructional videos, including Robin Taylor Daugherty: Splint Basketry I—Appalachian Egg Basket & Melon Basket (includes rim and handle variations, finishing techniques; 79 minutes), and Splint Basketry II — Spoked and Plated Techniques (variations for spoked service basket and plaited twill market basket; with several handle decorations; 96 min.). (And 19 other video tapes, on variety of subjects.)

Walters, Ltd.
Mountain Rd.
Washington Isle, WI 54246
414-847-2276

Send SASE for full information.

Basketry materials: English basket willow (imported from Bristol, England); propagated root, for growing of own materials, comes with rooting powder, instructions.

Wild Willow Press
P.O. Box 438
Baraboo, WI 53913

Send SASE for full details.

Book: *Gifts From the Earth*, by Char TerBeest (field guide to plants and botanicals)—gathering instructions for basket-making materials in the midwest; illustrated by Rhonda Naas, for easy botanicals identifications.

Bead Crafts

❧❧❧❧❧❧❧❧❧❧❧❧❧❧❧❧

See also CRAFT SUPPLIES, INDIAN & FRONTIER CRAFTS, JEWELRY MAKING & LAPIDARY, MINIATURE MAKING, and related categories; BOOKS & BOOKSELLERS, PUBLICATIONS, and ASSOCIATIONS.

❧❧❧❧❧❧❧❧❧❧❧❧❧❧❧❧

Alohalei Hawaii
Box 3070
Pueblo, CO 81005

Catalog and pattern $1.00 (refundable).

Line of beads (pearls, others) and craft supplies; "How To Bead," others. "Lowest prices."

Art to Wear
4202 Water Oaks Lane
Tampa, FL 33624
813-265-1681

Catalog $1.00.

Bead stringing (jeweler's) tools: pliers, tweezers, scissors, pin vise, awl. Velvet bead board. Needles, bead tips, crimps, tigertail, cable chain, foxtail. Bullion wire, needle cards, silk cones, spool cord kit. Findings: clasps, earring findings, jump rings, others. Beads: sterling, 14K and gold-filled (rounds, corrugated, rondells, ovals, lanterns), semi-precious gemstone beads (amethyst, amazonite, aventurine, onyx, blue lace, bone, carnelian, garnet, lapis, malachite, rose quartz, others). Cultured and freshwater pearls. Coral (drilled). Designer bead kits for bracelets, necklaces, and others. Has small discount on large orders. Book: *Step By Step Beadstringing—A Complete, Illustrated, Professional Approach*, by Ruth F. Poris. (Also sells wholesale to dealers.)

Artway Crafts
P.O. Box 1369
Van Alstyne, TX 75095
800-722-0007

Catalog $1.00 (refundable).

Beads: acrylics, plastic, wood, crystal, alphabet, pearls, rocailles, glass fruit, seed, aurora borealis, others. Teardrops. Bead ornament kits and baskets. Rhinestones and setter. Spangles. 14 Ming tree kits (with wire form). Brass and beading wires. Tigertail. Quantity prices. Discover, MasterCard, Visa.

Bally Bead Company
P.O. Box 934
Rockwall, TX 75087

Catalog $4.95 (refundable).

Jewelry making: gemstones, fetishes, Heishi, old coins, other ethnic items. Beads: wood, Czech crystal, seed, antique silver, 14K, gold-filled, sterling, and plated types.

Designer jewelry parts (specalizes in ethnic and Santa Fe looks). Beading supplies. Knotting and beading lessons. (Also has finished jewelry.) Discover, MasterCard, Visa.

Beads-by-the-Bay
P.O. Box 5488
Novato, CA 94948
415-883-1098

Catalog $4.25.

Beads (specializes in Czechoslovakian beads): seed, bugle, fire polish, and others. Jewelry findings and supplies. (Also sells wholesale.)

Betty Fenstermaker Cochran
845 Willow Rd.
Lancaster, PA 17601
717-392-1865

Send SASE for list.

G.B. Fenstermaker's glass trade bead books series including: *Chinese Beads, Medicine Man, Late Beads in African Trade, Early Trading Post Beads, The Russian Bead, Colonial Turkish Colored Bead Chart*, others.

Boone Trading Company
562 Coyote Rd.
Brinnon, WA 98320
206-796-4330

Catalog $1.00.

Antique glass trade beads (strung) — including: circa 1800s "White hearts," translucent red/white center, blue smalls, jade green or medium blue glass. Padre beads (3/8" turquoise round, circa 1500s). Russian blues (3/8" faceted opaque blue, circa 1800s). Quantity prices. (Also sells wholesale to businesses.) (See SCRIMSHAW.)

Bovis Bead Co.
P.O. Box 111, 23 Main St.
Bisbee, AZ 85603
602-432-7373

Illustrated catalog $10.00 (refundable).

Rare antique beads from areas worldwide including religious, traders, merchants of antiquities, others: ceramic beads from Mexico, Peru, Guatemala. Navajo sterling beads. Malachite, garnet, and azurite beads; other gemstone beads; wide array of sizes, colors, types. Beading supplies: needles, cords, jewelry findings, others. Books.

Brahm Limited
P.O. Box 1
Lake Charles, LA 70602

Catalog $2.50.

Wide array of precious, semi-precious stones (abalone, agate, amethyst, aquamarine, carnelian, coral, facet crystal, dolomite, epidot, garnet, hematite, jade, jasper, onyx,

obsidian, malachite, peridot, rose quartz, turquoise, topaz, others). Acrylic beads (simulated stones—variety of shapes, colors). Costume jewelry beads—glass, acrylic, wood. Bead wire, silk cords, color-waxed linen cord, nylon coated wire, threads. Jewelry findings in 14K and gold-filled, sterling, rhodium, surgical steel. 26 rattail ribbons. Wires: sterling, gold-filled, tigertail, square brass, copper, sterling silver. $35 minimum order. Has quantity prices; allows discount to teachers and institutions.

Canyon Records & Indian Arts
4143 N. 16th St.
Phoenix, AZ 85016
206-266-4823

Request craft list.

Beads—variety of types/sizes: seeds, rocailles, bugles, crow, hexagon; metal, bone. Threads, quills, furs, shells, feathers. Findings, shawl fringes.

Hansa
4315 Upton Ave., So.
Minneapolis, MN 55410
612-925-6014

Catalog $2.00.

Venetian glass beads, hand-formed: millefiori, chevron, fiorato, floral, foil, lamp.

Kaydee Bead Supply
Box 07340
Ft. Myers, FL 33919

Catalog $2.00 (refundable).

Full line of beads, pearls, buttons, "quantity prices."

KUMAco
Box 2719
Glenville, NY 12325

Catalog $1.00.

Gemstone beads: jade, coral, turquoise, ivory, Chinese porcelain, crystal, bone, horn, shell, liquid silver, others. Jewelry findings, supplies, tools. Stringing kits. Books.

Mangum's Western Wear
P.O. Box 362
Blackfoot, ID 83221
208-785-9967

Catalog $1.00.

Seed beads (down to size 24); will match color swatches.

Ornamental Resources Inc.
Box 3010
Idaho Springs, CO 80452
303-567-4988

Catalog $25.00 (with one year's supplements) or SASE for details.

Full and complete lines of beads including glass (faceted, cut, pearlized, foiled, decorated, fancy, Pekina types, in variety of sizes, shapes, and colors). Beads, pendants, and drops of glass, metal, wood, ceramic, plastic, bone, stone, shell. Bugle beads—up to 1½" long.

Pony and seed beads (all sizes). Rare and unusual beads for collectors. Plastic and glass bead chains. Metal stampings. Applique materials and motifs. Rhinestones and studs (flat and point—30 colors). Beading tools and supplies. Sequin and glass sew-ons and jewels. Old bullion trims, tassels. Buttons and buckles. Reference and how-to books. Custom design. $50 minimum order.

Arapaho beadwork on hide

Promenade's
Box 2092
Boulder, CO 80306

Catalog $2.50 (refundable).

Full line of beadwork supplies (for beaded jewelry, trim on clothing, other). Beading kits, threads, needles. Bead instruction booklets for earrings, clothing, others.

Roxy Grinnell
P.O. Box 1155
Paonia, CO 81428
303-527-0365

Free catalog.

Beads: crow, pony, 9/0-3 cuts, 11/0 and 14/0 seeds, bugles, rounds, tubes, chevrons, mosaics; metal, bone, quills, mother-of-pearl. Supplies.

Shipwreck Beads
5021 Mud Bay Rd.
Olympia, WA 98502

Catalog $3.00.

Full line of beads: glass, metal, wood, plastic; antique types, others. (Also sells wholesale.)

Sidney Coe, Inc.
65 W. 37th St.
New York, NY 10018
212-391-6960

Catalog $2.00.

Full lines of beads in many styles, colors, sizes, types; glass, plastic, others.

The Bead Shop
177 Hamilton Ave.
Palo Alto, CA 94301

Catalog $3.00.

Line of beads and bead kits, sampler boxes: exotics, ancient, "jeweled," gemstone, metal, glass. Charms, findings, threads, others. (Also sells wholesale.)

Sequin Star. © Dazian Fabrics

The Freed Company
415 Central N.W., Box 394
Albuquerque, NM 87102
505-247-9311

Send SASE for list.

Beads including collector types, gemstones (coral, amber, ivory, others), clay, wood, glass, cinnabar, metal, cloisonne, others; oddities. Fetishes, netsuke, sequined appliques, milagros, others.

The Garden of Beadin'
P.O. Box 1535
Redway, CA 95560
707-923-9120

Catalog $2.00.

Beads: bugles in oz. up lots. Clay shapes (cube, short bugle, rectangle, cylinder). Glass seed beads (full range of colors), crow, pony, 12/0's 3X; by hanks. Hex beads.

Crystal and other gemstone colors. Other beads: Czech drops, West German crystal faceted, cut glass, smooth glass (and colors). Odd shaped beads, wood beads including large-hole. Hand-painted Peruvian beads. Other ethnic beads, satin glass, Venetian trade beads, and pseudo trade types. Heavy metal bead shapes. Semi-precious beads, hearts, chips, rounds. Needles, findings. Bulk prices. Credit cards. (And wholesale.)

Touch the Earth
30 S. Main St.
Harrisonburg, VA 22801
and in Wisconsin:
220 Main St.
La Crosse, WI 54601

Catalog $2.00.

Beads: trade beads (chevrons, ovals, white hearts, Hudson Bay), faceted (lead crystal and colors), crow. Abalone discs and pink conch beads. Metal (hawk bells, melon, solid brass, fluted), bone hairpipe. Glass strung beads—sizes 8/0—13/0 (transparent and opaque colors by hank). Fancy beads (lined, pearl colors, 3-cut, bugles, others). Jewelry findings: surgical steel, plated, sterling—ear wires, clips, ear screws, posts, clasps, rings, others. Needles. Nymo-nylon threads, beeswax, artificial sinew. Handcrafted Native American style jewelry and pottery.

Universal Synergetics
16510 S.W. Edminston Rd.
Wilsonville, OR 97070
503-625-7168

Catalog $2.00 plus $.52 postage.

Seed beads (11/0—22/0), bugles. Findings, threads, needles, books. (Also wholesale.)

Westcroft Beadworks
139 Washington Dr.
South Norwalk, CT 06854
203-852-9194

Catalog $10.00 (refundable).

Over 1,500 different beads: plastics, acrylics, glass types, wood, metals, others; variety of sizes and shapes. (Also wholesale.)

Cakes & Candy Decorating

See also CRAFT SUPPLIES, MOLD CRAFTS, and related categories; BOOKS & BOOKSELLERS, and PUBLICATIONS.

Crafty Gifts & Treats
P.O. Box 1836
Peterborough, Ontario, Canada K9J 7X6

Send SASE for list.

Cake decorating and candy making supplies: molds, decoratives (ribbons, flowers, novelties, others). Cake decorating and chocolate making how-to books, others.

Kemper Mfg. Co.
13595 12th St.
Chino, CA 91710

Contact dealer or write for literature.

Cake/candy making: decorating sets (pan, spatula, 9 tools; instructions). Tools for flower making (petal cutters—6 sizes, other cutters), flower sticks, pattern cutter sets (8 designs), flower roller, mini ribbon sculpting, detail carving, flower sticks, bud-setter, rose and leaf cutter sets. Others. (See CRAFT SUPPLIES.)

Meadow's Chocolate & Cake Supplies
Box 448
Richmond Hill, NY 11419

Catalog $2.00.

Cake decorating and chocolate molding supplies—full line, instructions, accessories, tools, trims, molds, icings, others. "Quantity discounts."

Sweet Creations
1217 Oxford Ave.
Oakville, Ontario, Canada L6H 1S4

Catalog $4.50.

Full line of cake decorating supplies, by Wilton and others: variety of pans and molds, in heart, round, and novelty shapes; ingredients, colors, aids, stencils, others. Also general crafts supplies.

Video Sig
1030 East Duane Ave.
Sunnyvale, CA 94086
408-730-9291

Free catalog.

Instructional videos in many categories, including some crafts, and (1) Cake Decorating for All Occasions, with close-up photography and expert instruction for home viewing or home economics classes. (2) How to Construct and Decorate a Wedding Cake—a show-and-tell video demonstration; gives how-tos of all aspects of making the wedding cake with closeups, detailed and thorough explanation. (Also other videos on woodworking, home repair and decorating, photography, origami, watercolors, other general topics.) MasterCard, Visa.

Wilton Enterprises
Woodridge, IL 60517

Contact dealer or send SASE for information.

Cake/candy decorating materials, supplies, tools, equipment: cake pans, sheets, shapes (baseball mitt, goose, teddy, kitten, mouse, Big Bird, hearts, others); wedding cake pans, accessories; special occasion supplies; bags for decorating, cookie cutter shapes, cake novelties, decorating sets and items, booklets; 18 icing colors, and sets (concentrated paste). Candy-making molds, supplies.

Ceramics

❧❧❧❧❧❧❧❧❧❧❧❧❧❧❧❧❧❧

See also CRAFT SUPPLIES, SCULPTURE, and DOLL & TOY MAKING—RIGID, and other related categories; BOOKS & BOOKSELLERS, PUBLICATIONS, and ASSOCIATIONS. Those having difficulties with ceramic techniques will find Custom Services helpful—noted in company listings and in the index.

❧❧❧❧❧❧❧❧❧❧❧❧❧❧❧❧❧❧

Aegean Sponge Co., Inc.
4722 Memphis Ave.
Cleveland, OH 44144
216-749-1927

Write for price lists and supply catalog.

Imported water mount decals including farm animal motifs (duck, cow, others), Teddi Bear. Ceramic tools. Ceramic supplies including Christmas tree lites, twists, star lites, birds, holly, candle rings, pin-lites, berry beads, stars and tops, tree wiring kits, hi-lites, strobe kits, blinking bulbs, cords, sockets. Clocks, music boxes (electronic), turntables, Blinkie pinback, touch, banks, Twinkle-tone, design tools, liquid gold.

Aftosa
1034 Ohio Ave.
Richmond, CA 94804
510-233-0334

Free catalog.

Supportive items: votive chimneys (clear, frosted), and lamp kits (cup, mushroom shade), candles. Mini lamp kit and shade. Disposable lamp oil cartridge, oil by 12-pints. Hummingbird feeder stopper, dispenser pump with glue-down collar, hardwood honey stick, wire whips (wire or wood handles). Jewelry findings: bar pins, French hook earrings. Wax resist. Others. MasterCard, Visa.

AIM Kilns
369 Main St.
Ramona, CA 92065

Write or call for free literature.

Doll Kiln (designed by doll makers for doll makers), 15 amps, cone 10, 8" high, 8" wide, 9" deep, with shut off, infinite switch. ("Dealer and distributor inquiry invited.")

Alberta-Meitin Ceramic Decals
323 No. Roscoe Blvd.
Ponte Vedra Beach, FL 32082
904-285-2969

Catalog $4.00.

Decal Imagery™ kit—iridium and gold decals, instructions. Decal Imagery™ Video (iridescent and metallic decals; tips on using on dark glazes, and backgrounds with Satelite colors). Wax-resist technique with decals and application over decals.

Alberta's Molds, Inc.
P.O. Box 2018
Atascadero, CA 93422
805-466-9255

Catalog $6.00.

Full line of ceramic molds: classics, early American, novelty/holiday figures, animals, music box carousels, dinnerware, others.

American Art Clay Co., Inc.
4717 W. 16th St.
Indianapolis, IN 46222

Contact dealer, or send SASE for details.

AMACO ceramic supplies and glazes. Clays — firing, nonfiring, modeling, others. Electric kilns including cone 10 gas models, others. Potter's wheels including a rehabilitation model; electric types. "Custom decal factory-supplies to make-your-own ceramic decals" (handbook, screen bed, light post, clamp light with photo flood, c-clamp hinges, screen, Styrofoam buildup, plate glass, acetate, squeeges, film packet, others); instructional video (VHS or Beta) How to Make Your Own Custom Ceramic Decals. Manufacturer. (See SCULPTURE.)

Ann's Ceramics
282 St. Martins Rd.
Vine Grove, KY 40175

Send $.35 and large SASE for list.

Line of Alberta bisque Christmas ornaments, others.

Arnel's Inc.
2330 S.E. Harney St.
Portland, OR 97202
503-236-8540

Color catalog $5.00.

Arnel's molds for ceramics: 65+ mugs with decorative fronts, boxes (ring, powder, tissue, cigarette, flowered egg, others), cornucopias, plates, bowls, butter dish, bases, 25+ vases, pitchers, pitcher/bowls, cups, serving dishes, wall plaques, 2 chess sets, animals, snowflakes, birds, Oriental pagoda, pedestals, ashtrays, gravy boat, cups. Christmas Santa and Mrs., boot, sets of bells; trees; gingerbread people, angels, nativity sets, small Santas snowmen, wreaths. Figures (religious, Oriental, others). Mushroom series kitchenware: canisters, cruets, cups, casseroles, bowls, pitchers, others.

Arrow Mold Co.
1040 West Ave.
Dallas, GA 30132
404-445-5440

Send SASE with specific inquiry.

Custom mold-making service from your sculpture or model. "Reasonable prices."

Art Decal Co.
1145 Loma Ave.
Long Beach, CA 90804
213-434-2711

Send SASE with inquiry.

Custom ceramic decals: complete art service, 125 minimum; food-safe colors available.

Artfare Products
1 Village Green Rd.
Longwood, FL 32779
407-322-7187

Send large SASE ($.45 stamps) for flyer.

Decals: graphics, verses, country motifs, others; "low prices." Custom decal service: artwork, typesetting, low minimum orders. (Call for price quotes.)

Atlantic Mold Corp.
55 Main St., Groveville
Trenton, NJ 08620

Contact your dealer. Color catalog $6.50.

Molds: figurines (children, historical, doll parts, birds, animals, others), Christmas (nativity, angels, candle, dishes, Santas), Easter (baskets, eggs, bunnies,), pumpkins, turkey server, shamrock. Spaceman and craft. Decoratives, plaques, bookends, banks, vases, clocks. Containers, beer steins, emblems, chess sets, planters, platters, casseroles, cookie jars. Bathroom items. Bases. Accessories: lamp parts sets, Lanshire clock movements, Lucite lights. MasterCard, Visa. Manufacturer.

Brickyard House of Ceramics
4721 W. 16th
Speedway, IN 46224
317-244-5230

Write or call for information.

Parts for kilns and wheels: Amaco, Brent, Reward, Skutt, Duncan, Paragon, Crusader. Molds, glazes, tools.

Byrne Ceramics
95 Bartley Rd.
Flanders, NJ 07836
201-584-7492

Free brochures.

Stoneware slip (5 colors), for kilns cones 6 to 10. Other slips, clays (earthenware, raku, reduction, black, grogged) porcelains, glazes, marbleizers, others. Equipment: wheels, kilns, tools.

Carol Reinert Ceramics
Box 310, RD 1
Boyertown, PA 19512
215-367-4373

Send SASE or call for list.

Ceramic molds by Dona's Molds, Scioto, Nowell, Georgie's Bulldog, Starlight, Catskill, Gator, Kimple.

Dona's Hues, Kimple stains, Royal brushes, music boxes, electrical supplies, decals, plastic lights, others.

Cer Cal Inc.
626 N. San Gabriel Ave.
Azusa, CA 91702
818-969-1456

Send SASE for full details.

Custom decals, complete art service, color matching, sheet runs, gold and combination colors.

Ceramic Bug Supplies
17220 Garden Valley Rd.
Woodstock, IL 60098
815-568-7663

Send SASE for list.

Ceramic bug slip marbelizer. 20,000 ceramic molds.

CeramiCorner, Inc.
342 Bolt View Rd.
Grants Pass, OR 97527

Ceramicorner color decal catalog $6.00. Matthey Florals color catalog $6.00.

Decals in over 800 designs: florals, kitchen verses, labels, others in traditional motifs.

Ceramic Specialties
Box 608
Seal Beach, CA 90740

Send for catalog.

Books: *Ceramics for Fun and Profit, Mold Making, Porcelain Painting, Designs, Eyes & Expressions*, many others.

Ceramic Tile Art
Box 28217
Oakdale, MN 55128
612-735-3715

Free brochure and samples.

Ceramic decals, art facilities.

Clay Magic Inc.
21201 Russell Dr., P.O. Box 148
Rockwood, MI 48173
313-379-3400

Catalog $6.50.

Ceramic molds (whimsical/fantasy): Halloween small pumpkin boxes, cat witch with kittens (or pumpkins), bow, bat, vine wreath, lanterns (with vampire bats/ monster or bats/mummy). Items for other holidays.

Creative Ceramics
9815 Reeck
Allen Park, MI 48101
313-382-1270

Write or call with inquiry.

Lines of ceramic supplies—known brands. Has MasterCard, Visa.

Creative Corner
Box 121
Canistota, SD 57012
605-296-3261

Catalog $4.50.

Over 1,200 items in bisque ware: vases, covered dishes, mugs, cups, corn holders, corn set, vegetable dishes, fruits, canisters, plaques, frames, racks, bookends, animals (rabbits, squirrels, cows, ducks, kittens, geese, dinosaurs, dogs). Pumpkins, haunted houses, Pilgrims, tree houses. Christmas: snowman, Santa and sled, wreath/ Mary/Child, Santa mice, angels, reindeer, village scene, nativity sets and scene. Folk Santa and mule. Trees/ lights. Wide-base vases with Indian motifs. Open mailbox. Figures (Pilgrims, Indians, angels, others). Carousels (ducks, bears, etc.), carousel horses. Duncan paints, brushes, accessories. (Also sells wholesale to businesses.)

Cridge Inc.
Box 210
Morrisville, PA 19067
215-295-3667

Free catalog.

Full line of porcelain jewelry blanks. Ornaments. Findings, inserts. Quantity prices.

Custom Ceramic Molds
P.O. Box 1553
Brownwood, TX 76804
915-646-0125

Brochure $5.00.

Molds for ceramics: jewelry, Indian thunderbird, desert cactus, buffalo, Indian fetish bear, chili pepper, and Indian pot jewelry. Large chili peppers (for Ristras pepper strings), Indian pots, peace pipe bowls.

Daisy Books
3824 Smith Ave.
Everett, WA 98201
206-252-1648

Free catalog.

Ceramic books: *Pour Molds, Christmas Projects, Ceramic Stains, Cleaning Greenware, Leaves Motifs*, others. (Also sells wholesale.)

Dakota Specialties
P.O. Box 655
Mandan, ND 58554
701-663-3682

Send SASE for price information.

Mold-making kit: "How to Make Your Own Molds" and materials and instructions for making 2-piece molds. Book: *Advanced Mold Making*.

Debcor
513 W. Taft Dr.
South Holland, IL 60473

Free catalog.

Art/ceramic furniture: drying and damp cabinets, kiln carts, kiln stands, wedging boards (steel, 20" X 24", snap-on canvas wedging cloth), clay carts, others. (Also has graphic arts furniture—write for details.)

Decal Liquidators
229 Shelby St.
Indianapolis, IN 46202

Sample decals $1.00; Stock catalog $1.50.

Ceramic decals: quality production designs, fires at cone 017/018 (016 on china); new patterns monthly ("not seconds or misprints"). Open stock decals. Designs include: traditional, holiday, floral, children, animals, others.

NEWSPAPER CERAMIC: *To put a periodical into a figure's hands, select a favorite and repeat successive reductions using a reduction-type plain paper copier until you have the appropriate scale (usually three reductions at 65%). The final reduction is secured on the ceramic piece using brush-on high gloss sealer under and over the "newspaper." Trim around the edges with an X-acto knife. When the sealer has dried thoroughly, spray with porcelain mist to reduce the gloss. The same process can be used on the inside of the newspaper. Courtesy of Bruce Dransfeldt of Arnel's Inc.*

Dona's Molds
P.O. Box 145
West Milton, OH 45383
513-947-1333

Catalog $7.00; SASE for flyer.

Molds including traditional, whimsical, holiday and novelty figures and sets, others.

Dongo Molds
15 School St.
Morriston, FL 32668
904-528-5385

Catalog $3.00.

Over 150 molds for aquariums, terrariums, and other items — medium to large tanks. Custom mold-making from specifications.

Duralite, Inc.
8 School St.
Riverton, CT 06065
203-379-3113

Write for prices and information.

Kiln elements, replacement coils for any kiln (including Stoker).

East Bay Ceramic Supply
P.O. Box 4346
East Providence, RI 02914

6 color charts and price lists $2.00.

Ceramic colors: Kimple, Ceramichrome, Duncan, Studio Stain, Dona's Hues, Scioto. Minimum order $25. ("Dealer inquiries invited.")

Edward Orton Jr. Ceramic Foundation
P.O. Box 460
Westerville, OH 43081

Contact your dealer or write for details.

Pyrometric products: self-supporting cones, pyrometric bars, others to measure heat treatment, indicate or control kiln shut-off, monitor firings.

Engelhard Corporation
70 Wood Ave. So.
Iselin, NJ 08830

Contact a dealer. Free technique sheets.

Hanovia overglaze products: lusters, metallics, opal, mother of pearl (for ceramics, china, glass). Cerama-Pen™ gold or platinum applicator. Manufacturer.

Evenheat Kiln Inc.
6949 Legion Rd.
Caseville, MI 48725
517-856-2281

Free brochure.

Line of kilns (variety of sizes and types) and kiln accessories, supplies, and parts.

Favor-Rite Mold Co.
516 Sea St.
Quincy, MA 02169
617-479-4107

Catalog $3.50.

Molds for ceramics—Africana and Fash-enHues lines.

Gare, Inc.
165 Rosemont St.
P.O. Box 1686
Haverhill, MA 01832
508-373-9131

Flyer $1.00.

Molds including traditional figures, "The Sophisticates" 1920s stylized figures, holiday designs (including "Christmas Windows" series), others. Saharastone ™ textural glazes, others. Stains, fired colors. Tools, brushes, kilns.

Goldline Ceramics
3024 Gayle St.
Orange, CA 92665
714-637-2205

Send SASE for list.

Ceramic decals—1500 personal names, in black-hobo style letters, 20 name minimum order.

Hill Decal Company
5746 Schutz St.
Houston, TX 77032
713-449-1942

Write or call for information and samples.

Custom decal service: your artwork, photo, or sketch, or complete art services—for glass, china, ceramics.

Holland Mold Incorporated
P.O. Box 5021
Trenton, NJ 08638

Mold catalog $7.00.

Molds: "Country Pets" series—straw ducks, kittens, others. Holiday items and sets, historical figures, wild animals, birds, eggs. Steins, mugs, bowls, serving pieces, canisters, candlesticks, picture frames, plaques (marriage, birth, graduation, others) clocks, lamp bases, pedestals, jewelry, bells, boxes. Accessories: clock movements, tree lights. Glaze, porcelain slip. Custom mold service (write for information). "Your ideas for new designs are welcomed." Manufacturer. MasterCard, Visa.

Howe To Publications
576 Carroll Ave.
Sacramento, CA 95838

Free catalog.

Book: *How to Repair Your Kiln at Home in Easy Step by Step Directions* (repair manual), by C.A. Wier, Kiln Design Engineer. Replacement parts for all kilns. Brick, elements, switches, lids, others. "Discounts to distributors, dealers, and service people."

Jay-Kay Molds
P.O. Box 2307
Quinlan, TX 75474
903-356-3416

Color catalog $4.00.

Molds: "The Leather Wrap Collection" of vases with oval inserts (changeable faces) in one- and two-neck styles, with and without handles. Other types of molds. "Distributorships available."

Kiln Kapers
956 S. Anaheim
Anaheim, CA 92805

Send SASE for details.

Feature pens with China paint, Gold pens—for detail work or precise feature lines (for ceramic, porcelain, and doll craftspeople). MasterCard, Visa. "Quantity discounts. Please inquire."

Lamp Specialties Inc.
Box 240
Westville, NJ 08093

Catalog $3.00.

Electronic music boxes with "Touch Me" (including with blinking lights or harmony type) multi-tune. Clocks. Lamp parts.

Laukhuff Mold Co.
Box 306
New Holland, PA 17557

Send SASE with inquiry.

Custom service: molds rebuilt from old molds; custom molds from sculpture or model.

Lehman
Box 46
Kentland, IN 47951

Free information.

Slip handling equipment: "Paint safe" drying table, Trim'N Clean tools, STK-1 slip testing kit, slip-doppe, original and jumbo stencil pencils. Manufacturer.

Lily Pond Products
2051 E. Tyler
Fresno, CA 93701
209-485-5115

Send SASE for further information.

Lil' Pumper 1/3 HP pump, with plexiglass removable lid, heavy-duty container, operates on 1 to 5 gal. slip, stainless steel strainer and shaft. Lil' Puddle for table top, in fiberglass, removable hardwood rack, spigot, holds 5 gallons. Big Puddle mix/pour/reclaim machine, 2' X 6' size, includes mixer; all hardwood rack, 70 gallon tank, metal propellers, stainless steel mixing shaft, fiberglass. Others.

Magic Musicland
18312 Hollister Rd.
Orlando, FL 32820
407-548-1550

Catalog $1.50.

Touch music boxes (50 tunes), bank coin-slot boxes (20 tunes).

Marjon Ceramics
3434 W. Earll Dr.
Phoenix, AZ 85017
602-272-6585

Send SASE for full details.

Instructional Video: Mold Making, with Bill Anderson (step-by-step creating of molds), complete mold-making kit (mold box, textbook, tools, supplies)—order video and kit together for savings. MasterCard, Visa.

Maryland China Company
54 Main St.
Reisterstown, MD 21136

Contact dealer or send SASE for information.

Over 850 white porcelain blanks: tableware, giftware, novelty, souvenir items, white and gold banded dinnerware, coffee and beer mugs, promotional items, ashtrays and trivets, bells, plaques, desk accessories, others.

Mayco Colors
4077 Weaver Court So.
Hilliard, OH 43026

Contact your dealer or write for information.

Ceramic colors, finishes, glazes (Satina matte colors, exotics, others), stoneware glazes, lead-free glazes, crystal patterned. Bisque colors, underglazes. Non-firing opaque stains, translucents, metallics, non-fired pearls. Stain kits. Sealers. Accent glazes, wax resist. Manufacturer.

Minnesota Clay
8001 Grand Ave. So.
Bloomington, MN 55420
612-884-9101

Send SASE for further information.

Clays: pre-mixed clay bodies, colored stonewares and porcelains, non-firing clays. glazes (liquid and dry). Chemicals, stains, lusters, overglazes. Plaster, pouring tables. Kilns and kiln parts, the products of: Skutt, Cress, Amaco, Brent, Lehman, Ohaus, Creative Ind., others.

Mitizi's Exclusive Molds
141-Hwy 22
Waupaca, WI 54981
414-622-3513

Send SASE with inquiry, send model for evaluation.

Service: custom-made specialty molds per specification.

National Artcraft Co.
23456 Mercantile Rd.
Beachwood, OH 44122
216-292-4944

Handcrafts catalog $4.00.

Musical movements: 220 windup tunes, Touch-N-Play, Light-N-Play, Save-N-Play, Blink-N-Play types, tune medleys, Haunt-N Eyes; accessories. Ceramic decals.

National Ceramic Eq. Sales & Leasing
32784 U.S. Highway 441
Leesburg, FL 32788
904-787-2267

Write for information.

Lease-to-own kiln program: "no interest lease" of Reward Shurefire kiln for one year, and own it; choose from 18" X 23", 24" X 27", or 29" X 29" sizes. MasterCard, Visa.

Natural Metals
P.O. Box 5371
Uvalde, TX 78802

Send SASE with inquiry.

Service: custom designed cookie cutters from drawings; increases production.

Nowell's Molds
1532 Pointer Ridge Pl.
Bowie, MD 20716
301-249-0846

Card catalog $3.00.

Molds for ceramics including whimsical shadowbox plaques—3 molds make over 20 combinations: window seat, rocking chair and oval shadow box; bear, rabbit, dog, oil lamp, table lamp, bell, boot, bonnet, parasol, ballet, vase, pitcher, bowl, cat, picture frame, grapevine wreath, bicycle, others; sizes vary from ½" to 3". Other molds. Super Brute ¾" disc magnets (3X as strong as ordinary). Has quantity prices. MasterCard, Visa.

Finished piece from bisque. © *Creative Corner*

Peek-A-Boo Ceramics
821 Shunpike Rd.
North Cape May, NJ 08204
609-886-2726

Catalog $3.00 (refundable).

Molds: bisque (including from Duncan, Holland, White Horse, Blackbirds, Atlantic, Yozies, others) — over 2,000. Specializes in bisque with glaze inside items needed, includes: Nativity sets, village set, Santa, snowman, figures, candleholders, Christmas plates, stocking, wreaths. Country figures, birth announcements, steins, plaques, Easter animals, dragon planter, goose neck lamp, cornucopia, ashtrays, wall hooks, holders, boxes, baskets, clocks, others. Quantity prices and large order discounts. Discount to teachers and institutions.

Pierce Tools
1610 Parkdale Dr.
Grants Pass, OR 97527
503-476-1778

Free catalog.

"Gold line" ceramic modeling tools, sets. Has MasterCard, Visa.

Pine Tree Molds
14596 South Main St.
P.O. Box 33
Mill Village, PA 16427

Send SASE for information.

Ceramic molds, including: Victorian houses, gazebos, plaques (doves/bells, ducks/daisies, church, lighthouse, others). Planters.

Q.P.R.
Box 3543
Lennox, CA 90304
213-973-5281

Send SASE for price lists.

Quick paint remover for ceramics, fired-on paint, decals, gold, lusters—from china, bisque, glass; 12 bottle minimum. (Also sells wholesale.)

Reward Ceramic Color Mfrs. Co.
4717 W. 16th St.
Indianapolis, IN 46222
317-244-6871

Contact your dealer, or send SASE for details.

Glazes, stains, tools, brushes; wide variety of ceramic molds in traditional and other styles including figures, figure groupings, scenes, animals, others. Manufacturer.

RiverView Molds, Inc.
1660 W. Post Road S.W.
Cedar Rapids, IA 52404
319-396-5555

Color catalog $6.00.

Line of molds including holiday designs, figures, others.

Rocking B Mfg.
3924 Camphor Ave.
Newbury Park, CA 91320
805-499-9336

Send SASE for further information.

Music boxes: Sankyo 18 jewel movement, mini, mobile, electronic Touch-Me, bank slot, Touch-Me with blinking lights—tunes include children's, Christmas, popular melodies. Accessories. MasterCard, Visa.

Rynne China Company
222 W. 8 Mile Rd.
Hazel Park, MI 48030

Free catalog.

Full and complete line of china blanks—plates, bowls, cups, saucers, creamers, sugar bowls, serving dishes, and others. Gold rimmed items. Manufacturer.

Schoolhouse Ceramics
3860 Columbia Rd.
North Olmsted, OH 44070
216-777-5155

Send SASE for pictures of specific breeds.

Line of bisque in many popular breeds of dogs and cats.

Scioto Ceramic Products, Inc.
2455 Harrisburg Pike
Grove City, OH 43123
614-871-0090

Mold Catalog $6.00.

Molds: traditional figures, animals, holiday; others. Full line of doll molds. Ceramic colors.

Scott Publications
30595 W. 8 Mile Rd.
Livonia, MI 48152

Send SASE for list.

Book: *Basics of China Painting*, by Bill Thompson, with color illustrations and instructions on all phases of china

painting by the editor of *Ceramic Arts & Crafts* magazine. Other books on ceramics and related subjects.

Skutt Ceramic Products
2618 E. Steele St.
Portland, OR 97202
503-231-7726

Write for information and nearest dealer.

Electric kilns: multi-sided models in modular sectionalized construction, easy replacement of firebrick, with stainless steel jacket, reversible firebrick bottom slab; cone 1 to cone 10 models. Cone 6 portable, small-sieve, works on 120 volts. Supersized models. Enviro-Vent™ unit for kilns — removes fumes (vents them outdoors when firing metallics or high sulfur clays). Kiln furniture, parts, accessories. Potter's tools and aids. Manufacturer.

Spectrum Ceramics, Inc.
960 So. Bellevue
Memphis, TN 38106
901-942-5242

Contact your dealer, or write for details.

Casting equipment: 18 gal. caster, submersible pump, removable mold rack, others. Slip, modeling clay, molds. Manufacturer.

Star Stilts Company
P.O. Box 367
Feasterville, PA 19047
215-357-1893

Contact your dealer, or write for catalog.

Stilts: napkin ring, star tree, rods (setter for beads, buttons, trinkets, others), bell type, junior shelves, high stilts (5 sizes), element retaining stable, others.

Sugar Creek Ind., Inc.
Box 354
Linden, IN 47955
317-339-4641

Free catalog.

Pouring room equipment: over 60 items including pouring machines (4 gal. Flow Baby through basic 125 gal. unit). Pumps (immersion red heads, reversible, external). Mixers—reclaimers (1 gal. porcelain through 200 gal.). Tables (4' through 16'—6 sizes). Spraymaster booth (for greenware, airbrush, other); and in larger model—30" X 40" area, with exhaust fan with enclosed motor mounted to rear (outside ventilation recommended).

Tampa Bay Mold Co.
2724 22nd St. N.
St. Petersburg, FL 33713

Catalog $2.00.

Original molds—full line of traditional designs.

Trenton Mold
329 Whitehead Rd.
Trenton, NJ 08619
609-890-0606

Color catalog $4.00.

Molds including dog figurines (32 popular breeds), other animals, holiday, figures, plaques, vases, pitchers, others.

Vito's Ceramic Supply
P.O. Box 422
Tewksbury, MA 01876
508-851-4232

Catalog $3.00.

Ceramic bisque from the molds of a variety of manufacturers. Has quantity discount packages.

Westwood Ceramic Supply
14400 Lomitas Ave.
City of Industry, CA 91716

Catalog $5.00.

Casting clay bodies: earthenware, stoneware, porcelain (in 50 lb. and up). Special clay formulas, low-fire clays, raku, high/low-fire casting bodies. Chemicals. Colors and finishes: metallics, texture and other glazes, lusters. Egyptian paste. Engobe stains. Equipment (known brands including Kemper, Kingspin, Ohaus, Cress, Olympic, others). Books. Manufacturer, distributor.

Wise Screenprint, Inc.
1015 Valley St.
Dayton, OH 45404
513-223-1573

Free color card, price list, and samples.

Custom ceramic and glass decals from customer's rough sketch, photo, or artwork: complete art services, design and technical assistance, low minimum order.

Zembillas Sponge Co., Inc.
P.O. Box 24
Campbell, OH 44405
216-755-1644

Catalog $3.50 ($4.50 outside U.S.).

Mediterranean silk sponges, variety of sizes. Imported ceramic decals, in wide assortment of traditional motifs.

Kiln. © AMACO *(American Art Clay Co., Inc.)*

Clock Making

🐦🐦🐦🐦🐦🐦🐦🐦🐦🐦🐦🐦🐦🐦🐦🐦

See also CRAFT SUPPLIES, CERAMICS, JEWELRY MAKING & LAPIDARY, MINIATURE MAKING, WOODWORKING, and other related categories; BOOKS & BOOKSELLERS, and PUBLICATIONS.

🐦🐦🐦🐦🐦🐦🐦🐦🐦🐦🐦🐦🐦🐦🐦🐦

B & J Rock Shop
620 Claymont Est. Dr.
Ballwin, MO 63011
314-394-4567

Catalog $3.00 (refundable).

Line of clock kits (clock movements with hands and numbers, polished/drilled agate clock face and clear Lucite stand), desk clock kits and large model (with 5" to 6½" face). Quartz clock movements—Seiko, battery with 5/16" or 11/16" shaft (with hour, minute, second hands, hanger, hardware, numbers/dots). Has quantity prices. (Also has bead supplies, crystals.)

Beeman's Clock Mfg.
109 W. Van Buren
Centerville, IA 52544

Catalog $2.00.

Clock movements, over 400 clock faces (classic, contemporary, others). Wood cutouts, foil prints. "All at wholesale."

CNT
Rt. 3, Box 94
Foxworth, MS 39483

Catalog $1.00.

Quartz clock motors, accessories, clockmaking items. Has quantity prices.

Creative Clock
Box 565
Hanson, MA 02341
617-293-2855

Free catalog.

Full line of clock components, movements, others.

Emperor Clock Company
Emperor Industrial Park
Fairhope, AL 36532
205-928-2316

Color catalog $1.00.

Clock kits: grandfather, mantel, wall models; black walnut, cherry, or oak; with solid brass West German movements and dials. Furniture kits, assembled clocks.

Clock dials, glass, and bezels. © Klockit™

Harold's
P.O. Box 170
Aurora, IL 60507

Free catalog.

Quartz battery clock movements—mini, regular, pendulum chimes. Clock numerals, dials, resin epoxy, accessories. "Discount."

Hurst Associates Ltd.
405 Britannia Rd. E., #10
Mississauga, Ontario, Canada L4Z 3E6
416-890-0269

Send SASE for full information.

Folk art clock-making supplies: folk art dials, decoy patterns, cross stitch clocks, basic clock supplies.

Klockit
P.O. Box 636
Lake Geneva, WI 53147

Write for catalog.

Clock kits (quartz or quartz Westminister chime movements): wooden gears, shelf, schoolhouse, alpine steeple. Wood blanks for clocks—shapes. Stitchery clocks, country wood kits (easy), desk, wall, wall jumbo watch. Desk sets, contemporary wood/brass, time and weather, mantel, banjo/cloth, gallery, nautical, carriage, time zone, cottage, carriage/moving moon, 400 day crystal and wood, regulator types. Grandfather and grandmother. Cypress. Parts: West German chimes, hardware, bezel fit-ups, quartz movements, pendulums. Clock plans. Router and precision pantographs. Wood parts, shapes,

slabs. Brass nameplates. Lamp items. Desk sets. Ship's bell movement. (Also has ready-made clocks.)

Kuempel Chime
21195 Minnetonka Blvd.
Excelsior, MN 55331

Catalog $2.00.

Red-i-Kut clock kits (grandfather and other types) of walnut, cherry, mahogany, or oak, with precision West German movements, handcrafted pendulums, hand-painted moon wheels. Brass pendulums, tubular bell, or Westminster rod chimes. Traditional styles.

Mason & Sullivan
586 Higgins Crowell Rd.
W. Yarmouth, Cape Cod, MA 02673

Free catalog.

Antique reproduction clock kits, over 20 models, precut, including grandfather, grandmother, wall, desk, mantel, others. Clock parts and accessories: hardware, imported precision movements and chimes, brass dials. Books.

Precision Movements
2024 Chestnut St., P.O. Box 689
Emmaus, PA 18049
215-967-3156

Write or phone for color catalog.

Full line for clock making: quartz movements, variety of styles, and accessories. Clock hands, dials, bezels, other parts. "Quotations upon request."

School of Clock Repair
6313 Come About Way
Awendah, SC 29429

Free catalog.

Instructional videos: clock repair, comprehensive home study course; "approved for veterans."

Steebar
P.O. Box 463
Andover, NJ 07821

Catalog $3.00 (credited to order).

Complete clock kits, music movements, components, plans, epoxy, prints; over 800 clock-making supplies (chimes, hands, dials, faces, blanks, others).

Tegarden Enterprises
Box 73
Knightstown, IN 46148
317-345-5165

Catalog $2.00.

Mini-Quartz clock movements, clock dials, epoxy resin, posters. Has quantity prices.

Yankee Ingenuity
Box 113
Altus, OK 73522

Catalog $1.00 (refundable).

Line of battery clock movements, variety of styles and sizes; "below wholesale prices."

Construction—Structures

🐦 🐦 🐦 🐦 🐦 🐦 🐦 🐦 🐦 🐦 🐦 🐦 🐦 🐦 🐦 🐦

See also MINIATURE MAKING, MODEL MAKING, TOOLS & EQUIPMENT, WOODWORKING, and other related categories; BOOKS & BOOKSELLERS, PUBLICATIONS.

🐦 🐦 🐦 🐦 🐦 🐦 🐦 🐦 🐦 🐦 🐦 🐦 🐦 🐦 🐦 🐦

Ashland Barns
990 Butler Creek
Ashland, OR 97520

Catalog $5.00 (refundable).

Plans/blueprints for the construction of 82 classic (traditional) barns, mini-barns, garages, craftshops.

Barton's Barnwood
RR 3 Carp
Ontario, K0A 1L0 Canada
613-839-5530

Send SASE for full details.

Weathered barn siding, old flooring, hand hewn beams, other barn material; by square foot.

Brown Engineering
Box 40
West Point, CA 95255

Send SASE for full information.

Lumberjack chain saw sawmills—power-feed, cuts forward-reverse.

Carlisle Restoration Lumber
HCR 32, Box 679
Stoddard, NH 03464
603-446-3937

Send SASE for full information.

Wide pine flooring/paneling: eastern white or southern yellow pine, or wide oak. Installation service nationwide.

Conklin's
R.D. #1, Box 70
Susquehanna, PA 18847
717-465-3832

Send SASE for information.

Authentic antique barnwood and hand hewn beams, old flooring, Pennsylvania flagstone and wall stone. (Also sells wholesale.)

Design Works Inc.
11 Hitching Post Rd.
Amherst, MA 01002

Send SASE for full details.

Cardboard model designing kit—aids in visualizing designs before you build or add on to a home, etc.; using miniature doors, stairs, windows, skylights, furniture and appliance cut-outs; includes floor-plan grids, scale ruler, and roof-slope calculator.

Ebac Lumber Dryers
5789 Park Plaza Court
Indianapolis, IN 46220
317-577-7870

Write or call for information.

Lumber dryer system (construct kiln, and Ebac supplies this drying equipment) for drying green lumber.

Fantasia Trains
Box 1199
Port Washington, NY 10050
516-883-1120

Send SASE for price list and availability.

Railroad cabooses, used, in operating condition—for remodeling to guest cabin, restaurant, store, office.

Foley-Belsaw Co.
6301 Equitable Rd.
Kansas City, MO 64120

Free book: *How to Saw Lumber.*

One-man sawmill—portable, use with PTO or low HP diesel or electric unit. "Factory-direct selling."

Follansbee Dock Systems
State St.
Follansbee, WV 26037
304-527-4500
800-223-3444 (except WV)

Write or call for catalog.

Dock products: heavy galvanized wood dock hardware, hinges, pipe and pile holders, ladders, dock boxes, power systems, boarding steps, uprights, fasteners, accessories, floating and stationary docks. Polyethylene float drums, air or foam filled. Swim float kits. "At discount prices."

Greatwood Log Homes, Inc.
P.O. Box 707
Elkhart Lake, WI 53020

Free booklet. Plan book (100 models) $8.95.

Traditional full log or insulated log home kits—with to R-40 roof system of white cedar or pine, "free delivery."

Historic Housefitters Co.
Farm to Market Rd.
Brewster, NY 10509

Catalog $3.00.

Period hardware: hand forged iron hinges, thumblatches. Crystal, porcelain, and brass items. Light fixtures.

Home Planners, Inc.
3275 W. Ina Rd.
Tucson, AZ 85741
and in Canada:
20 Cedar St.
N. Kitchener, Ontario N2H 2Q8

Send SASE for list.

Home plans for 315 1 story homes under 2,000 sq. ft.; for modest building budgets. Other 1-story, 1½ story, 2 story and multi-level homes; vacation homes. Contemporary or traditional exteriors. Has major credit cards.

Homestead Design
P.O. Box 1058
Bellingham, WA 98227

Designs book $3.00.

Floor plans for small barns, workshops, garages, studios, compact country homes (including "Barnhouse" series of starter homes); new designs in traditional styling combined with modern construction methods.

Key Dome
P.O. Box 430253
So. Miami, FL 33143

Plans/how-to book $5.00.

Dome home plans — for 14' to 50' domes; variety of shape combinations; claims that a 20' dome for garage or storage building can be built "for less than $400."

Lindal Cedar Homes
P.O. Box 24426
Seattle, WA 98124

Order catalog—200 pages of plans for $15.00.

Full line of plans for contemporary homes including: A-frame, modified A-frames; houses for full-time use, vacation homes; one and two story models.

Marshalltown Tools, Inc.
P.O. Box 1684
Fayetteville, AR 72702

Booklet: Troweling Tips — guide to working with cement, brick, concrete, block, drywall, and plaster, $1.00.

Monterey Domes, Inc.
1760 Chicago Ave.
Riverside, CA 92507

98 page catalog & plans book $7.00 or *The Basic Dome Assembly Manual* $5.00.

Dome home plans in variety of sizes, cluster plans; ceilings to 28', skylight interiors, "energy efficient."

Oregon Dome Inc.
3215 Meadow Lane
Eugene, OR 97402
503-689-3443

Catalog, price and planning set $12.00

Geodesic dome plans, in variety of design arrangements.

Panther Lodges
Box 32
Normantown, WV 25267

Catalog $2.00 (refundable).

Tipis, tipi poles, other pre-1840's products.

Salter Industries
P.O. Box 183
Eagleville, PA 19403
215-631-1360

Free brochure.

Metal spiral staircases, in install-it-yourself kit form; for 3'6" to 6' diameters, adjustable to any height; oak and brass options. Manufacturer. MasterCard, Visa.

Sandy Pond Hardwoods
921 A Lancaster Pike
Quarryville, PA 17566
717-284-5030

Send SASE for full information.

Tiger and bird's eye lumber and flooring, other figured woods.

Shelter Systems
P.O. Box 67
Aptos, CA 95001

Catalog $1.00.

Instant dome shelters; many quick-assemble models.

The Iron Shop
P.O. Box 547, 400 Reed St.
Broomall, PA 19008
215-544-7100

Send SASE or call for free brochure.

Oak stairs kits: with 2 1/16" thick stringers and treads of red oak; open riser design; to-be-assembled "in just a few hours," complete with all hardware. Handrail kit offered as optional accessory. In-between spindle kits, matching oak rail kits for enclosing landings. Five different kits. American Express, MasterCard, Visa.

Timberline Geodesics
2015 Blake St.
Berkeley, CA 94704
415-849-4481

Information packet/catalog $12.00.

Pre-fabricated dome home kits (pre-cut and pre-drilled, color coded for easy-construction, with heavy-duty steel connector system). Kits with floor plans/choice of (1) Complete kit with 2" X 6" coded struts, studs, t-blocking, triangular plywood panels. (2) Street Framing Kit—with all but pre-cut plywood. (3) Connector kit, with full assembly instructions. Tools needed for construction: locket wrenches, hammers, ladders, scaffolding, nail gun. Optional items available: skylights/windows in triangular, hexagon, or pentagon and other shapes; cupola (retreat) addition. Versatile dome designs available.

Dome Home. © *Timberline Geodesics*

Troy-Bilt Mfg. Co.
102nd St. & 9th Ave.
Troy, NY 12180

Write for full details.

Greenhouse kit (to-be-assembled with hand tools) with over 50 square feet of usable space, with 7'6" peak; of glass (with double-strength glazing) and aluminum frame; sliding door and built-in rain gutter.

Vegetable Factory
P.O. Box 1353
Stamford, CT 06904

Informative color catalogs $2.00.

Greenhouse/screenhouse combo assembly kit — an insulated winter sun space that converts to summer screen room with bronze aluminum frame, shatter-resistant 1" doublewall glazing; can also be a spa/hot tub room or incidental space; with instructions.

Vintage Wood Works
Hwy. 34, Box 2265
Quinlan, TX 75474

50 page illustrated catalog $2.00.

Victorian and country gingerbread trims for buildings (solid wood) including brackets (for openings), porch turnings, gable decorations, spandrels, doorway embellishments; wide range of styles, sizes. Manufacturer.

Vixen Hill
Elverson, PA 19520
215-686-0909

20 page color catalog $3.00.

Gazebo kits—wide selection of architecturally authentic gazebos, pre-engineered for easy assembly by the non-carpenter; variety of styles and sizes.

Wilderness Log Homes
Rt. 2
Plymouth, WI 53073

Planning guide $9.00.

Log home kits: cedar or pine pre-cut kits with everything needed to build, "insulog system" that permits a variety of wall treatments — solar adaptable; many models.

Wood Built of Wisconsin, Inc.
P.O. Box 92
Janesville, WI 53547
608-754-5050

Send SASE for catalog.

Hardware kits to build a variety of playground sets — slides, swings, playhouse, ladders, others.

Wood-Mizer Products, Inc.
8180 W. 10th St.
Indianapolis, IN 46214
317-271-1542

Catalog $2.00. Demonstration video $10.00.

Portable sawmills—with remote hydraulic log handling, capacities to 32" diameter by 33' long; bandsaw cutting head. Solar Dry™ kiln, Vacu-Kiln™.) MasterCard, Visa.

Construction—Vehicles

🐦🐦🐦🐦🐦🐦🐦🐦🐦🐦🐦🐦🐦🐦🐦🐦

See also MODEL MAKING, TOOLS & EQUIPMENT, and other related categories; BOOKS & BOOKSELLERS, and PUBLICATIONS.

🐦🐦🐦🐦🐦🐦🐦🐦🐦🐦🐦🐦🐦🐦🐦🐦

A-Mac Fabrication
1745 Grant St., Ste. 2
Santa Clara, CA 95050
408-727-9288

Send SASE for information.

AM-6 model racing car kit: for 1000 cc engine—steel frame, fiberglass body; uses motorcycle engine/transmission unit with chain drive.

A-1 Racing Parts Inc.
770 Rt. 28, Box 4
Middlesex, NJ 08846
201-968-2323

Send SASE or call with inquiry.

For cars—Mustang II/Pinto-type struts, heavy duty strut rods (production struts made from 1" stock—originals were ³/₄"), with same angle as Ford D5FZ3468 units; with strut bushings and retainers. Visa, MasterCard.

Aero-Projects
Box 5118
Clinton, NJ 08809

Send SASE for full details.

Aero-Car hovercraft plans for you-build (using ordinary tools); lawnmower engine powered; carries one person.

Air Car
Box 1822
Newport Beach, CA 92659

Send SASE for details.

You-build one-seater air car, floats on air powered by vacuum cleaner motor; lifts 200 pounds.

American Classics
93 NP Ave.
Fargo, ND 58102

Send SASE for details.

Car kits: replicas of 1957 Corvette, 1957 T-Bird, others.

Antique & Collectible Autos, Inc.
35 Dole St.
Buffalo, NY 14210

Free brochure.

Car kits, including a reproduction of the 1937 Jaguar™ SS-100, with: the chrome features of the SS-100, 2" X 3" X 3/16" structural steel frame for front engine (ready for assembly); pre-drilled, with protective chassis paint; many pre-assembled components. American Express, Diners Club, MasterCard, Visa.

Arizona Z Car
2110 W. Devonshire St.
Mesa, AZ 85201
602-844-9677

Catalog $2.00.

Performance parts for Datsun 240Z through 280ZX: exotic GTO body kit, race bodies, spoilers. Springs, swaybars, racing brakes, tube chassis, roll cages, carb kits, turbos, G-nose. Cams, headers, flywheels, shocks, others.

Atlanta Kit & Custom Cars
2560 S. Hairston Rd.
Decatur, GA 30035
404-981-4143

Send SASE or call with inquiry.

Custom kit car assembly service—any, from crate to turn key. Kit car accessories, aero packages, lowering kits, aluminum and ceramic thermal coating.

AutoTek Unlimited
2190 Ste. J Coffee Rd.
Lithonia, GA 30058
404-482-8327

Write or call for details.

Convertible Car kits and conversions for '82-'89: Camaro, Firebird, Escort, Lynx, Fiero, MR2, Eldorado, Seville, Riviera, Probe; of vinyl or Hartz cloth, reinforced frame and chassis; Targa tops available.

B.G.W. Ltd.
2534 Woodland Park Dr.
Delafield, WI 53018

Catalog $11.50.

Hot rod car kits for Super Beetle: California speedster, Opera coupe, and Special Delivery (van), '40 Ford—'36 Ford, mid engine or VW based. MasterCard, Visa.

Bikecar Corp.
P.O. Box 7077
Endicott, NY 13760

Send SASE for details.

Plans for the Bikecar—with electric motor and pedal power, 4-wheel, with seat. "Street legal."

Benney Aerocraft Co.
100 Kings Rd.
Nampa, ID 83687
208-466-1711

Information pack $10.00.

"Kitfox" aircraft kit, pre-welded, to build in about 500 hours; with folding wings. Has major credit cards.

Bernie Bergmann, VW Motor Spec.
340 N. Hale Ave.
Escondido, CA 92029

Photo products display $2.00.

Car parts: turbocharged VW motors—single and dual carbureted, blow through and draw through types. Single and dual carbureted engines for sedans, Baja, Rail, kit car, others. Engine kits and parts matching. Hydraulic lifter, unleaded heads, shuffle pins, others.

British Coach Works, Ltd.
Arnold, PA 15068
412-339-3541

Information package/buyer's guide $3.00.

BCW 52 Car kit—replica of MG-TD, assembles without welding, sanding, or fiberglassing; pretrimmed, predrilled body panels are color finished; chromed brass grill, fold-down windscreen, authentic exterior hardware.

C. F. Enterprises
California Ace Division
P.O. Box 1347
Long Beach, CA 90801
310-404-0522

Information package $5.00.

Cal Ace car lot: Classic AC Bristol Ace replica, utilizes stock MGB; V-8, V-6 engine options.

California Convertible Co.
587 N. Ventu Park Rd., Suite 445
Newbury Park, CA 91320
818-706-3919

Send SASE for full information.

Convertible car conversion using factory duplicated parts, XJ-S, 2+2, Camaro, and others.

Cardiac Cobra Sports Cars Ltd.
1823 Columbia St.
No. Vancouver, B.C., Canada V7J 1A3
604-987-6350

Send SASE or call for information.

Cobra replicar—basic kit; of hand-laid steel reinforced body, steel beams in doors, stiff chassis, small or big block, final drive Ford or Jag I.R.S. Custom builds Cobra replica bodies and chassis.

Clarkcraft
16 Aqualane
Tonawanda, NY 14150

Catalog $3.00.

Boat kits/plans/patterns—250 designs, 8'—70' models in plywood, fiberglass, steel: powerboats, inboards, outboards, jets, cruisers, sports fishers, hydroplanes, houseboat, runabouts, sailboats, motorsailers, multihulls, kayaks, canoes (over 35 models). Kit materials include hardware, fastenings, master rigging, sails, plywood, fiberglass, foams, resins, glues, polyesters, mats, cloth, others, depending on type. Book: *Amateur Boatbuilding*.

Classic Instruments, PKC
1678 Beavercreek Rd.
Oregon City, OR 97045
503-655-3520

Information and Catalog $2.00.

Classic vehicle instruments—originals: speedometer, indicators for oil pressure, petrol, battery voltage, water temperature; programmable electric instruments, electric senders, lighting, and matching quartz clock. "Factory direct ... at below dealer cost."

Classic Motor Carriages
16650 N.W. 27th Ave.
P.O. Box 10
Miami, FL 33054
305-625-9700

Free Speedster and Street Rod brochures.

Car kits: Classic 359™ sports car with "racing performance," the Classic Speedster model with yesterday's styling; and Classic Speedster C™ of near-today. Other replica car kits: '34 Ford street rod, Gazelle classic RD. American Express, Discover, MasterCard, Visa.

Classic Roadsters, Ltd.
1617 Main Ave.
Fargo, ND 58103
800-437-4342 (except ND)

Free brochure.

Automobile kits including Classic Roadsters—reproductions of The Marlene, '65 Mercedes 500K, and Sebring Austin-Healy. Reproduction kits for the Jaguar, MG, and 4 passenger Mercedes; (cars equipped with V-8 power). Free color brochure, parts and options data, and corporate report. Send $5.00 for 16 page product catalog and 24 pages of component and pricing information. MasterCard, Visa.

Classic Sports Cars, Inc.
765 W. State Rd. 434
Longwood, FL 32750

Brochures $3.00 per car.

XC-53 authentic scale car, a reproduction of the 1953 Corvette (in easy-build kit assemblies or V-8 powered turnkey models). Among its features are "rocketship" tail lights, and classic chrome "tiger teeth" grill. Daytona Migi car kit—replica of the 1952 MG-TD: with front or rear engine drive. Has one piece main body construction, steel reinforced, steel frame, fold down windshield, 3-piece hood (also in turnkey model).

Classique Custom Coachworks Ltd.
45 Lewis Rd., #3
Guelph, Ontario N1H 1E9 Canada
519-837-2100

Information package $5.00.

European Daytona Spyder replica in kit form: designed for '68-'82 Corvette chassis, with many engine and transmission combinations. Also 308/328/F40 kits (and turn key) for Fieros.

Contemporary Classic Motor Car Co.
115 Hoyt Ave.
Mamaroneck, NY 10543
914-381-5478

Color brochure, information, prices $4.00.

Cobra replica kit cars—package variations available for builder or restorer. Has authorized dealers in CA, DE, NY, VT, NV, OK, PA, TX, VA; and in Canada.

Copy Cars, Inc.
1980 Rt. 30, Unit 13
Sugar Grove, IL 60554
312-466-7540

Send SASE or call for information.

Cobra car kits, line of parts and accessories. Powder coating. Custom services: restoration, assembly, or partially completed kits.

Custom Cars by Robbie
17115 Alburtis Ave.
Artesia, CA 90701
213-860-5092

Write or call for information.

Custom services: partially built kits finished, new kits assembled; builds to personal preference. Artesia auto electric repair. Custom exhaust systems and engine work.

Dolphin Vehicles
Box 110215
Campbell, CA 95011

Information poster $12.00.

Plans for futuristic 3-wheeled vehicle.

Doran Motor Co.
1728 Bluehaven Dr.
Sparks, NV 89434

Brochure $5.00.

Plans for electric (or gas) 3-wheel, 2-seater car.

Dory Skiffs
Box 720
Galveston, TX 77553

Brochure and photos $5.00.

Plans for "Gloucester Gull" rowing dory—you-build.

Eagle Coach Work, Inc.
760 Northland Ave.
Buffalo, NY 14211
716-897-4292

Color brochure $3.00.

Replica car kits: Jaguar SS100 replica, with plexiglass wide windows, imported wood dash, triple chrome-plated steel radiator shell, 6 additional inches of leg room (adjustable seats), and simplified construction, approved lighting, 50% increase in interior storage space, restyled rear deck. XK120G sports car kit, with rigid side windows, wood dash, authentic style, and simplified assembly. Both cars are built on custom-engineered steel chassis for easy-bolting to Ford Pinto or Mustang II running gear. (Also has completed cars.)

Electro Automotive
P.O. Box 1113
Felton, CA 95018

Send SASE for information.

Voltsrabbit™ bolt-in-kit for converting gas or diesel Rabbit to electricity. "Conversion can be done in one week."

EVA Sportscars
Pleasant Corners
Vankleek Hill, Ontario, Canada KOB 1RO
613-678-3377

Send $3.00 for full information.

The Beva sportscar kit, with Toyota drivetrain/parts, MIG welded space frame chassis with mounting brackets for all components; with fiberglass body including all interior moldings, "superb autocross competitor." Optional wet weather equipment.

HOVERCRAFT: *An air cushion vehicle that travels on air trapped in a chamber beneath the craft. This chamber must be continuously supplied with air under pressure to replace the air escaping from the bottom edge of the chamber. The air is contained in the chamber by a flexible curtain or skirt which is fastened to the outer edge. Courtesy of Universal Hovercraft.*

Everett-Morrison Motorcars
5137 W. Clifton St.
Tampa, FL 33634
813-887-5885

Cobra replica catalog $2.00. Component catalog $3.00.

Replica 427SC Cobra car kits (Mustang or Pinto components bolted on 4" round tube frame kit); Cobra bodies, body frame kits; optional Jaguar front and rear end, optional Corvette suspension. "Factory direct." (Also has rolling chassis turnkeys.)

Fiberfab International, Inc.
6807 Wayzata Blvd.
Minneapolis, MN 55426
612-546-7336

Write for brochure.

"Replicars" kits: replicas of 1952 MG-TD (with front or rear engine drive), 1929 Mercedes Benz ssK, 1955 356-A Speedster, and Speedster Californian models; "easier to build than you might imagine." With average mechanical skills and ordinary tools; kits come with step-by-step assembly guide. American Express, MasterCard, Visa.

Fiero Plus
11 Doe Rd. #2
Carleton Pl., Ontario K7C 3P2 Canada
613-253-0617

Catalog $4.00.

Fiero: 11 body conversions, variety of styling packages, V-8 conversions, turbo chargers, suspension systems.

Folbot

P.O. Box 70877
Charleston, SC 29415

Send SASE for full details.

Boat kits: Folbot™ kayaks, folding boats, and rigid models; "rotomolded" polyethylene and fiberglass including sailrigs and a variety of other accessories.

Gas Saver/Dory Skiffs

Box 720
Galveston, TX 77553

Send SASE for full information.

Gloucester Gull rowing dory—boat plans for fishing, surfing, sailing power dories, runabouts, motor cruisers, prams, skiffs, schooners. "Low cost boats you can build."

Gatsby Production

1801 Almaden Rd.
San Jose, CA 95125
408-267-0900

Cabriolet/Griffin brochure and prices $5.00.

Component cars: Gatsby Cabriolet and Griffin roadster kits. Assembly manuals and template packages.

Gennie Shifter Co.

930 So. Broadmoore Ave.
West Covina, CA 91790
818-337-2536

Send SASE for list.

Street and racing hot rod parts, including Gennie shifter and hand brakes for GM, Ford, and Mopar. Rear mount shifter. Boot kits, brake pedal pads, Lo-Line™ hand brake, Gennie hood prop, throttle cable, kickdown cable. Stainless headlight bars, brake cables, flush-mount mini antenna kit. Gas pedals with splined shift knobs, Billet aluminum mirrors, column dress-up kit. Midland brake booster, Gennie lites, others. Master-Card, Visa.

Glen-L Marine

9152 Rosecrans, Box 1804
Bellflower, CA 90706

Free catalog.

Boat kits, plans, patterns (full-sized) for fishing boats, duck boats, sailboats, inboards, outboards, cruisers, jets, runabouts, dories, workboats, hydroplanes, pontoons, houseboats—from 8' to 49' models; of wood, steel, aluminum, fiberglass. Boatbuilder's supplies. Books on fiberglass boatbuilding, plywood boats, inboard motor installation, rigging small sailboats, building boat trailers, Tunnel Mite patterns and plans; others.

Goldbergs' Marine

201 Meadow Rd.
Edison, NJ 08817
800-BOATING

Call or write for catalog.

Boating products—full line of parts, accessories, kits, others, "everything for boating, sailing and fishing, great discount prices."

Golden West Motorsport, Inc.

27732 Industrial Blvd.
Hayward, CA 94545
415-783-7555

Catalog $5.00.

Cobra replica car kits, rolling chassis, and turnkey cars; replicas from ERA, NAF, and contemporary; "award winning sports convertibles." Gran Sport Vette and Daytona Spyder replicas.

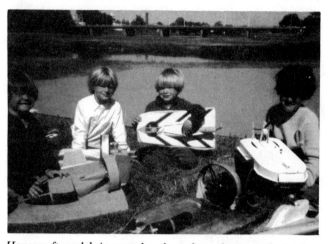

Hovercraft models in eager hands—of styrofoam, with plastic trash bags as skirts, and small DC or airplane electric motors.
© *Universal Hovercraft*

Hardy Motors

P.O. Box 28338
San Diego, CA 92128
619-562-9860

Information package $5.00.

Allard J2X Laser car kit—reproduction of the British Cad-Allard classic racing machine (only 88 original cars were built); in ready-to-complete component form. Also turnkey. "Dealer inquiries welcome."

Harris Engineering

Box 885192
San Francisco, CA 94188
415-469-8966

Information package $5.00.

Kit car—Countach SRT 9000 body kits, round tube space frame for Countach or Cobra; suspension equipment, any drive train equipment; equipment—V8-ZF/Porsche, V6 Transverse, Fiero. Turnkey models.

Helicraft

P.O. Box 50
Riderwood, MD 21139
301-583-6366

Catalog and kit information $10.00

Build-your-own helicopter plans and kits, several models. Accepts credit cards.

Hydrajet
P.O. Box 1246
Troy, AL 36081

Send SASE for information.

You-build jet boat or ski plans—uses 50 HP engine and pump kit.

Innovations in Fiberglass
P.O. Box 60642
Phoenix, AZ 85082
602-377-0104

Brochure $4.00.

Convertible car kits. "Home of the 930-VEE."

Johnex Cobras
18 Strathearn Ave., Bldg. A North, Unit 43
Brampton, Ontario L6T 4L8 Canada
416-790-0470

Brochures $5.00.

Cobra replica car kits, parts and accessories, hand-laid fiberglass bodies, roll-cage race-designed chassis. Assembly service for other kits.

Kart World
1488 Mentor Ave.
Painesville, OH 44077
216-357-5569

Catalog $3.00.

Go Karts—kits, engines, and parts; also for minicars, minibikes. "Largest selection. Discount prices."

Ken Hankinson Associates
Box 255
LaHabra, CA 90633
213-947-1241

Catalog $5.00 (includes dinghy plans).

Boat plans and kits for hundreds of models, 7' to 55'; from world famous designers: powerboats, inboards, outboards, rowboats, sailboats; variety of types and sizes.

Kustom Motorcars
P.O. Box 230
Hereford, TX 79045
806-364-1811

Send SASE or call for details.

Custom building of kit cars service, completion of unfinished kits; V-6 installations a specialty; dealer for West Coast Cobra and other major manufacturers.

Legendary Motorcars, Inc.
P.O. Box 292434
Columbus, OH 43229
614-848-3687

Complete information package $1.00.

Car kits, of yesterday's wood-paneled four passenger wagon, delivery van, and pickup.

Louisell Enterprises Inc.
6516 Bellinger Dr.
Mt. Pleasant, MI 48858
517-772-4048

Information $10.00.

Kit car components—exotic automotive designs.

Marauder & Co.
R.R. 2
Potomac, IL 61865

Catalog and complete information $12.00. Foreign mailing of catalog $15.00.

Marauder kit cars—replicas of the Lola, McLaren, Ferrari, and Chevron sport racers; VW versions, with 35 MPG to full Can-Am street cars with 25 MPG. Kits combine VW components with aluminum/steel monocoque; others give the performance of fully independent Can-Am type suspension, ZF transaxle and the customer's V-8 engine.

Masterworks
P.O. Box 511
Fallston, MD 21047

Send SASE for details.

Plans for the "Automite" personal car (fully enclosed, all-weather cab), "inexpensive to build."

McCoy Aircraft
P.O. Box J, Suite 243
Manhattan Beach, CA 90266

Brochure $1.00.

Airplane and hang glider designs.

Mid States Classic Cars & Parts
835 W. Grant, P.O. Box 427
Hooper, NE 68031
402-727-6645

Free brochure. Information package $5.00

Parts for classic and other cars: windshields, seats, bumpers, frames, bodies, windshields, frames. Has Re-chrome, repair or replacement glass service.

O.G.C.
Box 340
St. Claude, MB, R0G 1Z0 Canada
204-749-2094

Information package $5.00

427 Cobra replica kits, rolling assemblies.

Performance Automotive Wholesale
21050 Lassen St.
Chatsworth, CA 91311
818-998-6000

Giant parts catalog $5.00.

Performance products for home car rebuilders. Performance and racing engine parts and kits feature top name brands. Super Stock master kits, crank kits, piston kits. SIS performance hydraulic cams, Milodon water pumps (Chevy, Ford), automatic transmissions, converters, camshafts, Crane cams. Carburetors, clutches, distributors, electric fuel pumps, and mechanical pumps. Chrome accessories, timing chain covers, starters, alternators, transmission oil pans and dipsticks, water pumps, air cleaners, water necks). Others. MasterCard, Visa.

Poli-Form Industries
783 San Andreas Rd.
La Selva Beach, CA 95076
408-722-4418

Catalog $3.00.

Kit cars—individual parts to complete kits: track roadster kit using molded fiberglass parts—Ford bodies including '27 Roadster, '27 four-door Touring car, '29 Roadster, '29 Highboy, '34 3-Window Coupe. Full line of bodies, fenders, aprons, dashes, and other parts for '26-'34 Fords and '29-'34 Chevrolets. Wiring components, frames. Custom windshield posts.

Premier Marketing
P.O. Box 96
Lake Oswego, OR 97034
503-636-9245

Send $2.00 and SASE for information packet.

Total restyle kit for Porsche 914, fiberglass construction; do-it-yourself installation.

R & W Sales & Engineering
P.O. Box 126
Elyria, OH 44039
216-365-3256

Send SASE or call for information.

Custom services: chassis fabricated for any application. Specializes in V-6 installations.

Redline Roadsters
30251 Acre Place
Orange, CA 92669
714-771-0533

Send SASE or call with inquiry.

Donor car parts for: Sebring, Speedster, Cobra, Corvette, VW-based or whatever car being built. Donor parts are rebuilt, with new bushings and bearings; recondition arms, rack and pinions, springs, differentials, custom power steering units, motors, transmissions—all built to specification. Custom kit building.

Renegade Hybrids
12004 Rivera Rd.
Santa Fe Springs, CA 90670
213-696-1344

Brochure $3.00 (specify model of Porsche).

You-build it conversion of Porsche, 911 V8 or 914 V8. Optional brake and suspension upgrades; also in V6 kit for the 914. MasterCard, Visa.

Rowan Replicars
P.O. Box 2133
Salisbury, NC 28145
704-636-7020

Color brochure $2.00.

Car component kits—for the 427 SC Cobra: heavy-duty frame; one-piece molded bodies with hinged doors, hood, and trunk; extra features to aid the assembler.

RPM Design Ltd.
29 Benton Rd.
Newport, RI 02840
401-849-7288

Information package $5.00.

Pontiac Firebird conversion '82-'91 kits.

Sand Yacht, American
7184 Hwy. 101
Yachats, OR 97498

Send SASE for details.

Plans for a landsailer vehicle.

Sevtec
Box 846
Monroe, WA 98272

Information package $4.00 (refundable).

Hovercraft plans—for craft that flies over land, sea, or air; with 3 to 160 HP.

Shell Valley Motors, Inc.
RR #1, Box 69
Platte Center, NE 68653
402-246-2355

Brochure $4.00.

Cobra car kit or plans: sports convertible type, that, with exception of paint and interior, can be completed "by the average home mechanic." Has advanced molding processes, precut body holes, wiring design for beginners; optional front and rear suspension and Kevlar body.

Shoemaker Specialty Cars
Rt. 66 South
Ford City, PA 16226
412-763-9203

Send SASE for information.

Specialty car kits, V8 conversions and turnkeys.

S.I.A.C. Int'l
1418 Industrial Way
Gardnerville, NV 89410
702-782-4037

Complete information $5.00.

Midtec™ Spyder "supercar" kit: 90's styling and one-piece body, custom mid-engined spaceframe chassis, independent suspension and 4 wheel disc brakes. Builds using variety of 4-cylinder or rotary engines and 4 or 5 speed transmission.

Sportscraft
Box 640
Meeker, OK 74855

Catalog $3.00.

Airboats — hovercraft plans, kits, propellers, engines, other supplies and accessories. Wind machines.

Struck-Kit
Box 307
Cedarburg, WI 53012

Catalog of uses $1.50.

Kits and plans for mini-dozer tractors including Magra-trac™—landscapes home or road, excavates (for basement, pool, etc.), hauls, clears areas; in kit form (also assembled). Technical manual (with construction details).

Sun Ray Products Corp
8017 Ranchers Rd.
Fridley, MN 55432
612-780-0774

Free parts list.

Bradley GT parts — original equipment replacements, including doors, windows, gaskets, wiring harnesses, other items; some of limited quantity.

Sundance Auto Fabrication, Inc.
3906 W-Ina Rd.
Tucson, AZ 85741
602-744-1457

Color photos and information $4.00.

Sundance Cobra 427 SC replica car—big block Ford engine, round tube frame, Jag rear end — automatic, quality body and frame from Midstates Classics parts. Experts in Beck 500 Spyders and other replica cars.

Tag-Along
Box 15107
Salem, OR 97309

Catalog $4.00 (refundable).

172 Trailer plans: motorcycle, utility trailer, car construction; others. Component kits.

TCS Fiberglass Boats
375 State St.
Albany, NY 12210

Write for information packet.

Fiberglass cruiser and other hulls, assembled, to-be-finished.

The Classic Factory
1454 E. 9th St.
Pomona, CA 91766
714-629-5968

Information package $5.00.

Auburn and Cord replicas—basic body kits (hand-laid fiberglass, indexed for assembly ease); reinforced chassis and heavy steel bird cage in body to eliminate rattles.

Ultra Designs
35 Clarence St.
Brockton, MA 02401
508-586-3112

Brochure, Countach data $12.00 each (U.S.).

Sienna Sales Countach component kit car (from England)—with double skinned body panels, recesses cut out of the body, head lamp pods in one piece, doors come hung, window frames and winders fitted into doors. Curved side glass. Wheel arches and front spoiler are bolt-on as original. Ultima "C" and PR type racing cars.

Universal Hovercraft
Box 281, 1204 3rd St.
Cordova, IL 61242

Catalog $2.00.

Hovercraft plans—include performance and operating data; over 15 models—from 10' to 26'—that can travel to 75 mph. A 2-3 person model can be constructed in 80-160 hours, uses 4 cycle mower engines, will ride 30-50 MPH at 8" hover height. Other models that seat to 16 persons. Hovercraft propellers and lift fans (for direct drive) tin engine, belt driven props, and for single engine. (Contact Hovercraft of America, P.O. Box 216, Clinton, IN 47842 for information on the only organization of amateur and professional hovercraft enthusiasts. A national rally is held in Troy, OH, in early June each year.)

Wings & Wheels for Kids
P.O. Box 2400
Mission Viejo, CA 92690
714-951-5351

Send SASE for prices.

Plans/kits for "sidewalk" airplanes (5 models) and pedal cars (3 models)—for ages 2 to 7 years.

Zenith Wire Wheel Co.
155 Kennedy Ave.
Campbell, CA 95008
408-379-3136

Send SASE for full information.

Zenith wire wheels for kit car application—real knock-offs that adapt to American and imported chassis (sizes 12" through 16" with varying widths available).

Doll & Toy Making—Rigid

❧❧❧❧❧❧❧❧❧❧❧❧❧❧❧❧❧
See also CERAMICS, MINIATURE MAKING, MODEL MAKING, WOODWORKING, and other related categories; BOOKS & BOOKSELLERS, PUBLICATIONS, AND ASSOCIATIONS.
❧❧❧❧❧❧❧❧❧❧❧❧❧❧❧❧❧

AIM Kilns
369 Main St.
Ramona, CA 92065
800-647-1624 (except CA)
800-222-5456 (in CA)

Free literature.

AIM Doll kiln, 8" high, 8" wide, 9" deep; 120V, to cone 10; with kiln sitter shut off and infinite switch; optional timer. ("Dealer and distributor inquiry invited.")

Anne
P.O. Box 371
West Linn, OR 97068
503-656-9556

Send stamp for list.

Doll eyes (hand glass—all styles, German glass). Doll teeth.

A.R.T. Originals
12815 N.E. 124th St.
Kirkland, WA 98034
206-821-2997

Send SASE for full information.

Head molds and complete set (head, arms, legs, S/P, body pattern, technique sheet) for girl dolls, Hmong child, others. Has MasterCard, Visa.

Banner Doll Supply
P.O. Box 32
Mechanicsburg, PA 17055

Send SASE for list.

Doll stands (adjustable height, vinyl-coated steel wire) in 10 sizes for dolls from 3½" to 48"; in lots of 6 or dozen. Has quantity prices. Visa, Discover, MasterCard.

B. B. Doll Supplies
4216 Grandview Rd.
Kansas City, MO 64137
816-761-4900

Send SASE for list.

Doll supplies: doll molds, materials, tools, accessories, wigs, lashes, shoes, socks, tights, pellets, dresses (Vee's Victorian). Granny molds and wigs. Distributor of major brands. MasterCard, Visa. (Also sells wholesale.)

Byron Molds, Inc.
4710 Beidler Rd.
Willoughby, OH 44094
215-946-9232

Doll catalog $6.50. Pattern catalog $9.95.

Doll molds and supplies including bodies, wigs, eyes, others. Has MasterCard, Visa.

Carvers' Eye Company
P.O. Box 16692
Portland, OR 97216
503-666-5680

For information send $1.00.

Glass or plastic eyes, noses, joints, growlers, and eye glasses for teddy bears, dolls. (And sells wholesale.)

Collectible Doll
1421 No. 34th
Seattle, WA 98103

Send SASE for further details.

Instructional video: Painting Reproduction Antique Dolls (with Jean Nordquist). China paints. Over 170 rare/classic molds. Eyes, wigs. Kilns, books.

Colorado Doll Faire
3307 S. College Ave.
Ft. Collins, CO 80525
303-226-3655

Send SASE for further details.

Composition doll repair kit: Craze Control restores minor crazing, cleans; Care-Repair flesh-tinted compound fills cracks, rebuilds fingers and toes, resurfaces chips.

Create An Heirloom
160 West St., P.O. Box 301
Berlin, MA 01503
508-838-2130

Catalog $2.00.

Over 50 painted porcelain doll kits (includes dress and body patterns): 19" Goose Girl, 21" Peddler and Bye-Lo Baby dolls, 16" Mammy, 24" Pierrot, 21" Gibson Girl, 19" Little Women (4), 9½", 21" Scarlett. Porcelain doll heads (2½") with hole in top—for ornaments, potpourri, etc. Dollhouse dolls, character dolls, toddler and twin dolls. Doll stand, baby chairs, eye setter tool. Socks, tights, composition bodies. Trims, furniture. Book: *Create An Heirloom*, by Eileen Heifner. Skull crowns, pates, acrylic eyes (8-18mm), teeth, lashes, shoes, plastic pellets. Quantity prices. Sells wholesale to businesses.

CR's Crafts
Box 8
Leland, IA 50453

Catalog $2.00.

Doll and animal patterns, kits, supplies: teddies, monkey; wrap-around puppets, dolls (plastic heads). Craft fur, fabrics, fiberfill, animal parts, music boxes. Doll parts. Others. Has quantity prices.

Creative Paperclay Co.
1800 S. Robertson Blvd., Suite 907
Los Angeles, CA 90035

Send SASE for details.

Creative Paperclay™ (air hardens, durable, lightweight).

Dollspart Supply Co.
46-50 54th Ave.
Maspeth, NY 11378
718-361-1833

Free color catalog.

Full and complete line of doll-making supplies: doll kits —baby, fashion, ethnic, others. Doll parts, bodies, heads, hands, feet, eyes, wigs, ceramic supplies/paints. Doll shoes, clothing, costume, hats. Doll stands. Elastic cords, rubber loops. Doll sewing notions, trims. Major credit cards. "Distributorships available."

Dunham Arts Ltd.
36429 Row River Rd.
Cottage Grove, OR 97424
503-942-2836

Send SASE for further information.

Original doll molds including Her Majesty, by Susan Dunham; head, arms, legs, bust, for 14", 18", 24" sizes. Body and costume pattern included.

Enchanted Dolls
3674 East Hastings St.
Vancouver, BC V5K 2A9 Canada
604-298-1079

Catalog $5.00.

Doll supplies: original molds, patterns/technique sheets from Doll Artworks, Bella Bambina, The Ultimate Collection, Irma's Gallery, Precious Heirloom Dolls and Syndee's. (Also sells wholesale.)

Glass House
Woonsocket, SD 57385

Free catalog.

Line of doll eyes including sleeping, movable with lashes, others; for variety of doll types and sizes, and for toys.

Good-Kruger Dolls
1842 Williams Penn Way
Lancaster, PA 17601
717-687-7208

Send SASE for further details.

Doll molds — heads, hands; including "Hard Lessons" and "Simple Pleasures," 15" soft-body types who share same hand mold and body pattern. "Loreli" doll molds.

Hamilton Eye Warehouse
Box 450
Moorpark, CA 93021
805-529-5900

Catalog $1.00.

Doll/toy eyes: hollow blown glass, acrylics, solid glass paperweights (antique-look); over 8 colors, 8mm to 28mm sizes, each pair matched. "50% off."

© *The Wonderful World of Dolls*

Hartville Woodcrafts
Box 1059
Hartville, OH 44632

Patterns and price list $1.00.

Toy cutout patterns: cars, trains, others.

Howee Toys
Rt. 7, Box 633
Joplin, MO 64801
417-623-0656

Free catalog.

Wooden toy plans: vehicles (trucks, antique cars, Model A and T Fords, jalopies, roadster, coupe, trains, farm equipment, "heavy haulers," trucks). Hardwood wheels, balls, Shaker pegs, drum, barrel, milk can. Candle cups/inserts. Toy parts, axle pegs, plugs, others. Spindles, hardwood dowels. 5" scroll saw blades. Quantity prices, large order discounts. Also sells wholesale to businesses.

Huston's
7960 U.S. Rt. 23
South Chillicothe, OH 45601

Catalog $2.00.

Over 200 handmade porcelain doll kits (and dolls); old-fashioned girls and babies; others.

IMSCO
1620 So. Sinclair St.
Anaheim, CA 92806

Color catalog $5.00.

Great American Doll Company's artist and antique doll molds, including Puyi & Suzi (by Rotraut Schrott), doll

wigs (full line of styles and colors, eyes (blown glass, Puppenaugen eyes with glass lens), doll parts, elastic cords, body and clothing patterns. Porcelain or composition slip. Stands, shoes, hats.

Intl. Porcelain & Glass Repair, Inc.
P.O. Box 205
Kulpsville, PA 19443

Send SASE for further details.

Instructional video (52 min.): Doll Repair and Restoration—repairing a German china head and Jumeau; detailed step-by-step views of techniques (replacing missing pieces, filling cracks, repainting, others).

Jewel Sommars
P.O. Box 62222
Sunnyvale, CA 94088
408-732-7177

Send SASE for further information.

Instructional video (Beta/VHS): Delightful Dolls—Collecting and Making. Techniques for portrait, original, reproduction; expert instruction in sculpting, molds, casting, finishing, wigs, eyes, costume making, more.

Jone's Ceramic Studio
8620 Wright Rd.
Hillsboro, OH 45133

Catalog $1.00.

Reproduction antique doll kits—china head and porcelain. Doll clothes patterns.

Judith Howe
1240 No. Jefferson
Anaheim, CA 93807
714-630-0677

Send SASE for catalog sheets.

Porcelain doll eyes in 16 shades of gray, green, brown, lavender, aqua, blue, amber, bronze. Designer doll armatures, stands.

Lifetime Career Schools
101 Harrison St.
Archbald, PA 18403

Free booklet.

Doll repair/restoration home study course; also dressing, antiques, other aspects; for business or hobby.

Ma's Body Shop
1628 Eifert Rd.
Holt, MI 48842
517-694-9022

STUFF THE BODY: *Stuff the body of the porcelain reproduction doll as firmly as you can. This is important as otherwise the doll may droop or the stuffing become separated at the doll's waist when held by the stand for a long time. Courtesy of Eileen Heifner of Create An Heirloom.*

Send SASE for price list.

Composition bodies for dolls—finished or straight from the mold, in variety of sizes and types.

Pekin Porcelain Slip Co.
RR 3, Box 403
Pekin, IL 61554
309-346-7916

Send SASE for price list.

Porcelain slip for doll making, etc. in 39 colors. Ceramic and stoneware slip.

Rivendell Inc.
8209 Proctor Rd.
Painesville, OH 44077
216-254-4088

Catalog $3.00.

Dolls, doll parts and supplies of: Seeley's Wee3, Kemper, Playhouse, Virginia La Vargna, Global, Judith Howe, Kais, Sugar Creek Scharff, Langnickell, Bell Research, European Colours, Kaiser, Orton, others; doll clothes and patterns. MasterCard, Visa. (Also sells wholesale.)

Standard Doll Co.
23-83 31st St.
Long Island City, NY 11105

Catalog $3.00.

Doll making: china doll kits (with head, arms, legs, and body patterns): clown, 62+ old-fashioned dolls, pincushion ladies, Mary Poppins; Gone With the Wind characters. Americana portrait dolls (presidents, first ladies). Porcelain bisque kits (antique reproductions of Heubach and other dolls). Porcelain bisque doll heads, parts; body patterns in 12 sizes. Plastic head parts, dolls. 11½" dolls, 12" boy. Doll stands, covers. Clothespins.

Doll accessories. Voices, sounds, squeakers, growlers, music boxes. Shoes. Coil screws, hooks, stringing items. Eyes, wigs. Body skins (leather). Bags, tags. Miniature wood furniture kits, patterns. Magna-Sighter magnifier. Books, patterns (including antique doll clothes). Fimo and Sculpey modeling compound. Paper dolls. Quantity prices. American Express, MasterCard, Visa. (See DOLL & TOY MAKING—SOFT.)

Tallina's Doll Supplies, Inc.
15790 S.E. Hwy. 224
Clackamas, OR 97015
503-658-6148

Catalog $1.00.

Dollmaking kits, bodies, eyes, lashes, wigs; other extensive supplies—for collector and craftsperson.

The Teddy Works
46-50 54th Ave.
Maspeth, NY 11378
718-361-1833

Catalog $2.00.

Teddy bear supplies. Accepts major credit cards.

The Ultimate Collection, Inc.
12773 W. Forest Hill Blvd., Suite 1207
West Palm Beach, FL 33414
407-790-0137

Catalog $5.00.

Doll molds including baby heads — "Sweetness" (eyes open), "Serenity" (eyes closed); hands, wigs, patterns, body joints; 21" baby, others. MasterCard, Visa.

Van Dyke's
Woonsocket, SD 57385

Catalog $1.00.

Doll restoration products: eyes (for all purposes); modeling, casting, and filling materials.

Vickie Anguish Original Molds
1704 Morrison
Topeka, KS 66605
913-232-5676

Mold list and photo, send $3.00 and large SASE.

Doll head and hand molds (and body and clothing patterns) including for 19" baby "Cuddle Bug," "Elizabeth" 9½ head circ. (head only—fits Byrons) makes 14" or 15"; "Rachel" darker skin (head only can be used on Phylis dolls), "Melody" (head only circ. 8") darker skin, "Phylis" 25" doll (head circ 8½") light skin, open crown head; hand and foot molds. MasterCard, Visa.

Wooden Toy
Box 40344
Grand Junction, CO 81504

Catalog $1.00.

Wood toy patterns, wood parts.

BODY UP: *When choosing doll body fabric, use a tightly woven fabric such as unbleached muslin—the best quality you can afford for the heirloom you create. Courtesy of Eileen Heifner of Create An Heirloom.*

Frames & Picture Framing

See also CRAFT SUPPLIES, ARTIST'S SUPPLIES, WOODWORKING, NEEDLECRAFT SUPPLIES, QUILTING, and related categories; BOOKS & BOOK-SELLERS, PUBLICATIONS, and ASSOCIATIONS.

American Frame Corporation
1340 Tomahawk Dr.
Maumee, OH 43537
800-537-0944

Send SASE for list.

MICA laminated section frames (13 colors)—easy assemble, by pairs (2 pairs for 1 frame) in 2 widths, in inch sizes from 5" to 40"; or custom cut; frames include corner inserts, hangers, spring clips, wall protectors. Metal picture frames (by section pairs) in 10 anodized and 24 enameled colors; 6 sizes and styles. Hardwood section frames. American Express, MasterCard, Visa.

Cos-Tom Picture Frame
1121 Bay Blvd.
Chula Vista, CA 92011
619-429-9500

Free catalog.

Frames in a many finishes and styles—classic, contemporary, traditional, baroque, others. Bonus coupons.

Documounts
3709 W. 1st
Eugene, OR 97402

Catalog $2.00.

Assortment of wood picture frames in variety of sizes, styles, colors. Bevel edged mats in neutrals and colors.

Frames by Mail
1155 Adie Rd.
St. Louis, MO 63043

Free catalog.

Picture frames: wood and metal, wide range of sizes. "Quantity discounts."

Frame Fit Co.
P.O. Box 8926
Philadelphia, PA 19135
215-332-0683

Send SASE for information.

Custom aluminum frame sections (by pair) in 4 styles/widths, 17 colors, and metallics, with corner hardware; 8" to 30" lengths. Bulk chop frame sections by 50 pairs of same size, color, and shape, at discount.

Frame Strips
Box 1788
Cathedral City, CA 92234
619-328-2358

Send for free samples.

Framestrips™ clear self-adhesive channel for mounting, framing, and attaching changeable artwork, signs, etc.

Frame Wealth
R.D. 2, Box 261-7
Otego, NY 13825

Write for catalog.

Frames: wood, metal. Length mouldings. Tools, hardware. How-to books.

Franken Frames
214 W. Holston Ave.
Johnson City, TN 37604

Write for catalog.

Picture frames—quality wood moldings in variety of styles, sizes, and colors; custom sizes, "low prices."

Graphic Dimensions Ltd.
41-23 Haight St.
Flushing, NY 11355

Free color catalog.

Picture frames—line of modern metals, lacquered, classic woods; frames with linen, burlap, or suede liners. Other styles include rustic, traditional, contemporary, Oriental, European; from "discount frame source."

Imperial Picture Frames
P.O. Box 598
Imperial Beach, CA 92032

Free color catalog.

Frames, many styles, types, sizes at "wholesale prices." They "pay all freight in continental United States."

Stu-Art
2045 Grand Ave.
Baldwin, NY 11510
516-546-5151

Free catalog and mat samples.

Mats, picture frames: mats—conservation type in 17 sizes, 5-in-1 Ready-mats in 23 sizes, hand-cut beveled edge mats. Frames: Neilsen aluminum frame sections, wood and Tenite and ash frame sections, pre-assembled aluminum and wood frames, variety of sizes. Plastic picture saver panels. Shrink wrap.

Tennessee Moulding & Frame Co.
1188 Antioch Pike
Nashville, TN 37211

Full color catalog $5.00.

Picture frames—including 450 choices of metals, woods (oaks, pines, poplar, painted colors/metallics, others): Ashwood "Pastel Collection" of soft stained shades. "Classy" art deco look, others, in over 90 natural woods/styles, some with metallic trim; gilded frames. Designer molding with aluminum Designer Mates™ profiles, color bonded coatings, mirrors, etc. Crescent Mat Board—acid-free, 63 color shades. Regular mat board, foam center and thick newsboards, black core, and simulated fabrics. Oversizes, museum boards, and barrier papers.

The Fletcher-Terry Company
65 Spring Lane
Farmington, CT 06032

Send SASE for full details.

Picture framing tools: FrameMaster™ stapler, fires flat points; claims points don't dent backing or split wood. Fletcher #5 point driver fires stacked triangle points and #1 and #2 diamond points for picture framing or glazing. FrameMate™ presses flat framer's points or brads into frame molding up to 3" wide and 1½" deep.

World Frame Distributors
107 Maple St.
Denton, TX 76201
817-382-3442

Free brochure and price list.

Frames—traditional ready-made types and sizes, gallery style ornately crafted, supplies, canvases. Manufacturers, importers, distributors.

Furniture Making & Upholstery

🐦🐦🐦🐦🐦🐦🐦🐦🐦🐦🐦🐦🐦🐦🐦🐦

See also BASKETRY & SEAT WEAVING; MINIATURE MAKING; PAINTS, FINISHES & ADHESIVES; WOODWORKING; and other related categories; BOOKS & BOOKSELLERS, PUBLICATIONS, and ASSOCIATIONS.

🐦🐦🐦🐦🐦🐦🐦🐦🐦🐦🐦🐦🐦🐦🐦🐦

Accent Southwest
P.O. Box 35277
Albuquerque, NM 87176

Catalog $3.00.

Plans for Santa Fe style furniture (in popular and traditional designs)—chairs, tables, cabinets, others.

Emperor Clock Company
Emperor Industrial Park
Fairhope, AL 36532

Color catalog $1.00.

Furniture kits—traditional style cabinets, chests, tables, chairs, desks, others; in black walnut, cherry, or oak. Grandfather and other clock kits, movements, and dials.

Family Handyman/Plan Service
P.O. Box 695
Stillwater, MN 55082

Send SASE for list.

Furniture plans: game and coffee table, low-buck outdoor pieces, lawn glider swing, redwood lounge and table, PVC pipe outdoor furniture, outdoor dining set, captain's desk, child's rocker, baby cradle, others. (Publishes *The Family Handyman* magazine.)

Furniture Designs, Inc.
1827 Elmdale Ave.
Glenview, IL 60025
708-657-7526

Catalog $3.00.

Plans for furniture—over 200 professional designs—traditional, Early American, Spanish, modern styles: full-sized plans for tables, desks, chairs, cabinets, dry sink, buffets, corner cupboard, cupboards, hutches, cradle, chests, rockers, tea cart, trestle table, bench. Base units (chests, cabinets) and upper units (shelves, bookcases). American traditional living room grouping. Accessories (lamps, shelves, mirrors, racks, stools). Credenzas, crib, high chair, child's furniture. Gun cabinets, wheels, beds, headboards, bookcases. Allows discount to teachers and institutions. (Also sells wholesale to businesses.)

Genesis
Box 1526
Mendocino, CA 95460

Send SASE for details.

Instructions for willow-chair making.

J & L Casual Furniture Co.
P.O. Box 208
Tewksbury, MA 01876
508-851-4514

Send SASE for details.

Full line of PVC pipe furniture kits, plans, and supplies.

KC Enterprises
P.O. Box 45
Springville, UT 84663

Send SASE for details.

Plans for glider rockers (ball bearing design).

Minuteman, Inc.
Box 8
Waterloo, WI 53594

Wholesale supply catalog $2.00.

Refinishing products for stripping, repairing, refinishing, veneering, mirror resilvering; business opportunity data.

Table made from full-sized plans. © *Furniture Designs, Inc.*

Owen Company
Battle Ground, WA 98604
206-887-8646

Send SASE for complete details.

Starter guide to PVC furniture making (indoor and outdoor): chairs, tables, love seat, couch, chaise lounge, swing sets, recreation items, children's things, wood stacker, others; with plans and diagrams for 24+ "top sellers." Also shows sources of materials, cushion patterns, ways to profit with PVC furniture, others.

R. Berger
3452 Hermitage Dr.
Hopkinsville, KY 42240

Plans $4.00.

Detailed plans to build an authentic rope bed "for less than $50."

Spec. Furniture Designs of Michigan
797 W. Remus Rd.
Mt. Pleasant, MI 48858

Send SASE for full details.

Plans for building an octagon picnic table with attached bench seating (pictured instructions). MasterCard, Visa.

Terry Craft
12 Williams Ct.
Shelby, OH 44875
419-342-6376

Send SASE for further details.

Adirondack chair kit; with instructions; optional leg rest.

Thom's, Inc.
2012 Wilkins
Laurel, MT 59044

Send SASE for further details.

Picnic patio table plans—octagonal, seats 8, lazy susan, umbrella holder, 7' 1" diameter; made from 2 X 4s.

V. Wilmoth
1202 Vine
Norman, OK 73072

Send SASE for price list.

Polystyrene beads (washable, dryable filler) for bean bag chairs, infant "cuddle sac," stuffed animals, and dolls.

Van Dyke's
Woonsocket, SD 57385

Catalog $1.00.

Furniture components: fiber and leather seats, table and poster bed parts, Queen Anne legs, roll top desk tambours, curved sides, and pigeon hole unit. Chair and piano stool kits, parts. Cane webbing, cane, rush, reeds. Turnings. Wood carvings: gingerbread, filigrees, others. China cabinet glass. Lumber, plywood. Springs, border/brace wire. Spring cutter and bender tools, lever spring stretcher, spring puller hood. Spring straps, metal tacking strap and fastener strip. Klinch-It tool. Zippers and chain. Sewing machine for leather and heavy material. Rubber webbing, hemp twine, jute webbing. Dual clamp, glides. Nylon cord. Webbing stretcher. Super Steamer for upholstery work. Threads: nylon, linen (and waxed). Clips, helicals, torsion, and rocker springs. Needles. Fabrics: felt, duck, burlap, cambric, denim, twill, camouflage. Rayon braids, gimp, trims. Tools: awl, pinking machine, stuffing iron, seam and webbing stretchers, punches, nippers, sewing palm/thimble, mallet, staple guns, shears, calipers, pliers, kniever, others. Snaps, fasteners, grommets; kits. Instructional video: Elementary Upholstery, with Dwight Hunter. Furniture and cabinet hardware (brass, wood, cast iron). Quantity prices. (See MOLD CRAFTS and WOODWORKING.)

WHITEWASH IT: *Strip off all finishes from the item, and sand it. Mix one part white enamel paint and one part mineral spirits (paint thinner) and apply to the item, then wipe off with a cotton cloth. When dry, apply a sanding sealer and dry again. Sand lightly. Courtesy of MAB.*

Verano Upholstery
Box 126, 19411 Riverside Dr.
El Verano, CA 95433

Free brochure.

Upholstery instructional/training videos (2 hours, VHS or Beta): (1) Furniture Fundamentals—how to recover 80% of all furniture. (2) Auto-Marine—Renew/recover car, truck, and boat seats. Manual: *How to Start an Upholstery Business.* Also has tools, upholstery supplies, and follow-up. MasterCard, Visa.

Glass Crafts & Stained Glass

🐦🐦🐦🐦🐦🐦🐦🐦🐦🐦🐦🐦🐦🐦🐦🐦

See also CRAFT SUPPLIES, BEAD CRAFTS, CERAMICS, and other related categories; BOOKS & BOOKSELLERS, PUBLICATIONS, and ASSOCIATIONS.

🐦🐦🐦🐦🐦🐦🐦🐦🐦🐦🐦🐦🐦🐦🐦🐦

AmeriGlas
Box 27668
Omaha, NE 68127

Catalog $1.00.

Full line of stained glass tools, supplies, kits, others—for novice or artisan.

Anything in Stained Glass
P.O. Box 444
Rio Grande, NJ 08242

Catalog $3.50.

Stained glass supplies: "discount" glass, bevels, foil, solder, tools, patterns, books.

ASG
Box 552
Glendale, AZ 85311

Catalog $1.00.

Stained glass supplies, tools, equipment, and books.

C & R Loo Inc.
1085 Essex Ave.
Richmond, CA 94801
415-232-0276

Contact dealer or send SASE for information.

Flashed color/clear glass; in over 20 combinations; double flashes on clear and color.

Coran-Sholes Industries
509 E. Second
Boston, MA 02127

Free catalog.

Stained glass supplies: stained glass and came, leads, solders; variety of glass cutters, soldering irons, other tools. Manufacturer.

Covington Engineering Corp.
715 W. Colton Ave., P.O. Box 35
Redlands, CA 92374

Send SASE for list.

Glass machinery: glass beveling system—vertical machine for inside or outside curves, 2-station unit, will mount 10", 8", and 6" wheels, with cork and felt polisher. (Or unit without wheels.) 16" horizontal glass lap (for any size bevels); sphere cutting cups. Glass smoothing beveler—16" horizontal machine, for any size bevels. Glass lap kit—1" arbor shaft with flange, 16" taper iron plate, grit feed. 8" Diamond mini-lap, ball bearing arbors (for vertical glass units). Belt sander/polishers (for straight line glass bevels). Basic wet sanders (also mounted, and commercial). Large sphere maker (1¼" to 9" sizes) and cutter cups, supplies. Heavy duty 8" and 10" trim saws (precision glass cutters). Heavy duty slab saws, combination saws. Arbors and accessories. Glass lathe (engraver/cutter), Diamond glass router (shapes, deburrs, bevels). Koolerant pumps. Water and drain items. (See JEWELRY MAKING & LAPIDARY.)

Creek-Turn, Inc.
Rt. 38
Hainesport, NJ 08036
609-261-1170

Write or call for information.

Glassmold mix for mold making, kiln fired glass, antique reproductions, Tiffany style lamps, dimensional glass, draping, and slumping. Self-stacking™ slumping molds (no shelves needed), glass separator, mold release, mold makers' clays. Line of glass fusing kilns and firing kilns; kiln lids with elements. Glass crafting tools. Instructions.

Delphi Stained Glass
2116 E. Michigan Ave.
Lansing, MI 48912

Catalog $4.50 (refundable).

Stained glass kits/projects—variety of designs, including lampshades, windows (over 90 shapes/sizes). Stained glass: imported and domestic opalescent, iridescent, Chicago Art, streaky, confetti types; antique, ripple backed, cathedral, handblown types, others; "hundreds" of colors.

Glass cutters, circle cutter, drills, pliers, soldering irons, router. Supplies: lead came, copper foil, glass paints, others. Has quantity prices. MasterCard, Visa.

Denver Glass Machinery, Inc.
3065 S. Umatilla St.
Englewood, CO 80110
303-781-0980

Write or call for full information.

Glass machinery: hot glass and glory hole—electric glass furnace and propane glory hole (requires no special hookups), runs on 110V circuit. Glass bevelers—industrial model with 2 units, professional compact unit, studio beveler for table top use (works glass up to 15"). Engraver, bandsaws, kiln for fusing, slumping, or painting.

Eastern Craft Supply
P.O. Box 361
Wyckoff, NJ 07481
201-447-5476

Catalog $2.00 (refundable).

Glass etching kits (framed table mirrors, etching kits, others). Glass engraving course. Rotary engraving power

tool (to carve, engrave on glass, plastic, metal, wood). Supplies: stencils, slab glass (standing shapes), glass etching cream. Glass Etching and Mirror Decorating video course (VHS or Beta): mirror stripping, etching; transform glassware and mirrors into decorative accents; numerous projects shown. MasterCard, Visa.

START OFF RIGHT: *Learn stained glass crafting from a professional! Courtesy of Rebecca R. Palumbo of Ed Hoy's Stained Glass Distributors.*

Ed Hoy's Stained Glass Distributors
1620 Frontenac Rd.
Naperville, IL 60563
312-420-0890

Contact dealer or send SASE for order details.

Glass crafting supplies: glass bevels (shapes, clusters, color, mirror, panel, engraved). Painted/fired shapes, gems, marbles, nuggets, jewels. Colored sheet: antiques, glashed, streakies, crackles, mirror, Oceana, textures, art, Bullseye, cathedral, Spectrum, others. Scraps. Microsave fuser, fusing kilns. Clay molds, supplies. Fusing supplies/ tools. Fusible glass. Fusing kits/projects. Glass paints, brushes, stains. Tools: circle and other cutters. Pliers, shears, engravers, soldering irons; tools to bend foil, glass drill, burnish. Grinders, routers, belt sanders, saws. Projectors. Foil, came, channel. Chemicals. Lamp forms/ bases. (Sells wholesale to businesses.)

Forglass Tools
1224 Woodbridge
St. Clair Shores, MI 48080
313-776-0449

Contact dealer, or write for brochure.

Score 1™ glass cutter units (scores strips and perfect circles in variety of dimensions).

Franklin Art Glass
222 E. Sycamore St.
Columbus, OH 43206

Send SASE for list.

Stained glass tools: metal running pliers, glazing hammers, lead nippers; breaker-grozier, breaker and other pliers. Foil, lead, two-in-one pattern and other shears.

Glass Magic
Box 67213
Lincoln, NE 68506

Send $3.00 and SASE for details.

Stained glass kaleidoscopes making instructions.

Glastar Corporation
19515 Business Center Dr.
Northridge, CA 91324
818-993-5091

Free brochure.

Glass equipment including the studio disc grinder — high-speed 6" disc, grinds straight edges leaving smooth edge; puts 15 degree bevel on thick or uneven pieces.

Great Bell America Corp.
P.O. Box 78640
Los Angeles, CA 90016
213-931-2506

Send SASE or call for information.

Hi-Lite™ beveled glass pieces, clusters, panels; engraved and etched bevels, mirrored bevels; decorative shapes. Has four other outlets.

Houston Stained Glass Supply
2420 Center St.
Houston, TX 77007
713-868-5296

Send SASE or call for information.

Beveled glass: ComboClusters™ series—modular clusters in 28 designs to use alone or mix with any other clusters; 175 designs in all (also in BevelGraphic™ layout design sheets).

Lamp forms for stained glass work.
Ed Hoy's Stained Glass Distributors

Hudson Glass Co., Inc.
219 N. Division St.
Peekskill, NY 10566
800-431-2964 (except NY)

Catalog $3.00 (bulk) or $5.00 (UPS). Refundable.

Stained glass supplies from: Glastar, Inland, Motron, Worden, Reusche, Venture, Quicksilver, Ungar, Weller, Pop Lock, McNeil, Diamond, Fletcher, Seerite, Diegel, Sunray, Carolyn Kyle, Toyo, Uroboros, Dover, Canfiel, LW, Edco, PPG, Armour, Novacan, Armstrong, Glass Hues; others. Stained and other glass, crystals, chemicals, foils, patterns, tools and equipment, electrical parts, box accessories, books; others; with "discounts."

International, Inc.
P.O. Box 40
Westfield, NY 14787
716-326-6060

Contact dealer or send SASE for information.

Mika bevel glass shapes in traditional designs, 3/16" bevel clusters and bevel panels. Tote-carryall; holds crafting tools, other. Tools: scissors and set, soldering iron and stand, pliers, others.

LVR Products
P.O. Box 4907
Gardena, CA 90249
213-217-8823

Send SASE for further information.

Micro-Kiln EZ-5 — for small fusing glass projects; reaches fusing temperature in 3-5 minutes; cools in about 20 minutes; can heat it in microwave oven; for professionals and hobbyists.

From Floral Stained Glass Pattern Book, *by Ed Sibbett, Jr.*
© *Dover Publications, Inc.*

Nervo International
11257 Floridan Ave.
Naples, FL 33962
813-775-8336

Send SASE for full information.

Beveled glass, German jewels, and hand tools for glass crafting—in cast quantities only. High minimum order; "below importer prices."

P & E Manufacturing
45698 Samuel St.
Sarasota, FL 34233
813-924-6401

Contact dealer or send SASE for information.

Jen-Ken glass kilns—4 models; one model runs on 120V household current, others on 240V. Slumping molds. Automatic kiln shutoff and soak control.

Paragon Industries
P.O. Box 850808
Mesquite, TX 75185

Contact your dealer or write for details.

Glass fusing kiln with digital temperature controller, fir-

ing chamber dimensions 22"w X 13 1/8"h X 22"d.

Premium Products of Louisiana, Inc.
424 E. Vermillion St.
Lafayette, LA 70501
318-237-5691

Send SASE for information.

Beveled glass (tempered and insulated) in variety of designs, mirrored bevels. Stained glass sheets, paint/fired and etched glass. Custom beveling; mirror resilvering.

Prism Glassworks
1000 W. Bradley Ave., Suite J
El Cajon, CA 92020
619-449-2954

Contact dealer or send SASE for information.,

Brass and zinc-crowned lead came; Pro-Glaze™ thin foam strip on the inside of the came cushions the glass, eliminates the need for putty. Has 12 distributors throughout the U.S. and Canada.

Professional Stained Glass
245 W. 29th St.
New York, NY 10001

Send SASE for complete list.

Technical information sheets covering all aspects of the glass craft including: acid etching, beveling, brass and other cames, cementing, copper came and foil, cutting, design, doors and entries, fusing and enamels, framing aspects of fusing, glass types, installation, kilns, lamps (box, special effects, chandelier, others), marketing, molds for lamps, painting glass, specific projects, photographing glass, reinforcement, resists, safety, sandblasting, selling, soldering, sources, stencils, zinc; others.

Reusche & Co.
2-6 Lister Ave.
Newark, NJ 07105

Contact dealer or send SASE for information.

Stained glass artists' colors and accessories; student stained glass paint kit with brushes. Manufacturer.

Stained Glass Artworks
42400 Nine Mile Rd., #B
Novi, MI 48375
313-347-3488

Send SASE for full list.

Stained glass instructional manuals: math guide and adviser, setting up a stained glass studio, drawing methods of lamp construction, others.

Stained Glass Workshop
8285 Jericho Turnpike
Woodbury, NY 11797
516-367-3803

Free catalog.

Odyssey stained glass lamp system, in full line of "Tiffany" shade designs, shapes, sizes.

The G.A. Avril Co./White Metals
2108 Eagle Ct., P.O. Box 12050
Cincinnati, OH 45212

Contact dealer or send SASE for information.

Lead came, including special alloy type for restoration. Custom alloyed came and solders. Manufacturer.

Tritec
635 Strander Blvd.
Tukwila, WA 98188
206-575-1424

Write for catalog.

Straight line glass bevels—shapes, clusters, units; full line of designs/sizes (including rounds).

United Art Glass Inc.
1032 E. Ogden Ave.
Naperville, IL 60540
312-369-8168

Catalog $5.00.

Supplies/equipment: bevels, engraved, star, faceted, mirror, color, clusters. Jewels, nuggets, marbles. Glass — Bullseye, Chicago Art, Cotswold, Emaille, flashed, Flemish, antique Kokomo, Oceana, Waser, Wissmach, mirror, plate, others. Chemicals. Tools: 10 cutters, lead cames, shears, engravers, flexible shaft, glass drills, foiling machine, Foilomatic guide rollers, Glastar tools, others. Motron Surface system (cutting shops). Routers, saws, soldering irons. Etching items. Metal lamp bases.

Fusing projects. Jen-Ken fusing kilns, packs, equipment. Badger spray gun, paints. Kiln firing items. Patterns—lamp forms. Quantity prices. (Also sells wholesale.)

V.E.A.S., Inc.
P.O. Box 278
Troy, MI 48099
313-443-9000

Send SASE for brochure.

Instructional video on Glass Erasing (a controlled form of sandblasting)—can also be used for wood, plastic, or metal—program teaches techniques for professional results, for mirror decorating, monogramming, other projects; shows embellishing process on crystal wine glass. MasterCard, Visa. ("Dealer inquiries welcome.")

Whittemore-Durgin
Box 2065
Hanover, MA 02339

Catalog $2.00.

Stained glass: French and German antique, cathedral types (sheets, by pound), antique, opalescent; clear beveled, jewels, others. Stained glass kits with tools, basics, pre-cut lamps. Tools/supplies kits. Suncatcher kits, lampshade maker kits. Tools: glass cutters, pliers, lead straighteners, soldering irons, glass grinder; accessories. Lead came, copper foil, brass channel and banding. Lamp parts, decorative chain. Hinges. Metal lamp bases. Lead castings. Patterns, books. Quantity prices.

Inlaid circle/strip glass cutter combination. Ed Hoy's Stained Glass Distributors.

Indian & Frontier Crafts

🐦🐦🐦🐦🐦🐦🐦🐦🐦🐦🐦🐦🐦🐦🐦🐦

See also BASKETRY, BEAD CRAFTS, LEATHER CRAFTS, designs in NEEDLECRAFTS; and BOOKS & BOOKSELLERS, PUBLICATIONS.

🐦🐦🐦🐦🐦🐦🐦🐦🐦🐦🐦🐦🐦🐦🐦🐦

Buffalo Tipi Pole Co.
3355 Upper Gold Creek
Sandpoint, ID 83864

Send SASE for information.

Tipis (variety of sizes) and tipi poles. "Best prices."

Crazy Crow Trading Post
P.O. Box 314
Denison, TX 75021
214-463-1366

Catalog $2.50.

American Indian and historic apparel kits: buckskin pants, dresses, rifle frock, half-leggings, woman's buckskin leggings. Capote coats. Buckskin bag, tobacco and other bags. Footwear kits: moccasins, buckskin high tops, others. Missouri River clothing patterns: pants, shirts, jacket, ribbon shirt, leggings, moccasins, dresses.

Indian costume kits: war bonnets, bustles, chokers, moccasins, fans, leggings, shield, breastplates, breechclout, belts, bell, roaches. Bags, kits. Shooters' items. Primitive tinware. Wood kegs and buckets. Tipi poles and covers. Knives. Jewelry findings, rivets, others.

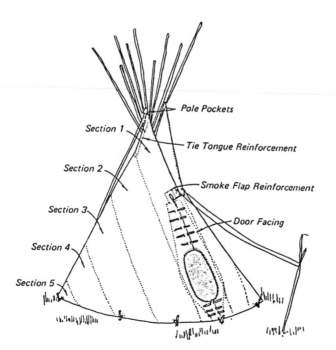

Fifteen foot pitched Tipi cover, as illustrated in The Canvas Tipi, *by Jaime Jackson.* © Lodgepole Press

Leathers: thongs, suede lace, sinew, faux sinew, hides, skins (otter, skunk, rabbit, ermine, red fox, beaver, coyote, others). Horns, skulls, claws, quills, hair, tails, garment buckskins, craft bundles, suedes, strap, latigo, rawhides. Brass nails, spots, bells, tin cones, buttons, sheet metal (silver, brass). Feather hackles, fluffs, wings, others. Fabrics. Brass buckles, buttons, conchos, hairpipe, pewter/silver shapes.

Tools: awl, cutters, knife, scissors, pliers. Beads: glass seed, pony, bugle, iris, flower, crow, trade, brass, metal, antique trade; kits, looms. Books. (Other Indian products.) Quantity prices, runs sales.

Diamond Forge Shop
12955 Archibald Whitehouse Rd.
Whitehouse, OH 43571
419-875-6868

Send SASE for complete information.

Instructional video: How to Make a Tipi, by Charlie Two Feathers—step-by-step instructions, from peeling poles to complete set-up. Tipis complete ready to set up, with critter beds, canvas, poles, stakes, ropes, and instructions.

Eagle Feather Trading Post
168 W. 12th St.
Ogden, UT 84404
801-393-3991

Catalog $1.00.

American Indian costume kits: single feather, beaded pouch, 17 chokers, 4 headdresses, bustle, necklace, bandolier, breastplate, bell set, medicine pouch. Authentic clothing patterns: war shirt, frontiersman's shirt, leather dress, others. Beading: loom kit, threads, beeswax, graph paper, beading sets, kits, wire, looms.

Beads: bugle, striped pony, wood, and large holed; faceted glass and plastic, tile, loose seed, trade. Conchos, tin cones, cowrie shells. Scissors, glue. Tools: leather punch, automatic awl, cutter, chisel. Buckle blanks. fringes (28 colors). Blankets. Numerous books: Indian skills, beading, crafts, basketry, history. Quantity prices.

Earthworks
Box 28
Ridgway, CO 81432

Brochure $1.00.

Tipis—buffalo hide reinforced, mildew/flame retardant; variety of sizes.

Grey Owl Indian Craft Co., Inc.
132-05 Merrick Blvd.
Jamaica, NY 11434

Catalog $3.00.

Indian crafting supplies including costume kits and parts (roaches, headdresses, others); beading and beads (trade, seed, cut beads, crow, pony, brass, others). Bone

hairpipes, elk teeth, tin cones, feathers. Shawl fringe, leathers (cowhide, others), furs. Cotton calicos and other cloth. Blankets. Others. Has quantity discounts.

Lodgepole Press
1073 Via Alta
Lafayette, CA 94549
415-284-1961

Book: *The Canvas Tipi*, by Jamie Jackson, describes the process of tipi making (and patching with cutting charts, diagrams, and step-by-step directions. Chapters cover materials, stitching, layout and design, tools needed, consideration of cover, liner, ozan, floor tarp, and door flap. Aspects of pitching the tipi are presented; and the selection and preparation of tipi poles; $7.50 plus $1.00 postage and handling. (Also sells wholesale.)

Northwest Traders
5055 W. Jackson Rd.
Enon, OH 45323

Free catalog.

Frontier apparel kits: capotes—pre-cut from the blanket of choice, with directions. Buckskin pants. Frontier patterns: pants (French fly front), trousers (side button), war shirt, frontier shirt, capote jackets. Witney blankets: traditional "point," early, rug, classic "point." Baron blankets, trade blanket solids, Hudson's Bay "point," trapper blankets. Wool felt mountain hats. Sashes. Imitation sinew. Books on buckskinning. Ready-made apparel.

Panther Primitives
P.O. Box 32
Normantown, WV 25267

Catalog $2.00.

Tipi poles, lacing pins, instruction books (also ready-mades including for store booths). Waterproof canvas and cottons by yard. Frontier clothing, kits, patterns. Fancy buttons. Beads, pendants, supplies, skins. Books.

Wakeda Trading Post
P.O. Box 19146
Sacramento, CA 95829
916-485-9838

Catalog $1.00.

American Indian crafts: garment patterns — authentic early American fur hat, war shirt, other shirts, leather pants, leggings, breechclout, dresses (cloth, leather), capote, frock coat, leather accessories. Costume kits: chokers, war bonnets, quillwork, moccasins, fans, hair roaches, breechclout. Shawl and metallic fringes.

Trade cloth, wool, calico. Indian blankets. Beads: Czech seed, 3-cut, pony, iris cut, luster, crow, Italian crow, tile, bugle, crystal, fire polish, others. Beading threads, beeswax, sinew; loom. Mirrors, brass nails, tin cones, buckles, metal spots, bells, brass sequins.

Naturals: sweetgrass and ropes, sage, gourds, cedar. Hides and furs—sheep, beaver, coyote, red fox, ermine; tails. Leathers — garment buckskins. Thongs, straps, rawhide, latigo. Porcupine quills and teeth. Feathers, shells. Bone items. Books on quill and beadwork, Indian crafts, others. Has quantity prices. MasterCard, Visa.

Western Trading Post
P.O. Box 9070
Denver, CO 80209
303-777-7750

Catalog $3.00.

Beads: metal, brass, wood, bone, hairpipe, berry; glass iris, seed (Czech, Italian), crow, pony, cut, tile, bugle. Beading supplies, looms. Cones, conchos, feathers, jewelry findings, bells (sheep, dance, sleigh, sets), bucklelanks. Buffalo horns, bladder, skulls. Shells, buttons. Claws, teeth. Leather (latigo, rawhide, buckskin, white deer, others).

Porcupine hair, pheasant skins, ermine, horse tails. Dance accessories, chainette fringe, wool trade cloth. Paterns: Indian and frontier garments. Kits: beading, feather headdress, feather bonnets, quilt top. Books. Quantity prices. Accepts major credit cards. Service charge on orders under $45.00.

Hopi Wedding Shawl. From American Indian Design & Decoration, *by Leroy H. Appleton.* © *Dover Publications, Inc.*

Jewelry Making & Lapidary

🐛🐛🐛🐛🐛🐛🐛🐛🐛🐛🐛🐛🐛🐛🐛🐛

See also CRAFT SUPPLIES, BEAD CRAFTS, INDIAN & FRONTIER CRAFTS, METALWORKING, TOOLS & EQUIPMENT; and other related categories; BOOKS & BOOKSELLERS, PUBLICATIONS, and ASSOCIATIONS.

🐛🐛🐛🐛🐛🐛🐛🐛🐛🐛🐛🐛🐛🐛🐛🐛

AG Findings
55 N.E. 1st St.
Miami, FL 33132
305-374-4141

Write for catalogs.

Line of jewelry findings, tools, diamonds.

A. Goodman
P.O. Box 667
Beaumont, CA 92223
714-845-8525

Send SASE for list.

Instruction — lapidary videos: lost wax casting, Meet-Point faceting, carving techniques, crystal and mineral energy, jewelry design, handcrafted jewelry, forming/plating/stripping, sphere making, emerald cutting, soldering, opals, faceting, bead stringing, gemstone carving, first steps in lapidary, carving highlights, others (VHS/Beta). MasterCard, Visa. (Also sells wholesale.)

Alpha Supply, Inc.
1225 Hollis St.
P.O. Box 2133
Bremerton, WA 98310
206-377-5629

Catalogs $1.00 (refundable).

Over 10,000 items for casting, jewelry making, faceting, wax casting, display. Equipment for lapidary, casting, faceting, prospecting. MasterCard, Visa. Quantity prices. Allows discount to institutions and professionals. (Also sells wholesale to businesses.)

Amazon Imports
P.O. Box 58
Williston Park, NY 11596
516-621-7481

Free price list.

Gemstones from Brazil: amethyst, aquamarine, emerald, garnet, kunzite, topaz, tourmaline, other stones.

Amber Company
Shelloak Rt. 3, Box 74
Crossville, TN 38555

Send stamp for price list.

Amber, from Dominican Republic — clear or layered with leaves and bugs, etc.

A.R.C. Traders, Inc.
Box 3429
Scottsdale, AZ 85271

Send SASE for information.

Beads (from the manufacturer): sterling, gold filled, 14K —variety of sizes. Full line of findings, chains, earrings.

ARE, Inc.
Box 8
Greensboro Bend, VT 05842
802-736-4273

Catalog $4.00 (refundable).

Cabochons: jade, malachite, rose quartz, tiger eye, lapis, garnet, amethyst, others). Faceted garnet, citrine, peridot, topaz. Gemstone beads (4mm to 8mm+): amazonite, carnelian, crystal, lapis, red jasper, sodalite, turquoise, others. Jewelry findings (14K gold filled, sterling) — bails, cages, jump/spring rings, earring findings, snap-in settings, beads, bezels, clasps, clutch backs and posts, others. Sheet metal in 14K gold, gold filled, fine silver. Round wire in sterling, 14K gold, gold filled. Half round wire in sterling and 14K gold. Sterling square wire, strip, beaded wire, and tubing. Fine silver bezel. 14K gold filled sheet, wire, bezel. Silver casting grain, easy and hard solder wires, discs, bezel, IT solder and 30 gauge sheet. Craft metal wires and sheet. Casting alloys: jeweler's bronze, nickel silver, pewter ingots. Scrap silver.

Arizona Gems & Crystals
414 5th St.
Safford, AZ 85548
602-428-5164

Catalog $1.00.

Chop beads, gold plate and silver plate beads, findings; cabochons: malachite, lapis, paua shell, coral, garnet, amethyst, others. MasterCard, Visa.

Art 'N Craft Supply
P.O. Box 5070
Slidell, LA 70469

Send SASE for list.

Jewelry findings (in bulk): barrettes, ponytail barrette, comb, earring posts (surgical steel and Hamilton gold). Clutch earrings, nuts. Silver plate and Hamilton gold fingernail posts. Others. Discover, MasterCard, Visa.

B & J Rock Shop
14744 Manchester Rd.
Ballwin, MO 63011
314-394-4567

50 page catalog $3.00 (refundable).

Faceted gemstones: amethyst (assorted), others. Quartz crystals. Amethyst crystal clusters. Bead stringing supplies: gemstone beads, 14K, SS, and others, big earring mountings. Quartz clock movements, kits. Has quantity prices. Minimum order $15.

Bakik International
Box 220014
Charlotte, NC 28222
704-364-7460

Send SASE for prices.

Tumbled and cut gemstones—may include tourmaline, amethyst, andalusite, golden beryl, zircon, garnet, emerald, ruby, sapphire, opal, star ruby, lapis, others.

Big Rock Trader
P.O. Box 757
Summerland, CA 93067

Single copy $2.00.

Trade/barter newsletter for minerals, fossils, gold, gem, and lapidary hobbies; low cost advertising.

Bombay Bazaar
Box 770727
Lakewood, OH 44107
216-521-6548

Send stamp for flyer.

Lapidary/jewelry making: crystalite facet polishing laps, crystal ring and disc kits. Diamond drills, compounds, powder, kits. Carving and polishing tools. Diamond saw blades. Raytech gem saw, 4" faceter's saw, 10" slab and trim Pacific, Forsaw, 6" saw. Covington saw mill carriage slab saw kits, 8" and 10" trim saws, heavy trim saws. Slab saws and combos. Rock Rascal gemmaker, 6" trim saws, 6" arbor. Graves and Raytech faceting machines and complete units. Mark 1 faceting machine. Graves cabochon maker, cab-mate. Diamond discs and laps; Genie and Titan units. Foredom mini and other power tools, handpieces, drill press, bench grinder. Collets/burrs/points sets. Vibratory tumblers. Other tools: pliers, cutters, needle files and sets, 18 tweezers. Eastwing tools. Selection of rough facet material, synthetic stones, preforms, cabochons, faceted gemstones.

Bourget Bros.
1636 11th St.
Santa Monica, CA 90404
215-450-6556

Free catalog.

Jewelry findings: variety of beads and gemstones. Jewelry displays and cases. Electronic scales (grams)—Ainsworth, Microline. Bead stringing kits, books. Polybags, others. MasterCard, Visa. (Also sells wholesale.)

Brown Brothers Lapidary
2248 S. 1st Ave.
Safford, AZ 85546
602-428-6433

Send 29-cent stamp for catalog.

Morenci turquoise rough material, cabochons, stabilized rough. Coral, fire agate, chip inlay material; beads, other items. MasterCard, Visa.

Castex Casting Crafts
P.O. Box 57316
Hayward, CA 94545

Free brochure.

Lost Wax Jewelry casting kit.

Contempo Lapidary
12273 Foothill Blvd.
Symiar, CA 91342
818-899-1973

Catalog $3.00 (refundable).

Lapidary equipment: Diamond saws (4" to 36"), vibratory laps—rotary laps with cast iron and diamond plates, small dual action overhead laps; heavy duty grinders (6", 8", and 10") with dual wheel to multi-wheel combinations, stainless steel shafts. Diaflex diamond polishing system. Tumblers from 3# hobby size to 40# industrial rotary and vibrating styles. Grits, tumbling media, and polishes. Diamond saw blades, loose abrasives, diamond wheels, drills, carving points, lap plates. Sanding belts (silicon carbide and diamond for 6" and 8" expanding drums). Custom cuts and polishes non-ferrous materials.

> STONES: *A cabochon is a smoothly rounded stone. A faceted stone is cut into many sides (facets) to catch the light.*

Colbaugh Processing, Inc.
Box 209, So-Hi Estates
Kingman, AZ 86401
602-565-4650

Send SASE for list.

Gemstone cutting and carving materials: turquoise (nuggets, drilled and undrilled, block), azurite, malachite. So. African stone. Beads, cabs, others.

Continental Treasures Corp.
Box 29
Garden City, NY 11530
516-486-8844

Call, or send SASE for brochure.

Manufacturing service—custom work for jewelry, decoratives, artworks—precious or costume type, any quantity. Designing, modeling, molding, casting, soldering, assembly, finishing, electroplating, refining. Gold/silver bought and sold. "Use your materials or ours."

Covington Engineering Corp.
P.O. Box 35
Redlands, CA 92373
714-793-6636

Contact dealer or send SASE for list.

Lapidary equipment: Diamond faceting unit, 8" beginner's gem shop (saws, grinds, sands, polishes), 6" Rock Rascal gem maker and gem shop. Portable horizontal

combo units (compact). 6" combination unit (multi-use). 4" and 6" gem shops. 8" combo units with 10" trim saws. 6" faceter trim saw/grinder. 8" and 10" trim saws (also heavy duty). Slab saws and vise, trim saw vises. "Shorty" units to "build-as-you-go." 8", 10" trim saw kits. Saw mill carriage slab saw kits. Dry unit, wet grinder. Motorized diamond or regular heads. Multi-grinders. Belt sanders/ polishers. Tumblers—16 barrel type/sizes, 3 vibratory. Slab lapper, vibrating lap. 5" bead mill. Sphere makers. Gem drill, diamond drill. Jewelry buffer. Sanders, grinding wheels, polishing items, diamond blades, lap grits and polishes, compounds. Arbors. Diamond drill bits, grit, carvers, wire saw, blade dressers. Templates. Dop stove. Adhesives. Eastwing tools. Visor magnifiers.

Danville Engineering, Inc.
1341 Camino Tassajara
Danville, CA 94526
415-838-7940

Free brochures.

Jewelers' and gemstone carvers (etch/carve without heat, finishes with bead blasting, removes matrix, engraves glass), with finger button control, 6' flexible line. Dust cabinets.

Davidson Rock Shop
531 Randolph St.
Traverse City, MI 49684
616-946-4520

Catalog $2.00.

Ring mountings (sterling silver, gold filled): for men, women; for variety of stone shapes. MasterCard, Visa.

Diamond Pacific Tool Corp.
25647 W. Main St.
Barstow, CA 92311
619-253-5580

Contact dealer or write for catalog.

Diamond lapidary equipment, Vanguard saw blades, Foredom power tools, Eastwing tools, jeweler's supplies, rockhound items, others.

Dyer's
4525 Guadalupe St.
Austin, TX 78751
512-451-5655

Findings catalog $3.00. Tools/Eq. catalog $4.00. Wax pattern catalog $4.00. (All refundable with $25.00 order.)

Jewelrymaking tools, equipment, findings, gems and stones, displays, waxes, rubber molds. Others.

Eastgem, Ltd.
Box 1954
East Brunswick, NJ 08902

Send SASE for bulletin.

Cut and tumbled gemstones—parcel closeouts, variety of kinds, sizes, shapes. "Free appraisal service."

Ebersole Lapidary Supply, Inc.
11417 W. Hwy. 54
Wichita, KS 67209

Catalog $2.00.

Lapidary equipment, supplies. Jeweler's supplies, mountings, cabs and other gemstones and beads. May have specials. Quantity prices.

Eloxite Corp.
806 Tenth St.
Wheatland, WY 82201
307-322-3050

Free catalog (if in business or plan to be).

Jewelry making tools. Supplies: bola parts, belt buckles, inserts, tie tacks, tie slides, money clips, key rings and chains, ball point pen, openers, clock movements, blanks, supplies. Diamond blades. Epoxy coatings. Pendants, pins, lockets, snap-tite settings, bracelets, rings; findings (jump rings, bails, loops, eyes, backs, clasps, cages, spring rings, and others). Glass cabs, gem balls and beads, beading supplies. Artist's supplies. MasterCard, Visa.

Florida Jewelry Crafts Inc.
Box 2620
Sarasota, FL 34230

Catalog $2.00.

Jewelry findings and supplies: earrings, bar pins, pendants, bolas, barrettes, neckchains, beads, rhinestones, pearls, mirrors. Boxes, bags, glues, magnets. Others.

Frey Finishing
4422 Cherokee Ave.
Sierra Vista, AZ 85635
602-378-2873

Send SASE with inquiry.

Services: casting, finishing, plating of brass, silver, gold, for the producing craftsperson and small manufacturer.

G & G's Miracle House, Inc.
P.O. Box 23234, 5621 W. Hemlock
Milwaukee, WI 53223
414-353-1900

Send SASE for list.

Jewelry making: settings (3 and 4 prong, in 14K gold)—marquise, basket, oval, heart, emerald, flat back; Miracle Snap'N Setting. Plates and tops, trims and settings, ring shanks, mountings. Jewelry parts in 14K gold: clasps. Earring parts, posts. Coin frames. Hooks and catches. 14K golds in sheet (many gauges), round wires. Other round wires: platinum, palladium, sterling. Half-round wire in 10K and 14K golds; bezel wires, triangular, channel, twist, tubing in 3" lengths. Casting grain, alloys, solders (14K gold, silver, platinum). Gold bullion. Tools: abrasive and grinding wheels (sanding kit), mandrels. Foredom flex-shaft machine, accessories, handpieces. 50+ buffs. Miniature wheels and cones. Setting tools: bezel pusher, bezel rocker, prong pusher, beading burnishers, tools, scrapers, buts and sets. Swiss needle files, pliers, tweezers, ring clamps, jeweler's saw frame, double clamp soldering stand, third hand. Kerr furnaces and

wax injector, casting machines and accessories. Waxes and kits. Electromelts, alcohol lamps. Others.

GBS Distributors
P.O. Box 145
Liverpool, TX 77577
713-393-2842

Free catalog.

Faceted gemstones: blue topaz, blue sapphire, aquamarine, cubic rhodolite, zirconia, opal, others, including larger calibrated sizes. Jewelry mountings.

Gem Center of America
48 W. 48th St.
New York, NY 10036
212-398-0392

Send SASE with inquiry, or call.

Precious and semi-precious gemstones: emerald, ruby, sapphire, amethyst, citrine, garnet, peridot, blue and smoky topaz, diamond, others. Has special values, "discounts for volume buyers." Accepts credit cards.

Gemco International
P.O. Box 833, Howard Bank Building
Fayston, VT 05673

Free catalog.

Gem facet rough: ruby, tsavorite, emerald, aquamarine, tourmaline, sapphire, golden beryl, imperial topaz, rhodolite garnet, malaya rhodolite, almandite garnet, amethyst, citrine, gilson emerald, facet opal, others. "Big discount" gemstones — may include emeralds, beryl, spinel, peridot, rubellite, ruby, aquamarine, others.

Gems by Alexander
4835 N. Courtenay Pkwy.
Merritt Island, FL 32953
407-453-1429

Catalog $3.00.

Supplies for lapidary, gold and silver smithing. Equipment, supplies, crystals, books, rocks, findings, gemstones, others. Products of Graves, Raytech, Diamond Pacific, Lortone, Crystallite, Foredom, others. "Ask about discount."

Gemstone Equipment Mfg.
750 Easy St.
Simi Valley, CA 93065
805-527-6990

Write for call for information.

Lapidary equipment: slant cabbing machine, and as kit. Vibratory tumblers. Bench rollaway sand blasters. Saws —4", 6", and 10" trim; 8" dynamo trim and drop saw, 16" gravity drop type. Saw blades. Diamond products—carving points, blades, discs, drills, points, dressers, files, compounds. Stone and metal finishing kits. Router bevelers, sculpture router, and super buffer. Plastic gold pans.

> SOLDERING GOLD: *If soldering gold to sterling silver findings, always use gold solder, never silver solder. The reason for this is that if you get a little gold solder on the face of the gold nugget or even on the silver, it is not unsightly. But if you get silver solder on the nugget it is VERY unsightly. So always use gold solder when attaching gold nuggets, even to sterling silver. Courtesy of Paul Badali of Paul J. Badali Jewelry Design.*

Gold Spells
7055 19th Ave. N.E.
Seattle, WA 98115
206-523-3659

Send SASE with inquiry.

Service: precious metal casting (karat gold, gold alloys).

Goodnow's
3415 Hayden
Amarillo, TX 79109

Send SASE with inquiry.

Rough gemstone material, may include: aquamarine crystal, piranha agate, black fire agate, Afghanistan lapis lazuli, St. Mary's star garnet, Australian tiger iron and tiger eye in jasper, rutilated quartz, Botswana agate, golden tiger eye. Tourmaline crystal assortments, quartz (angel's hair, raspberry, others). Quantity price breaks.

Graves
1800 Andrews Ave.
Pompano Beach, FL 33069
305-782-8000

Write for free catalog and nearest dealer.

Lapidary equipment: Cab-Mate (grinds, polishes, sands, rock vise, electric pre-former), saws, cabochon pre-forms, metal polisher, crowner, spool polisher, 6-wheeler unit, faceting pre-forms, faceting machine.

Faceted gem shapes. © *Tripps, Inc.*

Grieger's
P.O. Box 93070
Pasadena, CA 91109

Free catalog.

Jewelry making/lapidary supplies, equipment, tools, accessories. Jewelry making: cements, cleaners, adhesives, kits, boxes, cases, trays, stands. Jewelry findings: earrings, clasps, rings, chains, pendants, snap-in pendants, ring mountings, cinch mounts, bola tips and cords, eyes, jump rings, tacks, bails, caps. Gemstones and round beads, baroque chip necklaces. Cubic zirconia, cabochons, and polished stones. Diamonds, pearls, faceted stones. Beads and beading supplies including 14K, SS, filled, others. Key rings, buckles, money clips.

Hand tools: pliers, files, tweezers, shears, pin vises, ring clamps, saws, mallets, hammers, anvils, burnishers, third hand. Power tools: engravers, laps, diamond saws (belts, abrasives), tumblers, gem drills, combo, wet belt sander, saws, gem makers, buffs, brushers, polishers, soldering machines, torches. Silversmith set. Scales. Picklers and supplies. Wax injector. Casting: metals, materials, waxes, SS sheet, wires; 14/20 gold filled and 14K round wires. 14K gold sheet, faux casting metals. Clock parts, stands. Music boxes. Books. Quantity prices.

Griffith Distributors
Box 662
Louisville, CO 80027
303-442-8284

Send SASE for list.

Chemicals: Self pickling and Prip's flux, Waxolvent, Instaclean, Silver Blk, Vac Pump oil, diamond lube, others. "Dealer inquiries invited."

Gryphon Corporation
101 E. Santa Anita Ave.
Burbank, CA 91502
818-845-7807

Call or write for free catalog.

Lapidary equipment: 10-in-1 Lapidary Workshop—basic lapidary machine with accessories (work surface tilts); use as cabber, trim saw, faceter, sliver/slabber, cab crowner, "Starmaster," sapphire cup, sphere maker, tumbler, glass beveler; also use with flexible shaft, ¼" chuck used with accessories mounted on spindles up to ¼"—diamond drills, carving points and burrs, metal buffs, deburring tools. Other equipment: diamond band saw, diamond micro wire saw, diamond lathe. Manufacturer.

Harper Mfg.
3050 Westwood Dr. #B-5
Las Vegas, NV 89109
702-735-8467

Brochure $1.00.

Custom jewelry stamps from your logo, trademark, or special design. Other standard jewelry marking stamps.

House of Onyx
120 North Main St.
Greenville, KY 42345

Free 120 page catalog.

Gemstones: faceted smoky quartz, Brazil mix, moonstone, cat's eye cabs, blue topaz, sapphires (white, blue), amethyst, emerald cabs, aquamarine, garnets, others. 15% discount on large orders. MasterCard, Visa.

Irons Lapidary
Box 11551
Phoenix, AZ 85061
602-242-8398

Write or call with specific inquiry.

Lapidary supplies of: Pro-Sliver and MK (saw blades), Tagit pre-former saw, Maja diamond products, Vibra-Six (tumblers), optivisors, Raytech, Foredom, Lapcraft, Graves, Eastwing, Ultra-Tec, Facetron, Ainsworth (scale). Clock movements, abrasive, gemtree supplies.

Jeweler Aids Company, Inc.
12651 Elmwood Ave.
Cleveland, OH 44111

Free bulletin.

Ferris™ wax forms for casting buttons, cuff links, pendants, brooches, rings, buckles, plaques, sculptures. (Also sells wholesale.)

Jim's Gemology
P.O. Box 172
Louisville, OH 44641
216-453-4628

Send SASE for list.

Faceted gemstones: emerald, ruby, sapphire melee; amethyst, andalusite, aquamarine, chrysoberyl, chrome diopside, citrine, epidot, rhodolite garnets, blue iolites, helidor green beryl, lolites, peridot, spinels, smoky quartz, tourmaline, tsavorite, zircon. Cabochons: amethyst, apatite cat's eyes, aquamarine cat's eyes, sapphires, emeralds, enstatite, garnets, star garnets, 6-color jade, moon agates, others. Cabochons. Beads: agate, amethyst, bloodstone, aventurine, quartz, others — strung. Metaphysical cut stones and items. (No dealer discounts.)

John Lenhard
P.O. Box 362
Hannibal, NY 13074

Send SASE for prices.

Custom faceting service: specializing in hearts, pointed, stars, briolettes, freeforms, barions; standard cuts and fine repair of damaged gems. "22 years experience."

Kellys
2533 Pine Knoll Dr., #7
Walnut Creek, CA 94595

Send SASE for list.

Books on Square Wire Jewelry.

Kent South American Diamond Mines
15920 W. 12 Mile Rd.
Southfield, MI 48076
313-557-3353

Write or call for further information.

Precious and semi-precious cut gemstones: diamond, blue topaz, ruby, sapphire, emerald, tourmaline, amethyst, imperial topaz, citrine, aquamarine, peridot, garnet, tanzanite, opal, others.

Kingsley North, Inc.
910 Brown St.
P.O. Box 216
Norway, MI 49870
906-563-9228

Free catalogs and flyers.

Lapidary tools, equipment, and supplies: Diamond tools—drill kits, ripple drill, files, bar dressers, wire saw, needle files. Others: mandrels, finger gauges, ring sizer, stretcher, cutters. Gravers, gauges, tweezers, ring adjuster, jump ringer, pliers, screwdrivers, ring gripper, and clamp. Third hand, pickhammer, electronic waxer kit, wax machine super kit (tools, supplies, instruction). Ring guards, jeweler's torch, others (micro, Little Torch™). Accessories, soldering machine and supplies. Electroplating set and metal finishing solutions. Dust collectors, polishers, vibratory tumblers, barrel tumblers, Dremel Moto-Tool, Foredom unit, arbor, vibrating lap, glass grinder, gem maker, slab saw, slab-trim and heavy trim, and combination saws. Drill press, rolling mills.

Material: cabbing rough gemstone — may include thodonite, jaspers, rose quartz, agate, hematite, others. Tumbling rough material: agate, amethyst, snowflake obsidian, others. Jewelry findings: necklace parts, earring findings, ring and pendant mountings. Bola parts, chains, gold filled chains. Also woodworking tools. Has quantity prices; allows discounts to teachers, institutions, professionals. (Also sells wholesale to businesses.)

Knight's
Box 411
Waitsfield, VT 05673
802-496-3707

Free price list.

Gem rough: emerald, tourmaline, black star sapphire, jade, star garnet, amethyst, opal, topaz, cat's eye, turquoise, jade, smoky quartz, India star ruby, moonstone, lapis lazuli, peridot, others. (Also sells wholesale.)

Laney Company
6449 So. 209 East Ave.
Broken Arrow, OK 74014
918-355-1955

Free brochure.

Wires: round, square, ½ round, low dome, rectangle, triangle, fancy, twist, triangle twist, square twist, ½ round twist, channel, sheets, solders, fluxes, nickel pickle, leaves, bezel cups, ring shanks, soldered beads, concha buttons, bolas, buckle backs, squash blossom, rosette. (Also sells wholesale.)

Lapcraft, USA
195 W. Olentangy St.
Powell, OH 43065

Free catalog.

Tools: pre-forming/diamond grinding wheels, drilling/diamond drills, core drills, faceting/diamond discs, carving/diamond points, polishing/diamond powders.

Lapidabrade, Inc.
8 E. Eagle Rd.
Havertown, PA 19083
215-789-4022

Catalogs are refundable. Findings Catalog $5.00; Jewelry Tool Catalog $4.00; Lapidary Equipment & Supply Catalog $2.50. (Also sells wholesale.)

Lortone, Inc.
2856 N.W. Market St.
Seattle, WA 98107

Send SASE for catalog.

Rotary tumblers; 13 models, 1½ to 40 lb. capacity.

M. Nowotny & Co.
8823 Callaghan Rd.
San Antonio, TX 78230
512-342-2512

Catalog $2.00 (refundable).

Gemstone material: amethyst and quartz clusters, crystals, faceted smoky quartz, Brazilian agate slabs, mosaic opal cabs, blue topaz, freshwater pearls, others. Minimum order $25. MasterCard, Visa.

Mearle's Gem Shop
5109-A Capitol Blvd.
Tumwater, WA 98501

Discount catalog $2.00.

Lapidary equipment: grinders, buffing machines, saws, faceting machines, cabochon cutter, others (Genie, TemTec, Raytech, F1-D), balances, and metal test kits. Sonic cleaners, ring castings, findings, wax patterns. Industrial laps: 8" in 100-14,000 grit; 6" size in 100-14,000 grit. American Express, MasterCard, Visa.

MIMports
590 Silverado Dr.
Lafayette, CA 94549
415-284-4196

Free list.

Full line of synthetic gemstone material: djeva green, spinel and corundum boules, CZ (5 colors, clear), YAG (colors), lithium niobate, rutile, strontium titanate, ruby, sapphires (white, star), stoudees (colors); others.

Minnesota Lapidary Supply Corp.
2825 Dupont Ave. So.
Minneapolis, MN 55408
612-872-7211

Free catalog.

Lapidary equipment; Diamond saw blades, silicon carbide sanding belts, and grinding wheels, Diamond wheels and belts, Diamond products, tumbling grit.

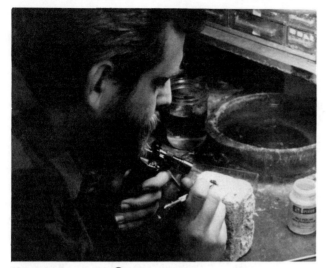

Using torch on gold. © *Paul J. Badali*

NC Gem Supply
716 North Ave.
High Point, NC 27262
919-882-6463

Send SASE with inquiry.

Synthetic gemstone rough material: GGG (garnet), lithium niobate; sizes 2 to 100+ carats. (Also sells wholesale to dealers.)

New Era Gems
14923 Rattlesnake Rd.
Grass Valley, CA 95945
916-272-1334

Send $1.00 for price list.

Gemstone rough material, may have: chevron amethyst, tiger eye, Madagascar spectrolite, tiger eye in jasper, beryl, raspberry rhodolite, Sierra blue topaz, Imperial topaz, Brazilian smoky quartz, peridot (facet), optical quartz, tanzanite, Afghanistan tourmaline. Sterling chain. Has MasterCard, Visa.

NgraveR Company
879 Raymond Hill Rd.
Oakdale, CT 06370
203-848-8031

Catalog $1.00 (refundable).

Hand-engraving flexible shaft machines, gravers and liners, rotary handpieces, engravers' blocks, chasing hammers, engravers' pencils, electric etchers, graver sharpeners, sharpening stones; practice media, magnifiers, holding fixtures, punches, Florentine tools, others.

Panafram
255 Seventh Ave.
Riviera, TX 78379

Lists (subscription) $2.00.

Cut/tumbled gemstones: padparadscha, tsavorite, sapphires (red, fancy types), tanzanite, scapolite, rhodolite, grossulars, malaya, aquamarine, ruby. Tourmalines: orange, chrome, bi-colors. Amethyst, spinels, zircon,

alexandrite, colored diamonds, morganite, heliodore, emerald, kunzite, cherry opal, citrine, hessonite, pink topaz, peridot, iolite. Quartz (rose, smoky, green), others.

PAPM
Lockbox 4467
Corpus Christi, TX 78469

Catalog $1.00.

Gemstone cabochons: may include rutilated quartz, parrot wing, snow quartz. Lavender, red, and yellow cat's eye jades. Fire agates, garnet, amethyst. Opals (black, cherry, crystal, white). Rhodochrosite, star rubies, sapphire. Lapis, hematite, carnelian, onyx, coral, turquoise, azurite, moonstones, poppy jasper, bloodstone, sardonyx. Tiger eye in blue-gold, gold, red, honey. Leopard skin, laguna, tiger iron, malachite, others. Beads, crystals, slabs, rough material.

Parser Minerals Corporation
P.O. Box 1094
Danbury, CT 06813
213-744-6868

Send SASE for list.

Rare and unusual gemstone cutting materials (rough): from Brazil — watermelon tourmaline, andalusite, jacobina amethyst, rutilated quartz, water clear topaz, rose quartz crystal, blue (indicolite) tourmaline. Others include rhodochrosite (Argentina), wine red garnet (India), Labradorite moonstone and apatite (Madagascar), iolite (Tanzania). Diamonds in white, silver, cream, gray natural cubes. Has $25 minimum for orders.

Paul J. Badali
944 So. 200 E.
Layton, UT 84041
801-546-4086

Send large SASE for catalog.

Instructional video (VHS): Making Gold Nugget Jewelry, with Paul J. Badali—how to design, use of tools; making pendants, earrings, rings, bracelets, necklaces, others; learn to mount nuggets; for beginner through advanced experienced silversmith or jeweler. Gold ore concentrate (black sands/gold) by 10 gram bag (to be panned), with directions. Gold samples (in vials) 50 mg to 400 mg. Jewelry findings (sterling silver, gold filled). Quantity prices. (Also sells wholesale to businesses.)

Peri Lithon Books
Box 9996
San Diego, CA 92169
619-488-6904

Catalog $2.00.

Books including out-of-print and rare titles. "Hundreds of books" on jewelry and jewelry making, gems, gemology, minerals, fossils, geology, and more.

Peterson Turquoise Co.
Box 303
Sanford, CO 81151
719-274-5895

Send SASE with inquiry, or call.

Custom cabbing service of natural and stabilized turquoise—specializing in calibrated and non-calibrated cabochons.

Pioneer Gem Corporation
P.O. Box 1513
Auburn, WA 98071
206-833-2760

Send SASE with inquiry.

Faceted gemstones: amethyst, blue topaz, citrine, emerald, garnet, lapis lazuli, opal, ruby, sapphire, smoky quartz, others. Has quantity prices. MasterCard, Visa.

Plush "Diamond" Works
P.O. Box 198
Keno, OR 97627
503-883-8636

Send SASE for list.

Oregon sunstones rough material, hand graded: rare green, red, bi-colored, pink schiller, red centered, colorless—in 1-20 ct. pieces. Minimum order $25, "quantity discounts."

Rainbow's End
P.O. Box 723
Golden, CO 80402
303-233-6877

Write or call for information.

Gemstone material: garnet types, blue topaz, amethyst; zircon and other faceting gem rough (citrine, golden beryl, tourmaline, aquamarine, others). Zircon facet rough colors.

Ray Gabriel
Suite 2, 1469 Rosena Ave.
Madison, OH 44057

Free catalog.

"Shapes"—contemporary gem cuts in variety of popular materials: bullets, wedges, pyramids, oddities, moon, others. Many one of a kind. Custom approval service for university/art center jewelry programs.

Reactive Metals Studio Inc.
P.O. Box 890
Clarksdale, AZ 86324
602-634-3434

Send SASE for information.

Shining wave metals: Mokume-gane, Shakudo, and Shibuichi. Niobium, Tantalum, Titanium — in sheet, wire, and tubing. Anodizer units. "Sparkie" instant welder unit — fuses earposts and tie tacs to most metals (including reactive metals). Others.

Rebshan's
16200 Ventura Blvd., Ste. 302
Encino, CA 91436
818-363-8461

Catalog $2.00 (refundable).

Gemstones and gemstone beads, bead stringing kits, findings, supplies, kits.

Riviera Lapidary
10292 Mesquite
Riviera, TX 78379
512-296-3958

Catalog $2.00.

Beads, slabs, cabbing rough material, gems, crystals. Cabochons including turquoise, lapis lazuli, Congo malachite, Finland spectrolite, Mexico parrot wing, Brazil amazonite and malachite, amethyst, Botswana agate, goldstone, hematite, leopardskin jasper, abalone, mother of pearl, black onyx; assortments. Strung rice pearls. Turquoise nuggets and chips, topaz crystal groups. Others. MasterCard, Visa.

Roadrunner Imports
P.O. Box 4569
Fairview, NM 87533
505-753-2340

Send SASE for details.

Instructions: wire art jewelry. Videotape course. Learn to make: rings, bracelets, pendants, chains. VHS or Beta. MasterCard, Visa, Discover.

Rockhound's Surplus
4450 North Kildare
Chicago, IL 60630

Catalog $1.00 (refundable).

Gemstone slabs and cabbing rough. Petrified and opalized wood, Brazilian agate, Mexican lace, Australian/African rough material. Gemstones from the U.S.—over 200 varieties.

Roussels
107-355 Dow
Arlington, MA 02174

Wholesale catalog $.50.

Jewelry supplies: chains, ear wires, others; polybags.

Royal Findings, Inc.
P.O. Box 92, 301 W. Main St.
Chartley, MA 02712
617-222-8173

Catalog $2.00 (refundable).

Jewelry findings: complete line of precious metal findings for Sparkle Midget Welder. Friction ear nuts, ball earrings, diamond settings, pendants, beads (roundels, corrugated), Karat Katch™, lobster claws, bead clasps, Omega ear clips, Easy Loc, others.

Running T Trading Co.
1201 Iron Springs Rd., Suite 11
Prescott, AZ 86301
602-778-4274

Send for catalog.

Jewelry mounts (pre-notched types, earring types, for

emerald cut) in 14K, sterling, gold filled; chains. Beads (14K, SS, gemstones). Jewelry making tools, plastic bags, others. MasterCard, Visa.

Sherwood Designs
P.O. Box 2106
Lakeside, CA 92040

Send SASE for information.

Beaded jewelry instruction books (using seed and other beads) in native, ethnic, and glamour styles; earrings, necklaces, others. (Also wholesale.)

Stone Age Industries, Inc.
Box 491
Spanish Fork, UT 84660
801-873-3213

Catalog $1.00.

Gemstone rough material: from India — bloodstone, moss agate, red fancy jasper, orange aventurine, mysore green aventurine, black zebra, others. From Brazil — agate modules. Mexico—cathedral agate. U.S.—Crafton Hills rhodonite, Needles Peak agate. Lapidary equipment and supplies. MasterCard, Visa. (Dealers send resale tax number.)

Swest, Inc.
P.O. Box 540938
Dallas, TX 75354
214-350-4011

Write for catalogs: (1) Jeweler's Tools, Equipment Supplies; (2) Jewelry Findings; (3) Gemstones; (4) Wax Patterns and Preforms; (5) Jewelry-making Workshops; (6) Refining Services; (7) Precious Metals. "We have it all."

The Rock Peddler
35 Burningtown Rd.
Franklin, NC 27634
704-524-6042

Send SASE for specific quotes.

Lapidary equipment/supplies of Graves, Raytech, Diamond Pacific.

Treasure Chest
P.O. Box 108
Rodgersville, MO 65742

Write for catalogs.

Lapidary equipment and supplies for cabbing, faceting, and tumbling. Jewelry making supplies (for casting and smithing). Crystals and clusters: amethyst, quartz, citrine, others. Bulk rough rock. Clock making supplies.

Tripps Inc.
407 California NW
Socorro, NM 87801

Free catalog.

Jewelry making: easy mounts in 14K gold and sterling: pendants, ladies and men's rings — plain and fancy shapes, ring shanks, wire and other earrings, prenotched easy-mount heads; pendants, earrings. Gold-

filled chains, 14K gold chains, sterling chains. 14K, sterling, and gold-filled findings—clasps, earring clips and blanks, wires, balls, posts, nuts. Rings and jump rings. Sterling castings. Gem set pliers. Synthetic stones — round, emerald, heart, pear, and other shapes. Natural faceted stones — may include peridot, garnets, rubies, others. Has quantity prices. American Express, MasterCard, Visa.

TSI
P.O. Box 9266, 101 Nickerson St.
Seattle, WA 98109
206-282-3040

Free catalog.

Full line of lapidary and jewelry-making tools, equipment, supplies; beads and beading supplies. Has quantity prices. Allows discount to teachers, institutions, and professionals. (Also sells wholesale to businesses.)

Universal Wirecraft Co.
P.O. Box 20206
Bradenton, FL 34203
813-745-1219

Send large SASE for price list.

Solder-less wirecraft supplies: 18K gold and sterling silver wire, gold-filled wire (in square, round, and half round; gauges 24 to 16 on some), by 1 oz., 3 oz. coil. Gold plate and silver-filled square and round wires; by 3 oz. up coil. Wirecraft tools: round, flat, and chain nose pliers, side cutters, pin vise, iron ring mandrel. Variety of cabochons including onyx, goldstone, hematite, amethyst, agate, tiger eye, others. Gemstone beads. Books. Videos. Has quantity prices. (Also sells wholesale to businesses.)

Valco
633 Lindegar St.
Linden, NJ 07036

Write with specific inquiry.

Lapidary equipment and supplies, these brand names: Covington, Foredom, Graves, Lee, Raytech, Crystalite. "Up to 25% discounts."

Victoria House
2107 Peterborough Rd.
Punta Gorda, FL 33983

Free price list.

Gemtree supplies: tumbled gemstones, wire, tools, metal leaves, manzanita burlwood, Brazilian agate bases, glues, sprays, starter kits. Books. "Quantity discounts."

W.D. Hudson Jr.
255 Ranchette Rd.
Alpharetta, GA 30201

Price list $1.00.

Cutting rough gemstone material (for faceted gems): garnet, golden citrine, emerald, golden topaz, amethyst, peridot, zircon—golden to brown, danburite crystal tips, green quartz, sapphire, apatite, andalusite, diopsid aquamarine, yellow beryl, green tourmaline. Rough material

for cabochon gems: emerald, cabbing ruby, star ruby, black star sapphire. Others. Minimum order $5.00.

Warfield Fossils
Box 316
Thayne, WY 83127
307-883-2445

Informative price list $1.00.

Fish fossils: stingrays, gars, others. Fossil leaves, insects. Trilobites, ammonites, crinoids, Badlands material. "Great wholesale prices."

Wax Factor
509 Monroe
Oregon City, OR 97045
503-656-0709

Catalog $4.00.

Wax patterns for a line of rings, charms, bracelets; assortments; custom molds made.

Weidinger, Inc.
19509 Kedzie Ave.
Flossmoor, IL 60443
708-798-6336

Findings catalog $2.00. Machinery catalog $2.00.

Lapidary machinery and equipment, tools, cutting materials—full lines. Jewelry mountings and findings in gold-filled or sterling: necklaces, pendants, earrings, brooches, bracelets. Men's, women's sterling ring mounts. 10K, 14K gold ring mounts; men's jewelry mounts (tacks, bars, chains, cuff links), coin mounts. Flexible link bracelet mountings in filigree, baroque, contemporary, and other styles. Bola slides. Boxes: ring, cotton filled, utility, display. Display cards, envelopes, aluminum chains. Soldered sterling, gold-filled, and other neck chains, chain by the yard. 14K neck chains. Link, chain bracelets in sterling, gold-filled, other. Jewelry findings in sterling, 18K, 14K gold, gold-filled, others. Visa, MasterCard.

West Wind
P.O. Box 18320
Reno, NV 89511
702-851-8090

Call or write for catalogs.

West Wind wax designs for jewelry: waxes—freeforms

and specials (antiques, ocean, wedding sets, diamonds, channel set), bracelets (link, nugget, bangles), findings.

Wilson's
Box 34030
Truckee, CA 95734
916-587-9372

Free catalog.

Professional wax patterns (over 5,000 styles): pendants, rings, charms, bracelets, basket settings, others.

Wm. Harris Rock Shop
1118 Snead Ave.
Sarasota, FL 34237
813-366-6608

Send SASE for list.

Gemstone rough material/slabs: obsidian, Brazilian agate, India garnets, Oregon plume agate, Wild Horse picture jasper, Botswana agate, Tampa Bay coral, aventurine, green moss agate, rutilated quartz, petrified wood, India agates. African carnelian, pink thulite, unakite, phantom amethyst, blue lace. Wyoming turritella, Mexican hickoryite. Others. Sold by pound+ lots. MasterCard, Visa.

Wood-Met Services
3314 W. Shoff, Dept. CSS
Peoria, IL 61604

Catalog $1.00.

Plans for the home workshop person to build his own machines, tools, and attachments, including investment casting equipment, and items for welding, metalworking, hand tools, grinding wheels, drill presses, others. Has quantity prices. (See METALWORKING.)

Wykoff, Inc.
P.O. Box 5504
Washington, DC 20016

Send SASE for list.

Books on gems and lapidary including newest: *You Can Master Jewelry Design & Creation*, by Gerald L. Wykoff, GG; tells of "secret process" used in his own jewelry-making plant for almost 25 years. "If a person can trace a straight line, cut, and glue a piece of paper then that person can make fine jewelry like a pro—every time."

Leather Crafts

🐦🐦🐦🐦🐦🐦🐦🐦🐦🐦🐦🐦🐦🐦🐦

See CRAFT SUPPLIES and other categories for supplies; and BOOKS & BOOKSELLERS, PUBLICATIONS, and ASSOCIATIONS.

🐦🐦🐦🐦🐦🐦🐦🐦🐦🐦🐦🐦🐦🐦🐦

Al Chandronnait
29 Winnhaven Dr.
Hudson, NH 03051

Send SASE for full details.

Ultra thin, soft leather for models, doll making, and miniature work, jewelry, etc.; in 3" X 6" sheets, in off-white (can be dyed), brown, blue. Has quantity prices.

Berman Leathercraft
25 Melcher St.
Boston, MA 02210
671-426-0870

Catalog $3.00 (refundable).

Leathers: pigskin, sheepskin, cowhide suede splits, deerskin, elk, antelope, rabbit, garment cowhide, bat leathers—by skins. English line back, latigo, crepe, elk butt, English kip, wallet leathers, calfskin; assortments. Belt blanks, full line of buckles. Leather kits. Garment leathers: smooth, sueded, unusuals; cowhide, calfskin, others. Tools: knives, edgers, punches, gouge, shears, hammers, strap cutter, anvil, stripper; stamping and sewing tools. Embossing machine. Carver-tool kits for stamping, carving. Swivel cutters. Leather preservatives and finishes. Hardware including purse clasps, briefcase locks, others. Books. Has large order discounts.

Blevins Mfg. Co. Inc.
Wheatland, WY 82201

Send SASE for full information.

Stirrup buckles in 3 widths; stainless steel and heat treated aluminum, sleeves leather covered; in improved, regular, or four-post types; all metal buckles in 3 widths. New four-post tongue for 3" buckle. Manufacturer.

C.S. Osborne & Co.
126 Jersey St.
Harrison, NJ 07029
201-483-3232

Write for free catalog and name of dealer.

Leather crafting tools: snap setters (snaps), edgers, pliers, hot glue gun, shoe and other hammers, punches, rawhide hammers, scratch compass, nippers, creasers, gauges, gasket cutter. Splitting machine. Knives, shears, pincers, grommet dies (and grommets), hole cutter. Awl hafts and awls, modeler tools, chisels, eyelet setter, space marker, embossing wheel carriage, needles. Upholstery repair kits. Sail, palm, thimble. Others. Manufacturer.

Campbell Bosworth Machinery Co.
720 N. Flagler Dr.
Ft. Lauderdale, FL 33304
305-463-7910

Free catalog.

Leather machines/hand tools: splitting machines, airbrushes and compressor. Harness stitchers (for lease), high speed overlocks, lock stitch wax thread sewing machine, electro-pneumatic embosser. New/used/reconditioned machinery (sewing machines, shears, skivers, strap cutters, clicking, hot stamper), heavy duty sewing machines, hot stamping machine with printing fonts. Cut-out machines, hand and kick presses, others. Hand tools: hammers, pincers, gouges, bevelers, pliers, knives (and swivel), shears, rotary and other punches, scratch compass, snap setter, groover, stapler, wheel cutter, edgers, chisels, mallets, modeling tools, awls, 4-in-1 awl, gauges. Sewing palm cutting pads. Twist presses for setting jewels, rivets, snaps, grommets; cut round holes—jewel leather to 1/8" thick. Italian jeweled head rivets.

Drake Leather Co., Inc.
3500 W. Beverly Blvd.
Montebello, CA 90640
213-721-6370

Catalog $1.50.

Leathers and leather crafting supplies: garment and accessories leathers, suedes, others. Tools, dyes, finishes, hardware, aids. Quantity prices; discount to teachers, institutions, and professionals. (Also sells wholesale.)

Dyo Chemical Company
P.O. Box 15771
Dallas, TX 75215

Print name and address on postcard. Send for free trial bottle and directions.

Dyo Color Cote dyes in full of colors; Sun Blok protector finish. Manufacturer. ("Dealer inquiries are welcomed.")

Fiebing Company, Inc.
516 S. Second St.
Milwaukee, WI 53204

Free catalog.

Leather dyes: 27 colors (mixable for full range of shades) by 4 oz. bottles. Resolene finish. Manufacturer.

Flannagan
370 McLean Ave.
Yonkers, NY 10705
914-968-9200

Write or call for catalog.

Leathers: harness, bridle, skirting, others. Buckles, horse bits, stirrups, spurs, spots, snaps, rivets, chains, rings, others; Osborne tools, Fiebing dyes, finishes. Others.

Gomph-Hackbarth Tools
R.R. #1, Box 7
Elfrida, AZ 85610

Send SASE for information.

Leather crafting tools: swivel knives (½" and 5/8" barrels, ball bearing curved finger yoke), letter bevelers sets, edgers (for strap leather, with concave-convex cutting edge), others; variety of sizes and types.

Hallmark Leather
512 Industrial Ave. East
Greensboro, NC 27406
919-272-9700

Send SASE for information.

Leather scrap trimmings, by the pound and sorted to customer's needs. Aniline dyed hides—whole and half hides in full range of colors for leather crafting. Hallmark leather formulated cleaners and conditioners.

Horween Leather Company
2015 Elston Ave.
Chicago, IL 60614
312-772-2026

Write for information.

Leathers: horse fronts, side leathers, shell cordovan, etc.

Leather Unlimited
7155 Hwy. B
Belgium, WI 53004
414-999-9464

64 page catalog $2.00 (refundable).

Leather kits—purses, cases, bags, belt, visor, billfolds, belts, wineskin, moccasins, pouches. Leathers: garment/bag sides, splits, oak cowhide, deerskin, sheepskin, cowhide splits, chamois, elk, exotic animal prints (special order — leopard, python, zebra). Pieces: upholstery, strap, alligator print, pigskin suede, black cross, football leather. Assorted grain leathers. Calf laces, spiral and suede laces. Buckles — alloy with brass hooks, gold-plated resin, zinc, and brass. Nickel silver and copper conchos. Rings, hardware. Antler tips, buttons. Leather dyes, finishes, cements. Missouri River frontier clothing patterns. Tools: stamping, saddle stamps, gold stamping machine. Punches, cutting tubes, slots and stabs, rivets, screws, snaps. Custom fabrication of cutting dies. Has quantity prices; large order discounts. MasterCard, Visa. (Also sells wholesale to businesses.)

M. Siegel Company, Inc.
120 Pond St.
Ashland, MA 01721
508-881-5200

Catalog $3.00.

Leathers: cowhide vesting and garment leathers, luxury garment (deerskin, chamois, horse, elk, goatskin, suedes, antelope, lambskin, Napa skin). Bag and belt leathers (sides, latigo, shoulders, ochra, oiled and retan shoulders). Wallet, tooling, and sandal leathers (buffalo calf, English calf, kip, side, pig, sheepskin skiver). Specialty: chrome moccasin sides, lizard pieces, shearling (and scraps). Saddlery and briefcase types. Close-out lots (inquire). Full line of buckles—solid brass (and plate), plain and designs; and in pewter, copper on brass; 60's designs, contemporary, others. Saddle leathers. Key case and other parts and 30+ snaps (including swivels). Bag closures and fasteners. Tools: knives and handles, bevelers, shears, edgers, awls, chisels, pincers, modelers, hammers, mallet, punches, stamps. Supplies: stones and honing oil, laces, threads and waxed thread, needles. Others. Has quantity prices. (Also sells at wholesale.)

Mid-Continent Leather Sales Co.
P.O. Box 4691
Tulsa, OK 74159

Free catalog.

Leathers: saddle (skirting, latigo, others), rawhide, tooling (sides, English sides, strap sides, shoulders, others). Chap and garment leathers—sides, splits, deerskin. Lacing, stirrup leathers. Conchas, snaps, grommets, inserting dies. Buckles, rings, rigging plates, fasteners, zippers. Threads: nylon, waxed linen, Nytex. Tools: hammers, knives, blades, chisel, anvil, rivet and spike setters, beveler, groover, skiver; Osborne tools—hot glue gun, canvas plier, rawhide hammers, nippers, rivet set, needles. Fiebing conditioners, finishes. Quantity prices, large order discounts; "wholesale prices for everyone."

Pilgrim Shoe & Sewing Machine Co.
21 Nightingale Ave.
Quincy, MA 02169
617-786-8940

Free parts catalog or send SASE with inquiry.

New, used, rebuilt shoe and leather machines, sewing machines, eyelet setters, patchers, clickers, skivers, splitters, cementers, trimmers, 5-in-1 bench cutters, others. Needles and awls for all machines. Machine parts: Singer, U.S.M., Landis, American, Fortuna, Puritan, Consew, Union Special, Adler, Pfaff, Juki, others. Obsolete and hard-to-find parts.

Pocahontas Leather
P.O. Box 253
Garrettsville, OH 44231
216-527-5277

Send SASE for price list.

Deer and elk skins (by ft. and up lots), tannery deep-Scotchgarded for water and soil resistance and pre-stretched "for honest, usable footage."

S-T Leather Company
P.O. Box 78188
St. Louis, MO 63178
314-241-6009
and at P.O. Box 15152
2135 S. James Rd.
Columbus, OH 43232

Write or call for catalog.

Leathers: embossed, gator print, print cowhides, calf, upholstery cowhides, lambskin skirt, suede. Garment leathers: haircalf, metallic pigskin, cowhide, tooling, double shoulders, tooling backs, goatskin; scrap bags.

Cowsplits, skirtings, latigo, saddle shearling, horsehide, rawhide sides, deerskin, Sonora calf, kidskin, horsehide, bag sides. Furs: fox, coyote, others. Suede and scraps. Kits and patterns: moccasins, billfold, boots, bags, chaps, others). Grommets, rivets, snaps, posts, lacings, waxed threads. Dyes (Fiebing, antique, packs). Acrylics. Cement, finishes, neatsfoot oil, Tan-Kote, others. Solvent. Brushes. Leather crafting tools: awls, pliers, shears, mallets, knives/blades, skiver, punches (revolving, heavy, oblong, lacing, punch plier, strap end, round arch). Thonging chisels, punch sets, grommet dies, snap setters, anvils, chisels. Midas tools. Modelers and tooling sets. Buckles: brass types, swivel backs, others. Books. Quantity prices.

Sav-Mor Leather & Supply
1626 So. Wall St.
Los Angeles, CA 90015
213-749-3468

Catalog $2.00.

Leathers: sandal, saddlery, scrap, garment types, belt blanks (odd lots), leathers. Buckles. Wallet and bag kits. Tools. Fiebing dyes. (Also sells wholesale.)

Solomon Brothers
12331 Kelly Rd.
Detroit, MI 48224
313-571-9466

Send SASE for further information.

Industrial sewing machines (for leather, other); buys, sells, trades, repairs; machine parts. Attachments made.

Tandy Leather Co.
P.O. Box 2934
Ft. Worth, TX 76113

Catalog $2.50.

Leathers: full line, pigskin, deerskin, cowhides (smooth, suede), sheepskin, grain leathers, saddle skirting, others; garment, upholstery, utility, and exotic leathers. Leather crafting kits for accessories (belts, billfolds, purses, moccasins, credit card wallet, others) and suede items. Leather crafting tools—full line, dyes, laces, patterns. Kodel lining (like sheepskin); saddle trees, stirrups, hardware. Patterns. Instructional videos, books. "Low prices, quantity discounts."

The Leather Factory
P.O. Box 50429
Ft. Worth, TX 76105
817-496-4874

Free catalog.

Leathers: saddle skirtings, shearling, seating splits, rawhide sides (translucent, latigo, double shoulders), har-ness (backs, latigo, sides), carving leather sides, Tennessee oak. Double shoulders, tooling and lining leathers (pigskin, chrome woolskin, skivers; tooling, lining kip, cow). Garment leathers: velvet suede (thin), cowhide, motorcycle sides, cabretta sheepskin, deerskin, elk, rabbit. Specials: sueded splits (overruns), remnant packs. Exotic leathers: python, cobra, hornback gator. Specialty: upholstery, apron splits, sole bends, moccasin splits, rawhide chap. Sewing machines for leather. Hand sewing: threads, sinew, needles, awls, lace rolls. Latigo packs. Chisels, full line of punches, hammers, knives, stamping tools, skivers, tool sets, strippers, cutters, leather splitter. Dyes, stains, finishes. Airbrushes, compressors. Home tanning kit. Cements. Buckles, snaps, belts. Garment patterns. Wallet parts. Kits: wallets, cases, purses, guns, visor, practice, starter sets, deluxe learning, moccasins. Wallet bulk pack kits. Books. Wholesale leather club (inquire). Allows discount to teachers and institutions. (Also sells wholesale to businesses.)

Veteran Leather Co.
204 25th St.
Brooklyn, NY 11232
718-768-0300

Write for catalog.

Leathers: grained cowhide, splits, skivers, chrome and kip sides, English morocco, sueded cowhide splits, others; remnants by pound. Belt blanks. Tools: stamps, rivets, punches, cutters, fasteners, lacing and stitching types, eyelet setters, others. Buckles. Leather kits for handbags, others. Dyes. Laces, sewing items. Has quantity prices.

W. Pearce & Brothers, Inc.
38 W. 32nd St.
New York, NY 10001
212-244-4595

Send SASE for price list and description.

Leathers: tooling kips, variety of garment leathers, and belt and wallet leathers. Exotics: snakes, elephant, lizard, python, alligator, and ostrich leathers. Stencil springboks in 15 patterns. MasterCard and Visa.

World Trading Inc.
121 Spencer Plain Rd.
Old Saybrook, CT 06475
203-399-5982

Send SASE for list.

Smooth imported leathers: kangaroo (6 colors), buffalo calf, Sierra calf, Eurolux (Belgian calfskin), Balinapa (soft). Exotic skins: ostrich, stingray, elephant, shark. Teju and Java lizard skins. Snake: rattlesnake, diamond python, majunke python, karling.

Metalworking

🐛🐛🐛🐛🐛🐛🐛🐛🐛🐛🐛🐛🐛🐛🐛🐛🐛

See also JEWELRY MAKING & LAPIDARY, MINI-ATURE MAKING, MODEL MAKING, SCULP-TURE & MODELING, and other related categories; and BOOKS & BOOKSELLERS, PUBLICATIONS, and ASSOCIATIONS.

🐛🐛🐛🐛🐛🐛🐛🐛🐛🐛🐛🐛🐛🐛🐛🐛🐛

American Art Clay Co., Inc.
4717 W. 16th St.
Indianapolis, IN 46222
317-244-6871

Free information packet.

Mesh metal enamels (opaques, transparents; sets) and in dry form (bagged). Metal enameling kilns — table models. Metal enameling kits. Glass and metal enamel-ing: decorating colors. Floral wafers, semi-moist over-glaze colors, liquid metals and lusters. Pre-formed cop-per shapes, findings. Cleaners, enamel flux, gum solution. Sprayer. Tools, kiln shelves, racks, forks. Pyrometer, thermocouple. (Sells wholesale to legitimate business.) (See CERAMICS and MOLD CRAFTS.)

Atlas Metal Sales
1401 Umatilla St.
Denver, CO 80204
303-623-0143

Send SASE or call for quotations.

Silicone bronze: sheets and plate (1/16" — 3/8" thick-nesses), rod (1/16"—1½" diameter; tubing (.540 O.D.—1.90 O.D.); rectangles, circles; thin gauge strip; ingots.

CEI
R.R. 1, Box 163
Cameron, IL 61423

Send SASE for list.

Metals (sheet, bar): brass, aluminum. Supplies, plans.

Dye Com
P.O. Box 12294
Roanoke, VA 24024
703-345-4241

Detailed catalog $3.00 (refundable).

Aluminum dye starter kits, dyeing and sealing service, aluminum dyes and sealer, pre-anodized aluminum sheets, colored aluminum tubing. Gloves, books.

Edmund Scientific
912 Edscorp Bldg.
Barrington, NJ 08007
609-573-6260

Write for catalog.

Technical and scientific products and useful aids in-cluding some for metal crafting: electroplating kit, sub-mersible pumps, compressor, small motors. Miniature tools: Dremel Moto-Tool, pin vise, drill, hammers, jeweler's drill press, mini-torch, and table saw. Engraver tool. Wire benders. Magnifiers and loupes. Diffraction grating. Others. (See XYZ—SELECTED OTHERS.)

Extra Special Products Corp.
P.O. Box 777
Greenville, OH 45331
513-548-3793

Contact your dealer or write for catalog.

House of Copper™ die-cut copper shapes for trims, win-dow decorations, tree ornaments, candle trims, quilt and applique templates, wreath decorations. Designs include animals, fruits, hearts, buildings, baskets, holiday, star, gingerbread man, others. Project booklets for shapes.

Lindsay Publications
Box 538
Bradley, IL 60915

Catalog $1.00.

Technical books including hard-to-find, on: melting metal, electroplating, building equipment, iron working, old-time equipment. Manuals, industrial handbooks.

Pressure Tool Center, Inc.
P.O. Box 23
Brewster, OH 44613
216-832-6134

Send SASE for full details.

Sheet metal brake; bench mount brake and optional floor stand. (Has a sandblasting unit and other tools.)

Pyramid Products
3736 South 7th Ave.
Phoenix, AZ 85041

Brochure $1.00.

Small foundry furnace for home craftspeople; supplies.

Wood-Met
3314 W. Shoff, Dept. CSS
Peoria, IL 61604
306-637-9667

Catalog $1.00.

Over 250 plans for tools, machines, and attachments: universal clamping system, metal spinning, metal lathe, wood turning chisels, electric band sander, photographic equipment, air compressor, drill press items, router and band saw items, welding items, hand tools, fixtures, wood lathe items, circular saw items, shop metal ben-ders, power rasps, milling machine, others. Investing casting equipment, circular saws; wood jointer, others. Woodworkers' kits and sets. Quantity prices.

Miniature Making, Miniatures & Dollhouses

❧❧❧❧❧❧❧❧❧❧❧❧❧❧❧❧❧

See also MODEL MAKING; PAINTS, FINISHES & ADHESIVES; TOOLS & EQUIPMENT, and specific categories of interest; BOOKS & BOOKSELLERS, PUBLICATIONS, and ASSOCIATIONS.

❧❧❧❧❧❧❧❧❧❧❧❧❧❧❧❧❧

A-C's Emporium
Box 12532
Pittsburgh, PA 15241

700 page catalog $15.00 ($5.00 refundable).

Lines of miniatures—known brands, others.

A Touch of the Past
2853 Acushnet Ave.
New Bedford, MA 02745
508-998-1277

Send SASE for full information.

Lighthouse dollhouse scale miniature kits (lighthouse has 4 levels with central stairway, front opening) and finished; other dollhouses. Line of miniature furniture and electrical kits. All major credit cards.

Al Chandronnait
19 Winnhaven Dr.
Hudson, NH 03051

Send large SASE for catalog.

Leather for miniature work—thin, pliable; for scale upholstery, purses, shoes, gloves, trunks, luggage, others; in off-white (can be dyed), brown, and blue; by 3" X 6" pieces. Has quantity prices.

Andy's Little Houses
P.O. Box 363
Clatcona, FL 32710
407-295-1258

Send SASE with inquiry.

Doll house kits, plans and drawings; custom built houses. (Also sells wholesale.)

Applied Design Corporation
P.O. Box 3384
Torrance, CA 90510

Catalog $.50.

Tools for miniatures and model crafting: mini sander (adjustable tension, hand belt type), 10" mini hacksaw (receding nose and adjustable 6" blade — cuts wood, plastic, metal, hardened music wire). Sandpaper strips and self adhesive sheet sandpapers. Tee bar aluminum extrusion sanding block (2 sizes). Others.

B.H. Miniatures
20805 N. 19th St., Suite 5
Phoenix, AZ 85027
602-582-3385

Catalog $3.00.

Scale miniatures kits including Victoriana Collection wall cupboards (with microthin leaded glass door panels) and china cabinets, others. Finished miniatures.

Barbara J. Raheb
30132 Elizabeth Court
Agoura Hills, CA 91301

Catalog $5.00.

Miniature books: over 315 selections of abridged and unabridged editions of well-known favorites, classics, reproduced antique books, masterpieces. Professionally typeset, illustrated, handsewn, hardbound, with titled decorative spines and cover designs stamped in 24K gold. Books are limited, numbered, fully readable editions in 1" scale. "Dealer inquiries invited."

Barbara's Miniatures
1037 California
Collinsville, IL 62234
618-345-5025

List and photo $4.00.

Line of porcelain doll kits.

Beauvais Castle
141 Union St., P.O. Box 4060
Manchester, NH 03103
603-625-8944

300 page catalog $3.00.

Over 6,000 miniatures and accessories, known brands; furniture, figures, components, others.

Bruce H. Phillips
8903 Camfield Dr.
Alexandria, VA 22308
703-360-1533

Send large SASE for pictures and price list.

Scale miniatures of the furniture of Woodlawn Plantation (home of the foster daughter of George Washington); Chippendale style.

Builders Choice
71 Hilliard St.
Manchester, CT 06040

Send SASE for full information.

Miniature landscaping systems—scenic line of pre-made timbered flower-shrub beds, pre-made bricked flower-shrub beds, variety of shrubs and vines, earth, cedar chips; paths, sidewalks, and accessories.

Chesko Enterprises
P.O. Box 1468
Camarillo, CA 93011

Brochure $1.00.

Miniature dollhouse furniture—colonial and contemporary.

Cir-Kit Concepts Inc.
407 14th St. N.W.
Rochester, MN 55901
507-288-9181

See your dealer or send $4.00 for catalog.

Complete line of wiring kits and lamps including the deluxe wiring kit (will wire a 10 to 12 room dollhouse). With 20-watt transformer to light up to 46 16-volt bulbs; cut glass ceiling globes, and a tester; with 8 popular plugs and outlets for realism. Others.

CJ Originals
P.O. Box 538
Bridgeville, PA 15017

Catalog $4.00.

Over 100 scale miniatures kits (with 40 silk gauze, DMC floss, needle, chart, instructions), for Rose Trellis chair seat, Cluny pillows in variety of designs; others.

Claudette Priddy
840 N. Robinson St.
Los Angeles, CA 90026

Catalog $1.00 and SASE.

Miniature beads: full inventory of hard-to-find antique Victorian glass beads, French-cut steel beads, tiny no-hole glass beads, French sequins, tiny Austrian crystals, no-hole pearls. Jewelry-making items.

Concord Miniatures
P.O. Box 99, 400 Markley St.
Port Reading, NJ 07064

Contact your miniatures or hobby dealer. Catalog $5.00.

Miniature furniture and accessories—over 200 pieces, mahogany furniture, some ½" scale items; baby's, children's, and teen bedroom pieces; others. Manufacturer.

Country Miniatures
895 Cold Spring Rd.
Williamstown, MA 01267
413-458-5633

Send SASE for list.

General stores, fixtures, and accessories, room boxes. No frills starter dolhouse kits and shells.

Covered Bridges
Box 150
Hancock, VT 05748

Brochure $1.00 (refundable).

Miniature wooden covered bridges kits (and assembled). Other kits: barns, saltbox houses.

Criss-Cross
Box 324
Wayne, NJ 07470
201-835-9339

Catalog $1.00.

Plans (in 1"-1' scale, full-size cutting details, hints, assembly views, and photos) for replica of Peddlers wagon (of late 1800s) like one at Longstreet Farm Museum, Holmdel, NJ; plans for Concord stagecoach and Conestoga covered wagon. Miniature wheel making plans. Accepts credit cards, with $20 minimum.

GLUING UP: *When you fill your monojet glue gun with glue, take a 3" piece of magic Scotch tape and write on the end of it what kind of glue is in the monojet. Then wrap the tape around the shaft of the monojet so that it covers the writing and you have a permanent record of what kind of glue is in that monojet. Courtesy of Mac Willson of Miniatures & Collectibles, Inc.*

D. Anne Ruff
1100 Vagabond Lane
Plymouth, MN 55447
612-473-7565

Send SASE for full information.

½" scale hat box (room setting) vignette kit, with die-cut parts, fusing material, and instructions. And companion kits—12 piece furniture, coordinated fabric/trims in 2 color combinations. Visa, MasterCard.

Dee's Delights, Inc.
3150 State Line Rd.
North Bend, OH 45052

Contact dealer or send SASE for information.

Scale miniatures "Stone Mountain Originals" hillbilly figures (and cowboys, cats, dogs) — 28 hand-painted characters, hand-cast from a blend of resin and china clay. Rustic log cabin (unfinished or stained) with front porch.

Diamond "M" Brand Mold Company
15081 91st St.
Hinsdale, IL 60521
708-323-5691

Catalog $2.00 ($3.00 foreign).

1" scale miniature molds (poured in ceramic) including 3-mold Victorian bath set (claw tub, pedestal sink, water-closet toilet). Molds for tea sets, pots, vases, and country accessories; dolls, furniture, fireplaces, others.

Diminutive Specialties
10337 Ellsworth Dr.
Roscoe, IL 61073
815-623-2011

Send large SASE for information. Catalog $5.00.

Nite-Lite Boxes (hold miniatures) for any occasion; miniature photos. MasterCard, Visa.

Don Perkins Miniatures
1708 59th St.
Des Moines, IA 50322

Send SASE for price list.

Cords for miniature wicker work: white linen, by half pound spool (or pound); natural linen spool. Quarter-pound spool of 3-cord (for ½ scale work).

Dwyer's Doll House
1944 Warwick Ave.
Warwick, RI 02889
401-738-3248

Catalog $5.00.

Over 4,000 miniatures and dollhouses, including miniatures kits and accessories, others. Tools, finish items. MasterCard, Visa.

Elect-A-Lite, Inc.
742 E. Arctic Ave.
Santa Maria, CA 93454
805-928-4331

Contact dealer or send SASE for information.

Scale dollhouse lighting systems kits and accessories (copper tape wiring system, fabricated for shadow boxes, and 3-5 room dollhouses to largest 9-12 room models); complete with patented connectors, parts; instructions.

Fernwood Miniatures
12730 Finlay N.E.
Silverton, OR 97381

Send large SASE for catalog.

Scale miniature furniture kits including Hepplewhite flip-lid lady's desk; other desks, cupboards, armoires, pie safes, chairs, others.

Fideler
20 Shadow Oak Dr., Apt. 6
Sudbury, MA 01776

List $1.00 (refundable) and large SASE (2 stamps).

3,000 miniature items: toy soldiers, airplanes, parts, decals, tires, tank treads; others.

Fine Art in Miniature
1336 Lincoln Ave.
San Jose, CA 95125
408-286-8098

Catalog $2.00 (refundable); for brochure send SASE.

"Kit of the Month" Club: choose from 4 kits per month of handcrafted miniatures by noted craftspeople — 20 Celebrity dollhouse kits. Christmas items, chessmen, etchings, plaques, Niglo™ lamps (antique, Victorian), shopping bags, picnic basket, others. Garden tools, kitchen and farm items. Chandeliers, figures (storybook people, teddies, others). Greenhouse, potted flowers, photos, silk bonnets. Bridal items. Patio house, small room house, Southwestern furnishings, Kachina dolls, sand paintings. Blown art glass. Clowns. Cage, chests, table, desk, rocking horse. Copper pots, kitchen items. Store and building kits. Others. Tools for crafting.

Flatland Miniatures
7534 Winterberry Ct.
Wichita, KS 67226

Samples/list, send $2.50 and 2-stamp SASE.

Miniature wallpapers—full line of country, traditional, and contemporary designs. (Also sells wholesale.)

Fred's Carpenter Shop
Rt. 7
Pittsford, VT 05763
802-483-6362

136 page catalog $4.00.

Complete line of building materials, dollhouse kits, furniture, accessories. Custom service: replicas of homes, remodeling, wiring, and wallpapering of dollhouses.

G.E.I. Products, Inc.
19 Grove St.
Vernon, CT 06066
203-872-6539

Contact local dealer or send SASE for list.

Doll house kits (pre-clapboarded, dove-tail assembly, solid wood parts; deluxe and expandable add-to kits). Videos, instructions.

Gold and Betty Rimer
515 Crystal Ave.
Findlay, OH 45840
419-423-2016

Send SASE for price list.

Handcrafted scale miniatures including furniture (hutch, cabinet, dry sink, others). Custom-made miniatures by special request (send picture or good description).

Greenberg Dollhouse Publication
7566 Main St.
Sykesville, MD 21784
301-795-7447

Send SASE for full information.

Book: *Finishing Touches*, by Jack Robinson (techniques for creating miniature realistic bricks, actual wood floors, foundations, trims, others; with detailed diagrams).

His & Her Hobbys
15 W. Busse Ave.
Mt. Prospect, IL 60056

Send SASE for list.

Miniature dollhouse and furniture kits, lighting, moldings, siding, staircases, roofing, landscaping, hard and soft woods, hardware. Miniatures: furniture, figures, others. Custom remodeling and wiring of dollhouses.

Hofco House, Inc.
1 Council Drive
Woodsboro, MD 21798
301-898-7834

Contact dealer or send SASE for information.

Scale miniature dollhouses—The Junior Collector Series (townhouse, Swiss chalet, Victorian, Gettysburg, general store)—as assembled kits (unfinished).

House of Caron
10111 Larrylin Dr.
Whittier, CA 90603
213-947-6753

Illustrated price lists, $2.00.

Parker-Levi and Keni's miniature doll molds, posable people and elves, others. Completed dolls. Pewter miniature animals. Others.

Innovative Photography
1724 NW 36th
Lincoln City, OR 97367
503-994-9421

Catalog $2.50.

Framed miniature photos of Old Masters, Impressionist, and modern paintings: Da Vinci, Rembrandt, Botticelli, Van Gogh, Degas, Picasso, Pollock, others. Gutmann babies, Eisley, C.B. Barber, Victorian photos. Stereoview cards. Diplomas, certificates, postcards, color maps. Display racks. Others. Custom reduction of photos.

It's a Small World
560 Green Bay Rd.
Winnetka, IL 60093
708-446-8399

Catalog $7.00 (U.S.); $11.00 others.

Miniatures including: flowers by Bagot, Robin's Roost, M. Meyer, Fruit by Kim's, dolls by Hantel, Nix, Innes. Picnic baskets by Maryn Johnson, Mirrors by Leeds; silver and gilt items by Fisher, Kupjack, Acquisto. Also has many other finished miniatures (furniture, lamps, chandelier, kitchenware, accessories, ship models, games, holiday items, stuffed animals, others).

J & W Hobbies
11437 Meath Dr.
Fairfax, VA 22030

Send $1.00 for list.

½" scale miniature wooden building kits (to assemble), with over 200 personal property items and accessories to go with them. "Dealer inquiries invited."

J. Hermes
P.O. Box 4023
El Monte, CA 91780

Catalog $3.00. 1:4 scale swatchbook $2.00.

Miniatures. ½" scale wallpapers and floor papers—100 designs and color combinations. Smaller ¼" scale wallpapers and projects (breakaway box kit and others).

Jacqueline's
1155 Fifth, #405
Oakland, CA 94607

Catalog and newsletter $5.00 (refundable).

Dollhouse making catalog: plans, building supplies, accessories, dolls, others. "Bonuses, freebies, discounts."

Janna Joseph
P.O. Box 12367
Palm Desert, CA 92255
619-324-6217

Brochure $4.00.

Line of scale miniature doll molds; adults, children.

Joan Wheatley
9A Cedarwood Dr.
Asheville, NC 28803

Large SASE for price lists. Color Portfolio $5.00 and large SASE—2 stamps—(refundable).

Wee Trees original miniature tree houses (¼" and ½" scale): tree houses in 10 models. Dutch furniture.

Karin's Mini Garden
6128 McLeod N.E., Apt. 15
Albuquerque, NM 87109
505-883-4561

Catalog $1.50 (refundable).

Miniature garden items: variety of indoor and outdoor plants (in containers), cacti, succulents, and arrangements, other realistic items.

Kathryn's Doll Artists' Supplies
7915 Woodridge #207
Woodridge, IL 60517

Send large SASE for information.

Oven-baked clays: Fimo, Cernit, Super Sculpey. Others.

Kilkenny Miniatures
10685 Johansen Dr.
Cupertino, CA 95014

Send SASE for catalog.

Ultrafine glitter kits: 1" romantic glitter masks. Mini topiary tree kits, others.

Kimberly House
2953 Industrial Rd.
Las Vegas, NV 89109
702-735-4371

Contact dealer or send SASE for information.

Wall mount miniature display box kits (pre-molded Plexiglas and easy-assemble redwood), room box garden kits (with tree kit and landscaping). Store showcases; candy case, bakery case. Room box cast kits. Doll case kits. Custom room box sizes. Dollhouse books. Others.

Kitchen Table Miniatures
P.O. Box 1234
Vienna, VA 22183

Catalog $1.00.

"Kitchen table" 1:12 scale miniatures: food platters, candies, whole/sliced fruits, vegetables, hamburger, others.

La Casa Photos
P.O. Box 36035
San Jose, CA 95158

Catalog $3.00 and large SASE.

Dollhouse photographs: Victorian reproduction sets, scenics, portraits, other subjects, black-and-white photo sets, baby and wedding photos; small and medium sizes; 1" scale vintage greeting cards and postcards. Gold imprinted albums, framing mats, photo folder kits.

Ligia Durstenfeld
1215 Caracas St.
La Crescenta, CA 91213
818-248-8058

Catalog $2.00 and SASE (refundable).

Scale enameled miniatures including Faberge flower arrangements, other flowers, Oriental screen (enamel on copper); others. Custom enameled miniatures.

Sandpaper makes great shingles and can be obtained at any hardware or handy-man store. Select a color and texture which will complement your dollhouse, cut into strips with slits as shown and then glue to the roof with rubber cement. I think rubber cement is a good idea because ordinary white glue will cause the sandpaper to shrink and curl. The sketch shows two sets of dimensions (the dimensions in the brackets are ½" scale). Courtesy of Pamela Quint Chambers of Michigan, as written to Nutshell News *Magazine.*

Little Goodies
P.O. Box 1004
Lewisville, TX 75067

Catalog $2.00.

Miniature kits (pre-cut paper parts): 75+ flowers (roses, carnations, daisies, violets, others). Also sells wholesale.

London Bridge
1325 Chestnut St.
Emmaus, PA 18049
215-967-6887

Catalog $2.00. Full brand name figures catalog $5.00.

Britans figures — castings to restore/convert: arms, heads, horse parts, band arms, wheels. Figures by Imperial, Britains, Ducal, Esci, others.

Lysene Enterprises
1505 N. Evergreen, Space 9
Chandler, AZ 85224

Send SASE for brochure.

Brass engravings to identify miniatures.

Marion's Mini Heirloom Quilts
133 Charles Ave.
Shreveport, LA 71105

Brochure $1.50 (refundable).

Miniature quilt kits (or finished).

Martha's Miniatures
6440 McCullom Lake Rd.
Wonder Lake, IL 60097

Send large SASE (2 stamps) for list.

Unpainted pewter: baby bottles, pacifier, spoon, frame, shoes, cup, Teddy. Baby carriage frame/wheel kit. Others. (Also sells wholesale.)

Masterpieces in Miniature
13083 Drummer Way
Grass Valley, CA 95949

Send SASE for full details.

"Instant age" weathering liquid wood, painted/unpainted —ages shingles, others. ("Dealer inquiries welcome.")

Midwest Carriage
7472 Goldenrod Dr.
Mentor, OH 44060

Brochure $2.00 (refundable).

Horse drawn vehicle kits, wheels, plans, books. Breyer horses. Weathering antique solution.

Mini-Facets
7707 Indian Springs Dr.
Nashville, TN 37221
615-646-0695

Send SASE for information.

½" and 1" scale handcrafted and commercial accessories including furniture, household items, outdoor (swing set, lawn mower, others). MasterCard, Visa.

Mini Graphics
2975 Exon Ave.
Cincinnati, OH 45241

Catalog $5.00.

Line of miniature wallpapers, variety of fabrics, carpeting, others. Miniature needlecraft book (needlepoint, cross-stitch for rugs, bedspreads, others).

Mini Lumber
3238 12th Ave.
Council Bluffs, IA 51501

Exotic wood samples and price list $3.00. Send large SASE for list of trees and landscaping items.

Mini Stitches
Rt. 3, Box 143
Clinton, TN 37716

Color photo/price list $1.00 and large SASE.

Miniature needlepoint sampler kits—on silk gauze.

Miniature Accessories of the Month
P.O. Box 90686
Henderson, NV 89009

Send $1.00 and SASE for introductory offer.

Members receive a 1" scale miniature accessory designed and created for the club at "one low price per month."

Miniature Displays
Box 215 Mattydale, NY 13211

Catalog $5.50.

Miniature dollhouses and kits; room boxes, gazebos, others—"for every budget, scale, and style." Other kits and finished miniatures.

Miniature Image
P.O. Box 465
Lawrenceburg, IN 47025

Full catalog $12.00 (refundable).

Scale dollhouses, dollhouse kits, and basic building supplies. Scale miniatures including furniture kits and finished; accessories including hard-to-find items. Reference and how-to books. Others.

Miniature Lumber Shoppe
812 Main St.
Grandview, MO 64030

Wood items catalog $2.00. ¼" scale catalog $2.50. ½" scale catalog $1.00.

Miniature Saw Works
Rt. #1, Box 188
Palmyra, IN 47164

Send large SASE for details and prices.

Miniature metal items to paint on: saws (hand, crosscut, round types), flat irons and skillets, others. Bucksaws.

Miniatures & Collectibles, Inc.
8330 Gulf Freeway
Houston, TX 77017
713-645-0855

Send SASE for information.

Complete line of scale miniatures—known brands and others: dollhouses and building components, plans; people, furniture, accessories. Claims broadest/largest miniatures inventory in a retail store. MasterCard, Visa. Allows discount to teachers and institutions.

Miniatures and More, Ltd.
39 Hilbert Pkwy.
Eatontown, NJ 07724

Catalog $2.00.

Custom miniature landscaping—portable landscaping system on wood bases, adaptable to any environment; landscape components, parts, accessories.

MJ's Marketplace
8904 24th Ave.
Kenosha, WI 53143

Catalog $3.00 (refundable).

Dollhouse supplies: electrical items, wallpapers, flooring, furniture, accessories in ½" and ¼" scale.

Morey's Miniatures
R.D. 2
Unadilla, NY 13849
607-369-9578

Send $1.00 and SASE for list.

Miniature pedigree dogs in 1", ½", and ¼" scales.

Mosaic Press
358 Oliver Rd. #8
Cincinnati, OH 45215
513-761-5977

Catalog $3.00.

Full line of miniature books—readable, illustrated; including cover of antique paper over boards with leather spine; book of very limited editions.

Mott Miniatures
P.O. Box 5514
Fullerton, CA 92635
714-527-1843

Catalog $25.00 refundable deposit. ($28.00 in Canada.) Real Good Toys and Greenleaf Houses list $1.00.

Known brands of miniatures and items for miniature crafting, kits, dollhouse kits, electrical wiring, supplies.

My Sister's Shoppe Inc.
1671 Penfield Rd.
Rochester, NY 14625

Catalog $2.00.

Scale dollhouses and miniatures (authentic detailed reproductions, and/or whimsical in style) including "Laura's Linens" — English coordinated bedding; English country gifts (soaps, fragrances, geraniums in pitcher/bowl, pillows, luggage, potpourri jar); others.

Native American Miniatures
13415 Lamel St.
North Edwards, CA 93523
619-769-4144

Send SASE for information.

Scale miniature pottery (each painted and signed by Navajo Indians), horsehair baskets (woven by Papagos). MasterCard, Visa. "Volume discounts available."

Noonmark
Box 75585
Seattle, WA 98125

Send large SASE for information.

Handcrafted 1" scale kitchen appliances—acrylic and

brass: stove with or without microwave oven, refrigerator, microwave oven, dishwasher, sink. Micro-thin glass in bulk size or custom cut.

Norm's Originals
16520 Densmore N.
Seattle, WA 98133

Send large SASE for brochure.

Furniture kits: cherry, walnut; in 1" or ½" scale.

Northeastern Scale Models Inc.
P.O. Box 727, 99 Cross St.
Methuen, MA 01844
508-688-6019

Catalog $1.00 (refundable).

Model building components, laser cut items: precision scale basswood structural shapes, dollhouse molding, carving blocks, decking, strip and sheets. Hardware. Model railroad kits.

Olde Mountain Miniatures
RD 3, Box 163
Fort Plain, NY 13339

Catalog $1.00.

Scale miniatures including "The Casa Pequena" room box kit (with 2 sides, framework top, open front). Others.

Paul C. Moore
6127 Boughton Hill Rd.
Farmington, NY 14425

Catalog $2.00.

Scale miniatures (including traditional) — handcrafted furniture, dollhouses, room boxes, cabinet houses.

Petit Maison
580 Bank Lane
Lake Forest, IL 60045
312-234-0585

Send SASE for complete information.

Scale miniatures including dollhouses, crafted furniture (from England), scratch building supplies, and accessories. Custom crafted rooms a specialty.

Phyllis Stafford
939 North St.
Suffield, CT 06078

Send SASE for full information.

Scale miniature carpet kits including Armenian design reproduction (from 17th century)—40 silk gauze mesh with DMC floss (7³/₄" X 3 7/8"); also "Our Lady of Czestochowa" design kit. Also has finished carpets.

Pinckneyvillage Miniatures
R.R. 2, Box 416
Pinckneyvillage, IL 62274
618-357-9040

Send SASE for information.

Wall-hanging dollhouses (Victorian or Colonial style) 18"w X 8"d X 30"h of pine, birch plywood, or luan.

Pinocchio's Inc.
465 Main St.
Frankenmuth, MI 48734
517-652-2751

Send SASE for information.

Supplies: Jack Nash assembled houses, kits, others.

Quad Company
12 Grove St.
Ballston Spa, NY 12020

Send large SASE for brochure and order form.

Tiny turnings furniture kits for tables, chests, screens, planters, chairs, others.

Real Good Toys
10 Quarry Hill
Barre, VT 05641
802-479-2217

Contact a dealer or write for nearest.

Miniature dollhouse kits including Parkland deluxe front-opening model (3 stories) and finishing kit. Other collector's dollhouse kits.

Rumakers
1806 N. Fairview
P.O. Box 6037
Santa Ana, CA 92706

Send SASE for details.

Battery operated miniature train set with buildings and foliage, 1" scale. "Dealer inquiries invited."

Rustic Miniatures
71 Richmond Ave.
Pittsfield, MA 01201

Send large SASE for brochure.

Log cabins (5 models), stone cottage, Cape Cod, barn, stable—many as kits. "Dealer inquiries invited."

Sandy's Miniatures
28 Crazy Horse Ranchos
Weatherford, TX 76086

Send large SASE for price list.

Scale vegetable gardens: cornstalks, vines, scarecrows, chickens, chicken coop, accessories.

Sequoia Enterprises
664 South Bank Rd.
Wima, WA 98541

Send SASE for full details.

Miniature kit club: Amish bench, water bench, tool box, other country items for beginner or experienced, all wood.

SM Ogreenc
P.O. Box 09298
Milwaukee, WI 53209

Send large SASE for details.

Miniature architectural details: room box windows (Gothic, Palladium, Colonial and others). Custom designs service.

The Depot Dollhouse Shop
215 Worchester Rd., Rt. 9
Framingham, MA 01701
617-431-1234

Catalog $4.99.

Full line of scale miniatures, including 3/8" cabinet grade dollhouses from known manufacturers; children's line of dollhouses and furniture; handcrafted accessories for all rooms, by established artisans.

The Doll Lady
P.O. Box 121, Homecrest Station
Brooklyn, NY 11229

Send large SASE for information.

Scale miniature patchwork quilt sets—solids with prints or solid coordinated colors, dust ruffle and 1-2 pillows.

The Doll's Cobbler
P.O. Box 906
Berlin, MD 21811

Catalog $3.75.

Full line of miniature doll shoes in leather, other materials, variety of styles including boots, slippers, high-button shoes, flats, sandals, heels, shoe ice skates, others.

The Dollhouse Factory
Box 456, 157 Main St.
Lebanon, NJ 08833
908-236-6404

120 page catalog $5.50.

Over 4,300 miniature products: dollhouse plans, scale dollhouse kits (1" to 1" scale—most with precut wood, windows, doors, stairs; optional additions). Store and building kits. ½" scale dollhouse kits, furniture. Shadowboxes and display case kits. Scale furniture kits (X-acto, Realife, others), quilling kits, mini needlework kits (petit point, crewel, cross-stitch, punch rugs, upholstery, etc.). Building materials, hardware; 52 windows, 40+ doors/shutters, stairs. Wicker, Fimo, stencils, decals, 70+ wallpapers, carpet, cords, glass stains. Extensive furniture, dolls. Custom made dollhouses. Complete lines of dollhouse kits, parts, miniatures, and: finishing materials (glues, adhesives), brushes, 32 picture frames. Wicker furniture supplies. Landscaping materials.

Electric: lamps, components, transformers, wiring kits, bulbs. Tools: mitering items, magnetic gluing jig, clamps, airbrush, air compressor, miter box. Saws, pliers, files, anvils, extra hand, magnifiers. Power tools: drill press, saws, (micro, jewelers, etc.), Dremel motor shop, Moto-Tool, Jarmac, Unimat flexible shaft tools, sanders. Quantity prices. (Also sells wholesale to businesses.)

The Enchanted Doll House
Manchester Center, VT 05255
802-362-3030

Catalog $3.00.

6,000 miniatures, dollhouses, miniatures kits, and room settings, workshop materials and kits, books. (Many handmade or exclusives by renowned artisans.) Has a collectors club.

The Fieldwood Company, Inc.
P.O. Box 6
Chester, VT 05143
802-875-4127

34 page illustrated catalog $3.00.

Precious Little Things scale accessories including food (artichoke in pewter bowl, apples in wicker basket, vegetables in basket, wire egg basket with eggs, others). Other furnishings and accessories in 1" and ½" scales.

The Fimo Factory
525 N. Andreasen #G
Escondido, CA 92025
619-741-3242

Send SASE for full information.

Fimo modeling material in bulk: hardens in 275 degree oven, can be lacquered; for miniatures and small items.

The Happy Unicorn
22825 Mastick Rd.
Fairview Park, OH 44126
216-734-5244

Photofolio $4.50.

Miniature electrified lighting: chandelier with 6 bi-pin candles, 3 center bulbs, 12V size (2½" X 3"), candlesticks with bi-pin replaceable bulls (1¼" tall); these and other lighting also available in rose crystal.

The Hobby Suite
P.O. Box 613
McComb, MS 39648

Mail order catalog $8.50.

Over 16,000 brand name miniatures: furniture kits (and finished), dollhouses, components, wallpapers, rugs, accessories, electrical systems and items; tools. Others.

The House of Miniatures
147 Lake St.
Delaware, OH 43015

Send SASE for full information.

Members of this society receive furniture kits monthly; no obligation to buy. Kits include classic Chippendale style, Queen Anne, and other traditional styles, scaled 1/12 of full size; with hardwoods, solid brass fittings.

The Mary Elizabeth Miniatures
49-04 39th Ave.
Woodside, NY 11377
718-429-4114

Send large SASE for brochure.

Miniature ice cream parlor furnishings (by R.E. Duffy), handcrafted mirrored wall case and companion counter in white lacquer; ice cream table and chair set. Pieces lend themselves to variety of settings (soda shop, etc.).

The Miniature Image
P.O. Box 465
Lawrenceburg, IN 47025

Catalog $12.00 (refundable).

Dollhouses and kits, kits for furniture and accessories; from known manufacturers. Books. MasterCard, Visa.

HELPFUL HINT: *Mix food coloring in white glue to get the color you want. Courtesy of The Dollhouse Factory.*

The Miniature Merchant
1957 So. Broadway
Denver, CO 80210
303-698-2615

Catalog $12.50.

Miniature supplies—all major miniature lines are represented, with building supplies, finishing material, furniture, and accessories; kits and components.

The Oakridge Corporation
P.O. Box 247
Lemont, IL 60439

Catalog $3.00 (refundable).

Dollhouse kits (1" scale) in variety of models; line of building supplies and accessories of many manufacturers including: Real Good, Greenleaf, American Craft Products, Hofco House, Houseworks, others. ¼" and ½" scale wooden craft kits, scratch builder's supplies, landscaping, miniature accessories, and dollhouses.

The Picture Show
Box 17482
Tucson, AZ 85731

Send $1.75 and 3 stamps for catalog.

Miniature paper accessories: vintage boxes, labels, signs, holiday items, paper dolls. Celebrity advertising posters, movie star "glossies," and others.

The Side Door
Box 573 (Route 28)
Dennis Port, MA 02639

Brochure $2.00.

Bisque dollhouse doll kits, patterns; dressed dolls, trims, accessories.

The Valley Crafts
Box 972
Orem, UT 84059

Send two stamps for catalog.

Dollhouse plans, 1" scale, variety of models.

Treasure House Gallery
1518 Dixie Hwy.
Park Hills, KY 41011
606-291-3412

Send SASE for full information.

Miniature furniture including bedroom set by Dor Moore in 1" and ½" scales (skirted dressing table, mirror, stool, bed, comforter, dust ruffle, pillows). Others.

Twin Palms Miniatures
P.O. Box 263295
Escondido, CA 92030

$1.00 & large SASE for brochure (refundable).

Miniature (1" scale) cane furniture kits: cushioned living room group (loveseat, sofa, chair, ottoman, "glass" table, coffee table, etagere). "Dealer inquiries invited."

Victorian Times
2888 S. Highland Dr.
Salt Lake City, UT 84100
801-486-0328

Contact dealer or send SASE for information.

Scale miniature building kits include Country Victorian store (with 2-bedroom flat and balcony upstairs).

Village Miniatures
Box 142
Queenston, Ontario, Canada L0S 1L0
416-262-4779

First-time catalog $5.00 ($4.00 after).

Miniatures: wallpaper and floor coverings, electrical wiring, doors, windows, stairways. Dollhouses, kits, and plans. Porcelain doll kits. Specialized lumber, landscaping materials. Mini holiday decorations, handmade accessories. Dremel and X-acto tools. Others.

W & D Mini Homes
P.O. Box 1654, 415 E. 4th St.
Bloomington, IN 47402
812-332-2499

Large SASE ($.50 postage) & $1.00 for brochure.

American Indian scale miniatures (of clay, fibers, wood, etc.) including a variety of clothing, costumes, pottery, baskets, blankets, rugs, figures, paintings, others.

Warling Miniatures
22453 Covello St.
West Hills, CA 91308
818-340-9855

Send large SASE for Price List.

Miniature (1" and ½") wicker furniture kits, of Victorian to modern styles; includes chairs, rockers, tables, peg bed, sofas, chests, others.

Wisconsin Crafts
Box 457
Necedah, WI 54646

Write for information.

Craftwoods, soft and hardwoods for miniature work; custom orders.

Model Making—General

❧❧❧❧❧❧❧❧❧❧❧❧❧❧❧❧

See also MINIATURES, MODEL MAKING—RAILROAD; and BOOKS & BOOKSELLERS, PUBLICATIONS, and ASSOCIATIONS.

❧❧❧❧❧❧❧❧❧❧❧❧❧❧❧❧

32nd Parallel
P.O. Box 804
Pismo Beach, CA 93449
805-481-3170

Color catalog $3.00.

Scale model submarines—3 models, in l:32 scale with variety of ballast control systems and options including working torpedoes. Models available from hull kit only, to complete kits with all required parts (except radio) to operate submerged.

A.J. Fisher, Inc.
1002 Etowah Ave.
Royal Oak, MI 48067

Illustrated catalog $2.00.

Model ship and yacht fittings to scratch build a competitive R/C model yacht in the 36/600, l meter, 50/800 or 20 rater class. Kits of Great Lakes and oceangoing vessels. Model building plans and books.

Ace R/C
116 W. 19th St., P.O. Box 511
Higginsville, MO 64037
816-584-7121

Catalog $2.00.

Model products—"Amazing Hinges" of latex rubber allow surfaces to be butt-fitted as hinges install with small amount of tension that pulls surfaces in contact with each other; works in open or sheeted frames, skinned foam or solid balsa. Can be spaced and painted after hinging. With instructions. Other items.

Aerospace Composite Products
P.O. Box 1662
Irvine, CA 92714
714-250-1107

Send SASE for complete listing.

Composite materials: vacuum bagging supplies, carbon fiber laminates, Rohacell™ (light rigid foam in three thicknesses), carbon or Kevlar mat, glass closth, carbon fiber (tape, ribbon) fabric tapes, E-Z lam epoxy laminating resin. Others. Has MasterCard, Visa.

American/Gryphon Decals
4373 Varsity Lane
Houston, TX 77004

Send 3 first class stamps for catalog.

Decals: for WWI aircraft models; line of C.A. Atkins metal aircraft kits.

American Sailplane Designs
2626 Coronado Ave. No. 89
San Diego, CA 92154

Catalog $3.00.

Model aircraft: Ultima (129" wingspan, airfoil: selig 406l, controle-ailerons, flaps, stabilator, rudder; bolt-on wing, removable nose cone, fiberglass fuselage) "for the serious competitor." Others.

America's Hobby Center, Inc.
146 W. 22nd St.
New York, NY 10011

R/C models catalog $2.50; Airplane catalog $2.50.

Model R/C aircraft, boat and car kits, parts, and supplies—known brands for systems (Airtronics, Futaba, Challenger, Cannon) motors (Enya, O.S. Technopower, GMark, K & B, Cox, OS, Royal, others). Kits, starter kits, kit combos with engines or systems; for airplanes, boats, ships, cars. Tamiya cars/accessories. Glider accessories. Retracts, batteries, plugs, engine starters, others. R/C model car kits/combos: Futaba, Tamiya, Marui, others. Power tools: Dremel, Miller (sprayer set), Taig micro lathe; accessories. Aero publishers books.

Amherst Miniatures
917 N. Terrace Lane
Ypsilanti, MI 48198

Catalog $1.50.

Ship model kits: USS Kidd, Fletcher Cl., 1:96 size, for static and R/C; others; fiberglass hulls, plastic structure.

Andes Hobbies
P.O. Box 3077
Laguna Hills, CA 92654
714-582-5203

Send SASE for list.

R/C Model car kits/combo deals: Ultima, Kyosho Big Brute, MRC Indy and Monster series. Turbo Optima, Salute Assault, Futaba FX10, Schumacher CAT XLS, MRC Lotus-Honda, Williams-Honda. Kyosho Optima Mid; others. Test equipment: motor dresser, motor torque checker, running machine, aging (motor break-in) machine. Customizing parts list: HD oil dampers, damper oil, nerf bars, dog bones/universal drive shafts, wheels, tires, bumpers, under-guards, wings, anti-roll bars, ball bearings, others. Challenger, Futaba, and Novak electronics—pistols, servos, quick chargers, speed controls. Racing batteries. MasterCard, Visa.

APC Hobbies
Box 122
Earlysville, VA 22936
804-973-2705

New kit catalog and updates $2.00.

Merlin Models including 1:72 metal accessories (WWII engines, pilots, gunners, bombs, seats, etc.) and aircraft; 1:48 injected aircraft; Merlin injected aircraft with decal and metal parts; Harper 1:35 resin armor conversions (turrets, fighting compartment, others). APC 1:35 armor. Kaufman's conversion kits, others. MasterCard, Visa.

Applied Design Corporation
P.O. Box 3384
Torrance, CA 90510

Catalog $.50.

Tools for model building, etc: mini hand belt sander (adjustable tension), mini sandpaper strips. Tee bar aluminum sanding block (2 sizes). Ruff Stuff adhesive sheet sandpapers (3 grains). Mini compact hack saw (10" — saws wood, plastic, metal, hardened music wire). Others.

Archer's Hobby World
15432 Alsace
Irvine, CA 92714
714-552-3142

Catalog $4.00.

Plastic kits for aircraft, ships, military vehicles, by: Ace, Airfix, Arc, Bandai, Crown, Detail Master, DML, ESCI, Fujini, Glencoe, Masegama, Keller, Hobbycraft, IMAI, Italeri, Johan, Lindberg, LS, MPC, Matchbox, Mikro, Minicraft, Mitsowa, Model Tech, Monogram, Pegasus, Pioneer, Red Star, Revell, Skywave, Supermodel, Ysksts, Tamaya, Testor, Trimaster, others. Vacuform kits by: Airframe, Air Vac, Combat, Contrail, Elliott, Execuform, Falcon, Formaplane, Joystick, Rareplanes, Wings. Decals, finishes, tools, modeling supplies, books.

Armor Research Co.
P.O. Box 8583
Cedar Rapids, IA 52408

Catalog $5.00.

Photo etched and cast detailing items and accessories for armor models. Tank and artillery ammunition; others. Building information. TM excerpts, photo scale drawings for many models and items. "Dealer inquiries welcome."

Astro Flight Inc.
13311 Beach Ave.
Marina Del Rey, CA 90295
213-821-6242

Send SASE for full information.

Model airplane kits (electric powered) including Astro Sport (37" wing span) high wing sport trainer, Partenavia P68 Victor Twin—redesigned for Astro Cobalt 05 motor (airfoil section changed to Eppler-195 for improved aerobatics, wing span 50"). Challenger sailplane with 12" folding propeller, a climber, with distinctive wing platform with elliptical tips for aerodynamic efficiency; balsa parts (wing span 72"). Porterfield Collegiate sport scale model, beginners add Astro Cobalt 15 geared motor; advanced can install the Astro Cobalt 25 geared motor for realistic maneuvers (wing span 69.5"). Other aircraft kits.

B & D Models
P.O. Box 12518
Reno, NV 89510

Illustrated plan book $2.50.

Model aircraft plans—old timers and antiques for the reed valve engine: Diamond Zipper, Flying Quaker, Red Zephyr, Miss Philly, Eaglet, Commodore, others.

Balsa USA
P.O. Box 164
Marinette, WI 54143
906-863-6421

Send SASE for information.

Balsa model aircraft video (VHS): How to Build the Stick 40; 2 hours, step-by-step methods for most "trainer type" planes. Balsa model airplane kits: Piper L-4 "Grasshopper." Stick 40 and Stick 40 Plus trainers (span: 60, power: .30 to .45, 3 channel). MasterCard, Visa.

Benson Hobby Products
7119 N. Chimney Rock Place
Tucson, AZ 85718

Send SASE for brochure.

Model electronic accessories for electric R/C, wide range of products, "low prices."

Blue Ridge Models
Box 429
Skyland, NE 28776

Catalog $.50.

Free flight model aircraft kits (for competition, sport)— rubber powered models (with 13½" to 40" span) and Dargon Fli helicopter. Hand-launched gliders, variety of models. Others. ("Dealer inquiries invited.")

Bondus Tool Ltd.
1400 E. Broadway
P.O. Box 660
Monticello, MN 55362
416-453-7470

See your dealer or send SASE for information.

"Wiha" precision fastening tools with steel blades, oxide tips, with precise control finger tip rotation cup; and sets.

Byron Originals, Inc.
P.O. Box 279
Ida Grove, IA 51445
712-364-3165

Catalog $3.00.

28 Model R/C aircraft kits: biplanes, aerobatics, warbirds, ducted fan jets, amphibians, others. Christen Eagle, P-47 Thunderbolt, F-4U-1 Corsair, Seawind Amphibian, P-51 Mustang, G-17S Staggerwing, F-16 Fighting Falcon, Glasair RG, F-15 Eagle, others. Manufacturer.

C.B. Tatone, Inc.
21658 Cloud Way
Hayward, CA 94545
415-783-4868

At your dealer, or send SASE for list.

Model motor mounts (aluminum)—four cycle of alloy aluminum, machined beams, drilled and tapped (O.S., HP, Webra, Enya, Saito) two cycle and giant scale types. MasterCard, Visa.

Cannon R/C Systems
2828 Cochran St, Suite 281
Simi Valley, CA 93065
805-581-5061

Contact your dealer or write for brochure.

R/C Systems ("world's smallest") including 910 transmitter with servo reversing, end point adjustments, lite-touch sticks; optional dual rate, mixer circuits. Super-Micro RX (smallest), Super-Nova RX (versatile) are narrow-banded on new frequencies and work on 1991 20 khz narrow band spacing. Super-Micro servos (.43 oz.), available separately. Larger Super-Nova and Charlie's Classic systems. MasterCard, Visa.

Carlson Engine Imports
814 E. Marconi
Phoenix, AZ 85022

Catalog $1.00.

Model aircraft—imported diesel engines, selections, by Aurora, Cipolla, D-C, Enya, KMD, Mikro, MK-17, MVVS, RAW, Pfeffer, Silver Swallow, and USE. Mills and Taplin twin replica diesels, imported glow engines.

Central Model Marketing
P.O. Box 772
Aurora, CO 80040

Send SASE for list.

R/C model car kits, kits with computer matched pack and charger, or kit with charger and 2Channel 2Stick radio: Grasshopper, The Hornet, The Falcon, Wizard, Lunch Box, Blackfoot Monster Truck, Midnight Pumpkin, Monster Beetle, Clodbuster, Royal Crusher, Rockbuster, hopped-up Rockbuster, Royal Ripper, Futaba FX-10, Grasshopper II; others. MasterCard, Visa.

Charles River Landing
Box 775
Needham Hts., MA 02194

Catalog $2.00.

Aviation and nautical memorabilia: prints, keepsakes, balsa wood airplane kits, basswood ship kits, videos, books; display models.

Cheetah Models
14725 Bessemer St.
Van Nuys, CA 91411
818-781-4544

Send SASE for complete information.

Model aircraft—slope acrobatic, combat gliders includ-ing super model (wingspan 64") and Cheetah (wingspan 48")—both with "unbreakable fuselage." ("Dealer inquiry invited.")

Chris Rossbach
RD 1, Queensboro Manor
Gloversville, NY 12078

Catalog $8.00; foreign $20.00.

Antique model ignition engines and parts: precision cast timers, original cylinder heads, point sets, drive washers, spark plugs, tanks. Wide range of engines.

Clark's Aircrafters Supplies
501 Raintree
Malvern, PA 19355

Free catalog.

Decals for models—major brands/types, wide array of aircraft, "good prices."

Cleveland Model & Supply Co.
9800 Detroit Ave.
Cleveland, OH 44102
216-961-3600

Catalog price list $2.00; price list $1.00.

Model aircraft (C-D) plans (for giant scale models, R/C, electric, rubber, or gas powered) for early birds, warbirds, commercial and racers, private models, homebuilts and jets, others: Supermarine, Cur.Hawk, Boeing, Beech, Piper CBS, Fokker, Lindberghs, Waco Taper-Wings, Bristol, Grum., Stins, Lock Air Express, Curtiss, others.

Clover House
Box 62
Sebastopol, CA 95473

Catalog $3.00.

Model—N, HO, S, and O Scale dry transfer lettering: Alphabets in variety of type styles, stripes, signs, and RR lettering. Scratch building supplies.

Coastal
P.O. Box 1053
Brick, NJ 08723

Catalog $1.00; free brochure. Metal kits catalog, $3.00.

Lead soldier molds, casting and mold-making supplies.

Concept Technology
P.O. Box 669
Poway, CA 92064
619-486-2464

Free catalog.

Model plans enlarged—large scale specialists; model drafting software, PC model software.

Cox Hobbies, Inc.
1525 E. Warner Ave.
Santa Ana, CA 92705

Contact your hobby dealer.

Model R/C aircraft kits, electric ARF (almost ready to

fly) models; with Mabuchi RK-370 moyot, 52" sliger-like styling, with or without Cadet 2-channel radio. Others.

CS Flight Systems
31 Perry St.
Middleboro, MA 02346
508-947-2805

Catalog $3.00.

Model aircraft—electric flight systems: R/C and other kits—Astro, Micro-X, Davey, J.M. Glasscraft, Guillow, Goldberg, Topflight, Sig, Airtronics, Easybuilt, others. From over 40 manufacturers: motors, accessories, props, connectors, batteries, carbon fiber sheet, Kevlar mat, tube and solid rods, angle, composite. Model kits, easy built electric kits. Heat guns, irons, films, heat shrink tubing. Float kits. Motor glider kits. Astro Flite variable rate chargers, DC/DC charger, racing motors, speed controls, hub kits, "Pro" control systems, motor mounts. "At discount prices." MasterCard, Visa.

D & J Hobby & Crafts
96 San Tomas Aquino Rd.
Campbell, CA 95008
408-379-1696

Send SASE with specific inquiries.

Model materials—complete lines of: imported aircraft, ships and armor kits, fantasy miniatures and games, minitanks and GHQ micro armor, scratch building supplies; materials by Humbrol, Polly S, Floquil, Paasche Airbrushes and parts. Dollhouses, miniatures.

D & R Aircraft Mfg.
P.O. Box 23056
Austin, TX 78736
512-288-3055

Write or call for full information.

Model airplane kits including P-51 Mustang sport scale (75" wingspan, rec.eng: .90-1.08 cycle, 1.20 4 cycle). P-51 retracts. MasterCard, Visa.

Dane Art Miniatures
3138 SW 9th St.
Des Moines, IA 50315

Send SASE for current products list.

Detailed model parts and accessories for 1:35 scale military (armor, vehicles, figures) and 1:48 scale military aircraft; others. "Dealer inquiries welcome."

Davey Systems Corporation
675 Tower Lane
West Chester, PA 19380
215-430-8645

Send SASE for information.

Model aircraft kits, including electric "Fly Baby" scale "fun ship" designed for 05 electric power: does aerobatics or slow easy flying/landings; with precut parts, hardware, rolled plans and instructions, formed landing gear and windshield; Electro-combo includes motor, fused switch harness with Tamiya connector, propeller adaptor and 8/4 propeller (40" span). Others.

Delta Shamrock
P.O. Box 211
Saegertown, PA 16433

Send large SASE for information and prices.

Model: styrene and clear plastic sheet, LTD's, flashing LED's, lights; others. "Dealer inquiries invited."

DGA Designs
135 E. Main St.
Phelps, NY 14532
315-548-3779

Contact dealer, or catalog $1.00.

Model aircraft—Jet Pilot Kit (pilot bust with modern jet helmet, face mask, oxygen hose, weight ½ oz.), 9 other pilot styles and sizes, 1:8 scale, 1:7 scale, others.

Diamond Enterprises
Box 537
Alexandria Bay, NY 13607
613-475-1771

Catalog $5.95 (refundable).

Live steam model train kits—complete Wilesco & Mamod line. Kits for tractors, marine craft, cars, trucks; stationary engines and accessories. Wide array of parts. Service department. "Large discounts."

Don Smith
2260 N. Dixie Hwy.
Boca Raton, FL 33431
407-395-9523

Information, $1.00.

Scale R/C aircraft plans: Messerschmitt, Henschel, Lavochkin, Heinkel, Hawker Sea Furn, Curtis R3C2, others. Cowls, canopies.

Du-Bro Products
P.O. Box 815
Wauconda, IL 60084

Catalog $1.00.

Model airplane materials: "Kwik" hinges (insert with hobby knife to make slot in wood) super thin, strong, with glue pockets—by hinge or sheet. Foam rubber, by sheet. Others. Manufacturer.

Eric Clutton
913 Cedar Lane
Tullahoma, TN 37388

Lists and information $1.00.

P.A.W. diesels for model aircraft—.049 to .35, RC and STD. Davies-Charlton diesels (English made) including Dart .03, Merlin .045, Spitfire .06, Sabre .09.

Evergreen Scale Models
12808 N. 125th Way
Kirkland, WA 98034

Contact dealer, or handbook and samples $1.00.

Styrene products: board and batten, 3/16" and ¼" square strips, larger telescoping tubing, wide spaced clapboard,

others. Handbook of tips and techniques.

Exact Miniatures
P.O. Box 402
Oxford, MD 21654

Send large SASE and $1.00 for catalog.

Scale model ship fittings—blade props (2, 3, 4, 5, and 6 prop types). Other fittings.

Fiberglass Master
Rt. 1, Box 530
Goodview, VA 24095
703-890-6017

Catalog $1.00.

Model aircraft cowls (fiberglass): Balsa USA, Bud Nosen -A&A Industries, Carl Goldberg kits, Day Ridge Models, Great Planes, Lance D & R Aircraft Mfg., Model Airplane News, Pica, Sig, Scale Plans and Photos, W.E. Technical Services Plans, World Engine. For other models: wheelpants, radial cowls. MasterCard, Visa.

Flying Scale Inc.
1905 Colony Rd.
Metairie, LA 70003

Send SASE for list.

29 scale model rubber aircraft plans (collectors'): Ryan, Stinston, Boeing, Curtiss, Thompson; Japanese, French, and German models.

Flying T Model Company
1234 N. Edgemont St. #204
Los Angeles, CA 90029
213-662-9323

Send first class stamp for catalog.

Model aircraft kits—antique and vintage types.

Flyline Models, Inc.
P.O. Box 2136
Fairfax, VA 22031
703-273-9593

Catalog $.50.

Model aircraft kits—"old favorites" including Heinkel HE100-d, rubber powered flying scale (24" wingspan). A whole line of others. "Dealers and distributors invited."

Formula 1
5 Keane Ave.
Islington, Ontario, Canada M9B 2B6
416-626-5781

Free price list.
Scale model classic racing and other cars by Tamiya, Fujimi, Heller, Protar, ESCI, Union, Gunze, Monogram, others. Minimum order $25.00. American Express, MasterCard, Visa.

Galactic Trade Commission
10185 Switzer
Overland Park, KS 66062

Catalog $3.00.

Science fiction models from: Robotech, Star Trek, Tunderbirds, Star Wars, Galactia, Starblazers, Macross, others. "Dealer inquiries are invited."

GM Plastics
7252 Industrial Park Blvd.
Mentor, OH 44060
216-953-1188

Contact a dealer or send SASE for details.

Model R/C aircraft kits (machine cut parts, sheeted foam wing design, solid balsa tail feathers, one piece ABS cowl, plans, instructions, hardware, decals): YAT-28-E Sport (wingspan 66"), 4 channel required, F4U Corsair (wingspan 71 3/4") 2 cycle, 4 cycle; Mooney 201 2" scale (70" wingspan), 2 cycle. North American YAT 28-E, 1 5/8 scale (66" wingspan") 2 cycle. Others. MasterCard, Visa.

Gold Medal Models
12332 Chapman Ave. No. 81
Garden Grove, CA 92640

Send SASE for full information.

Photo-etched fittings for model ships including WWII Japanese IJN battleships: two types aircraft recovery cranes, radar, searchlight tower support girders, seaplane transfer carts, catapults, propellers, ladders, mailing material, others. Separate fittings for Yamato class. Others.

Graco Models
Box 18358
Kearns, UT 84118

Send SASE for full details.

Model building product—plans for a 4" X 8" vacuum former with self-contained heat source (construct from local materials). Also available as completed unit.

Great Northern Hobbies
328-340 Fifth Ave.
Troy, NY 12182
518-233-1300

Send SASE or call for information.

R/C model cars, kits, combos, accessories, electronics. Cars include by Associated (RC-10), Futaba (FX-10), Tamiya MRC Hornet, Koyosho (Turbo Ultima, Hi-Rider, Big Brute), Schumacher's XLS Cat, Top Cat. TRC's 2-wheel drive racer PRO 10 graphite chassis, and fiberglass chassis. Tamiya clod buster, Clodbuster Saddle Pak, Monster Beetle, Lunch Box, Super Sabre, The Fox, Midnight Pumpkin. Tamiya Avante, Porsche 959, Falcon, Boomerang, others. Racing paks, speed controllers, motors (Trinity), ball bearing sets. Futaba controllers, radios. Others. MasterCard, Visa. (Has model planes.)

Great Planes Model Manufacturing
P.O. Box 9021
Champaign, IL 61826

Free brochure.

Model R/C aircraft kit — Electro Streak™ aerobatic model that performs "just about any maneuver" including rolls, loops, spins, inverted, etc., with stability; has

Goldfire motor, prop, prop adapter, all hardware; use with 4-channel radio (with 3 micro servos), speed control, battery, charger. Kit has computer-designed parts; comes with detailed plans and instructions. Kyosho Express™ electric ARF 1/11 scale glider (64.5" wingspan), Cessna Cardinal, Valencia Eppler 178 airfoil, P-51 Mustang, and Zero Mk11 models. Kyosho peak charger, others.

H-R Products
P.O. Box 67
McHenry, IL 60051

Send SASE for listings.

Scale model ship fittings for U.S. Navy WWII era; many scales from 1:384—1:16. "Dealer inquiries invited."

LIGHTEN UP: *Building lightweight models is important for good electric flight. The use of carbon fiber materials allows you to do this and doubles the strength where used; especially important on wing beams. Courtesy of Charles S. Sylvia of CS Flight Systems.*

Heath Company
P.O. Box 8589
Benton Harbor, MI 49023

Write for catalog.

R/C Model kits: MRC—Tamiya and other racing cars: Fox 15.4 Hotshot II competition, All-terrain Clod Buster (1:10 scale). Aircraft — Electric Kyosho Express (61" wingspan), Cessna Cardinal (1:9 scale) with 4 channel radio, gas powered MCR's Trainer Hawk (4' wingspan). Kyosho R/C sailboat (5' tall). Soldering irons. Magnifiers. (Also has electronic kits for variety of products, see XYZ—SELECTED OTHERS.)

Herrills Execuform
P.O. Box 7853
Laguna Niguel, CA 92607
714-495-0705

Send SASE for catalog.

Model aircraft—vacform kits in 1:72 scale (Beech, Boeing, Cessna, Convair, Curtiss, Douglas, Fairchild, Howard, Lockheed, Martin, Northrop, Ryan, Sikorsky, Stinson, Vultee, Waco).

Historic Aviation
1401 Kings Wood Rd.
Eagan, MN 55122
612-454-2493

Free catalog.

Books on historic aviation useful to model aircraft builders — classic planes, Fokker fighters, American fighters, Piper classics, military aircraft, Curtiss from 1907-47, test pilot planes, carrier bombers; pilot manual skyplanes in detail and scale; others. MasterCard, Visa.

Hobbies New
P.O. Box 687
Minot, ND 58702

Send SASE for full details.

Modeler's Helper support vise set (for model aircraft, cars, boats, sailboats): holds assemblies, for installing parts, holds during engine run up and check out, or when installing radio equipment, changing gear ratios, repair rig, adjusting, others.

Hobby Horn
15173 Moran St.
P.O. Box 2212
Westminster, CA 92684
714-893-8311

76 page catalog $2.00.

Model aircraft kits with FF and R/C, quality parts, wood, wire, window material, of P & W Model Service (1935-41 planes, 46" to 108" size models), Midway Model Co — full kits (1936-40 planes, 50" to 84" size models). Model sailplane kits—electric power or gas—of Midway Model Co., Electric Model Design. Full line of electric systems and parts. MasterCard, Visa.

Hobby House Inc.
8208 Merriman Rd.
Westland, MI 48185
313-425-9720

Send SASE for list.

R/C model car kits/products: kits by Bolink (1:10 eliminator 10 Com. and basic fiberglass, graphite, Enduro, and Enduro conversion, others). Model Racing Products, Associated, Composite Craft, McAllistor. NMB bearings, 1:10 bodies (Bolink), MRP bodies (Spider, T-Bird, others). TRC tires, Protec chargers, Parma batteries (variety of types). MasterCard, Visa.

Hobby Lobby International, Inc.
5614 Franklin Pike Cir.
Brentwood, TN 37027
615-373-1444

Free catalog (U.S.); $2.00 elsewhere.

Model boat/ship items, including the unusual: electric flight props, fast scale offshore racing cat, 400 watt elec-tric flight motor, 1-meter racing sailboat, 3-meter electric soarer, 4 ft. steam launch, wood colored old-timer props, electric flight propulsion systems; others.

Hobby Shack
28480 Bandilier Cir.
Fountain Valley, CA 92708

Free 96 page "Sport Flyer" catalog.

Model R/C aircraft kits, ARF models and others, by Two Tee, Parma International, others. Model hydro racing boat, Tamiya Grasshopper II Racer; others. Supplies, parts: silk-like material in 2-meter and 5-meter rolls, 11 colors. Miller deluxe airbrush spray set. Pacer products. Others. R/C model car kits and combos including by Tamiya (Blackfoot, Clodbuster, Thunder Shot, Lunch Box, Grasshopper II, Hornet racer, Midnight Pumpkin custom pickup, Monster Beetle, others). Bolink eliminator (1:10 scale), others. Speed controls, chargers; Futaba 3-channel radios, Tekin speed controls, pistols. Battery packs, 1:10 motors. MasterCard, Visa.

© *CS Flight Systems*

Horizon Models
1296 Franquet St.
Chambly, Quebec, J3L 2P6 Canada

Catalog $3.00.

Model airplane kits: pre-built fiberglass laminated fuselage, balsa covered foam wing panels; complete hardware.

I/R Miniatures, Inc.
P.O. Box 89
Burnt Hills, NY 12027

Illustrated catalog $5.00.

Miniatures kits (54mm and 76mm scale) including military of most conflicts worldwide, others.

Indoor Model Supply
Box 5311
Salem, OR 97304

Illustrated catalog $2.00.

Model airplanes—endurance rubber models, including copters, "Easy B" 18" span, 3IMS gliders, "Slowpoke" 16" span, Parlor planes, others. Contest/sport scale model aircraft kits (light sheet and strip woods, Japanese tissue, hardware, and prop): 20" Daphne, 22" Korda Embryo, and 20" Embryo sport. 13" scale aircraft kits. Others. Supplies: balsa, Japanese tissue, condenser paper, rubber lube, Microlite, cement, thrust bearings, others.

Jet Engine Technologies
10241 Ridgewood
El Paso, TX 79925

Send SASE for full details.

Plans for model jet engine (no machining or welding)—gasoline fueled, produces three foot flame and powers planes to 228 mph. You-build "in about 8 hours."

Jim Pepino's Scale Plans & Photo
3209 Madison Ave.
Greensboro, NC 27403
919-292-5239

Catalog $5.00. (Foreign $9.00).

Super-scale giant sport R/C construction plans, cutaway drawings, "85,000" documentation photos.

Jim Walston Retrieval Systems
725 Cooper Lake Rd. S.E.
Smyrna, GA 30082
404-434-4905

Send SASE for brochure.

Free flight model retrieval system — lightweight, long range miniature transmitter with sensitive receiver and directional antenna to track and locate model aircraft.

John Sullivan
1421 Second St.
Calistoga, CA 94515
707-942-5095

Write for product brochure.

Model float plane products including foam cores in six sizes (28" to 48"). Instructional video (VHS) on Floatplanes. West Epoxy system. Spray adhesives.

K & B Manufacturing
12152 Woodruff Ave.
Downey, CA 90241

Send SASE for information.

K & B model aircraft and marine engines, fuels (9 blends), glow plugs (4 choices); "Matched finish system" items: fiberglass cloth, super poxy resin and primer, micro-balloons filler, super poxy thinner and paints.

K & S Engineering
6917 W. 59th St.
Chicago, IL 60638
312-586-8503

Catalog and price list $.25.

Metal products for model building, etc.: aluminum tube (8 sizes), round brass tube (20 sizes), copper tube (4 sizes), soft brass fuel tubing, rectangular brass tube (4 sizes), brass strips (20 sizes), square brass tube (7 sizes); brass angle, channel, and solid brass rods—many sizes. Sheet metal (4" x 10"), brass (4 thicknesses), tin, aluminum (3 thicknesses), .025 copper. Soldering tools, 4 models; 30, 60, or 100 watt capacity.

K And W Enterprises, Inc.
7824 Lexington Ave.
Philadelphia, PA 19152

Send SASE for catalog sheet.

For scale model aircraft, full and complete line of high performance folding props.

Lencraft
P.O. Box 8010
Calabasas, CA 91302

Send large SASE for list, monthly mailing.

Models including out-of-production and hard-to-find aircraft, ships, armor, and decals, others, of: Italeri, Matchbox, Hawk, Vacuforms, Hasegawa, Frog, Novo, ESCI, Revell, KP, Airfix, US Airfix, MPC Airfix, VEB, Heller. Free search service for those wanted kits.

M-A-L Hobby Shop
108 S. Lee St.
Irving, TX 75060

Send #10 SASE for catalog.

Model books and magazines from U.S., Belgium, England, France, Germany, Verlinden, and Japan (Koku-Fan, Maru Mechanic). Aircraft kits from England in 1:48, 1:72 and 1:444 scales. Others.

Masterpieces in Miniature
P.O. Box 387
Medford, MA 02155

Catalog and sample $2.00.

Photo-etched model ship fittings (detailed, brass): ladders, grating, valve wheels, cable/hawser reels, vents, life raft/floater net baskets, tool kit, 40mm gun sights, .50 cal. machine guns, UHF antennas, stokes stretcher, others. 1:96 scale USN model kits (with vacuformed hulls and photo-etched brass fittings): 56' LCMs, 40' motor launch, 26' MTR whaleboats and personnel boat. Others.

Matrix Enterprises Inc.
7015 Carroll Rd.
San Diego, CA 92121
619-450-9509

Contact dealer or send for catalog.

Spacecase carrying cases for: transmitters, Competition cars, Circuit Master cars, HO trains, N trains, Heli.222/ Airwolf, HeliPod & Boom; field case and legs. "Prices lower than ever."

Micro-Mark
340-671 Snyder Ave.
Berkeley Heights, NJ 07922

Catalog $4.00; add $2.00 outside U.S.

Hard-to-find modeler's tools (hand and power types): saws including miter cut off type, others. Dremel moto-shop attachments, Moto-Tool and holders, flexible shaft, drill press attachment, table shaper, disc/belt sander and router attachment for Moto-Tools. Jeweler's drill press, Mini-Vac micro cleaner, Miter-Rite tool, nippers, tweezers, brushes, file sets, mini bolt cutters, knife blades and sets. Badger air brush sets and compressor. Others. American Express, MasterCard, Visa.

Midwest Products Co., Inc.
400 S. Indiana St.
P.O. Box 564
Hobart, IN 46342
219-942-1134

Contact your hobby dealer.

Model aircraft kits — Aero-Lectric™ electric R/C including trainer (3-channel, wingspan 50") Aero-Star.40 — both "self-recover from any attitude and assume a normal glide by itself," when throttle is closed and sticks released. Kit has hardware, parts to complete. .05 electric motor with pre-wired on-off switch. Nylon prop and aluminum prop hub, spinner, wheels, wheel collars, oth-

ers included in kit. Wood parts are 90% pre-cut, rolled plans. Construction manual/handbook on R/C building and flying. Others. Manufacturer.

Millcott Corporation
177 Riverside Ave.
Newport Beach, CA 92663
714-642-3799

Send SASE for information.

Systems for model aircraft—Specialist brand—maneuver, mix, adjust, reverse, monitor in 3, 6, and 8 channels.

Miniature Aircraft USA
2324 No. Orange Blossom Tr.
Orlando, FL 32804
407-422-1531

Send SASE for information.

Model aircraft kits—"X-Cell Quick-Silver" competition helicopter (quick-silver fuselage for forward speed, aerobatic precision); epoxy-fiberglass, with rear gyro mounting kit, torque tube rail rotor drive. Precision scale Bell 20L-3 Long Ranger 111 fuselage kit. Rotorsport, Magna-Pipe, JMW Gyrosensor, Tuf-Strut, Scalesport others.

Miracle Models
P.O. Box 98042
Lubbock, TX 79499

Catalog $1.00.

Models—brand name kits, supplies, accessories (and games) of: Hasagawa, Tamalya, Monogram, MPC, AMT, DML, Dragon, Dremel, Fujimi, Testor, Pactra, Gunze, Floqull, MSC, Avalon Hill, TSR, FASA, Victory, West End, Task Force, GDW, others; "at 10-20% off."

MK Model Products
12420 Burbank Blvd.
No. Hollywood, CA 91607
818-766-6772

Send SASE or call for information.

R/C model cars, kits, combos: Blackfoot, FX10, RC-10, Midnight Pumpkin, Striker, Turbo Ultima, Lunch Box, Hornet, Traxxas Bullet, Monster Beetle, Clod Buster, JRX2, Grasshopper II, Fox, Boomerang, Falcon, Hotshot II, Super Sabre, Lotus Honda 99T, Sonic Fighter, others. Products of Protech, Novak, others; basic combo upgrades, deluxe combos. Discover, MasterCard, Visa.

Model Builder Products
898 W. 16th St.
Newport Beach, CA 92663

Send SASE for full details.

A Cut Above precision cutting instrument set for model building, etc.: Uber Skiver with stainless steel blades, rear draw-bar clutch, advance collet design, hex cross-section, with anodized handles; variety of blades. Wood boxed. MasterCard, Visa. "Dealer inquiries invited."

Model Covering Company
2320 Ocean Parkway
Brooklyn, NY 11223
718-375-1288

Free swatch and information.

Japanese silk fabric for model aircraft—closely woven, 9 colors, any length; checkerboard pattern, 1 yd. up only.

Model Expo, Inc.
353 Richard Mine Rd.
Wharton, NJ 07885

Send SASE for full details.

Model ship kit—Fair American Revolutionary War brig; a plank-on-bulkhead ship with over 60 laser cut or shaped basswood parts and 200 wood strips for the hull Has 500 fittings (wood, brass, brittania metal)—24 brass cannon, anchors, gratings, others. Can be built single or double planked; with 7 sheets of plans and instruction booklet. Separate display base and pedestals. Other model kits and supplies. MasterCard, Visa.

Model Expo, Inc.
23 Just Road
Fairfield, NJ 07007

Catalog $1.00.

Historic ship model kits (from Europe): replicas (many over 4' long) with walnut and mahogany planking, fittings and details in bronze, brass, and rare hardwoods; large scale plans, instructions, all materials included. Models include clipper and other sailing ships like The Bluenose II (replica of the last of the tall schooners). Instructional video: You Take the Helm shows how to build the Bluenose step-by-step. Major credit cards.

Model Finishers
78 Trotter Dr.
Henrietta, NY 14467

Catalog $1.00 (refundable).

Model—Japanese imported accessories: complete selection of paints, thinners, putty, rubbing compound, primers, metallizing agents, brushes; weathering kits.

Model Rectifier Corporation
2500 Woodbridge Ave.
Edison, NJ 08817

Contact your hobby dealer.

Model R/C systems including 2-channel radios for car or boat—"Top Gun" 2-channel wheel unit with high tech features, 2-channel dual stick radio; others. MRC Tamiya's R/C buggy "Thunder Shop" in 1:14 scale kit with 2-channel super set radio (features proportional steering), plastic body, with turbo speed gear. Other model cars. R/C model boat kits (cruisers, racers)—plastic with chrome fittings and details (searchlights, radar bar, seats, simulated wet bar, others). Mabuchi electric motors, model parts and items. Manufacturer.

NK Products
P.O. Box 94
Landing, NJ 07850

Catalog $1.75.

1:35 scale diorama accessories (variety of buildings, walls, fences, vehicles, others).

Northeast Screen Graphics
21 Fisher Ave.
East Longmeadow, MA 01028
413-525-4110

Brochure $1.00.

Major Decals (pressure sensitive, water transfer types) over 750, in 1:4 scale, .60 and .40 sizes in sheets; propeller decals, kill markings, nomenclature markings, letters, and numbers (¼" to 4 13/16") in 10 colors, flags (U.S., U.K., Confederate), stars in 10 colors, 9 sizes. Trim sheets in 10 colors.

Northwest Hobby Supply
P.O. Box 44577
Tacoma, WA 98444
206-531-8111

Send SASE for information.

Model aircraft kits including super sport, aeromaster bipe, Scat Cat 500, Prather Lil Toni; Sig's Banshee, Chipmunk, and magnum. Starter package, electric packages. 2 Cycle engines (O.S., Supertigre models). The Edge quickie 500 Racer (fiberglass foam kit, with wood and hardware). 4 cycle engines (Saito, O.S. Max, Futaba). Accessories: firewall mounts, spinners, nylon racing wheels, and axles for wheels, Pylon racing accessories. Rev-Up Zinger props, blues, others. MasterCard, Visa.

Old Time Plan Service
P.O. Box 90310
San Jose, CA 95109
408-292-3382

Each list of plans $1.50.

Model aircraft plans "largest selection . . . at the most reasonable prices." (1) Old Timer F/F Gas Plans, (2) Old Timer Rubber/Towline Plans, (3) Old Timer Flying Scale Plans—A through K, (4) Old Timer Flying Scale Plans L though Z.

Oldtimer Model Supply
P.O. Box 7334
Van Nuys, CA 91409

Illustrated catalog $2.00.

1930s model aircraft — sawed prop blanks, Balloon Streamline balsa wheels, Hinoki wood, color nitrate, sticks, tissue, bobbins, prop hinges, bamboo. Old scale/contest plans. Others.

Omni Models
P.O. Box 3397
Bloomington, IL 61702
309-663-5798

Send SASE for list.

R/C Model car kits and combo deals, parts and accessories, electronics, by: Advanced, Airtronics, Aristocraft, Associated, Astro Flight, B & B, Bolink, Cox, Dean's, Dynaflite, Futaba, Higley's, KO Propo, Leisure, Losi, McAllister, MRC, MRP, Novak, Paragon, Parma, Proline, Protec, Ram, Robart, Royal, Sanyo, Schumacher, Tekin, Traxxas, Trinity, Twister, Varicom, World Engines, Yokomo, others. MasterCard, Visa.

Paper Models International
9910 S.W. Bonnie Brae Dr.
Beaverton, OR 97005

Send 3 first class stamps for catalog.

Paper card model kits for ships (90 naval and civil ships in 1:250 scale; other scales), planes, cars, castles, others.

Peck-Polymers
Box 2498
La Mesa, CA 92044
619-448-1818

Catalog $2.00.

Model aircraft kits—variety of rubber power, CO2, and electric models. Model aircraft building plans. Parts: bearings, wheels, props, others. Electric motors including the "super lightweight—2.6 oz. type, others"; R/C and FSystems. CO2 engines: Telco, Modela, Brown, Davis. The "1300 R/C Blimp" and others.

Penron Products
Box 13051
Arlington, TX 76094

Send SASE for catalog.

Supplies including for model aircraft, "at discount."

Product Design Inc.
16922 N.E. 124th St.
Redmond, WA 98052
206-883-4007

Write or call for catalog or more details.

Model boats (electric) items including the hydro zeta speed controller (for single or twin motors), 180 amps, 600 amp surge, takes up to 20 cells—24 volts. Others.

R/C Extra's
RR 1, Box 28
Sergeant Bluff, IA 51054
712-943-4102

Send SASE for list.

Model aircraft kits: Stand off scale, "Extra 230" kits, in 3 sizes (1:3 scale, 30% scale, 1:4 scale) models. Others. MasterCard, Visa.

RAM
4736 N. Milwaukee Ave.
Chicago, IL 60630

Contact a dealer, or send SASE for details.

Model equipment: battery backer, dual servo setter (automatically controls 2 servos), audio battery alarm (monitors), transmitter switch alarm (beeps when Tx. is "on"), big airplane RF de-glitcher (kills long wire RF), big model battery backer, battery peak detector (protects R/C car battery), simple servo setter (automatically controls l servo). Strobe lights. Others.

Rare-Plane
3747 Church Rd./Princeton Mall
Mount Laurel, NJ 08054
609-234-4537

Monthly report $9.00 year.

Model kits—plastic, including out-of-production, rare, and hard-to-find kits in variety of scales. (Purchases unbuilt model kits and kit collections.) Model supplies, accessories, books, and magazines. Visa, MasterCard.

Repla-Tech International
48500 McKenzie Hwy.
Vida, OR 97489
503-822-3280

Aircraft catalog $2.50.

Scale model aircraft drawings, plans, photos, books.

Robart
P.O. Box 1247, 310 N. 5th St.
St. Charles, IL 60174
312-584-7616

Send SASE for full details.

Robart's model incidence meter (for setting proper thrust, wing and stabilizer incidence on a new model, or to determine why a present model won't fly straight)—with pivoting V-blocks, magnified anti-parallax meter scale (precison pointer allows fine tuning model incidences to 1/8 degree accuracy), and bubble level.

Roberts Model
18 E. Clay Ave.
W. Hazleton, PA 18201

Send large SASE for details.

Model aircraft parts (1:72, 1:48, and 1:32 scales), complete line of injection molded accessories: engines (radial, inline, opposed), props (2 to 6 blade), control columns, throttles, radio fronts, instrument panels, seats, rudder pedals, guns (22 types), spinners (12 types), helicopter rotors, wheels (15 sizes), U/C struts (20 types). ADF loops, exhausts, tailwheels, intakes; others.

Rosemont Hobby Shop
P.O. Box 139
Trexletown, PA 18087
215-398-0210

Catalog $2.00 (refundable).

72nd scale aircraft and other kits: Roseplane vacuum form (Armstrong Whitworth, Martinsyde Elephant, Packard, Nieuport, others), Meikraft injected kits (Hansa Brandenburg, Vindicator, Piper Cub, other early planes); WWI kite balloon. Other aircraft kits from 1919 to modern, all scales; armor, WWI to present, all scales; ships, all scales, all eras. Icarus and Proteus models. Discover, MasterCard, Visa. "Dealer inquiries invited."

Royal Products Corp.
790 W. Tennessee Ave.
Denver, CO 80223

Contact your hobby dealer, or catalog $4.00.

Model R/C products—"Head Start" systems including heavy duty starter (standard or jumbo, for engines up to 1:4 scale), Power panels, 12V fuel pump (fills or drains model or diesel fuel), locking socket (lock-on battery clip, fits 4-cycle plugs). Other model aircraft; accessories.

Rykco Toys
325 Beach St.
Revere, MA 02151

Information packet $3.00.

R/C model flying saucer plans, for you-build (illustrated, with step-by-step instructions).

SABO Designs in Paper
P.O. Box 161742
Altamonte Springs, FL 32716

Send SASE for complete details.

Model NASA space shuttle—Orbiter kit (8" wingspan) printed on gloss paper (for display or hand launch).

S C H Wholesale
P.O. Box 7268
Sussex, NJ 07461
201-875-4661

Catalog and price list $2.00.

Precision modeling tools including knives, others. "Dealer inquiries invited."

S. Carwin & Sons Ltd.
P.O. Box 147
Canoga Park, CA 91305

Send SASE for list.

Books of interest to model crafters: aircraft (earliest aviation to today's models), aviation and flying proficiency books, armor and military history, ships of yesterday and today—pleasure, military, ocean liners, sailing types. Ship model books (on rigging, naval architecture, ancient and medieval ships, how-to guides, dioramas, others).

S.S. Edmund Fitzgerald
Box 494
Lathrup Village, MI 48076

Catalog $2.00.

Detailed scale model ship building kits and supplies.

Satellite City
P.O. Box 836
Simi, CA 93062
805-522-0062

Send SASE for free tip booklet and fiberglassing instructions.

Glues for fiberglass or Kevlar™—instant and penetrating odorless types.

Schlueter Free Flight Models
3508 Poinsettia Ave.
Manhattan Beach, CA 90266

Send SASE for list.

Model aircraft kits with rolled plans (print and strip)

balsa, wire, wheels, plastic prop or balsa blank, nylon thrust bearing, ball bearing washer, Japanese tissue, plywood and aluminum motor peg—including Pacific Ace and Black Bullet (20", 30", 40" models).

Sheldon's Hobbies
2135 Old Oakland Rd.
San Jose, CA 95131
408-943-0872
800-228-3237 (except CA)
800-822-1688 (in CA)

Free 136 page catalog.

Model products—4 to 8 channel systems and servos by Airtronics, Futaba, World, Aristo. Aircraft engines by Como, Cox, Enya, Fox, K & B, Magnum, RJL, Rossi, Royal, Saito, World, YS. Model aircraft kits by Ace, Airtronics, Bridi, Cox, Duracraft, Dynaflite, Davey's, Flite Line, Carl Goldberg, Leisure, Bob Martin, Pica, Royal, Sig, Top Flite, World. Model aircraft parts, components, supplies. R/C model car kits and combos: Associated (RC-10), Marui (Big Bear, Ninja), Minicraft Roadrunner II, Royal (Ripper), Tamiya (Hornet, Avante, others), World Rockbuster. Parts and radios. MasterCard, Visa.

Sid Morgan
13147 Ormond
Belleville, MI 48111

Catalog $1.00.

Over 50 vintage model aircraft (R/C) plans including 9' wing span PBY-5A consolidated "Catalina" and 6' wing span model PBY-5A. Engine cowls, gun blisters, others.

Sig Manufacturing Co., Inc.
Montezuma, IA 50171

Contact a dealer or send $3.00 for catalog.

Model aircraft kits (balsa, plywood)—classics, biplanes, stunts, sports, multiwing, military, racers, trainers, gliders, others; for flying in confined area; for one to four-channel radio equipment; beginners' models; variety of scale sizes. Aircraft parts—cowlings, canopies, wheels, gears, decals. Kit plans. Balsa wood (sheets, blocks, others). Engines: Fox, Fuji. Metal sheets (aluminum, brass). Materials: heavy silk, "Plyspan" tissue, nylon, polyester, flight foam. Plastinamel gloss paints for foam ARF models. Casting materials (resin, fiberglass), Control line, radios—MRC, Kraft, Futaba. MasterCard, Visa.

Sky Books International
48 E. 50th St.
New York, NY 10022
212-359-6969

12 page catalog $1.00.

Model books and magazines: *After the Battle (WWII Then and Now)*—62 issues in stock (Normandy, Ruhr Dams Raid, Battle of the Bulge, Dieppe, V-Weapons, Tarawa, Singapore, Pearl Harbor, Atomic Bomb, Battle for Okinawa, Telemar, Anzio, Victory, U-Boat Bases, others). *Wheels & Tracks (Review of Military Vehicles)*— 25 issues. *The Blitz (Volume 1, 2), War in the Channel Islands—Then & Now, Battle of Britain—Then & Now, Flanders, Before Endeavours Fade;* others. Dealer enquiries: Bill Dean Books Ltd. at above address or phone.

Sovereign Military Miniatures
P.O. Box 590
Altoona, PA 16603

Catalog $2.00.

Model figures (cast and hand painted in Wales by Marlborough Military Models): India Britannica, Bengal Lancers, Skinners Horse, elephants, camels, Indian civilians, snake charmer/cobra basket, fire eater, other figures.

Square Cut Tools
905 N. Harbor City Blvd.
Melbourne, FL 32935

At your dealers, or send for catalog.

Model kit or scratch building tools: balsa cutters (square cut tools in 3 or 5 piece sets, cutting 1/8" to 5/16" squares; of machined zinc plated steel). MasterCard, Visa. ("Dealer/distributor inquiries invited.")

Stangel Enterprises
P.O. Box 336
Waukesha, WI 53187

Catalog $2.00.

Model aircraft kits and plans for variety of C/L and R/C types, "inexpensive," and easy-build.

Superior Aircraft Materials
12020 Centralia
Hawaiian Gardens, CA 90716
310-865-3220

Send SASE for catalog.

Balsa wood: sticks, wide sheets, "superlite," planks, others. Bargain balsa. Birch plywood.

Su-Pr-Line Products, Inc.
18800 State Rt. 47
Sidney, OH 45365

Send SASE for further information.

Model push rods and linkages—Nyrod™ flexible push rod with metal fittings for any action: rudders, elevators, ailerons, throttle control, boats, seaplanes, etc. (34" long, assembled length).

T & D Fiberglass Specialties
30925 Block
Garden City, MI 48135
313-421-6358

Complete list $1.00.

Model products—fiberglass parts: over 237 cowls for kit or scratch built models. Over 34 round cowls, 4" to 14 7/8" diameters. 55 different size and shape wheelpants. Custom made parts and vacuum form canopies. Brazed and heat-treated wire gears and cabanes. (Call 313-261-9064). MasterCard, Visa.

Tech-Toys
370 Rt. 46 W.
Parsippany, NJ 07054
201-227-7012

Call or send SASE with inquiry.

R/C model car customizing parts for on and off road cars and trucks, boats; in 1:4, 1:6, 1:10, 1:12, 1:24 scales (specializes in 1:4 and 1:6); for specialty and racing; finishing materials and equipment; electronics of over 10 manufacturers including A & L, Advance, Airtronics, AstroFlight, Badger, Blue Ribbon, Bolink, Buds, Goldberg, Champion, Cobra Int., Composite, Cox, CRP, Custom, Dahms, Deans, Delta, Dremel, Dubro, Duratrax, Floquil, Fox, Futaba, Higley, Houge, JG, K & B, KO Propo, Lavco, M&M, Marui, MCS, MIP, Monogram, MPE, MRC, MRP, NMB, Novak, Panasonic, Paragon, PDI, Pro Cut, Pro-Shop, Raceco, Race, Sanyo, Tekin, Thorp, Ungar, Universal. MasterCard and Visa.

Teleflite Corporation
11620 Kitching St.
Moreno Valley, CA 92387

Brochure and sample igniter $2.00.
Model rocket motors—you build (using a rock tumbler and simple hand tools), finished product gives 40 pounds thrust. Electric igniter—from household materials.

The Dromedary
6324 Belton Dr.
El Paso, TX 79912
915-584-2445

Catalog $6.00 (U.S.); $7.00 outside U.S.

Model ship builder supplies—full lines of tools, rigging, and fittings, ship kits (U.S. and plank-on-frame imported, variety of woods, and others). MasterCard, Visa.

The Kit Bunker
2905 Spring Park Rd.
Jacksonville, FL 32207

Send $1.00 and $.44 SASE for list.

Line of aircraft, armor, ships, and figures kits (old and new). Also purchases kits, small or large quantity.

The Toy Soldier Company
100 Riverside Dr.
New York, NY 10024
212-799-6348

Monthly lists: lead list $12.00 year, plastic list $20.00 year.

Toy soldiers, plastic and lead. 600 figures from U.S. and foreign manufacturers, 1900 to present (15mm to 70mm scales). Lead soldiers by Authenticast, Bastion, Benbros, Britains, Charbens, Cherilea, Citadel, Crescent, Dorset, Games Workshop, Grenadier, Heritage USA, Herrings, Imperial, Marlborough, Mignot, Minifigs, Ral Partha, S.A.E. Steadfast, Taylor & Barrett, Timpo, Trophy, Tunstill, Wend-Al. Plastic soldiers by: Airfix, Atlantic, Auburn, Blue Box, Charbens, Cherilea, Crescent, Deetail, Elastolin, ESCI, Eyes Right, Giant, MPC, Marx, Merton,

Rel, Remsea, Starlux, Superior, Swoppet, Timpo, others.

Tin Lin's
17 Andrews Dr.
Daleville, AL 36322
205-598-2287

Send SASE for full information.

Fiberglass cloth, 3/4 oz. and other weights. 10 yard minimum. "Lower prices on 30 yards+."

Tower Hobbies
P.O. Box 778
Champaign, IL 61820
800-637-6050
800-252-1113 (in IL)

320 page catalog $3.00.

Model RC equipment, kits, and supplies/parts for model cars, boats, planes, tanks, engines, radios. Accessories of over 300 manufacturers including ACE R/C, Astroflight, Dave Brown, Cox, Cressline, Davey Systems, Dremel Tools, Du-Bro, Future Flight airplane, Flitecraft models, Futaba (servos, sticks), Carl Goldberg model kits, Great Planes airplane kits, Guillows, Hobbico, Hot Stuff, K & B, Kyosho (aircraft kits, chargers), Master Airscrew, KJ Miller, Milt Video, Royal (starter, fuel pump), Sanyo, Supertigre, Top Flite aircraft. Tower Hobbies: charger, hydrometer, voltmeter, fuel pump, battery, fuels, tools, balsa assortment, heatgun, sealing iron. Others.

Twelve Squared
P.O. Box 21-567
Eagan, MN 55121

Send SASE for illustrated catalog.

Model aircraft kits—1/700 B-2, Bell X-1, Northrop X-4, Heinkel HE-278. In injected kits and conversions: 1:44 scale and 1:72 scale. Model stands for aircraft. Others.

Valley Aviation
18 Oakdale Ave.
Farmingville, NY 11738

Send SASE for more information.

Model aircraft—P-47 semi-kit, 2.3"/ft. scale, 92" wingspan: with fiberglass fuselage and cowl, plastic canopy, plans (showing ribs and formers and wing, stabelevator and fin-rudder structures). Razorback version available.

Vanguard Model Marine
P.O. Box 708, Station B
Ottawa, Ontario, Canada K1P 5P8

Catalog $2.00.

Ship drawings for Canadian warships and government vessels of many types.

Vantec
460 Casa Real Placa
Nipomo, CA 93444
805-929-5055

Send SASE for full details.

Radio control — 18 channel — for boats, subs, robots, quarter scale models; 6 servo channels for control surfaces, electric drive motors, proportional functions, and eight momentary on-off functions for guns, torpedoes, horns, cranes, sub diving pumps; 4 key on, key off channels for lights etc. KYF-18 channel radio is complete with four s-28 servos, dual rate transmitter with keypad, Futaba receiver with keykoder receptor, nicads, and charger. MasterCard, Visa.

Venture Hobbies
747 W. Dundee Rd.
Wheeling, IL 60090
312-537-8669

Send SASE for list.

Plastic imported and domestic kits and accessories: Micro-scale, Scalemaster, Cady, ATP decals, Verlinden products, Gunze Sangyo, Modelmaster, Tamiya, Humbrol, other kits including hard-to-find. Paasche and Badger air brushes. Imported books and magazines.

Victoria Products
930 Foul Bay Rd.
Victoria, B.C., Canada V8S 4H8
213-274-1283

Send for newsletter.

Model aircraft kits — vacuform and cast resin types, in 1:72 scale. Vacuform kits (Canadair Tutor, Sukhoi, Grumman, Bachem, MIG, Aero, Blohm and Voss, BereznyakTsev BI, others). Resin kits (Canadair Tutor, Sukhoi, Grumman, Polikarov, MIG, others).

Vinylwrite Custom Lettering
16043 Tulsa St.
Granada Hills, CA 91344
818-363-7131

Write or call for information and sample.

Model service — custom lettering, pre-spaced, pre-aligned, custom computer cut in 3M premium cast vinyl, 2 mil. thin. Vertical or horizontal text, in custom lengths, 15 colors and 6 type styles including military block, slanted or upright text, ½" to 12" high. No minimum charge.

VL Products
7871 Alabama Ave. #16
Canoga Park, CA 91304

Illustrated catalog $1.00.

Mini-Electric model aircraft systems: motor/gearbox props, propulsion systems, chargers, and flight batteries.

Volant Plastics
P.O. Box 433
New Cumberland, PA 17070

Send SASE for information and sample.

Engraved brass nameplates in scale with models.

Wescraft
9626 Purline
Chatsworth, CA 91311
818-998-8533

Send SASE for information.

Model R/C aircraft kit — B17 with all-fiberglass body, of size for .45 to .60 engines. Others.

Williams Bros. Inc.
181 Pawnee St.
San Marcos, CA 92069

Illustrated catalog $3.00.

Scale model wheels for radio control, control-line, and free-flight aircraft: vintage (11 sizes), smooth contour type (10 sizes), golden age style (11 sizes), and new balloon style in 5 sizes. Scale pilots, cylinders, engine kits, machine gun kits. Plastic display models.

Wingair Graphics
531 Kenilworth Lane
Ballwin, MO 63011

Send $1.00 for information.

Model — scale drawings with 4 plus views, section cuts, interior detail — for scratch builders and superdetailers; in 1:32, 1:48, 1:72, TR-1A, F-5E/F, S-3A, XB70 scales. Rolled blackline prints.

Yellow Aircraft & Hobby Supplies
11918 98th Ave. E.
Puyallup, WA 98373
206-845-8195

Send SASE for list.

Model aircraft — Quarter-scale CAP with 75" wingspan, 62" length; kit includes fiberglass fuselage with formers, fiberglass rudder and wheelpants, balsa-foam core wings and stabilizer precut landing gear blocks, vacuum formed canopy. Other model kits for F-4 phantom single engine, F-18 Hornet, SR-71 (108" length), ¼ Corby Starlet (75" wing), A-4 Skyhawk (40" scale wing, 45" sport wing). MasterCard, Visa. Also in Toronto, Canada.

Zenith Books
P.O. Box 1
Osceola, WI 54020

Check with dealer, or send SASE for list.

Model aircraft books: R/C modeling (advanced, beginner guides, R/C systems, R/C boats, designing and building, flying PC planes), handbooks for variety of building, on Vietnam aircraft, directory of plans, superbases series. Books on actual planes — military, choppers, today's models, jets. Giant scale aircraft books and directory of plans. R/C cars books. R/C videos. Buyer's guides. Magazines. Videos (VHS or Beta): postwar jets, flying R/C models, stunt flying, Thunderbirds, others. American Express, MasterCard, and Visa.

Model Making—Railroad

❦❦❦❦❦❦❦❦❦❦❦❦❦❦❦❦
See MINIATURES, MODEL MAKING—GENERAL, and other related categories; BOOKS & BOOKSELLERS, PUBLICATIONS, and ASSOCIATIONS.
❦❦❦❦❦❦❦❦❦❦❦❦❦❦❦❦

America's Hobby Center, Inc.
146 W. 22nd St.
New York, NY 10011

Model Railroad brochures $.75.

Model railroad—HO and N gauge: locomotives, cars, coaches (ready to run) by Riverossi, Bachmann, MDC, Athearn, Int. Hobbies, Atlas, Con-Cor, others. Automatic switches, track, crossings, switch machines, coupler, switches, MRC power packs, dual pack. (See MODEL MAKING—GENERAL.)

Ashland Barns
990 Butler Creek
Ashland, OR 97520

Comprehensive catalog $4.00.

Blueprints for 77 classic structure designs (barns, depots, mini-barns, garages, others) "simplified, economical."

Bachmann
1400 E. Erie Ave.
Philadelphia, PA 19124

Contact your dealer.

Model railroad trains, sets, cars, locomotives, others; including HO scale limited production run cars, decorated or not. Others.

Bookbinder's "Trains Unlimited"
84-20 Midland Parkway
Jamaica, NY 11432
718-657-2224

Illustrated catalog $5.00.

Model railroad—Lionel Standard and O Gauge trains—pre-war and post-war locomotives, diesels, 6464 boxcars, accessories, operating cars, Hudsons, tinplate freights and passenger cars, track, switches, transformers and signals (from 1915 to 1985): American Flyer, Bascule Bridge, Lionel cars, N & W Vista Dome passenger cars, Southern RR Railroad, Union Pacific RR Set, and others; in new, mint, like new, excellent, or restored condition. American Express.

Burt Industries
P.O. Box 1163
Altamonte Springs, FL 32715

Send large SASE for details.

Automobile traffic stoplights in HO and N scales (light controls traffic in two directions in correct sequence).

Caboose Hobbies
500 So. Broadway
Denver, CO 80209
303-777-6766

Send SASE for information.

Model railroad building kits in HO scale (by Builders in Scale), 150 building kits by Colorado Scale Models.

Cape Line Models
Box 493
Wilbraham, MA 01095

Send SASE for price list.

Model railroad—HO trucks in 51 styles (freight, passenger, and traction).

Central Valley
1203 Pike Lane
Oceano, CA 93445

Contact dealer or send SASE for details.

Model railroad—HO scale black styrene plastic kits: Pratt truss bridges, bridge tie sections, girders, fences, railings, steps, ladders, end beam, and brake shoes.

Charlie's Trains
P.O. Box 158
Hubertus, WI 53033
414-628-1544

Send large SASE for samples and price list.

Model railroad—Lionel-type flat cable (3, 4, 5, and 6 wire), flexible wire for pick-up rollers. Tinplate repair parts, light bulbs, and supplies.

Con-Cor
Box 328
Bensenville, IL 60106

Contact a dealer or send SASE for list.

Model railroad car kits (metal): 40 ft. sliding door boxcars (of '40s-'60s)—Santa Fe, Southern Pacific, Baltimore & Ohio, Conrail, Southern Railway, SOO Line. N gauge locomotives (Great Northern, Heavy Pacific, Berkshire, Hudson, others. Other cars and coaches.

Custom Finishing
379 Tully Rd.
Orange, MA 01364

Send large SASE for illustrated listing.

Model railroad HO scale brass detail parts: steam generator stack, high hood bells, side mount bells, modern cab signal box (Conrail, etc.), exhaust stack, RS handbrake underframe chain guides set, cooling coils. Others.

Donald B. Manlick
2127 South 11th St.
Manitowoc, WI 54220

Send #10 SASE for information, samples.

Custom designed decals for model railroads—HO, N, O, and S scales. (U.S. and Canadian orders only.)

Eastern Car Works Inc.
P.O. Box 624
Langhorne, PA 19047

Contact dealer, or send SASE for list.

Craftsman Style HO Model Railroad kits (undecorated without couplers): pullman-standard heavyweight cars (combine, coach, business, observation), Pullman-standard smooth-side streamline cars, Osgood-Bradley (Pullman-Bradley) cars, freight cars (covered hoppers, gondolas, others). "Dealer inquiries invited."

Express Stoppe Books
4901 Morena Blvd., Suite 511
San Diego, CA 92117

Free book list.

Railroad books on: Alaska railroad, Amtrak, steam locomotives, railroad bridges, Berkshire and Texas types, Big Boy, Broadway Limited, Canadian Pacific, Pullman Cars, circus on rail, Colorado narrow gauge railroads, Donner Pass (So. Pacific), E-Units, Erie Railroad, Hiawatha, Limiteds, New York Central, Milwaukee rails, Northern California, and Pennsylvania railroads. Railroad work equipment, Seaboard, Short Line, and Texas Electric railroads. Steam, Steel, & Limiteds. War engines, Santa Fe Steam, Rio Grande, others. Books on ships, planes, military, cars; used books.) "Discount prices."

Gene's Trains
159 Primrose Lane
Brick, NJ 08724

Send SASE for price list.

K-Line electric trains in 0 and 027 gauge: Budd car set, Pennsylvania Maintenance of way set, United States Army set, SP boxcar, CSX ore car, NYC hopper car 4-pacs; operating cars, and smoking caboose.

Green Frog Productions
950 Bream Court
Marietta, GA 30068

Contact dealer, or catalog $1.00 (refundable).

Railroad videotapes — Standard gauge (Steam in the 50's, Diesels '86, Rails Chicago, Rails Canada, New Georgia Railroad, Michigan Fast Freight, Detroit Toledo and Ironton, Rails in Transition, others); narrow gauge (Slim Rails through the San Juans, Twilight of the Rio Grande, Worktrain to Silverton, The Chama Turn, others). Instructional video—Modeling Your Favorite Railroad. Audio tapes: Steam & Diesel Sounds of the 50's, Thundering Narrow Gauge, Sounds of the New Georgia Railroad, Diesels '87, Steam/Diesel Sounds of 80's, Diesels '86, others. MasterCard, Visa.

Hobby Surplus Sales
P.O. Box 2170CS
New Britain, CT 06050
203-223-0600

128 page catalog $1.00.

Model railroad items: Lionel, American Flyer, HO, N gauge, LGB; full lines of train repair parts. "Free shipping in USA with order." (Also has other models R/C, plastic and wood; and model accessories.)

Hoquat Hobbies
Box 253
Dunellen, NJ 08812

Contact dealer, or send SASE for listing.

Model railroad—Hoquat/CDS dry transfers in over 300 sets, in N, HO, S, and O scales.

International Hobby Corp.
350 E. Tioga St.
Philadelphia, PA 19134
215-426-ATSF

Contact dealer, or order catalogs (see below).

Model railroad structures/buildings: IHC carnival series (HO scale carousel and ferris wheel; motorizing kits), HO scale 5 pack gingerbread houses in HO, N, or O scale kits. O Scale Pola HO and N scale building kits (block of buildings, antique shop/home, old time bank, brewery, buildings, pickle factory). HO and O scale model trains, kits by Rivarossi. Model trees—15+ types, by IHC. IHC catalog $3.98, Preiser Catalog $7.98, Rivarossi Catalog—all scales $9.98, Parts Catalog/Scratch Builders Bible $9.98. Parts Price List $1.98. SASE—Rivarossi list. SASE—List HO and N Scale Structures. ROCO 1:87, HO Military Miniatures Catalog $3.98.

Iron Horse Models
1120 Gum Ave.
Woodland, CA 94695
916-662-8823

Send SASE for list.

Model railroad — HO/HOn3 scale wood pile trestles: single bridge with tapered bents (51' span), center fill-in section (45' span), 2 ends and 1 center section (147' span)—assembled and stained.

Jeff's Decal Co.
1747 Selby Ave.
St. Paul, MN 55104
612-646-5069

Send SASE or call for details, estimates.

Custom decals for all models in sets of 25+, matches type styles from any sample, special quality mixed inks available; "free estimates, lowest prices."

John Rendall
P.O. Box 910, 261 Brock St.
Gravenhurst, Ontario, Canada POC 1GO

Contact dealer, or brochure $1 (refundable).

Model railroad layout buildings: Alden Farms in HO scale (pens, pole barn, office, platforms, ramps, water tank, other)—wood; livestock, details. HO stockcar kit. Others. MasterCard, Visa. "Dealer inquiries invited."

Kar-Line Model Railroad Products
Rt. 1, Box 7
Stanardsville, VA 22973

List $.35 or free with large SASE.

Model railroad—160 lines; never lube trucks, couplers; kits or RTR in HO scale.

Ken's Trains
P.O. Box 360
Babson Park, MA 02157

Send $1.00 for list (refundable).

Model railroad—N Scale trains with New England road names (custom painted). Line of products from all major manufacturers including Kato, Green Max, Tomix, others. "Good prices." MasterCard, Visa.

Korber Models
P.O. Box 101
Clementon, NJ 08021

32 page illustrated catalog $3.00.

Model railroad — O scale structures; over 50 Korber Model products.

Kratville Publications
2566 Farnam St.
Omaha, NE 68102

Send SASE for list.

Railroad books: *Steam, Steel & Limiteds*—golden age, 1907-47), *The Challengers* — UP's 4-6-6-4 locomotive, *Motive Power of The Union Pacific*—motive power book covering steam, diesel, electric locomotives). *Union Pacific Streamliners*—history (1934-72) of steam powered Fortyniner and Treasure Island Specials, *Big Boy*—the world's largest steam locomotive, the UP's 4-8-8-4's. Most books with hundreds of photos. Others.

Locomotive Workshop
RFD 3, Box 211-B-1
Englishtown, NJ 07726

Send large SASE for current newsletter.

Model Railroad economy 0-6-0 kits in O scale brass; scale and highrail. Wide range of O Scale kits of Athearn, Lobaugh, Loco Works parts for steam operation.

Madison Hardware Co.
105 E. 23rd St.
New York, NY 10010
212-777-1111

Send SASE with inquiry or description including number of unit on which part is to be used.

Model railroad—old original Lionel repair parts. Engines, cars, railroad accessories, figures, parts, others. Full line of HO, N, and LGB gauge items.

Mantua Metal Products Co., Inc.
P.O. Box 10
Woodbury Heights, NJ 08097
609-853-0300

Contact dealer, or catalog $2.00.

HO gauge model railroad engines, rolling stock, and sets: series of steam locomotive kits and 25 ready to runs—5 diesel locomotives, streamliner, railroad cars (baggage, room, diner, vista-dome observation, combines, coach). Vintage cars: combines, passenger, box, horse, water, log, cabooses. Freight car kits: gondola, flat, tank, hopper, steel refrigerator, steel box, wood stock, boom tender, operating floodlight, Vanderbilt, other tenders, operating crane, covered gondolas. Train sets, track, signals, people. (Also has sporting goods and games.)

Master Creations
P.O. Box 1378
Chino Valley, AZ 86323
602-636-5313

Contact dealer, or send SASE for information.

Model railroad — HO scale structure kits including "Grand Hotel" with handmade components, metal castings, wood trims, dry transfers, posters, instructions. Others. Manufacturer.

MDK, Inc.
P.O. Box 2831
Chapel Hill, NC 27515

Catalog $5.00 (refundable).

K-Line™ model railroad trains including 0-27 gauge 6 unit train set, "The Pennsylvania Workhorse," with realistic detailing on metal chassis, cars that swivel, raise/lower, lights work; with signs, poles, track section, transformer, and lock-on with wires. Others in a line of trains.

Model Engineering Works
P.O. Box 1188
Ramona, CA 92065

36 page illustrated catalog $3.50.

Model railroad—rare and quality train restoration parts.

NJ International, Inc.
77 W. Nicholai St.
Hicksville, NY 11801

Send SASE for newsletter.

Model railroad coaches HO and O scale — Penny rebuilts for name trains — never before modeled (single window semi-STL, wide window semi-STL, wide windows-STL-full skirts, w/ice chests).

Noel Arnold
84 Twin Arch Rd.
Washingtonville, NY 10992

Send $.75 and large SASE for newsletter.

Model railroad products of 200 manufacturers (locomotives, diesels, cabooses, variety of cars); kits, parts, accessories; layout structures and materials. "Offer discounts."

O-Car Company
Box 4345
Bangor, PA 18013

Contact dealer, or send $.65 SASE for details.

O scale model railroad—traction equipment, trucks, car body details, cars, hardware, finishing kits, others.

Old Line Graphics
1604 Woodwell Rd.
Silver Spring, MD 20906

Send SASE for list.

Railroad books: *Chicago & North Western Memories*—railroad of 1970s, with track charts, timetables, maps, rosters. *Before Guilford*—paint schemes on New England railroads—late 1960s on, with timetables, maps, rosters of Clinchfield Country—entire railroad from Elkhorn City, NY to Spartanburg, SC; track diagrams, timetables, maps. *Erie Lackawanna Memories*—action on the railroad from Griffith, IN to Jersey City, NJ including electric operations on the line to Gladstone, NJ. All books have 150+ photographs. MasterCard, Visa.

P & D Hobby Shop
31902 Groesbeck
Fraser, MI 48026
313-296-6116

O Scale list, send large SASE with $.85 stamps.

Model railroad components including conversion for Weaver RS-3, early Weaver R-S Units, and RS 4/5 conversion kit. Parts and parts kits with components and instructions. RS and FA parts. Parts include windshield wipers, headlight, flag pole holder, market lights, stacks, steam vents, grills, horns, marker lights, fans, others. "O" scale model railroad locomotives and cars (40 ft. box cars, others). MasterCard, Visa.

Patal Engraving & Engineering Co.
37 Halleck St.
Newark, NJ 07104
201-482-2328

Send SASE for list.

HO model structures (easy lock fit assembly, painted, molds cut from architectural drawings): houses including Cape Cod, contemporary, etc., police station and city hall, shopping center, school, firehouse, church, others.

Polyterrain
HCR 66, Box 93
Witter, AR 72776

Send SASE for information. Instruction booklet $1.00.

Polyterrain water soluble scenery materials: paste, sculpting mud, gloss, matte medium, water gel, colors. "Dealer inquiries invited."

Portman Hobby Distributors
851 Washington St.
Peekskill, NY 10566

Contact dealer, or send SASE for list.

Scenic layout materials including variety of trees, hedgerows, water, lichen, building materials, others.

Rail Mail
401 Tharpe Rd.
Warner Robins, GA 31088
912-953-4478

Send SASE or call with inquiry.

Model railroad trains, sets, cars, equipment, parts, etc. from Walthers, PFM, Key, Hallmark, NP, Overland, Oriental & Sunset; in HO, O, N scale brass, etc. Uses all Walthers catalogs for information and prices. May run special and discount sales. MasterCard, Visa.

Rail Road Progress
P.O. Box 233
Gibbsboro, NJ 08026

Send SASE for brochure.

Model railroad—HO hopper car kits (29 styles with lengths, heights, number of panels, and types of peaks for most common hopper car users). Manufacturer.

Railroad Book Newsletter
P.O. Box 684
Anoka, MN 55303

Send SASE for list.

Railroad books: *Milwaukee Road*—narrow gauge lines, Milwaukee rails and road east, road west, decline and fall, electrics, Hiawatha story, others; *Great Northern*—history; *Northern Pacific*—NP diesels, NP steam, Northern Pacific views, Class A, Duluth Union Depot; *Chicago Burlington & Quincy*—high plains route, Highline scrapbook, Burlington Route across Iowa; *Chicago Great Western*—corn belt route, Iowa in merger decade, pencil drawings of CGW depots; *Chicago & North Western*—rails, C & NW power, NW motive power, others.

Rails 'N Shafts
P.O. Box 300
Laury's Station, PA 18059
215-799-2530

Send SASE for catalog.

Books on America's railroads, B & O Steam, Canadian national railways, Chessie, C & NW power, Chicago's trains, Colorado rail, North Shore, diesel locomotive rosters, electric locomotive plans, Grand Trunk Western Guide to Tourist Railroads, Pennsylvania, Kansas City Southern, Katy railroad, Lehigh and New England, MR Cyclopedia, Milwaukee electrics and rails, N & W, New York Central, Grand Central, Norfolk & Western, Old Dominion, passenger trains, cabooses, Mexican railroads, Red Arrow, St. Clair, Santa Fe Trails, Seaboard, Southern Pacific, trolleys, traction classics, Union Pacific; others. MasterCard, Visa.

Railworks
P.O. Box 148
Woodbury, NY 11797

Contact dealer, or send SASE for details.

First in series of Pennsylvania Railroad steam locomotives in HO scale brass (painted, lettered, with multistriping); or unpainted; Erie Stillwell baggage, combines, and coaches.

Roanoke Electronics
7035 Amherst
St. Louis, MO 63130

Catalog $1.00.

Model railroad products: Horn south package/module (digital sound in choice of 12 different diesel and steam locomotive horns), speaker and pushbutton (3" X 4" circuitboard). Others.

Ron's Books
P.O. Box 714
Harrison, NY 10528

Send large SASE for complete list.

Railroad books on: Baja California railways, railroad bridges, Before Guilford, B & O steam, Dawn of Diesel age, Detroit Toledo & Ironton, Erie railroad, E-Units, Interurbans, locos of the Duluth Missable & Iron Range, cyclopedias (steam, diesel), Milwaukee electrics, NP, N & W, NYC, Penn Central, Pennsylvania railroad, PRR, Tristate steam railroads, Short Line, SP, Sante Fe, Seaboard, Trollies, Union Station, others. "Discount prices."

Signs of Olden Times
Box 62
Sebastopol, CA 95473

58 page catalog $3.00.

Model railroad—over 575 dry transfer lettering sets. Full line of scratch building supplies in N, HO, S, and O scales.

Special Shapes Co.
P.O. Box 487
Romeoville, IL 60441
818-342-7501

Catalog $1.00.

Model structural shapes of brass products.

Sumpter Valley Depot
135 N.W. Greeley Ave.
Bend, OR 97701
503-382-3413

Free brass list.

Model railroad—O scale engines, cabooses, cars (tank, fox, stock, water tank, reefers, others).

The Red Caboose
16 W. 45th St., 4th Floor
New York, NY 10036
212-575-0155

Send SASE or call with specific inquiry.

Model railroad trains and accessories, American and foreign prototypes; in N, HO, and other scales: by Kadee, Atlas, Tivakato, Rivarossi, Mantua, Stewart, Bachmann, Magnuson, Peco, Shinohara, Tichy, Walthers, Kibri, Vollmer Faller, Patal (buildings), Fleischman, Con-Cor; European trains, all scales. LGB and O scale. HO and N scale brass. Foredom equipment, Paasche and Badger airbrush sets. Contact resistance soldering units. Books. Buys toy trains. Accepts major credit cards.

The Train Master Ltd.
P.O. Box 5208
Albany, NY 12205
518-489-4777

N Scale price list/catalog $2.00 ($1.00 refundable).

N Scale model railroad items—kits, freight, passenger, box, other cars, turntables, locomotives, track, switches, many other parts, model structures, kits, scenery. Others of major manufacturers: Acme, AMM, Aim, Alloysn Limited, AMI, APAG, Arbour, Arnold, Atlas, B-R, Bachmann, Beli, Bev-Bel, Bowser, Brawa, Caboose Ind., Campbell, Cooch, Colorite, Con-Cor, Cork, Crummy, CS, Detail Assn., DMK, EKO, Faller, Green, Haljan, Herpa, Highball, JMC, JV, Kadee, Kato, Labelle, Lifelike, Magnuson, Max, Midwest, ML, Minitrix, MLR, Model Dynamics, Model Rectifier, Mossmer, MTS, MZZ, MJ Int., Noch, Peco, Period, Pola, Rix, Roco, Stewart, Walthers, others.

Tichy Train Group
25 Central Ave.
Farmingdale, NY 11735

Contact dealer, or send large SASE for catalog.

HO Scale model railroad trains, kits (boxcars, others), including reproductions from early 1900s to 1950s; wood and metal construction.

TNC Enterprises
318 Churchill Court
Elizabethtown, KY 42701
502-765-5035

Full color catalog $1.00.

Williams electric trains including 4-62 Pacifics (USRA, Pennsylvania, Southern); all brass construction with sprung drivers, automatic couplers, electronic reverse, in O-Gauge 3-rail, or O-scale 2-rail. Others. Miniatures.

Toy Train Heaven
P.O. Box 24
Hughesville, PA 17737

Send SASE with request for information.

Model railroad trains, kits, and sets: Atlas HO engines, cars, bridge kits, piers, girders, degree crossings, terminals and joiners, track assortment, remote snap switches, others. Model Rectifier HO engines. Mantua RTR HO steam locomotives. Athearn HO diesels. Kadee Trucks, couplers, and accessories. Kadee N Gauge MagneMatic coupler conversion kits. N scale steam locomotives. Atlas N gauge diesels. Kato N Scale trains. Atlas N Scale track, joiners, pier sets, girders, bridges, degree crossings, switches, others. MRC HO power packs. MasterCard, Visa.

Trackside Specialties
P.O. Box 460
Manheim, PA 17545

List $1.00 (refundable).

Model railroad — HO and O scale scratch builder's items: drivers, rods, valve gear, cabs, pilots, boiler fronts; lost wax parts, Puffing Billy parts and cars.

Train World
751 McDonald Ave.
Brooklyn, NY 11218
718-436-7072

Send SASE for list.

Model railroad trains: LGB — collectors' cars (reefer, tank, dump, refrigerator, caboose, box, others), power packs, and electronics, boxcars, gondolas, over 90 buildings, replacement parts, starter sets with track and transformer, locomotives, street cars, passenger, and freight cars, accessories, electrical items. Aristo Craft "G" scale model buildings. Mantua locomotives, cars. Lionel releases, engines and cabooses, rolling stock, operating cars; classics, standard gauge classics, collector sets, cars, others. Accessories. Bowser and Rivarossi trains: locomotive, cars, kits, sets. Athearn cars, MRC power packs, Others. May have closeouts. MasterCard, Visa.

Valley Model Trains
3 Fulton St.
Wapplingers Falls, NY 12590
914-297-7511

Send $.45 SASE for newsletter and list.

Model railroad building kits in all scales ("Z" to "LBG") and most manufacturers, including Design Preservation Models series 2 kits for buildings, stores, garage, packing house, others. Faller buildings. Others. HO scale model automobiles: Cadillac, Buick, Bentley models, Rolls Royce Silver Cloud, Volvo, Mercedes, others.

W.N. Rich
137 Old Long Ridge Rd.
Stamford, CT 06903

Catalog and samples $2.50.

Over 350 model railroad emblems (embroidered cloth, for most major railroads), and railroad (hickory) hats. "Dealer inquiries invited."

Walker Model Service
5235 Farrar Ct.
Downers Grove, IL 60515

Send SASE for list.

Model railroad—HO scale vehicles: semi tractor, tractor trailer, railspeeder, dump truck, tank truck, basic chassis, semi with F.B. trailer, delivery van, stake body.

Warren Matt
E 1489, Hwy 54
Waupaca, WI 54981

List $2.00.

Model railroad — cabooses, gondolas, hoppers, some steam locomotives; kits by Athearn; parts, cow catchers, smoke box fronts, others.

Woodland Scenics
P.O. Box 98
Linn Creek, MO 65052

Contact a dealer, or send 4 stamps for catalog.

Model scenics: turf, variety of foliage, and lichen in realistic colors; all formulated to coordinate colors. Decals —model graphics for letters, lines, numbers (any scale), dry transfers with authentic advertising, posters, signs, railroad heralds (full color).

World of Trains
105-18 Metropolitan Ave.
Forest Hills, NY 11375
718-520-9700

Catalog $2.00.

Model railroad trains, kits, accessories, parts by: Gargraves (track), Lionel (trains, track), LGB locomotives, caboose, and cars (passenger, platform gondola, box, flat, hopper, tank, others). Bachmann steam locomotives, diesels (HO). Atlas (HO trackage), Bachmann N scale locomotives, N gauge locomotives. HO and N gauge powerpacks. Bachmann N scale buildings. Transformers, tracks. Prewar and postwar trains and accessories. May run specials. Buys train collections (old Lionel, American Flyer, M.P.C., and store inventories). Repairs all 027.0 and standard gauges. Discover, Visa, MasterCard.

Ye Olde Huff 'N Puff
P.O. Box 53
Pennsylvania Furnace, PA 16865

Contact dealer, HO-HOn3 Scale Catalog $1. (Also see below.)

Model railroad: Wood Craftsman kits — HO (freight cars, structures, detail parts), HOn3 (mine train kits and freight cars), S (freight cars, detail parts, figures), On3 freight cars, O freight cars, detail parts. Models: AG, LW, Sugar Pine, Main Line, and Silver Streak. Manufacturer. S Scale List, SASE. O Scale Catalog $1.00. On3 Scale List, SASE.

Mold Crafts

🦆🦆🦆🦆🦆🦆🦆🦆🦆🦆🦆🦆🦆🦆🦆🦆

See also CAKE & CANDY DECORATING, CERAMICS, and related categories: BOOKS & BOOKSELLERS, PUBLICATIONS, and ASSOCIATIONS.

🦆🦆🦆🦆🦆🦆🦆🦆🦆🦆🦆🦆🦆🦆🦆🦆

American Art Clay Co., Inc.
4717 W. 16th St.
Indianapolis, IN 46222
317-244-6871

Free information packet.

Mold/modeling supplies: Sculptamold (clay/ plaster/ papier mache), instant papier mache, casting compound, carving wax, Superdough modeling compound. Modeling tools. Mix-A-Mold (powder mix with water, makes reproduction molds in minutes, can fill with casting medium). CreaStone stone-like material, for casting. Rub 'N Buff metallic finishes (wax base) for decorating, antiquing — 18 colors. Brush'N Leaf liquid metallics. Stain 'N Buff wood finishes. (See CRAFT SUPPLIES, CERAMICS, and METALWORKING.)

Barker Enterprises, Inc.
15106 10th Ave. S.W.
Seattle, WA 98166
206-244-1870

Catalog $2.00.

Candle making supplies: dyes, waxes, additives, releases, glaze. Candle molds (plastic, metal) over 650 shapes: tapered, novelties, holiday, 2-part, others; a variety of sizes.

Candlechem
Box 705
Randolph, MA 02368

Catalog $1.00.

Candle making chemicals, essential oils, perfume oils.

Castings
P.O. Box 915001
Longwood, FL 32791
407-869-6565

Send SASE for details.

Silicone rubber molds for casting metal: toy soldiers, Civil War figures/horses, cannon, weapons. Cowboys, Indians, and cavalry. Action soldiers of WWI, WWII, aircraft. Medieval horses/riders. Napoleonic foot soldiers, artillery, riders/horses. German marching band. Carousel molds. Chess set molds: fantasy, Waterloo, and King Richard's Court. Winter village molds: carolers, Santa, snowman, skaters, boy and girl on sleds, street lamp. Has quantity prices. Paint kits for mold sets. Introductory complete starter kit. Casting metals. Instruction booklet.

Castolite
4915 Dean
Woodstock, IL 60098

Catalog $2.00.

Liquid plastics for casting, coating, fiberglassing, reproducing, embedding, additives, fillers.

Cementex Latex Corp.
480 Canal St.
New York, NY 10013
212-226-5832

Send SASE for complete information.

Natural latex molding compounds: high solids type with medium viscosity (brushable or sprayable) to cast plaster, Portland cement, and some waxes; also in pre-vulcanized type. Latex for casting hollow articles (pours into plaster mold)—when used with filler, very hard articles may be obtained. Two-part RTV polysulfide rubber for flexible molds (pourable — for casting plaster, cement, and others). Manufactures and compounds natural and synthetic latex materials.

Coastal
Box 1053
Bricktown, NJ 08723

Catalog $1.00.

Lead soldier molds, mold making and casting supplies—full line. (Also castings, collectibles.) Hard to find items.

Craft Time
211 S. State College Blvd., #341
Anaheim, CA 92806

Catalog $2.00 (refundable).

Plastercraft figures: ready-to-paint; full line, many with instructions and color guide; includes people, children, houses, scenery, animals, others.

Creative Paperclay Co.
1800 S. Robertson Blvd., Ste. 907
Los Angeles, CA 90035

Send SASE for details.

Paperclay™ modeling material. Molds for masks, doll heads, others.

DMK Enterprises
333 Orchard Ave.
Hillside, IL 60162

Catalog $3.00 (refundable).

Plastercraft, complete line of molds, ready-to-paint figurines, kits, instructions.

Manuel Thies
Owendale, MI 48754

Send SASE for prices.

Pure beeswax, by pound.

Meg Int'l
41 Union Square West, Suite 1040
New York, NY 10003

Catalog $1.00.

Plaster castings (for paint, marbling, gilding): brackets, candlesticks, cherubs, consoles, ornaments, plaques, others.

Mold 'Ums
P.O. Box 367
Centerville, UT 84014

Send SASE for price list.

Molds (for Jello™, chocolate, cakes, rice crispy treats, others): bear, bunny, duck, dinosaur, turtle, heart, train, snowman, Santa, tree, others.

Moldcraft
Box 991
Alexander City, AL 35010

Send SASE for further details.

Instructions for making concrete birdbaths, statues and other shapes, and items from concrete molds.

Polytek
P.O. Box 384
Lebanon, NJ 08833
908-534-5990

Free newsletter.

Polytek brand mold rubber (mixes 1:1, cures bubble free, casts all materials except metals), and liquid plastic (some grades mix 1:1, can be thickened and applied by trowel; paints well. Resins, polyurethanes, waxes. Tools, supplies. Has MasterCard, Visa.

Pourette Mfg. Co.
P.O. Box 15220
Seattle, WA 98115
206-525-4488

Catalog $2.00 (refundable).

Candlemaking: full line of molds (plastic, metal), additives and fixatives, colors, waxes, wicks, other supplies. Manufacturer.

Smooth-On, Inc.
1000 Valley Rd.
Gillette, NJ 07933
908-647-5800

Free literature.

Rubber mold compound (polyurethane elastomer) for quick hand-mix, setting at room temperature, low viscosity, pourable for at least 20 minutes after mixing (no bubble entrapment, no vacuum degassing). Optional "Part C" compound achieves varying degrees of hardness, optional "Part D" increases viscosity to light grease consistency for brush-on. Will not stain plaster.

CAST METALS: *Use of a new super-fine graphite powder improves the casting quality and figure detail. One quick and easy application can improve your results dramatically at a very low cost. Courtesy of Robert Blanc of Castings, Div. of Reb Toys, Inc.*

Synair
P.O. Box 5269
Chattanooga, TN 37406
615-698-8801

Contact dealer or send SASE for details.

Por-A-Mold™ molding system, 1:1 mix, cures room temperature (12 to 24 hours). Por-A-Kast™ urethane casting resin for reproductions (for sculptors, taxidermists, wood carvers, hobbyists) — can be sanded, painted, sawed, drilled, machined; 1:1 mixes, sets in 10 minutes.

Van Dyke's
Woonsocket, SD 57385

Catalog $1.00.

Molding: plaster, Hydro-cal, Hydrostone, rock putty, resin putty, Sculpall. Polymer finish kit. Scenery resin. Fiberglass cloth, chopped strand mat, strands. Polyester resin. Color paste, gel wax. Fillers: granulated cork, paper pulp. Talc, whiting. Mold-making materials: silicone rubber, polymold, latex. Epoxy putty sticks. Plastic resin dyes. Flocking gun, adhesive. Airbrush sets, compressors, spray guns, booth. Finishes, glues. Dremel Moto-Tool sets. Woodworking and upholstery tools and materials. Quantity prices. MasterCard, Visa. (See FURNITURE MAKING & UPHOLSTERY and WOODWORKING.)

Nature Crafts

🐦 🐦 🐦 🐦 🐦 🐦 🐦 🐦 🐦 🐦 🐦 🐦 🐦 🐦 🐦 🐦

See also CRAFT SUPPLIES, BASKETRY, MINIA-TURE MAKING, MODEL MAKING, FABRICS & TRIMS, and related categories; BOOKS & BOOK-SELLERS, PUBLICATIONS, and ASSOCIATIONS.

🐦 🐦 🐦 🐦 🐦 🐦 🐦 🐦 🐦 🐦 🐦 🐦 🐦 🐦 🐦 🐦

Art by God
7123 S.W. 117 Ave.
Miami, FL 33183
305-274-4044

Send SASE for price list

Ostrich eggs, by six and up lots.

Ashcombe Farm & Greenhouses
906 Grantham Rd.
Mechanicsburg, PA 17055
717-766-7611

Send SASE for full information.

Dried flowers: silver king artemisia, crested celosia, globe amaranth, and others. (Also sells wholesale.)

Benjane Arts
P.O. Box 298
W. Hempstead, NY 11552

Catalog $5.00

Assorted shells, and in sets; shellcraft ideas booklet, supplies/accessories.

Cadillac Mountain Farm
4481 Porter Gulch Rd.
Aptos, CA 95003
408-476-9595

Dried flowers, herbs, exotics, supplies. (Also sells wholesale.)

Countree
4573 Blender
Middleville, MI 49333
616-795-7132

Free price list.

Dried flowers: silver king artemisia, baby's breath, etc.

Crooked-River Crafts, Inc.
P.O. Box 917
La Farge, WI 54639
608-625-4460

Send SASE for list.

Basket-Tree Rattan™ floral rattan (to weave or curl, swirl) in kits: wreath, flair, viney round, and heart wreaths; made into wreaths and floral sprays. Rattan reed—8 sizes/types in 1 oz. or 4 oz. packs, 1 lb. coils. Can be heated/curled with curling iron into coils and swirls; reed in 31 colors and natural; in 3 color mixes and Christmas patterns. Assortments: pack of 24 beginner country kits, 24 flaire assortments, 24 wreath collections, 32 floral assortments; dyes — 24 colors. Rattan vine wreaths (ready to trim). Basket making kits. Quantity prices; discount to teachers, institutions, professionals. MasterCard, Visa. (Sells wholesale to businesses.)

Dody Lyness Co.
7336 Berry Hill Dr.
Palos Verdes Peninsula, CA 90274

Send SASE for list.

Potpourri supplies: 36 fragrance oils (1/8 oz. to 4 oz. sizes). Fixatives. Dried blossoms, herbs, and spices for potpourri mixtures (by cup or oz. lots), including allspice berries, chamomile flowers, coriander seed, frankincense "tears," myrrh gum granules, rose hips, sassafras root bark, tilia star flowers, others. Dried flowers for wreaths, candle rings, etc. including pansies (and roses after March 1). Pressed flowers, stems, leaves. Quail eggs (Coturnix and Australian). Book: *Potpourri . . . Easy as One, Two, Three!* by Dody Lyness (potpourri how-to with facts, hints, directions). Has quantity prices. (Also sells wholesale to businesses.) Publishes *Potpourri Party-Line*.

Dorothy Biddle Service
Box 900
Greely, PA 18425

Free catalog.

Flower drying/arranging products: floral clays, foam blocks, snips, stem cutters, picks, pins, wire, covered wire, tapes. Flower press, holders, moss, beach pebbles, and white marble chips. Adhesives, silica gel. Real butterflies (flat). Pressed ferns, feathers. Garden tools. Accessories, books.

RECYCLED FOR POTPOURRI: *Needing large quantities of supplies for potpourri "I happened to stop at an Orange Julius stand at our mall...and saw all those orange peels. They gave me a box...yielding 1 1/2 gallons after I cleaned and dried them." Then "I found a greenhouse throwing out balsam fir wreaths after Christmas, [got] 40 to dry and use." Courtesy of Ellen Blocher as told to* Potpourri from Herbal Acres *publication.*

Dried Naturals of Oklahoma
Rt. 1, Box 847
Ramona, OK 74061

Send SASE for price information.

Assortment of 10 dried weeds, grasses, and cultivated material (some bleached and dyed).

Earth Healing Arts
P.O. Box 162635
Sacramento, CA 95816
916-878-2441

Catalog $1.00 (refundable).

Potpourri blends and supplies. Herbs and herb blends. (Also has skin care and gift items.)

Eggs O' Beauty
Box 547
Bayshore, NY 11706

Catalog $2.00.

Eggs: ostrich, goose, quail — variety of sizes. Rhinestones, ornaments, findings (metal, others), metallic braids and trims. Metal egg stands. Miniatures, books.

Everlasting Designs
P.O. Box 97
Rainbow Lake, NY 12976

Free price list.

Everlastings (Adirondack grown) including statice, larkspur, artemisia, others. Wreaths, bouquets, others. Custom orders accepted.

Fabricraft, Inc.
P.O. Box 11270
Albany, NY 12211
518-233-1184

Contact dealer, or send SASE for information.

Floral fabric kits (with duotone polyester fabric strips, tools, instructions) makes 10 "pom-pom" flowers that are washable, permanently creased into honeycomb pleats; 50 colors. Flowers become centerpieces, wreaths, bouquets, clothing ornaments; or cut into snowflakes, etc.

Frontier Cooperative Herbs
Box 299
Norway, IA 52318
319-227-7991

Free price list/order form.

Herbs and spices, spice blends, potpourris. Custom-printed labels for bulk herb jars. (Teas, sprouts, others.)

Gailann's Floral Catalog
821 W. Atlantic St.
Branson, MO 65616

Catalog $1.00.

Full line of floral supplies. Dried flowers: roses, larkspur, German statice, heather. Holly wreath bases. Ribbons, corsage boxes, others. (Also sells wholesale — inquire, with resale number.)

Grapes of Wreath
3804 Holdborn Ct.
Baldwinsville, NY 13027

Brochure $1.00.

Vine-wreaths — undecorated, in kits (or finished), 2 sizes.

Green House
24 Grove St.
Massena, NY 13662

Catalog $1.00.

Potpourri—18 handblended mixes and bountiful selection of "scented delights." (Also sells wholesale.)

Herb Shoppe
215 W. Main St.
Greenwood, IN 46142
317-889-4395

Catalog and newsletter $3.00 (refundable).

Bulk herbs, potpourri supplies, essential oils, herb bunches and wreaths, others.

Herbal Gardens
4645 South Dr. West
Fort Worth, TX 76132
817-292-7670

Send SASE for price list.

Scented oils, fragrant oils, others.

Herbs Unlimited
P.O. Box 3100
Willowdale, Ontario, Canada M2R 3G5

Catalog $1.00.

Herbs, extracts, fragances, oils, tinctures (from areas worldwide). Also has herb roots, leaves, gums, barks, flowers. Full line of potpourri mixes. Accessories, others.

Hill Floral Products Inc.
2117 Peacock Rd.
Richmond, IN 47374
317-962-2555

Send SASE for price list.

Dried roses (18-20 count stemmed bunches), rose buds (design/decorative quality). (Also sells wholesale.)

Hoffman Hatchery
Gratz, PA 17030

Send SASE for prices.

Eggs (blown): goose, guinea, duck, turkey, quail, pheasant—variety of sizes.

Hundley Ridge Farm
Box 253
Perry Park, KY 40363
502-484-5922

Send SASE for price list.

Dried flowers and herbs including silver king artemisia, yarrow, blue salvia, sinuata statice, feverfew, globe amaranth; line of dried herbs.

IMI
P.O. Box 154, 216 Main St.
Whitesburg, GA 30285
404-834-2094

Also at:
P.O. Box 405
106 Lillian Springs Rd.
Quincy, FL 32351
904-875-2918

Catalog $5.00 (refundable with $100.00 purchase).

Naturals decorating: ribbons including prints, Christmas, plaids, others; satin, picot, plastic, lace/satin, gingham, velvet, lacy, others. Silk flowers—Christmas, other made-ups, and petals and parts. Styrofoam shapes, wreaths. Floral foam, bouquet holders, pick machines, florist wire, tape, picks, wire, pins. Floral sprays. Straw hats and doilies, market baskets. Naturals: cones (pine, split, pinyon, spiral, plumosum, subulasum, saligum, spruce), pods (cotton, lotus, sweet gum, teasel head, tinctum, cholla, manzanita) and in bulk lots. Spanish moss. Kraftee Design picture kits (cattail, others). Brooms, bamboo rakes. Baskets in variety of sizes/shapes —woven types, crate, barrel, rattan, minis, wood chip, palm leaf, bamboo, others. Dried grasses and materials, straw wreaths. Feathered birds, nests, eggs. Naturals (also painted): cattails, corn shucks, eucalyptus wreaths, garlands, bulk, excelsior (and dyed), rope excelsior, cedar excelsior. Grapevine — wreaths (and painted), baskets, heart shapes, knot. Willow baskets. Mini and other gypsophila wreaths, bulk, swag, garland. Lotus pod heads, picked, other. Other cones (and painted), oak leaves, pine cone wreaths, pine straw, sheet moss. Spanish moss wreaths, bulk, nest. Wreaths of statice, decorated types, twig, wheat, wood bases. Bells, beads (fossil, metallics, wood, small glass, glass chip strings). Has quantity prices. (Also sells wholesale.) (See MACRAME for line of supplies and equipment.)

Island Farmcrafters
Waldron Island, WA 98297

Catalog $.50.

Everlastings, herbs, potpourri mixes, dried statice wreaths; elephant garlic braids, others.

J & T Imports
143 So. Cedros, P.O. Box 642
Solana Beach, CA 92075
619-481-9781

Send SASE for list.

Dried/preserved flowers and fillers: baby's breath, statice, capsia, pepper grass, eucalyptus, moss, raffia, cedar, juniper, lycarpodium, larkspur, roses, pennyroyal, silver king, straws. Branches, accents, wreaths, herbs. Preserved Country French and Southwest bouquets. Floral supplies, artificial birds and other decoratives, variety of ribbons. Others.

J.L. Hudson Seedsmen
P.O. Box 1058
Redwood City, CA 94064

Detailed ethno-botanical seed catalog $1.00.

Rare seeds—specializes in hard-to-find species, worldwide; for plants for drying, fragrances, dyes, wreaths.

Joe Miller
113 E. King St.
Boone, NC 28607
704-264-8696

Write for catalog.

Canadian hemlock cones — very small for potpourri, wreaths (by pound — approx. 1,200-1,400 cones). Foil lined bottles (½ dram, 1 or 2 dram) by gross lots. Others. Discover, MasterCard, and Visa.

Lily of the Valley
3969 Fox Ave.
Minerva, OH 44657
216-862-3920

Herb catalog/reference guide, $2.00.

Rare/unusual herbs: ephedra, carob, passion vine; and popular standard varieties (470+); everlastings. Others.

LIRA Company
209 Renwood Cir.
Lafayette, LA 70503

Catalog $1.00 (refundable).

Potpourri blends, ingredients; essential oils, extracts, spices, herbs (also teas, others). Has quantity discounts.

Little Red Hen
Rt. 11, Box 328
Greenville, TN 37743

Send SASE for price list.

Everlastings — dried flowers, undecorated artemisia wreaths, herb bundles, others. (Also herb wreaths, other finished items.)

Magnolia's
318 Main St. N.
Markham, Ontario, Canada L3P 1Z1
416-294-6919

Mail order price list $1.00.

Wide variety of dried flowers, pods, fungus, mosses, cones, wreaths, vine hearts. Potpourri fixatives and oils. Floral supplies—wires, tapes, ribbons, others. Baskets.

Floral rattan arrangement. © *Crooked-River Crafts, Inc.*

Mari-Mann Herb Co., Inc.
R.R. 4, Box 7
Decatur, IL 62521
217-429-1404

Free wholesale catalog.

Line of herbs and spices, potpourri blends, fragrant and essential oils, wreaths (and culinary products).

Meadow Everlastings
149 Shabbona Rd.
Malta, IL 60150

Catalog $2.00 (refundable).

Wreath and herbal crafting kits, dried flowers (for arrangements, wreaths, crafting), potpourri.

Mountain Farms
P.O. Box 108, Candlewood
New Fairfield, CT 06812

Illustrated catalog $1.00.

Full and wide array of naturals: cones and pods in variety of sizes; potpourri mixes, spices, others. "Wholesale."

Nature's Finest
P.O. Box 10311, Dept CSS
Burke, VA 22015

Catalog $2.00 (refundable).

Potpourri: over 185 herbs and spices — by ounce or pound lots. Traditional potpourri dry mixes (without weed chips), by cup; simmer mixes. Over 115 essential oils and fragrances, reviving solution, simmer dry mixes (by cup), simmer oils. Other dry ingredients: caucarina cones, heliotropin crystals, sea salt, talc, wood chips, others. Fixatives. Styrax. Bath mixes and fizzles. Pomander kits and rolling mixes. Scent rings. Bags — muslin, lace, poly, and cellophane. Jars. Books. Quantity prices, large order discounts. (Also sells wholesale to businesses.)

Nature's Herb Company
P.O. Box 40604
San Francisco, CA 94140
415-474-2756

Send SASE for list.

Over 350 bulk spices and herbs. Potpourri ingredients in bulk quantities ("1 to 2,000 pound prices"); all products milled and blended in-house. (And has teas and powdered botanicals and bulk gelatin capsules, package teas and spices.) Also sells wholesale (inquire to San Francisco Herb & Natural Food Co., 4543 Horton St., Emeryville, CA 94608, 415-547-6345).

Nature's Holler
R.R. 1, Box 29-AA
Omaha, AR 72662
501-426-5489

Catalog $2.00 ($1.00 refundable).

Naturals: wild grapevine (6" to 24" and in bulk), grapevine curls. Grapevine wreaths (rounds, hearts, ovals). Buttonbush balls, teasel, purple cone flowers, corn tassels. Sycamore balls and bark. Sweetgum and cockleburs. Locust, magnolia, and okra pods. Buckeyes, milkweed pods, devil's crown, and ninebark pods. Woolly mullein, hickory nuts. Wheat, sphagnum moss, and lichens. Dried grasses. Pine needles and cones. Cattails, bamboo canes (6"-24" pieces). Locust thorns and branches. Acorns. Driftwood slabs: pine, cedar. Has quantity prices. May run sales. Allows discount to teachers, institutions, and professionals.

Our Nest Egg
205 South Fifth
Mapleton, IA 51034

Catalog $3.00 (refundable).

Eggs: ostrich, and complete line of egg shells, stands, findings, egg decorating materials.

Pecan Hill Farms
Rt. 1 Box 1244
Montgomery, TX 77356
409-597-4181

Catalog $3.00.

Grapevine wreaths, baskets, custom shapes, potpourri, dried flowers.

Phelps
Rt. 1, Box 109
Shenandoah Junction, WV 25442

Send SASE for price list.

Dried roses, "Fairy," pink or yellow, by dozen lots.

Pine Row Publications
Box 428-MB/CH
Washington Crossing, PA 18977

Large SASE for free Herb Growth/Use Chart.

Book: *The Pleasure of Herbs*, by Phyllis Shaudys — a month-by-month guide to growing, using, and enjoying herbs—280 pages of gardening tips, crafts, projects, recipes; 130 culinary recipes, 50 potpourri mixes, wreaths and other craft projects, garden designs; a directory of over 200 sources of herbal products; bibliography of 74 books/periodicals; encyclopedia of popular herbs. (Ms. Shaudys also publishes *Potpourri from Herbal Acres*.)

Sally Booth-Brezina
944-466 Kauopua
Mililani, HI 96789

Send SASE for brochure.

Containers (for potpourri, sachets, etc.): calico and satin sachet bags, stenciled spice trivets, cellophane bags, drawstring bags, catnip toys (empty, to be filled), others.

San Francisco Herb Co.
250 14th St.
San Francisco, CA 94114

Ingredients catalog free.

Full line of herbs, potpourri. 65+ potpourri ingredients: allspice, apple pieces, cedarwood chips, chamomile, cinnamon, coriander, feverfew, ginger root, hibiscus, laven-

der, lemon verbena, oak moss, orange peel, pine cones, rosebuds, rosemary, rose hips, sage, sassafras, statice flowers, yarrow, others. 4 potpourri mixes, 29 mix recipes, 6 simmering potpourri recipes, 7 sachet recipes. 24 Fragrance oils: frankincense, exotic spices, floral bouquet, and others. 60+ botanicals. Minimum order $30.00. Sells wholesale to all. (Has culinary herbs and items.)

HOLIDAY HOUSE FRESHENER RECIPE: *Take 4 pieces of whole ginger root, 3 3" cinnamon sticks, 1 t. whole cloves, 1 t. whole allspice, 1 t. pickling spice (remove red pepper). Package dry spices in muslin bag for freshener. Or combine one bag mixed spices with 4 cups water; boil in large kettle (enamel is best) for 10 minutes. Reduce heat and simmer. Courtesy of Betha Reppert as reported in* Potpourri From Herbal Acres *publication.*

Shaw Mudge and Company
P.O. Box 1375
Stamford, CT 06904
203-327-3132

Contact dealer, or send SASE for information.

Complete line of fragrances for gift manufacturing and processing. Custom design and stock compounds available. Manufacturer.

Simply De-Vine
654 Kendall Rd.
Cave Junction, OR 97523

Send SASE for catalog and price list.

Grapevine wreaths — ovals, teardrops, heart shaped, matted back; baskets. Grapevine bundles. Manufacturer.

Spring Valley Gardens
S 6143 RR 1
Loganville, WI 53943

Send SASE for supplies information. Plant catalog $1.

Homegrown potourri blends, homegrown fixatives, variety of dried herbs, flowers, leaves, and petals. Potted herbs, everlastings, scented geraniums, perennials.

Statice Symbols
220 Lindenwood
Frankfort, KY 40601
502-695-3987

Send SASE for price list.

Dried flowers including yarrow and other — specialty: Colonial colors. Decorated gourds. Also sells wholesale.

Stone Well Herbs
2320 W. Moss
Peoria, IL 61604

Send SASE for brochure.

Pre-cut stencils; booklet "Decorating with Herb Stencils," with ideas and herb stencil patterns.

Straw Stix
Rt. 1, Box 85
Pocatello, ID 83202

Send for information.

Wheat for weaving (and floral use). Wheat wreaths. (Also sells wholesale.)

Sunshine Farms
P.O. Box 249
Newberry Springs, CA 92338

Send SASE for list.

Dyed eucalyptus (blue, red, orange, natural), baby's breath, and other dried naturals.

T & D Feathers
P.O. Box 428
Olathe, CO 81425

Send SASE for information.

Assortment of feathers and furs for craft use.

The Reef
2407 Brittany Rd.
Artesia, NM 88210

Catalog $5.00.

Seashells, shell samplers, and coral for crafts, aquariums, collections.

ESSENTIAL FRAGRANT OILS: *They are expensive but last a long time. Only a few drops are needed if mixed first with ground or "pinhead" orris root. Because orris root "captures" the oil's essence and preserves its aroma, you can make any plant or flower smell of any scent you choose – for years. Courtesy of Phyllis V. Shaudys, Editor of* Potpourri from Herbal Acres *publication.*

Tom Thumb Workshops
Rt. 13, P.O. Box 357
Mappsville, VA 23407
804-824-3507

Catalog $1.00.

Potpourri/naturals supplies: 21 potpourri mixes—apple flower, aramis woods, forest fresh, rose fantasia, seaside, Tahitian fantasy, Victorian bouquet, Yuletide, others. Dried flowers: statice, star, tansy, wheat, wild iris, sugarbush, eucalyptus, coxcomb, bruneia, salvia, broom, hill flowers, others. Cones/pods: alder, eucalyptus, floral buttons, hemlock, lotus and nigella pods, teasel, others. Supplies: foam brick, cholla wood, twist paper ribbon, floral tape, moss, silica gel, Styrofoam rings, cones. Wire. Straw and moss wreaths. Hot glue gun. Full line of herbs, spices, and essential oils. Patterns: dream pillows,

Floral rattan arrangement. © *Crooked-River Crafts, Inc.*

spice ball, tree ornaments, twist bows, and dolls. Containers for potpourri: plastic jars (apothecary in 4 oz., 8 oz.), ginger jars, Pandora boxes, round sample and gold grain boxes. Muslin bags, plastic display minigrip reclosable bags (3" X 4"). 38+ books on herbs, dried flowers, wreaths, perfumes, garden plants, others. Has some quantity prices. Has discount on very large orders. (Publishes *Herbal Crafts Quarterly Newsletter*.)

Val's Naturals, Inc.
P.O. Box 832
Kathleen, FL 33849
813-858-8991

Send SASE for full information.

Spanish moss (by 2.7 cubic ft., box-fumigated, dried, pliable). Garlic braids, Brazilian pepper berries, tropical birchcones and small pinecones, country brooms, Guatemalan Worry People; others.

Wintergreen
10970 Burnett Rd.
Charlevoix, MI 49720
616-347-7399

Send SASE for catalog.

Dried floral wreaths, swags, and brooms. 10 hand-blended potpourris. (Other herbal products and gifts.) Also sells wholesale (inquire on letterhead).

Wood Violet Books
3814 Sunhill Dr.
Madison, WI 53704
608-837-7207

Free catalog.

Over 300 titles of herb and herb gardening books from independent publishers and small presses.

Paints, Finishes & Adhesives

🐦🐦🐦🐦🐦🐦🐦🐦🐦🐦🐦🐦🐦🐦🐦🐦

See also TOLE & DECORATIVE CRAFTS, and other specific categories: BOOKS & BOOKSELLERS, PUBLICATIONS.

🐦🐦🐦🐦🐦🐦🐦🐦🐦🐦🐦🐦🐦🐦🐦🐦

Art Essentials of New York Ltd.
Three Cross Street
Suffern, NY 10901
Also in Canada: 508 Douglas Ave.
Toronto, Ontario M5M 1H5

Send SASE for product lists.

Gold leaf, genuine and composition, sheets and rolls (22K patent, 23K patent, 22 and 23K glass type, white gold, French pale gold, lemon gold, gold metal or composition types). Silver leaf. Supplies: gilding size and gilding knife. Burnishing clay. Other tools and brushes. Technical books.

Benbow Chemical Packaging Inc.
935 E. Hiawatha Blvd.
Syracuse, NY 13208
315-474-8236

Free price list.

Fezandie & Sperrle dry pigments for artist's colors.

Createx
14 Airport Rd.
East Gransby, CT 06026
203-653-5505

Send SASE for information.

Createx colors, acrylics, fabric shades, permanent dyes, pearlescents, iridescents, pure pigments. Manufacturer.

Crescent Bronze Powder Co.
3400 N. Avondale Ave.
Chicago, IL 60618
312-529-2441

Contact dealer, or send SASE for information.

Cres-Lite metallic mix (liquid); bronze powders in 72 colors including over 28 gold shades, metallic colors, bronzes, silvers. Colored fritters (coarser powders). Metallic paints: acrylics, aluminum paint and paste, bronzing liquids (heat resisting), aerosol metallics, pearl and essence toners (lacquers for Lucite, acrylic, others). Finishes: glazes, plastic aerosols. Tinsel and glitters: plastic and foil glitters, diamond dust; glass tinsel and beads. Introductory kits. Manufacturer.

Crystal Sheen
Box 1339, 614 Hi-Tech Pkwy.
Oakdale, CA 95361

Check with dealer or write for information.

Krack-N-Kraze fracture finish (water-based); also works as wood glue; gives European antique look.

Delta/Shiva Technical Coatings
2550 Pellissier Place
Whittier, CA 90601
213-686-0678

Contact a dealer, or send SASE for details.

Ceramcoat™ wood glazes (water soluble, transparent stain, dries in 15 minutes)—12 colors, may be applied over or under Ceramcoat acrylics; in 2 oz. and 8 oz. squeeze bottles or 2 size jars; 12 colors. Tempera Poster™ markers in 20 bright colors, 2 widths applicators, Shiva acrylic paints. Paintstik™ oil paint in solid form (dries to flexible film, for many surfaces including paper, wood, plastic, metal, and fabric). (See also BATIK & DYEING and FABRIC DECORATING.)

Don Jer Products Inc.
Ilene Court, Bldg. 8B
Belle Mead, NJ 08502
908-359-7726

Free brochure.

Spray-on suede finish.

LAZY SUSAN: *A lazy susan comes in handy for spray painting without having to hand-move the item. Drape a dropcloth behind it to make a spray "booth." Courtesy of MAB.*

Gold Leaf & Metallic Powders, Inc.
74 Trinity Pl., Ste. 1807
New York, NY 10006
212-267-4900

Send SASE for full information.

Gold leaf—22K and 23K patent gold, glass gold, roll gold. Metallic powders.

Illinois Bronze
Lake Zurich, IL 60047
312-438-8201

See your dealer, or send SASE for information.

Judy Martin's Country Colors™ water base acrylics, water base varnish/sealer; also soft pastel country colors. Gimme fabric colors: Glitters, Iridescents, Puffs, Dyes, and others. Other colors. Manufacturer.

J.W. Etc.
67 W. Easy St. #102
Simi Valley, CA 93065
805-526-5066

Send SASE for full details.

Wood care products: polyurethane varnish (water base)

for new or previously finished wood. Wood filler—can be stained, painted, varnished, lacquered, drilled, cut or planed; can be mixed with acrylic paints to get special colors or paint on for special effects. White Lightning white stain and sealer (for all woods, can mix with any acrylic paint, adheres acrylic paint to board, paper, metal, glass, fabric). Creme brush cleaner, hand and fabric cleaner. Right-Step water base clear varnish—matte, satin, gloss. Manufacturer.

Lefranc & Bourgeois
357 Cottage St.
Springfield, MA 01104

Contact dealer, or send SASE for information.

Flashe™ artist's pigments (permanent, quick-dry vinyl paint for brush, airbrush, roller, or palette knife on any non-oily ground)—use alone for matte qualities or under oils or acrylics to accentuate tonal depth; or instead of gouache, or for indoor murals or decoration.

Nova Color
5894 Blackwelder St.
Culver City, CA 90232
213-870-6000

Free price list.

Nova Color artists' acrylic paints (4 oz. jars, pints, qts., gals.) in over 70 colors including pearls and metallics, fluorescents, gesso, gels, mediums. "Discount prices."

Sepp Leaf Products, Inc.
381 Park Ave. So.
New York, NY 10016
212-683-2840

Call or send SASE for full information.

August Ruhl gold leaf (22, 23 karat), glass gold XX, patent gold, Palladium leaf, variegated, white gold 12K, pale gold 16K, lemon gold 18K, roll gold 23K and 22K. Gilders tips. LeFranc oil size—3Hr and 12Hr. Instructional video: Gold Leaf Basics, with Kent H. Smith.

The Durham Co.
54 Woodland St.
Newburyport, ME 01950
508-465-3493

Send SASE for full information.

Gold leaf (hand beaten) including XX deep patent, glass, and surface types.

U.S. Bronze Powders, Inc.
P.O. Box 31, Rt. 202
Flemington, NJ 08822
201-782-5454

Send SASE for further information.

Metallic pigments and paints; silver lining paste; others.

Paper Crafts & Paper Making

🐝🐝🐝🐝🐝🐝🐝🐝🐝🐝🐝🐝🐝🐝🐝🐝

See also CRAFT SUPPLIES, ARTIST'S SUPPLIES, and related categories; BOOKS & BOOKSELLERS, and PUBLICATIONS.

🐝🐝🐝🐝🐝🐝🐝🐝🐝🐝🐝🐝🐝🐝🐝🐝

Bee Paper Co.
P.O. Box 2366
Wayne, NJ 07474

Send SASE for complete information.

Aquabee plotter paper for check plots, charts, graphs, etc.; from economy bond to 100% rag vellum; by sheets or rolls or cut to specifications.

Gerlachs of Lecha
P.O. Box 213
Emmaus, PA 18049

Catalog $2.25.

Papercutting supplies: variety of papers, scissors, pattern packets and other designs.

Gold's Artworks Inc.
2100 N. Pine St.
Lumberton, NC 28358
919-739-9605

Send SASE for catalog.

Paper-making supplies/equipment: cotton linter pulp in 5 grades—long and short fiber, mill run medium, unbleached short, staple/strong: by 20 sheet minimum. Raffia, sea grass, abacai (manila hemp)—by pound. Perma color-dry pigments, Texicolor pearlized. Paper making kits. Molds and deckles, synthetic chamois cloths. Used heavy synthetic felt, new felt. Methyl cellulose paste powder, sizing calcium carbonate. Jewelry findings. Sculptamold, Marbelex, hydrated pulp. Equipment: Garrett hydropulper and mixer (studio and portable). Pulpsprayer, pulp buckets, vats, processors. PVA block. Books. Quantity prices. (Sells wholesale to businesses.)

Good Stamps—Stamp Goods
30901 Timberline Rd.
Willits, CA 95490
707-459-9124

Send SASE for Paper Swatch Book.

Blank paper goods (14 colors) in business cards, postcards, giant tall and regular greeting cards (scored), bookmarks, envelopes, stationery. Mixed scrap bag, "Stamper's sampler." Cutout greeting cards (hearts, stars, trees,); also with envelopes, in tags. Has quantity prices. May run sales. (See RUBBER STAMPING.)

Just Needlin'
P.O. Box 433, 14503 So. Hills Ct.
Centreville, VA 22020

Send SASE for list—specify paper.

Scherenschnitte (paper cutting) papers: parchment (natural, antiqued), colors, country print (in bound tablet), black silhouette (one side black, one side white), Williamsburg blue, metallic gold foil (white backing), "bright and beautiful" papers, patterned paper in colors. Perforated paper by sheet, in colors and gold. Cross stitch supplies and chart booklets; see EMBROIDERY.)

Lake City Craft Company
Rt. 1, Box 637
Highlandville, MO 65669

Color catalog $1.50.

Quilling kits (papers, patterns for standard sized frames) including Honeycomb Posies, Magnetic Charmers, Hearts, Christmas motifs, quotes, announcements, alphabet sampler, floral bouquets, mini-designs. Papers: over 25 colors, precut 80 lb., color assortments. Parchment paper (9 colors, cut). Mini shadowbox frames. Quilling tools, accessories. Miniature (1" to 1' scale) furniture and accessories kits.

Quill-It
P.O. Box 130
Elmhurst, IL 60126

Catalog $1.00 (refundable).

Quilling papers (full line of colors, widths), kits, tools, fringers, frames, paper snipping supplies. Books.

Sax Arts & Crafts
P.O. Box 51710
New Berlin, WI 53151

Catalog $4.00 (with coupon off purchase).

Arts/crafts supplies. Paper making: kits, vat, molds, felts, cotton linters, unbleached abaca pulp, methyl cellulose, retention aid (for colors). Books. Papers (in colors, sheets, rolls, pads): drawing, construction (and large), sulphite, color kraft, backgrounds; plates, bags; origami packs, papers. Fadeless colors, corrugated and borders, doilies, precut puzzle sheets, fluorescent, gummed, neon, flint, cellophanes, crepe and streamers, metallics, tissue, mod podge paper tape, sketching, velour, printing, etching. rice papers, pads, assortments. Art papers. Boards, scratchboards. Arts and crafts supplies. Quantity prices, discount to teachers and institutions. American Express, MasterCard, Visa. (Also sells wholesale to businesses.) (See CRAFT SUPPLIES and ARTIST'S SUPPLIES.)

The Paper Tree
18150 Strathern St.
Reseda, CA 91335

Paper scrap list $1.00. Gold foil list $1.00.

Old Victorian papers, lacy dollies, gold foils, and satin ribbons.

Photography

❧❧❧❧❧❧❧❧❧❧❧❧❧❧❧❧

See also ARTIST'S SUPPLIES and other related categories; and PUBLICATIONS.

❧❧❧❧❧❧❧❧❧❧❧❧❧❧❧❧

AAA Camera Exchange, Inc.
43 Seventh Ave.
New York, NY 10011
212-242-5800
800-221-9521 (except NY)

Send SASE or call for list.

Camera outfits: beginner—with camera, lens, film, tripod, gadget bag, strap, flash; "Dream Kit" and Delux SLR outfits—with choice/selection of cameras (Canon, Minolta, Fujica, Pentax, Olympus Ricoh, Yashica). Cameras—these brands, also Chinon, Mamiya, Konica, others. I.D. cameras: Polaroids, Shackman, Beatti. Lenses: Leitz, Minox, Nikon, Minolta, Canon, Sigma, Soligor, Tamron, others. Flashes by Vivitar, others. Slik tripods. Tamrac gadget bags. Others. Has reduced and special prices. MasterCard, Visa.

Abe's of Maine
1957-61 Coney Island Ave.
Brooklyn, NY 11223
718-645-0900

Send SASE or call for list.

Cameras: Canon, Nikon, Minolta, Pentax, Olympus. Auto focus cameras: Nikon, Olympus, Pentax, Canon, Minolta, Fuji, Ricoh. Lenses and flashes: Vivitar, Tokina, Sigma, Canon, Tamrac, Minolta, Telesor, others. Video camcorders by Panasonic, Sony, and JVC. Slik tripods. Others. Some reduced prices. Major credit cards.

Albums Inc.
P.O. Box 81757
Cleveland, OH 44181

Free wholesale catalog.

Albums for wedding, studio, portrait photographers. Plaques, line of frames in variety of styles and sizes; the products of Holson, Topflight, Camille, Sureguard, Pro-Craft, Yankee Plak, Lacquer-Mat, Marshall's. Master-Card, Visa. Has outlets in six locations.

B & H Photo
119 W. 17th St.
New York, NY 10011
212-807-7474

Send SASE or call for list.

Video cameras including Canon camcorders, Minolta master series, RCA, Olympus camcorders, Panasonic OmniMovie models, Sony, others. Filter sets (starter and special effects), Tenba camera bags (5 travelers and 4 pro traveler types). Still cameras and equipment: Hasselblad, Polaroid, Rollei, Bronca, Pentax, Mamiya; view cameras lenses/equipment by Sinar, Wista, Omega, Polaroid, Fujinon, Schneider, Nikkor-W, Rodenstock. Studio lighting, strobe and tungsten lighting. Copy systems, underwater photo equipment. Used equipment (known brands). Lenses, filters, Video film processor.

Blue Mountain Photo Supply
Box 3085
Reading, PA 19604

Send SASE for information.

Supplies for cyanotype printing (known as "blueprint" method).

Bogen Photo Corp.
565 E. Crescent Ave., P.O. Box 506
Ramsey, NJ 07446

Contact dealer or write with inquiry.

Photographic equipment including Bogen tripods and the mini fluid head (fits the tripods), the fluid-damped head pans and tilts 45 degrees up and 90 degrees down; accomodates cine or video cameras up to 8.8 lbs., features quick-release mounting plate, the handle can be positioned on either side; optional second handle.

Cambridge Camera Exchange, Inc.
7th Ave. & 13th St.
New York, NY 10011
212-675-8600
800-221-2253 (except NY)

Free catalog.

Cameras and equipment, known brands: Agfa-Gevaert, Bronica, Cambron, Canon, Casio, Chinon, Exakia, Fuji, Hasselblad, Kodak, Konica, Leica, Lindenblatt, Mamiya, Minolta, Minox, Miranda, Nikon, Olympus, Pentax, Petri, Praktic, Ricoh, Rollei, Topcon, Vivitar, Contax/Yashica, Polaroid, Passport, others. And 4 X 5 cameras. Full line of lenses, electronic flashes, exposure meters, tripods, darkroom equipment, enlargers, lenses, film, projectors, viewers, movie film, equipment cases. Also has used cameras and equipment in working order. Some reduced prices. Discover, MasterCard, Visa.

Camera One of Sarasota, Inc.
1918 Robinhood St.
Sarasota, FL 34231
813-924-1302

Send SASE for list.

Cameras and equipment by: Nikon (compacts, zooms, micros, teleconverters, lenses, motors, professional camera), Pentax (autofocus, others; lenses), Ricoh, Olympus (super zoom, compacts, others; flashes). Leica, Hasselblad, Sunpak, Mamiya, Lowe, Sigma, Gossen meters. Accessories. Other equipment.

Camera World of Oregon
500 S.W. 5th & Washington
Portland, OR 97204
503-227-6008

Send SASE or call for list.

Cameras and accessories by Canon, Fuji, Chinon, Nikon, Ricoh, Minolta, Konica, Pentax, Olympus, Yashica, Tamron, others. Video camcorders by Sony, Panasonic, Chinon, Canon, Hitachi, Olympus, Minolta, Nikon, Quasar, JVC, RCA, Magnavox, Pentax. Camera lenses by Sigma, Tokina, Vivitar, others. Flashes, light meters; others. May have reduced prices. Visa, MasterCard. Toll free number for orders.

Canon USA Inc.
1 Canon Plaza
Lake Success, NY 11042
516-488-6700

Send SASE for information.

Variety of 35mm AF SLR cameras, and others.

Charles Beseler Co.
1600 Lower Rd.
Linden, NJ 07036
908-862-7999

Free brochure.

Photographic equipment: Beseler 23CII-XL enlarger—with rigid twin-girder construction ("vibration-free"). Manufacturer. Also in Canada from W. Carsen Co., Ltd., Markham, Ontario L3R 1E7.

Chinon America Inc.
1065 Bristol Rd.
Mountainside, NJ 07092
908-654-0404

Send SASE for information.

Full line of cameras including the 35mm AF SLR, others.

Colorex
6121 Oxon Hill Rd.
Oxon Hill, MD 20745
301-567-5262

Send SASE for details.

Custom enlargement of slide or print to poster size (from 35mm, 6" X 4", 6" X 6", 6" X 7", enlarges to 16" X 20", 20" X 24", or 20" X 30" sizes).

Competitive Camera
363 7th Ave.
New York, NY 10001
212-868-9175
800-544-5442 (except NY)

Send SASE or call for list.

Cameras and equipment by Minolta, Ricoh, Nikon, Canon, Olympus, Yashica, Pentax, Konica, others. Hasselblad, Mamiya medium format and others, Bronica. Autofocus cameras (Pentax, Minolta, Canon, Fuji). Shackman passport camera. Flashes, lenses, cases, tripods, darkroom equipment (enlarger, printmaker, color analyzers, Jobo products). Light meters. Video camcorders: Minolta, Chinon, Elmo, RCA, Panasonic, Sony, Ricoh. Copiers, FAX machines. May have below-list prices.

Cullmann
P.O. Drawer U, 1776 New Hwy.
Farmingdale, NY 11735
516-752-0066

Contact dealer, or write for information.

Cullman "Magic" tripods (compact, lightweight, rigid, stable) in 5 models: "Mono" that doubles as monopod; "Chest" model for action/mobility; "Clamp" vise-grip model, and "mini magic" table-top tripod; all tripods feature a unique locking system and aluminum/fiberglass reinforced polycarbonate construction. "Magic II" floor model also has a quick-release head for instant camera mounting, or remove a leg to convert monopod or duopod. Line of camera bags also includes tripods.

Custom Photo Mfg.
10830 Sanden Dr.
Dallas, TX 75238
214-349-9779

Free catalog.

Darkroom equipment, supplies, and accessories including stainless steel sinks, 8 ABS plastic sinks, mix tanks, algae removers, floor mats. Computer controlled demand water heaters, others.

Dale Laboratories
2960 Simms St.
Hollywood, FL 33022

Send SASE for full details.

Custom 35mm film developing—prints or slides or both from the same roll of film, and fine-grain negatives for enlargements; processing includes replacement film.

Day Lab
400 E. Main
Ontario, CA 91762
714-988-3233

Free catalog.

Daylight enlarger-processor: make color of black and white prints from negatives or slides in normal room light. Works with any chemistry including Cibachrome.

Delta 1 Custom Photo Mfg.
10830 Sanden Dr.
Dallas, TX 75238
214-349-9779

Free catalog.

Darkroom products: water filters, stainless steel sinks and trays, fans, louvers, mixing tanks, ABS sinks, demand heaters, others.

Dial-A-Photo, Inc.
P.O. Box 5063
Jacksonville, FL 32247
904-398-8175

Send SASE for further information.

Dial-A-Photo computer system for all cameras, films. Pocket-sized system helps predict shots day or night— during lightning, fireworks, moon, star trails, circus, electric parade, concerts, etc. Color log with photos, logsheets, action chart ASA/SO scale, filter information. Vinyl dial. MasterCard, Visa.

Essex Camera Service, Inc.
100 Amor Ave.
Carlstadt, NJ 07072
201-933-7272

Send SASE or call with inquiry.

Camera repairs for most models from antique to latest electronic autofocus. Gives free estimate.

Executive Photo & Electronics
120 W. 31st St.
New York, NY 10001
212-564-3592

Write for catalog.

Cameras/accessories: Nikon, Minolta, Canon, Pentax, Yashica, Leica, Fuji, Konica, Polaroid Passport models, EW Marine underwater equipment, Mamiya, Hasselblad, others. Lenses: Sligor, Kiron, Tokina, Sigma, Pentax, Canon, Ed-IF, others. Flashes: IQZoom, Mirrai, Vivitar, Pentax, Canon, others. Slik tripods. Slide projectors and viewers. Studio kits, stands, umbrella light reflectors, other studio equipment. Darkroom equipment and supplies: Beseler enlarger outfits, timers, accessories. Safelites, copy stands, enlarging lenses, print washers and dryers, sinks. Film, print papers, chemicals. Video camcorders. May have reduced prices.

Focus Camera Inc.
4419-21 13th Ave.
Brooklyn, NY 11219
718-436-6262

Send SASE or call for list.

Cameras and equipment: Nikon, Hanimex, Contax, Yashica, Konica, Canon, Olympus, Pentax, Vivitar, others. Lenses (Vivitar, Kiron, Sunpak, Sigma, Tokina, Polaroid, Tamron, Canon, Nikon, Metz, others), carousels, flashes, digital flashes, meters, others. Camera cases and gadget bags, Bogen and Slik tripods; others. May have below list prices. American Express, Visa, MasterCard.

Foto Cell Inc.
49 W. 23rd St.
New York, NY 10010
212-691-3718

Send SASE or call for information.

Cameras/accessories: Canon, Nikon, Minolta, Pentax, Olympus, Hasselblad, Leica, Chinon, Konica, Fuji, Polaroid, others; filters, flashes (Vivitar, Kiron, Cobina, others); lenses (Canon, Nikon, Zuiko, Tokina, others). Underwater equipment by Nikonos-V, Sea & Sea, EWA-Marine. Pelican watertight cases. Camera bags by Cullmann, Tenba, others. Tripods by Cullman, Slik, Bogen, others. Light stands, films. Video camcorders: Panasonic,

Mitsubishi, Magnavox, Olympus, Sharp, Canon, Minolta, RCA, Hitachi; compact models. Video accessories. Used photographic equipment (known brands). Takes trade-ins. May have reduced prices. Major credit cards.

Freestyle
5120 Sunset Blvd.
Los Angeles, CA 90027
213-660-3460

Send SASE or call for list.

Darkroom supplies/accessories: stainless steel tanks and reels, thermometers, 35mm bulk film loaders, slide mounts, reloadable cartridges, optical glass filters, rotating polarizers, mount boards, dry mount tissue, neg/slide pages. Black and white film (35mm, 120) of Ilford, Arista, Kodak, Ortho Litho. Color and b/w papers by Mitsubishi, Arista, Ilford, others. Color paper and film — Kodachrome, Kodacolor, Ektachrome; professional and European papers. Color films—Fuji, Konica, Agfachrome, Arista. Some reduced prices. MasterCard, Visa.

47th St. Photo
38 E. 19th St.
New York, NY 10003
212-921-5200

Send SASE for full information.

Camera equipment: known brands, view cameras too; accessories, darkroom equipment, supplies, studio equipment/supplies. Has some specials. Has used trade-in hotline (212-228-3016); major credit cards.

Giftime Discount Center
6508 Bergenline Ave.
West New York, NJ 07093
201-869-8180
800-443-8463 (except NJ)

Send SASE or call for information.

Cameras/accessories: Canon, Olympus, Minolta, Nikon, Yashica, Konica, Ricoh, Pentax, others. Lenses: Tokina, Vivitar, Kalimar, Nikon, Sigma, Sakar, Sougor, Tamron, Ricoh, Pentax. Velbon and Slik tripods. Flashes: Vivitar, Sakar, Sunpak, Protech, others. Films. Video camcorders: Sony, Ricoh, Canon, Minolta, Chinon, Olympus, Nikon, Kyocera, Panasonic. Other products. Some below list prices. MasterCard, Visa.

Hamilton Studios
Box 39
Claymont, DE 19703

Free brochure—specify interest.

Instructions for retouching photos and negatives. Instructions for professional oil coloring of photographs.

Hillcrest
10018 Spanish Isles Blvd.
Boca Raton, FL 33498

Send SASE for list.

Custom prints — Cibachrome prints from slides, dry mounting available; "affordable prices."

Light Impressions
439 Monroe Ave.
Rochester, NY 14607

Free catalog.

Photography supplies: archival storage and display products, studio and darkroom equipment, photography gear. Wide range of fine art photography books—classics to most recent, hard-to-find titles "all at 15% discount."

Mamiya America Corporation
8 Westchester Plaza
Elmsford, NY 10523
914-347-3300

Contact dealer, or send SASE for information.

Mamiya photographic equipment: variety of cameras including the M645 Super—6 X 4.5 medium format camera with almost 300% larger film area, interchangeable magazines (for 120, 220, 35mm), plus Polaroid proofing holder, 20 interchangeable lenses and 4 finders, 5 focusing screens; has electro-magnetic moving coil focal plane shutter with speeds to 1/1000th sec., instant return mirror; and options; and in an economy model with pre-loadable film inserts (instead of magazines). Others.

Media West Home Video
10255 S.W. Arctic Dr.
Beaverton, OR 97005

Send SASE for further information.

Instructional videos: The Business of Photography (meet art directors and editors who buy pictures and give out assignments—in 3 half-hour chapters). On Assignment: series of 7 90-minute videos for amateur to professional, by Brian Ratty, nationally known photographer; covers breaking in, portfolios, business workings, staff, major markets, reps, freelancing, other. MasterCard, Visa.

Melrose Photographics
50 E. Butler Ave.
Ambler, PA 19002
215-646-4022

Send SASE for full details.

Custom printing: Cibachrome enlargements, prints from 35mm to 6 X 7 transparencies only; variety of sizes, in pearl or glossy surface; flush mountings. "Wholesale."

Merit Albums, Inc.
19338 Business Center Dr.
Northridge, CA 91324
818-886-5100

Free wholesale catalog.

Albums: wedding, others; variety of styles and sizes. Proof books. Photo mounts and folios. The products of Topflight, Leathermark, Tap, Holson, Camille, Dimension. MasterCard, Visa.

Mibro Co., Inc.
64 W. 36th St.
New York, NY 10018
212-967-2353

Send SASE or call for list.

Cameras—SLR outfits: All-in-one, 3-Lens Beginner, All purpose action, Sports minded 3-lens, For-starters, Minimax pickup/go, Nature lover, Professional, others. Cameras by Minolta, Pentax, Ricoh, Canon, Fuji, others. Full line of lenses, flashes (Vivitar, Tokina, Sigma, Tamron, Kalimar, Kiron, Pentax, Canon, Minolta, others). Tripods by Slik, Velbon. Gadget bags. (Also Commodore computers.) "Discounts on all your photographic needs." Accepts major credit cards.

Minolta Corporation
101 Williams Dr.
Ramsey, NJ 07446

Contact dealer, or write for information.

Minolta line of cameras and accessories including the Maxxum™ 7000i, that works like a computer; optional programming with use of "Creative Expansion Card" to capture quick-action, bracket a subject, etc.; with fast autofocus, predicts subject's speed/direction, has integrated multi-pattern real-time metering system. Exposure bracketing card programs exposure variations of 3, 5, or 7 frames in ¼ stop, ½ stop or one-stop increments. Sports action card sets camera for continuous autofocus, keeping fast shutter speed. Auto Depth Control adjusts settings. Customized function card allows reprogramming of 7 camera functions. Others.

Minox U.S.A.
1315 Jericho Turnpike
New Hyde Park, NY 11040

Contact dealer, or write for information.

Minox photographic equipment including "the smallest full-frame 35mm camera in the world," (1989) — The 35GTE ultra-compact auto-everything camera has a f/2.8 lens, autoexposure, built-in skylight filter, and ISO setting from 25-1600; has depth-of-field indicator, shutter speed readout in viewfinder, autoexposure range of 1/500 to 8 seconds; lithium powered; size is 3.9" X 2.4" X 1.3" with a weight of 7 ounces.

New York Institute of Photography
211 E. 43rd St.
New York, NY 10164

Free Career Guide and Catalog.

Photography home study course — 30 lesson program covering all basics and advanced, professional aspects of photography, including a mini-course in video techniques; also training materials, cassette tape communication, and individual attention and constructive criticism to enhance learning.

Nikon Consumer Relations
1300 Walt Whitman Rd.
Melville, NY 11747

Contact dealer, or write for information.

Photographic equipment: full line of cameras, including those with 5-segment Matrix Metering, and synchronized, cybernetic, rear-curtain fill-flash; other advanced systems. Speedlight and other flashes.

NRI School of Photography
4401 Connecticut Ave. NW
Washington, DC 20008

Free catalog.

Photography and Video Production home-study course —professional training in all facets of still photography, and hands-on video instruction with state-of-the-art camcorder (included). Provides knowledge of studio and darkroom equipment, and techniques for their use—integrating both studies together. Instructors provide critiques and communication with students from a professional vantage point. (A McGraw-Hill Continuing Education Center.)

OMNI Photo & Supplies
Brooklyn Navy Yard, Bldg. #27
Brooklyn, NY 11205
718-875-4297

Send SASE for list.

Known brand cameras: Nikon, Canon, Olympus, Pentax, Chinon, others. Point/shoot cameras, flashes, equipment. Has MasterCard, Visa.

Paul C. Buff Inc.
2725 Bransford Ave.
Nashville, TN 37204
615-383-3982

Send SASE for full details.

White Lightning Ultra system—control box that produces to 1800W effective light output, adapts to all studio uses from bare-bulb to soft-box, feature 5 f-stops of flashpower adjustments (connect four to one [RC-1] remote control and can adjust flash and model intensity for each unit right from the camera—while looking through the viewfinder); in 3 models.

Peach State Photo
1706 Chantilly Dr.
Atlanta, GA 30324
404-633-2699

Call or write for list.

Camera equipment (known brands): Canon, Nikon, Minolta, Fuji, Pentax, Leica, others. Meters, filters, lenses, tripods, bags, cases, films. Video cams, accessories. Has major credit cards.

Pentax
35 Inverness Dr. E
Englewood, CO 80112
303-799-8000

Send SASE for list.

Full line of cameras: medium format, 35mm AF SLR's and others. Accessories. Manufacturer.

Photek
909 Bridgeport Ave.
Shelton, CT 06484
203-926-1811

Write for information.

"Backgrounds-In-A-Bag" lightweight, reversible backdrop designs.

Photo Stop
61 Washington Ave.
Westwood, NJ 07675
201-664-4707

Send SASE or call with inquiry.

Hasselblad photographic equipment: 500 C/M camera—body, 80mm CF lens, A12 MAG; ELM/ELX/FCW. CF lenses (666 mm, 150mm), prisms, quick focusing handle for CF lens, beattle screens; other accessories.

Photo-Therm
110 Sewell Ave.
Trenton, NJ 08610
609-396-1456

Write or call for catalog.

Darkroom equipment: temperature baths and modular controls, variety of models of "high precision" type; "reasonable cost."

Photoflex, Inc.
541 Capitola Rd.
Santa Cruz, CA 95062

Contact dealer, or write for information.

Photographic equipment including the Pro 4 automatic filter dispensing lens hood, with 4 filter flaps (change filters by pressing flap); for location shooting or whenever rapid changes are needed; rotates 360 degrees, is compatible with wide variety of camera, lens, and filter formats. Variety of lens-fitting rings available.

Photography Book Club
P.O. Box 2003
Lakewood, NJ 08701

Send SASE for full details.

Members of this book club receive photography books at savings "of at least 20% to as much as 50%." After choosing an introductory title at token cost, the member agrees to purchase 2 more books in the first year of membership (and thereafter earn bonus points for "even larger discounts"). Club bulletins are sent 15 times yearly; if main selection is declined, the provided card is returned. Among the book subjects may be: closeups, studio techniques, nature and landscape photography, insider's advice, creative techniques, photogaphing people, darkroom and processing data, others.

Photron Marketing Inc.
256 W. 38th St.
New York, NY 10018
212-221-1011

Send SASE or call for information.

Cameras—AF and standard SLR lenses and accessories: Minolta Maxxum, Canon EOS, Olympus, Nikon, Yashica, Pentax, Ricoh, Chinon, others. Flashes, lenses. Professional cameras: Bronica outfits, Metz, Mamiya, Pentax. Slik and Bogen tripods. Video camcorders: Panasonic, RCA, JVC, Olympus, Hitachi, Nikon, Tamron, Sony,

Sharp, Canon, Pentax, G.E., Minolta, Chinon, Magnavox. Video accessories: lenses, microphones, video lights, others. (Also copiers, VCR's, CD players.) May have closeouts, reduced prices. Major credit cards.

Porter's Camera Store
Box 628
Cedar Falls, IA 50613
319-268-0104

Write for photo catalog.

Over 4,000 cameras and photo equipment, accessories, and darkroom supplies.

Romney
Box 96
Emlenton, PA 16373

Catalog and free lesson $2.00.

Camera repair books, tools, supplies (for Leica and antiques, too).

Smile Photo
29 W. 35th St.
New York, NY 10001
212-967-5912

Send SASE or call for information.

Cameras/accessories by Canon, Nikon, Minolta, Ricoh, Nikonos (underwater equipment), Fujica, Yashica, Konica, Olympus, Nikon, Pentax, others; lenses (Canon, Nikon, Minolta, Rikenon, Yashica, Haxamon, Olympus, others); Vivitar and other lenses; lens cases and hoods. Cable switches, electronic flash cards. Polaroid Spectra-System (and film). Studio accessories: Sunpak light systems, Photoflex, Bowens Moonlights, Voyager Mono and others, Bogen booms, stands, copy systems, lighting assemblies, reflectors. Testrite copy stand, umbrellas. Slide projectors. Videos. Discover, MasterCard, Visa.

Southern Career Institute
Drawer 2158
Boca Raton, FL 33427
407-368-2522

Free catalog.

Professional photography home-study course—training in basic to advanced photography (techniques for a wide range of practices) and business and career are all focal points of this study program.

Supreme Camera
2123 Utica Ave.
Brooklyn, NY 11234
718-692-4110

Write or call with inquiry.

Known brand cameras: Minolta, Canon, Nikon, Chinon, Sdamsung, Pentax, others. "Will not be undersold." Has MasterCard, Visa.

Tamrac
9240 Jordan Ave.
Chatsworth, CA 91311

Write for catalog.

Camera and video carrying systems (cases) — over 40 models, including "Super Pro" (compartmentalized, for most photographic equipment), with zip out, fold out, easy accessibility. Others include "Zoom Traveler," smaller version with shoulder strap; and "Photographer's Vest" style for camera and lenses, etc.

The Morris Co.
1205 W. Jackson Blvd.
Chicago, IL 60607
312-421-5739

Contact dealer, or send SASE for information.

Camera products including the "Morris Mini" slave flash—twice the light for group shots or as a fill light; palm-size, triggered by camera's built-in flash. Manufacturer.

The Palladio Company, Inc.
P.O. Box 28
Cambridge, MA 02140
617-547-8703

Write or call for price list information.

Palladio™ paper (machine-coated platinum/palladium printing papers in 3 contrast grades), processing chemistry, UV light sources, and start-up kits.

The Photographic Arts Center, Ltd.
127 E. 59th St. #201
New York, NY 10022

Free catalog.

Books written for photographers interested in exhibiting and selling their work.

The Pierce Co.
9801 Nicollet Ave.
Minneapolis, MN 55420
612-884-1991

Catalog $2.00 (refundable).

Photography studio products: painted backgrounds (including scenics), photography supplies, photo albums, mounts, drapes, printed forms, poly bags, toys, others.

Tri-State Camera Exchange Inc.
160 Broadway
New York, NY 10038
212-349-2555

Write or call with inquiry.

Camera equipment (known brands): Canon, Nikon, Minolta, Fuji, Yashica, Pentax, Konica, others. Photo equipment. Video cams. Has MasterCard, Visa.

Wall Street Camera
82 Wall St.
New York, NY 10005
212-344-0011

Send SASE with inquiry.

The Zone VI wooden field camera. Zone VI Studios, Inc.

Camera equipment by Bronica, Hasselblad, Rollei, Pentax, Mamiya, Canon, Leica. Press/view cameras: Omega, Sinar, Fuji, Nagaoka. Lenses and light meters (known brands). Zoom outfits by Olympus, Minolta. Tiltall tripod and Kodak carousels. RCA, Olympus, Sony, and other video camcorders. Darkroom outfits (enlarger plus accessories). Allows trade-ins of cameras for new models. Some below list prices. Accepts major credit cards.

Yashica Inc.
100 Randolph Rd.
Somerset, NJ 08873
201-560-0060

Send SASE with inquiry.

Line of 35mm and other cameras and accessories. Manufacturer.

Zone VI Studios, Inc.
Newfane, VT 05345
802-257-5161
Free catalog.

Photographic specialties: Zone VI camera—handcrafted field camera with extensions and removable bellows, lenses to 360mm; mahogany with brass fittings; case. Archival print washers. Tripods and cases. Compensating enlarging metronome. View camera lenses by Schneider. Camera outfits (4 X 5 camera, tripod, case, film holders, lensboard, Schneider lens). Modified meters, Zone dials, meter bolsters and cases. Modified 4 X 5 cold light enlarger timer, print flatlever. Cold light heads, stabilizers. Developing timer, drying screens. Paper, chemicals, easels, film washers, others. Darkroom tanks, reels, oversize proofer, magnifier, others. Books. Credit cards.

Rubber Stamping & Stamp Making

🦆🦆🦆🦆🦆🦆🦆🦆🦆🦆🦆🦆🦆🦆🦆🦆

See also CRAFT SUPPLIES, ARTIST'S SUPPLIES, PAINTS, PAPER CRAFTS, FABRIC DECORATING, and other related categories; and PUBLICATIONS.

🦆🦆🦆🦆🦆🦆🦆🦆🦆🦆🦆🦆🦆🦆🦆🦆

100 Proof Press
R.R. 1, Box 136
Eaton, NY 13334
315-684-3547

Catalog $3.00 (refundable).

Over 2,900 rubber stamp images: Christmas—Greetings, Santas, Father Time, bells, trees, Wise Men/ camels, snowflakes, wreath. People, Make-A-Face parts, crowds, hands, on bicycles, ethnic, old-time, elves, Indians (tipi, shield), dancing, martini glass, soldiers, action sports, photographers (cameras). Moons, suns, lightning, comet, sun rise/set. Books. Playing cards, musicians/ instruments. Carousel animals, clowns, banners, old-time and other dolls, carriage, scooter, teddy bears, Kewpie, toy trucks, cars. Cupids, angels. Fantasy — bugs, dragons, serpents, leaf faces, unicorns, others. Frog musicians, dancing, lily pads. Animals—birds, dogs, chickens, squirrel, moose, insects, butterflies, cats; prehistoric. Monkeys, other wild and farm animals. Fish, shells, turtles, snakes. trees, flowers, plants, vegetables, fruits, food. Borders, medallions, ornaments. signs. Mail art. Zodiac signs, crowns, religious signs, stars, clover, globes, seals. Airplanes, balloons, ships, cars, trucks, trains, motorcycles, tools, pencils, pens, quill, pen in hand, hardware. Lamps, baskets, bucket, household items. Clocks, typewriters. Buildings, entranceways, columns, early historical figures. Coke motifs. Slogans. Add-A-Sign with figures. Alphabets. Half price or less for unmounted.

A Stamp In the Hand Co.
P.O. Box 5160
Long Beach, CA 90805
213-422-2591

"Kat-A-Log" and Supplements, $3.50.

Rubber stamps from favorite companies: hand-carved eraser designs; hearts, paper dolls, tree with hearts, animals. Custom stamps, paper, cards.

Acey Deucy
P.O. Box 194
Ancram, NY 12502

Catalog $1.25.

Rubber stamp designs including "Ugly Ties," or "Dumb Hats" postal stamps, assorted people, others. Has unmounted stamps at half price.

Acme/Star
1720 N. Marshfield
Chicago, IL 60622

Catalog $2.00.

Supplies/equipment: rubber stamp markers, letterpress and printing items.

All Night Media, Inc.
P.O. Box 10607
San Rafael, CA 94912
415-459-3013

Send SASE for list.

Rubber stamp designs: cartoonish images, hearts; Stamp-A-Face™, Creature Features™, Stamp-A-Zoo™, and Stamp-A-Farm™ sets (cartoon animal parts stamps). Winnie the Pooh. Teddy bears and sets, food treats, Bloomberg's animal designs/sets. Stamps-On-Wheels™, and "Global Cow," cats; others. Fish, shells, waves. Teachers' stamps, messages, birthday. Nature—clouds, stars, snowflakes, moon, smile star, trees, flowers. Wild animals, dragons, dinosaurs. Musical items. Country motifs. "Created by" borders. Bookplates (bears, flying carpet, owl/books, others). Easter rabbits flowers, eggs, heart, rainbow, teddies, rabbits, koalas, panda, cows, ducks, pigs, cats, dogs, birds. Classic and love motifs. Bears, rabbits, stars, palms, turtles. Birthday, balloons, paw prints, cats, Thanks, others. 18+ stamps per set for mixing: Teacher's Pets, dinosaurs, African animals, marine, mammals, alphabets, birthday, Halloween, Christmas. 150+ Namz™ name stamps. Supplies: glitter glue, Color Brushers™, stamp pads—colors, neons, metallics, rainbow. Reinkers, stamp cleaner. Embossing powder.

Anne-Made Designs
P.O. Box 697
Erwin, TN 37650

Catalog and card of unmounted stamps $5.00.

Decorative rubber stamps: whimsical and folk art images, others. Has unmounted stamps at very low cost.

Arben Stamp Company
413 Main St.
P.O. Box 353
Evansville, IN 47703

Catalog $2.50.

Rubber stamps: hearts, dolls, holiday motifs, others, Rollagraphs™, embossing powders, glitter, glue, others. (Also sells wholesale.)

Bizarro
P.O. Box 16160
Rumford, RI 02916
401-728-9560

Catalog $1.00.

Design rubber stamps: sports figures, map of U.S., alphabet stamp sets, others. Supplies: embossing powders, rainbow stamp pads. How-to-Use Rubber Stamps books.

Circustamps
P.O. Box 250
Bolinas, CA 94924

Catalog $1.00.

Scaled images in rubber stamps (to be used with one another) of an array of circus performers (action figures, 8 clowns, tightrope walkers, 6 trapeze artists, lion tamers, Oriental acrobats, 2 jugglers, man on stilts, 3-piece band. Action animals: bear on bicycle, tigers, lions, horses, zebra, seal and ball, elephants. Large ball with stars, ladder, 4 bases for animals. Animal wagon/cage (in parts) top, side, bars, bottom. Unmounted stamps at half price.

Co-Motion Rubber Stamps
4455 S. Park Ave. #105
Tucson, AZ 85714

Catalog $2.00.

Artistic rubber stamps including Southwestern (saguaro cactus, Indian pottery and designs), teddy bear, penguins, others. Techniques video. (Also sells wholesale.)

Ed Jacobs
7316 San Bartolo
Carlsbad, CA 92009
619-438-5046

Write or call for free information.

Custom design of your name as Chinese seal; others.

Emerald City Stamps
7925 Annesdale Dr.
Cincinnati, OH 45243

Catalog $2.00 (refundable).

Over 1,000 creative rubber stamps: "Cosmos" — star, planet, sun, moon, clouds, lightning, earth. Comic faces, people (dancing musicians, kids, action sports, clowns, Oriental, Alice, Wiz, cats, dogs, cows, horses; fantasy, wild; reptiles, bugs, birds, teddies, birds, fish, shells. Flowers, trees, pyramids, fences, historic/other buildings. musical motifs. Vehicles, balloons, food. Christmas/ special occasion; variety of slogans ("handmade," "handcrafted," "home grown," "Postcard," "Celebrate," "It's A Hit," others). Hands, handprints, footprints. Eyeglasses, eyes. Hearts. Stamp pads (16 colors), rainbow stamp pads. Sells unmounted stamps at half price.

Fruit Basket Upset
P.O. Box 23129
Seattle, WA 98102

Catalog $2.00 (refundable).

Rubber stamp images including over 100 new designs and 4 new alphabets.

Good Impressions
Shirley, WV 26434

Catalog $1.00 (refundable).

Rubber stamp images: people — women, girls, elves. Plants — palms, hanging, potted roses. Border designs. Animals: active bears and frog on bicycle, unicorn, cats, peacock, snail, pig, turkey, geese, rabbits, dog, others. Cupids, dove, hearts, moon, birds, angel. Silhouettes — people, folk art shapes. Quilting designs. Fruits, vegetables, buildings, flying machine. Holiday: Santa and tree, and toys; decorated tree, snowflakes, New Year baby and cork-pop bottle, others. Alphabet sets: people letters, print, sign language. Food stamping set. Letter Lock personal stamps — decorative banner and 250 piece alphabet set. Pyramids, mummy, masks. Eiffel Tower, woman on moon. Banner slogans: Do Not Despair, From the Desk Of (old typewriter), Fan Mail (in front of fan), Invitation, (sack with) Wizard Brand Sheep Manure, Homemade By, Thank You, Praise the Lord (with sun), Ex Libris (elves reading), Just for You (dog holds basket), Naughty Naughty (with pointed finger), Party! (with people), To:, From:, Happy Birthday!, Handle With Good News, Give Peas A Chance (with faces in pod), Confidential (with key); pen points with: Post-Script, Please Write Soon, R.S.V.P., You Are Invited; others.

Good Stamps—Stamp Goods
30901 Timberline Rd.
Willits, CA 95490
707-459-9124

Catalog $2.00; send SASE for paper swatches.

Rubber stamps in variety of designs including holiday, rainbows, Pot o' Gold, clover, leprechaun, sunrise, clouds, rabbits, ducks, broken egg (pair), 13 heart motifs; others. Blank paper goods. (See PAPER CRAFTS.)

Graphic Rubber Stamp Co.
11250 Magnolia Blvd.
No. Hollywood, CA 91601
818-762-9443

Catalog $4.00.

Over 3,000 designs on rubber stamps: circus performers, 18 sheep, photographers and cameras, castles, borders, people, telephones, bicycles, flowers, Hollywood items, dancing couples, sports motifs, trees, animals (domestic, wild, farm, cats, dogs, birds, sea life, dragons, dinosaurs). Quotations, alphabets. Others. Has unmounted stamps at half price. (Also sells wholesale.)

Gregory Mfg. Co. Inc.
P.O. Box 1303
Jackson, MS 39205

Send SASE for list.

Rubber stamp supplies: Crystalite™ acrylic stamp mount in over 100 sizes including circles; with maple base, with handles — in units of 10 by size. White cloth indexing tape, double sided white foam tapes. Mount strips, molding (maple) with red cushions in over 12 sizes; others. Has quantity prices. Minimum order $35.00.

Gumbo Graphics
P.O. Box 11801
Eugene, OR 97440

Catalog $2.00.

Over 2,000 rubber stamp images and sets including re-productions, bizarre items, animals, fish, plants, Indian, abstract, children, women, men, bugs, birds, beasts, dragons, others.

Heartfelt Impressions
P.O. Box 248
Pacific Palisades, CA 90272
213-459-6050

Catalog $1.00.

Design rubber stamps: whimsical—action rabbits, cats, action ducks, others. heart motifs. Paw print. Teacher and other slogans: Practice, Late work!!, ?, Spelling!; First Class, Paid; others. Calligraphy slogans: Heartfelt Greetings, Just for you!, Get well soon!, Open me first!, Surprise!, others. Star of David. Holiday motifs. English scenes. Teachers: apple on blackboard, apple and pencil, mini apple; tic tac toe, prancing unicorn. Circle of stars. Pumpkin, ghost. Soda bears, cupid bear. Merry Christmas tag. Others. (Also sells wholesale.)

Hippo Heart
Box 4460
Foster City, CA 94404

Catalog $2.00.

Design rubber stamps: mini motifs. Mini whimsical animals (pig, rabbit, bear swinging and on rainbow, Teddies, pandas, camel, koala, cats, dogs, dinosaurs, elephant, horses, hippos, rabbits, sheep, birds, ducks, pigs). Decorative borders, corners. Holiday — Christmas Greetings, angels, ornaments. Happy Birthday greetings on cakes. Borders, slogans, balloons. Fantasy—wizards, Pegasus, unicorns. Flowers, trees. Food items. 10+ hearts. Messages: Thanks, Handmade By, Handcrafted By, Homemade By. People — Oriental, barber shop quartet, mermaid, Oscar, stick people, clown. Fish. Suns, moon, clouds, tornado, snowflakes. Butterflies. Bookplate, games, music motifs, ballet shoes. Teacher stamps —"Corrected for . . .," "Please sign & return," "Excellent" (in smile star), "Good effort" banner and clown; others. Stamp pads. "Wholesale welcome."

CLEAN IT: *Keep your stamps CLEAN! Accumulated ink gives you fuzzy images and ink carried from one pad to the next will give you "muddy" colors. Plain water is the best thing for cleaning stamps. Courtesy of Betty Harris of 100 Proof Press.*

Jackson Marking Products
Brownsville Rd.
Mt. Vernon, IL 62864
618-242-1334

Free catalog.

Rubber stamp making equipment: Precision rubber stamp presses — redesigned for industrial use. Mazak and Standard Foundry types. Hand press machine, stamp die cutting machine. Hot stamping and laminating equipment. Mount strip in 6 styles, 18" or precut and drilled. Bakelite Matrix board. Rubber stamp gum, sponge cushions. Rainbow and prismatic pads and inks. Photographic paper ink. Solutions, cleaners, kits, self-inkers, racks. Type (standard 64 styles, Jazak Granby, condensed, others). Rubber stamp handles (17 types and styles). Services: Photoengraving of artwork, matrix board molding, rubber die molding. Has quantity prices.

Judi Kins Rubber Stamps
P.O. Box 6371
San Pedro, CA 90734

Catalog $2.00.

Rubber stamp images (original designs): seal and heart, ducks, monkey hangs from balloon, elephant, water drops, rabbits, others. Custom stamp service, from customer's designs. (Also sells wholesale to retailers.)

Kinky Ink Co.
P.O. Box 392
Little Silver, NJ 07739

Catalog $1.00.

Rubber stamp alphabets and numbers sets, others. Stamp pads and inks (child-safe, colors, dayglo, metallics, glitter). Dry stamp pads. Fabric stamping inks. Embossing powders and inks. Has quantity price breaks.

Klear Copy Design Rubber Stamps
55 7th Ave. S.
New York, NY 10014
212-243-0357

Catalog $2.00 (refundable).

Design rubber stamps: beetle, elephant, lion head, and other animals, drinks on tray, pocket watch; period images; historical locales and costumes; antiquities; unusuals (Spam, luggage, coins, bottles). Palmer Cox Brownie. Christmas designs, ornate alphabets, Cupids.

L.A. Stampworks
P.O. Box 2329
No. Hollywood, CA 91610
213-662-8847

Catalog $3.00 (refundable).

Rubber stamp images including Popeye characters in action, and balloon quotes. Air mail stamps. Animals: dogs, cats, fish, raccoons, elephant, giraffe, horse, stork, pigs, turtle, dinosaurs, panda, mice, teddy; calligraphy horses, deer, swan, others. Circle motifs: lion, music band, faces. Art Nouveau designs, florals, scenes. People: cowboys on fence and in saloon, generals, fat ballerinas, skinny dancers, mermaids, merbabies, super kid, "Me Jane," flappers and 1930s ladies. Old-time people, silhouettes of couples. Holiday—witches, pumpkin, ghost, cats, angel, cupids, reindeer, Santas; New Year's motifs. Teachers stamp certificates: Reward of Merit, and Perfect Attendance Certificate. Popeye stamps are sold mounted only. All other stamps are available unmounted at half price.

Lady and the Stamp
3358 E. Yorba Linda Blvd.
Fullerton, CA 92631
714-996-9592

Send SASE for list.

Rubber stamp images in an array of designs. Supplies: stamp pads, papers, pens and markers, embossing powder, ribbon, tissue, glitter supplies. Paper: stationery, tags, stickers, gift boxes, others.

Rubber stamp design. © All Night Media, Inc.

Lasting Impressions
1088 Irvine Blvd.
Tustin, CA 92680

Catalog $2.00 (refundable).

Rubber stamps in dog and cat images—lifelike, variety of species. Others. (Also sells wholesale.)

Loving Little Rubber Stamps
P.O. Box 2171
San Ramon, CA 94583

Free catalog.

Over 400 rubber stamp designs—originals and oldies: people, pens, pencils, ink bottle, hearts, others. Stamp pads in 16 colors.

Moonlight Graphics
P.O. Box 2700
Huntington Beach, CA 92647

20 page catalog $2.00 (refundable).

Rubber stamps—Roadstamps™ "Sign language" designs: Yield, One Way (with arrow), Merge, Stop, Keep Right, etc. all with short phrase.

Museum of Modern Rubber
187 Orangethorpe Ave.
Placentia, CA 92670
714-993-1198

Catalog $3.00.

Rubber stamp images (specialty is topical stamps, and "stamps-of-art"): Western—cowboys, pinto, pueblo, cactus, coyotes, cow skull, church, taco. Venus in shell, "American Gothic," Campbell's soup can, Dali time. Western/holiday motifs, cupids, zany characters. V.I.P's and others—George and cigar, Three Stooges, Elvis,

Georgia, Little Richard, Dick & Jane, jester. Bongos, teen dancers, Hollywood sign. Slogans—Rock and Roll, Tutti Frutti, Mercy, Don't Be Cruel!, Cha cha cha!, Surprise!, Calling all cars! Unmounted stamps at half price. (Also sells wholesale.)

Name Brand
P.O. Box 34245
Bethesda, MD 20827

Catalog $2.00 (refundable).

Calligraphic rubber stamps: We've Moved, Handmade By, Thank you, Junk Mail, others. Custom stamps (addresses, monograms, names); logos. "Wholesale inquiries welcome."

Nature Impressions
2007 Leneve Place
El Cerrito, CA 94530
415-527-9622

Catalog $1.35.

Over 400 rubber stamp images including New Active™ interacting images, characters, and changes of accessories and clothes; nature stamps, original animals. Stamp pads, brush marker pens.

Neato Stuff's Rubber-Stamp Cookbook
P.O. Box 4066
Carson City, NV 89710

Catalog $3.00 (refundable).

Rubber stamps in cooking images: 5 designs for recipe cards, 80+ words/phrases used in recipes; popcorn and other food motifs. Has unmounted stamps at half price.

Nifty Rubber Stamps
P.O. Box 2081
Hoboken, NJ 07030

Catalog $1.00 (refundable).

Rubber stamp designs: "Happy Stampers" faces, dance steps, car, cactus, ant, others.

Once Upon A Stamp
356 W. Eagle Lake Dr.
Maple Grove, MN 55369
612-425-6053

Catalog $1.00 (refundable).

Artistic rubber stamps: duck, cat, mouse with book and candle, frog and flower, ant, rabbit, butterfly, other. Wagon, other motifs, some with left and right versions. Unmounted stamps for half price. (Also sells wholesale.)

Orange Rubber Stamp Co.
59 Bacon St.
Orange, ME 01364
508-544-2202

32 page catalog $2.00 (refundable).

Graphic rubber stamps: dressed "Uncle Wiggly" rabbits, crow, dog, goat, crocodile, ladybugs running, others.

Palo Alto Rubber Stamps
3892 El Camino Real
Palo Alto, CA 94306

Catalog $1.00.

Design rubber stamps: man and camera with tripod, man with newspaper; postmark designs; others.

Peace Resource Project
P.O. Box 1122
Arcata, CA 95521
707-822-4229

Write for catalog.

Artistic rubber stamps with peace motifs and slogans: "Peace" in several languages, "Give Peace A Chance" with dove, "Arms are for Hugging" with children hugging, "World Peace" with smile face, "Sow the Seeds of Peace & Justice" with figure, "Create Peace" with Picasso dove/face, "Wage Peace," "Let Peace Begin with Me" and doves, "Nuclear weapons may they rust in peace," "Peace" with olive branch, peace sign, others. (Also has peace buttons, bumper stickers, T-shirts, posters, and a list of peace organizations.) Has quantity prices.

Print Play
P.O. Box 4252
Portland, OR 97208
503-274-8720

Free brochure.

Individual words rubber stamp collection — to mix for slogans, etc., or complement pictorial designs.

Quaker City Type
R.D. 3 Box 134
Honeybrook, PA 19344

Catalog $2.00 (refundable).

Type in a variety of styles, for printing and stamps.

Quarter Moon
P.O. Box 61185
San Jose, CA 95161

Catalog $2.50.

Artistic rubber stamps: teddy bears, cats, other animals, circus performers, borders, flowers, holiday items, people, rabbits, alphabets, hearts, train, boat, Asian art, borders, flowers, coins, others. Rollagraph roller stamps (animals, slogans, Asian dragon, others). Has unmounted stamps at half price. (Also sells wholesale.)

Remarkable Rubber Stamps
P.O. Box 2004
Snoqualmie, WA 98065

Catalog $2.50.

Rubber stamps in a wide variety of designs. (Also sells wholesale.)

Rubber Duck Stamp Co.
P.O. Box 3005
Granada Hills, CA 91394
818-831-1138

"Duckalog" $3.00.

Rubber stamps including ducks, rabbits, teddy bears, Easter baskets, flowers, others. Assorted die cuts. Supplies: pads, inks, wood blocks. (Also wholesale.)

Rubber Stamp Express
1409 Kuehner Dr., Ste. 205
Simi Valley, CA 93063

Catalog $4.00.

Design rubber stamps including postmark designs with "Sheep's Post," "Royal Post," "Southwest Express," "Santa Fe Railroad," others. Animals (pigs, 4 chickens, 8 cows, deer, sheep, rabbits, rams, 23 dogs, 4 cats, fish, frogs; wild animals). "En route" — cars of the past, airplanes, bus, bicycles, trains, balloon. Borders, other designs. People in action, variety of sports, dancing, vintage poses, babies. Face parts (eyes, ears, nose, lips). Objects: kitchen items, fruits, veggies, trees, 2 skylines, globe, flowers. Holiday — cupids, heart, flag, turkeys, witch, 5 Santas, Greetings. Southwest — symbols, Indians, 10 cactus, cowboys, peacepipe, 3 tipis, canoe, borders, scenes, boots/hat. Surfing stamps: 5 figures on surfboards, scuba diver, waves, others. Supplies: stationery — deckled textured, 6 colors. Blank postage stamps. Embossing powder (clear gloss). Postcards, gift tags, label paper. Sells unmounted stamps at half price. (Also sells wholesale.)

Rubberstampede
P.O. Box 246
Berkeley, CA 94701
415-843-8910

30 page catalog $2.00.

Rubber stamp designs (mostly original): trees, flowers; Rocky & Bullwinkle, Betty Boop motifs. 4 dinosaurs, unicorns, dragon, animal groups, Noah's ark, ballet cat, cows, cats, horse, pigs, sitting girls, teen dancers. Valentine motifs (teddies, hearts, cupid), slogans, and bears. "Happy Birthday, "Thank You" and heart, and others. 15 action striped cats, 58+ teddies, ducks, tigers, giraffe, turtle, birds. Holiday — mouse in wreath, teddy wreath, angel, "Peace on Earth." Teacher stamps — "Good Job" dinosaur, "Neater Please" (and pig), "Super Star" (chicken), "I Think You Can, I Know You Can" (train), others. 17 roller stamps — borders (slogans, footprints, garland, teddies, cat tracks, others). Face Case: eyes, noses, mouths — to mix. Love kit — teddies, hearts, flowers, animals, alphabet; alphabet kits. Christmas — cats in bed, Santa, reindeer, bears, trees, others. Menorah. Turkey, witch. Posh Impressions stamps from variety of companies: fish, swimmers, springboard, suns, vacation items, sports, music, school days, people, punctuation (slogans), signboards, presents, bags. Birthday and celebrations, planes, balloons, hearts, holiday motifs. Brushes, art marker sets, wrapping papers (colors). 14 ink pads (and rainbow), giant pads, 2" pads; metallics and inks.

Sonlight Impressions
17517 Fabrica Way
Cerritos, CA 90703
714-739-LITE

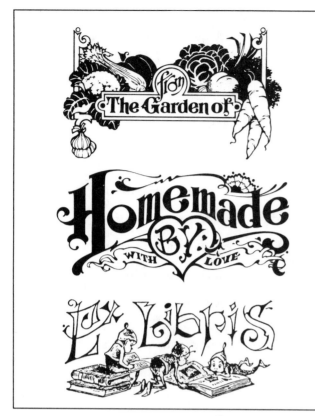

Rubber stamp designs. © Good Impressions.

Catalog $3.00.

Rubber stamps—Christian Design series (in English and Spanish): Peace dove, dove with word "Peace;" cross, sun and clouds; lighthouse "Let Your Light Shine," "Born Again," with butterfly. "Love One Another as I Have Loved You," with heart; others. Other series of designs. Has unmounted stamps at half price. (Also sells wholesale.)

Square Beans
P.O. Box 234
Oceanport, NJ 07757

Catalog $2.00.

Artistic rubber stamps including 5 realistic dinosaurs; other motifs.

Stamp Berry Farms
1952 Everett St.
No. Valley Stream, NY 11580

Catalog $2.00 (refundable).

Artistic rubber stamps: 6 face playing cards with cartoon, other signs and banners; old time figures and items, humorous figures and faces; copyright free designs; designs on dance, sports, music, food, household items, vehicles, textures, quotes, hands, 36 Christmas, 24 Halloween, 26 Valentine. Over 60 animals, religious items, mail, greetings, alphabets. Birthday cake, and number candles. Cartoon sets of hands and feet; special effects sets. Custom face stamps from customer's design (or photo, passport, etc.). Supplies: markers, sets, fabric transfer paint set, blank cards and envelopes. Stamp pads. Has unmounted stamps at half price.

Stamp of Excellence
1824 Pinion Ave.
Canon City, CO 81212
719-275-8422

Catalog $1.00.

Rubber stamps including valentine designs and others. (Also sells wholesale).

Stampendous!
1945 W. Commonwealth "N"
Fullerton, CA 92633

Catalog $3.00.

Original design rubber stamps: Handcrafted By and other slogans; bears and rabbits and other "creative" figures in action. Mini-stamp sets, supplies. Has MasterCard, Visa.

Stampinks Unlimited
P.O. Box 386
Mentor, OH 44061

Catalog and supplement $2.50.

Artistic rubber stamps: peace motifs/slogans — "Wage Peace" and globe, peace dogs, peace (in several languages, and in Chinese). "You're Special" and stars, "World Peace (patchwork/dove) Piece by Piece," "World Peace (sun rising) Begins Within." E. Robin Allen's carousel/stylized designs: 21 horses, camel, griffin, zebra, chariot, jester, and cherub motif. Other carousel animals (cow, rabbit, dragon, others). Cindy Pacileo's round frog pond, zoo and woodland animals, cats, zebras, others. Mail art—stamps, "Postcard." Star motifs, hearts. Animals—elephants, pig, camel, birds. Indian animals and motifs. Phoenix, cats, penguins in action. 2 castles, 3 cathedrals, trees. Messages: Happy Hanukkah! Thank You, PS., Postcard, others. Whimsical teddies, Peggy Trauger international dolls. People, roses. Custom stamps made from black/white artwork, logo, child's art, other. Supplies: Niji stamp pads in dream hues, metallics, rainbows, 15 standard pads, 4 large pads. Blank puzzles, postcards (glossy, textured, colors). Has unmounted stamps at half price. (Also sells wholesale.)

Stewart-Superior Corp.
1800 W. Larchmont Ave.
Chicago, IL 60613
312-935-6025

Send SASE with inquiry.

Rubber stamp manufacturing equipment/supplies: vulcanizers, stamp gum, matrix, imprinted stamp pads, cements, daters, seals, photopolymers, acrylic mounts, inks (over 35 colors), cushions, molding, brushes, bottles, sign makers, others.

The Country Peddler
541 W. Country Hills Dr.
La Habra, CA 90631

Send double-stamped large SASE for list.

Artistic rubber stamps: teacher stamps in English and Spanish, including dinosaur holding "Excelente" sign, others. Calligraphy months of the year. Flower borders. Others.

Rubber stamp images. © E. Robin Allen & Stampinks Unlimited.

The Rubber Room
P.O. Box 7149
Redwood City, CA 94063

Catalog $2.00 (refundable).

Novelty rubber stamps in a variety of designs.

The Stamp Pad Co., Inc.
P.O. Box 43
Big Lake, MN 55309
612-263-6646

Catalog $1.00.

Rubber stamps—over 2,000 designs; or script or block types. Custom first name stamps in three styles. Others. MasterCard, Visa.

Top Drawer Rubber Stamp Co.
RR 2, Box 990
Rochester, CT 05767
802-767-4761

Catalog $2.00.

Pictorial rubber stamps: Christmas greetings, angel, star, minis, stockings, present, trees, others. Wreath, angel/kids/tree. Flowers and plants. 6 dinosaurs. Fantasy—boy and girl/bubbles, dragons, unicorns, mermaids, fairies. Space — stars, saucers, planet. Oceanic — fish, waves, palms, shells. Animals—dogs, cats, insects, geese, elephants, singing frog, sheep, spider/web, horse, pig, cow, 11 teddies. 7 hearts and 4 rainbows. 3 bookplates. Bamboo set. Indian borders, opticals. People — crowd, in action, silhouettes. Fruits, food, computer, locomotives, telephone ringing. Messages — "From the Kitchen Of," "From the Garden Of." Slogans. Comics motifs and: film strip, sun, heart, candy box, bears border, stars, balloons, birthday cake. 4 screen (background) stamps. Paper

items: card sets, stationery sets, postcards, gift tags, bookmarks—all in bright colors, pastels, cream, white. Blank playing cards. 10 colors stamp pads, and inks.

Toybox Rubber Stamps
P.O. Box 1467
Healdsburg, CA 95448

Send SASE for list.

Pictorial rubber stamps including heart designs, others.

Uncle Rebus Stamp Company
P.O. Box 334
Rutherford, CA 94573

Send stamp for catalog.

Line of rubber stamp designs.

W.C. Ward Stamps Etc.
3165 Rainbow Glen Rd.
Rainbow, CA 92028
619-295-5044

Catalog $2.00.

Artistic rubber stamp designs. (Also sells wholesale.)

Wood Cellar Graphics
P.O. Box 409
Randolph, NE 68771
402-337-1627

Catalog $2.00.

Works of Heart
P.O. Box 15007
Portland, OR 97215

Catalog $2.00.

Artistic rubber stamps, including dual-use stamps for fabric and paper. Fabric paints and supplies.
Over 700 original rubber stamp designs; custom stamps. "Wholesale welcome."

Rubber stamp images. © Circustamps.

Scrimshaw

🐚🐚🐚🐚🐚🐚🐚🐚🐚🐚🐚🐚🐚🐚🐚

See also JEWELRY MAKING & LAPIDARY and related categories for materials; BOOKS & BOOKSELLERS, PUBLICATIONS, and ASSOCIATIONS.

🐚🐚🐚🐚🐚🐚🐚🐚🐚🐚🐚🐚🐚🐚🐚

An Alaska Old Ivory Dealer
1825 Loose Moose Loop
North Pole, AK 99705

Send SASE with inquiry.

Fossil walrus ivory material (also has finished scrimshaw, carvings).

Boone Trading Company
562 Coyota Rd.
Brinnon, WA 98320
206-796-4330

Catalog $1.00.

Raw materials: fossil walrus ivory (teeth, 3 sizes), chunks, tips, polished pieces, tusks—5 sizes, scrap chips. Elephant ivory: scrap (2 grades), tusk tips, slabs, tusk sections, whole tusks, tusk hollows. Mammoth ivory.

Elephant ivory jewelry blanks. Polished ivory slabs. Ivory/metal belt buckle blanks. Scrimshaw kits (ink, tools, patterns, ivory). Polycast simulated stag, amber, and ivory (30-50% original material bonded with resin). Stag antler burrs, crowns, rosettes. Sheep horns. Scrimshaw book. (Also has animal skins, trade beads, ancient coins, others). Has quantity prices. MasterCard, Visa. (Also sells wholesale to businesses.)

Hunters Ivory
1022 lst Place
Springfield, OR 97477
503-747-1973

Free catalog; or catalog plus generous sample $5.00.

Fossil walrus ivory (small, to whole tusks), beads. Walrus teeth. Scrimshaw kits. (Also has carvings, artifacts).

Scrimshaw Unlimited
1511 Oxford
Grosse Pointe, MI 48236

Free catalog.

Scrimshaw tracing patterns, findings, tools, ivory. Scrimshaw kit (ink, scribe, practice piece, ivory blank, etc.). (Also has finished scrimshaw.)

Example of scrimshaw, on ivory. Boone Trading Company, Inc.

Sculpture & Modeling

🐦🐦🐦🐦🐦🐦🐦🐦🐦🐦🐦🐦🐦🐦🐦

See also CERAMICS, METALWORKING, MOLD CRAFTS, WOODWORKING, and other related categories; BOOKS & BOOKSELLERS, PUBLICATIONS, and ASSOCIATIONS.

🐦🐦🐦🐦🐦🐦🐦🐦🐦🐦🐦🐦🐦🐦🐦

American Art Clay Co., Inc.
4717 W. 16th St.
Indianapolis, IN 46222
317-244-6871

Contact a dealer or send SASE for details.

Fimo™ modeling material for small items, miniatures, jewelry, other sculpting, home oven fires; in 36 bright colors. Sculptamold modeling compound, clays, others. (See CERAMICS.)

Art Studio Casting
234 Huron St.
Brooklyn, NY 11222
718-389-7200

Send SASE or call for full information.

Custom foundry services in the lost wax process. Mold making, fine finishing, patination, and fabrication.

Boyd's
P.O. Box 6232-F
Augusta, GA 30906

Formulas for modeling materials (from home ingredients), with directions: 16+ modeling "clays" (most air dry), 3 carving "stones," and casting materials; making molds for plaster casting; glues, paints; and candle making materials; hints; $4.50 ppd.

BRI Metal Fabricators
72 Knowlton St.
Bridgeport, CT 06608
203-368-1649

Send SASE or call for information.

Metal sculpture service: flame cutting, press forming, shearing, machining, plasma cutting, roll forming, welding, and finishing.

Bryant Laboratory, Inc.
1101 Fifth St.
Berkeley, CA 94710
415-526-3141

Write for price list and formulas.

Patina chemicals: ammonium chloride, ferric nitrate, ammonium sulfide, potash (sulfurated), silver nitrate, barium chloride and sulfide, borax, calcium carbonate, eucalyptus oil, gold chloride, mercury, potassiums, sodiums, talc, patina preservative, urea, zincs. Others. Lab items: alcohol lamps, 10 sizes beakers, bottles, paper (filter), bunsen burner, cylinders, clamps, flasks, funnels, hydrometers, petri dishes, slides, droppers, pipets, stoppers, stirrers, test tubes, tubing, thermometers, others. Glassware. Books: Patina recipes. Sculpting methods. Quantity prices. Discount to teachers and institutions.

Dick Blick
Box 1267
Galesburg, IL 61401

Catalog $3.00.

Full line of sculpture materials: soapstone (Bermuda sea green), alabaster. Stone sculpture tool set (4 pc, booklet). Modeling: Friendly Plastic (and sticks, pencils), instant papier maches (and white mache), Sculptamold, plastercraft gauze roll, plaster of Paris (and molds), Sculpey, Sculpey III colors, modeling clay, Plasticolor. Clays: Mexican pottery, Marblex, Westwood ovencraft. Egyptian Paste, earthenware types, other kitchen oven-fired clays. Glazes. Tools: ceramic and modeling sets. Aids. (See CRAFT SUPPLIES and ARTIST'S SUPPLIES.)

Dodd
P.O. Box 298
Woodland Hills, CA 91365
818-718-2824

Send SASE or call with inquiry.

Sculpting marble in large sizes, up to 6 tons: blacks (Belgian, Portoro, Carrara); pinks (Portugal, France, Norway, Italy), whites from Biano P., Carrara, Statuario, Arrabescato. Rust-peach from Verona, San Lorian. Pallisadro blue-white-purple. Classic beige-white-brown; gray, green, Roso Levanto, Calcata, Siena, beige. Travertine in red, silver, beige. Alabaster and onyx in many colors. Others. Bases (squares, cubes, rectangles, cylinders).

Durham
Box 804
Des Moines, IA 50304

Send long SASE for handcraft booklet.

Durham's Rock Hard Water Putty: molds, carves, sculpts, models, or casts (no firing).

East Mesa Inc.
P.O. Box 315
Thermal, CA 92274
619-564-4560

Send SASE for further details.

Soapstone soft sculpture stone, cleaned and cut (polishes like marble), by the pound.

First Base of New York
1651 Third Ave.
New York, NY 10128
212-348-3102

Send SASE or write for estimates.

Bases for sculpture, antiques, art objects, others; professional mounting, on-site installations.

Hoheb Studios
689 Washington St.
Ashland, OR 97520
503-488-0835

Send SASE with inquiry.

Custom sculptural enlargement services — works from models or drawings, and enlarges sculpture to any size for final execution in bronze, stone, fiberglass, or plaster.

Jerry Porter
P.O. Box 3241, University Station
Charlottesville, VA 22903
804-293-6858

Send SASE or call with inquiry.

Virginia Alberene black soapstone (a soft cross between African wonderstone and Belgian black soapstone) — small to huge pieces. From the quarry.

Laran Bronze, Inc.
310 E. 6th St.
Chester, PA 19013
215-874-4414

Send SASE with inquiry.

Lost wax ceramic shell foundry. Custom services: bronze and aluminum casting, rubber mold making, polyester and fiberglass castings in large sizes, and enlarging.

Montoya/MAS International, Inc.
435 Southern Blvd.
W. Palm Beach, FL 33405
407-832-4401

Catalog $3.00.

Carving stones imported from areas worldwide; huge stock of marble bases—all sizes, colors. Custom mounting. Over 1600 types of sculpture tools — hard-to-find and exclusive imports. Full custom service art foundry: mold making, casting, enlarging, patination, mounting.

Paul King Foundry
92 Allendale Ave.
Johnston, RI 02919
401-231-3120

Write or call with inquiry.

Custom services: sculptural and architectural castings, lost wax and French sand process; bronze, aluminum, and other non-ferrous metals.

Polyform Products Co.
9420 W. Byron St.
Schiller Park, IL 60176
708-678-4836

Contact your dealer or write for details.

Super Sculpey ceramic-like sculpturing compound (chip and shatter proof), for miniatures, plaques, jewelry, sculpture; workable until baked in home oven at 300 degrees; can be molded by hand, sanded, drilled, painted, engraved, carved, antiqued, glazed, or bronzed; white color. Sculpey III in 30 colors. Boxed or multi-packs. Glaze. Idea booklet.

Premier Wax Co., Inc.
3327 Hidden Valley Dr.
Little Rock, AR 72212
501-225-2925

Send SASE or call for full information.

Microcrystalline waxes (for sculpting and casting): Victory, in 3 colors. Be Square types. In 10 lb. and up lots.

Sculpture Studio & Foundry
1150 Clare Ave.
W. Palm Beach, FL 33401
407-833-6950

Send SASE or call with inquiry.

Art casting services: enlargements, mold making, bronze casting via ceramic shell, resin and stone casting, patina.

Steatite of Southern Oregon, Inc.
2891 Elk Lane
Grants Pass, OR 97527
503-479-3646

Send SASE for prices.

Oregon soapstone — sculpturing/carving stone, mined and inspected. (Also sells wholesale.)

Tallix
175 Fishkill Ave.
Beacon, NY 12508
914-838-1111

Send SASE or call for price quotes.

Custom services: This foundry, with enlarging studio, has a technique of scraping that enables them to enlarge "with accuracy and detail far beyond traditional armature building and pointing." Will enlarge any sculpture to any size and to any degree of finish.

Trow and Holden Company
P.O. Box 475
Barre, VT 05641

Free catalog.

Line of stone sculpting and cutting tools: pneumatic carving, carbide tip chisels, ripper, chisels (machine, splitter, cleaning up, double blade, marble lettering, four point, nine point, marble tooth & cutting types), carver's and other drills. Slab splitter, striking and mash hammers, paving cutters buster, others. Wedges and shims. Straight edge, and parts. Air stopcocks. Stone Lewis, lifting dogs. Allows discount to teachers and institutions. (Also sells wholesale to businesses.)

Sign Making

🐦🐦🐦🐦🐦🐦🐦🐦🐦🐦🐦🐦🐦🐦🐦🐦

See also ARTIST'S SUPPLIES; PAINTS, FINISHES & ADHESIVES; TOLE & DECORATIVE CRAFTS; and other related categories; and PUBLICATIONS, ASSOCIATIONS.

🐦🐦🐦🐦🐦🐦🐦🐦🐦🐦🐦🐦🐦🐦🐦🐦

Americraft Corporation
904 4th St. W.
Palmetto, FL 34221
813-722-6631

Free catalogs.

Florida Plastics™ Letters: formed, dimensional, molded, cut-out, Side Lites™ 2-color letters, Sign Language™ and Bronze-Lite™ products, Grafix™ panels. E-Z Change™ changeable copy Plexiglas™ letters; others.

Art Essentials of New York Ltd.
Three Cross Street
Suffern, NY 10901

Send SASE for product lists.

Gold leaf, genuine and composition, sheets and rolls (22K patent, 23K patent, 22K and 23K glass type, white gold, French pale gold, lemon gold, gold metal or composition types). Silver leaf. Supplies: gilding size, gilding knife, burnishing clay, tools, brushes. Books. In Canada at 508 Douglas Ave., Toronto, Ontario, M5M 1H5.

Booger "T" Signs
1228 South Marion St.
Lake City, FL 32055
904-752-0039

Send SASE for full information.

Dream Easel frame—raises and lowers with touch of button, adjusts to any angle; in kit form that includes 1/3HP Dayton motor and all mechanical components, easy assembly instructions (you furnish 2 pipe uprights and a 48 or 4 X 10 easel board). Dream Stool portable, knockdown lettering stool with padded seat that adjusts from 6" to 24"; on casters. Manufacturer.

Capitol Design
2644 William Tuller Dr.
Columbia, SC 29205

Send SASE for full details.

Redwood sign blanks in 1 3/4" or 3" thick, kiln-dried, vertical grain — by square foot. Unfinished sandblasted signs (ready-to-paint). Penofin™ wood finishes.

Chromatic Paint Corporation
P.O. Box 690
Stony Point, NY 10980
914-947-3546

Contact dealer, or send SASE for information.

Chromatic sign paints: prime coats (for metal, wood), top coats (bulletin color, one-coat lettering enamel, background and industrial enamel, structural steel coatings), acrylic and synthetic enamels. Specialty paints: art poster colors, Japanese, oils. Gold leaf. Clear coatings: LeFranc and Bourgeois gold size. Varnishes, acrylic top coat. Chromatic brushes (produced jointly with Raphael), handmade fine brown and gray quills, flats, fitches, cutters, stripers. Manufacturer.

Commercial School of Lettering
513 E. Hawthorne St.
Ft. Wayne, IN 46806

Send SASE for full information.

Instructional sign painting video courses for beginners. Volume I covers brushes, basic strokes, materials, pricing (with book, price guide, pinstriping booklet). Volume II: layout, doing banners, showcards, trucks, etc.

Creative Assemblies
1700 Freeway Blvd.
Minneapolis, MN 55430
612-566-8031

Free Swatches and Price List.

Blank banners and supplies — of materials including polyethelene, Tara sign cloth, Tygerag, Columbus sign cloth; many vinyls. All banners with double-stitched hems, ropes, and grommets. Flexel enamel-receptive banner material by yard or pre-sewn blanks. Enamel-receptive vinyl (10 oz. plus) with enamel paints, without top coating. Aqua Paint colors (alternative to vinyl inks).

Dick Blick
Box 1267
Galesburg, IL 61402

Catalog $3.00.

Arts, crafts, graphics, and sign making supplies including: brushes, paints, airbrushes, banners, sign blanks, sign cloth. Sandblaster units. Supplies and equipment for screen printing, gold leafing, pin striping. Lettering and other books. (See ARTIST'S SUPPLIES.)

Earl Mich Company
806 N. Peoria St.
Chicago, IL 60622
312-829-1552

Write or call for information.

Sign letters—vinyl and reflective types (computer pre-spaced or individual die cut): computer digitized logos, punched materials, universal symbols, alphabet sheets, screen printing—police and fire decals, 1/8" thick plastic dimensional letters, static lettering. Magnetic sheeting, letters, signs. Pre-spacing tapes. Vinyl and reflective material in sheets, rolls, striping. Other die-cut sign graphics. 100+ colors and type styles. MasterCard, Visa.

E-Z Sign
23 S. Fairview
Goleta, CA 93117

Sample lesson $1.00.

Lessons in sign painting.

Finesse Pinstriping Inc.
P.O. Box 1428, Linden Hill Sta.
Flushing, NY 11354
718-939-8837

Write or call for free sample.

Striper™ paint pinstriping stencils, 26 styles. The Edge™ ultra-thin tape for fine masking (on any smooth surface, for clean, sharp edge line) in 10 widths.

Gemini Incorporated
103 Mensing Way
Cannon Falls, MN 55009
507-263-3957

Free catalog.

Letters: vacuum formed plastic, injection molded plastic, cast aluminum, cast bronze, flat cut-out plastic and metal types, edge trim gemlite letters. Aluminum and bronze plaques. Custom metal cutouts, custom formed plastic. Also has videos, manuals.

Graphics Etc., Inc.
P.O. Box 295
Bensenville, IL 60106
312-860-2834

Send SASE or call for full information.

Vinyl graphics, prespaced, ready-to-apply: 84 type styles (½" to 48") and extensions, condensations, italics, outlined. Paper and pounced patterns (1" to 100" high), 130 vinyl colors. Custom services: logo digitizing and scanning; screen printing (any size, quantity) of magnetics, cards, paper, decals, banners, metal. MasterCard, Visa.

Hartco
1280 Glendale-Milford Rd.
Cincinnati, OH 45215

Send SASE for full information.

Sandmask stencils: vinyl, in 4 widths for sandblasting raw or treated wood, plastic, or glass; 2 widths for border work; pin-feed stencil materials, and etching tape in 2 widths for light frosting and multi-stage carving of glass.

Haynes Sign Co.
Hwy. 27 South
Murrels Inlet, SC 29576

Send SASE for details.

Video on Sign Painting from veteran painter; with step-by-step directions, demonstration of techniques.

Herculite Products, Inc.
1107 Broadway
New York, NY 10010
212-691-7550

Send SASE for full information.

Bantex laminated banner fabrics; 4 colors, for pressure sensitive vinyl lettering and vinyl silkscreen inks; in 4 widths and 2 roll lengths.

Indiana Sign Supply
1919 E. Jefferson St.
Kokomo, IN 46901
317-457-1711

Write or call for catalog.

Full line of sign making supplies.

Kaufman Signs
Centertown, MO 65023

Free catalog.

Sign making supplies; pinstriping items. Books.

Kurfees Coatings, Inc.
P.O. Box 1093
Louisville, KY 40201

Send SASE for full information.

Panoramic™ paint for commercial, industrial, and professional use. Apply by brush, roller, or spray; durable, gloss, hiding; in maintenance, bulletins, block-out whites, fluorescents (primers, gloss clear coat, gloss modifiers).

Leo Uhlfelder Co.
420 S. Fulton Ave.
Mt. Vernon, NY 10553
914-664-8701

Send SASE for full information.

Gold leaf — quality Florentine gold, XX deep patent, glass, surface gold, roll gold. Gold size (quick and slow forms). Importers.

Letters Unlimited
32 W. Steamwood Blvd.
Steamwood, IL 60103
708-529-6029

Free catalog and samples.

Computer cut vinyl letters and numbers (letters prespaced), in many type styles, colors (no charge for reverse). No minimum order.

Muller Studios Sign Co.
Ridge Road
Union, CT 06076
203-974-2161

Write or call for details.

Sign blanks constructed of Simpson Signal™ M.D.O., mahogany frames, waterproof glued; variety of sizes and shapes (old-tavern, oval, round, rectangular, other old-world look). Custom wood signs to specifications.

Neon
Box 4410
Arlington, VA 22204

Send SASE for full details.

Course in neon-lighting, includes free video.

Nudo Products, Inc.
2508 So. Grand Ave. E.
Springfield, IL 62703

Write or call for sample.

White-wood sign panel (smooth vinyl surface, factory laminated to exterior plywood on one or both sides); interior or exterior surface is scratch and impact resistant; ready to hand or screen letter with no preparation, or use with vinyl letters, flame resistant; variety of sizes and other substrates. Fiberglass surfaced sign panels.

POUNCE WHEEL HOLDER: *Misplaced your pounce wheel? Try this: Put a pencil clip on your pounce wheel and carry it in your shirt pocket along with your pencils. You'll have it when you need it. Courtesy of Clifton F. Jordan of South Carolina, as reported to* Signcraft *magazine.*

Paxar Corporation
530 Rt. 303
Orangeburg, NY 10962
914-359-4100

Contact dealer, or send SASE for information.

Flexel™ woven polyester (smooth surfaced) banner fabrics, and banner blanks for lettering, enamels, pressure sensitive vinyl graphics, screen inks; blanks have reinforced hems, D rings; many lengths and widths, 5 colors.

Peter Horsley Publications
115 Riverbirch Crescent, S.E.
Calgary, Alberta, Canada T2C 0B8

Write for details.

Home study course in neon. Course clearly written with photos and diagrams, 140 pages, complete technical information; where to order materials; shop setup. Visa.

Pressure Tool Center, Inc.
P.O. Box 23
Brewster, OH 44613
216-832-6134

Send SASE for full details.

Heavy duty sandblaster with easy-load funnel top, 100# sand capacity, HD hose, water extractor, safety valves, patented BRUT squeezer II valve; with one hand operation and automatic shut off; includes hood, with lens extra ceramic nozzle, and seal block.

Rayco Paint Co.
2535 N. Laramie Ave.
Chicago, IL 60639
312-889-0500

Write or call for catalog.

Banner blanks — strong white drill cloth, nylon rope sewn top and bottom, to letter on two sides, if latex coated on one side to opaque cloth; stock sizes from 3' X 8' to 4' X 40'. Sign, screen process, painter's supplies.

Scott Plastics Co.
P.O. Box 1047
Tallevast, FL 34270
813-351-1787

Free catalog.

Sign making materials — raw products, and full line of letters and signs; unfinished high density foam in 3 thicknesses; letter quality; by cut sheet to entire skid. Others.

Sepp Leaf Products, Inc.
381 Park Ave. So.
New York, NY 10016
212-683-2840

Call or send SASE for full information.

August Ruhl gold leaf (22, 23 karat), glass gold XX, patent gold, Palladium leaf, variegated, white gold 12K, pale gold 16K, lemon gold 18K, roll gold 23K and 22K. Gilders tips. LeFranc oil size — 3Hr and 12Hr. Instructional video: Gold Leaf Basics, with Kent H. Smith.

Sign-Mart
1657 N. Glassell
Orange, CA 92667
714-998-9470

Send SASE for full information.

Blank vinyl banner material: 3' X any length; hemmed and grommeted, for lettering or silkscreen; in 12 colors.

T.J. Ronan Paint Corp.
749 E. 135th St.
New York, NY 10454
212-292-1100

Contact dealer, or send SASE for information.

Ronan paints: lettering enamels ("one-stroke," solid hiding, in 28 glossy colors) for metal, wood, others. Bulletin colors, background enamels, brushing and spraying acrylics, Japan colors, fluorescents, non-tarnish liquid gold, specialty sign finishes.

Tara Materials Inc.
Box 646
Lawrenceville, GA 30246
404-963-5256

Write for information.

Vinyl banner cloth — three types, including: Taravyn™ 9 oz. reinforced (for vinyl paints or inks and pressure sensitive graphics). Taravynall™ 10 oz. reinforced and coated on one side to accept paint, ink, enamel, and pressure sensitive graphics. Taracloth III™ ultrasmooth moisture resistant polyflax™ fabric triple coated to accept all paints and pressure sensitive graphics. Tyvek™, Tygerag™, and Taracloth™ banner cloth. Manufacturer.

The Cutawl Company
Rt. 6
Bethel, CT 06801
203-792-8622

Free catalog.

Cutawl™ machine (knife, chisel, saw blades; cuts curves, logo, or pattern; blades swivel 360 degrees) cuts most sign and display materials.

GOLD SIZE: *Adding a little boiled linseed oil to your lettering enamel will retard drying. This also makes an excellent quick size for surface gold work. Courtesy of Val Gemme of Alabama, as reported to* Signcraft *magazine.*

The Durham Co.
54 Woodland St.
Newburyport, ME 01950
508-465-3493

Send SASE for full information.

Gold leaf (hand beaten) including XX deep patent, glass and surface types.

TIP Sandblast Equipment
7075 Rt. 446, P.O. Box 649
Canfield, OH 44406
216-533-3384

Free catalog.

Combination sandblaster and paint units—design is cut after resist material is applied; and wood is sandblasted with blaster unit that includes nozzles, sand hose, hood, (requires 7-15 air). Then wood is spray painted with turbine that has its own air supply (adjusts from 15" fan to ¼" dot) and includes 1 quart gun and hose. 3M™ Buttercut resist material by the yard or roll.

Trademark Sign Systems
89 Turkey Hill Rd.
Ithaca, NY 14850

Color brochures.

Carving and sandblasting blanks: old growth redwood, with vertical grain, splined glue joints, ready to finish; matched boards. (Also sells wholesale to dealers.)

Wenzco Sign Supplies
Box 1728
Grand Rapids, MI 49501
215-966-3555

Send SASE for complete information.

Sandblasted sign supplies (for wood, glass, stone, brick, others): sandblast machines, air compressors, tape masking materials. SignLife products, automatic letter cutting machines, hoods, nozzles, others. Banner supplies.

Yarder Mfg. Co.
708 Phillips Ave.
Toledo, OH 43612
419-476-3933

Send SASE for full details.

Sign blanks—steel and aluminum, stock sizes; "factory-to-you pricing."

Signpainting artists at work. © *SignCraft Magazine, Ft. Myers, FL*

Tole & Decorative Crafts

See also CRAFT SUPPLIES; ARTIST'S SUPPLIES; MINIATURE MAKING; PAINTS, FINISHES & ADHESIVES; FABRIC DECORATING; and other related categories; BOOKS & BOOKSELLERS, PUBLICATIONS, and ASSOCIATIONS.

ACP Inc.
P.O. Box 1426
Salisbury, NC 28145
704-636-3034

Catalog $1.00.

Decorative painting/artists' supplies: Folk Art acrylics—128 shades, 10 color sets (use on canvas, paper, wood, plaster, bisque, clay, leather, fabric, primed metal, basket reed). Media, varnish, brush cleaner. Basins and organizer. Brushes, sponge applicators, steel wool, sandpapers. Loew-Cornell brushes (red sable). Decorative painting books. Calligraphy supplies: pens, inks (also colored), and papers. (Line of basketry materials.) Discount to teachers, institutions, and professionals. Also sells wholesale to businesses. (See BASKETRY.)

Adrienne's Attic
2271 Highview Trail
Vista, CA 92084
619-598-0877

Send SASE for details.

Painter's Tote™ carryall—holds 50 2 oz. bottles (with free printed labels). Made to hold Delta, Illinois Bronze, and Folk Art bottles. "Dealer inquiries invited."

Adventures in Crafts
P.O. Box 6058, Yorkville Station
New York, NY 10128
212-410-9793

Catalog $2.50.

Decoupage, faux finishes, gilding kits and supplies; decoupage kits (by Dee Davis). Prints (traditional, contemporary), miniature ancient Chinese paintings, animals, butterflies, birds, flowers, bouquets, Oriental, Godey's Ladies, Anton Pieck. Black/white small and large prints—botanicals, borders, birds, animals. Wood: boxes (scalloped, sectional, Shaker, trinket, melon, curved trunk, tissue, recipe); lap desks, fireplace, tall screens. Gilding: Dutch metal gold and silver leaf; marbleized. Repousse moldable epoxy, silicone adhesives, sizing. Box hardware. Marbleized papers. Graining tools, brayer, burnisher, mini-tool sets. Finishes, Mod Podge. Books.

All Things Special
P.O. Box 237
Midway City, CA 92655
714-895-6126

Send SASE for complete list.

Pattern/design packets for decorative painting, by Barbara Bertrand. The designs are a bit more contemporary, yet nostalgic; children with animals, with birds, others.

Animal Art
4122 Irving Ave. N.
Minneapolis, MN 55412

Catalog $1.00.

Natural wood animal boxes—3-D animal shapes, top lifts to show opening: rabbits, ducks, pigs/piglet, rooster, ducks, cats, dinosaurs, others.

Annie's Calico Cat Originals
Box 1004
Oakdale, CA 95361

Catalog $1.00.

Woodcrafting patterns (full-sized) including cats. Also in wood cutouts.

Art Craft Wood Shop
Box 75, Hwy. 69A
Crestline, KS 66728
316-389-2574

Catalog $4.00.

Wood items, ready to paint, including table, bench, spool cabinet, glove and trinket boxes, and other cabinets, boxes, secretary, desk.

Art Horizons
P.O. Box 1709
Zilah, WA 98953

Send SASE for full details.

At-home course: Tole and decorative painting (by Meldra Johnson, Artist/Developer); shows how-to's on painting, preparing surfaces, selecting brushes; produce artwork with first lesson; available for oils or acrylics.

B & B Publishing, Inc.
P.O. Box 268
Kissimmee, FL 32742
407-870-2121

Send SASE for list and prices.

VHS videos (60 min. each)—decorative painting instruction: Bountiful Harvest, Wild Rose Tray; by Donna Bryant, using acrylics. Introduction to Color, Blending Techniques; by Ann Kingslan, using oils. Round Ferruled Brush technique, Flat Ferruled Brush; by Maureen McNaughton, using acrylics. Teddy and Balloons (multimedia technique, using acrylics, oils, alkyds) and Old English Country Floral (flower built in stages; using acrylics, oils, alkyds) by Linda Wise.

Barney Roberti, Daughters and Sons
Youngsville, PA 16371

Catalog $2.50 (refundable).

Wood parts, stenciled shapes: country, animals, others.

Bear Woods Supply Co.
Box 40, Bear River
Nova Scotia, Canada B0X 1B0
902-467-3703

Free catalog.

Unfinished wood items — parts, boxes, spindles, toy parts, candle cups, mug pegs, Shaker pegs, others.

Bridgewater Scrollworks
Rt. 1, Box 585
Osage, MN 56570

Catalog $5.00 (refundable).

Wood cutouts in over 1,000 shapes: hearts, animals, flowers, figures, circus pony/rocking horse, others. Custom cutting service. Quantity discounts.

Brushstroke Design Studios
Box 1489
Buzzards Bay, MA 02532

Free color brochure.

Fractur designs, easy-to-paint patterns (pre-printed on parchment, color-coded with instructions); 12 motifs, including some to personalize with names, dates, events.

Cape Cod Cooperage
1150 Queen Anne Rd.
Chatham, MA 02660
508-432-0788

Send SASE for prices.

Barrel staves—sanded, ready-to-decorate/paint. Hinged top chests and boxes.

Cedar Hills Enterprises
Rt. 2, Box 107A
Booneville, MS 38829
601-728-3706

Contact dealer, or write for catalog—$1.00.

Book: *Adventure with Nature*, by Jo Hollingsworth—design/instructional book of 14 subjects in oils, including deer, Canada goose, goldfinch, kinglets, cardinals, bluebirds, and others. 57 painting packets of wildlife and flower motifs. (Also sells wholesale to businesses.)

Charlotte Ford Trunks
Box 536
Spearman, TX 79081
806-659-3027

Illustrated catalog $3.00.

Trunk repair/restoration supplies: hinges, lock sets, other hardware, finishes, linings, others. How-to books to restore, refinish, line, and decorate all kinds of trunks.

Chroma Acrylics Inc.
P.O. Box 510
Hinesport, NJ 08036

Free sourcebook, color card, and booklet.

Jo Sonja's artists' colors/media—for wood, metal, fabrics; 50 "country" colors in matte finish. Media include tanning blocking sealer, antiquing medium (slows drying time), crackle ("ages" the item), texture paste (relief), and clear and wood stain glazing mediums.

Cupboard Distributing
P.O. Box 148
Urbana, OH 43078

Catalog $2.00.

Wooden ware: Shaker pegs, hearts, candle cups, country racks, baskets, checkerboards, spice cupboards, carousel animals, buckets. Paints. Has quantity prices.

Custom Cut-Outs Unlimited
P.O. Box 518
Massillon, OH 44648

Catalog $2.00 (refundable).

Over 550 wood cutouts—variety of shapes/sizes. Custom wood cutting service.

Darcie Hunter Publications
P.O. Box 253
Littlerock, CA 93543
805-944-4559

$.52 SASE for catalog.

Books: tole, country folk painting, others. Has MasterCard, Visa.

Decorative Design Studio, Inc.
Rt. 3, Box 155
Smithburg, MD 21783
301-824-7592

Contact dealer, or catalog $1.00.

Educational videos — "View It 'N Do It" decorative painting lessons (60 minutes each with Jackie Shaw, Ardi Hansen, Nancy Michael, Sherry Gunter; others), total of 60 videos and books. Video subjects include: Angels, Wildflowers, Birds & Butterflies; Cat, Goose; Grandpa Turtle; Simple Strokes & Faux Finishes (close-ups catch every detail as Jackie Shaw and others demonstrate brushstroke techniques). How-to pattern books: folk art titles, wood cutout painting, realistic and Oriental titles—fabric painting, painting, tin punch, stenciling, free handing. Brushes and kits.

Designs America
Box 956141
Duluth, GA 30136

Send SASE for full information.

Wood cutouts (3/4" pine—8" to 24" tall): pull-toys, bookends, mailbox signs, cutouts—Santa, Uncle Sam, eagles, sailors, farm grouping; other figures, animals, shapes. Some with pattern painting packets.

Designs by Rhonda
P.O. Box 289
Poplarville, MS 39470
601-795-8809

Contact dealer, or send SASE for details.

"Designs by Rhonda" books, including Carousel Collection of patterns/instructions for wood, fabric, others; 20 projects with carousels, using brush sculpting techniques. "Wholesale invited."

Factory 2 U Inc.
Box 250
Glenmont, NY 12077
518-371-2790

Catalog $2.00 (refundable).

Woodenware (pine, ready to finish): pegboards (Shaker, country, square edge, others), shelves (heart cutouts), shadow boxes. Over 90 maple and poplar cutouts, 36 minis, "doorknobbers." Plaques and sign boards: hanging, tavern, banner. Wreaths, lap desk. Parts: pegs, wheels, axles, candle cups, dowels. Bases: display, wheel, napkin holder. Baskets. Sliding bookrack, napkin presses, stools, video racks, boxes. Towel bars, racks. Boxes, sconces, candle holders. Quilt rack. Pencil holder, handles. Plywood sheets (1/8" poplar, ¼" Finnish birch, ½" poplar). Custom cutouts to order. Quantity discounts.

Faith Rollins
13010 W. 66th
Shawnee, KS 66216

Catalog $1.00.

"Really Country" painting series (pattern/instructional books) by Faith Rollins, including people, traditional motifs, Christmas, folk art, animals, toys, patriotic motifs, scenics, florals, others. "Dealer inquiries welcome."

Folk Art Etc., Inc.
24-2727 Portage Ave.
Winnipeg, Manitoba, Canada R3J 0R2
203-888-0606

87 page catalog and color chart $3.00.

Folk art and decorative painting supplies: Delta, Ceramcoat, Jo Sonja's Artists' Colors, Acrylics & Stuff, Loew-Cornell brushes, Folk Art acrylics. Unfinished wood cutouts and items; wind chimes, door harps, others.

Forte Industries Inc.
P.O. Box 276
Stephenson, MI 49887

Catalog $1.00.

Wood cutouts and unassembled kits: miniatures, wall units, collector boxes, shadow boxes, basket covers, Christmas shapes. Basswood lumber — 1/8", ¼", ½" widths.

Heritage Saw Co.
11225 6th St. East
Treasure Island, FL 33706
813-367-7557

Catalog $2.00.

Steel saws (selected types) with wood or plastic handles for tole painting.

Heritage Craft Studio Inc.
520 Westney Rd. S #23
Ajax, Ontario, Canada L1S 6W6
415-427-6666

Catalog $3.00.

Woodenware in variety of sizes and shapes; line of paints, brushes, and books. Folk Art painting supplies. (Also sells wholesale.)

Hofcraft
P.O. Box 1791
Grand Rapids, MI 49501

Catalog $3.00.

Tole art supplies: full line of paints (Priscilla, Permanent Pigment, Shiva), dyes, brushes; hand-crafted wood items. Books. "Save up to 40%." MasterCard, Visa.

Homestead Handcrafts
N 1301 Pines Rd.
Spokane, WA 99206
509-928-1986

Catalog $3.00.

Tole and decorative painting supplies: paints (acrylics, fabric, sponging, inks), brushes and cleaners, canvas, mediums, stencils, resin, stains, finishes, unfinished wood. Artist's supplies. Tole books.

House Works Plus
P.O. Box 432
Randolph, VT 05060

Catalog $2.00 (refundable).

Wooden cutouts: hearts on string, peg racks, clam and teddy bear basket, cat silhouettes, others.

Jennings Decoy Co.
30 Lincoln Ave. N.E.
St. Cloud, MN 56304

Free catalog.

Decoy painting kits (blank, eyes, paint, pattern), others. MasterCard, Visa.

Jo Sonja's Folk Art Studio
P.O. Box 9080
Eureka, CA 95501

Catalog $2.00 (refundable).

Pattern/instruction books for decorative painting, including Tea & Chintz (designs for metal items — tray, coffee pot, creamer and sugar); others. (See also PAINTS, FINISHES & ADHESIVES, Chroma Acrylics Inc.)

Julie's White House Originals
2115 E. Edgewood
Springfield, MO 65804

Handcrafted ready-to-finish woodenware. © Factory 2 U Inc.

Contact dealer, or write for information.

"Country Club" series of design/instructions/wood pattern books (each with 15 designs) in variety of designs (Victorian ladies, country dolls, Tulip Garden, Christmas, country animals, floral motifs, others).

Knottingham's Crafts
2312 Jonathan
Rockford, IL 61103

Catalog $2.00 (refundable).

Unfinished wood cutouts, patterns: bears, bunnies, hearts, cats, shelves, children's motifs, dinosaurs, others.

LadyBug Art Center
1901 E. Bennett
Springfield, MO 65804
417-883-4708

Free catalog.

Decorative painting instruction/pattern books: traditional and country designs, including country kids, florals, whimsical animals (rabbits, bears, donkey, cats, dogs, others), wildlife, "Patticakes" characters and animals, "Light in the Window" angels; Victorian Designs, American Reflections scenics, others. MasterCard, Visa.

Laila's
22 Strathearn Ave, Units 1 & 2
Bramalea, Ontario, Canada L6T 4L8

Color catalog $20 or send SASE with inquiry.

Decoupage prints by variety of artists in traditional, classics, florals, animals, birds, and others. Books.

Larson Wood Mfg.
Box 672
Park Rapids, MN 56470

Catalog $3.00 (refundable).

Woodenware: boxes, plaques, frames, toys, novelties, game parts. Stains, paints, hardware. Manufacturer.

Manor House Designs
1909 Kingswood Court #1A
Annapolis, MD 21401

Portfolio subscription $3.00.

Stencil patterns: birdcages, wreaths, potted flowers,

topiaries, tabletop trompe l'oeil, others—patterns with detailed cut and paint instructions.

Marlene Stevens Publications
719 N. 2nd Ave.
Upland, CA 91786

Contact dealer, or send SASE for list.

Marlene Stevens pattern/instructional books: Kottontail Kisses—rabbits, kittens, lambs; Kitty Kapers and Bunny Tails—kittens and rabbits; Huckleberry Hollow country folk and scene, Kitty Kapers Winter Wonderland scenes, others. "Dealer & distributor inquiries welcome."

New England Country Designs
20 Hatheway Rd.
Ellington, CT 06029
203-871-0033

Catalog $2.00.

Pattern packets for New England homes in wood and acrylic (miniature collectibles) — with instructions, drawings, photos, wood. "Dealer inquiries welcome."

Northern Map
Dunnellton, FL 32630

Catalog $1.00.

Maps (70-120 years old) state, railroad, county, Civil War, others; all states.

Plaid Enterprises
P.O. Box 7600
Norcross, GA 30091

Send SASE for further information.

Instructional video (55 min., VHS): Marbleizing, faux finish techniques for home decor using waterbase Folk Art acrylic paints.

Rainbow Woods
20 Andrews St.
Newnan, GA 30263

Free catalog.

Hardwood turnings, unfinished: dowels, wheels, axles, candle cups, hearts, napkin rings, eggs, Shaker pegs, boxes, checkers, fruit, balls, knobs, spindles, others.

Rhonda Williams
P.O. Box 289
Poplarville, MS 39470
601-795-8809

Send SASE for list.

Decorative art painting books: folk art designs (with brush sculpting technique, hand-carved look); Berries & Bows traditional motifs with cross-stitch accents; Touch of Puff sweatshirt designs. Others.

Roberts Reflections
5503 Glenwick Lane
Dallas, TX 75209

Send SASE for brochure.

Decorative painting instructions and patterns with color pictures, for oils, watercolor, arcylic watercolor, and drawing. May have sale prices.

Sammy's Stamps 'N Stuff
P.O. Box 20164
San Diego, CA 92120

Send large SASE for catalog.

Pattern packets for decorative painting: "BearyOriginal" whimsical designs by Elaine Williams (with instructions and photo). Rubber stamps (of several manufacturers).

Sandeen's
1315 White Bear Ave.
St. Paul, MN 55106
612-776-7012

Catalog $2.00 (refundable).

Rosemaling and folk art supplies: wood items, paints, books. Major credit cards. (See EMBROIDERY.)

Sawdust and Paintings
376 E. Rialto Ave.
San Bernardino, CA 92408
714-381-3885

Catalog $2.00 (refundable).

Unfinished wood products—line of shapes, wheels, others.

Scottie's Bavarian Folk Art
6415 Rivington Rd.
Springfield, VA 22152

Contact your dealer or write for packet.

Books: *Scottie's Guide to Bauermalerei* — Book 1 has flower charts/projects in color with step-by-step instructions; Book 3 has German style fruit designs in color.

Sivers Wood Ideas
7710 Cherry Park #140
Houston, TX 77095

Portfolio of patterns $2.00 (refundable).

Original art patterns for tole; wood items.

Stencil House of N.H.
P.O. Box 109
Hooksett, NH 03106

Catalog $2.50 (refundable).

Over 175 stencils (cut from Mylar) in an array of designs including reproductions, children's designs, florals, traditional, others—use stencils on hard surfaces or fabric. Paintstiks™ acrylic paints, brushes, brush cleaner, stencil adhesive, floor cloth. Custom stencils to order.

Sternbergh's White House
221 E. Branch St.
Arroyo Grande, CA 93420

Send SASE for full details.

Instructional decorative painting videos — with Herta (one hour) including rose techniques, "Lucky Duck" on

towel rack, and fabric painting.

Stonewell Herbs
2320 West Moss
Peoria, IL 61604

Booklet $5.50.

Decorating with Herb Stencils, by Jan Powers, includes 7 full-size patterns and instructions, ideas, and herb information; patterns include border repeating types, others.

Susan Scheewe Publications
13435 N.E. Whitaker Way
Portland, OR 97230

Contact dealer, or send SASE for list.

Decorative painting books by Susan Scheewe: pattern/design books including Heritage Trails scenics, Western images, Rustic Charms country scenes, wildflowers, country people, traditional and nostalgic designs, others; "Watercolor Made Easy," and "Painting It's Our Bag" tote bag motifs; others.

The Magic Brush, Inc.
215 Towson Ave.
Ft. Smith, AK 72901

Write for information.

Lois Hulse's how-to's, others. Design/pattern packets.

The Painting Peasants
2145 Slater St.
Santa Rosa, CA 95404

Send SASE for details.

Book: *Faux Finishes*, by Hildy Henry: basic text for painting decorative acrylics with instructions and photos for 12 techniques including malachite, lapis lazuli, marbling, putty graining, combing, tortoise, and others.

The Strawberry Tree, Inc.
One Merrimac St.
Newburyport, MA 01950
617-465-5053

Catalog $1.00.

Unfinished pine wooden ware: spice chests in 3 sizes; boxes, cutout shapes, toy items, decoratives, others.

The Wooden Heart
Rt. 11, Box 2260
Elizabethton, TN 37643

Send SASE for catalog.

Wood designs, plates, birdhouses. Design pattern packets. (And sells wholesale.)

Toft's Tole House
Box 249X21
Waynesville, MO 65583

Catalog $2.00.

"Precious Littles" collection of cutout patterns/kits in folk designs for bookends, others; with photo and instructions.

Tole & Decorating Arts Home Course
P.O. Box 1709
Zillah, WA 98953

Write for information.

Tole and Decorative Painting home study course: step-by-step lessons on how to paint, prepare surfaces, select brushes, and more, for either acrylics or oils.

Town & Country Folk Art Supplies
523 Annette St.
Toronto, Ontario, Canada M6P 1S1
416-766-1088

Send SASE for retail catalog.

Tole painting and folk art supplies: paints, brushes, tinware and wood items, books. (Also sells wholesale.)

Treasures
Box 9
Huntsville, OH 43324

Catalog $3.00 (refundable).

Plans and cutting patterns for furniture pieces and home accessories (as shown in books by Jo Sonja, Helan Barrick, Pat Clarke, Folk Art Finish, and others)—all shapes full size. Also in kits.. (Also has assembled items.)

Ursa Major
695 Mistletoe Rd. #2
Ashland, OR 97520

Send SASE for further information.

Night Sky Star Stencil kit: stars stencil for ceiling, luminous paint (invisible daytime, but shines in the dark 30+ minutes); stencil can be reused if carefully taken down.

Val-Chris Originals
22605 Cantara St.
West Hills, CA 91304

Samples $1.00.

Craft cards designed for tole and decorative painters, in 4 styles; for professional display.

Viking Folk Art Publications
1317 8th St. S.E.
Waseca, MN 56093
507-835-8043

Contact dealer or send SASE for list.

Pattern/instruction books for decorative painting: transparent flowers (acrylics and bronzing powder), traditional and country designs, for all levels of ability; decorated dimensional frames, sweatshirt designs; others.

White Pine Designs, Inc.
RR #1, Box 99
Roland, IA 50236
515-388-4601

Catalog $3.00.

Raw wood boxes: pantry, recipe, jewelry, trunks, tissue. Doll toys and furniture. Others. (And sells wholesale.)

Wolford Enterprises
P.O. Box 3321
Fontana, CA 92335

Send SASE for details.

Little doll pictures (ready to paint), on ivory bristol (5 ½" X 8½"). Others.

Worden's World of Crafts Inc.
3359 No. Federal Hwy.
Pompano Beach, FL 33064

Free catalog.

Papier tole kits (75 designs)—traditional and classic motifs, florals, others.

Handcrafted ready-to-finish woodenware. © Factory 2 U Inc.

Tools & Equipment—Multipurpose

See also specific crafts and hobbies.

Addkison Hardware Co., Inc.
126 E. Amite St., P.O. Box 102
Jackson, MS 39201
800-821-2750 (except MS)

Write Tool Dept. with inquiry.

Machines and power tools: Powermatic machines, Dewalt radial-arm saws; power tools by Bosch, Freud, Makita, Skil, Porter-Cable, Jorgensen Clamps. "35% discount" off list on Bosch router bits and shaper cutters.

Aldy Graphic Supply Inc.
1115 Hennepin Ave.
Minneapolis, MN 55403

Send SASE for full information.

Art projectors: large-scale model with removable copy cover that holds copy flush to glass aperture to ensure accurate image projection; featuring a scale range from 2X to 40X enlargement, a copy aperture of 8" sq. Multi-directional freestanding model, with multi-directional lens holder that rotates 360 degrees; copyboard size of 11" X 24", vertical range of 50% reduction to 5X enlargement and horizontal range of 50% to 40X enlargement; will accommodate large artwork, 3-D objects, slides, transparencies. Transparency model (projects large-scale image at a short distance). MasterCard, Visa.

Artograph, Inc.
13205 16th Ave. No.
Minneapolis, MN 55441
612-553-1112

Inquire for nearest dealer.

Artograph art projectors including the DB400 model—projects sharp image on anything, from anything (photos, line art, type, slides, 3-D objects, transparencies) and goes up to 800% or down to 33% instantly; mounts on drawing board. Model AG100 enlarges up to 20 times, with horizontal or vertical projection. Other models.

Blue Ridge Machinery & Tools, Inc.
Box 536
Hurricane, WV 25526
304-562-3538

Catalog $1.00.

Machinery/tools: lathes, milling machines, hand and power tools from Unimat, Compact, Maximat, Myford, Sherline, Atlas, Jet, and others; machine shop supplies, accessories. (Also sells wholesale to businesses.)

Brandmark
462 Carthage Dr.
Beavercreek, OH 45385
513-426-6843

Send SASE for details.

Branding iron: solid brass, with convenient torch heating; first line of brand reads "Handcrafted by" and a custom-made second line up to 20 letters and spaces maximum; ¼" letters; also electric model. MasterCard, Visa.

Campbell Tools
2100 Selma Rd.
Springfield, OH 45505
513-322-8562

Catalog $2.00.

Industrial and hobby lathes. Other equipment and supplies. Metals.

Dremel, Inc.
4915 21st St.
P.O. Box 1468
Racine, WI 53406
414-554-1390

Contact dealer or write for guide.

Power tools, attachments, and accessories including redesigned Moto-Tool high speed rotary tools—shaft attachment, drill press. Two-speed 16" scroll saw (the frame has a blade mounting jig and blade storage case, saw accepts pin-type or plain 5" blades; cuts thin aluminum to 2" woods and has a round aluminum table). Disc/belt sander, table saw, engraver; attachments. Over 165 different bits. Accessories. Manufacturer.

Foster-Trent, Inc.
29 Beechwood Ave.
New Rochelle, NY 10801

Send SASE for full details.

Craft projector: enlarges pictures, patterns, drawings ("up to 25x bigger"). Use for prints, plans, photos, gems. Projects to wall, paper. Rolling ruler. Others.

Gold Company
P.O. Box 24986
Tampa, FL 33623

Write for details.

Gold foil printer (personalizes business cards, pencils, matches; other uses).

Hurley Tool Industries, Inc.
5100 Gamble Dr., Suite 90
Minneapolis, MN 55416

Send SASE for information.

V-4 Master Combination Sander—sands, grinds, sharpens, and polishes (wood, metal, stone, plastic). Sands

flats, contours, corners, ends. (Can purchase parts, in stages, as needed.) Custom welded band saw blades, wheel bands. Band saw accessories: roller guides for metal cut-off saws, worm and worm gear, plastic automatic adjusting guard (fits all makes).

Jolie Custom Textiles
Unit 1797 Mt. Alto Rd. S.W.
Rome, GA 30161
404-291-0851

Send SASE for brochure.

Bright Box (non-electrical) with adjustable glare shield, portable with 15" square work surface; designed to capture light for trace/transfer of designs for quilting, machine knitting, textile design, graphics, calligraphy, photography, others.

Kemper Tools
Box 696, 13595 12th St.
Chino, CA 91710

Send SASE for information.

Tools for variety of crafts and hobby work. The new Fluid Writer Pen that creates fine lines (ink, acrylics, liquid gold) and "ink and scrub" technique, pen/ink drawings, fabric painting, French matting. Tools for tole and decorative painting, ceramics, cake/candy making: palette knives, decorators (wire forms), designer dots sets (country and Christmas designs), flower making tools, rollers, cutter sets, pattern cutters, clay gun, knives, brushes. Tools for quilling, carving, piercing, lace, plaster cleanup. Brush/tool caddy. Modeling compound. Quantity prices, large order discounts. (Sells wholesale to businesses.)

Lex-Aire—Nationwide
Arlington, MA 02174
617-646-1102

Send SASE or call for full information.

Lex-Aire spray painting outfits — 6 models, including model with 20 foot hose for small and home use; 40 foot hose model for overalls, priming, woodworking; model with 2 air outlets to operate 60 feet (or 2 guns 30 feet) for cars, boats, planes, other. Model that operates 40 feet of hose (with 2½ gallon pressure pot and cup gun), and others. All models come with turbine and cup gun. Spraying outfits are totally self-contained, paints with ½-3 lbs. air pressure, operates on 110V; sprays paints, primers, urethane, grip-flex, dyes. Accessories: additional hose, guns, fluid tips, and others. Video orientation tape.

Magni-View
4362 Collins Way
Lake Oswego, OR 97035

Send SASE for complete information.

Non-projector method of projecting image onto any surface—"illuminated and absolutely undiluted by room lights." A viewer that holds a slide near the eye while painting or drawing; when looking through the viewer, a sharp image appears to float beside the painting; 5 power lens is available. Quantity prices; large order discounts.

Microstamp Corp.
2770 E. Walnut St.
Pasadena, CA 91107
818-793-9489

Send SASE for full details.

Trace Mark micro-marking system (for permanent identification of cameras, most metals, plastics, other smooth surfaces). This hard steel tool is custom micro-engraved with name, number, or i.d. code. Imprint is only .010" high (virtually invisible) yet legible under magnification.

Northern
P.O. Box 1219
Burnsville, MN 55337

Free 136 page catalog.

Complete lines of hand and power tools, parts, and equipment including: sandblasters, drills, variety of saw models, gas engines, generators, hydraulic parts, welders and welding sets, winches and jacks, air compressors, and air tools. Speed reciprocal saw, orbital and other sanders, speed drill bit sets, others. Pro-Mac chain saw, 16 ton log splitter, 12V chain saw sharpener. Variable speed reciprocating Sawzall™ kit. Portable Migwelder, 4000W Coleman/Powermate generator (or with electric start). Vulcan 10 fire pen pocket torch. 120V gasless wire feed welder. 1500 PSI pressure washer. Heavy duty ½" Magnum™ hole shooter for industrial drilling. 5 speed 8" bench drill press. High speed drill set, electronic Digitape™ measure, Monster Maul (log splitter). Adjustable steel workbench kit (with drawer). Heavy duty tool box, Tough Tarps (6' X 8' to 30' X 60'). "Save 20 to 50%."

Norton Prod. Dept.
Box 2012
New Rochelle, NY 10802

Send SASE for details.

Craft projector (enlarges patterns, pictures, plans, projects, slides, coins, gems, etc.) to wood and other surfaces. MasterCard, Visa.

Nova Tool Co.
12500 Finigan Rd., P.O. Box 29341
Lincoln, NE 68529
402-464-0511
800-826-7606 (except NE)

Free brochure.

Branding iron (for hard and soft woods): solid brass head, deep cut letters, first line says "Hand crafted by" and second line to 20 characters/spaces of choice; and 3-line model iron. MasterCard, Visa.

Paragrave Corporation
1455 W. Center St.
Orem, UT 84058
801-225-8300

Send SASE for full information.

Paragrave™ hi-tech engraving system (with thin ultra-high speed drill in Parapak)—engraves glass, vehicles, and other valuables (for identification), other metal arti-

cles (tools, tool boxes, name plates, etc.), with the control, detail, and precision of a pencil. Major credit cards.

Plan Man
Merrifield, VA 22116

Send SASE for details.

Plans for sawmill, you-build "for under $300.00."

PS Uniques
3330 South Columbine Cir.
Englewood, CO 80110
303-761-0429

Free catalog.

Magnifying glass pendants, variety of styles and sizes; in gold or silver — serve as aid in checking needlework stitches. Magnifiers are designed with optical quality of 1 3/4" and 1½" tinted lens.

Rex Graphic Supply
P.O. Box 6226
Edison, NJ 08818
201-613-8777

Send SASE or call for full information.

The Creator table for draftsman, artist, graphic artist: white melamine top and heavy gauge tubular steel base (enamel finish), dual position foot rest, rear stabilizing bar, built-in floor levelers; adjustable for height and angle; in 2 size models.

Smithy
3023 E. 2nd St.
The Dalles, OR 97058
619-449-1112

Write or call for information.

Lathe/mill/drill—3-in-1 machine shop (multi-use for any shape or size work in metal, wood, plastic).

Testrite Instrument Co., Inc.
135 Monroe St.
Newark, NJ 07105

Free art catalog.

Stanrite easels—aluminum lightweight units and High Style chrome steel studio types, in 8 portable, indoor and outdoor models (holds paint box between legs) and 9 table models (use also as wet canvas carriers), 6 studio models rigidly durable). Seerite™ opaque projectors—for drawings, sign painting, stained glass, quilt, and other designing in 4 models including with accessory book tray, bottom loader, top loader, and unit with clamp stand accessory. Stanrite™ and Seerite™ lighting: Northlight for artists, floor model, swivels, with 10" reflector (folds). Clamp-on exhibition lights, with 7" reflector, mounted on 24" flexible arm; C-clamp. Others.

The Dan-Sig Company
P.O. Box 2141
Memphis, TN 38101
901-525-8464

Contact dealer, or send SASE for full details.

Dazor line of magnifier lamps, variety of styles, types, including floating arm pedestal and floating arm model on rollers; others. Replacement lamps and bulbs.

The Foredom Electric Co.
P.O. Box 262, Rt. 6
Bethel, CT 06801

Send for catalog and name of dealer.

Power tools—flexible shaft models with 1/10 and 1/8 HP motors, choice of speed controls, 21 handpieces; wide array of accessory tools to cut, grind, buff, polish, sand, deburr, and more. Bench lathe — variable speed with high torque PM motor (use to polish, clean, debur, texture) with two spindles and wheel mandrel. Handpiece holders in 2 models. Other power tools and accessories for jewelry making.

Ultravision
5589 Cote des Neiges
Montreal, Quebec, Canada H3T 1Y8

Send large SASE for catalog.

Work lamps in variety of styles, and magnifiers including model that hangs from neck, others; needle threaders.

Wedge Innovations
532 Mercury Dr.
Sunnyvale, CA 94086

Send SASE for full information.

Smartlevel™ self-balancing professional level with built-in electronic measuring system (LCD digital readout): calculates and displays exact incline of any surface — even a radial arm saw; measures slopes 4 ways (degree, percent of slope, rise, and run in inches per foot, and as simulated bubble). Can adjust accuracy of the reading from ½ degree for rough work, to 1/10 for a critical fit. In 2 ft. to 6 ft. sizes.

Wine & Beer Making

Beer & Wine Hobby
180 New Boston St.
Woburn, MA 01801

Free catalog.

Line of wine and beer making supplies and equipment.

Brewers and Winemakers Market
Box 12
Waukon, IA 52172

Free catalog.

Beer and wine-making supplies—wide selection includes concentrates, additives, fermenters, hops and malts, finishing aids; bottling and other equipment.

Cellar
Box 33525
Seattle, WA 98133

Free catalog.

Supplies and equipment for beer and wine making.

Continental
Box 1227
Daytona Beach, FL 32115

Free catalog.

Wine-making supplies/equipment: additives, yeasts, concentrates, Noirot extracts. Vinometers, thermometers, hydrometers. Presses, steamers, crushers. Air locks, corks, stoppers. White oak barrels. Accessories, bottle corkers, bottles, seals. Beer-making items and domestic and imported yeast and hops. Beer kits. Additives, brew testers. Bottles, caps, cappers. Malt extracts. Mini-brewery equipment kit. Accessories. Fermentation vessels. Books. Has quantity prices. MasterCard, Visa.

Great Fermentations
87 Larkspur
San Rafael, CA 94901

Free catalog.

Pub quality home brew supplies.

Kraus
Box 7850
Independence, MO 64054

Free illustrated catalog.

Beer making/wine making: fruit press, crusher, siphons, tubing. Extracts (liqueur, wine, soda pop), hops, malted barley grains, malt extracts, yeasts, heading powder, brewing salts, gypsum, fruit concentrates. Food grade containers, fermenters, fruit press, grape crusher. Hydro-

meters, wine filter kit, filters, brushes, pitter, sieves, fermentation bags, funnels, caps, cappers, labels, bottle capping and corking machines. Corks. MasterCard, Visa.

O'Brien's Cellar Supplies
Box 284
Wayne, IL 60184
312-289-7169

Free catalog.

Wine and beer making supplies. Wine making—concentrates, additives, fruit acids, neutralizers, tannin, nutrients, pectin, sorbate inhibitor, oak chips. Equipment sets (pails, covers, siphon hose, airlock and grommet, additives, hydrometer, others) in 4 types and sizes. Pressure and other barrels, pressing bags/cloths, transferring items. Vinometer, balance scale, press, kits, corkers, cappers. Beer making—malt extracts, kits, 16 beer kits. Malt syrups, dextrose, lactose, additives, brewing enzymes, 8 malt grains. Grain mill. Hop pellets and extracts. Screw caps, corks, crown, stoppers. Books. Has quantity prices. Visa, MasterCard.

Semplex
P.O. Box 11476
Minneapolis, MN 55411

Free illustrated catalog.

Beer and wine making supplies/equipment: nutrient tablets, clarifiers, filters, yeasts. Filter kit, stoppers, bungs, spigots. Fermentation locks, hand-corking machines. Hydrometer, vinometer. Other accessories. Pressing bag, funnels. Wine bases, concentrates (15), bottle cappers, chemicals, tannin. Fruit press, crushers, bottles. Beer yeasts, hops, dextrose, maize, barley, dried malt extracts (and liquid). Brewing salts. Others. T. Noirot extracts (45 flavors). MasterCard, Visa.

Specialty Products Intl.
Box 784
Chapel Hill, NC 27514

Free catalog.

Beer and wine making supplies: kits (fermenters, hydrometer, etc., and ingredients). Beer and wine brew-it-yourself ingredient packs. Bottle capper set. Fermenters, siphon units, hydrometer and jar, others. Enzymes, test strips, tannin, descaler/sterilizer. Malts. Books.

William's
Box 2195
San Leandro, CA 94577

Free catalog/newsletter.

Line of beer-making supplies including yeast, hops, malts; bottles, caps, equipment, others.

Woodworking

See also CRAFT SUPPLIES, CONSTRUCTION — STRUCTURES, DOLL & TOY MAKING — RIGID, FURNITURE MAKING, PICTURE FRAMING, and other related categories; BOOKS & BOOKSELLERS, PUBLICATIONS, and ASSOCIATIONS.

Accents
Box 7387
Gonic, NH 03839

Catalog and sample pattern $2.00.

1000 woodcraft (blueprint) patterns: 200 packet for jigsaws, scroll, and band saws. 100 "Country Critters" "wind-action" whirligigs, 100 yard ornaments (animals, birds, others), country projects patterns and "show-stoppers."

Acme Electric
Box 1716
Grand Forks, ND 58206

Catalog $2.00.

Power tools: Delta woodworking machines — Unisaw, edge sander, overarm router/shaper, saws (scroll, band, tilting arbor, others), disc sander, heavy duty shaper, wood lathe, jointer. Skilsaw, Milwaukee drills, saws. Porter-able jointer, router, saw boss. Powermatic saw unit, Black & Decker saws, Piranha, Hegner Multi Max II, Baldor, Biesemeyer, Senco finish nailer, Bostitch coil nailer, Makita cordless drill, Freud jointing system, Bosch belt sander, jigsaw, plunge router. DeWalt compound crosscutter saw. Ryobi router and portable planer. Hitachi miter saw, Jet portable planer, ShoVac, Elu plunger router. Others. MasterCard, Visa.

Adams Wood Products, Inc.
974 Forest Dr.
Morristown, TN 37814
615-587-2942

Free brochure.

Stock wood legs in maple, cherry, oak, mahogany, walnut, variety of styles, sizes; "no minimum order."

Adjustable Clamp Company
415 N. Ashland Ave.
Chicago, IL 60622

Free details. How-to-clamp-it catalog $1.

Clamps: Jorgensen™ and Pony™ clamps of variety of types, for woodworking, furniture repair, maintenance. (Sells wholesale to dealers.)

Advanced Machinery Imports Ltd.
P.O. Box 312
New Castle, DE 19720

Write for information.

Full line of scroll saw blades, accessories, and improvements for almost any scroll saw; Hegner precision scroll saws. Lathes, lathe duplicators, and jet clamps. Workbenches. Felder systems. Others.

Albert Constantine & Son Inc.
2050 Eastchester Rd.
Bronx, NY 10461
212-792-1600

116 page catalog $1.00.

Woodworking and veneering supplies: kits (basic, deluxe, learning course); sample set. 80+ veneers: ash, beech, birch, butternut, cedar, cherry, ebony, elm, hickory, koa, oak, pecan, tamo, walnut; Monarch veneers, dyed, specials, flexible, trim. Veneering tools: cutter, stripper, trimmer, others; veneer inlays and overlays, borders. Marquetry kits and starter kits; Optivisor, Pantograph.

Tools: Birdsmouth and clamp, knives, pin vise, incra-jig, Radi-plane, router bit set, blind nailer, wood-turning tools. Chisels, mallets, draw-knives, carving. Wood-burning pens. Planes, spokeshaves, scrapers, sharpeners, lots saws, circle cutters, drill bits, measurers, rasps. Power tools by Dremel, Foredom. Joiners, routers, doweling, planer, sanders, power sprayers, heat gun, engraver.

Gilding supplies, stains, adhesives, finishes, brushes. Furniture plans (full-size) for hutches, tables, beds, desks, others. Carving and decoy kits. 200 sizes/ kinds of cabinet lumber, exotics; turning squares, blocks, tropical woods, cedar drawer lining. Clock parts, dollhouse and furniture kits. Model kits, toy parts, leg turnings. Casters.

Upholstery tools/supplies, cane, webbing. Guitar and dulcimer parts, woods. Lamp kits, parts. Workbenches. Books. Accepts major credit cards.

Armor
Box 445
East Northport, NY 11731
516-462-6228

Catalog $1.00.

Woodworking plans including heirloom rocking horse. 4 wood balls, Shaker pegs, cradles, cups (8 sizes), toy wheels, axle pegs. Door harp parts, variety of shapes, harp wire, plywood, tuning pins, pin wrench. Has quantity prices. MasterCard, Visa.

Aviation Industrial Supply Co.
3900 Ulster St.
Denver, CO 80207

Write or call for prices.

Tools/equipment: Bosch (saws, drills, sanders, routers, trimmers), Hitachi saws. Others. Has MasterCard, Visa.

Badger Hardwoods
Rt. 1, Box 262
Walworth, WI 53184
414-275-9855

Catalog $1.00.

Hardwood lumber: red oak, white oak, ash, walnut, cherry, maple, butternut. Oak flooring on ramp, widths and lengths. Paneling — oak, cherry, butternut, ash, maple. MasterCard, Visa.

Black & Decker
10 North Park Dr.
Hunt Valley, MD 21030

Contact your dealer.

Power tools including standard drills and Holgun 3/8" reversible variable-speed drill with built-in two-way level (for horizontal and vertical alignment), heavy duty model; variable speed 3/8" cordless drill. Palm grip sander. Power driver rechargeable cordless screwdriver with indicator light. Auto-scrolling jigsaw (blade pivots. Precision router. Workmate™ work center. Sweepstick™ cordless broom, CarVac™, and Air Station™ electric inflator/compressor. Car polisher. Manufacturer.

Bogert & Hopper Inc.
Box 19
Northport, NY 11768
516-261-6173

Free catalog.

Wood parts: wheels, axles, Shaker pegs, candle cups, dowels, others.

Buckeye Saw Company
P.O. Box 14794
Cincinnati, OH 45250
513-621-2159

Catalog $1.00.

Saw blades for: band saw (welded to exact length desired), other band saw, saw mill, scroll saw, circular saw. Other saws: hand, hole, hack types. Sanding belts, router bits, sanding disks. Files, rasps, scrapers. Others.

Cascade Tools Inc.
P.O. Box 3110
Bellingham, WA 98227

Write for catalog.

Tools: carbide tipped router bits and shaper cutters, cabinet sets, ½" shank cabinet door set; routers: dovetail, flush trim, cove bits, roundover, core bull nose, Roman ogee, slot cutter, beading. For the shaper: straights, flutes, beads, corner rounds. Right arm clamp with pivoting arm. Wood shaper unit. Others. MasterCard, Visa.

Casey's Wood Products
15½ School St.
Freeport, ME 04032

Catalog $1.00.

Wooden ware—factory seconds: Shaker pegs, beanpot candle cups (by 100+ lots). Turnings, dowels, novelties in first and second quality, "at lowest possible prices."

Cherry Tree Toys
Belmont, OH 43718
614-484-4363

Color catalog $1.00.

Quality woodcrafting parts, supplies, kits, and plans: whirligigs, doll houses, clocks, music boxes, weather instruments, crafts, tools, toys, dollhouses, clock parts, stencils, paints, hardware, books. "Bulk prices."

Colonial Woodworks
P.O. Box 19965
Raleigh, NC 27619

Product and design catalog $10.00.

Architectural interior mantels, mouldings, paneling, windows, custom items, others.

Crafters Mart
Box 2342
Greeley, CO 80632

Catalog $2.00 (refundable).

Wood parts/shapes: turnings (Shaker pegs, candle cups, balls) wheels, door harp tuning pens, clapper balls, others. Harp wire, hangers, others.

Craftpatterns
4820 So. 93rd Ave.
Omaha, NE 68127

Send SASE for price information.

130 country woodcraft patterns (full-size): Americana, carousel horses, dolls, animals, holiday, shelves, others.

Crafts by Cash
4215 Hill St.
Mims, FL 32754

Information list $1.00.

Plans for custom rustic mailboxes—3 full-sized plans with instructions. Others.

Crafts by JG's
Rt. 1, Box 168
Galena, MO 65656

Send SASE for list, prices.

Full-sized woodcraft patterns (with painting instructions): towel bar, memo pad, cow and owl, duck and pig, bunny and chicken. Others.

Croffwood Mills
RD #1, Box 14
Driftwood, PA 15832

Free catalog.

Pennsylvania hardwoods—over 2000 sizes, 12 species, 1/8" to 2" thick, surfaced, kiln dried. No minimum order.

Dakota Wind
Box 866
Jamestown, ND 58402

Catalog $1.00.

Wood cutout patterns including "Windowsill cats" series.

Designcraft
729 Grapevine Hwy., Suite 358
Hurst, TX 76054

Send SASE for full details.

300 scroll saw patterns for bookends, puzzles, frames, novelties, others (uses Easy Trace transfer system).

Dollar Trading Corp.
P.O. Box 8433
Grand Rapids, MI 49518

Send SASE for details.

Wood tools—brad point drills (brad-center pushes into marked spot, locks into position and hole can be drilled where wanted without splintering); of high carbon, alloy steel; fits 3/8" or larger chuck; in 25 piece drill set, for 1/8" to ½" sizes. American Express, MasterCard, Visa.

Donna's Wooden Palette
P.O. Box 11205
Yardville, NJ 08620

Catalog and sample pattern $2.00.

80 woodcraft patterns with instructions: country, folk, holiday items—trace, cut, paint.

Eagle America Corporation
P.O. Box 1099
Chardon, OH 44024
216-276-9334

Free catalog.

Router bits—"largest selection . . . American made" titanium coated and carbide bits: straights, spiral flute, stagger tooth, hinge, mortising, carbide abrasive. Laminate trims—flush trim, flush and bevel, bevel flush, hole and flush cut, others. Groove forming round nose, vee groove pattern cutter, dovetail, dovetail template cutter, ogee plunge cutting, slot cutters, others.

 Edge forming — rabbeting bits, ball bearing pilot (and chamfer bits), roundover, bull nose, edge beading, Roman ogee, wavy edge, others. 5 specialty molding cutter types. Classics. Door construction—lip, drawer pull, hinge boring. Glue joints — vee tongue and groove, locker drawer, glue joint, more. Router accessories; router bit sets. "Save up to 50%." MasterCard, Visa. Discounts for schools, technical institutes, volume users, woodworking clubs, guilds, associations.

Econ Abrasives
P.O. Box 865021
Plano, TX 75086
214-377-9779

Free catalog.

Sandpaper: belts, discs, sheets, wide belts, rolls, flap wheels, pump sleeves, cabinet paper, finish paper, jumbo cleaning stick. Abrasive belts, bar clamps. "Discount."

EDLCO
P.O. Box 5373
Asheville, NC 28813
704-255-8765

Write or call for catalog.

Over 20 species of hardwoods and softwoods including Appalachian woods and hard-to-find imported woods—select and project grades. "Quantity discounts offered."

FINISHING: *When finishing soft woods such as pine, fir, or spruce, always apply a coat of sanding sealer prior to staining, to achieve a nice uniform color of your desired shade. This step eliminates blotching. Courtesy of Glenn Docherty of Albert Constantine & Son, Inc.*

Farris Machinery
309 N. 10th
Blue Springs, MO 64015

Free information kit; VHS video, $14.95.

"K5" home workshop wood machining center, saws, planes, molds, mortises; takes up less than 12 square feet of space, runs on 110V AC power.

Foley-Belsaw Co.
6301 Equitable Rd.
Kansas City, MO 64120

Free woodworking booklet.

Workshop power unit—four-in-one operations (planes, molds, saws, sands) for all types millwork, hard to soft woods; automatic power feed. "Factory prices direct."

Formby's Workshop
Olive Branch, MS 38654

Free booklet, "Successful Refinishing."

Formby's products for wood: furniture refinisher—dissolves old varnish, lacquer, shellac; conditions the wood.

Fourth Dimension
85 Helmar Dr.
Spencerport, NY 14559

Catalog $1.00.

Patterns/instructions for wood cutouts: bunnies, sheep, frogs, skunks, raccoon, pigs, flamingos, others.

Frog Tool Co. Ltd.
P.O. Box 8325
Chicago, IL 60680
312-648-1270

Catalog $3.00.

Woodworking tools/supplies: German carving tools (chisels, gouges, punches, others), Swedish carving knives. Hammers, screwdrivers, pushpins, Japanese and other sharpening items. Rasps, riflers. Doweling jigs, bevelers, plugs, cutters, circle cutter. Drills, scrapers, measurers. Planes (wooden, joiner, bench, router, compass, circular, radi). Drawknives, spoke shaves.

 Musical instrument tools, clamps, fret rules, cutters, bending iron, calipers. Saws, files, veneering and turning

tools, panovise, others. Power tools: grinders, grinder/polisher arbor, Foredom tools and handpieces, burrs. Woodburning system, hot glue gun, turning lathe (chucks). Birch dowels. Safety equipment. Table hardware. Clamps, sanding items. Log cabin tools. Brushes, finishes, stains, rubbing compounds, waxes. Furniture plans. Workbenches. Books. MasterCard, Visa. (See FURNITURE MAKING & UPHOLSTERY.)

Garrett Wade Co., Inc.
161 Avenue of the Americas
New York, NY 10013
212-807-1757

212 page catalog $4.00.

Full line of hand tools including the new advanced precision honing guide (sets micro bevels), "blind nailer" tool (like a positioning jig), scrapers with prepared edge for longer use, multi-angle aluminum gauges. Band saw blades including 1/16" narrow, in raker style, and "cabinetmaker's special" skip-tooth appearing blades (each tooth a hook, every 5th tooth an un-set raker), and other scroll and cabinet styles. Saw setting gauge. Gap filling glue. Other common and unique hand tools.

Gilliom Manufacturing, Inc.
P.O. Box 1018
St. Charles, MO 63302
314-724-1812

Brochure $2.00.

Power tool kits (construct your own): 12" band saw, 18" band saw, 10" tilt/arbor saw, lathe/drill press combination, 9" tilt table saw, 6" belt sander, spindle shaper, circular saw table. Kits include step-by-step plans and all necessary metal parts and components (except wood and motor). Some accessory kits, including a speed reduction kit for cutting steel, for the 18" band saw. Power tool plans available (individually, or as a set at a savings).

Grizzley Imports Inc.
2406 Reach Rd.
Williamsport, PA 17701
206-647-0801

And: P.O. Box 2069
Bellingham, WA 98227

Write or call for information.

Shop equipment: sanders (drum, combo, others), saws (heavy duty, band, others), planers, jointers, shapers, dust collectors, others. Has MasterCard, Visa.

Hogue
P.O. Box 2038
Atascadero, CA 93423
805-466-4100

Send SASE for information.

Exotic woods (cut-off sizes, others): rosewood, gonedlo alves, pau ferro, coco bolo, others. Use for jewelry, inlays, knife handles, parquet tables, other.

Horton Brasses
Nooks Hill Rd., P.O. Box 120
Cromwell, CT 06416
203-635-4400

Catalog $3.00.

Full line of cabinet and furniture hardware for homes and antiques: handles, knobs, latches, hinges, slides; many styles (brass, antiqued, others).

House of Starr
P.O Box 783
Angels Camp, CA 95222

Patterns list $1.00.

Patterns for wood crafting (and fabric painting, etc.); each in 3 sizes.

How-to Book Club
Blue Ridge Summit, PA 17214

Send for details and current book list.

Club offers member's prices "up to 50% off," and a bonus book plan. Club news bulletins are sent 14 times yearly; can order, or return form and decline; members receive introductory books at near-nothing cost and agree to purchase at least 3 books during 2 years. How-to/project books include toy making, home accessories, furniture making, grandfather clocks, outdoor building, pine projects, frames/framing, clock making, remodeling, wood turning, power tool references.

International Luthiers Supply
Box 580397
Tulsa, OK 74158

Catalog $1.00.

Violin and guitar making materials, accessories, and how-to books.

International Violin Company
4026 W. Belvedere Ave.
Baltimore, MD 21215

Catalog $1.00.

Violin and guitar kits. Tools, parts, accessories, tone wood; strings, cases, bows, others.

Kayne & Sons Forged Hardware
76 Daniel Ridge Rd.
Candler, NC 28715

Catalog $4.00.

Hardware: household, reproduction, handforged and furniture; locks. Tools and accessories. Fireplace items. Custom handforging, repairs, restorations.

Larson Wood Mfg.
Box 672
Park Rapids, MN 56470

Catalog $3.00 (refundable).

Wooden ware (variety of sizes/shapes): plaques, frames,

boxes, toys, novelties, game parts. Hardware. Paints, stains, finishes. Others. Manufacturer.

Leichtung Workshops
4944 Commerce Pkwy.
Cleveland, OH 44128

Free catalog.

Over 400 hand and power woodworking tools, including usual and exclusive innovative tools for workbench, cabinet work; to sharpen, clamp, dowel, make instruments, mat, frame; for miniature crafting. Major credit cards.

Manny's Woodworkers Place
602 S. Broadway
Lexington, KY 40508
606-255-5444

Free catalog.

Woodworking books and videos, variety of instructional subjects.

Manzanita Decorative Wood
P.O. Box 111
Potrero, CA 92063
619-478-5849

Call or send SASE with inquiry.

Manzanita burls — full range of sizes, full inventory. (Also sells wholesale.)

Marlin Industries, Inc.
Rt. 70, Box 191
Cashiers, NC 28717
704-743-5551

Brochure and price list $1.00.

Carving machines for professionals and hobbyists, including Sign Carver (machine follows templates) and Supli-Carver series.

Marling Lumber Company
P.O. Box 7668
Madison, WI 53707

Send SASE or call for information.

Makita power tools: cordless driver-drill (2-speed, variable speed), 25-piece ratchet set, 3/8" cordless drill (variable speed), finishing sander, 3/8" drill; others. MasterCard, Visa.

Mastercraft Plans West
P.O. Box 625
Redmond, WA 98073

Send SASE for list.

Patterns (full-sized) for gifts and novelties: lawn figures, action windmills, birdhouses, shelves, alphabets, Dutch boy/girl, penguin, animals, birds, others; by packets.

MCLS, Ltd.
P.O. Box 4053
Rydal, PA 19046

Send SASE for catalog.

Woodworking tools: 33+ tungsten carbide tipped router bits including reversible combination rail/stile set, raised panel types, tongue/groove, drawer pull, multiform molding maker, others. Router speed control (adjusts from full speed to 0 RPM's) change speed at flip of switch; for all 3HP or less routers. Merle adjustable corner clamp—forces frame to perfect square for all sizes (2 5/8" to 66"). MasterCard, Visa.

Meisel Hardware Specialties
P.O. Box 70
Mound, MN 55364

Catalog $1.00.

Door harp plans and kits (door harp mounts on inside of door to welcome guests with tune when door opens) in 5 designs (raccoon, eagle, hen, big apple, barn); plans are full sized (22" X 34" blueprints) with instructions. Hardware parts kits also have tuning pins, clapper balls, music wire, plastic eyes. MasterCard, Visa.

Midwest Dowel Works, Inc.
4631 Hutchinson Rd.
Cincinnati, OH 45248
513-574-8488

Write for catalog.

Dowels, plugs, and pegs, variety of sizes: oak, walnut, hickory, maple, cherry, mahogany, teak; treated dowels. "Quantity discounts."

Olson Catalog Sales
Rt. 6
Bethel, CT 06801
203-792-8622

Free catalog.

Band saw blades: flex-back, new furniture band, thin gauge for bench top and 3 wheel saws, welded to length, or in 100' coils. Scroll saw blades: plain or pin end; fret, spiral, and jeweler's type. "Save up to 50%."

Original Wood Designs
Box 1141
Los Branos, CA 93635
209-826-5541

Write or call for prices.

Manzanita burlwood — raw burls, finished pieces, and slabs, in a range of sizes.

Penn State Industries
2850 Comly Rd.
Philadelphia, PA 19154
215-676-7609

Write for catalog.

Woodworking machines: 15" scroll saw and accessories. Planer (portable, 12½" power feed, for up to 6" stock): accessories. Dust collector unit. Sanders, planers. MasterCard, Visa.

Performax Products, Inc.
12211 Woodlake Dr.
Burnsville, MN 55337

Write or call for free brochure.

Power tools: component drum sander, with radial saw attachment or stand alone; manual or power feed option conveyor unit. 22" drum sander with open end. Others.

Planfan
Box 473
Bridgeport, NE 69336

Send SASE for full details.

Complete plans to build gun cabinets in 4 styles.

Quinn Tool Engineering Co., Inc.
1806 C. Boonslick
St. Charles, MO 63301

Free brochure.

"Sure Set" precision saw gauge, aluminum, self-stick scale (elminates marking). Has MasterCard, Visa.

Popular Science Book Club
P.O. Box 1763
Danbury, CT 06816

Write for current book list.

Do-it-yourself book club: members receive bulletins 15 times yearly, can choose or return form within 10 days; "up to 75% discounts" on books. Members choose introductory books at near-nothing cost and agree to purchase at least 2 others within a year; may cancel afterward. Books include woodworking skills, home workshops, house building, wiring, plumbing, home improvement, remodeling, repair, carpentry, masonry, house building, furniture making, toys, tools, others.

RB Industries, Inc.
1801 Vine St.
P.O. Box 5177
Harrisonville, MO 64701

Free information kit.

RBI Hawk line of precision scroll saws; for beginners through professionals; with camover tensioning (install blades in seconds), adjustable tilt table, counter-rotating gearbox, and flex bellows; makes cuts from 1/64" in diameter, turns work 360 degrees. With aluminum table. Work stand. Cuts wood silhouettes, inlays, metals; stack cuts, compound cuts, and cuts bevels and corner brackets. Offers revolving charge plan.

RJS Custom Woodworking
P.O. Box 12354
Kansas City, KS 66112

Toy carousel plans (full-sized, for scroll saw project) with accessory parts; 2 sizes. Woodworking tools. Plans.

Safety Speed Cut Manufacturing Co.
13460 No. Hwy. 65
Anoka, MN 55304
612-755-1600

Write or call for complete details, prices.

Panel saws: cut large panels down to size, with new features and options. "Lowest base price in the industry."

SCMI Corporation
5933-A Peachtree Ind. Blvd.
Norcross, GA 30092

Contact dealer, or send SASE for information.

Mini Max machining center—Jointer/Planer with Mortiser unit that handles rough lumber to precision joinery; has 13½ " jointer, 13½" planer, independent mortiser. Sliding table shaper unit (with 3 spindle speeds and reversing, 2 spindle sizes). Stroke sander—jobs that require 8 hours with a belt sander can be finished on this unit in 60-90 minutes; with stationary bed and belt drawn back and forth across the workpiece. Copy Lathe "The Submissive Copier" unit, a simpler essence of more complex copy lathes; with wide range of accessories. Jointer planer 2-for-1 unit, with optional horizontal borer. 12" and 18" bandsaws, with 45 degree tilt cast iron table.

Shopsmith Inc.
3931 Image Dr.
Dayton, OH 45414
513-898-6070

Send SASE for further details.

Workshop power tools: all-in-one units, scroll saw—20" variable speed model, with sawdust blower. Others.

Singley Specialty Co., Inc.
P.O. Box 5087
Greensboro, NC 27435
919-852-8581

Send SASE for list.

Sleeveless drum sanders for use on drill press, motor, lathe, combo-tools, radial saw, drills, in 9 sizes.

Skil Corporation
4300 W. Peterson Ave.
Chicago, IL 60646

Send SASE for information.

Power tools: drills, cordless drill (with 5-position variable torque clutch, 2-speed, with 7.2 volt rechargeable battery pack). Variety of saws. Others. Manufacturer.

Steuss Creations
334 Atherton
Novato, CA 94945

Free brochure.

Eze-Angleguide™—guides cuts in 160 different angles with no saw adjustment needed.

Steve Wall Lumber Co.
Rt. 1, Box 287
Mayodan, NC 27027
919-427-0637

Catalog $1.00.

Woodworking machinery including Mini-Max and Delta units; Hawk and planer-molder; others. Lumber (kiln dried rough, sold by board): aromatic red cedar, cherry, red or white oak, hard maple, mahogany, walnut, butternut, and others; has quantity discounts.

Sun Designs
173 E. Wisconsin Ave.
Oconomowoc, WI 53066
414-567-4255

Send SASE for full details.

Design/mini-plan books for 55 gazebos (mix and match designs for railings, fascia, etc.), bird feeders and houses, arbors, strombrellas. Backyard structures. Bridges and cupolas. *Privy: The Classic Outhouse* book. Books have numerous designs and one or more miniplans. Also has full construction plans for all designs. MasterCard, Visa.

TCM Industries, Inc.
322 Paseo Sonrisa
Walnut, CA 91789
714-594-0799

Send SASE for information.

Power woodworking equipment: 12" auto planer (12.5" X 6" capacity), 3HP shaper, 10" table saw, 15" auto planer, edge sander, 20" auto planer (20" X 8" capacity, ¼"), 8" jointer, 18" band saw, 6" X 12" belt sander (tilting table). Others. MasterCard, Visa.

The Taunton Press
63 S. Main St., Box 5506
Newtown, CT 06470
203-426-8171

Free catalog.

Video Workshops (woodworking instruction by professionals), videos on: Shaker table, mortise-and-tenon joints, radial arm saw joinery; furniture repairing, refinishing; router jigs, small shop tips/techniques; wood finishing, turning; tiling floors, walls, countertops; carving ball-and-claw foot, projects, chip carving, dovetail drawers; installing doors/windows, trims.

Books: Some of above subjects, marquetry, chainsaw, making/modifying machines, bending wood, turning, workshop, furniture design; timber, frame, stone, log, earth homes. Others. (Sells wholesale to businesses.)

The Winfield Collection
1450 Torrey Road
Fenton, MI 48430
313-629-8158

Catalog $1.00.

Full-size country woodcraft patterns: shadow boxes, miniatures, goose designs, jointed figures (St. Nick, Amish couple, Hare couple), folk art figures, shelf critters, folk art horses; shelf-sitters, swivel leg figures, teddies, patriotic shapes, animals, shorebirds, country dogs, barnyard set and barn pattern. Country scenes. farm animal and base mount, Shaker pegs (and train, teddies, puppies), candleholder designs, action toys, basket crit-

ters. Holiday items. Cutouts, racks, stool, wood boxes and baskets, lap desk, weather vanes, vehicles, dinosaurs, carousel spinner toys; others. (Also sells wholesale.)

The Woodworkers' Store
21801 Industrial Blvd.
Rogers, MN 55374
612-428-2199

Catalog $2.00.

Wood veneer kits, veneers (35 species). Tools (punches, cutters, roller, saw, others). Inlays and bandings, wood strips. Hardwood lumber: mahogany, cherry, walnut, birch, maple, white oak; over 350 sizes. Wood trims, moldings, parts (finials, spindles, balls, shelf parts). Hardware: hinges, handles, catches, locks, grills, slides, fittings, Turn-a-shelfs, lazy susan bearings, Accuride slides. Furniture hardware. Upholstering: rush, caning. Flexible shaft tool, carving tools. Clock parts. Musical movements. Finishes. Plans (furniture, dollhouses, toys, others). Woodworking books. Major credit cards.

Tool Crib of the North
Box 1716
Grand Forks, ND 58206

Catalog $3.00.

Name brand tools: AEG, Wedge, Panasonic, Bosch, Makita, Skil, Black and Decker, Frend, Milwaukee, Selta, Englo, Porter Cable, others.

Toolmark Co.
6840 Shingle Creek Pkwy.
Minneapolis, MN 55430
612-561-4210

Free literature and price list.

Wood lathe accessories for wood turning including spindle duplicators, duplicator systems, bowl turners, Unicenter systems, woodshavers, steady rests, safety shields.

Tools, Inc.
1567 Harbor Blvd.
Fullerton, CA 92632
714-525-3581

Send SASE for list.

Power tools: Hitachi plunge router, Bosch top handle jigsaw kit. Porter-Cable finish sander, omni-jig dovetail machine with template and template guide kit, biscuit joiner. Elu variable speed plunger router. Carbide blades and variety of sets. Others. Major credit cards.

Total Shop
P.O. Box 25429
Greenville, SC 29616

Catalog $1.00.

Total Shop multi-purpose machine (converts to 5 basic power tools). Other units: 6" long bed jointer, wood shaper, 6" belt sander, 12" (or 15", 20") thickness planer, sanding machine (table tilts), 14" bandsaw. Dust collectors—industrial, commercial types. Others.

Tremont Nail Co.
8 Elm Street, Box 111
Wareham, MA 02571

Sample kit and list $4.50.

Old-fashioned cut nails, 20 varieties using old patterns—rosehead, wrought-head, others.

Trend-Lines, Inc.
375 Beacham St.
Chelsea, MA 02150
617-884-8882

Free catalog.

Over 3,000 woodworking tools. Saws — circular, trim, miter, 8" and 10" table, "superscroll" radial arm, contractor's, Unisaw, sawbucks, portable radial arm, others. Routers, planers, bands, deluxe band, jointers, grinders, drills and cordless, screwdrivers, planer jointer, sanders, mortising tools, drill presses, biscuit joiner, dovetail laminate slitter, trimmers. Dremel MotoShop, sander-grinder. Accessories — sanding items, saw blades, saw horses, supports. Nail guns, spray guns, airbrushes, bland blaster (compressor), clamps, frame clamp, vices, measurers, dividers. Wood sign layout kit. Hardware. Hand carving, turning tools. Router bits.

Workbench. 10+ dollhouse kits. Wood project plans. Plugs, balls, wheels, pegs, metal wheels, cedar liners and blocks. Folding table legs, drawer slides, casters, lazy susan bases. Glues, stains, finishes. Major credit cards.

Vaughan & Bushnell Mfg. Co.
11414 Maple Ave.
Hebron, IL 60034

Contact dealer, or send SASE for information.

Vaughan hand tools, including hammers, picks, and axes.

Video Sig
1030 East Duane Ave.
Sunnyvale, CA 94086
408-730-9291

Free catalog.

Instructional videos including woodworking series: Building Bookcases, Building Cabinets, Building Tables, Woodworking Projects, and home improvement (Basic Carpentry, Decks, Exterior Projects, Furniture Refinishing; Finishing); also Hexagonal Picnic Table, Paneling, Building Tables, Building Cabinets, and Bookcases; Easy-Build projects. (Also has videos on watercolors, photography, origami, and many other non-craft categories). MasterCard, Visa.

Whole Earth Access
2990 7th St.
Berkeley, CA 94710
415-845-3000

Send SASE for list.

Power tools: Porter-Cable saws, drills, TEKS driver, laminate trimmers, routers, paint remover, sanders (disc, sheet pad, belt, worm drive belt). Skil cordless drill kit, worm drive saws, trim and circular saws. Freud router bits, carving, chisel, Forstner bit, others. Milwaukee drills, drill kits, dustless belt sanders, chainsaws, jigsaws, others. Hitachi router, plane, laminate trimmer, drywall screwguns, portable planer, saws, sanders, others. Makita cordless driver drill, other drills, sander/polisher, framer's saw, dustless belt sanders. Delta shop machinery.

Wilke Machinery Company
120 Derry Court
York, PA 17402
717-764-5000

Catalog $1.00.

Bridgewood™ woodworking machinery: shaper units, planers, jointer, others.

Williams & Hussey
Riverview Mill, P.O. Box 1149
Wilton, NH 03086

Free information kit.

Molder-planer unit (cuts moldings and planes hardwood) with "two-minute" cutter changes; for professionals and hobbyists. Manufacturer.

Wood Moulding & Millwork Prod. Assn.
Box 25278
Portland, OR 97225

Copy of booklet $4.05.

Booklet: 500 Wood Moulding Do-It-Yourself Projects (for birdhouses, bookshelves, door trims, drawer dividers, planters, others); illustrated traditional projects, and scores of new ways to use molding.

Woodartist
Box 31564
Charleston, SC 29417

Send SASE for price list.

Antique birdhouse plans for bluebirds, martins, others.

Woodcraft
313 Mount Vale Ave.
Woburn, MA 01888

Free catalog.

Woodworking tools: carving tools and sets, sculptor's sets. Gouges, punches, adzes, hooks. Rasps, rufflers, needle rasps, and files. Measuring tools. Drafting and layout tools and equipment. Specialty tools: planes, vises, saws. Miters, clamps (miniature C, 3-way, others). Wooden planes. Iron planes, framing tools/equipment. Musical instrument making tools. Tools for boring, doweling, wood turning, log building, marquetry, veneering.

Branding irons. Power tools: Dremel, Foredom, Rockwell. Accessories: glass domes, magnets, glass inserts, lamp parts, clock parts, musical movements. Hardware. Wood parts. Plans. Books. MasterCard, Visa.

Woodcrafters
11840 North US 27
Dewitt, MI 48820

Catalog $1.00.

Woodcraft patterns: windmills, wishing wells, weather vanes, birdhouses, whirligigs, jigsawing; others. Wood parts. MasterCard, Visa.

Woodmaster Tools
2908 Oak
Kansas City, MO 64108

Free information kit.

Woodmaster power-feed machine (variable speed): planes, molds, and sands—two sizes, 12" or 18" planer; it picture frame molds, quarter-rounds make casing, tongue and groove, with quick-change molding head. Choose over 250 standard trim and picture frame patterns. Quad-drive drum sander (for even sanding) with variable power feed; quad-drive feed system (4 rollers for maximum traction); in 26" and 38" models. Others.

Woodshed
Box 10822
Lynchburg, VA 24506

Catalog $2.00.

Outdoor furniture plans: Chairs, tables, units, others.

Woodworker's Supply
5604 Alameda Place, N.E.
Albuquerque, NM 87113

And: 1108 N. Glenn Rd.
Casper, WY 82601

And: 1125 Jay Lane
Graham, NC 27253

Free catalog.

American brands machinery: Mill-route, boring, Dewalt saws (radial arm, miter). Plunge router, heavy-duty shapers, large capacity scroll, planer, belt sanders, accessories, pantograph.

Wood: pegs, wheels, hard dowels, plugs, candle cups, pulls, handles, knobs, rope molding. Cedar lining, veneers. Bosch power tools: laminates, trimmers, screwdriver and drill, compact drill, router. Porter Cable routers, drill, sander. Radial arm saws, routers, compressor, angled screwdriver, Hardware: grommets, shelf clips/supports, hinges (door, magnetic, touch, glass door).

Lights, plugs. Circle cutter. Many drawer slides, lock sets. Folding table legs, latches, hinges (cabinet, overlay, insert, cylinder, box-mount, European). Doweling tools, aids. Picture framing staple guns, Framemate ⊨, pliers, miter box, clamps. Boring bits, drill presses, bradpoint drill bits, rotary bits. Full line of router bits. Edge banding systems, biscuit joining machine. Cutters. Saw blades, woodworker chisel sets. Drill press vise. Has some quantity prices. MasterCard, Visa.

> STAIN THE SMALL STUFF: *Using tongs, dip small pieces of wood into a jar of stain and set out to drain and dry. Courtesy of MAB.*

Woodworks
4500 Anderson Blvd.
Ft. Worth, TX 76117
817-281-4447

Catalog $1.00.

Wood parts: Shaker pegs (economy, premium, mini), bean pot, candle cup, mini bean pot. Hearts in 4 sizes (1/8" to ½" thick), maple toy wheels (3 sizes), axle pegs, maple spindles (2 sizes). Door harp parts — pre-bored balls, tunings, round balls, large and small eggs, apples; others — most items by 100 piece lots. Door harp wire (12 gauge), screw eyes, sawtooth hangers. MasterCard, Visa.

XYZ—Selected Others

ᐓᐓᐓᐓᐓᐓᐓᐓᐓᐓᐓᐓᐓᐓᐓᐓ
Adorn the body or stuff one; experiment, build, go woodsy, fish around—these catalogs show you how.
ᐓᐓᐓᐓᐓᐓᐓᐓᐓᐓᐓᐓᐓᐓᐓᐓ

Analytical Scientific
11049 Bandera
San Antonio, TX 78250
512-684-7373

225 page catalog $3.00 (refundable).

Scientific-related products: chemicals, variety of lab equipment, glassware, experiments/projects. Books. "Save to 30%."

American Science & Surplus
601 Linden Pl.
Evanston, IL 60202
708-475-8440

Write for information.

Usual/unusual items: tools, equipment, lab/arts/crafts items, bottles, bags, boxes, science items and kits, optics, magnets, electrical and lighting, wires, cords. Others.

Dan Chase Taxidermy Supply Co.
13599 Blackwater Rd.
Baker, LA 70714

Free catalog.

Complete line of taxidermy supplies and over 500 instructional videotapes on subjects related to taxidermy.

Dyvirg, Inc.
4138 E. Grant Rd.
Tucson, AZ 85712

Free catalog.

Line of precision tattoo machines—custom made, handcrafted models (signed and numbered). Custom repair/tuning service for tattoo machines.

Edmund Scientific
913 Edscorp Bldg.
Barrington, NJ 08007
609-573-6260

Write for catalog.

Technical/scientific products: kits — mini hot air balloons, steam engines, microscope accessories, optics, ES lens, diffraction grating, kaleidoscope, science subjects. 16 microscopes and pocket models. Eyepieces, prism (turns microscope into a projector). Alcohol lamp, flexible tubing, goggles, gloves, pH paper, clocks, timers, scales/balances, 35+ magnifiers, loupes. Electroplating kits. Pencils and drawing sets.
　　Plastic bottles, dispensers. Fiber optics fibers, light guides, helium-neon laser and others. Solar supplies: panels, cells, photovoltaics, trackers, others. 9 types of magnets. Mirror film (colors, metallics).
　　Latex rubber mold compound, modeling plastic, and others. Foam tapes. 6 submersible pumps, compressor, vacuum pressure pump. 20+ small motors, fans, components. Mini-tools: Dremel Moto Tool kit/accessories, pine vise, drill/driver, pliers, ratchet, mallets, hammer, rifler files, pickup tools, rasps, needle files, jeweler's drill press, torch, mini-table saw, hot wire cutter, heat gun, engraver, tumbler. Measuring items. Projectors, light boxes. Steam driven models: vintage cars, trucks, train. Flocked and colored papers. Many others.

Heath Company
P.O. Box 8589
Benton Harbor, MI 49022

Write for catalog.

Heathkit™ electronics kits (with fully illustrated step-by-step format assembly manuals); kits on 3 skill levels. Home entertainment—TVs, camcorders, VCRs, stereos. Security and lighting products, weather stations, marine products—loran, video sonar, others). Home products—clocks and others. Amateur radio equipment, computers —laptop, others, peripherals. Oscilloscopes, DMMs, PC Logic Analyzer. Radio control model cars, planes, boat. Educational Systems trainers and courses for home study: Basic Electronics, Digital Technology, Electro-Optics, Microprocessing, Robotics, Beginning Electricity, Soldering Course. Classroom and computer courses.

Hegenow Laboratories
1302 Washington
Manitowoc, WI 54220

Catalog $2.00.

Laboratory chemicals and glassware.

McKenzie Taxidermy Supply
P.O. Box 480
Granite Quarry, NC 28072

Free catalog.

Full line of taxidermy supplies; deer and animal forms.

Lure-Craft Industries, Inc.
P.O. Box 1
Solsberry, IN 47459

Catalog $2.00.

Fishing lure maker's supplies: full line of plastic worm making supplies, Poly-Sil paint, and lead castings. Skirts, hooks, other lure-making items.

Midland Tackle
66 Rt. 17
Sloatsburg, NY 10974

Free catalog.

Fishing rod building supplies—lure parts, molds, others.

Pacific Outdoors Supply
Box 10239
Spokane, WA 99209

Send SASE for price information.

Lure and jig making: moldmaking materials, plastics, pigments, others.

Spaulding & Rogers Mfg., Inc.
Rt. 85, New Scotland Rd.
Voorheesville, NY 12186

Color catalog $5.00; foreign $10.00.

Full line of tattooing supplies: tattoo machines (stainless steel), shaders, outliners; 1-14 needles, in lightweight, supreme, quick-change, state-of-the art, and other models. Power packs. Parts, needle bars, needles, and needle jigs. Hand punches, files, T-handle hex wrench. Ultrasonic cleaners, rack for machines, autoclave, dry heat sterilizers, electric stencil cutter. Medical supplies. Eye loups, lamps, mini ink mixer. Skin marker. Body paint kit, colored pencils. Tracing paper, carbon, hectograph pencils, stencil cutter and powder. Plastic caps, bottles, jars. Colors: Sta-Glo sets, tattoo inks. Cosmetic colors. 2600+ Designs sets: birds, animals, flowers, fantasy, figures, ships, cartoons, fish, emblems, religious, fantasy, Indian, Egyptian, romantic, warriors, bikers, reptiles, Oriental, others. How-to books, instructional videos.

Tackle Shop
Box 830369
Richardson, TX 75083

Free catalog.

Fishing rod building supplies, tackle components, lure components. Plastic lures, other fishing items.

Tate Unlimited
Box 440003
Aurora, CA 80044

Send SASE for information.

Kits/plans for you-make ice age weapons—atlati spear throwers.

Van Dyke's
Woonsocket, SD 57385

Catalog $1.00.

Taxidermy kits for beginners, instructional videos and books. Advanced/professional supplies — full line for taxidermists and tanners.

Woodmen's Workshop
P.O. Box 462
Rhinebeck, NY 12572

Catalog $1.00.

Unusual projects, plans, supplies, kits, books including carving decoys, making live catch traps for wildlife pets (animals, reptiles, birds, fish, others), Indian crafting skills, building a trail bike, snake crafts; making fishing lures, game calls, boomerangs, whirligigs, mountain men crafts, blow guns. Others. Expect something different.

Section II
Needlecrafts, Sewing & Fiber Arts

Needlecraft Supplies—Variety of Needlecrafts

🐦 🐦 🐦 🐦 🐦 🐦 🐦 🐦 🐦 🐦 🐦 🐦 🐦 🐦 🐦

See also specific categories in Section II; BOOKS & BOOKSELLERS, PUBLICATIONS, and ASSOCIATIONS.

🐦 🐦 🐦 🐦 🐦 🐦 🐦 🐦 🐦 🐦 🐦 🐦 🐦 🐦 🐦

Aardvark Adventures
P.O. Box 2449
Livermore, CA 94551
415-443-2687

Catalog $2.00 (refundable).

Needlecraft supplies: cross-stitch/embroidery fabrics — Aida, hardanger, Congress Cloth, Lugana. Threads—Anchor floss, 2, 3, 8 Pearl, Lystwist rayon, 28 "Neon Rays," ribbon floss, 112 Ping Ling silks, DMC cordonnet, Nateesh rayons (light, heavy, unplied), and color cards. Candlelight, Balger, other metallics, Mettler, Iridescents.

Yarns — mohair, cotton, angora, nylon, metallics, furry, and other oddities. Trims: 1/8" faux silk ribbons, metallic braids and ribbons, buttons, tassels, shisha mirror, diffraction foil, lame foil, metal disks.

Fabric decorating — Deka paints, iron-on and silk type, Liquid Glitter™, and pens. Paint spinner. Crayons. Seta color paints, fine pens, Lumiere paints. Silk scarves. Needlepoint canvases (and metallic). Tweezers, scissors, stabilizers. Sculpey III polyform, tassel and pom-pom makers. Squeakers. Glass beads, shells, beader set. Rubber stamps by L.A. Stampworks, Rubberstampede, etc. Trims, grab bags. Many other unusuals. Sewing/ needlework patterns, iron-ons.

Book set: *Jerry's Two-Needle Pyramid*, by Jerry R. Zarbaugh (directions for a wide variety of 3-dimensional pyramid forms. Other needlecraft books including hard to find, one of a kinds. Specials. MasterCard, Visa.

American Handicrafts/Merribee
P.O. Box 2934
Ft. Worth, TX 76113
817-921-6191

Free catalog.

Embroidery and other needlecraft kits, tools, equipment, and supplies. (Also has craft supplies.)

Beck's Warp 'N Weave
2815 34th St.
Lubbock, TX 79410
806-799-0151

Catalog $2.00.

Knitting kits, yarns, tools. Weaving and lace making yarns and items. Books. Runs specials. Quantity bulk discounts. MasterCard, Visa.

Bette S. Feinstein
96 Roundwood Rd.
Newton, MA 02164

Catalog $1.00.

Hard to find needlework books: needlepoint, embroidery, fibers, sewing, others. Search service. Libraries bought.

Boye Needle
4343 North Ravenswood Ave.
Chicago, IL 60613

Contact dealer, or send SASE for information.

Sewing notions and aids, quilting frames, hoops, knitting needles, crochet hooks. Others.

Buffalo Batt & Felt Corp.
3307 Walden Ave.
Depew, NY 14043
716-688-4111

Brochure and swatches $1.00 (refundable).

Polyester stuffing—lb. bags, Super Fluff™ bag or bulk rolls. Super resilient stuffing in bulk roll. Quilt batts of Super Fluff™ in queen/king size or roll. Traditional weight quilt batt (crib to queen/king sizes). Comforter style quilt batts—high loft, 2" thick. Has quantity prices.

Celia Totus Enterprises
P.O. Box 192
Toppenish, WA 98848

Send SASE for list.

Designs printed on Pellon, over 1,000 subjects: florals, animals, scenes, country and classic motifs, children's.

Craft Gallery
P.O. Box 145
Swampscott, MA 01907
508-744-2334

Catalog $2.00.

Needlecraft supplies: kits—crewel, silk Balger™, Mini-rugs (silk), cross-stitch, drawn and counted thread, needlepoint, Brussels and other lace making, Brazilian embroidery, hardanger designs, antique doll. DMC needlepoint canvases in 38 designs. Frames: wood floor, nested, roller, grip-it, scroll. Magnifier lamp, "Enlarger Lite," holders, blocker, "Hi-Lite" light. Markers, thimbles, scissors, needles.

DMC, machine embroidery, tatting and quilting threads, and supplies. Knitting and crochet DMC yarns, needles, hooks, accessories. DMC crochet cottons. Beads for counted work. Ribands, lace net. Iron-on transfers, shisha mirrors, 33+ scissors. Needles, pins, aids. Canvas: mono, apricot toile, petit point, 9 double mesh, quickpoint double mesh, Penelope, 6 waste, linen, 4 silk gauze, metallic mesh, congress cloth, rug, 5 interlock, stitchpoint Zweigart. Perforated paper. Threads: 14 metallics, 18+ silks, rayons, 9+ wool, DMC pearl, matte, floss; 6 linens; Persian tapestry. Fabrics: 5 Aidas, hardanger, Linda, linens, wool Java, Davos, Herta, Rustico, Novara, British satin, Ofensburg, Sondrio; Egyptian cotton, huck.

Stitchery Home Study Course. Extensive patterns

and books for all needlecrafts. Allows discount to teachers, institutions, and professionals. (Also sells DMC wholesale to businesses.)

FIBERFILL WISE: *If you spend your time making a doll or toy, sewing a quilt or covering a pillow, it pays to use quality fiberfill, batts, and pillow inserts. Courtesy of Annette Buhsmer of Buffalo Batt & Felt Corp.*

Creative Craft House
Box 1386
Santa Barbara, CA 93102

Send SASE for list.

Line of trims: braids in variety of styles and widths, plastic and other beads, rhinestones, naturals; others.

Fashion Able
Box S
Rocky Hill, NJ 08553

Send SASE for list.

Self-help aids: magnifiers, prism glasses, recliner viewer (purse size, headband type), clamp-on embroidery hoop, self-opening scissors, others; and non-craft self-help aids.

FW Publications
Box 49770
Austin, TX 78765

Send SASE for information.

Book: *The Fiberworks Directory of Self-Published Books on the Fiber Arts*, by Bobbi I. MacRae (lists include many hard-to-find, specialized subjects).

Gingher
P.O. Box 8865
Greensboro, NC 27410

Contact dealer.

Full line of sewing scissors/shears.

Golden Threads
120 E. Main St.
Humble, TX 77338
713-446-8766

Catalog $2.00 (refundable).

Imported and domestic yarns including yarns by Susan Bates, Filatura Di Crosa, Missoni, Unger Yarns. Supplies and a wide selection of patterns for knitting, weaving, needlepoint, others. Instructional videos for learning knitting, crochet, needlepoint, embroidery, weaving and spinning. "Bulk sales discounted."

Gossamer Publishing
P.O. Box 84963
Seattle, WA 98124

Catalog $3.00.

Over 400 needlecraft books: 60+ sewing—dressmaking, Ultrasuede™, fur, silks, satins, lingerie, heirlooms, wedding, tailoring. Pattern and fit—pattern making from clothes, patternless clothes, basic, Perfect Fit, others. 9 serger titles.

Sewing for children—clothes, crafts, toys, Halloween costumes, dolls. Textiles. Fiber arts—weaving, spinning, dyeing. Fashions. Interior design — colors, upholstery, decorating. 50+ quilting titles—patchwork, designs, patterns, etc. Crochet, knitting, stitchery, lace making, cross-stitch, needlepoint, smocking. Crafts — aids for elders, leathercraft, project designs, teddy bears, dolls and toys, American crafts, quick gifts, rugs.

Business—crafts marketing, start business, sewing home business, *Homemade Money* (home business), *Creative Cash* (sell crafts). Booklets and bulletins. Videos: 19 sewing — Pants That Fit, Clotilde, Nancy Zieman, etc. 4 Serger titles, Bobbin and Needlelace, Stenciling, Needlepoint, Applique, Spinning, 10 Weaving titles, Basketry. Visa, MasterCard.

Hallie's Handworks
6307 NE 2nd Ave.
Miami, FL 33138

Send SASE for catalog.

Judaic needlework: patterns, stitchery supplies (threads, aids, others). Also gifts.

Handy Hints
P.O. Box 83015
Milwaukee, WI 53223

Catalog $.50.

Illustrated phrase designs/specialty gift items for sewers and crafters. Decorate sweatshirts, T-shirts, buttons, rubber stamps, coffee mugs, aprons, stationery, stickers, totes, magnetic notekeepers, bumper stickers, others.

Hard-to-Find Needlework Books
96 Roundwood Rd.
Newton, MA 02164
617-969-0942

Catalog $1.00.

Scarce and markdown books: fashion, textiles, tapestry, weaving, lace, knit, crochet, quilt, sewing, rare. Search service. Libraries purchased.

Herrschners
Hoover Road
Stevens Point, WI 54481
715-341-0604

Catalog $2.00.

Tools and equipment: frames (quilt, scroll, adjustable, tapestry). Magnifiers, adjustable dressmaker form, Fiskars scissors. Kits: cross-stitch, crewel, cloth dolls, candlewicking, quilts and thread-its. Stamped table linens and pillow cases, others. Holiday kits. Afghan kits, yarns, DMC, and Star floss. Fiberfill. Fabrics (flour sacking, toweling, flannel, linen, hardanger, Aida, linen toweling). Plain pillowcases, towels. Canvases. Laces, trims. Crochet kits. Latch hook and needlepoint kits.

Transgraph-X™ clear grid overlay—converts pictures to charted designs. Waste canvases. Sewing aids, notions. Yarns. Ball point paints and stamps for fabrics. Needlework totes, mounting boards, organizers, thread carousel. Has some quantity prices. MasterCard, Visa.

Ident-Ify Label Corp.
P.O. Box 204
Brooklyn, NY 11214

Send SASE for list.

Personalized labels on white cotton, with stock phrases. Name tapes (1 line). Has quantity prices.

From the book, American Indian Needlepoint Designs for Pillows, Belts, Handbags and other Projects, © *Dover Publications, Inc.*

Interweave Press
306 No. Washington Ave.
Loveland, CO 80537

Contact dealer, or send SASE for information.

Needlecraft books: weaving—multishaft, finishing touches, structure, learning (four-harness), coverlets, clothing, fabrics, designing, double weave, warping, samplers, miniature, tapestry; designer patterns. Hands on series —dyeing, weaving, spinning, rigid heddle weaving, knitting, sweaters. Knitting—sweater design, history, color, dyeing. Spinning—encyclopedia, designer yarns, fleece, care of spinning wheels.

And: textiles, silk notebook, yarn guide. Design Collections (project booklets). Others. (Publishes *Handwoven, Spin-Off,* and *The Herb Companion* magazines.)

Janaleese Designs
Box 125
St. Thomas N5P 3T5 Canada

Catalog $2.00.

Kits/supplies: counted cross stitch, embroidery, needlepoint pictures and tablecloths.

Kathleen B. Smith
Box 48
W. Chesterfield, MA 01084

Catalog $3.00.

18th century needlework items: natural dye worsted yarns, silk floss, silk/cotton tapes, fabrics, kits for canvas work and samplers—all natural fibers.

Lacis
2982 Adeline St.
Berkeley, CA 94703

Catalog $4.00.

Books: needlework, costume, and embroidery titles.

Lynn-Lee Painted Possessions
421 Clara Dr.
Trenton, OH 45067

Catalog $2.00.

Needlepunch yarn and supplies. Transfer patterns. Cameo fabric paints. Others.

Magic Needle
P.O. Box 144
Biddleford, ME 04005

Catalog $1.00 (refundable).

Quilting kits, patterns. Silk ribbons, embroidery materials, buttons, others.

Mary Maxim
2001 Holland Ave.
Port Huron, MI 48060

Write for catalog.

Kits: cross-stitch, candlewicking, quilting, crewel, others. Craft fur. Cloth doll items. Notions, threads. Sewing aids, quilting frames/stands. Holiday supplies. Stencils. Batting and fiberfill, pillow forms. Other needlecraft supplies. Has quantity prices.

Nancy's Notions
Box 683, Dept. 32
Beaver Dam, WI 53916
414-887-0391

Free catalog.

Complete line of sewing aids and notions. Glass cross-locked beads. Charted needlework designs and kits, hoops. Appliques. Gosling drapery tapes, shade tapes. Reflective tapes, material. Machine embroidery and other threads. Rag rug items. Quilted clothing (and many other) patterns. Instructional videos—many on machine sewing, knitting, cross-stitch, quilting, 3 decorating titles, weaving, rug braiding, others. Has video club rental plan. Allows discounts to teachers, institutions, and professionals. (See SEWING.)

Newark Dressmaker Supply
6473 Ruch Rd., P.O. Box 2448
Lehigh Valley, PA 18001
215-837-7500

Catalog $1.00.

Needlecraft/sewing items: threads — Swiss Metrosene, machine rayon, silk, Coats & Clark, elastic, cotton, upholstery, metallics, ribbon floss, overlocks, stretch nylon,

Candlelight. Zippers—full line and make-your-own, and doll's. Cottons, blends. Buckles, bow tie clips. Silk flowers, dry flowers/aids. Decor baskets. Ribbons: satin, grosgrain, metallics, patterns.

58+ laces, metallics. Notions, bindings, tapes, elastics, Banrol, buttons and molds. Fabrics—calicos, stretch Lycra, sweatshirt fleece, ribbing, knit collar and bands, muslin, denim, sheeting, flannel, satin, voile, batiste, buckram, cheesecloth, huck, jiffy grip, ticking, tubing, silvercloth, silicon coated, clear plastic. Interfacings, appliques. 15 scissors, Olfa cutters, mat.

Bridal accessories, fabrics, veiling, flowers, others. Sewing videos. Pattern books. Smocking kit. Doll items —stretch tubing, muslin, knit velour. Joints. Eyes, eyelashes, whiskers, noses, noise makers. Craft fur, curly chenille, dolls, heads, eyes, shoes, doll stands. Felt. Drape/upholstery and pressing items. Adhesives, magnets. embroidery fabrics, China silk, stencils, Deka paints, sequins, rhinestones, beads. Has quantity prices, large order discounts. (See COSTUMES—HISTORIC & SPECIAL OCCASION.)

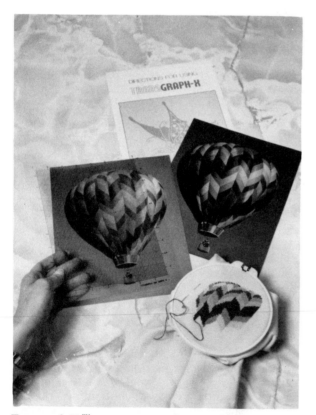

Transgraph-X ™ *transparent graph, converts photo into graph pattern, for needlepoint.* © *LJ Original, Inc.*

Peddler's Wagon
Box 109
Lanier, MO 64759
417-682-3734

List $2.00.

Pre-owned needlework books and magazines.

Peggy Sue Designs
P.O. Box 756
Northport, MI 49670

Brochure $2.00.

Original kits to sew, hook, or knit. Patterns: dolls, furniture, others.

Poston's World of Ideas
300 S. Prosperity Farms
No. Palm Beach, FL 33408

Write for catalog.

Crewel and other kits and supplies; doll parts and dolls, fabrics, variety of plastic and other beads, needlecraft equipment and aids; quilting frames; others.

R.L. Shep
Box 668
Mendocino, CA 95460

Catalog $2.00.

Out of print books on textiles, and costumes; reprints of old tailoring and needleworking books.

S & S Arts & Crafts
Mill St.
Colchester, CT 06415

Send SASE for list.

Group and bulk packs: soft sculpture, felt items, bags, boxes, leather items. Supplies: beads, linen thread, ribbons. Batting. Fabrics: calico, burlap, felt, muslin.

Snowflake Designs Needlework Shop
114 N. San Francisco St.
Flagstaff, AZ 86001
602-779-2676

Catalog subscription $3.50.

Handpainted needlepoint, fibers, canvas, evenweaves, linens; counted cross stitch supplies, charts, yarns. Knitting kits. Has MasterCard, Visa.

Susan Bates, Inc.
8 Shelter Dr.
Greer, SC 29650
203-526-5381

Contact dealer or send SASE for information.

Full line of sewing notions and aids; knitting and crochet hooks, crochet tools and accessories.

Taylor Bedding Mfg. Co.
P.O. Box 979
Taylor, TX 76574

Contact dealer, or send SASE for information.

Line of fiberfill, batting, pillow forms, others.

Taylor's Cutaways & Stuff
2802 E. Washington St.
Urbana, IL 61801

Brochure $1.00. Catalog $3.00 (see below).

Fabrics by pound: polyester, satin, felt, cottons, blends, silks. Remnants: velour fleece, tricot. Fabric packs: craft velvet, calico, cotton prints, solids. Doll clothes, minicalicos. Fabric by ¼ yard. Craft fur and scraps. Lambswool fake fur pieces. Squares: cotton blends, satin, polyester. Lace, trims, ribbons, buttons. Bargain trims.

Doll/animal joints, growler, eyes, ma-mas, squeakers. Shrink art. Potpourri fragrances, silica gel. Pre-cut sachet hearts, satin ornaments. Satin pillow kit. Iron-on transfers. Patterns: crochet, soft doll/toy, craft projects, bears, holiday items. Hawaii and quilted pillow patterns and supplies catalog—cost refundable with order.

The An* Ser
P.O. Box 548
Penngrove, CA 94951

Catalog $5.00 (refundable).

Fabrics: Zweigart, Mono, Interlock, hardanger, aida, lines, others. Threads: floss, metallics, silk, wool. Tools, magnifiers, lamps. Over 3,000 cross stitch charts.

The Taunton Press
63 S. Main St., Box 5506
Newtown, CT 06470
203-426-8171

Free catalog.

Patterns/books: sewing patterns — ethnic and vintage styles (see COSTUMES). Knitting patterns: set-in sleeve Aran sweater, Sleigh-Ride Gloves. Book: *The Fabric and Fiber Sourcebook: Your One-and-Only Mail-Order Guide*, by Bobbi A. McRae (650+ entries for fiber supplies, resources and services, with descriptions). *Alice Starmore's Book of Fair Isle Knitting. Knitting Counterpanes: Traditional Coverlet Patterns for Contemporary Knitters*, by Mary Walker Phillips. From Spring 1990: instructional videos. (Publishes *Threads* magazine.)

The Unicorn
1338 Ross St.
Petaluma, CA 94954
707-762-3362

Catalog $1.00.

Needlecraft videos and books—weaving: ancient looms, coverlets, boundweave, cardweave, Chilak blankets, woven clothing, tapestry, satin, monk's belt, damask, art weave, design titles, embroidery weave, double weave, backstrap, patterns, rugs, Master Weaver series, Japanese, inkles, Mexican, Native American, rag rugs, 16 harness weaving, warp painting, miniature, others. Spinning titles—textiles, designs, wools, sheep, guide, hand spindles, flax, projects, others. Dyeing naturals, plants, indigo, others. Knitting — animals, mohair, Fair Isle sweaters, fashions, baby, machine, charted designs, coats, Aran, cotton, Disney, Passap handbooks, British, others.
Fabric decorating, painting on silk, Japanese patterns, Shibori, stencil, others. Colors: fiber, harmony, perception, designer's guide, others. Business titles: photographing artwork, others. Videos: weaving—4 harness, card, countermarch loom assembly/warping, cut pile rug, dressing the loom, rigid heddle. Fundamentals of hand spinning.

Machine knitting: basic ribber techniques, leader skills for pattern freedom, double bed color changes, pattern knitting techniques. Others. MasterCard, Visa.

Victorian Video Productions
P.O. Box 1540
Colfax, CA 95713

Free catalog.

Instructional videos: lace making, weaving, applique, basketry, stenciling, needlepoint, spinning; 1-2 hours each. (See BASKETRY & SEAT WEAVING, LACE MAKING, and SPINNING & WEAVING.)

Wooden Porch Books
Rt. 1, Box 262
Middlebourne, WV 26149
304-386-4434

Send $3.00 for next three catalogs.

Used and out of print books (fiber arts and related categories): sewing and dressmaking—garments, pattern design, historical/ethnic costumes, fabric design, Godey's Lady's books, French, bridal, children's, smocking, Civil War uniforms, leather and fur, tailoring, others.
Needlework: beaded bags, wig making, silk making, on color, masks, others. embroidery: Oriental, cross-stitch, Victorian, crewel, Greek. Lace making (bobbin, Irish-point, tatting). Crochet, knitting, and quilting titles. Dyeing, basketry, needlepoint (Bargello, chair covers, others). Weaving. Others.

WSC
Box 212
Alamogordo, NM 88310

Catalog $2.00.

Over 150 patterns and designs for crochet Indian rugs, afghans, Kachinas. Needlepoint and latch-hook motifs.

Actual sizes. Use for felt animals, dolls, toys, costumes, crafts, etc.

Yarnworks
519 Main St.
Grand Junction, CO 81501
303-243-5365

Send SASE for information.

Supplies and equipment for handknitting, machine knitting, weaving, spinning, basketry, cross-stitch, needlepoint, dyeing, and crochet. Knitting: needles—Inox (W.

German), Takumi (Japanese), accessories, holders, bags. Yarns of many manufacturers. Handcrafted porcelain buttons. Crochet hooks.

Weaving: Glimakra, Schacht looms. Reeds, heddles; loom accessories. Dyes, mordants. Glimakra floor model warping mills. Navajo batten and beaters. Schacht tapestry beaters, inkle loom, belt shuttle. Dola tapestry loom.

Umbrella swifts, winders. Knitking and White knitting machines. Ashford and Louet spinning wheels. Basketry supplies. Books. Has large order discounts.

YLI Corporation
P.O. Box 109
Provo, UT 84603

Catalog and candlelight color chart $2.50.

Threads: woolly nylon serging threads in 78 solids and 5 variegated combinations. Candlelight metallic yarns — for serger, sewing machine bobbin, hand/machine knitting, needlepoint, weaving, others; 18 colors on 75 to 5000 yard cones. Ribbons: silk, Spark organdy, synthetic silk, fancies. Silk threads in 215 colors. Silk batting. Olfa rotary cutters, mats. Others.

Batik & Dyeing

🐛🐛🐛🐛🐛🐛🐛🐛🐛🐛🐛🐛🐛🐛🐛🐛

See also ARTIST'S SUPPLIES, FABRIC DECORAT-ING, FABRICS & TRIMS, NEEDLECRAFT SUP-PLIES, RUG MAKING, SPINNING & WEAVING, and other related categories; and BOOKS & BOOK-SELLERS, PUBLICATIONS, and ASSOCIATIONS.

🐛🐛🐛🐛🐛🐛🐛🐛🐛🐛🐛🐛🐛🐛🐛🐛

Aiko's Art Materials Import
3347 N. Clark St.
Chicago, IL 60657

Catalog $1.50.

Fabric dyes and equipment. Oriental art supplies including variety of brushes, inks, papers. (See ARTIST'S SUPPLIES.)

Aleene's (Div. Artis)
Box 68
Temple City, CA 91780

See your dealer or send SASE for details.

Batik supplies: Hi'Dye Procion™ natural fiber dyes, batik wax, tjanting pens. (See CRAFT SUPPLIES and FABRIC DECORATING.)

Aljo Mfg. Co.
81-83 Franklin St.
New York, NY 10013
212-226-2878

Free catalog.

Dyes: direct dyes (for cotton and rayon), acid dyes (for silk, wool; batik, tie-dye, printing), Zymo-Fast vat dyes (for cotton; batik, tie-dye), alcohol/water base dyes (for hand painting on silk), cold process, fiber reactive dyes (for painting on silk, cotton, rayon, wool; batik), acid dyes for nylon (7 fluorescent colors), acetate nylon/ disperse type dyes (for nylon, synthetics).

Tjanting tools, beeswax, paraffin. Chemicals and agents: washing soda (ash), Pro-fix for direct dye, hydrosulfite, lye, gum thickener, Al-Rrzist waxless hot water set-up, rinsing agent, salts. Has quantity prices, large order discounts; allows discount to teachers, institutions, and professionals. (Also sells wholesale to businesses.)

Brooks & Flynn Inc.
Box 2639
Rohnert Park, CA 94927
707-584-7715

Free catalog.

Equipment and supplies for marbling, tie dye, batik, silk painting: Procion MX dyes (90 colors), Chromasilk liquid dyes, Tulip fabric paints, Deka fabric paints. Silk fabrics from China; silk scarves. Brushes. T-shirts. Others. American Express.

California Colors
1075 W. Twentieth St.
Upland, CA 91786

Send SASE for details.

Microwave dye kits: with dye for 10 to 60 pounds of wool, and instructions.

Cerulean Blue, Ltd.
P.O. Box 21168
Seattle, WA 98111
206-634-2636

Catalog $3.00 (refundable).

Synthetic fabric dyes (for immersion or direct application): 14 color Procion MX — use on cotton, linen, rayon. Fibracon — use on natural fabrics, jute, paper, reed. 9 Liquid Procion H colors—use on natural fabrics. 10 Teana colors, for silk, wool, nylon, fur blends. Inkodye for cotton, rayon, linen. Dyes also come in starter sets, and auxiliary chemicals are available. Also has fabric paints—4 types; starter sets; auxiliary chemicals. Discharge supplies. Resists and tools. Beeswax, paraffin, cessava, Nori. Shibori kit. Fabrics: cottons, blend, rayon, silks. Japanese supplies: Tsutu cones, tips, wax resists. Tools/brushes, gloves, masks, others. Books.

A dyer dyes cloth various colors for merchants the 16th Century way.

MAKING RED OR YELLOW ONION SKIN
DYE: *This is a simple dye recipe for one yard of fabric. The color will vary from off-white or beige to rosy tones. (1) Combine two cups of crushed red onion skins with sixteen cups of water in a two-gallon enamel container. (2) Boil until the skins are almost clear, then cool. (3) Remove all skins. (4) Add washed, wet, un-folded fabric (about 1/2 to 3/4 yard) to your dye bath. (5) Simmer until fabric looks one to two shades darker than desired, or up to thirty minutes. Stir the dye bath and fabric during the dye process. (6) Set the dye and dry as follows. SETTING THE DYE: This easy method will make the dyed fabric colorfast for future washings. (1) Do not rinse the dyed fabric. (2) Simmer dyed fabric in sixteen cups of water and 1/2 cup vinegar for ten minutes. (3) Rinse in warm to cool water until water is clear. (4) Squeeze out excess water. DRYING: Dry dyed fabric in shade or partial shade. A clothes dryer will set wrinkles which are difficult to iron out. Iron fabric while still damp so fabric will be easy to sew. Courtesy of Lynn K. Johnson, doll artisan and writer, of Minnesota.*

Delta/Shiva Technical Coatings
P.O. Box 3584
South El Monte, CA 91733
213-686-0678

See your dealer or send large SASE with inquiry.

Fabric dyes or Deka Iron-on (for transfers). Ceramcoat acrylics. Marble-Thix powder—creates marbleized patterns when combined with acrylics or fabric dye, on fabric. Other colors and mediums.

Dharma Trading Co.
Box 916
San Rafael, CA 94915

Free catalog.

Fabric dyes: Procion reactive, Jacquard silk type, Tinfix, Deka series L. Fabric paints. Waxes (paraffin, sticky, beeswax, inkodye resist). Gutta resists, Dekasilk resists. Chemicals. Jars, squeeze bottles. Tjantings (3 sizes). Work frame. Fabric pens, syringe set. Fabrics: T-shirt cotton, other cottons, velveteen, silks. Silk and cotton scarves. Cotton garments for dyeing: T-shirts (to XXX lg.), pants, T-dress, others. Steamers. Has quantity prices. MasterCard, Visa. (Also sells wholesale to businesses.) (See FABRIC DECORATING.)

Houston Art & Frame, Inc.
Box 56146
Houston, TX 77256

Contact dealer or send SASE for details.

Dylon Micro-Dye (from England) for cotton, cotton and polyester, linen, silk; 6 colors; for tie-dye in microwave.

Ivy Craft Imports
5410 Annapolis Rd.
Bladensburg, MD 20710
301-779-7079

Catalog Grapevine booklet $4.50.

Batik Tintout dyes; 29 Pientex ink dyes (for all fabrics, all techniques), sampler set. Fabric paints. Fabrics: 6 silks, pima and other cottons, silk scarves (8 sizes). Instructional Videos with Diane Tuckman or Naomi Barsky (on Tinfix and Pientex). Additives, resists, steamers, brushes. Minimum order $20. (Also sells wholesale to businesses.) (See FABRIC DECORATING.)

Rupert, Gibbon & Spider
718 College St.
Healdsburg, CA 95448
707-433-9577

Free catalog.

Silk fabrics: Habotai China silk, crepe de chine, charmeuse, satin twill, tussah, chiffons, organza, raw silk noils, Fuji broadcloth, metallic chiffons, dupioni, shantungs, spun silk taffeta, silk knits, others. Jacquards. Imported natural and bleached cottons. Sold by yard, bolt, and over. Silk scarves (hand-rolled edges) in crepe de Chine, habotai, and Indian cotton; variety of sizes. Jacquard silk colors (dyes) and Gutta resist in clear, black, gold, silver. Vertical fabric steamer. Deka fabric paints/dyes; brushes, books, patterns. Has quantity prices. ("Dealer inquiries invited.")

Textile Resources
20592 Bloomfield St.
Los Alamitos, CA 90720
213-431-9611

Write or call for brochure.

Textile decorating—dyes, chemicals, waxes, variety of fabrics and materials for hand application.

WHAT IS RESIST? *A resist is any substance that keeps dye from reaching fabric. Any resist can be used with any dye.*

The Batik and Weaving Supplier
393 Massachusetts Ave.
Arlington, MA 02174
617-646-4453

Supplies catalog $2.00.

Batik and dyeing supplies: dyes, waxes, tjanting tool, others. (See SPINNING & WEAVING.)

Clothing & Accessories

🦃🦃🦃🦃🦃🦃🦃🦃🦃🦃🦃🦃🦃🦃🦃🦃
See also COSTUMES—HISTORIC & SPECIAL OCCASION; DOLL, TOY & CLOTHES MAKING — SOFT; OUTDOORS & OUTERWEAR; SEWING; and related categories; BOOKS & BOOKSELLERS, PUBLICATIONS, and ASSOCIATIONS.
🦃🦃🦃🦃🦃🦃🦃🦃🦃🦃🦃🦃🦃🦃🦃🦃

Alpel Publishing
P.O. Box 203-CSS
Chambly, Quebec, Canada J3L 4B3
514-658-6205

Free brochure. With sample infant pattern $1.00.

Patterns/instruction books, including: *Easy Sewing for Infants* (with 70 patterns), *Easy Sewing for Children* (75 patterns for 3-10 years old), *Easy Sewing for Adults* (78 patterns), and *Easy Halloween Costumes for Children* (60 costumes for 3-12 years old). Books also have ideas and patterns for accessories, visual pattern index, miniature patterns (easy to enlarge). Duplicut wipe-clean vinyl sheet (to enlarge patterns), with 1" and 2" grid. Has quantity prices. (See CRAFT SUPPLIES and COSTUMES—HISTORIC & SPECIAL OCCASION.)

Artful Illusions
P.O. Box 278
Ector, TX 75439

Send SASE for list.

Designer jackets instructions and layout; with yokes, designer detailed wrists. Shredded cloth design jacket. Others.

BBD, Inc.
P.O. Box 75
Mt. Angel, OR 97362

Send SASE for list.

Baby diaper pattern (with adjustable Velcro™ fasteners, extra center padding, elastic legs) for tiny to toddler sizes. "Distributor inquiries welcome."

Cabinet of Vintage Patterns
3522 Deerbrook
Windsor, Ontario, Canada N8R 2E9

Catalog $4.00.

Clothing patterns: reproductions of women's and children's patterns of 1905-30; long and short skirts and dresses, jackets, tops, others.

Campbell's
P.O. Box 400
Gratz, PA 17030

Catalog $4.50.

Vintage and ethnic garment patterns: over 100 of 1950s and before; patchwork garment patterns, country craft patterns, buttons, semi-precious beads, accessories. Patterns from the 19th century. Books on period clothing.

Cardin Originals
15802 Springdale St. #1
Huntington Beach, CA 92649
714-897-2437

Pattern brochure $2.00.

Garment patterns including for rag "fur" coat (all cotton, in one pattern piece). "Recycle" jacket, others. ("Wholesale inquiries invited.")

City Safe
1075 N.W. Murray Rd. #163
Portland, OR 97229

Send SASE for details.

Pattern for travel vest—with 10 hidden pockets, lined, multi-sized.

Create-A-Tie
P.O. Box 3015-CS
Renton, WA 98056
206-226-2419

Send SASE for information.

Clip-on bow tie patterns and clip-on tie patterns for children through adult sizes (each pattern includes 3 tie clips, full-sized pattern pieces, and illustrated instructions). Tie clips—large and small sizes. Has large order discounts. (Also sells wholesale to businesses.)

Dos De Tejas
425 W. McGee
Sherman, TX 75090

Send SASE for brochure.

Sewing patterns: tote and garment bags, "chameleon" vest, broomstick skirt, "Hobo walk about" bags, new-sew hats, companion hardware to patterns. Has MasterCard, Visa.

Double D Productions
4110 Willow Ridge Rd.
Douglasville, GA 30135

Catalog $1.00.

Square dance apparel patterns—over 60 items, including full skirts, petticoats, tops; others.

Fair Winds Pattern Co.
819 N. June St.
Hollywood, CA 90038

Brochure $1.00.

Patterns for classic clothing of a bygone era (1900-1945).

© The Taunton Press

Fashion Blueprints
2191 Blossom Valley Dr.
San Jose, CA 95124

Catalog $1.00.

Classic ethnic clothing patterns — over 20 designs in blueprint format, multisized; for women, men, children. Some fashionable today: wrap dress, tunics, pants, jackets, vests, tops, robes, shirts, coats — with Oriental, far eastern, African, Mexican, European origins. Early American patterns adapted to today: prairie skirt, gown, apron, shirts. (Also sells wholesale to businesses.) (See COSTUMES — HISTORIC & SPECIAL OCCASION.)

Fashion Design Methods
264 H St., Box 8110/10
Blaine, WA 98230

Send SASE for further details.

Book: *Hundred Hats* — full size patterns for pillbox, fez, fedora, safari, sailor's, others. You're the Designer: design/sew action wear.

Fashion Touches
P.O. Box 804
Bridgeport, CT 06601

Send for catalog.

Service: custom covered belts and buttons, from customer's fabrics or suede.

French Camel Pattern Co.
12235 Rocker Rd.
Nevada City, CA 95959

Send large SASE for brochure.

Sewing patterns.

Friends Patterns
Box 1753
Homestead, FL 33030

Illustrated catalog $1.00 (refundable).

Amish clothing patterns (traditional): Mennonite dresses (sizes 6-18), surplice apron, traditional, and slat bonnets. Child's cap. Broadfall pants (men's, boys sizes) sack coats (interchangeable collars), coat type shirt, man's vest, collarless placket shirt. Girl's waist dress and side pleated apron, round collar shirt and vest, boy's broadfall pants (and suspenders) and sack coat. Amish doll patterns. Swimsuit patterns in classic designs for active swimming and diving; in women's and girls' S,M,L sizes: tank, surplice tank, bikinis. Man's bikini. T-dress.

Ghee's
106 E. Kings Hwy., Suite 205
Shreveport, LA 71104
318-868-1154

Catalog $1.00.

Handbag making: metal frames — variety of sizes and shapes, magnetic closures, chains, accessories, notions.

Great Fit Patterns
11675 Wildflower Ct.
Cupertino, CA 95014

Catalog $1.00.

Modulars patterns for sizes 38-60 (18W-40W): basic pattern shapes requiring very little fitting; wear a variety of ways with other modular pieces; flattering, stylish; suitable for knits and wovens. Modular tops (hooded coats, jackets, vests, sweaters, tunics, jumpers, T-tops, dresses); Modular skirts and pants, accessories). Others.

Harriet's
P.O. Box 1363
Winchester, VA 22601
703-667-2541

Adult catalog $7.00. Children's $3.00.

Patterns and costumes (of 1690-1910 eras — especially Victorian).

Hesson Collectables
1261 S. Lloyd
Lombard, IL 60148
312-627-3298

Send SASE with specific inquiry.

Old, original fashion prints, and plate reprints of fashion plates. Old mail order catalogs.

MATERNITY/NURSING DRESS: *Women planning to start families can sew clothes with hidden nursing openings to wear even before pregnancy and during early pregnancy, because the nursing openings do not show. Courtesy of Stephanie Downs Hughes of The Mother Nurture Project.*

Honey's House
301 Bonnie Pt. Rd.
Grand Rapids, MN 55744

Send SASE for list.

Sweatshirt patterns: neck placket and collar, cardigan, sailor, and other neck treatments. Sweatshirt applique patterns: birds, ladybug, Las Vegas theme, seashells, snowflakes, geese, skiers, animals, children's, others.

Jean Hardy Patterns
2151 La Cuesta Dr.
Santa Ana, CA 92705

Brochure $1.00.

Riding clothes patterns for English, Duster, Western, and Saddle Seat riding; men's, women's. Action patterns: tennis dress, skirts, blouses, sport sets, body suits, pep squad or square dance dresses and skirts. Others.

Joy
P.O. Box 135
Nevis, MN 56467

Send SASE for list.

Jumpsuit patterns (drop-seat style) in misses, boys, girls sizes.

Logan Kits
Rt. 3, Box 380
Double Springs, AL 35553

Brochure $1.00.

Garment kits (and refill kits) of patterns, fabric (elastic for some): lingerie (girdles, camisoles, 3 teddies, tank tops, panties, half slips, short and long nightgowns, and robes); men's briefs, tank tops, robes; girls' slips, camisoles, panties. Master pattern for baby wardrobe.

Refill kits have elastics and fabrics including tricots, cottons, jersey knit, terry, satin polyester, stretch lace, robe velours, cotton Lycra, stabilized nylon, power net, bra filler, others; assortments—robe velour pieces, garment pieces, cottons, T-shirting, small pieces for dolls. Sweatshirt fleece pieces, T-shirt patterns (adult, child). Has quantity prices. (Also sells wholesale.)

Lois Ericson
Box 5222
Salem, OR 97304

Send SASE for further details.

Creative sewing books: Design and Sew It Yourself (techniques, drawings), Print It Yourself, The Great Put On (a wealth of progressive techniques). (Also sells wholesale.)

Madhatter Press
P.O. Box 7480
Minneapolis, MN 55407

Send SASE for details.

Book: *From The Neck Up*, by Denise Dreher. Definitive text on hat making—designing, use of materials, equipment, stitches and techniques, pattern designing, foundation; shaping, edging; trims, finishing; renovations and alterations; 60 historical hat pattern/guides; illustrated.

Mary Ann's Personal Touch
2230 Vemco Dr.
Bellbrook, OH 45305

Send SASE for details.

"Star attraction" purse pattern: with Velcro™ fastener; shoulder strap, with long crossing zipper, and "star" pocket design (to quilt, applique, cross stitch, etc.)

Mary Wales Loomis
1487 Parrott Dr.
San Mateo, CA 94402

Send SASE for full information.

Books: *Make Your Own Shoes*, (sandals, slippers, handbags) using sewing machine and shoemaker's cement, with illustrated instructions. *Make Your Own Beautiful Belts*, create from Ultrasuede™, leather, braid, jewels, etc.; has illustrated instructions for 12 designs; ideas for more.

Pattern Works
307 Lakewood, S.E.
East Grand Rapids, MI 49506

Send large SASE for full information. Include details on pattern, with sketch or picture if possible.

Custom-drafted garment patterns to specification.

Patterns
P.O. Box 350734
Palm Coast, FL 32035

Send SASE for full information.

Custom-fitted personal pants pattern—computer and hand drafted to exact measurements; with illustrated instructions on working with pattern for fit, balance, and style changes.

Queen Size Patterns
RD 4, Box 135
Meyersdale, PA 15552

SASE for measuring instructions & details.

Queen size bra patterns (35 and up, cup size 4" up); bra kits. ("Dealers and seamstresses welcome.")

Quinnbird Designs
P.O. Box 84, Port Credit P.S.
Mississauga, Ontario, Canada L5G 4L5

Send SASE for leaflet.

Dinosaur overalls kit (for children sizes 1 through 9): washable dinosaur-blue print on green twill; all supplies included. (Also has ready-made overalls.)

R Indygo Junction
P.O. Box 30238
Kansas City, MO 64112

Catalog $3.00 (refundable).

Over 25 clothing and craft patterns (adult, children's);

jackets, shirts, appliques, others. (And sells wholesale.)

Seams So Easy
P.O. Box 2189
Manassas, VA 22110
703-369-5897

Send SASE for list.

Swimwear patterns: bikini, tanga, thong, bandeau, boomerang, kitty kat, and 12-in-1 types; man's briefs, fringe patterns; beach coverup, others. American Express.

Sew Little Pattern Co.
P.O. Box 3613
Salem, OR 97302

Brochure $1.00.

Master sewing patterns (full-size) each with 4 sizes and 16 or more garments — in full, European styling for all bodies; with instructions, for regular or serger sewing machines. Quick/easy playwear for preemies to 12 month size; layette (or Cabbage Patch) clothes, "Just Girls" garments (toddler sizes 1-4) with special "grow features" (gro-cuffs, adjustable straps and buttons) for sunsuits, dresses, jumpers, pinafores. (Also has soft doll patterns.) Quantity prices. (Wholesale to businesses.)

Sew Sassy Lingerie
815 Cornelia Dr., Dept. CSS
Huntsville, AL 35802

Catalog $2.00 (refundable).

Lingerie kits/fabrics: Line of kits — teddies, short and long pj's, gowns, robes, panties, briefs, bikinis, slips, short poncho/capes. Larger sizes; girls' sizes; wide array of styles. Kwik-Sew and Stretch & Sew patterns. Tricot pillow case kits. Fabrics: tricot, stretch Lycra, Cuddleskin, cotton knit, Italian charmeuse, pintucking, others. Laces. Bra closures, garters, slip strap holders. Do-Sew™ for tracing multi-size patterns. Books.

Sewing Basket
112 N. Mitchell
Cadillac, MI 49601
616-775-8221

Send SASE for information.
Service: custom fabric covered belts, buckles, and buttons. "Reasonable rates."

Sewing Shop
Rt. 3, Box 225
Mitchell, SD 57301

Instructions $4.00.

How to Grade Patterns (change size) — charts and instructions.

Slippers
8600 N. Charlotte
Kansas City, MO 64155

Send SASE for list.

Sew Little ™ Toddler clothes from pattern "Just Girls".
© *Sew Little Pattern Co.*

Patterns for children's clown slippers (all sizes in one), fabric baby booties, others.

Suitability
1355 W. 89th St.
Cleveland, OH 44102

Free catalog.

Equestrian clothing patterns for Western duster; others.

Sunrise Designs
Box 277
Orem, UT 84059

Color catalog $1.00.

Infants and children's clothing pattern sets — with 12 or more multisized garments in 4 age groups — preemies through size 12; including school clothes, dresses, dress-up, swim and sports wear, western outfits, sleepwear. Over 200 sewing projects in all; also accessories, patterns, notions, special items. Manufacturer.

The Kwik-Sew Pattern Co.
3000 Washington Ave. N
Minneapolis, MN 55411

See your dealer or send SASE for information.

Patterns for dance dresses, petticoats, ruffled panties, Western styles for men.

The Mother Nurture Project
103 Woodland Dr.
Pittsburgh, PA 15238

Catalog $2.00.

Breastfeeding pattern aids (clothes have hidden nursing openings): jumper, tops, Modest Mariner™ coverups, Pop-over top™, dresses (tee, cowl-neck, other), knit turtleneck blouse. Cooperative clothes patterns (for breast feeding and body transition): 5 dresses, 2-piece dress, pleated-ruffled and other tops, jumpsuit, sun dress, swimsuit, jumper, actionwear (pants, skirts, tops) slip, lounger. (Also has ready-made clothes.)

Costumes—Historic & Special Occasion

🐦🐦🐦🐦🐦🐦🐦🐦🐦🐦🐦🐦🐦🐦🐦🐦

See also CLOTHING & ACCESSORIES; DOLL, TOY & CLOTHES MAKING — SOFT; FABRICS & TRIMS; and other related categories; BOOKS & BOOK-SELLERS, PUBLICATIONS, and ASSOCIATIONS.

🐦🐦🐦🐦🐦🐦🐦🐦🐦🐦🐦🐦🐦🐦🐦🐦

Alpel Publishing
P.O. Box 203-CSS
Chambly, Quebec, Canada J3L 483

Free brochure; with sample infant's pattern $1.00.

Book: *Easy Halloween Costumes for Children* (and children at heart?)—60 costumes for 3-12 year olds, and 14 other designs (over 250 line drawings) of "no-cost/low-cost" costumes—traditional favorites and others—from African dancer, to gift box, to gnome, pirate, Peter Pan, robot, and many others.

Patterns are small sized; easy directions included for enlarging. Includes a wealth of illustrated accessories to costumes, with directions, using home items. Makeup and wigs are also covered. Can inspire adults to adapt costume ideas to wacky larger sizes (see CLOTHING & ACCESSORIES for adult pattern book). Duplicut wipe-clean vinyl grid sheet (for pattern enlarging).

Amazon Drygoods
2218 E. 11th St.
Davenport, IA 52803
319-322-6800

Catalog $2.00; pattern catalog $5.00.

Nineteenth century inspired products: over 700 historic/ethnic clothes patterns of 1390 to 1950+, with emphasis on 1800s — coats, cloaks, hats, bonnets, gowns, suits, corsets, lingerie, underwear, formal clothes, everyday, work outfits, and military uniforms; (sizes: ladies 6-44+, men's 32-48+) not all sizes in every pattern.

Sewing supplies: hoop wire, boning, stays, other wires, ostrich plume. Specialty fabrics: cottons, red taffeta, damask, satin, gold "bullion" frieze (on Scarlett's dress). Tradecloth. Uniform wools—dark and sky blue, butternut. Military buttons. Feathers, veilings. Indian and frontier patterns. MasterCard, Visa.

Atira's Fashions
3935 S. 113th
Seattle, WA 98168

Catalog $4.00.

Middle Eastern patterns (men's, women's). Imported accessories. Custom bras for Renaissance look. Others.

Baer Fabrics
515 E. Market St.
Louisville, KY 40202
502-583-5521

Sample sew #11211—$5.00.

Special bridal collection of fabrics: taffetas, satins, chiffons, organzas, nettings, and laces in a range of colors. (Also has other fabric collections of cottons, knits, polyesters, Lycra and others, some at discount — see FABRICS & TRIMS.)

Bridals International
45 Albany St.
Cazenovia, NY 13035

Catalog $8.50.

Line of imported bridal fabrics and laces for designer gown look; patterns from major companies.

Brides 'N Babes
P.O. Box 2189
Manassas, VA 22110

Send large SASE for brochure.

Wedding: you-make bridal gown and accessories, bridesmaids gowns, party favors, others. Instructions for bridal headpieces (hats, veils, combs, garland, halo, coronet, cascades, nosegays, corsages, rice roses, others).

Campbell's
P.O. Box 400
Gratz, PA 17030

Catalog $4.50.

Historic patterns—over 100 multi-sized vintage designs covering 1805 through 1950 by Past Patterns: day and evening gowns, ball gown bodices, skirts, undergarments, cloaks, jackets, others. Accessories including pewter buttons, others. Books.

© *The Wonderful World of Hats*

Celebrations by Post
11120 Gravelly Lake Dr. SW
Tacoma, WA 98499
206-588-2080

Free brochure.

Bridal hardware for home sewing: Austrian crystals, bridal sequins, luster pearls (3 sizes), rhinestones, crystal iris bugle beads, aurora pearls, bridal buttons (satin or organza covered, pearl), button loops, iridescent bridal veiling, French veiling, English net. Rope pearls (hot strung). Milliner's wire, featherlite boning, hoop boning, horsehair. Carriage back petticoats, hoop skirts, tea-length petticoats, others.

Doering Designs
68935 233rd St.
Dassel, MN 55325

Brochure $1.00.

Selection of Scandinavian costume patterns; women's, men's, children's—multi-sized. Braid. Pewter.

Fashion Blueprints
2191 Blossom Valley Dr.
San Jose, CA 95124

Catalog $1.00.

Classic ethnic clothing pattern — over 20 designs in blueprint format, multisized for women, men, children: Korean coat and jacket, Thai wrap dress, Vietnamese tunics and pants, Chinese jacket and vest, Mandarin jacket and vest, East Indies jacket and pants, Judean bridal dress, Kashmir tunic and top, Japanese robes and shirt, Bethlehem jacket, nomad dress and coat, Mexican shirt, dress and top, Volga shirtdress, tunic, African dress and top. Early American patterns: prairie skirt and petticoat, short gown and apron. Sioux ribbon shirt. Dutch shirt. All patterns adapt to style changes and trims. (Sells wholesale to businesses.)

Folkwear
The Taunton Press
63 S. Main Street
P.O. Box 5506
Newtown, CT 06470

Catalog $2.00.

66 Folkwear sewing patterns (for men, women, children—multisized): Ethnic—of Gaza, France, Syria, Turkey, Afghan, Japan, China, Russia, Croatia, Tibet, Hong Kong, Austria, Bolivia, Australia, Morocco, India, Native American, others. Vintage—Edwardian, Victorian, Early American of 20s-50s. Major credit cards. (Also sells wholesale.)

Harriet A. Engler
P.O. Box 1363
Winchester, VA 22601
414-228-8835

Catalog $7.00, Children's $3.00.

Garment patterns (men's, women's) of Civil War era; variety of day and evening gowns, undergarments, blouses, skirts, coats. Trousers, jackets, shirts, others. Hats and crinolines for hoop skirts. Accessories.

Heidi Marsh Patterns
810 El Caminito
Livermore, CA 94550

Catalog $1.00.

Civil war era garment patterns—copies of originals; for men, women, children; including a variety of long dresses, bodices, skirts, jackets, coats, others.

IM-EX
870 Market
San Francisco, CA 94102

Send SASE for list.

Wedding shower/baby shower: patterns for baby shower centerpiece cake (of diapers, ribbons, silk flowers, baby doll, baby socks), mother's corsage. Wedding shower centerpiece pattern. Patterns include instructions and color photo. Has quantity price discounts.

WHEN BUYING VINTAGE CLOTHING: *It is important to keep in mind that long-term stains are virtually impossible to remove in most fabrics. Underarm stains, caused by storing a garment for decades without cleaning it first, are permanent damage to the fabric; as are scorch marks, and discoloration from exposure to light. Often the only solution is an applique. Courtesy Terry McCormick of* Vintage Clothing Newsletter.

Medieval Miscellanea
6530 Spring Valley Dr.
Alexandria, VA 22312

Catalog $2.00.

Patterns for garments of the medieval era—variety of gown styles, headgear, others. Also fabrics, supplies, equipment (See SEWING). Also has jewelry reproductions. ("Dealer inquiries welcome.")

Newark Dressmaker Supply
6473 Ruch Rd., P.O. Box 2448
Lehigh Valley, PA 18001
215-837-7500

Catalog $1.00.

Full line of sewing and needlecraft supplies, aids; fabrics. Bridal—pearl buttons, looping, hair boning, appliques, bands, garters, flower (garland, sprays) accessories, veil, fabrics (lace, satins, moire, organza, esprit, nylon net, tulle, illusion). Pressing items. Fabric paints, sequins, rhinestones, beads. Others. Has quantity prices, large order discounts. (See NEEDLECRAFT SUPPLIES.)

Old World Enterprises
29038 Kepler Ct.
Cold Spring, MN 56320

Catalog $2.00.

Patterns for garments of the 19th century (screened on brown paper) for (today's) sizes 8-12; including gowns for day and evening, bustled styles, men's informal suit, frock coat. Others.

Past Patterns
P.O. Box 758
Grand Rapids, MI 49510

Catalog $3.00.

Historic garment patterns of late 1800s to the present (on brown paper), authentic styles of gowns, blouses, suits, petticoats, nightwear; men's duster, suit; full line of garments from 1911 to 1950s for women, children. (All patterns in today's sizes.) MasterCard, Visa.

Patterns of History
816 State St.
Madison, WI 53703

Send large SASE for list.

Patterns for garments of the 19th century; gowns in variety of styles, others.

Pegee of Williamsburg
P.O. Box 127
Williamsburg, VA 23187
804-220-2722

Brochure $2.00.

Historic patterns including: Scarlett's Barbecue Party Dress (original is in Los Angeles County Museum of Art), The Green Velveteen Dress (from her mother's portieres), hoop skirt (for the Barbecue Party Dress). Other historic garment patterns (each with all sizes): ladies' cloaks (3 styles), long dresses of 1776 (2 styles), 1810 empire style. Girl's 1776 dresses. Men's/boy's 1776 garment patterns: shirts, breeches, waistcoats, and military/civilian coats. Custom designed apparel by Ms. Pegee Miller. (Also sells wholesale to businesses.)

© Patterns from Historie. The Green Velvet Dress made from Her Mother's Portieres, © 1987 Peggy Abbott Miller

Rainments
P.O. Box 6176
Fullerton, CA 92634

Catalog $5.00.

Historical fashion patterns (1100-1950s) of 24 companies. Corset kits and supplies. Millinery patterns and supplies. Costume books.

The Cutting Corner
4112 Sunset Dr.
San Angelo, TX 76904
915-942-9780

Catalog with samples $10.00 (refundable with $75.00 purchase).

Pageant and bridal fabrics: laces, sequins, silk, iridescents, metallics, velvets, taffetas, satin, lame, glitter dot, others. Fringes, rhinestones, other trims and appliques.

Doll, Toy & Clothes Making—Soft

🦢🦢🦢🦢🦢🦢🦢🦢🦢🦢🦢🦢🦢🦢🦢

See also DOLL & TOY MAKING—RIGID, MINIATURES, FABRICS & TRIMS, KNITTING & CROCHET, and other related categories; BOOKS & BOOKSELLERS, PUBLICATIONS, and ASSOCIATIONS.

🦢🦢🦢🦢🦢🦢🦢🦢🦢🦢🦢🦢🦢🦢🦢

Abbott
8600 N. Charlotte
Kansas City, MO 64155

Send SASE for list.

Reversible rag doll patterns: Red Riding Hood, Grandma, Wolf, Cinderella, Goldilocks, 3 bears, black-white, awake-asleep, topsy-turvy princess. Doll patterns (with clothes): 18" old fashioned, 17" Mary Poppins, 22" Honeychile (black), 14" Kewpie, 22" Little Lulu.

Antoinette Designs
906 Lincoln St.
Rockville, MD 20850

Send large SASE for illustrated price list.

Soft sculpture doll patterns (dollhouse scale to 22") with historic, storybook, and international costumes. 10" soft sculpture ballerina doll pattern. Others.

Atlanta Puffections
P.O. Box 13524
Atlanta, GA 30324

Catalog $1.50.

Over 75 soft doll patterns including Puff™ Ima Mouse doorstop, Nanny and the Twins, others.

Barrett House
P.O. Box 585
North Salt Lake, UT 84054
801-299-0700

Catalog $2.00.

Kit: "Sweet Dreams" 18" doll in Victorian nightclothes. Others, and readymades.

Blocker's Guides
Box 1305
Richmond Hill, GA 31324
912-756-4909

Send SASE for guides information.

Booklets: 24 Pantyhose People soft sculpture projects (for ornaments and decoratives, puppets, others). 50 Uses for 2 Liter Plastic Bottles (craft ideas, clever holders, games, decorations, etc.), others. Quantity prices.

Bonnie's Crafts
83 Mary Court
Waterford Works, NJ 08089

Send large SASE and $.50 for brochure.

Soft animal/fabric lined basket combination patterns, including "Woolly Lamb" and "Just Ducky"; others.

By Diane
1126 Ivon Rd.
Endicott, NY 13760
607-754-0391

Catalog $1.75.

"Fuzzy Friends" toy kits and patterns including teddy bears: 5½", 12", 20", 28" sizes, 29" walking bear. Sea creatures, rhino, lion, elephant, hippo, giraffe, kangaroo, panda, racoon, mink, badger, skunk, frog, dog, otter, cat, cow, duck, parrot, poodle, camel, deer, others. Hand puppet kits and patterns. Animal eyes, noses (plastic, glass), joint sets, music boxes; furs—synthetic and mohair. (Also sells wholesale to businesses.)

Cabin Fever Calicoes
P.O. Box 550106
Atlanta, GA 30355
404-873-5094

Catalog $2.50.

Soft doll patterns: 26" country girl and quilt, 15" doll, 16" antique-look doll and clothes, lady doorstop doll. Apple Annie 22" doll and country clothes (and wardrobe pattern). Shaker sisters, 24" museum quality doll and authentic clothes. About 3" country folk dolls. 15" goose/girl doll. 3 bears (17", 20", and 24"). Doll kits: 21" Amish girl, boy and quilt. Amish family (34"), 2 folk dolls with heart between. Topsy-Turvy doll, country bear. Full line of quilting patterns, kits, fabrics, notions/aids, including scissors, threads, needles, markers, batting, fabric paks (cotton shade groups), stenciling and cutting tools & items. Books. (See QUILTING.)

Canille's Designs
1811 Harve Ave.
Missoula, MI 59801

Color brochure $1.00.

Toy patterns (full-sized) including clowns. Others.

Carolee Creations
787 Industrial Dr.
Elmhurst, IL 60126

Catalog $2.00.

Over 200 cloth doll patterns (full-sized): clowns (3 sizes), kitty dolls (5", 14"), 18" cowboy, 10+ little girl dolls (from 8" to 25"), and boys. 19" Baby Love, and Pretty Baby (and layette). Amish baby and kids. Oriental baby, ethnic doll. Soft animal patterns: rabbits, cats, dogs, autograph hounds, long neck goose, "Whats Its" long legged creatures.

Country critters, fuzzy rabbits, dressed mouse and babies. Supplies: furs (hair, shortcraft), real hair wigging, hair loom tool. Fabrics: muslin, broadcloth, flesh-tone

fleece. *Sew Sweet Hair Style Book* by Carolee (uses hair loom, 15 yarn styles). MasterCard, Visa.

Carvers' Eye Company
P.O. Box 16692
Portland, OR 97216
503-666-5680

For information send $1.00.

Glass or plastic eyes, noses, joints, growlers, and eye glasses for teddy bears, dolls.

Charles Publishing
Box 577
Weatherford, TX 76086

Large two-stamp envelope for list.

Crochet patterns: Roger Rabbit, country goose, California Raisins, Santa, Sylvester, Tweetie, Dumbo, Tyrannosaurus, Stegosaurus, others.

Classic Doll
32362 Lake Pleasant Dr.
Westlake Village, CA 91361
818-889-6262

Catalog $2.00.

Cloth doll kits—with hand painted faces (blue or brown eyes) and blond or brown wig; fabric trimmings, shoes and tights for "Cee Cee 21" and "Be Be 19". Others.

Clonz
P.O. Box 60333
Santa Barbara, CA 93160

Send SASE for further details.

Transfer magic allows the ironing of a photograph onto 28" portrait doll (or other fabric).

Cousins Designs Ltd.
P.O. Box 4216
Salem, OR 97302

Brochure $1.50.

Mermaid doll pattern, other soft sculpture and baby accessories patterns. "Wholesale inquiries welcome."

CR's Crafts
Box 8
Leland, IA 50453

80 page catalog $2.00.

Doll and animal patterns, kits, supplies: teddies (and posable bears filled with plastic beads), monkeys; wraparound puppets, dolls (plastic heads). Craft fur, fabrics, fiberfill, animal parts, animal voices (cow, lamb, bear, puppy, bird, cat), cow and other bells, music boxes. Doll parts. Others. Has quantity prices.

Curious Characters Ltd.
2609 S. Blauvelt
Sioux Falls, SD 57105

Send SASE for brochure.

Soft sculptured doll patterns including 20" Amanda baby, Emily newborn hand puppet, "Sunday's Child" 16" preemie doll/puppet, Toby and Lucy chimps (and outfits), others. Sculpture Skin fabric, hair, doll needles. Nyloop fabric for chimps face/hands/feet. Others.

Cynthia Thiele
Alexander Creek Lane #4
Anchorage, AK 99695

Send SASE with inquiry.

Demuremaids™ soft sculpture doll patterns.

D.L. Canborn
3142 Mt. Pleasant
St. Louis, MO 63111

Send SASE for list.

Soft toy kits including snap-together "Bunny Hugs".

Darlinda's Patterns Plus
1060½ N. Main St.
Logan, VT 84321

Free catalog.

Over 200 soft doll patterns including cows, babies, others.

Diana Baumbauer Designs
215 W. 1st St.
Tustin, CA 92680

Brochure $1.00.

Doll patterns (with illustrated instructions) for Yollonda (30" jaunty rag doll), and clothes; 27" LeClown. Others.

> FACING THE FACE: *After the head is stuffed and pinned on the doll body, pin the eyes in place, then proceed with the hair. When hair is finished, return to the face. One reason to wait to do the face is that you get to live with it a little while. Sometimes small adjustments are necessary to achieve the best expression. If you embroider the facial features last you'll get a smoother looking stitch. Also the stuffing affects the appearance of the face. Courtesy of Carolee Luppino of Carolee Creations.*

Dollhouse Factory
Box 456
157 Main St.
Lebanon, NJ 08833
908-236-6404

Catalog $5.50.

Full line of name brand dollhouses and supplies — needlework, wood, lighting, components, accessories, wallpapers, furniture, moldings, hardware, masonry. Kits, tools.

Donna Lee's Sewing Center
25234 Pacific Hwy. S.
Kent, WA 98032

Catalog $4.00.

Doll patterns and books. French handsewing and smocking items. Imported fabrics: batiste, silks, embroideries, laces, trims, silk, embroidered ribbons. Others.

Edwina L. Mueller
228 Dogwood Lane
Washington, NJ 07882

Send SASE for list.

Doll fashion patterns: Adaptation of old Patsy doll wardrobe (fits 8-9" toddler dolls), patterns from Dorita Alice Doll Fashions (Barbie and Batman outfits), others for 11½" fashion dolls.

Fabricraft
P.O. Box 962
Cardiff, CA 92007

Catalog $2.00.

Victorian flair sweatshirt, "Sweatshirt Pals" applique patterns.

Gabriele's Doll Studios
Box 8195-91
Blaine, WA 98230

Catalog $2.00.

Soft doll kits with a "Dollmaking System": handscreened faces on muslin, fabric bodies, instructions, suggestions for trims and hair. Kits include: Baby Clowns, Victorian French fashion "bebe" for 18" to 20" size (with patterns for French fashions) — extra faces available (Bru, Jumeau, Steiner) to make more than one doll per kit.

Ginger Snap Junction
7301 W. 64th Pl.
Arvada, CO 80003

Brochure $1.50.

Soft dolls and toys: snowmen buddies, kitten, 16" doll on a 9" mop, cat and mouse, others. "Wholesale inquiries welcome."

Golden Fun Kits
Box 10697, Dept MB
Golden, CO 80401
303-279-6466

Catalog $1.00.

Soft toy animal patterns ("low-priced"), including puppets. Animal eyes, noses, squeakers, joints, touch 'n play, animal voices (growlers, others), musical movements. Long pins for basting furs. Has quantity prices. Stuffing pellets. Books. (Sells wholesale to businesses.)

Guiliani Creations
1737 River City Way
Sacramento, CA 95833

Catalog $1.00.

Cloth doll kits/patterns (a silkscreened face is included in kits). Patterns are full-sized including very tall girl dolls: 18" Chubby, 28" angel, 3'4" Polly, 4'8" Patricia; with clothing. Credit cards.

Hand of the Creator
P.O. Box 7941
Beverly Hills, CA 90210

Send SASE for list.

Barbie fashion patterns—Hollywood glamor designs.

Happy Hearts
Rt. 1, Box 164
Lexington, MO 64067

Catalog $2.00 (refundable).

Doll costuming items: feathers (small ostrich plumes, pom-poms, boas, marabou, pheasant fluff, peacock, others). Elegant laces and trims. Fabrics and accessories.

Jean Caviness
150 Old Marietta Rd.
Canton, GA 30114

Send SASE for list.

Old Black Mammy soft doll patterns (full-size, with instructions): 20" Jemima (big mammy type), 22" Honey Chile (fat baby with pigtails all over head), 17" Liza Jane (pickaninny girl with pigtails all over head).

Joseph's Coat
26 Main St.
Peterborough, NH 03458
603-924-6683

Send SASE for catalog.

19th century heirloom cloth doll kits (by Gail Wilson): snowman, angel, Santa, Pinochio, Humpty Dumpty; other dolls and character dolls.

Kalico Kastle
45 North Lone Peak Dr.
Alpine, UT 84002

Brochure $1.50.

Rope art country dolls kits (for 10"-16") from wood beads, wire, rope, fabric scraps — Mammy, quilt doll, peasant girl, and pickaninny, others. (Also wood cutout doll kits—stand at 13", sit at 9½"—ready-to-paint, with covered buttons so legs and arms move.)

Karres
P.O. Box 4534
Marietta, GA 30061

Send SASE for full information.

Cloth doll patterns including French clowns (with full-size cutout templates for doll and costumes), Earth Angel, and smaller Earth Angel (with clothing, instruction book); Universal Toddler boy or girl for 8 sizes—12" to 36", for porcelain or vinyl head, arms and legs, and 8 ethnic variations.

Krafdee & Co.
1788 Karen Ct.
Hemet, CA 92343

Catalog $1.00.

Dollmaking patterns including for cat, Betsy girl and cat, rag boy and girl, others. Doll supplies.

Ledgewood Studio
6000 Ledgewood Dr.
Forest Park, GA 30050

Illustrated catalog $2.00 and large SASE.

Heirloom sewing supplies for antique doll costumes: braids, French laces, silk ribbons and taffeta, China silk fabric, Swiss batiste. Swiss embroidery. Small beads, buttons, metal buckles. Jacquard ribbons. Other fabrics and trims. Doll costume patterns.

Lotte's Crafts
P.O. Box 816
Lakeport, CA 95453

Doll/toy patterns including "Furples," fuzzy creatures with jointed limbs (19", 13"), others.

Guardian Angel 15" doll from a pattern. © *Material Memories*

Luba's Crafts & Stuff
R.R. 2
Lucknow, Ontario, Canada NOG 2HO

Send SASE for full details.

Doll tent (and 2 sleeping bags) kits and patterns—for fashion dolls (Barbie, Ken, Rambo, etc.). Kits are pre-cut, in 8 colors or camouflage fabric choices. ("Dealer inquiries welcome.")

Lucy White
Box 982
Westbrook, CT 06498

Samples $1.00 and large SASE.

Mini-curls for small dolls, variety of shades.

Lyn Alexander Designs
P.O. Box 8341
Denver, CO 80201

Catalog $2.00.

Authentic period design patterns for antique or reproduction dolls: dresses — party, Indian, 1800s, Gibson Girl, bride, lingerie. 1880+ French and German girl's Bru (1886) outfits; 1900-30 dresses; infants' and baby items. Boys' outfits. Large sizes. Book: *Pattern Designing for Dressmakers*, by Lyn Alexander. Hats: many bonnets, cloche, 1908-24 hat styles. Underwear, leggings. 1904-20 capes, coats. Body patterns: Bru, Gibson Girl. Basic clothes, variety of shoe patterns (and for leather shoes). (Also sells wholesale to businesses.)

Magic Cabin Dolls
Box 64
Viroqua, WI 54665

Free catalog. Swatches $3.00.

Dollmaking kits and patterns (for natural fibers). Skin-tone cotton knits. Yarns (mohair, alpaca, boucle).

Magic Threads
719 'P' St.
Lincoln, NE 68508
402-435-2101

Send large SASE for brochure.

Cloth storybook doll patterns: 15" dolls — Christmas Elves, Rapunzel, Knight, Sprite Fairy, Raggedy Ann, Tippi Tallsocks, Anne of Green Gables, Little Mermaid, Magic Dragon, Merlin/Father Christmas. And pattern for 22" Santas, with directions for quilt block robes. Log cabin and patchwork designs. Custom designs dolls. (Julie McCullough has won awards and been featured in doll magazines.) Sewing supplies: chainette fringe (for hair), animal eyes, scaled lame. (Also wholesale to businesses.)

Mary Cantrell
505 Pratt
Huntsville, AL 35801
205-533-4972

Send SASE for information.

Soft sculpture doll patterns (with clothes) by Miss Martha—17 assorted books.

Material Memories
P.O. Box 39
Springville, NY 14141

Catalog $1.00.

Folk art doll/toy patterns (full sized): 5" Raggedy Ann & Andy, 14" Merlin, 5" sheep, bear, duck, 12" round headed doll (and quilt, apron). Round bottom (standable) dolls. 11" Amish girls, 16" cat, 15" Guardian Angel, 8" girls. Large floppy eared rabbits (girl and boy), 7" Little Wagon gang—black kids and watermelons. Amish girl and goose. 19" girl (can put music "round" inside her bonnet). 6" Cherub dolls, 11" Amish couple & country

kids, 14" Santa, 11" Sugar Babies, topsy-turvy, 8" thumb sucking doll (and quilt). 3½" jointed teddies. Birth certificates. Black curly chenille. Patterns folded and stuffed by the disabled. (Also sells wholesale to businesses.)

Milk Jug Creations
P.O. Box 35500-235
Billings, MT 59107

Send SASE for list.

Soft sculpture animals/dolls patterns and kits: milk jug doll, "Princess D," rabbit, bear, piglet, guardian angel, clown, others.

Mimi's Books & Supplies
P.O. Box 662
Point Pleasant, NJ 08742

Free catalog.

Patterns for Universal Toddler 16" cloth doll, with ethnic variations, cloth or body accepts porcelain head (patterns full-size). Tub-time toddlers clothing patterns; other patterns for 12" to 36" dolls. Doll clays, "skin," stuffings, fabrics, "hair." Books.

My Sister & I Patterns
3385 Sam Rayburn Run
Carrollton, TX 75007

Catalog $1.50.

"Ragg-Bagg" doll patterns including 24" Inga, Teddy and the Bear, others.

Nona "Granny" Strutton
330 Pine Oaks Rd.
Colorado Springs, CO 80926

Catalog $2.50.

Crochet doll/clothes patterns (using thread). Has MasterCard, Visa.

One & Only Creations
Box 2730
Napa, CA 94558

Send SASE for information.

Doll's iron-on face embroidery appliques (eyes, mouth, nose, eyebrows)—laser trimmed.

Patch Press
4019 Oakman S.
Salem, OR 97302

Send SASE for information.

Cloth doll patterns for Ballerina/Good Fairy (21" jointed doll with ballerina and fairy costumes); and others.

Pattern Crafts
P.O. Box 25370
Colorado Springs, CO 80936

Catalog $1.00.

Cloth doll/toy patterns including "Udder Bliss" whimsical cow—5", 9", and 13" size. Others.

Patterns
P.O. Box 106
Berne, IN 46711

Send SASE for details.

Pattern for "Draft Dodgers" rag dolls that also stop household drafts; old fashioned outfit.

Platypus
Box 396, Planetarium Station
New York, NY 10024
212-874-0753

Catalog $2.00.

Soft doll and animal patterns (full-size) in booklet form, with instructions: doll (some sewn joints, with clothes pattern)—13" boy and girl (extra clothes pattern); 16" girl; 19" girl with proportional figure (3 hair styles, 6 clothing patterns); 24" fashion doll (mannequin figure, posable) and period clothing; 18" peddler/mature doll.

4 little dolls (bearded man, cherub, etc.); 7½" angel (fits over paper cone); 24" "Giggle" jester; Mermaid; Unicorn; Dragon. Pattern leaflets: 8" pocket doll, platypus, star fish and crab, clown doll comforter, doll quilt, soft box, chipmunk. Holiday items from scraps. Train (uses pre-quilted cotton, foam slabs) with engine and six cars; 61" long. 6 African animal silhouettes and 7 menagerie animals. 2 turtles, armadillo and bird, hen and chicks, cat and mouse. Supplies: muslin, wigging fur, buttons, buckles, snaps, doll sewing needles. White work (quilting) booklets, pillow motifs.

Booklets: The Fine Art of Stuffing Cloth Dolls and Animals ($2.50); and The Fine Art of Making Faces on Cloth Dolls; both by Colette Wolfe. (Also sells wholesale to businesses.)

Ragpats
Box 175
Caroga Lake, NY 12032

Catalog $5.00.

Doll and toy animal patterns—over 200 commercial, 1930s-70s, and artists' designs—copied from originals.

Remember When
P.O. Box 212
Elfrida, AZ 85610

Catalog $1.00.

Cloth doll/toy patterns for animals with clothes—pig in skirt and loafers, variety of cows including Victorian Bovine Beauty with umbrella, Topsy-turvy doll. Others.

Roslyn L. Herman
124-16 84th Rd.
Kew Gardens, NY 11415

Catalog $6.00.

Over 1,700 doll clothes, shoes, accessories; 1950s items, warehouse finds, box lots, antiques.

Sew Little Pattern Co.
P.O. Box 3613
Salem, OR 97302

Brochure $1.00.

Full-size patterns for folk art style (X eyes, round bottom; use also for doorstops, decoratives, small for sachets, etc.): Farm Folks, rabbit family, "Sweet Innocence" girls—with illustrated instructions, for quick/easy sew, stuff with sand, rice, or birdseed for stability. Layette pattern for Cabbage Patch and similar dolls and infants. Has quantity prices. (Also has other baby/ toddler garment patterns—see CLOTHING & ACCESSORIES.)

Sew Special
9823 Old Winery Pl., Suite 20
Sacramento, CA 95827
916-361-2086

Catalog $1.00.

Original soft sculpture kits/patterns. Country decor: mouse sew basket, shoe pincushion, sew machine covers. Broom covers/dolls: Peddler, Mammy, folk art, goose girl, Mary & ewe, others. Kitty door stop, sleeping in basket, thin-cat shapes. Cows. Puppet pals dolls—girl, boy, clown, bear. Crayon apron, colorbook tote. Collector soft doll patterns: 13" bride and groom, 19" gypsy, 16" graduate, others. Easter "24 carrot" bunny patterns/ kits. Bunny as basket, duck or bear as basket. Patterns/ kits for boy and girl doll pairs: Irish, Pilgrim. Witches, elves, Santa and Mrs., snowman. Mice, cats, teddies. (Also sells wholesale to businesses.)

Shirley Ann Gifts
1139 Autumn St.
Roseville, MN 55113

Catalog $2.00.

Patterns for fabric folk families (originals) including Amish family, black or country family; each has 22" father, 7" baby; clothes. 30 bear patterns.

Standard Doll Co.
23-83 31st St.
Long Island City, NY 11105
718-721-7787

Catalog $3.00.

Doll making: doll parts, heads, faces, legs, arms, hands; body patterns (8" to 36"). Voices and sounds, squeakers, growlers, pull-cord music boxes (2"), rattle disc, chime unit, electronic touch movements. Shoes, socks, animal eyes, lock-tight joints, curly chenille, stuffing pellets.

Fabrics: muslin, denim, batiste; tube fabrics, one-way stretch poly (flesh tones), nylon net, satin, felt. Lace, other trims, elastics, metallics, sequins, bells, marabou feathers, buttons, mini-zippers, ribbons, threads.

Tags, polybags, folding boxes. Beading wire, seed beads, buckles. Doll accessories. Magnifiers. Books, patterns (soft dolls, toys, clothes patterns for doll fashions, period, others). And complete line of porcelain and other dolls. Has quantity prices. American Express, Master-Card, Visa. (See DOLL & TOY MAKING—RIGID.)

Sweet Home Designs
P.O. Box 2007
McKinleyville, CA 95521

Penelope dressed in 1830 style clothing. Patterns © Platypus.

Catalog $2.00.

Doll patterns: 12" bunny babies (girl, boy), Sunshine girls (18" with jute, mop, or carded wool hair) — includes clothes.

Tea Party Friends
P.O. Box 221806
Sacramento, CA 95822

Catalog $1.00.

Doll patterns for "Peanut Butter & Jelly" boy/girl dolls, 4" doll and 5" frog. Floppy rabbit 22" boy and girls with clothes and 6" carrots. Others.

The Cloth Doll—Patterns
P.O. Box 1089
Mt. Shasta, CA 96067

Send SASE for list.

Pattern Fair soft doll patterns: by Judi Ward—22" Oriental, 22" boy, 30" bed doll, 22" girl and boy dolls. "Gracie" and baby dolls. Sailor and school girl dolls. "Henry and Hannah" 16" dolls by Lyn Alexander—toddler twins, with two-piece wardrobe of period costumes. Others. (*Publishes The Cloth Doll magazine.*)

The Country Folk Collection
P.O. Box 5572
Woodridge, IL 60517

Catalog $2.00.

Dress-up girl tote pattern (with doll pocket to store outfits, folds to tote). Others. "Wholesale inquiries welcome."

The Design Factory
P.O. Box 1088
Hughes Springs, TX 75656
903-639-2012

Catalog $2.00.

Doll patterns: 22" angel/toddler with lace lined wings, curly hair. Other soft doll patterns including Grandbaby bunnies, other babies.

The Kezi Works
P.O. Box 17631
Portland, OR 97217

Send $1.00 for flyers.

Cloth doll patterns and instructions for Marianne, 18" porcelain-look, fully jointed girl with old-fashioned costume. "Country Dreamer" and "California Dreamer" series of dolls.

The Sewing Centipede
P.O. Box 218
Midway City, CA 92655

Color catalog $2.00.

Soft doll/toy patterns (full sized) including 19" rag dolls (with real rag hair), Pig and Mouse, doorstop, "Clara Belle cow" and broom cover "Clover Cow." Other kitchen broom covers; "Beehive Bears," geese in braided fabric wreath, "Greta Goose" centerpiece. 24" clown doll, baby doll with moveable arms and legs, others. Body fabrics: muslin, other shades. Animal eyes.

Thehan Ventures
4326 S.E. Woodstock, Suite 570
Portland, OR 97206

Catalog $2.00 (refundable).

Dollmaking hats book and pattern for molded felt, wire frames and hand plaited straw. Millinery techniques for doll hat construction, antique reproductions and contemporary designs.

Toys for Dolls
P.O. Box 426
Montebello, CA 90640
213-721-6977

Send large SASE for catalog.

Over 115 doll molds: mermaids, cherubs, jewelry, animals, babies, Pierrots, tree ornaments, orientals. Molds of collectable dolls from the 1930s.

Unicorn Studios
P.O. Box 370
Seymour, TN 37865

Catalog $1.00. (refundable).

Musical movements and voices (full line of tunes, electronic types, windup types): mobile music box with wand and clamp. Music, animal, and doll voices (12), accessories, mini-light sets, kits, wooden boxes (28), animal and doll parts. Wyndo cards. Instructions, books.

Viv's Ribbons & Laces
2395 Pleasant Hill Rd.
Pleasant Hill, CA 94523

Catalog $3.50 (refundable).

Doll sewing supplies: silk and organza ribbons old and new French and English cotton and other laces. Narrow braids, trims, and ribbons, Swiss embroideries and hat straw. Flowers, buttons, buckles. Dollhouse doll dressing books, patterns, and others. (Also sells wholesale.)

Quilters Logcabin and Santa Patchwork.
© Magic Threads

Embroidery & Cross-Stitch

❧❧❧❧❧❧❧❧❧❧❧❧❧❧❧❧❧

See also MINIATURE MAKING, MINIATURES & DOLLHOUSES; NEEDLEPOINT; QUILTING; SEWING; and other related categories; BOOKS & BOOKSELLERS, PUBLICATIONS, and ASSOCIATIONS.

❧❧❧❧❧❧❧❧❧❧❧❧❧❧❧❧❧

A.E. Robins Supply
P.O. Box 534
Southeastern, PA 19399

Catalog $1.00 (refundable).

Cross-stitch designs/kits in a variety of motifs.

Anne Powell Ltd.
P.O. Box 3060
Stuart, FL 34995

Catalog $4.00.

Imported needle tools, Glenshee linen evenweaves, counted thread designs.

Aunt Mary's Hobby
20 S.W. 27th Ave.
Pompano Beach, FL 33069

Stitchery catalog $1.50. Cross-stitch catalog $1.50.

Full line of embroidery supplies: threads, evenweaves, and other fabrics, notions and sewing aids, others; designs, books. (See NEEDLEPOINT.)

BetteKaril's Needlecrafts
Box 1383
Shreveport, LA 71164
318-688-4473

Catalog/Needlearts Guide $5.00.

Needlecraft supplies, for cross-stitch (and crochet, knitting, needlepoint, punch work, quilting, tatting). Threads in wide variety—DMC, metallics, Craft World blending filaments, Ginnie Thompson Flower (103 colors), others. Yarns. Beginner kits. Fabrics: 19 colors Aida, 35+ others including usuals, and Colorado, Dublin, Gretchen, Hampton Square, Kappie, Vail. Grab bag. Waste canvas. Sewing aids/notions. Cross-stitch projects (with inserts): table linens, Christmas stockings, wood racks, others. Perforated paper. Stand, magnetic board, totes, others. Design/chart books. 20-30% discount off retail. Custom framing/finishing. Free craft kit with first order.

Brazilian Embroidery
P.O. Box 53411
San Jose, CA 95153

Catalog $2.00 (refundable).

Brazilian embroidery supplies: threads, fabrics, knits. Books.

Brit Stitch
P.O. Box 663
Carrollton, GA 30177

Catalog $2.00 (refundable).

Counted cross stitch: British designs of nature, gardens, cottages, landscapes, and Victoriana.

Canterbury Designs, Inc.
P.O. Box 204060
Martinez, GA 30917
404-860-1674

Catalog $3.00.

Over 80 cross-stitch books, leaflets, kits: country and traditional designs, "paper-snip" look and original and reproduced samplers, indoor and outdoor scenes, cats, kitchen design, minis, holiday motifs, baby and children's, florals, Amish quilts, borders, prairie designs, others. 6" and 12" brooms with bibs sets (18 ct. Aida).

Kali cross-stitch fabric (homespun look cotton) in 7 ct., 14 ct., 20 ct.; precut pieces and assortments in neutral shades. Stationery with cross-stitch reproductions. Pine wood accessories: coat rack, bread board, frames, cutouts, towel holders. (Also sells wholesale to businesses.)

Carolin Lowy
630 Sun Meadows Dr.
Kernersville, NC 27284

Send SASE for details.

Customized color coded graphs, on any subject.

Compucrafts
P.O. Box 326
Lincoln Ctr., MA 01773

Send SASE for complete information.

Cross-stitch, weaving software for Apple II computers.

Count'n Caboodle
P.O. Box 791330
San Antonio, TX 78279

Catalog $5.00. (Optional binder $3.00.)

Cross-stitch supplies: "hundreds" of specialty fabrics, over 800 photographs and detailed diagrams, over 2,000 books; updates to regulars. Fabrics include usuals and unusuals (Aida, Davos, Fiddler's, hardanger, many linens, blends, others).

Craft Happy
293 Clarlyn Dr. Box 28, RR 1
Keswick, Ontario, Canada L4P 3C8
416-476-2480

Free price list.

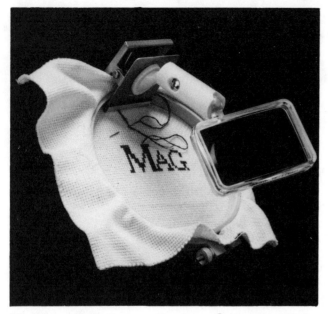

Magnifier with clamp accessory on hoop. © Magnistitch ™, Inc.

Needle Magic Punch embroidery supplies: yarns (acrylics in 80 colors, metallics in 74 colors, metallic silver, lite acrylic), transfers, punch accessories, fabric glue, others.

Cross Creek
5131 Industrial Blvd.
Maple Plain, MN 55348

Send SASE for list.

Embroidery floss (324 colors), organizer system, Scrollrods needlework frame, Aida fabric in 15 colors, fray check. Other cross-stitch items. Credit cards.

Cross Stitched Miracles
P.O. Box 32282
Euclid, OH 44132

Catalog $4.75. (Canada $6.00.)

Cross-stitch supplies: "everything you need," 3500 books.

Daisy Chain
P.O. Box 1258
Parkersburg, WV 26102

Catalog $2.00.

Embroidery fabrics including silk gauze, a ver a soie silk, others; Balger metallic ribbons. Gold and platinum plated needles; accessories. Charted design cross-stitch and resource books. Has quantity prices.

Digi-Stitch
11101 E. 41st St., Suite 349
Tulsa, OK 74146

Send SASE for complete details.

Service: charting for cross-stitch. Color or black/white photos are transformed to charted patterns, on paper, using symbols for all DMC floss colors; allows highly detailed family portraits, children, babies, animal, homes, automobiles. All two weeks delivery; MasterCard, Visa.

DMC Corporation
P.O. Box 5309
Clinton, IA 52736

See your dealer or send SASE for details.

Full line of DMC™ yarns (tapestry, Persian, Medicis), pearl and matte cotton threads, and 360 colors of long staple cotton embroidery floss (including 40 shades of red, 81 greens, 46 blues) that is double mercerized.

Eileen's
3646 23rd Ave. S., Unit 101
Lake Worth, FL 33461
407-586-8012

Catalog $1.00.

Cross-stitch supplies: fabrics (Aida, hardanger, Royal Classic, Fiddlers, Hopscotch, linens, Salem, Lugana, Monza, Rustico, Davos, others). Zweigert: Aida, linen, damask. Waste canvas (8.5, 11, 14, 16 ct.). Cross-stitch accessories (with insert/border): porcelain boxes, bibs, jar lids, "Country Keepers" jars, towels, pillow shams, glass paperweights, aprons, mitt, breadcover baskets, bookmarks. Wood accessories with inserts—towel rack, tissue holder, spoon and key racks, toothbrush holder, serving trays. Floss organizer, wood frames, mounting boards. Sachet kits on linen. Design/chart books (1,000+ titles), other books. "Everything at discount prices."

Embroidery Machine
P.O. Box 599
Pawtucket, RI 02862

Automatic punch embroidery tool ("up to 500 stitches a minute"), push button, spool on end feeds thread, with 3 needle sizes, use with punch patterns/materials, battery powered. Also as kit. Pattern books. MasterCard, Visa.

Eva Rosenstand
P.O. Box 185
Clovis, CA 93613

76 page color catalog $4.50.

Cross-stitch kits and designs from Denmark, in wide array of traditional and classic designs—people, scenes, flowers, animals, other motifs.

Fancywork
Box 130
Slaterville Springs, NY 14881

Catalog $2.00.

4,000 cross-stitch books. Categories of motifs include: country, classic, contemporary, holiday, men's, women's, children's, babies, whimsical, Oriental, western, nautical, early American, flowers, wild and domestic animals, scenes, geometrics, many others; large to mini sizes.

Franceval Enr.
P.O. Box 131
Chomedey, Laval, Quebec, Canada H7W 4K2

Catalog $2.75 prepaid.

Counted cross-stitch kits—wide variety of small projects, easy-to-makes; kits with floss, needle, cloth, frame, instructions; florals, traditional designs, others.

FLAT FLOSS: *To help keep your floss flat when cross-stitching, after threading your needle pass it through a lightly dampened sponge. A small makeup sponge works well. Courtesy of Lois Brandt of Just Countin'.*

Gene's
Box 1214
Franklin, TN 37065

Send SASE for list.

Cross-stitch patterns of Gene Gray collection: owl, panda, eagle, squirrels, quail, others. Quantity prices.

Graphs for Crafts
P.O. Box 6858
Wyomissing, PA 19610

Send large SASE for more information.

Service: any photograph or artwork converted into graphs for cross-stitch or needlepoint—graph is up to 30 colors; useful for gifts, preserving memories, pets, home, logos, special designs, others. Photo image in 1" and up sizes.

Heartdrops
P.O. Box 181
Oneonta, NY 13820

Catalog $5.00 (refundable).

Cross-stitch fabrics (Aida, hardanger, linens, Lugana, Jobelan, Davos, patterned, others). Cross-stitch frames and accessories; over 1000 graph designs. Others.

Hearthside Stitchery & Crafts, Inc.
234 E. Washington St.
Medina, OH 44256
216-723-1144

Catalog $2.00.

Embroidery fabrics (Aida, evenweaves, others). Frames, accessories, design books; "extensive selection."

Hieroglyphics Unlimited
Rt. 4, Box 100
Madison, IN 47250

Free cross-stitch chart, kit list, and sample chart.

Cross-stitch charts and kits, in these designs: over 40 Egyptian motifs, including King Tut Mask, Nefertiti, Sphinx, Horus, variety of animals, insects, birds, hieroglyphic silhouettes. Dinosaurs—14 species. 18 African animals: lion, cubs, rhinoceros, zebra, elephant, giraffe, oryx, antelope pair, others. Wild animals: koala, puffin, killer whale, Siberian tiger, others. 10 teddy bear designs.

14 Ancient Greek motifs: warriors, Achilles, Spartan warriors, discus thrower, Minotaur, Partheon. 11 heraldry and 13 medieval (knights, 5 castles), inspirational, religious. (Sells wholesale to businesses.)

Homestead Designs, Inc.
P.O. Box 18324
Spartanburg, SC 29318

Free catalog.

Cross-stitch designs and patterns, leaflets, books: quotations, hunting, wildlife, country samplers, Christmas, and others. Special Mat-Ters mats with 1 or 2 cutouts in cross-stitch reproductions (and graphs for) shows, Schooldays, kids, Families are Forever, Wedding Memories, others. Special cutout mats and frames. Baby bibs with 14 ct. insert.

Fabrics: Aida (8, 14, 18 ct.), Fiddlers, Rustico, Ragusa, Banjo, Davos, Floba, Florma, Herta, evenweaves. 7 Afghan fabrics (14 ct.) including Patrice, Gloria, Udine, Liberty Square, Dutch Garden, others. 4 linen-like fabrics. Pillows—Corner Block™ 3-color squares in block. Has quantity prices. (Also sells wholesale to businesses.)

In Stitches
10611 Abercorn Ext.
Savannah, GA 31419

Catalog $1.00 (refundable).

Custom cross-stitch: hand charting of home, car, scenes, logos, photographs, line drawings, others.

International House of Bunka
19 Tulane Cres.
Don Mills, Ontario, Canada M3A 2B9
416-445-1875

Write or call for price lists.

Bunka needle kraft (punch) tool and supplies—kits, threads, patterns, accessories; teach-yourself manual. Custom framing service. (Also sells wholesale.)

Just Countin'
Box 559
La Center, WA 98629

Catalog $2.00.

Cross-stitch supplies/accessories: fabrics—7 linens, cottons and cotton evenweaves, rayons, blends, polyesters, polyacrylic; Aida, Congress, Jobelan, Fiddlers, Tabby, others. DMC floss, waste canvas (8.5 ct. to 16 ct.). Notions. Organizer. Accessories (with inserts/borders)—bread covers, placemats, napkins, towels, potholders, bath items, bibs, paperweights, others. Mounting boards.

Perforated paper cards. Ribband, Country Keeper jars, fly swatter, pillow shams. Pine items: shelves, bar frames, racks, caddy, boxes, planter, bulletin and bread boards, fire screen, mini-frames, trays. Framing mats. Porcelain bases. 800+ design/chart cross-stitch books.

Just Needlin'
611 N.E. Woods Chapel
Lee's Summit, MO 64064

Catalog $3.00 (refundable).

Cross-stitch fabrics (policy: buy 1 yd., get 1/8 yd. of same free; fabrics 8.5 to 35 ct., most 55-60" wide): Aida (colors), Alice, Alma, Anne, governor block, Damask, Davos, Fiddlers, Floba, Gloria, Hampton, Hearthside, Hopscotch, Jobelan, Klostern, Linda, linens, Loomspun, Melinda, Monza, Patrice, Rustico, Shenandoah, others. Perforated papers.

Projects (with inserts) towels, bath items, potholders, sweatshirts, carryalls. DMC floss, color card. Balger metallics and filaments — 89 colors. Ginny Thompson flower threads. Hoops, scroll frames, rulers, magnifier, line keeper, mounting boards, needles, scissors. Over 1,200 design/chart cross-stitch booklets (policy: buy 12 and get 1 at half price). Has monthly newsletters and special order discounts. (See PAPER CRAFTS & PAPER MAKING.)

K & B Craftings
9313 Hadway Dr.
Indianapolis, IN 46256

Catalog $.50 (refundable).

Evenweave fabrics (Aida, linens, others—all colors and thread counts; custom cut to size wanted).

Kept in Stitches
Box 3850
Venice, FL 34293
813-485-7882

Contact your dealer or send SASE for list.

Watercolors in counted cross-stitch design books, adapted from the work of these artists: Dawna Barton, Ellen Stouffer, and The Real Mother Goose™.

Kreinik Mfg. Co. Inc.
P.O. Box 1966
Parkersburg, WV 26102

Send SASE for sample, specify interest.

French silk yarns—au ver a soie: 5 textures of threads for needlepoint, cross-stitch, embroidery, smocking, others. Soie d'Alger 7 ply silk in 438 colors. Other silks in 50 shades. Balger™ metallic threads in soft pastel colors. (Also sells wholesale.)

LJ Originals, Inc.
516 Sumac Place
DeSoto, TX 75115
214-223-6644

Information sheet $1.00.

Transgraph-X™ clear plastic grid kits—converts photos/drawings into charts for any counted needle art (overlays sized at 5, 11, 14, 18, 22, and 25 squares to the inch) with instructions, scales to calculate cloth and design size instantly. Reduce/enlarge patterns by interchanging sheets; use with non-permanent felt-tipped or engineering-type pens; bagged. (Use for cross-stitch, latch hook, needlepoint, etc.) Plastic grid sheets used in kit are tear-proof, printed on reverse side, bonded and film coated. (Also sells wholesale to businesses.)

Marilyn's Needlework & Frames
4336 Plainfield Ave. N.E.
Grand Rapids, MI 49505
800-346-8411 (except MI)

Catalog $5.00.

Stoney Creek Collection cross-stitch designs/kits. Wide selection of fabrics. Balger blending filaments, Wheatland craft frames, cross-stitch books by top designers. Needlepoint, crewel, and longstitch designs. DMC floss.

Mary Jane's Cross 'N Stitch, Inc.
5120 Belmont Rd.
Downers Grove, IL 60515

Catalog & Guide $5.00 (refundable).

Over 1200 stitchery books and leaflets, embroidery fabrics. DMC floss "special price." Magnet boards.

Meistergram
3517 W. Wendover Ave.
Greensboro, NC 27407

Write for information.

Automatic monogramming, embroidery equipment, and supplies (training, service, and marketing know-how).

MJ Designs
P.O. Box 633
Hopkins, MN 55343

Brochure $1.00 and large SASE (refundable).

Early American weaving patterns in cross-stitch.

N. Porterfield
621 S.W. 24th
Moore, OK 73160

Free brochures.

Line of counted cross-stitch kits; variety of designs including traditional, country. Embroidery floss kit.

Needlecraft Originals
Box 1679
Grand Centre, Alberta, Canada T0A 1T0

Send SASE for complete details.

Service: custom-designed charts from any photos for cross-stitch (and also needlepoint).

Ozark Punch Supplies
Box 114
Duenweg, MO 64841

Free catalog.

Punch embroidery supplies "at discount prices."

Pantograms Manufacturing Co., Inc.
6807 S. MacDill
Tampa, FL 33611
813-839-5697

Write or call for information.

Monogramming system equipment, variety of models, and accessories.

Photo-Stitch
1 Crawford Pl.
Old Bridge, NJ 08857

Free brochure.

Portraits in needlecraft: counted needlepoint or cross stitch chart from any photo. Precision color matching to DMC colors.

Photos-to-Floss
Box 155
Plum City, WI 54761

Send large SASE for color brochure.

Cross-stitch patterns from your photo, as easy-to-read graph keyed to DMC floss. MasterCard, Visa.

Pstitch
2103 Bristol Rd.
Champaign, IL 61821

Send SASE for price information.

Software for IBM PC compatible computers: "Create Cross Stitch Charts" version 3 (expanded editing and printing capabilities; no color/graphics card required).

Pure China Silk Co.
Rt. 2, Box 70
Holdrege, NE 68949
308-995-4755

Color card $1.25.

Silk embroidery threads in 14 yard skeins, multi-strand twist threads, 64 colors — for embroidery, cross-stitch, needlepunch, petit point, etc. (Also has pearl necklaces.) Has quantity prices, large order discounts. (Also sells wholesale to businesses.)

Robin Designs
12909 Turkey Blvd. Pkwy.
Rockville, MD 20853

Send SASE for brochure.

Custom cross-stitch kits from any photographs.

Robison-Anton Textile Co.
P.O. Box 159
Fairview, NJ 07022
201-941-0500

Contact dealer, or send SASE for information.

Super Luster™ embroidery floss on cones — 6 strand mercerized cotton on 1 lb. (500 yd) cones; in 228 colors. Specializes in cones for kit manufacturers.

Sandeen's
1315 White Bear Ave.
St. Paul, MN 55106
612-776-7012

Needlecraft catalog $3.00 (refundable).

Norwegian and Danish embroidery/handcraft supplies: Swedish kits, hardanger supplies, brackets, others. (See TOLE & DECORATIVE CRAFTS.) MasterCard, Visa.

> FRENCH KNOTS: *Use Fray Check on French knots to keep them from coming undone. Courtesy of Eileen Wiles of Eileen's.*

Shay Pendray's Needle Arts Inc.
2211 Monroe
Dearborn, MI 48124
313-278-6266

Catalog $2.00.

Japanese embroidery supplies: flat silk thread and tools, floor and other frames.

Stitch 'N Stuff
24401 Carla Lane
North Olmsted, OH 44070

Catalog $1.00.

Counted cross-stitch supplies, DMC floss, fabrics, accessories, plastic canvas, yarn, books. "Low discount prices."

Stitchers' Delight
2480 Iris St.
Lakewood, CO 80215
303-233-6001

Catalog $1.00 (refundable).

Colorado cross-stitch graphs and kits, books, fabric, and accessories. "Special inquiries welcome."

Strings 'N Things
1228 Blossom Terrace
Boiling Springs, PA 17007
712-258-6022

Send large SASE for brochure.

Threads — cotton, silk, metallic, wool. Tatting thread, embroidery and tapestry cottons, cutwork thread. Pearl cotton, sizes 5, 8, 12. DMC embroidery threads. Baroque and other crochet cottons. Metallics and metallic embroidery threads. 3 ply Persian wool, Brilliant crochet cottons. Balger blending filaments cords (50 basic colors, Hi-Lustre and cords): by 55 yard to 550 yard reels; color card. Balger braid (45 colors), by 11 yard reels.

Silks — Soie D'Alger, mini skeins, standards; color card; conversion chart DMC to silks. Schurer Threads: Marlitt, high luster embroidery and Nordiska, linens, metallics. Has quantity prices.

Sudberry House
P.O. Box 895
Old Lyme, CT 06371
203-739-6951

Contact your dealer, or $.25 for catalog.

Mini-Collection wood accessories and matching cross-stitch designs, carriage clock, 3½" X 5" design; others.

The Country Mouse
Rt. 5, Box 827
Richland Ctr., WI 53581
608-647-8343

Catalog $1.00 (refundable).

Cross-stitch: Magic Ring™ — 1" ring (frame), backing, magnet; holds 14 ct. cross-stitch design or other decoratives (or use for party favors, ornaments, macramé, pot holder hangers, etc.). Plastic rings in 24 colors or wood; plastic metallic with loop holder. Aida cloth sampler packs (1½" squares). Magic mirrors (1") fit rings.

Cross-bar frames (with hearts, bears, 4 sizes). Heart, mini cross-bar, house frames. 400+ cross-stitch patterns (14 ct.) for 1" rounds—leaflets and Magicards™ charts, cats, country, messages, rainbows, unicorns, spring, holidays, dancers, religious, etc. Quantity prices; discounts for professionals and teachers. (Also sells wholesale.)

X'ING LINEN: *When using linen fabrics for cross-stitch, don't use a hoop. It will pull the fabric out of shape. Count two threads ("steps") at a time—don't count the holes of the fabric. Liberty Square is a 14 count polyacrylic evenweave fabric that is machine washable. Davos is an 18 count cotton twist fabric. Fiddlers cloth is a poly/linen/cotton blend in beige, in 14 or 18 count. Alice cloth is a cotton evenweave of about 27 count, with contrasting dark/light squares. Herta is a 6 count braided weave cotton fabric that works best for bigger projects.*

The ETC Shop
P.O. Box 142
Freeport, NY 11520

Send SASE for catalog.

Perforated paper — 5 colors. Window cards (2 sizes, round and heart-shaped). Others.

The Homesteader
P.O. Box 18324
Spartanburg, SC 29318

Catalog $2.00.

Cross-stitch fabrics including Aida. Cross-stitch designs and coordinating "shaped" mats and frames. Others.

The Regal Touch Distributing Company
1164 Padua Ave. #1
Upland, CA 91786

Catalog $2.00 (refundable).

Punch embroidery and craft supplies: full line of Ultra-Punch™ "elegance" metallic yarn. adhesives, patterns. Jones Tones™ items. Sequin Art™, Cameo paints and punch, others.

The Yarn Shop
311 Third Ave.
Chula Vista, CA 92010
619-420-2443

Free catalog.

Home accessories to embroider: towels, pillow cuts, bibs, burp pads, coverlet, jewelry blanks, book marks—with borders or areas for cross-stitch. E-Z Stitch frame sets and knobs. Adjustable floor hoop stand and chart holder. Mat and mounting boards. Dazor magnifier, lights, hand magnifier.

Fabrics: linens, Aida, others. Waste canvas (8.5 or 14 ct.). Stitch-A-Shirt stitch kit (waste canvas, floss, needle, chart). Needles, needle organizer, floss tote. Graph paper. How-to cross-stitch pattern books. "All catalog items 25% off retail." MasterCard, Visa.

Theron Traditions
222 Williams St. #125
Glastonbury, CT 06033

Contact your dealer or catalog $1.50.

Counted thread kits: overdyed floss, variety of stitches, linen fabric, color photo, stitch charts, and graph, including samplers, quotations, others. ("Shop inquiries welcome.")

Threadbenders
224 7th St. NW
Barberton, OH 44203

Send SASE for list.

Brazilian embroidery: imported linens, canvas, Aida cloth. Balger and overdyed threads. Others.

Thumbelina Needlework Shop
P.O. Box 1065
Solvang, CA 93463
805-688-4136

Supply catalog $1.00.

Full line of counted thread designs, charts, and kits (with Aida, floss, chart): in classics, traditional, other motifs.

Other counted thread embroidery catalogs: (1) Danish Handcraft Guild $2.85; (2) Permin Christmas Designs/kits $2.25; (3) Permin Designs in kits $2.25; (4) Eva Rosenstand/Clara Waever $4.50; (5) Charts or kits, no Christmas $2.75.

Wendy Gresmer
Rt. 2, Box 46
Isanti, MN 55040

Send SASE for further details.

Cross-stitch kit: custom-charted from picture (of house, or other), includes Aida cloth, DMC floss and chart.

Fabric Decorating

🐦🐦🐦🐦🐦🐦🐦🐦🐦🐦🐦🐦🐦🐦🐦🐦

See also BEAD CRAFTS, NEEDLECRAFT SUPPLIES, BATIK & DYEING, EMBROIDERY & CROSS-STITCH, FABRICS & TRIMS, and SEWING. Check other related categories in BOOKS & BOOKSELLERS, PUBLICATIONS, and ASSOCIATIONS.

🐦🐦🐦🐦🐦🐦🐦🐦🐦🐦🐦🐦🐦🐦🐦🐦

Aleene's (Div. Artis)
Box 68
Temple City, CA 91780

See your dealer, or send SASE for information.

Tacky fabric glues, Hi'Dye Procion™ dyes (11 shades, by pkg.) for painting, screen, batik. (See CRAFT SUPPLIES and BATIK & DYEING.)

Aycee Creations
P.O. Box 722
Logan, UT 84321
801-753-7560

Free brochure.

Plain cotton items, ready-to-decorate: aprons, tote bags, waist packs, portfolios, athletic and lunch bags; 10 or 14 oz. heavy cotton. "Wholesale prices."

Blueprints-Printable
1504 #7 Industrial Way
Belmont, CA 94002

Catalog and fabric samples $3.00.

Printable clothing/accessories: silks, rayons, cottons (blueprint sensitized fabrics). Hair clips, buckles, earrings, handbags.

Cerulean Blue, Ltd.
P.O. Box 21168
Seattle, WA 98111
206-443-7744

Free catalog.

Fabric paints (for painting, stencils, rubber stamps, screen or mono printing, etc.): 16 Euro-Tex™ colors—use on most fabrics. Primal-Glow™ fluorescents. 8 Lumiere™ metallic colors, pearls; and 10 Neopaque™ colors—both can be used on most fabrics, leather, paper, wood, baskets. Paints also come in starter sets and with auxiliary chemicals. Synthetic dyes in 5 types. Other auxiliary chemicals, discharge supplies. Print base kits. Japanese art supplies for stenciling, painting, etc. Brushes, tools. Fabrics: 5 mercerized cottons, cotton/linen, rayon, 3 silks. Equipment (safety/lab): goggles, masks, scale, thermometers, others. Books.

Colleen's of New Orleans
9029 Jefferson Hwy.
New Orleans, LA 70123

Send SASE for list.

Design packets for tote bags, beach canvas bags and other supplies. Has Visa.

Colorcraft Ltd.
14 Airport Park Rd.
East Granby, CT 06026

Contact dealer or write for catalog.

Createx non-toxic fabric colors (water-based acrylics for all fabrics and porous surfaces) in 1, 2, and 4 oz. sizes; 35 colors and 44 pearlized colors. Color kits. Glitter powder (dust-like, non-metallic, can be mixed with colors; or in premixed) semigloss. Clear ply adhesive coating (flexible), gloss medium, perma seal. Marble colors, foils. Instructional videos on fabric painting. Minimum order $25.00. MasterCard, Visa.

Decart, Inc.
Box 308, Lamoille Industrial Pk.
Morrisville, VT 05661
802-888-4217

See your dealer or send SASE for information.

Deka™ fabric paints; full array of colors. Manufacturer.

Delta/Shiva Technical Coatings
2550 Pellissier Place
Whittier, CA 90601
213-686-0678

Send large SASE for free color guide.

Delta fabric dyes, colors, glitter, Shiny and Swell Stuff and Stitchless glue. Ceramcoat acrylics, Shiva Signa-Tex acrylic paints. Marble-Thix powder (mixes with water/paint to marble fabrics "in 5 seconds").

INSTANT AIRBRUSH: *Cut 2 thin foam carpet pads —1 3" X 3" and 1 5" X 5". Wad up the smaller piece, wrap the larger over it, and tie with a rubber band. A dauber! Spread out your fabric paint and dab gently, then dab gently onto fabric and you'll have a great airbrush effect. Courtesy of Wendy J. Kennedy of Color-Craft Ltd.*

Dharma Trading Co.
P.O. Box 916
San Rafael, CA 94915

Free catalog.

Line of fabric paints, Pientex silk inks, Deka-silk and metallics, Texticolor iridescent, Versatex textile paint, dyes. Fabric pens, brushes, jars, gloves, squeeze bottles. T-shirt and other cotton fabrics. T-shirts, T-dress, and pants. Silk fabrics. Silk and cotton scarves. Line of dyes

and batik products. Has quantity prices. MasterCard, Visa. (See BATIK & DYEING.)

Fabdec
3553 Old Post Rd.
San Angelo, TX 76901
915-944-1031

Send SASE for price list and details.

Procion fiber reactive dye kit: and individually, 14 shades in 3 oz. up lots. Dye kit suits experimenting, small workshop or group — painting, silkscreen, stencil, airbrush, fold/dye, batik; dye, yarn, fabrics, paper, wood, or baskets; has 4 colors, urea, and soda ash. Supplies: thickener, urea, soda ash, tjantings (3 sizes), beeswax, dyeing paper, natural fiber fabrics including cotton organdy and muslin, mercerized cottons, cotton-bleached duck, viscose rayon challis; by yard. Has large order discounts. MasterCard, Visa. (Also sells wholesale to businesses.)

G.H.T.A. Co.
5303 Hollyspring
Houston, TX 77056

Catalog $2.00.

Cotton and 50/50 blend plain clothing: tee and sweat shirts, leggings, long tees, golf shirts, shorts, others. "At wholesale prices."

Pillow with Sun Prints (from negatives) from kit.
© Gramma's Graphics, Inc.

Gramma's Graphics
20 Birling Gap
Fairport, NY 14450

Brochure $1.00 and large SASE.

Sun print kits (images are made by contact printing photo negatives or opaque objects, stencils, etc., on fabric treated with light sensitive solution. Exposure to sun or ultraviolet light produces permanent prints in shades of blue. Washable — for pillows, quilts, others. Untreated cotton by the yard. Color toning instructions (for other colors), assembly instructions for quilt or pillows. Quantity prices. (Also sells wholesale to businesses.)

Illinois Bronze
Lake Zurich, IL 60047
312-438-8201

See your dealer, or send SASE for information.

Gimme fabric decorating products: Glitters, Iridescents, Slicks, Puffs, Dazzling Dyes, Beachstreet Dyes, See-Through Sparkle Tints, Precious Metal, Fabri-coat, fabric media, Glitter Glue; wide range of colors. Acrylic paints in brights and pastels. Others. Manufacturer.

Ivy Craft Imports
12213 Distribution Way
Beltsville, MD 20705
301-595-0550

Free catalog.

Liquid dyes for all fabrics. Vision art dyes (instant dry). Books and videos (silk painting).

J. Trear Designs
2121 Slater St.
Santa Rosa, CA 95404
707-523-2840

Catalog and swatches $1.00.

All cotton clothing (for painting or dyeing), in fleece, crinkle cotton, sheeting, and cotton Lycra. "Quantity discounts."

Lauratex Fabrics
153 W. 27th St.
New York, NY 10001
212-645-7800

Send SASE for information.

Cotton fabrics prepared for painting and screen painting: sateen, ottoman, batiste. Linens.

Leesburg Looms & Supply
113 W. Van Buren St., Box 11
Leesburg, IN 46538
219-453-3554

Free brochure.

Weaving looms (2- and 4-harness) in pine and maple. Loom supplies.

Luv 'N Stuff
P.O. Box 85
Poway, CA 92064

Color catalog $2.00 (refundable).

Patterns for painted items including pillows, wall-hangings. Painting supplies.

Pentel of America, Ltd.
2805 Columbia St.
Torrance, CA 90503

See your dealer, or send SASE for information.

Fabrifun™ pastel dye sticks (for natural fabrics) in 15 colors; colorfast, washable. Artists pastels, watercolors, crayons, glues. Quantity prices; large order discounts.

Photo Textiles
P.O. Box 3063
Bloomington, IN 47402

Send SASE for details.

Transfer service: photos, drawings, artwork, and other, to fabrics.

Printables
P.O. Box 1201
Burlingame, CA 94011

Catalog and fabric samples $2.00.

Clothes for surface designers—casual and dressy styles in sizes XS to XL, in preshrunk, PFD, cotton sheeting, and rayon challis. Silk selections in several colors (but not preshrunk). Basic clothing ready for artistic embellishment. Cotton, silk, and leather earrings. Silk scarves. Quilted cotton and silk handbags, belts, and jackets.

> MASKING TAPE STENCILS: *When used with slightly thickened fabric paint, plain masking tape can be applied as a stencil directly onto the fabric in different shapes, lines, and curves to create and isolate areas of design. Courtesy of Ann Marie Patterson of Cerulean Blue, Ltd.*

Pro Chemical & Dye, Inc.
Box 14
Somerset, MA 02726
508-676-3838

Free catalog.

Full line of dyes for silkscreen, handpainting, batik, other; permanent cold water types that are washfast. Pigments, marbleing items, fluorescents, and auxiliaries. Has quantity prices. (Also sells wholesale to business.)

Qualin International
P.O. Box 31145
San Francisco, CA 94131

Send large SASE for catalog.

Silk scarf blanks imported from China, with hand-rolled hems. Scarf assortments. Silk fabrics. "Discount prices."

Savoir Faire
3020 Bridgeway, Suite 305
Sausalito, CA 94965

Send SASE for full information.

French dyes (Tinfix, and others), for brushes, steam ovens, stretcher frames.

Silkpaint Corporation
P.O. Box 18
Waldron, MO 64092

Send SASE for information.

Silkpaint™ water soluble resist (can paint just after applying).

Taylor Von Otterbach
56 San Marco Ave.
St. Augustine, FL 32084
904-825-4999

Free catalog.

Silk clothing blanks in crepe de chine, designed for dye or paint—60 styles in 3 sizes; 33 styles in 1X-3X.

Trudy Beard Publications
P.O. Box 4175
Rockford, IL 61110
815-964-2900

Send SASE for information.

Wearable Art books, by Trudy Beard, with designs for fabric painting (butterflies, flowers, whimsical animals, and scenes, others); with instructions and color photos.

Tulip Productions
180 Elm St.
Waltham, MA 02154

See your dealer or send SASE for details.

Fashion (fabric) paints—full line of Slick™, Pearl, and Puffy™ colors; colors may be blended. Liquid Glitter™, Fashion Tints™. Designer Dyes™—use directly, blend colors, or tie-dye (24 colors). "No heat setting required."

Yasutomo & Co.
235 Valley Dr.
Brisbane, CA 94005

Contact dealer, or send SASE for details.

Niji™ marking pen for fabric when used with permanent ink—non-fading, washable; or use with oil paints.

From American Indian Design & Decoration, *by Leroy H. Appleton.* © *Dover Publications Co.*

Fabrics & Trims

❧❧❧❧❧❧❧❧❧❧❧❧❧❧❧❧❧

See also most other categories in Section II; BOOKS & BOOKSELLERS, PUBLICATIONS, and ASSOCIATIONS.

❧❧❧❧❧❧❧❧❧❧❧❧❧❧❧❧❧

Activewear Fabric Club
P.O. Box 20755
Portland, OR 97220

Send SASE for information. Fabric sample $4.00 (refundable).

Members of this club receive at least 4 swatch mailings yearly in cotton and nylon blended Lycras™. "Below retail prices."

Baer Fabrics
515 E. Market St.
Louisville, KY 40202
502-583-5521

Notion catalog $3.00; sample sets as below.

Sample set #012111: Ultrasuede™ Facile, Caress and Lamous in over 125 solid colors, printed and embossed suedes, $7.50 a set.

Sample set #04211 Designer linens and looks, spring suitings—$5.00.

Sample set #05211: Jazzy knits and resort wear—knits, batiks, cottons—$5.00.

Basket Cases
Box 1808
Bethany, OK 73008
405-787-3351

Send SASE for details.

Feed sacks for sewing projects, in over 10 unique designs, or plain muslin sacks.

Bead Different
214 E. Chicago
Westmont, IL 60559

Catalog $5.00.

Stretch fabrics: Glitterskin, spandex, Lycra, satin, solids and prints. Lames, specialty fabrics, bead appliques.

Berman Leathercraft
25 Melcher St.
Boston, MA 02210
617-426-0870

Catalog $3.00 (refundable).

Garment leathers: suedes, smooth types, unusuals in cowhide, calfskin, bat leathers, elk, antelope, rabbit, others; accessories kits. (See LEATHER CRAFTS.)

Bill Mathews
4920 S.W. 188 Ave.
Ft. Lauderdale, FL 33332

Free price list.

Rhinestones and studs—all sizes and colors.

Britex-By-Mail
146 Geary St.
San Francisco, CA 94108
415-392-2910

Swatches (indicate specific interest) $3.00.

Fashion fabrics—"all types and fibers," domestic and imported; including cottons, blends, silks, woolens, linens, rayons, knits, spandex, and nylon spandex. Others.

By Sheryl
P.O. Box 609
Newburgh, IN 47629

Send SASE for brochure.

Applique kits—precut, Pellon fused, ready to applique; wide variety of designs from whimsical country fun to softly sophisticated.

C.M. Offray and Son, Inc.
261 Madison Ave.
New York, NY 10016

See your dealer or write for information.

Wide variety of ribbons and other trims.

Camille Enterprises
P.O. Box 615
Rockaway, NJ 07866

Fabric swatches $3.00 (refundable).

Designer fabrics, full array of colors and textures.

Carolina Mills
Box V, Hwy. 76 West
Branson, MO 65616
417-334-2291

Color cards for three fabrics $2.00.

Fabrics: London Fog line, polyester doubleknits, polyester gabardines, windbreaker fabric, wools, wool blends.

Century Leather
P.O. Box 256
Wakefield, MA 01880

Catalog and swatches $1.00.

Garment leathers: cowhide, sides, shoulders, suede and smoothsided, dyes, finishes. (See LEATHER CRAFTS.)

Cinema Leathers
1663 Blake Ave.
Los Angeles, CA 90031

Samples $20.00 (refundable).

Garment leathers: pig suede and others, variety of weights.

Code's Mill Factory Outlet
Box 130
Perth, Ontario, Canada K7H 3E3

Sample card and information $3.00.

Line of felt in 74 colors; burlap in 25 colors. Complete line of international scissors—variety of styles and sizes. MasterCard, Visa.

Commonwealth Felt Co.
P.O. Box 150
Easthampton, MA 01027

See your dealer or send SASE for prices.

Perfection brand felt—by piece-assortments or yard; felt applique shapes and letters.

Continental Felt Co.
22 W. 15th St.
New York, NY 10011

See your dealer or write for information.

Felt by piece, assortments, or yard; full line of colors.

WHICH STRETCH: *There are two kinds of Spandex fabric – tricot and raschel. Tricot has two-way stretch. Raschel stretches mostly one way (lengthwise).*

Dan River, Inc.
111 W. 40th St.
New York, NY 10018

Contact dealer or send SASE for information.

Line of fabrics for today's fashions.

D'Anton
3079 N.E. Oasis Rd.
West Branch, IA 52358
319-643-2568

Send SASE and $1.00 for information.

Luxurious garment leathers: sueded, smooth, fun types; variety of colors and color combinations. (Also sells wholesale.)

Dazian, Inc.
2014 Commerce St.
Dallas, TX 75208
214-748-3450

Free catalog and samples.

Boutique and theatrical fabrics/trims: plain fabrics — satins, nylons, China silk, castile lace, flameproof twill, patent leatherette, buckram, felt, crinoline, muslin, velvet. Fluorescents, novelties (stripe and check satins, prints, plaid taffeta, galoon lace, prints, others).

Metallic fabrics — mirrolahm, other lames. Metal boucle, nugget cloth, metal sheen coated, rayon/metal, pearlized mirrolahm, liquid metal, Nu-Lash, snakeskin, stretch net, "flower delight." Sequin trims, spangle cloths, rhinestone motifs, 26 sequin appliques, sequin tube top stretch, elasticized spangle trim, honeycomb, crowns and tiaras. Chainette fringes. Rhinestones and bandings (and setter tool). Mirror and other jewels, mirrors. Feathers — marabou, ostrich, boas, coq. Hats — plain, felt, straw, crystal plastic. Millinery and hoop wires, feather boning, plastic fringes and skirts, lei sets. Metallic trims, cords, braids. Vinyl fringe rain curtains. Has quantity prices. (Also sells wholesale.)

Dillon Salvage Shop
107 E. Main St.
Dillon, SC 29536

Send SASE for list.

Laces, large assortment of flat type, variety of widths (¼" to 15"), by 50 yard lots.

Drake Leather Co., Inc.
3500 W. Beverly Blvd.
Montebello, CA 90640

Catalog $1.50.

Leather for garment making: suedes, smooth sided types in variety of colors. Finishes and dyes. Has quantity prices, allows discount to teachers, institutions, and professionals. Also sells wholesale. (See LEATHER CRAFTS.)

Dyeing to Please, Inc.
1601 North 7th St.
St. Louis, MO 63102

Send SASE for full details.

1001 Color Club: on payment of membership fee, members receive a swatch catalog of the 15 fabrics available for custom dyeing, next season's swatches when available, informative newsletter. Fabrics are naturals (wool, silk, cotton, linen, rayon, cotton lace), and wool or silk knitting yarns; can be custom-dyed using computer controlled formula for fabric matching (or matching wallpaper, paint, or any favorite color). MasterCard, Visa. ("Wholesale inquiries welcome" — use company letterhead, with resale tax number.)

Elsie's Exquisiques
513 Broadway
Niles, MI 49120
616-684-7034

Send SASE with specific inquiry.

Trims: silk and satin ribbons, imported trims, ribbons, silk ribbon roses, others. (Sells wholesale to businesses.)

Euroflax, Inc.
P.O. Box 241
Rye, NY 10580
914-967-9342

Sample card and order form $2.00. Flax samples and form $2.00.

Flax and linen fibers: handspinning roving (30 colors), line flax. Knitting and weaving sport weight yarns (16 colors). Books.

Expressions in Silk Ltd.
8543 Argyll Road
Edmonton, AB 56C 4B2 Canada

Send SASE for information.

Silk scarf painting kits, microwave method: quick dry for a scarf "in ten minutes." Includes scarf, dye colors, brushes, instructions.

Fabric Bazaar
P.O. Box 84053
Houston, TX 77284

Send $3.00 for swatches.

Fashion fabrics: silks, designer prints and solids, others. "Below retail pricing."

Fabric Gallery
146 W. Grand River
Williamson, MI 48895

Swatches for one year $8.00.

Quality fabrics—silks, wools, cottons, blends, and synthetics; swatch mailings 4 times yearly.

Fabrications Fabric Club
Box 2162
South Vineland, NJ 08360

Send SASE for full details. Four seasonal catalogs $10.00.

Members of this club on payment of a yearly fee receive coordinated swatch collections four times yearly of designer and other quality fabrics. "Prices are reasonable."

Fabrics Unlimited
5015 Columbia Pike
Arlington, VA 22204
703-671-0325

Send SASE for information.

Ultrasuede™ and many other designer fabrics (including Adele Simpson, Calvin Klein, others, and exclusives), imports, silks, wools, cottons, quantity prices, large order discounts; allows discount to teachers, professionals, and institutions.

Field's Fabrics
1695 44th S.E.
Grand Rapids, MI 49508
616-455-4570

75 Swatches Ultrasuede™, Facile™, Caress™, Ultraleather™,—100 solid colors—$10.00.

Fabrics: Cuddleskin™ brushed back satin sleepwear, Polo cotton interlock, silks, velvets, Canton fleece, cotton twills, washable bridal satins, metallic fabrics, Pendleton™ wools. Bank credit cards accepted.

Finbar Fabrics
P.O. Box 80327
Seattle, WA 98108

Samples $5.00.

Fabrics: Australian Merino wool jerseys, Robert Holton fabrics, cotton knits, broadcloth solids, novelties and specialty fabrics.

G Goose & Gander Gallery
Box 335
Burrton, KS 67020

Send $2.00 for information.

Feed-sack design panels on all-cotton printed muslin—over 15 designs in two sizes.

G Street Fabrics
12240 Wilkins Ave.
Rockville, MD 20852
301-231-8960

Fabric sample charts $10.00 each (refundable) as below:

(1) Cotton prints, (2) pinwale cotton corduroy, (3) cotton batiks, (4) polyester/cotton, (5) silk charmeuse and crepe de chine, (6) wools, (7) linen—four weights

Has sample subscription service—monthly sample mailings; custom sample service; inquire with SASE. MasterCard, Visa.

Global Village Imports
1101 S.W. Washington #140
Portland, OR 97205

Swatches $3.50 (applies to first order).

Handloomed Ikat fabrics by yard, "from Mayan weavers." (And sells wholesale.)

Great American Sewing Factory
8 Croton Dam Rd.
Ossining, NY 10562
914-941-7444

Catalog $1.00 (refundable.)

Sewing trims: laces (eyelet, cluny, flat, ruffled, others),

ribbons, assortments, Christmas trims, elastics, Velcro™, appliques, other trims, threads. "Reduced prices."

Hermes Leather
45 W. 34th St., Room 1108
New York, NY 10001
212-947-1153

Send SASE for details.

Garment leathers: cowhide, pig suede, cabretta, others.

Iowa Pigskin Sales Co.
9185 210 St.
Walcott, IA 52773
319-391-0107

Sample suede swatches $4.00 (part refundable). European color swatches $4.00.

Pigskin leather: velvety suede in 22 colors, smooth full grain in 11 colors, perforated suede in 5 colors. Sewing book. Has quantity prices.

SILK FACTS: *It's the strongest of all natural threads, coming from the cocoon of the silk worm. Forty thousand silk worm larvae, hatched from 40,000 eggs weighing only one ounce, will eat almost two tons of chopped mulberry leaves, their exclusive diet, before they mature and spin their silk cocoons. The thread must then be unwound from the 40,000 cocoons but will yield only 12 pounds of raw silk. This raw fiber must then be wound onto reels, twisted, spun into thicker thread, and finally dyed. Courtesy of Lamont Clay of Pure China Silk Co.*

J. Flora
1831 Hyde
San Francisco, CA 94109

Send SASE for list.

Soft suede scraps (for trims, applique, crafts) by pound of mixed colors. Has quantity prices.

Jehlor Fantasy Fabrics
730 Andover Park West
Seattle, WA 98188
206-575-8250

Catalog $3.50 ($2.50 refundable).

Specialty fabrics: cracked ice fabrics, hand-beaded lace, sequined fabrics, metallic sheers, brocades, lames, satins, chiffons, nylon organza, lycra (solids, prints, stripes, animal prints) stretch satin, super stretch spandex stretch nude sheers, Eurolustre stretch suiting. Specialty trims: rhinestones, glass beads, glass jewels, beaded and sequined appliques and trims, fringe, feather boas, plumes.

Just Rite Fabrics
P.O. Box 1511
Emporia, KS 66801
913-877-5268

Brochure & swatches $2.00.

Fabrics: interlocks with dyed-to-match ribbings, fleece with matching ribbing, stripes and prints (children's, adult's). Lycra™, printed fleece. 5 sizes of collars, elastic (drawstring and waistband). TDI woven labels, and piping (12 colors). Healthtex terry prints, straight edge trim. Snaps (gripper, enamel, sport in 30 colors) and snap tool. Tack buttons. MaxiLock threads.

Kagedo
P.O. Box 4593
Seattle, WA 98104
206-467-9077

Send SASE for complete information and price list.

Vintage and antique Japanese silks. Fine kimono and obi fabrics for textile artists; small custom-sorted orders.

Kennedy Mills
2101 Kennedy Rd.
Janesville, WI 53545

Send SASE for samples.

Craft pile fabrics: long and short pile, in light and heavy density, full array of colors. Super Soft stuffing, by pound. "Factory direct."

Kieffer's Lingerie Fabrics
1625 Hennepin Ave.
Minneapolis, MN 55403

Free catalog—sale catalog two times yearly.

Lingerie fabrics—wide range of colors and prints: nylons, pound fabric assortments, satins, faux cuddleskin, sheers. Nylon stretch and other laces. Elastics (girdle, swimsuit, brief, bra). Bra stretch lace and nylon, filler, straps. Girdle fabrics. Novelties. Swimwear fabrics (nylon/Lycra) and linings. Polyester knits, polycotton prints, rub knits and sweatshirt fleece/knits, velours, stretch terry, thermal and 2-way action fabrics.
 Threads, ribbing, zippers, interfacings, notions, scissors, shears. Sew Lovely patterns (multi-size)—lingerie, swimwear; queen. Sequin novelties, metallic laces. "At lowest price possible" even "lower than wholesale." (Also sells wholesale.)

Lace Heaven
2524 Dauphin Island Pkwy.
Mobile, AL 36605

Catalog and swatches $3.00 (refundable).

Fabrics: ("save on") nylon, velour, ribbing, sweatshirt fleece, knits, lace, elastics, cone threads, more. "Discount prices."

Las Manos
123 W. North St.
Healdsburg, CA 95448
707-994-0461

Samples $2.00.

Guatemalan handwoven cotton fabrics—traditional and contemporary designs, variety of bright colors. (Also sells wholesale.)

Leather Unlimited Corp.
7155 Country Hwy. B
Belgium, WI 53004
414-999-9464

64 page catalog $2.00 (refundable).

Garment leathers—sides, deerskin, sheepskin, chamois, elk, exotic animal prints (by special order—zebra, leopard), others; dyes. (See LEATHER CRAFTS.)

Leo G. Stein Company
4314-4322 N. California Ave.
Chicago, IL 60618

Send $3.00 and large SASE for color cards.

Leathers including for garments—pig suede and plonge, others.

Libra Leathers
259 W. 30th St.
New York, NY 10001

Send large SASE and reference for color matching, for swatches.

Garment leathers: lamb nappa and suedes, prints, metallics, others.

Logan Kits
Rt. 3, Box 380
Double Springs, AL 35553

Send large SASE and $1.00 for fabrics brochure.

Fabrics by the pound: lingerie and activewear selections. (Lingerie kits—see CLOTHING & ACCESSORIES.)

M. Siegel Company, Inc.
120 Pond St.
Ashland, MA 01721
508-881-5200

Catalog $3.00.

Luxury garment leathers—chamois, horse, elk, deerskin, goatskin, antelope, lambskin, Napa, suedes; others. (See LEATHER CRAFTS.)

Made to Order
P.O. Box 621149
Littleton, CO 80162

Color catalog and sample $2.00.

Iron-on velour appliques: over 100 designs including animals, country holiday, Amish designs, dolls; others.

Mekong River Textiles
8424 Queen Annes Dr.
Silver Spring, MD 20910

Send $2.00 and SASE for samples.

Handwoven Thai Ikat fabrics (indigo-dyed cottons), variety of designs.

Michel Ferree
P.O. Box 958
Niwot, CO 80544

Samples $12.00 (refundable).

Fine fashion silks, variety of types, colors, textures. "Designer discounts and wholesale prices available."

Michiko's Creations
P.O. Box 4313
Napa, CA 94558
707-224-8546

Send SASE and $5.00 for information and color card.

Ultrasuede™ in 150 colors, by yard or remnants by yard. Ultrasuede™ samplers (40 colors in each package), Ultrasuede™ scraps by lb.

Mill End Store
8300 S.E. McLoughlin Blvd.
Portland, OR 97202
503-236-2128

Send SASE for brochure or with inquiry.

Fabrics: include imported cottons, wools, silks, drapery and upholstery fabrics, nylons, polyesters, velvets, velveteen, others. Patterns, notions, yarns, needlework items.

Monterey Mills
1725 Delavan Dr.
Janesville, WI 53545
608-754-8309

Send SASE for list.

Remnants of luxury furs and basic pile (12 styles in over 50 colors—plushes, shearling, Teddy bear and animal patterned). Stuffing, fiberfill (color and white). Wool mattress pads. "Closeouts."

Muriella Roy & Co.
67 Platts Mill Rd.
Naugatuck, CT 06770

Catalog $3.50.

Fabrics for skaters, dancers, swimmers: Lycra™ blend, Glissinette, lames, chiffon. Trims, feathers, others.

Natural Fiber Fabric Club
2259 S. Clinton Ave.
S. Plainfield, NJ 07080

Send SASE for full details.

On payment of fee, members in this natural fabrics club receive 4 scheduled mailings of swatches of fashion fabrics from areas worldwide, a handbook, and illustrated sewing aids catalog (tailoring items, scissors, linings, interfacings, patterns, buttons, others). Portfolio of swatches of 24 basic fabrics in stock — cottons, wools, silks. Also unscheduled mailings. Members get "a saving of at least 20% from the manufacturer's recommended retail price on all items." MasterCard, Visa.

Oppenheim's
120 E. Main St.
North Manchester, IL 46962
219-982-6848

Catalog $4.00. Swatches $4.00.

© *All The Trimmings*

Fabrics (including slight irregulars and blemishes): linen look and suiting types, Italian suiting, assorted linen looks in colors with slub weave. Challis, sportswear poplin. Variety of dressy knits. Broadcloth in soft colors. Lycra stretch in 7 patterns, denim and chambray, knits for sweaters, etc., in solids and prints.

Flocked and/or printed satins and 18 polyester and poly-cotton blend prints. Jogging fleece, corduroy, velour, terry, bandana print, rib knits, others. Special offers in: Pendleton wool remnants, Ultrasuede™ scraps, quilted Christmas motifs, calicos and patterns, rug weavers scraps, faux fur packages, doll clothes package.

Upholstery squares. Potpourri plains, flannels, others. Ginghams, burlap, Osnaburg, Aida, monks cloth, sheeting, toweling, "thermal suede" lining, rubber sheet, poly doll cloth, bridal satins, taffetas, netting, muslin, cheesecloth. Trim specials—laces, ribbons, metallic lace. Other trims, laces, and ribbons. Lace patches, cut/ sew aprons, holiday lace, table fabric.

Sewing projects almost completed (to finish-hem). Stamped quilt blocks (and applique), wool mattress pad pieces (remnants for you-sew). Foam pillow forms, polyfill. Floor wood quilting hoop. Custom name tapes and York woven labels. MasterCard, Visa.

Ornamental Resources
P.O. Box 3010
Idaho Springs, CO 80452
303-567-4987

Catalog $25.00 (with supplemental subscription). Send SASE for details.

Embellishments (including rare and unique items): beads, chain, rhinestones, jewels, shells, applique motifs, antique bullion tassels, brass stampings, feathers, and findings, supplies; display forms, tools, others. $50.00 minimum order.

Pellon Division
119 W. 40th St.
New York, NY 10018

Contact dealer or send SASE for information.

Pellon™ Wonder Under™ transfer fusing material (heat press fusible to fabrics, with peel-off backing). Pellon™ Craft-Bond™ backing material (fusible). Pellon™ Tru-Grid™ enlarging material. Use these materials for appliques, pockets, hatboxes, frames, box coverup, etc.

Penelopes
P.O. Box 1404
Brookline, MA 02146
617-738-1667

Send SASE for list.

Handwoven natural fibers textiles: antique silks, cotton/linens, Guatemalan cotton, gauze, and others.

Prairie Collection
3732 Tamager Dr. NE
Cedar Rapids, IA 52402
319-378-0125

Pattern catalog $1.00.

Clothing patterns including mother/daughter styles.

S.H. Kunin Felt Co., Inc.
Brussels St., P.O. Box 15014
Worcester, MA 01610
508-755-1241

Color card $2.50.

Felt, plush felt, adhesive backed felts and textiles, patchwork squares and die-cut shapes. Manufacturer. Has quantity prices, large order discounts; discounts to teachers, institutions, and professionals. (Also sells wholesale to businesses. Tax certification required.)

Sawyer Brook Distinctive Fabrics
Box 909
Boyeston, MA 01505
508-368-3133

Subscription $5.00.

Collection of imported and domestic fabrics—natural cottons and blends, silks, linens, denims, outing flannels, batik fabrics, others. MasterCard, Visa.

Seigel of California
324 C State St.
Santa Barbara, CA 93101

Free catalog. Swatches on request.

Full line of garment leathers: deer and pig suedes, plonge, and others.

Seventh Ave. Designer Fabric Club
P.O. Box 586
South Plainfield, NJ 07080

Send SASE for full details.

Designer fabrics club — offers fabrics from fashion houses and textile makers such as Nipon, Shamash, Picone, Givenchy, Villager, others; on payment of membership fee, members choose from quarterly selections shown in oversized swatches and illustrated catalogs. May have special sales; "save 20% to 50% on every yard." MasterCard, Visa.

Sew Natural
Rt. 1, Box 428
Middlesex, NC 27557
Free catalog. Swatch collection $2.00.

Cotton fabrics — 80 types, colors, textures; interlock, mesh, rib knits; others. Threads, patterns, books.

Sewing Sampler Productions
Box 39
Springfield, MN 56087
507-723-5011

Swatches $2.00.

French terry (all cotton) fabric in 15 colors. Matching ribbing.

Silk's Mystique
P.O. Box 6021
Richmond, VA 23222
Catalog $2.00.

Wedding fabrics and items. (Also sells wholesale.)

Specialties
236 Cotton Hanlon Rd.
Montour Falls, NY 14865
607-535-4105

Catalog $2.00.

Fine lingerie fabrics—coordinated fabrics and trims in tricots, satins, others; patterns, notions.

Stretch & Sew Fabrics
P.O. Box 085329
Racine, WI 53408
414-632-2660

Send SASE for full details.

Fabric swatches, color cards/packets and pattern offers by monthly subscription.

Sunflower Studio
2851 Road B ½
Grand Junction, CO 81503
303-242-3883

Catalog $2.50.

Traditional natural fiber fabrics (handwoven, hand-dyed —18th and 19th century adaptations).

Supplies 4 Less
13001 Las Vegas Blvd. S.
Las Vegas, NV 89124

Catalog and samples $3.50.

Variety of laces (eyelet, ruffled, flat, others), appliques, ribbons in colors, belt cordings, flowers; fabrics. Others. "Triple discount."

Suzanne Boehm
Box 695
Asheville, NC 28802

Samples $5.00 (refundable).

Handwoven fabrics from natural fibers; variety of colors, patterns, solids.

Tandy Leather Co.
Box 2934
Ft. Worth, TX 76113

Garment leathers—cowhides, suedes, deerskin, others. (See LEATHER CRAFTS.)

Testfabrics
P.O. Box 240
Middlesex, NJ 08846

Free catalog.

Line of fabrics including specialty types for museums, universities, other. Silk scarves. MasterCard, Visa. (Also sells wholesale.)

Thai Silks
252 State St.
Los Altos, CA 94022
415-948-8611

Free brochure.

Silk fabrics, scarves, lingerie. "Low prices."

The Golden Eye
2121 Woodhead
Houston, TX 77019
713-528-6160

Send SASE and $2.00 for list.

Antique beading, laces, trims, ribbons, clothing, jewelry.

LINGERIE SEWING: *Stitch from the narrow side of the garment to the wide part. Straighten seams so they are closer to the straight grain than to the bias. Courtesy of Kieffer's Lingerie Fabrics.*

The Hide & Leather House
595 Monroe St.
Napa, CA 94559
707-255-6160

Free catalog. $5.00 for each sample set.

Full line of leathers including garment types: elk, deerskin, lamb, buffalo, cabretta, doeskin, goat, lambsuede, splits, shearlings, others; prints, textures, metallics.

The Leather Factory
P.O. Box 50429
Ft. Worth, TX 76105
817-496-4874

Free catalog.

Leather skins for garment making: thin velvet suede, cowhide, cabretta sheepskin, deerskin, elk, rabbit, others; lining leathers—pigskin, kip, others. Exotic leathers: cobra, python, others. (See LEATHER CRAFTS.)

The Material & Lace Outlet
1202 Simmons Dr.
Houma, LA 70363
504-868-3725

Catalog $1.00.

"Discount" fabrics: tricot, cotton Lycra™, lace, elastics, sweatshirt fleece, t-shirt knits, polysatin, others.

The Material World
5700 Monroe St.
Sylvania, OH 43560
419-885-5416

Swatch collections (4 times yearly) $7.50.

Quality fabrics — imported and domestic silks, wools, cottons, blends, others; coordinated selections.

The Sewing Edge
3000 Old Alabama Rd., Suite 119
Alpharetta, GA 30202

Catalog $5.00 (refundable).

Special fabrics: tapestry and silk suitings, linens and linen blends, cotton interlock, Lycra™, and others.

The Wool Merchant
2331-E Crownpoint Executive Dr.
Charlotte, NC 28227
704-847-0054

Swatches $10.00 a set (refundable).

Fabrics: solid linens (over 50 colors) including Irish tissue. Cashmere, camel hair, worsted suitings; fabrics of Ralph Lauren, Pendleton, Liz Claiborne, Loro Piana, others.

Ultramouse Ltd.
3433 Bennington Ct.
Bloomfield Hills, MI 48301

Catalog $2.00.

Ultrasuede™ scraps, assorted colors, by 8 oz. lots. Other scrap materials. Rhinestones, setters. Patterns.

Utex Trading
710 9th St., Suite 5
Niagara Falls, NY 14301
416-596-7565

Send SASE for brochure. Sample deposits: white silks $8, colored silks $12 per set.

Couture collection silk fabrics: prints, crepe de chine, China and Thai silks in exotic colors, Fuji silks, raw silk noil, doupioni multicolors, organzas in designer colors. Silk knit, charmeuse, jacquard, crepe satin, shantung, taffeta, twill, chiffon, boucles, tussah, others—in dress and suit weights. Branch office in Toronto, Canada.

Vermont Country Store
Box 3000
Manchester, NH 03105
802-363-2400

Write for catalog.

Extensive old-time fabrics — cotton calicos, checks, stripes, solids; toweling, sheeting. Others.

WITH SILK: *Use only silk thread when sewing silk fabrics. Some silks can be washed. Test wash a scrap in warm soapy water.*

Veteran Leather Co., Inc.
205 25th St.
Brooklyn, NY 11232
718-768-0300

Write for catalog.

Garment leathers—suedes, kip sides, others. Dyes, laces. (See LEATHER CRAFTS.)

Vimaje Design Studio
P.O. Box 71721
Los Angeles, CA 90071

Swatches $6.00.

Fabrics including Ultrasuede™ in variety of colors, linens, others; "reasonable prices."

Women's Work
1316 Seward
Evanston, IL 60202
312-869-0688

Send SASE and $5.00 for swatches & brochure.

Marbelized silk and other fabrics, by ¼, ½, or yard; hand crafted—for clothing, quilts, wall hangings, other.

Zoodads
P.O. Box 15073
Riverside, RI 02915

Notions brochure and quarterly swatches $12.00 a year.

This club features children's fabrics (for from birth to preschool) including for boys. Has MasterCard, Visa.

Home Decorating

❦ ❦ ❦ ❦ ❦ ❦ ❦ ❦ ❦ ❦ ❦ ❦ ❦ ❦ ❦ ❦

HOME DECORATING See also most categories where home accessories are crafted; and BOOKS & BOOKSELLERS, PUBLICATIONS, and ASSOCIATIONS.

❦ ❦ ❦ ❦ ❦ ❦ ❦ ❦ ❦ ❦ ❦ ❦ ❦ ❦ ❦ ❦

American Blind & Wallpaper Factory
28237 Orchard Lake Rd.
Farmington Hills, MI 48334
313-553-6200

Write or call for quote on specific brand, give book name and pattern number.

Wall coverings—all national brands (traditional, classic, contemporary, florals, textured, embossed, etc.) "35% to 75% off, and special case discounts." Shades, blinds. Major credit cards.

Bennington's
1271 Manheim Pike
Lancaster, PA 17601

Write for price quote (give book name, pattern number).

Top brands of wallpaper (any book or pattern) coordinating fabric or borders. Free shipping. Save 35% to 75%. MasterCard, Visa.

Country Spice Collectables
P.O. Box 175
Hanover, VA 23069
804-730-0118

Send SASE for details and prices.

Country style toilet tank top and seat cover kits: quilted muslin centers with muslin ruffles, trimmed in chosen color (bows match color edges), in 15 color combinations. (Also has ready-made.)

Designer Secrets
Box 529
Fremont, NE 68025

Catalog $2.00.

Designer fabrics, wallcoverings, window treatments, bedspreads, furniture, accessories; "save up to 50 percent."

Dobry Enterpress
P.O. Box 112
Severna Park, MD 21146

Send SASE for details.

Instruction books on making draperies—custom draperies, swags and jabots, cloud shades: beginner to experienced, for any fabrics, even sheets; with step-by-step illustrated instructions. (Also sells wholesale.)

Donna Salyers' Videos
700 Madison Ave.
Covington, KY 41011

Send SASE for full details.

Sewing instructional videos: (1) Craft & Gift Ideas—projects for quilted accessories, boutique towels, fur throw, others; (2) Re-Do a Room in a Weekend—window coverings, tablecloths, pillows, others; (3) Time-Saving Sewing Tips; (4) Sew a Wardrobe in a Weekend—speed sewing plan. Videos in VHS or Beta.

Fabric Center
484 Electric Ave.
P.O. Box 8212
Fitchburg, MA 01420

Free brochure. Catalog $2.00.

Full line of home decorating fabrics.

Home Fabric Mills
882 S. Main St.
Cheshire, CT 06410
203-272-3529

Free brochure.

Decorator fabrics: chintz, wovens, textures, prints, tapestries, jacquards, lace, others. Fire retardant contact fabrics. Trims, accessories. "Up to 50% off."

Homespun
Box 3223
Ventura, CA 93006

Catalog and swatches $2.00 (refundable).

Seamless cotton drapery fabrics—10' wide heavy textured selections (for drapes, wall coverings, upholstery, bedspreads, tablecloths, clothing); "at factory direct prices." MasterCard, Visa.

Instant Interiors
P.O. Box 1793
Eugene, OR 97440

Contact dealer or send SASE for information.

Instant decorating how-to booklet series, by Gail Brown and Linda Wisner: Quickest Curtains, Bed Covers, Easiest Furniture Covers, Fabric Space Makers (including hanging fabric shelves, etc.), Table Toppings, and Lampshades. Booklets include illustrations, step-by-step directions, general sewing and serger tips.

Marlene's Decorator Fabrics
301 Beech St.
Hackensack, NJ 07601
201-843-0844

Send SASE with specific inquiry.

Major manufacturer's decorator fabrics.

Ozark Crafts
Box 805
Branson, MO 65616
417-334-3251

Catalog $2.00.

Original patterns for home accessories (doorstop, broom covers, others); in country and Amish designs. MasterCard, Visa.

Papers Plus
P.O. Box 204
Countryside, IL 60525

Write with book name, pattern number, retail price.

Brand name wallpapers, "35 to 75% off." Matching fabrics "30% off."

Rollerwall, Inc.
Box 757
Silver Spring, MD 20918

Send SASE for list.

Embossed paint rollers — to roll patterns on walls (florals, traditional, colonial, contemporary designs).

Sheffield School of Interior Design
211 E. 43rd St.
New York, NY 10017

Free illustrated catalog.

Interior Decorator home study course—taped/printed lessons on color, fabrics, furniture, accessories; individualized taped analyses of student's room designs.

T & M Creations
P.O. Box 3264
Traverse City, MI 49685
616-947-5695

Send SASE for details.

Videos: slipcovers and draperies sewing instructions—basics, zippers, cushions, difficulties, pinch pleated drapes. Has MasterCard, Visa.

The Fabric Center
484 Electric Ave.
P.O. Box 8212
Fitchburg, MA 01420

Catalog $2.00.

Decorator fabrics "at exceptional values"—known manufacturers, "thousands" of patterns and colors.

The Fabric Outlet
P.O. Box 2417
South Hamilton, MA 01982

© *Instant Interiors*

Send in fabric name, number, yardage.

Waverly and Robert Allen decorator fabrics "at tremendous savings." Waverly wall coverings "at half price." MasterCard, Visa.

Video Instructional Programs
781 Golden Prados Dr.
Diamond Bar, CA 91765
714-861-5021

Send SASE for videos list.

Instructional videos (VHS and Beta) including decorating: Home Decorating (window treatments, shade and curtain treatments including Roman, balloon, cloud); Instant Decorating (unique techniques for decorating bed, bath, and living rooms—dust ruffles, pillow shams, furniture, and more). Transcript for Home Decorating.

Booklets: Quickest Curtains, and Bed Covers. Also has over 35 sewing videos including machine embroidery, monogramming, using serger machine for decorative items, and others. (Videos may also be rented—rental can apply to purchase.)

Warm Products, Inc.
16120 Woodinville-Redmond Rd. #5
Woodenville, WA 98072

Send large SASE for instructional brochure.

Insulated shade lining.

Yowler & Shepps
3529 Main St.
Conestoga, PA 17516

Catalog $2.00 (refundable).

Wall stenciling designs, variety of styles/motifs. "Wholesale inquries welcome."

Knitting & Crochet

🐚🐚🐚🐚🐚🐚🐚🐚🐚🐚🐚🐚🐚🐚🐚🐚
See also NEEDLECRAFT SUPPLIES, RUG MAKING, SPINNING & WEAVING, YARNS, and other related categories; BOOKS & BOOKSELLERS, PUBLICATIONS, and ASSOCIATIONS.
🐚🐚🐚🐚🐚🐚🐚🐚🐚🐚🐚🐚🐚🐚🐚🐚

Aldea's
P.O. Box 667
Beaumont, CA 92223
714-845-5825

Free detailed list for Beta or VHS.

Instructional videos for machine knitters (most 2 hour lessons, by Alvina Murdaugh) for any Japanese made machine: Versatile Unusual Cables, Unisex Fashions, Beginner tapes (8 titles), Intermediate Techniques, Advanced tapes.

Other titles: Straight Skirt, Dolman Blouse, Coat, Tips & Techniques, Charting, Raglan Sleeve Cardigan, Professional Blocking, Machine Maintenance, Enhance Basics, Convert Hand Knits to Machine, Trims, Vests, Ribber Techniques, Afghans, Quick Garments, Dresses, Bulky Knits, other projects. 2 Crochet videos. Has quantity prices. MasterCard, Visa. ("Dealer inquiries invited.")

Alice Fowler Originals
P.O. Box 787
Colorado Springs, CO 80901

Catalog $.50.

Patterns/instructions for knit and crochet baby sets, sweaters, caps, booties. Others.

American Yarn Winding Co., Ltd.
P.O. Box 3222
Olathe, KS 66062
913-764-8945

Contact your dealer or send SASE for details.

Electric yarn winder unit: blends colors by winding several times, can knit directly from bobbins, a hands-free operation; with 2 bobbins. ("Dealer inquiries invited.")

Annie's Attic
Rt. 2, Box 212
Big Sandy, TX 75755

Free catalog.

Crochet kits/patterns: Hobnail items ("milk-glass"), 10+ afghans, scarves and hats, 16+ slippers, 12 clip-ons (Velcro) animals, 18 Pocket Pals™, crochet buttons, bows, jewelry (black, Irish crochet). 7 rugs, doilies. Ribbons/bows bath set, and flower set. Wildflowers, potholders. Layette items. Baby boy and girl outfits. Sweaters. Antique and other collars.

Fashion doll clothes, soft sculpture play clothes (for 16"-18" dolls). Toy chest toys and others. Dragons, dinosaurs, pillow toys. Sachets, baskets. (Also plastic canvas kits). Has a pattern club newsletter, crochet newsletter, and fashion wardrobe publication.

Apollo Knitting Studio
2305 Judah St.
San Francisco, CA 94122
415-664-2442

Send SASE for full details.

Instructional videos (VHS or Beta) for machine knitting, beginner or advanced, with Nobu Mary Fukuda; Part I Video—65 minutes (on casting on, decreasing, casting off, increasing) and Part 2 Video—50 minutes (on partial knitting, seaming, Kitchener stitch). And Nobu's Key to Machine Knitting and Finishing—100 minutes (on buttonholes, neckbands, sleeve caps, front bands). ("Dealer inquiries welcome.")

Ascend
P.O. Box 135
Kew Gardens, NY 11415

Instructions $1.00.

Crochet favorite knitting patterns—change knitting patterns to crochet patterns.

Auntie Knits Inc.
212 Rock Rd.
Glen Rock, NJ 07452
201-447-1331

Free catalog.

Over 40 sweater kits with yarns by many major companies—wide variety of styles including cardigans, pullovers, vests, others.

Bay Country Boutique
P.O. Box 1612
Carolina Beach, NC 28428
919-392-9469

Send SASE for list.

Knitting yarns, kits, patterns, implements. Quarterly knitting newsletter. 200+ books. Correspondence courses. Vega Bradley bags. Has MasterCard, Visa.

Beaded Images
P.O. Box 3415
Duluth, MN 55803

Send large SASE for information.

Bead-knit heirloom purse kits and instructional video.

Bonnie Triola
5694 Garwood St.
Fairview, PA 16415
814-474-3554

Color cards on yarns.

Color card $3.00: Bonnie Triola (cotton/rayon, wool/rayon, ribbon, cable cotton, Italian Florentine, angora).

Color card $3.25: Tamm Yarns (Bulky, Passy, Estilo, Diamante, Suavi, Can Cun, Sport Shetland, Chic, Astracrl, Rayito, Nice, Jeans Look, Lyon, and Perla).

Color card $6.00: Millor Yarns (Trenzado, Andino, Gloria, Tepeyac, Metalico, Vellon, Pupe, Carioca, Naturel, Infanta, Piropo).

Samples $1.00: for odd-lot designer yarns, closeouts of yarns. ("Dealer prices available.")

Bramwell Yarns, USA
P.O. Box 8244
Midland, TX 79708
915-699-4037

Write or call for nearest dealer.

Bramwell yarns, imported line, full array of colors. Knitting publications. Knitting machine accessories. ("Dealer inquiries are welcome.")

Candace Angoras
49 Bassett Blvd.
Whitby, Ontario, Canada L1N 8N5

Catalog $5.00; samples $3.00 (both $7).

Knitting and crochet kits of Angora fashions—variety of sweaters, vests, others; "one-of-a-kind." Angora yarn (handspun long stapled fibers, preshrunk and dye fast, washable) by 10 gram skeins. "Quantity discount."

Charda Classics
117 S.W. Scott St.
Ankeny, IA 50021

Send SASE for further details.

Knit-A-Name quick name charting system for knitting—magnetic letters and master chart for knit-in names and messages. ("Dealer inquiries welcome.")

Charles Publishing
Box 577
Weatherford, TX 76086

Send large 2-stamped envelope for list.

Crochet patterns: Oliver cat, Teeto chihuahua, Grapevine Raisins, Eetee, Minkey Mouse, Spuds MacDoggy, Biggest Bird, Bettie Boopsie, Roger Rabbit, Dumbo, Roadrunner, Coyote, Country Goose, Hulk Wrestler, Football Player, Basketball Player, Cheerleader, Unicorn, Tyrannosaurus, Stegosaurus, others.

Charmor's
108 So. Division St., Suite #4
Auburn, WA 98001

Send SASE for details.

Knitting machines: Brother, White. Also these lines: Melrose, Heirloom, Millor, Brown Sheep Wool, Yarn Country yarns. Has monthly knitting club.

Cochenille Computer Knit Products
P.O. Box 4276
Encinitas, CA 92023
619-259-9696

Send SASE for full details.

Home computer — knitting machine link: Bit Knitter computer design interface (for Brother 930/Knitking Compuknit III and the Amiga or IBM-PC) to create and modify color designs. See knit patterns in variety of garment bodies, make printouts of your work, send designs to your knitting machine in seconds, with visual computer prompts as knit, digitized/video images as design sources, and store designs.

Collins Dolls
6375 N. Figueroa #20
Los Angeles, CA 90042

Send SASE for full details.

Crochet pattern for 28" heirloom doll with old-fashioned skirt that hides a 5-gallon jug; braidable tresses, 22" long.

Cones & More
86 Cedar St.
Timmons, Ontario P4N 2G6 Canada

Shade cards $6.00 each.

Brother knitting machines. Machine parts for Japanese and Passap. Tamm-Diamond (Amber) and Canada yarns.

Country Crochet
Rt. 4, Box 198
South Haven, MI 49090

Send large SASE and $1.00 for catalog.

Crochet patterns: baskets, snowflakes, Christmas items, baby and filet items, potholders, frigies, sachets, butterflies, bells, others.

Cuniberti Enterprises
Box 308
Englewood, NJ 07631
201-569-8772

Free catalog.

Imported, designer yarns: wools, cottons, linen, novelty, blends, acrylics—from England, Switzerland, Italy, and U.S. Surprise yarn value packs (may include wool and blends, cottons and blends, acrylics, linen and linen blends, velveteen and cravanella, fancy wools and blends, fancy acrylics). "Below wholesale." Instructional videos. MasterCard, Visa.

Custom Knits & Mfg.
Rt. 1, Box 16
Lake Park, MN 56554
218-238-5882

Free catalog.

Wood yarn trees: floor model holds 72 cones of yarn, sealed bearing allows rotation; 28" diameter, 6'7" high. Ceiling model yarn tree. Knitting accessories: yarn plyer, pom-pom maker, cone holders, and book holders.

D.J. Stevens
109 So. Hubbards Lane
Louisville, KY 40207
502-895-0143

Send large SASE for catalog.

Knitting machines design patterns (for all machines—punch card, Mylar, and electronic) including florals, country, action figures and sports, zoo animals, birds, logos and emblems, and others. Bits N'Pieces designs now on floppy discs, also. Others.

D'Argenzio's
5613 Berkshire Valley Rd.
Oak Ridge, NJ 07438
201-697-1138

Information and prices $5.00.

Knitting kits of Manos of Uraguay, North Island, Prism, Rowan, S.C. Huber "Country Knits," and more. Studio knitting machines, instructional videos. Large selection of yarns and books.

Designs by Roberta
R.R. 1, Box 28
Charlotte Hall, MD 20622

Send SASE for information.

Crochet booklets: Make Someone Happy (lapel pins), Monthly Theme with Verse, Spread Sunshine (more lapel pins), All Occasion Theme with Verse, Christmas Trims (tree/package trims), Hats and Wee Beebe lapel pins and frigies. Also has *Crochet Potpourri* newsletter.

Dierks' Associates
P.O. Box 34266
San Francisco, CA 94234
415-468-0720
In Canada: MacGregor Drygoods Ltd.
4295 Dunbar
Vancouver, B.C. V6S 2G1

Send for free details. Demo disk $18.00.

Machine and hand knitting software (for MS-DOS, Apple, or Commodore computer with disk drive and printer). KnitRite™ pattern charting program, requires body measurements and stitch/row gauge. Each garment section is charted separately.

E. Gaela Designs
109 Pelton Center
San Leandro, CA 94577

Brochure $1.00 (refundable).

40 patterns for sweatshirt yokes and front panels (knit or crochet)—stitches attach with loop braid for professional look.

Erickson's Creative Crafts
71 Malibu Rd.
Winnipeg, Manitoba R2R 2J8 Canada
204-694-1888

Write for catalog.

Brother knitting machines and ribbers, accessories, stands, tables, yarn trees, others. Yarns: Tamm, Nomis, Denys, Amberyarn, Delaine.

Fibres
Box 135
Osterville, MA 02665
508-428-3882

Price list, order data $2.50 (refundable).

Current yarns offered by Aarlen, Brentwood, Classic Elite, Melrose, Plymouth, Reynolds, Silk City, Valentino, Flatura de Crosa, Knitting Fever, Scotts Woolen Mill, and Schaffhauser. "Free shipping." MasterCard and Visa.

Granny Hooks
35230 Law Rd.
Grafton, OH 44044

Send large SASE for brochure.

Crochet hooks: every type and size including very large.

Handiworks
P.O. Box 13482
Arlington, TX 76094

Color cards (15), price list $3.00.

Rag Elegance (fabric strip) knitting and crochet patterns including sweatshirt with knit yoke or crochet yoke, quick crochet unattached collars, crochet vest, others. Instruction sheet. (Also sells wholesale.)

Hazelcrafts
Box 175
Woburn, MA 01801

Send large SASE for list.

Over 70 knitting books, patterns: variety of sweaters, coats, hats, and other accessories, purses, skirts, tops, dresses; baby and children's patterns; men's items.

Howes House
114 Pascack Rd.
Hillsdale, NJ 07642

Send SASE for list.

Knitting and crochet patterns for baby bibs, sweaters, sweatshirts, afghans (3 sizes), baskets, animals, animal puppets, golf club covers, tissue toppers. Christmas ornaments, snowflakes, pumpkins (8 sizes), plastic canvas Easter baskets. Spiral animals, spiral people (7 different hats), shade pulls, minis, leg warmers, others.

Ileen's Needle Nook
4106 West Ely Rd.
Hannibal, MO 63401
314-221-9456

Write or call for information.

Knitting software—for IBM-PC compatible computer, color graphics compatibility, GW-Basic or IBM-Basic computer language, IBM compatible dot matrix printer, or IBM compatible daisy wheel printer: Design-A-Pattern (for sweaters and vests) and Design-A-Pattern II (for skirts and slacks) creates patterns, customizes measurements, designs sizes with one program, menu-driven selections. Can select styles and necklines and enter

swatch data and measurements, screen show patterns, can change or save measurements, rows and stitches are calculated, directions included.

Janknits
1500 Cohagen Rd.
Ingomar, MT 59039
406-354-6621

Send SASE for full information.

Knitting books by Janet Mysse: *The Classics* (on fisherman type), *Knitting for All Seasons—Book I* (30 classic knitting patterns for all seasons, for women and men).

Affordable Furs (how to work with fur/leather combined with knitting—40 patterns for jackets, caps, mittens, coverlets, coordinates, vests, others). *Cabbage Soup* (22 knitting patterns for children and their soft-sculptured dolls. Yarns. Has quantity prices and large order discounts. (Also sells wholesale to businesses.)

Jennifer Blake Designs
P.O. Box 2534
Boston, MA 02208

Send large SASE and $2.50 for brochure.

Unique designs for knitted sweaters, in kit form.

BINDING OFF: *When binding off in knitting, always use a needle size two or three times larger than the size used in working the ribbing. This will avoid a "too tight" neck or cuff opening when working sleeves from top to bottom. Courtesy of Jean Lampe of Northstar Knits.*

Joyce Williams
Box 7091
Springfield, MO 64801

Brochure $1.00 (refundable).

Crochet afghan patterns for large crochet hook: Weekend Wonder, Deep Forest, Blue Skies, Autumnfest, Grassy Knoll, Rainbows. (Patterns come with photo.)

Juanita Berry
Rt. 7, Box 99
Dothan, AL 36301

Send SASE for price list.

Crochet afghan patterns: Daffodil, Poppy, Dogwood, Rose Garden, Sunflower, Field Flowers, Striped Popcorn, Heirloom Lace, Shells, Candlewick, Illusion.

Knit Knack Shop, Inc.
Rt. 3, Box 104
Peru, IN 46970
317-985-3164

Send SASE for price list.

Extensive line of machine knitting books. Hauge D100 Linker for knitting machine. Others. (Also has dealer prices—send SASE, business card, tax number.)

Knit-O-Graf Pattern Company
958 Redwood Dr.
Apple Valley, MN 55124
612-432-5630

Color catalog $2.00.

Knitting patterns for 4-ply yarns: cardigan and pullover sweaters (with pictures knitted in) for children and adults; puppet mittens, afghans, socks, others.

Knitech, Inc.
914 Warwickshire Ct.
Great Falls, VA 22066
703-450-6282

Catalog $1.00.

Knitting software (for IBM-PC, Apple 64K, Macintosh, Commodore 64): Slopes And Curves . . . V2 (converts garment dimensions into knitting instructions, separates files for gauge, sloper measurements, and designs saved). Can type in notes after each step, change gauge of saved design, and more. Individual patterns, designer bulky book, drafting book, electronic designs, knitting accessories. MasterCard, Visa. ("Dealer prices available.")

Knitking
1128 Crenshaw Blvd.
Los Angeles, CA 90019

Send SASE for further information.

Knitting machine (for any skill level) including Compu-knit III with 555 built-in patterns and a 200stitch pattern width capability; advanced electronics technology.

Knitting & Weaving Studio
120 E. Main St.
Humble, TX 77338
713-446-8766

Catalog $2.00 (refundable).

Imported and domestic yarns for knitting, weaving, needlepoint, etc. Knitting machines, looms. "Bulk sales discounted."

Knitting Machine Center
7207 Evergreen Way
Everett, WA 98203
206-353-8742

Send SASE for list.

Knitting charting tools by Gauge Rite: bulky ruler, standard ruler (5 to 20 stitches per inch), template, calculator (converts inches to stitches). MasterCard, Visa.

Knitting Machines of Florida
380 Semoran Commerce Pl., Suite 107
Apopka, FL 32703

Send SASE for yarn sample sheets.

Cone yarns: ample stock of Amber yarns (Academy, Festival, Lurex, others) and Bouquet Spindlecraft (Ripley, Tara, Paisley, Auburn, Salem, and mercerized cottons, others) Craft Cascade 4-ply acrylic in 14 colors, 500 gram cones. MasterCard, Visa. ("Dealer inquiries welcome.")

Kruh Knits
P.O. Box 1587
Avon, CT 06001
203-674-1043

Catalog $5.00.

Knitting machines, machine accessories, computer programs, audio tapes, electronic patterns. Finishing tools, furniture, lamps, aids, videos, yarn winders. Motors, gauge helps, punchcards, ravel cords, sewing aids, washing solutions. Full line of yarns. Others.

Krystal Designs
107 W. 7th St.
Junction City, KS 66441

Yarn samples $3.50 (refundable).

Hand and machine knitting yarns. Singer knitting machines studio.

Laurel Yarns
P.O. Box 216
Jericho, NY 11753

Send $1.00 for samples.

Line of cone yarns—variety of types, color shades, plys.

Machine Knitters Video Magazine
637 Nicollet Ave.
North Mankato, MN 56001

Send SASE for full information.

Instructional videos by subscription—4 one-hour videos per year with Donna Seitzer, and others. Tapes include: knitting techniques, patterns, new products, personalities, studios and styles, reviews, events calendar, tips on maintenance, and more; all who take part are machine knitters. For Beta or VHS.

Marlene's International
P.O. Box 308
Englewood, NJ 07631
201-569-8772

Send SASE for catalog.

Knitting: tools, books, correspondence courses, videos.

Marty Clark Designs
5 Birch Rd.
South Easton, MA 02375

Send SASE for list.

Crochet patterns for 3-D home accessories—Canadian goose and gosling, duck, mallard and duckling, trumpeter swan. Also patterns for "playtime food"—over 20 food items. Others.

Mary Lue's Knitting World
101 W. Broadway
St. Peter, MN 56082

Color cards and details $5.00 (refundable).

Machine knitting coned yarns — full line, sizes 2/24 through 4/8—acrylics and blends. Service: Brother knitting machine conversions (older punch card models for use of garter carriage) and repair service. Knitting machine tables, folding or rigid. ("Dealer inquiries invited.")

Mary Wieser
Box 73
Plum City, WI 54761

Send SASE for list.

Crochet door knob cover patterns: pumpkin, turkey, Santa, bunny, others.

Mill House Yarn Outlet
P.O. Box 9016
North Dartmouth, MA 02747

Send SASE for more information.

Cone yarns (for knitting machines, etc.) by assortments of 20 lbs. and up, including 2/24 variety of acrylics, cotton mixed yarn types, others. "Low! Prices."

Mitzie's Madness
42 Crabapple Lane
Groton, CT 06340

Send SASE for list.

Easy crochet patterns: Just Duckie Tails (4 ducks), broom covers (girl, mouse, pig), crayon pillow, rug and curtain pull set, others.

Nancy Florschutz
2308 W. 5th St.
Washington, NC 27889
919-946-4440

Send SASE for full details.

Instructional video (VHS — over 3 hours): beginning knitting, basic instruction with index.

Needle Nuts
22 Jefferson St.
Brookville, OH 45309
513-833-5490

Send SASE for list.

Needle Nuts knitting machine accessories: double latch tool—2 sizes (latch 2 stitches beside cable or lace in half the time) and latch in combination with transfer tool in 2 sizes. Pickup and transfer tool (needles will not turn or pull out of holders). ("Dealer inquiries welcome.")

Newton's Knits
2100 E. Howell, Sp 209
Anaheim, CA 92806
714-634-0817

Contact your dealer or send SASE for nearest one.

Toyota knitting machines: the KS-950, 858 and bulky 610 and pattern bulky 650 II, for home knitters. Yarn Country cone yarns. ("Dealer inquiries invited.")

NSD Stitchery
P.O. Box 880
Brandon, MS 39043

Send SASE for list.

Camel crochet (uses crochet hooks but looks like knitting) — basic instruction book, patterns. Has Master-Card, Visa.

BUTTONHOLE IT UP: *When knitting a cardigan sweater and wondering where to place buttonholes, knit the side with the buttons first, mark location and knit the side with the buttonholes, placing them at the button markers. Courtesy of Janet Mysse of Janknits.*

P.Cox Expressions
1256 Pocket Rd. N.W.
Sugar Valley, GA 30746

Color card collection $3.00.

Machine knitting yarns: rayons, cottons, linens, silks, acrylics.

P.G. Roberts Co.
P.O. Box 2468, 514 Loves Park Dr.
Loves Park, IL 61132

Send SASE for list.

Interchangeable Delrin knitting needles — over 300 combinations, with sizes 5 to 15, 2 extenders, 2 stitch stops; in case. ("Dealer inquiries invited.")

Paradyme Agencies Inc.
908 Niagara Falls Blvd.
North Tonawanda, NY 14150

Send SASE for full details.

Tricot projects: intarsia carriage for duomatic knitting machines with built-in row counter. Intarsia multi-yarn brake (for right tensions, no tangles, 16 color yarn facility for single and double bed). De-Knot stitch removal cartridge (for several machine models and brands) and Not-A-Knot yarn defect indicator (for all machines with a yarn brake rod). Others.

Passap-USA
271 W. 2950 South
Salt Lake City, UT 84115

Write for nearest dealer.

Passap knitting machines including the Electronic; all operations, including shaping, are figured by computer; allows knitting from over 20,000 pattern possibilities; superimposes one pattern on another, enlarges patterns to 99 times their original length or width; with two-color changer.

Patternworks
P.O. Box 1690
Poughkeepsie, NY 12601

Send SASE for information.

Knitting accessories/aids: needles (plastic, metal; double-pointed, circular; bamboo; mini color coded; interchangeables, flex. Knitting patterns for entire family: bomber jackets, wallaby hooded sweatshirts, thermal vests (2-layer), sweater/accessories sets. Quilted jackets, baby set, scarf/tie and headbands, men's tie, beret and cloche. 6 sweaters, socks. Mohair kits — cocoon coat-wrap, hood/shawl. Aids: needle case, ball winder, guides, calculator wheel, hook dowel, knit rule, graph sheets, Gauge-O-Knit, finishing items, counters, measurers. Bond knitting frame (hand/speed knit), table, video. 14 yarns. Books. Allows discount to teachers, institutions.

Penelope Craft Programs, Inc.
P.O. Box 1204
Maywood, NJ 07607
201-368-8379

Send SASE or call for more information.

Software (for IBM or compatible PC/XT/AT or PS/2 with at least 19K and PC/MS-DOS 2.11 or higher): Knit One, adjusts knitting patterns to specified gauge and size (load into computer, type in size, gauge, and pattern, and program rewrites the pattern, line by line, for correct size and gauge) for both hand and machine knitting. American Express. ("Wholesale inquiries invited.")

Rafter-Four-Designs
P.O. Box 3056
Sandpoint, ID 83864

Catalog $2.00.

Rag rug making: knit, crochet, braid, knot, other methods.

Rittermere-Hurst-Field
Box 59, 15 Keele St. S.
King City, Ontario, Canada L0G 1K0
416-833-0635

Brochure $1.00.

Sweaters in a Sac country sweater knitting kits—variety of styles and designs.

Ruth Afghans
314 Cottage Grove
West Burlington, IA 52655

Send SASE for list.

Crochet afghan patterns: Easy Comfort, Shellabar, Rippleshell, Candy Cane, Scrapland Crossing, others.

Sew-Knit Distributors
9789 Florida
Baton Rouge, LA 70815
504-923-1260

Send large SASE for accessory price lists, or call for quotes.

New knitting machines; accessories by Brother (fits Knit-king), Toyota, Singer (fits Studio), Swiss-Made Passap: intarsias, video tapes, ribbers, links, winders, hobbies, lace, hand punch, transfers, strippers, tools, bed extension, Dazor lamp, tilt stand metal, Sussman iron, Jiffy

steamer, Baby lock serger and Knit Bond, Read Pleater, Stanley Pleater, Baby Lock models. Dress form, blocking cloth, sweater eggs and dryer, others. American Express, Discover, MasterCard, Visa. "We match prices +10% of difference."

Sheridan Yarns
P.O. Box 468
Coldspring, TX 77331

Catalog $3.00 ($2.00 refundable).

Fashion yarns for knitting and crochet; yarn kits. "Discount prices."

Stephanie's Studio & Yarn
Rt. 1, Box 14
Bybee, TN 37713
800-323-9411 (except TN)

Send SASE for list.

Cone yarns for knitting machines: Jade, spiral twist cotton, ragg cotton, 52 cotton, ravel cord, acetate, acrylics, "Shetland look" acrylic/poly heathers; 3/15 acrylics, wool blends, mohair blends, cotton blends, metallics in 6 colors; by pound, 1½ or 2 lb. cones. Has quantity prices. MasterCard, Visa.

Straw Into Gold
3006 San Pablo Ave.
Berkeley, CA 94702

Send large SASE for list.

Knitting yarns: Crystal Palace, Villawood, Chanteleine, Rowan. Needlework silk. Bamboo needles. Books. MasterCard, Visa. (See SPINNING & WEAVING).

Studio Products, Inc.
10002 14th Ave. S.W.
Seattle, WA 98146

Ask your dealer or send SASE for details.

Designer electronic knitting machine: knits most all stitch patterns and with "Electronic Extra," does up to 200 stitches wide and to 1,000 rows long.

Susan Bates
8 Shelter Drive
Greer, SC 29650

Ask your dealer or send SASE for information.

Knitting needles (including "Condoneedle"—1 large, 1 small head to convert from knitting to ribbing). Knitting and crochet aids and other accessories. Anchor floss.

The Carriage Trade Bookstore
20 Dalrymple, RR # 2
Camlachie, Ontario N0N 1E0 Canada

Catalog $2.00.

200+ knitting books, knitting instructional videos.

The Knit Works
2417 Lebanon Ave., Suite A
Belleville, IL 62221
618-277-4111

Contact your dealer or send SASE for list.

Cone yarns—Tamm in 11 lines and 2 metallic threads in a range of 335 colors. Amber yarns—15 lines, including natural fibers in a range of 211 colors. ("Dealer inquiries welcome.")

The Sewing Center
2581 Piedmont Rd.
Atlanta, GA 30324
404-261-5605

Send SASE for information.

Singer knitting machines—5 models for a variety of skill levels.

The String Slinger
P.O. Box 23272
Chattanooga, TN 37422
815-843-0272
Also at P.O. Box 5232, Station B
Victoria, B.C., Canada V8R 6N4

Send SASE for full information.

Instructional knitting machine videos (and workbooks): Machine Knitting Series—for Japanese machines; and the Pasap Tutorial Series.

Video Instructional Programs
781 Golden Prados Dr.
Diamond Bar, CA 91765
714-861-5021

Send SASE for video list.

Instructional videos for machine knitters (from Aldea's —Alvina Murdaugh with clear close-ups): Straight Skirt, Dolman Blouse, Coat, Tips and Techniques; instruction on measuring/charting, formulas — for most common shapes. Unisex Fashions, Raglan Sleeve Cardigan, Professional Blocking, Machine Maintenance & Tools, Dolman Sleeve Dress, and Enhance Your Basics (basics and beyond—covers cast-ons, bind-offs, and more).

Convert Hand or Retail Knits, Vests, Ribber Methods, Afghans, Quick'N Ezy Garments, Skirts, Tips/Methods, Alterations, Gifts, others. (Also 35+ sewing/other videos (may be rented—rent can apply to purchase.)

Westrade Sales, Inc.
2711—#3 Road
Richmond, B.C., Canada V7E 4P3
604-270-8737

Send SASE for list.

Coned knitting yarns from Forsell and Bramwell; in 30 styles, full line of colors. Forsell 20% wool 80% acrylic coned yarn (bulky but light) in 34 colors and Shetland-type mixtures. Others.

WKMG
P.O. Box 1527
Vashon, WA 98070
206-463-2088

Mail order catalog $1.50.

Machine and hand knitting pattern books: Iris Bishop, Bramwell, Kathleen Kinder, Mr. Le Warre (on French electronic machines), Val Love, Tami Nobuyuki (beginner workbooks), Nicely Knit, Patons, Wendy Phillips, Golden Unicorn, Jill Stern, Pat Varvel, Mary Weaver, Sandra Williams, others. McCalls machine knitting patterns. Fabric paints (Tulip, Delta) and instructions. Some quantity prices, sales. Back issues of *Western Knitting Machine Guide* magazine. (See PUBLICATIONS).

Wooden It Be Nice

29012 Vagabond Lane
Hayward, CA 94544
415-887-1716

Catalog $1.50.

Wood knitting machine (and other) accessories and aids including Handy Yarn Tree (for cone yarns) with 36 pegs, 24" base, stands 5' tall; allows for peg adjustment; cross bar and hanging closet tree for cone yarns.

Yarn-It-All

2223 Rebecca Dr.
Hatfield, PA 19440
215-822-7579

Write or call for prices.

Brother knitting machines—electronic fine needle, bulky punch card, punch card fine needle, and other models; ribbers (fine needle and bulky types). Brother stands and tables; accessories: knit leader, double bed color changer transfer carriage, garter bar, intarsia, linker, disk drive, linking machine, Calcuknit, others. Patterns, books 400+ titles, videos. Yarns: Melrosek, Phentex, Millor, Yarn Country, others. Services Brother machines.

Yarnarts

P.O. Box 950
Saratoga Springs, NY 12866

Send SASE for list.

Crochet patterns, computer designed; include picture cover sheets, diagrams, and graphs (allows lifelike details: doll fingers, toes, ears, noses, hand, arm, and leg shapes, bums, dimples, etc.) for: 16" Elvis, 24" girl with doll and boy with teddy, ballerina with costume/tights, shoes; 16" 3 month old baby. Animals: 18" Suds, 19" raisin, 21" alien, 20" pegasus, others.

Lace Making

🐛🐛🐛🐛🐛🐛🐛🐛🐛🐛🐛🐛🐛🐛🐛🐛

See also NEEDLECRAFT SUPPLIES, KNITTING & CROCHET, YARNS, and other related categories; BOOKS & BOOKSELLERS, PUBLICATIONS, and ASSOCIATIONS.

🐛🐛🐛🐛🐛🐛🐛🐛🐛🐛🐛🐛🐛🐛🐛🐛

Beggar's Lace
P.O. Box 481223
Denver, CO 80248
303-722-5557

Catalog $2.00 (refundable).

Beginner lace kits: bobbin lace, Battenberg, Needlelace, Carrickmacross, Teneriffe, Tambour, and tatting types—each separate. Complete lace-making tools and supplies. Books. Allows discount to teachers and institutions.

Bluebird Woodcrafts
Box 512
Allyn, WA 98524

Send SASE for details.

Tatting shuttles of handcrafted rosewood.

Carpenters' Crafts
P.O. Box 1283
Alton, IL 62002

Send SASE for prices.

Video: Learn the Art of Tatting Lace, 110 minutes. Shuttle and threads kit. MasterCard, Visa.

Craft Gallery
P.O. Box 145
Swampscott, MA 01907
508-744-2334

Catalog $2.00.

Lacemaking/tatting: tatting cotton (DMC 6 cord)—38+ colors. Tatting patterns, Battenberg lace ornament kits. 13 Tatsy patterns, threads. Lace threads (Belgian and Egyptian cottons, Swedish linen). Antique English and other lace bobbins. Lace pins. 18+ shuttles (Standard, German, Victorian, rosewood, hoare and flat types, tatting). Handkerchiefs/napkins (to edge). Lace sets. Wrist ball holder. Lace-making books: bobbin, Honiton, Battenberg, Torchow, Venetian, Bruges, Armenian, flower, braid, Teneriffe, Irish, old and Renaissance, needlemade, netting; 8 tatting titles. Other needlecraft supplies and aids. (See NEEDLECRAFT SUPPLIES.)

Glimakra Looms 'n Yarns, Inc.
1338 Ross Street
Petaluma, CA 94954
707-762-3362

Lace book catalog $1.00; sample color card $2.00.

Lace making: two-ply linen threads (bleached, unbleached, and colors), 3 and 5-ply threads. Lace-making equipment: lace pillow, roll, lace plate. Lace-making kit for beginners (bobbin lace with DMC thread, supplies). Lace bobbin winders (Swedish metal, wood). Lace bobbins and fancy bobbins. Pricking tool, glass and other pins, lace makers glass beads; tatting shuttles. Pattern sets. Instructional videos (Victorian Video Productions) on bobbin and needle lace. Books: needlelace, tatting, Batsford and Battenberg laces, bobbin lace (and lace braid), lace pattern books, needlepoint lace, from past eras, lace knitting, Honiton, Russian, machine, Torchon, Cluny, and others. Also has books. (See NEEDLECRAFT SUPPLIES and SPINNING & WEAVING.)

Snowgoose
P.O. Box 927
Conifer, CO 80433
303-838-2276

Send SASE for details.

Lacemaking: bobbin lace kit and instructional video; tatting kit and instructional videos.

Victorian Video Productions
P.O. Box 1540
Colfax, CA 95713
707-762-3362

Free catalog.

Instructional videos: (1) Needlelace—medallions, with Vima Micheli (basics, stitch techniques taught while working on 3 different medallions); (2) Bobbin Lace, with Doris Southard (bobbin lace-making tools and equipment, making and reading patterns are taught while working on projects of graduated difficulty—basic twist and cross, to Torchon ground, and finishing techniques). (Also has videos on weaving, applique, stained glass, basketry, needlepoint, others.) Allows discount to schools and libraries. (Also sells wholesale to businesses.)

© *Victorian Video Productions*

Macramé

🐦🐦🐦🐦🐦🐦🐦🐦🐦🐦🐦🐦🐦🐦🐦🐦

See also NEEDLECRAFT SUPPLIES, KNITTING & CROCHET, YARNS, and related categories; BOOKS & BOOKSELLERS and PUBLICATIONS.

🐦🐦🐦🐦🐦🐦🐦🐦🐦🐦🐦🐦🐦🐦🐦🐦

Acorn Crafts
3954 West 12 Mile Rd.
Berkeley, MI 48072

Catalog $3.00.

Full line of macramé supplies: variety of cords, aids, accessories, books.

Al Con Enterprises
P.O. Box 1136
Quincy, FL 32351

Send for information.

Macramé cord (direct from manufacturer), full line of colors, 6 to 8mm braided cords.

Bushfield
Romney, IN 47981

50 page list $2.00 (refundable).

Pattern/design books for macramé, other needlecrafts.

IMI
P.O. Box 154, 216 Main St.
Whitesburg, GA 30185
404-834-2094

Also in Florida at:

P.O. Box 405
106 Lillian Springs Rd.
Quincy, FL 32351
904-875-2918

Catalog $5.00.

Macramé: cords — twisted and braided in 2mm-6mm colors, heathers, and mixed. 10mm wire braid and knitted fancy cords. Waxed linens, cotton cables, jute and braided metallics. 9 purse closures, rings (60 types/sizes —wood, textured, bamboo, burnt, natural, and unfinished rattan). 22 purse handles (wood, others). Metal rings and frames—rings from 1½" to 27", and rectangular, Christmas tree, cross, frog, candy cane, Tiffany style lamp shades, game room lamp shade, table frame kits (cubes, drums), tissue box covers.

Wall brackets, ceiling hook set. Pellon™ Phun Phelt™ polyester felt pieces. Chenille and chenille curler. Ceramic eyes (frog, owl), wiggly eyes. Project boards (fiberboard circles 11" to 23", 2 macramé boards). T-pins. Wood hoops (3" to 23"), dowels (1/8" to 1¼"). Magnetic tape. 2 hot glue guns, glue sticks, adapter nozzle. Other glues. 2 fusing/cutting guns.

Plastic rings (2" to 9") round, D-rings, squares (2" to 9"). 10+ plastic purse handles, table top. Wood beads. Also has a line of silk flowers, naturals and trims. Has quantity prices. (Also sells wholesale.)

Suncoast
9015 US 19 N.
Pinellas Park, FL 34666

Full crafts catalog $2.00.

Maxi-Cord™ macramé cord (6mm polypropylene), in over 28 solids, over 18 mixed color rolls. Cord color chart. (Also has other craft supplies.) "Discount." Has MasterCard, Visa.

Needlepoint

🐚🐚🐚🐚🐚🐚🐚🐚🐚🐚🐚🐚🐚🐚🐚🐚
See also NEEDLECRAFT SUPPLIES, EMBROIDERY & CROSS-STITCH, YARNS, and other related categories; BOOKS & BOOKSELLERS, PUBLICATIONS, and ASSOCIATIONS.
🐚🐚🐚🐚🐚🐚🐚🐚🐚🐚🐚🐚🐚🐚🐚🐚

A & L Designs
201 E. Tabor Rd.
Philadelphia, PA 19120
215-329-7321

Brochure and swatches $3.00.

Religious designs charted for needlepoint and cross stitch.

Arts Array
P.O. Box 5415
Santa Maria, CA 93456
805-937-7798

Catalog $2.00.

Over 500 needlepoint designs of Tapex, Royal Paris, Margot Seg, Rico, others: European tapestries in full color, hand silkscreened on heavy 10/20 Penelope double weave canvas; variety of sizes and in kit form. Subjects include scenes—all seasons, wildlife, animals and people, peasants, flowers, children, horses and figures, masterpiece paintings, alphabets, water scenes, ships, Renaissance motifs, ballet dancers, clowns, religious designs, others. Oval petit point kits (9" X 12", 22" canvas) in 27 classic designs—people, children, religious, 10 florals, others. "New arrivals monthly." Runs sales.

Aunt Mary's Hobby
20 S.W. 27th Ave.
Pompano Beach, FL 33069

Needlepoint catalog $1.50 (refundable).

Hand-painted needlepoint canvases, kits, and prework—in traditional pet designs: 31 ducks (5" X 7" up), 30 birds, 29 cats (some with people, over 26 dogs, including some preworked centers), and horses. 33 designs for toilet seat covers—animals, fish, rainbow, monograms, flowers, hearts, others. Mini needlepoint pet portraits (#18 interlock canvas, 2½" rounds), bookmarks, stocking.

Hand-painted needlepoint canvases: 14 horse designs including hobby and carousel. Royal Paris canvases —over 30 horses, hunting and wildlife scenes, others. (See also EMBROIDERY & CROSS-STITCH for stitchery and cross-stitch catalogs.)

Carroll Meek
Pro. Mall
Pullman, WA 99163

Brochure $3.50.

Tiny needlepoint: 65+ kits and charts. Silk gauze, others.

Express Yourself Originals
Box 100
Waboasso, FL 32970
407-388-2620

Sample and information $1.00 (refundable).

Service: color photos or artwork enlarged on needlepoint or cross stitch canvas (no counting or charts).

Gitta's Charted Petit Point
289 Lakeshore Rd. East
Port Credit, Ontario, Canada L5G 1H3
416-274-7198

Catalog $4.00.

Needlepoint, petit point, and cross-stitch charts and kits, in 48 traditional designs (scenes, mountain man and woman, Victorian man and lady, Romeo and Juliet, Eskimo motifs, florals, ducks, others). Gauze, 3 canvases, silk-screen mesh. Fabrics: Aida, hardanger, linens. DMC and Anchor threads (wool and cotton). Custom framing for needlework. Allows discount to teachers and institutions. (Also sells wholesale to businesses.)

Jacob's Ladder, Inc.
3536 University Blvd.
Jacksonville, FL 32211

Send SASE for details.

Service: handpainting of needlepoint canvas, custom designed.

Jean McIntosh
P.O. Box 232
Pembina, ND 58271
Also:
1115 Empress St.
Winnipeg, Manitoba, Canada R3E 3H1

Catalog $4.00.

Needlepoint and petit point kits; counted thread charts —traditional and classic designs. Needlepoint supplies.

My Friend and Eye
4911 Warner Ave., Suite 218
Huntington Beach, CA 92649
714-846-0939

Catalog/newsletter $3.00.

Needlepoint supplies: Susan Porta's designs/kits, other designs. Yarns.

Ouran
P.O. Box 24102
Apple Valley, MN 55124

IDENTIFYING COLORS: *Before you start your petit point, sort the threads to keep them organized, avoiding any confusion. A simple way to accomplish this is to take a piece of cardboard about 4" wide and as long as you need to accommodate all your colors. Make slits down both sides at about 1/2" to 3/4" intervals. Then put a different color thread in each pair of slits and mark its symbol above it. Put the threads in the same order as listed on the chart. Courtesy of Brigitte Al-Basi of Bitta's Charted Petit Point.*

Catalog $2.00.

Australian needlepoint designs handprinted on Belgian woven canvas.

Peacock Alley
650 Croswell SE
Grand Rapids, MI 49506
616-454-9898

Brochure $2.00.

Contemporary needlepoint designs (handpainted on Zweigart canvas). Paternayan Persian yarn. (And sells wholesale.)

Snowflake Designs
114 N. San Francisco St., Suite 208
Flagstaff, AZ 86001
602-779-2676

Catalog $3.50.

Full line of needlepoint supplies: canvases, yarns, accessories. Has MasterCard, Visa.

Sundance Needleworks
6370 E. Broadway Blvd.
Tucson, AZ 85710
602-745-6272

Catalog $5.00.

Needlepoint/needlecraft supplies: canvas, fibers, finishing accessories; creators of DeGrazia, Tish, Seabourn, Tich, and E.T.A. designs.

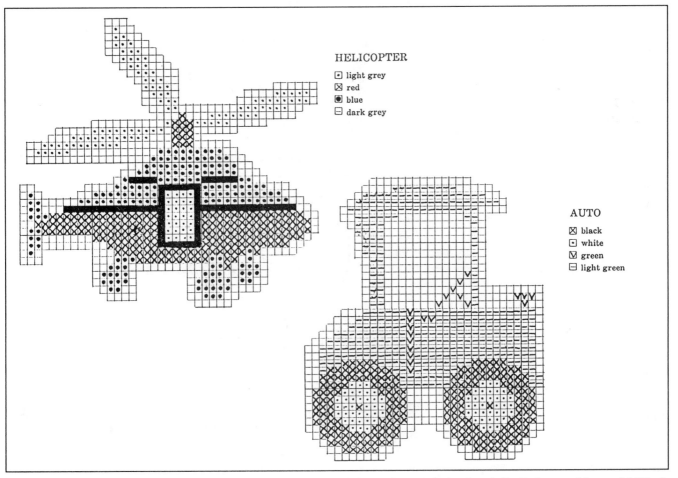

HELICOPTER
⊡ light grey
☒ red
◉ blue
⊟ dark grey

AUTO
☒ black
⊡ white
☑ green
⊟ light green

From the book, Treasury of Charted Designs for Needleworkers, *by Georgia L. Gorham and Jeanne M. Warth.*
© *Dover Publications, Inc.*

Outdoors & Outerwear

❦❦❦❦❦❦❦❦❦❦❦❦❦❦❦❦
See also CLOTHING & ACCESSORIES, FABRICS & TRIMS, KNITTING & CROCHET, QUILTING, SEWING, and other specific categories; BOOKS & BOOKSELLERS and PUBLICATIONS.
❦❦❦❦❦❦❦❦❦❦❦❦❦❦❦❦

Side release buckle. © Altra

Altra
100 E. Washington
New Richmond, IN 47967

Catalog $1.00.

Precut Outerwear Sewing Kits: 10+ jackets and pullovers, down coat, raincoat, wind pants, sweats, sweaters, parkas, gaiters, knickers, vests, kids' and adults' insulated coveralls, bunting items, hoods, robe, booties. Notions: Glides gauge, reflective tape (washable), snip clips, side release-buckle, hook/loop (colors). Zippers, thread, appliques, letters. Webbings. Insulations: down Thinsulate™, needlepunch. Hardware: bar slides, buckles. Luggage kits of urethane nylon: tote, kangaroo, carryalls, all-purpose, bike, fanny, others. Cuffs, ribbing. Fabrics: nylon, polycottons, pile blends. (Also has ready-made outerwear.) Allows discount to teachers, institutions.

Frostline Kits
2525 River Rd.
Grand Junction, CO 81505

Write for catalog.

Pre-cut outerwear kits (coats, jackets, baby wear, others) for entire family; robes, comforters—for you-sew. "Save 30-50%."

SEWING DOWN: *When you are making a down comforter or coat, freeze the down packets first for a few hours and the "flyaway" characteristics of down are greatly reduced. Courtesy of William Haan of Altra Inc.*

High Fly Kite Company
P.O. Box 2146
Haddonfield, NJ 08033
609-429-6260

Write for catalog.

Kites and kite kits—over 75 fabric styles, 26 stunt kites; variety of sizes and color combinations. Supplies: over 10 types of reels and handles, 100+ building items, and over 10 colors and types of ¾ oz. ripstop material.

KiteLines
P.O. Box 466
Randallstown, MD 21133

Send SASE for book list.

Reprints of articles important for kite crafting: (1) "Mastering Nylon," by G. William Tyrrell, Jr. (fabric types, tools, hot/cold cutting, seams, hems, edging, design transferring and coloring; source list $1.00. ppd.). (2) "Hundreds of Sleds, Hundreds of Smiles," by Shirley B. Osborne and Mel Govig. (Make sled kites indoors or out, with groups of kids; tips on getting the most educational value from it; $1.00 ppd.).(3) "New American Tradition: Kite Festivals!," by Valerie Govig (guidance in festival organizing beginning to end; includes "Figure Kiting," by Red Braswell $3.00 ppd.). And one on "World Records," $1.00 ppd. Full line of kiting books; publishes *KiteLines* magazine.

Gasworks Park Kite Shoppe
3333 Wallingford North
Seattle, WA 98103
206-633-4780

Write for catalog.

Kitemaking supplies—full range. "Dealer inquiries welcome."

Outdoor Wilderness Fabrics
16195 Latah Dr.
Nampa, ID 83651

Free price list. Full samples $4.00.

Outdoor fabrics: Gore-Tex, Ultrex, Taslan, Supplex, Ballistics, Cordura, others. Insulations, no-see-um netting, mesh. Hardware, supplies. Has MasterCard, Visa.

Pine River Textiles Inc.
10443A 124th St.
Edmonton, Alberta, T5N 1R7 Canada
403-488-9523

Catalog $2.00.

Outdoor/active wear fabrics: ripstop, nylons, canvas, denim, others. Known brand patterns. Threads, batting.

Quest Outfitters
2590 17th St.
Sarasota, FL 34234
813-378-4620

From the book, Easy-to-Make Decorative Kites, *by Alan & Gill Bridgewater.* © *Dover Publications, Inc.*

Free catalog.

Outdoor fabrics, wear and gear kits and sewing supplies.

The Green Pepper
3918 West 1st
Eugene, OR 97402
503-345-6665

Catalog $2.00.

Sewing patterns: whitewater jacket—of Polar Plus™ in women's, men's, and children's sizes. Other patterns for stretch fabric/outerwear. Fabrics: nylon/ spandex tricot, raschel, others. Teflon press cloths. Threads.

The Rain Shed
707 N.W. 11th
Corvallis, OR 97330
503-753-8900

Catalog $1.00.

Outerwear patterns/kits/supplies: Rain Shed kits (8 or 11 oz. Cordura, colors). Luggage—daypack, mini cases, ski bag, duffle and flight/diaper bags. Windsock. Thermal bottle bag. Multi-size patterns of Sew Easy, Coat Craze, Dais fiber by Kingdom, Donner, 4 Seasons, Green Pepper, Stretch 'N Sew, Suitability. Travel Pals: parkas, snow pants, mitts, vests, jackets, coveralls, stretch suits, gaiters, caps, sweatshirts, jogging and skiing suits, rompers, nightshirts, robes, tights, tops, swimsuits, wind/ rain pants, racing jersey and suit, poncho/cocoon, coats, shorts, riding outfits, others. Patterns for bicycle saddle bags, dog backpack, windsocks, insulated window shade, child's car seat covers, kiddie car tote, others.
Fabrics—coated and uncoated nylons (ripstop, taffeta, oxford). Uncoated Taslan, Supplex, Techtile. Coated Cordura, packcloth, vinyl. Waterproof breathables, wicking knits, fleece, ribbing, no-see-um netting, ribbing and cuffs, mesh (poly, nylon, power, leno). Lycra. Blends and cottons; camouflage in 14 fabrics.

Insulations: Thinsulate, Hollofil II, others. Reflective tape, sealer. Webbings and cords, nylon repair tape, Velcro Notions/tools: snaps and setter, eyelets. Hot tip tools, cutters, scissors. Zipper (on roll). Hardware.

Timberline Sewing Kits
Clark St., Box 126
Pittsfield, NH 03263

Catalog $1.00.

Outerwear kits: jacket (arms or not), vests, parka, foot mittens, gaiters. Comforter and other kits. Fabrics: Cordura™, nylon taffeta, ripstop; water repellent types. Goose down, duck down, insulation.
Luggage kits: cargo bag, travel bag (2 compartment, nylon zips, of Cordura™. Tote bag (2 sizes, in colors), bike bag (at handlebars); log lugger. Allows discounts to teachers, institutions. MasterCard, Visa.

World of Kites
525 S. Washington
Royal Oak, MI 48067
313-398-5900

Send SASE for list.

Over 250 varieties of kites, lines, reels, accessories, supplies.

Ski bag, from pattern or kit. © *The Rain Shed*

Quilting

🐦🐦🐦🐦🐦🐦🐦🐦🐦🐦🐦🐦🐦🐦🐦🐦

See also NEEDLECRAFT SUPPLIES, FABRICS & TRIMS, SEWING, and other related categories; BOOKS & BOOKSELLERS, PUBLICATIONS, and ASSOCIATIONS.

🐦🐦🐦🐦🐦🐦🐦🐦🐦🐦🐦🐦🐦🐦🐦🐦

Best Cottons
10 Mansfield
Gloucester, MA 01930
313-398-5900

Over 1,000 samples $7.50.

Cotton calico prints—wide variety of colors/designs, at low cost per yard.

Busy Bee
Box 1031
Decatur, GA 30031

Catalog $2.00.

Full line of quilting supplies: threads, templates, notions, fabrics, and variety of patterns and precut quilting kits.

Cabin Fever Calicoes
P.O. Box 550106
Atlanta, GA 30355
404-873-5094

Catalog $2.50 (refundable).

Quilting patterns/kits/supplies: patterns—original Sioux designs (and fabric paks) including Peace Pipe, Prairie Crocus, Flying Swallow, 8 Pointed Star, Starlight, Friends, School Days; mini-quilt patterns. Kits—Color Wheel, Kaleidoscope, Amish motif, and other pillows. Quilt sided magazine rack.

 Patterns: Amish Primer, Log Cabin-Round, Persian Star, Stars & Stripes, others. 15 color groups of pre-packaged fabric paks—¼ to 1 yard of cotton shades, and Amish colors. Cotton sheeting, homespun, polished pieces. Poly batting and others: Light, Fatt Batt, Fiberloft. Pillow forms.

 Notions/aids: needles, 8 Gingher scissors, ripper, thimbles. Yardstick compass. Slik Stik. Needles, guards, thimbles, threads (including Swiss Metrosene and sampler). Graph papers, markers, permanent pens, curve. Plastigraph™ template system, Lam-I-Graph™ clear graph, template plastic, miter marker, X-acto stencil cutter and set. Rotary cutters: Olfa, Salem Craft Mate, O-Lipfa. Rulers. Projector, lightbox, quilting frames. Quilted clothing patterns: vests, skirts, jacket, aprons, dress, tabard, bonnet. Soft doll/animal patterns. Instructional video series with Joe Cunningham & Gwen Marston: Piecing & Applique, Sets & Borders, Designs, Caring For/Displaying. (See DOLL, TOY & CLOTHES MAKING—SOFT.)

Colonial Patterns
340 W. 5th St.
Kansas City, MO 64105

See your dealer or write for information.

Aunt Martha's quilting designs, in full line of motifs.

Custom Quilting
9107 Somerset Rd.
London, KY 40741
606-878-7390

Send SASE for details.

Service: quilting of quilts, bedspreads, crafts—custom work.

Dakota Wind
Box 866
Jamestown, ND 58402

Catalog $1.00.

Quilt frame—"easy construction" with saw, screwdriver, and drill; adjustable and collapsible. (See WOODWORKING.)

Dover St. Booksellers
39 E. Dover St., Box 1563
Easton, MD 21601
301-822-9329

Catalog $2.00.

Quilting books—over 600 titles on patchwork, classic patterns, early American designs, contemporary garments, quilted accessories, children's quilts, easy quilting, machine quilting, and variety of other techniques; others.

Fairfield Processing Corp.
P.O. Box 1130
Danbury, CT 06813

Contact dealer.

Poly-fil™ polyester fiberfill, Extra-Loft™ traditional, low- loft, cotton classical, and ultra-loft battings. Pillow inserts. (Sells wholesale to business, with tax resale or business number.)

Frugal Fox
Box 369
Fontana, WI 53125

Send long SASE for price list.

Quilt batting and fiberfill, pillow forms, others.

Groves Publishing Co.
P.O. Box 5370
Kansas City, MO 64131

Send SASE for prices.

Kansas City Star quilting patterns of yesteryear (re-

printed for today): 10 volumes—Vol. 1 covers 1928-30, others 1955-61; each with over 80 patterns; spiral bound. "Postage paid on minimum 5-volume purchase."

> BATTING UP: *When using cotton batting for any application do not pre-wash, and stitch or sew. Courtesy of David Reaman of Mountain Mist.*

Hapco Products
46 Mapleview Dr.
Columbia, MO 65202

See your dealer or write for information.

Quilting accessories: Hapco snap frames, others.

Hinterberg Design, Inc.
2100 Northwestern Ave.
West Bend, WI 53095
414-338-0337

Send SASE for details.

Quilting hoops, adjustable height and tilt, 2 sizes. Has MasterCard, Visa.

Homecraft Services
340 W. 5th St.
Kansas City, MO 64105

Picture catalog $1.00.

Aunt Martha's precut quilt kits: Lone Star and Broken Star patterns with 80" square polycotton fabric, pattern, assembly instructions. Hot-iron transfer sets: animals, monograms/alphabets, Blue Onion, others.

J. Wengler
311 Preston Ave.
San Antonio, TX 78210
512-532-3356

Send SASE for brochure.

Quilting frames—two models; double, queen, and king sizes; collapsible and adjustable, in storage cases.

Jane C. Smith, Quiltmaker
RFD 1, Box 518A
South Berwick, ME 03908
207-676-9889

Send for brochure.

Quilting Booklets: (1) Trip Around the World, by Jane C. Smith, designer/teacher—pattern and instructions for radiating diamond (Amish "Sunshine and Shadow"), using simplified Seminole technique featured in her workshops. (2) Trip Around the World Variations, by Kathleen S. Drew—3 pattern designs in 5 quilt sizes.

Books: *The Teacher Workkit*, by Jane C. Smith — guide to organizing and teaching quilt seminars with "Trip Around the World," and Quilt in a Day™ techniques (has that book series by Eleanor Burns). Quilt kit for Log Cabin or Trip Around the World. Has quantity prices, discounts to teachers, institutions, and professionals. (Also sells wholesale to businesses.)

Jean Caviness
150 Old Marietta Rd.
Canton, GA 30114

Send SASE and $1.50 for sample and list.

Old quilt patterns (full-size, with instructions): Dutch Girl/Boy, Campbell Soup Girl/Boy), Shirley Temple, Cathedral Window, Little Red Schoolhouse, Scottie Dog, Teddy Bear, Three Kittens, Tulip, Rose, Jonquil, Wreath, Petunia, Butterfly, others. (See DOLL, TOY & CLOTHES MAKING—SOFT.)

Kaye Wood
4949 Rau Rd.
West Branch, MI 48661

Quilting hoop with floor stand, and quilting frame. © Quiltwork Patches.

Catalog $.50.

Quilting instructional videos, with Kaye Wood (1 hour tapes, VHS or Beta), on strip piecing: Basic Log Cabin, Log Cabin Triangles, Reversible Quilts, Log Cabin Diamonds, Starmaker Quilt Designs.

Keepsake Quilting
P.O. Box 1459
Meredith, NH 03253

Free catalog (or lst class mail $1.00).

Quilting supplies: patterns, stencils, variety of aids, fabric medleys. Quilting kits. Over 600 cotton fabrics (solids, plaids, patterns, textured, others); specialty fabric assortments. Batting and muslin. "Hundreds" of quilting books. (Also has gifts for quilters.)

Ken Quilt Mfg. Co.
113 Pattie
Wichita, KS 67211
316-262-3438

Send stamp for literature and prices.

Professional model quilting machine: easy to follow pattern, carriage moves forward, backward, sideways, or any way, to make a variety of designs; machine has variable speed to full capacity of 3500 RPM.

La Maison Piquee
P.O Box 1891
Milwaukee, WI 53201
414-332-4590

Send SASE for details and prices.

Quilting patterns: set of 19th century designs, Bicentennial sampler; floral designs (primitive, with applique), "Poinsettia Perfection" and "The Wade Rose." French quilting by machine pamphlets. Others.

Lois Cox
15 Tunis Way
Pacheco, CA 94553

Send SASE for brochure.

Quilting kits, including Lone Star, Broken Star, Dresden Plate, Grandmother's Flower Garden, Double Wedding Ring, Double Irish Chain; others.

Mary Mclear
905 Castaic Ave.
Oildale, CA 93308

Send SASE for list.

Doll quilt kits (fabric pieces, backing, binding, instructions), patchwork squares, basket applique or stencil type. Others.

Mountain Co-Op
2609 Shay Cove
Little Rock, AR 72204

Send SASE for full details.

Custom quilting services: top quilting, finishing, others; by Ozark women of co-op. (Also has handcrafted quilts.)

Mountain Mist
100 Williams St.
Cincinnati, OH 45215
513-948-5276

Contact dealer or send SASE for information.

Cotton batting, polyester batting, cotton covered pillowforms, polyester stuffing, roll batting. Quilt patterns (plastic templates) for all sizes of beds; variety of designs: Martha's Vineyard, House Quilt, Double Irish Chain, Old Fashioned Rose, Old Mexico, Jacob's Ladder, Mountain Star, Shoo Fly, Pennsylvania Dutch, Mariners Compass, Horn of Plenty, others. Manufacturer.

Needlearts International
P.O. Box 6447
Glendale, CA 91225

Catalog $2.00.

Quilting stencils — over 300, in international designs (Celtic, Oriental, Arabic, others). Sashiko Japanese embroidery/quilting patterns and supplies, books. Patterns for unusual quilting projects and garments. Imported cotton from Japan, Malaysia, Indonesia, others. Design books (fashion, geometric, historic, 3-D op art, dragons, castles, Victorian, mosaic, others).

Or Company
P.O. Box 917
Lima, OH 45802

Write for brochure and prices.

Poly-Down™ batting/stuffing, polyester fiberfill, Simply Stuffing™, Poly-Down™ fiberfill, PolyDown™ pillow inserts. "Buy direct and save."

NO-BASTE: *To avoid time-consuming basting on a quilt, use stainless steel safety pins every 3" to secure the three layers before quilting. Courtesy of Donna Wilder of Fairfield Processing Corp. Also Evelyn Rose of Pioneer Quilts.*

Paper Pieces
P.O. Box 2931
Redmond, WA 98073

Samples and price list $2.00.

Precut paper shapes for paper piece quilt-making: hexagons, diamonds, 6 & 8 pointed stars, triangles, squares, hearts, half diamond—for teachers, professionals, new quilters using English paper piecing method.

Pioneer Quilts
801 Columbus St.
Rapid City, SD 57701
605-342-6227

Send SASE for information.

Quilt-A-Kits — 114 custom-marked designs for quilt blocks, pillows, others; in 2" X 3" to 6" X 6" block sizes; for all size beds. Includes a variety of motifs: old-fash-

ioned girls, Jack and Jill, cornucopia, Dresden plate, crossed feathers, bridal wreath, boy and girl announcements, wedding, anniversary, monograms, Christmas.

Applique mobile kits (doves, hearts, butterflies). Granny ball kits (of arc shaped and quarter circle cloth pieces) to sew. Book: *Adventures in Quilting*, by Evelyn Rose & Catherine Eatinger (beginner patchwork, quilting, applique; project directions; quilting/feathering designs). Others. (Also sells wholesale to businesses.)

Quilt Gallery
250 Burton
Booneville, MS 38829

Send SASE for list.

Cotton blend quilting scraps of fabric in 14 pound assortments, printed designs; and 12 pound assortments of solid fabric scraps.

Quilt in a Day
1955 Diamond St., Unit A
San Marcos, CA 92069
619-436-8936

Free catalog.

Instructional videos on quilting (with Eleanor Burns); and Quilt in a Day by Eleanor Burns (including *The Sampler—A Machine Sewn Quilt*; *Bunnies & Blossoms*, as well as log cabin quilt instructions, layout and sewing techniques, with detailed illustrations and data charts, for easy—sew, and finishing). Quilting supplies: patterns, threads, others. Has quantity prices, large order discounts; discounts to teachers, institutions, professionals. (Also sells wholesale.) MasterCard, Visa.

Quilting Books Unlimited
1911 W. Wilson
Batavia, IL 60510
708-896-7331

Book list $1.00.

Quilting books—every quilting book currently in print, including traditional, contemporary, and other designs for quilts, clothing, home accessories, others; patchwork styles and methods, piecing, many others. "Ships postpaid in continental U.S."

Quilts & Other Comforts
Box 394, 6700 W. 44th Ave.
Wheatridge, CO 80034
303-420-4272

Catalog $2.50.

Quilting patterns and precut kits: designer, classics, country heirlooms, contemporary, log cabin, designer, children's, "quilted expressions"—welcome, etc., others, for all bed sizes. Pillow kits, quick and easy patchwork project kits. Fabrics (muslins, color packets, cottons by yard in over 20 solid shades). Quilting aids: templates, collections, and patterns. Adjustable hoop frames, frame stands. Notions, Olfa cutters, scissors, rules, pins, needles. Holiday boutique decorations. Threads. Bias binding, quilt linings. Quilt art clothing patterns. Over 65 books; *Quiltmaker* magazine. Discount to teachers and institutions. (Also sells wholesale.)

Ready-made, lightweight, and portable lightbox.

Quiltwork Patches
209 S.W. 2nd St.
Corvallis, OR 97333

Catalog $1.00. Fabric samples $2.00.

Precut quilt kits and patterns—variety of traditional and other designs. Cotton fabrics: solids, calicos, prints; muslin and sheeting; backings, precut cotton squares, sampler shades assortments, "fabric sticks" coordinated pieces. Batting: Poly-down™, PolyFil™, traditional and high and low lofts. Patterns: all-over stitching designs for double or queen size. Stencils. Templates. Q-Snap™ quilting frames (PVC pipe with snap-caps, floor model). Wood hoop, stand and floor frames. Gingher scissors, Olfa cutters/mats. Markers, transfers, others. Threads including wash-away basting type, notions. Fusible web, stencil kits (Mylar and electric pen, tips.). Books.

Quiltworks
2920 North Second St.
Minneapolis, MN 55411
800-328-8414

Send SASE for list.

Quilting fabrics: Concord, Marcus, Meritex, Wamsutta, Benartex, Peter Pan, Hoffman, Dan River, others. Full line of supplies. (Sells to businesses.)

St. Peter Woolen Mill
101 W. Broadway
St. Peter, MN 56082

Free brochure.

Natural wood batting. Recarding service. (And sells wholesale.)

That Patchwork Place, Inc.
P.O. Box 118
Bothell, WA 98041
206-483-3313

Catalog $2.00.

Line of design booklets, quilting/toy patterns. Book: *The Basics of Quilted Clothing*, by Nancy Martin — basic quilting techniques, pattern and fabric selection, batting

Jane C. Smith sits on a "Trip Around the World" quilt, from her workshop. © Jane C. Smith.

and materials are covered; and projects (jackets, vests, whole-block garments, skirts and totes, and other clothing using quilting and patchwork); illustrated.

The Gibbs Manufacturing Co.
606 Sixth St. N.E.
Canton, OH 44702

See your dealer or write for prices.

Gibbs quilting hoops, needlecraft hoops.

The Quilt Patch
1897 Hanover Pike
Littletown, PA 17340
508-480-0194

Catalog $1.00; with swatches $4.00.

Quilting supplies — full line of threads, stencils, aids, others. Fabrics: cotton prints and solids, designer fabrics. Books, instructional videos. (Also has handcrafted quilts.)

The Sewing Room
35353-CS Law Rd.
Grafton, OH 44044

Catalog $1.00 (refundable).

Quilting stencils (precut clear plastic) in over 600 designs: geometrics, florals, borders, stars, praying hands, bows, birds, filigrees, medallions, corner motifs, ropes, people, animals, grills, storybook people, boats, ship, train, fish, butterflies, old-fashioned girls, hearts, clovers, toys, feathers, swans, wreath, mushrooms, airplane, alphabets, music, house, baskets, bells, grapes, others; many in a variety of motifs. Marking pencils and set, chalk pencil, magic rub eraser, quilters masking tape. (Also sells wholesale to businesses.)

The Stearns Technical Textiles Co.
100 Williams St.
Cincinnati, OH 45215
513-948-5277

See your dealer or write for information.

Mountain Mist™ cotton batting (no prewashing), with Glazene™ finish. Grey poly-batting.

Rug Making

🐦🐦🐦🐦🐦🐦🐦🐦🐦🐦🐦🐦🐦🐦🐦🐦🐦

See also NEEDLECRAFT SUPPLIES, KNITTING & CROCHET, SPINNING & WEAVING, YARNS, and other related categories; BOOKS & BOOKSELLERS, PUBLICATIONS, and ASSOCIATIONS.

🐦🐦🐦🐦🐦🐦🐦🐦🐦🐦🐦🐦🐦🐦🐦🐦🐦

Braid-Aid
466 Washington St.
Pembroke, MA 02359
617-826-2560

Color catalog $4.00. Free price lists.

Rug making/weaving items, fabrics — hooking and braiding wools by yard; primitive and Scotch burlaps, monk's cloth, cottons, homespuns, rug warp. Wool remnants by pound. Kits — rug braiding (5 color choices, supplies, and tools) and accessory kit (without wool). Patterns. Shirret items. Tools/equipment: cutter units, hooks, magnifiers, shears, Braidkin bodkin, Braid-Klamp holder, kits. Braid-Aids. Dyes. Spinning and weaving yarns. (Allows teacher accounts.)

DiFranza Designs
25 Bow St.
N. Reading, MA 01864
508-664-2034

Illustrated instructional catalog $4.00.

Hooked rug patterns/kits: patterns—line designs on fine or coarsely woven burlap depending on width of strips used. Kits have precut wool fabric strips, color photo of finished piece and directions. Pattern designs: light-hearted motifs—Alice in Wonderland, Patchwork Cat, Hopscotch I, II. Americana — Shaker Tree, flowers, herbs, others. Cat and Indian motifs. Unicorn flora/fauna. New England scenes. Fruit motifs. Noah II and other biblical motifs. Primitives, New England designs, Orientals, others.

Hooked chair seat patterns (8 designs), 9 hooked pillow designs, and decorative-initial pillow patterns on white homespun. Hooked brick cover patterns. (Also sells wholesale to businesses.)

Earth Guild
33 Haywood St.
Asheville, NC 28801

Write for catalog.

Rug making: rug punches—Tru-Gyde old-style, heavy-duty rug, 4-in-1 punch needle kit. Hooks—latch, traditional. Burlap backings—primitive and Scotch. Twill rug binding. Rug braiding — Braid-Klamp, Braidkin lacer, Vari-Folder Braid Aid braider. Threads: linen, braided cotton. Rigby strip cutters—3 models, cuts 3/32" to 2" wide. Fabric dyes including Lanaset acid wool type, others. Dye equipment. Basketry items.

Full line of yarns. Wool rug yarn assortments; heavyweight rug/basket types, Berbers, birch heathers. Has quantity prices, large order discounts; allows discount to teachers, institutions, and professionals. (See NEEDLECRAFT SUPPLIES and SPINNING & WEAVING.)

Forestheart Studio
21 South Carroll St.
Frederick, MD 21701
301-695-4815

Send SASE for list and sample.

Rug hooking: Belgian linen backing fabric—by yard, 15 yard lot, or bolt. Rug wools, dyes. Rug hooking frames and cutters. Others. Has quantity prices. Frame rentals.

Fox Hollow Fibers
560 Milford Rd. South
Earlysville, VA 22936

Send SASE for prices.

Book: *Australian Locker Hooking – A New Approach to a Traditional Craft*, by Joan Z. Rough: hooking unspun wool into machine washable rugs, clothing, and wall hangings; illustrated instructions, locker hook.

Ginny Hildebrant
5167 Robinhood Dr.
Willoughby, OH 44094

Catalog $3.00.

Rug hooking: wide array of rug patterns in variety of motifs including American Indian, Eskimo, and others.

Glimakra Looms 'n Yarns, Inc.
1338 Ross St.
Petaluma, CA 94954
707-762-3362

Catalog $2.50.

Yarns, including rug warps in wools (Klippans Matt and Asbo Rya types), cotton rug warp (Bockens 12/6), and other weaving yarns. Books on rug weaving, rag rug weaving, dyeing, color, others. MasterCard, Visa. (See LACE MAKING and SPINNING & WEAVING.)

Great Northern Weaving
P.O. Box 361
Augusta, MI 49012

Catalog and samples $1.00.

Rug braiding and weaving supplies. Cotton rags on coils.

DEFINED: *Primitive rug hooking is a popular method done with wide (about 1/4" strips). Tapestry rug hooking is executed with thinner strips that allow for details and fine shading of colors.*

Harry M. Fraser Co.
Rt. 3, Box 254
Stoneville, NC 27048
919-573-9830

Patterns and supplies catalog $6.00.

Full line of supplies for hooking, braiding, and shirret—wool fabric by yard or pound, others. Rug hooks, braiding sets, needles. Rug cutter units. Others.

Hearthside Crafts
4555 N. Pershing
Stockton, CA 95207

Send SASE for details.

Crocheted heart or oval rug pattern using fabric strips and single crochet stitch.

Jacqueline Designs
237 Pine Pt. Rd.
Scarborough, ME 04074
207-883-5403

Catalog $5.50.

Rug hooking: over 250 patterns (primitive, traditional) in florals, scenics, others. Rug hooking kits, shade swatches.

Jane McGown Flynn, Inc.
P.O. Box 1301
Sterling, MA 01564
508-365-7278

Catalog: "Designs to Dream On" $7.50.

Rug hooking: over 300 designs (traditional, classic, others), on 12 oz. Scottish burlap (or primitive burlap or cotton backing available). Full line of supplies: Pearl K. McGown Hooks, pencil hooks, Puritan frame and stand, hoops (10", 14"). Cutters—Frazer 500, Rigby models D, H; replacement blades. Rug binding, 5" Marks Shears. TOD I, II, and III (and spoons). Dorr backgrounds, swatches. Colors by Maryanne.

Scottish burlap (40", 48", 60" 12 oz.) and 48" Angus primitive burlap. 48" and 60" cotton backing. Books. Custom stamping of designs on primitive burlap or cotton. Allows discount to teachers and institutions.

Jane Olson
P.O. Box 351
Hawthorne, CA 90250

Catalog $3.00.

Rug hooking: line of McLain swatches—72 colors hand-dyed on Dorr's wool. Books: *Hooked Rug and Flower Manual, Anyone Can Dye, Shading with Swatches, Braid a Reversible Rug. Rugger's Roundtable* newsletter.

SWATCHES: *Only cut the part of the swatch or background needed—small leftover parts of swatches can be dip-dyed in greens for small leaves. Courtesy of Jane Flynn of Jane McGown Flynn Inc.*

© *Rug hooking*

Janet Matthews
187 Jane Dr.
Syracuse, NY 13219

Contact dealer or send SASE for information.

Rug hooking: dye formula books (over 100 formulas per book)—TOD Books I & II, by Lydia Hicke, TOD Book III, by Janet Matthews. TOD snips (8 shade samples to put with each formula in TOD books). TOD dye spoon.

Mandy's Wool Shed
Rt. 1, Box 2644
Litchfield, ME 04350
207-582-5059

Samples $3.00.

Rug hooking/braiding: wool fabrics by yard — solids, tweeds, plaids, and pastel colors, white wool seconds. (Also sells to suppliers and teachers).

New Earth Designs
Beaver Rd.
Lagrandgeville, NY 12540
914-223-2781

Catalog $6.00 (refundable).

Rug hooking designs (silkscreen printed) in Oriental, primitive, and traditional motifs, with color photos on monk's cloth, burlap, or linen.

Oriental Rug Company
214 S. Central Ave.
Lima, OH 48501
419-225-6731

Free brochure and price list.

Rug weaving supplies: carpet warps, rug fillers, rags, prints and looper clips (in 10 or 50 lb. bales), others; rag cutter, beam counter, loom parts. Floor loom weaves 36" wide, with information, ready-to-weave. "At factory direct prices."

HOOK HOLDING: *Always hold the hook so the barb rubs your thumb. Courtesy of Happy DiFranza of DiFranza Designs.*

Pat Moyer
308 W. Main St.
Terre Hill, PA 17581
215-445-6263

Free brochure.

Rug hooking kits using wool cloth—original designs, can specify color choices.

Patsy Becker
18 Schanck Rd.
Holmdel, NJ 07733

Catalog $4.50.

Line of Patsy rug hooking designs in whimsical/folk art style; cat with flowers, ponies with tree, and birds (2 sizes), others. Custom designs.

Rittermere-Hurst-Field
Box 487, 45 Tyler St.
Aurora, Ontario, Canada L4G 3L6

110 page catalog $6.00.

Rug hooking designs: wide array of traditional, classic and other designs; scenics, florals, animals, geometric motifs, many others. Rug kits. Rug hooks, wools, other supplies and aids. (Also has knitting kits.)

Rigby
P.O Box 158
Bridgton, ME 04009
207-374-5830

Send SASE for details.

Cutters cloth stripping machine—cuts strips from 3/32" wide—for braiding, weaving, hooking.

Scott Group
5701 S. Division
Grand Rapids, MI 49548

Send inquiry.

Discounted rug yarns: wools, (cones, skeins; by pound). Full range of colors, send sample color, requirements—get sample.

Sea Holly Hooked Rugs
1906 N. Bayview Dr.
Kill Devil Hills, NC 27948
919-441-8961

Send large SASE for flyer.

Traditional rug hooking patterns, kits, equipment. Supplies: wool hand-dyed by yard or pound. "At reasonable prices."

Shillcraft
8899 Kelso Dr.
Baltimore, MD 21221

Color catalog $1.00.

Latch hook rug (and hangings, pillows) kits—designs stenciled on canvas with precut wool or acrylic yarn in contemporary, traditional, and international designs, Disney characters, nursery motifs, kitchen and bathroom ensembles; geometrics, florals, scenes, borders; other decorator kits.

The Dorr Mill Store
P.O. Box 88
Guild, NH 03754
603-863-1197

Free supply list. Swatches $3.00 (collection of 166 shades).

Rug hooking: wool fabric (exclusive decorator colors for hooking, braiding, quilting); tweeds. Hooking kits in va-·riety of traditional designs.

The Rugging Room
10 Sawmill Dr.
P.O. Box 824
Westford, MA 01886
508-692-8600

Pattern catalog $3.00

200+ rug hooking designs: primitives, geometrics, animals, pictorials. Custom designs, repairs.

W. Cushing & Company
P.O. Box 351
Kennebunkport, ME 04046

Send SASE for informational packet.

Rug hooking: potpourri wool swatches, Perfection and Jacobean swatches; spot dyed and studio swatches. Dorr background wools, plaids, and tweeds for primitives. Line of rug designs by Joan Moshimer, Edward Sands Frost, Ruth Hall, Pearl K. McGown, and others. Known brand frames. Rug hooks. Cushing Perfection dyes. Book: *Complete Rug Hooker*, by Joan Moshimer.

Yankee Peddler Hooked Rugs
57 Saxonwood Rd.
Fairfield, CT 06430
203-255-5399

Catalog $4.50.

Rug hooking wool by yard or pound. Line of other supplies including hooks, frames, new designs for spot dyed wools. Others.

Sewing

🐦🐦🐦🐦🐦🐦🐦🐦🐦🐦🐦🐦🐦🐦🐦🐦
See also most categories in Section II.
🐦🐦🐦🐦🐦🐦🐦🐦🐦🐦🐦🐦🐦🐦🐦🐦

A Bunch of Buttons
1416 Dove Rd.
Grapevine, TX 76051
817-488-0585

Catalog $2.00 and SASE.

Ceramic buttons (handcrafted) in almost 300 original shapes and sizes, in variety of colors (can be custom ordered with one hole or no holes to be used as jewelry, etc.); 7 primary and 7 pastel color choices: barnyard animals, train engine and cars, boats, vehicles. 4 bows, 9 hearts, 3 stars, moon, critters, "Summer Fun" items, hot air balloon, fix/paint items, 8 dollies, 4 teddies.

Baby and floral items. Texas/western, butterflies, fruit, veggies, holiday (angels, Santa, wreath, star, bells, pumpkin, flag, eggs, bunnies, others). Letters/numbers, classic shapes. (Also custom buttons as bisque or molds.) Has large order discounts. (Also sells wholesale.)

A Work of Heart
P.O. Box 1477
Nevada City, CA 95959

Send SASE for list.

Chatelaine kits (ribbons, rings, sewing items, instructions) in variety of color combinations. Sewing items: seam rippers, Gingher embroidery scissors, needle case, stiletto, beeswax, others.

Abraham's Sewing Notions
13104 Mason
Grant, MI 49327

Catalog $.50.

Line of sewing notions, laces, ribbons, threads, others.

Adapt-A-Cab
214 Fairway Pl.
Costa Mesa, CA 92627
714-646-0904

Send SASE for full information.

Adapt-A-Cab allows use of free-arm sewing machine in a flat-bed type cabinet—height adjustment for flat-bed or unobstructed free-arm sewing. Credit cards. ("Dealer inquiries welcome.")

Amazon Drygoods
2218 E. 11th St.
Davenport, IA 52803
319-322-6800

Catalog $2.00; pattern catalog $4.00.

19th century inspired clothes and accessories patterns. Sewing supplies: hoop wire, boning, stays, other wires, ostrich plume. Fabrics: nainsook, crepe plisse, batiste, lining cotton, duck, drill, white challis, red flannel, sheeting red taffeta, damask, satin; gold "bullion" fringe (on Scarlett's dress). Tradecloth, rogue, and moires, stripes. Feathers, hat veilings, spangles. Muslin and calico bags. Military buttons, uniform drygoods (dark blue wool, sky blue, and gray wool, butternut). Historical accessories. Needleworks: lace making, lace net embroidery. Victorian lettering, stenciling, others. Historic and other books. Ready-made historic clothing and accessories. American Express, MasterCard, Visa. (See COSTUMES—HISTORIC & SPECIAL OCCASION.)

American & Efird, Inc.
P.O. Box 507
Mount Holly, NC 28120
704-827-7556

Contact your dealer or send SASE for details.

Maxi-Lock™ cone threads (for sergers and other sewing machines) of polyester; in full line of colors.

Amici Creative Arts
P.O. Box 163
Rio Vista, CA 94571
707-374-6548

Catalog $2.00.

Lingerie fabrics (colors, by yard) Lustra tricot, print tricot (Enkalure nylon), satin nylon sheer, cotton knit, stretch lace, angel skin Lycra. Nylon laces, elastics (stretch lace, ruffled leg, swimwear, clear, plush, bra straps). Bra parts. Kwik Sew patterns: women's lingerie, jump and jogging suits. Men's and children's sleepwear. Kidsew patterns (tops, skirts, pants, shirts, shorts, sleeping bags). Iron-on transfers (country and other designs), Gingher scissors, tracing paper. Sewing books.

MERCERIZED: *Cotton thread that has been treated to shorten, strengthen, and harden it, for a lustrous result.*

Atlanta Thread & Supply Co.
695 Red Oak Rd.
Stockbridge, GA 30281
404-389-9115

Free catalogs.

Sewing supplies/aids: cone threads for serger and blind-stitching—most kinds. Zippers, fasteners, pliers, chalks, pins, linings/pockets, interfacings. 13 shoulder pads. Pliers, measurers. Elastics, binding. Athene dress form. 26 scissors. Hampers, caddies, baskets. Gauges, staples, pins and needles, drape pleaters. Cords, weights.

Pressing aids, machines, irons, steam sergers (Singer, Juki, Brother), Tacsew blindstitchers. High speed sewing machines (Tacsew, Singer, Juid, Pfaff, Consew), 3 cutting machines. Store supplies: racks—counter, bar, salesman's, spiral, 4-arm, 2-arm, adjustable, 3-roll garment, bagging type). Has quantity prices.

Baby Lock, Spa Inc.
P.O. Box 31715
Seattle, WA 98198
206-783-8087

Write for brochure.

Baby Lock brand of sergers and overlockers.

Barbeck English Smocking
1113 Caroline St.
Fredericksburg, VA 22401

See your dealer or send SASE for information.

Smocking: pleating machine, design patterns, books.

BEJ Sewing Methods Inc.
P.O. Box 681
Ridgewood, NJ 07451

Send SASE for full details.

Basic sewing instructional video: Basic Dress, step-by-step instructions; emphasis on putting in zippers, sleeves, and in-seam pockets. MasterCard, Visa.

Bernina
534 W. Chestnut
Hinsdale, IL 60521

Send SASE for information.

Bernina brand sewing machines and serger machines, including Bernette 334D model that cuts/finishes edges in fewer sewing steps; forms seams, with differential feed system (eliminates wavy seams); with all controls outside; in 4-thread and 3-thread overlock; with Elasticator, blind hem, and other attachments. Full line.

Bernina Sewing Center
3625 Weston Rd., Unit 8
Weston, Ontario, Canada M9L 1V9

Send SASE for information.

Bernina sewing machines and serger machines, including Bernette 334D model in 3 and 4 thread overlock; with blind hem, Elasticator, and other attachments.

Carol Suthers
Box 33305
Kansas City, MO 64168
816-741-8828

Send SASE for full information.

Sewing patterns for pantaloons (one size fits all); others. Book: *Victorian Designs, Collaged*, by Carol Suthers (easy designs using lace and other trimmings) for pillows, designer belts, collaged teddy, doll/tree angel, tree skirt (or round tablecloth), others. (Also publishes *Carol's Bits & Pieces* newsletter.)

> SEWING FELT: *When sewing with felt (for ornaments, etc.), sandwich polyester batting between two pieces of felt, sew together, then cut shape out since there's no need to turn fabric when using felt. Courtesy of Catherine Blocker of Blocker's Guides.*

Carolynn's Sewing Center
7003 J Manchester Blvd.
Alexandria, VA 22310
703-719-9106

Send SASE for details. Monthly swatches and letter, $15.00.

Complete line of Stretch & Sew patterns, notions, color coordinated fabrics, books.

Catherine's of Lexington
Rt. 6, Box 1227
Lexington, NC 27292
704-798-1595

Catalog and color cards $2.00 and large $.45 SASE.

Serger supplies: industrial polyester serger threads in .45+ colors, all purpose 100/2 (popular), and 7 colors polywrap (stronger 100/2, 70/2). Woolly nylon (stretch—for swimsuit and action wear, machine embroidery, etc.). Lingerie nylon (3 colors). Cone thread racks.
Looper threaders. Seam ripper, knives, serger needles. Thread stand. Books. Service: scissor sharpening. Has quantity prices, large order discounts; allows discount to teachers, institutions, and professionals. Minimum order $35.00 (except for items that can be mailed in an envelope). (Also sells wholesale to businesses.)

Ceramic Playhouse
420 N. Main
Grapevine, TX 76051

Send $2.00 and large SASE for catalog.

Buttons—over 200 designs and sizes including whimsical, traditional, unusual motifs — all handcrafted and copyrighted.

Clotilde, Inc.
1909 S.W. First Ave.
Ft. Lauderdale, FL 33315
305-761-8655

Free catalog.

Sewing supplies: quilting tools/aids—stencil plastic, templates, graph pads, thimbles, pins, machine/hand needles, threaders. Chalks, pens, markers. Olfa cutters, blades, arm. Scissors including pinking, folding, Tuf Kut. Weights, reflective tapes, glues, zippers, snaps. Ultrasuede pieces. Elastic, sequin appliques, cross locked glass beads. Ribbon floss (15 colors).
Threads: metallics, cottons, metrosene, serger, stretch, cone. Magnistitch, Third hand bias maker and tapes, drapery tapes, tracing wheel. Machine attachments. Pressing aids: irons, pad, holder, board, cloths, ham holders, tailor boards, cleaners. Shoulder pads and interfacings—variety of types. Boning, bra cups. Sewing — handbag parts: snaps, chains, frames, spring-action

and center open frames; patterns. Instructional videos by Clotilde: Seminar Video Series (4 in series), and T.V. Teaching Segments (6 in series)—on sewing, tailoring, designer methods, and custom dressmaking techniques. Other videos include Dress Form (Carol Stith), Generic Serger (Kathy Ruddy), Quilting—4 (Kaye Wood), Creative Sewing (Lois Ericson). Books: *Sew Smart* series, by Clotilde. Other books on sergers, quilting, sewing machines, Singer series, shade making, applique, sweatshirts, French, others. "Always 20% discount." Visa, MasterCard. (Also sells wholesale to businesses.)

Coats & Clark Inc.
P.O. Box 27129
Greenville, SC 29616
And in Canada: J & P Coats, Education Services
P.O. Box 519, Station A
Montreal, Quebec H3C 2T6

Contact your dealer.

J & P Coats threads—Dual Duty Plus™ cotton covered polyester cord; specialty threads. Super Sheen™ cotton; special hand quilting thread. Finesse long staple polyester thread. Core-Lock™ for overlock sewing. Koban—cotton wrapped polyester core threads. Super Sheen™ cotton threads. Specialty threads for hand quilting, overlock, etc.

Videos (VHS): Starting Embroidery, and Starting Tapestry (with instructional booklets and Stitch Cards illustrations/diagrams.)

© *Ginger Designs*

Consolidated Sewing Machine Co.
1115 Broadway
New York, NY 10010
212-929-6900

See your dealer or write for information.

Consew sewing machines: Tuffylock overlocks, others.

Consumer Products, Inc.
P.O. Box 6694
Virginia Beach, VA 23456

Send SASE for prices.

Singer sewing machines: Ultralock™, Ultra Unlimited and Micro-Computer Free-Arm models; others. "Wholesale to public." Major bank cards.

Creative Savings
7652 Sawmill Rd., Suite 184
Dublin, OH 43017

Brochure $1.00 (refundable).

Fabrics, sewing machines, supplies, yarns, craft materials.

Delectable Mountain Cloth
6 Elliot St.
Brattleboro, VT 05301

Send SASE and $1.00 for brochure.

Buttons: full line of shape, sizes, and materials, natural textiles.

Dogwood Lane
Box 145
Dugger, IN 47848
812-648-2212

Catalog $2.50.

Handmade porcelain buttons (folk shapes), classic clothing patterns, others.

Donna Salyers
700 Madison Ave.
Covington, KY 41011

Write for free brochure. Swatch books $5.00.

Ultraleather™ "luxury alternative"—buy by kit or yard. Sewing instructional videos—Donna Salyers: Sew Wardrobe in a Weekend, Sewing Tips, Craft & Gift Ideas, Re-Do Room in a Weekend (home accessories).

Dressmakers Supply
1212 Young St.
Toronto, Ontario Canada M4T 1W1
416-922-6000

Catalog $5.00.

Line of fabrics, threads, notions, tools, and equipment, bride's supplies.

Dritz Corporation
P.O. Box 5028
Spartanburg, SC 29304

Contact dealer or send SASE for information.

Dritz™ sewing aids: cutting mats, sewing/craft rulers, rotary cutters. Grommets and plier kit, rivets, snaps—heavy duty, 4-part, sew-on, jumbo, snap tapes. Attaching tool, kit. Grippers, elastics, snap fasteners. Pins, magnetic holder. Eyelets, belt and buckle kits, cover buttons.

20+ shoulder pads, 15+ scissors and shears, snips. Full line of elastics, braids, cable cord. Stitch Witchery, belting, tapes. Glues. Sewing tray, boxes. Seam roll, ham, press items. Lead weights. Rippers, threaders, gauges. Bra parts. Beeswax, Mark-B-Gone, Fray Check. Metallic threads, thread sets. Machine bobbins, bulbs, tool set.

Eastman Machine Company
779 Washington St.
Buffalo, NY 14203
716-856-2200

Send SASE for full details.

"Chickadee" professional electric rotary shear—cuts material to ½" thick, meets all safety codes, with blade sharpener enclosed; "cuts on any flat surface without damaging it." Weighs 30 ounces. Replaceable blades.

Elna, Inc.
7642 Washington Ave., So.
Minneapolis, MN 55344
612-941-5519

Contact dealer or send SASE for full details.

Line of sewing machines including the Elnita 200 series budget-priced models with more features than earlier styles; with feed-dog lever in bobbin case cover, interchangeable snap-on presser feet, universal thread tensions; automatic buttonholing, overcasting; triple zigzag and other stitches. Accessories and attachments.

Fit For You
781 Golden Prados
Diamond Bar, CA 91765
714-861-5021

Catalog $1.00 each.

Square Dance or Western Collection of patterns.

Gohn Bros.
Box 111
Middlebury, IN 46540
219-825-2400

Catalog $.50.

Clothing for Amish and plain communities; full line of fabrics and notions. Rubber sheeting. "Low prices."

Greenberg & Hammer, Inc.
24 W. 57th St.
New York, NY 10019
212-246-2835

Send SASE for catalog.

Fabrics, sewing notions, hard-to-find supplies and accessories for professional dressmakers, costumers, milliners, others; professional steamers. Also sells wholesale.

Hancock Fabrics
3841 Hinkleville Rd.
Paducah, KY 42001

Send SASE for list.

Specialty and bridal fabrics (satins, taffeta). Broadcloth, muslins, others. Batts, threads, Gingher scissors, cutters, other items. $25.00 minimum order; MasterCard, Visa.

Home-Sew
P.O. Box 4099
Bethlehem, PA 18018
215-867-3833

Catalog $.50.

Sewing: appliques, trims, closures, ribbons, laces, rickrack, elastics, eyelets, curly hair, "at bargain prices."

Islander—Video Division
P.O. Box 5216
Grants Pass, OR 97527
503-479-3906

Send SASE for brochure.

Sewing instructional videos by Margaret Islander of Islander School of Fashion Arts, Inc.: (1) Industrial Shortcuts Parts I & II (2 hours) — production techniques adapted from the garment industry (cutting, marking, machine control, professional pockets, zippers, waistbands, tucks, pleats, topstitching, mitering). (2) Shirts, Etc. Parts I & II (women's, men's) 2½ hours—industrial techniques adapted to home sewing in professional methods "in half the sewing time." No pins or basting, collars and cuffs "made easy," covers all steps; methods applicable to most other garments. MasterCard, Visa.

Jan Marie, Inc.
P.O. Box 449
Sparta, NJ 07871

Send SASE for details.

Designer cuts and imported fabrics (silks, wools, cottons, knits). Sold through home sales representatives.

JG Wear
22465 Berring Ave.
Farmington, MN 55024

Swatches $3.50.

All-cotton fleece—matching interlock and ribbing, in variety of colors.

Johnson's
2323 Lake Wheeler Rd.
Raleigh, NC 27603
919-833-2791

Contact your dealer or write/call for information.

Johnson ruffling machine (ruffles curtains, lace, other—up to 6 to 1 fullness).

Juki America
5 Haul Rd.
Wayne, NJ 07470
201-633-7200
And on West Coast:
3555 Lomita Blvd.
Torrance, CA 90505
310-325-5811

Contact a dealer or send SASE for details.

Juki Lock serger, models for one, two, or three to four thread convertible overlock machines that seams and edge-finishes in one, from sheets to heavy fabrics; the accessories and attachments (rolled hemming and blind stitch hemming, others); other 3-thread and 4-thread overlock machines.

UNDERSTITCHING: *Use a multi-zigzag for understitching. This stitch sews more thread per inch, creating a more tailored edge. This unconventional form of understitching can be used on most woven fabrics and even on knits, to prevent the seam allowances from curling. Courtesy of Nancy Zieman and Robbie Fanning, from* The Busy Woman's Sewing Book.

Kid Sew
P.O. Box 20627
Columbus, OH 43220

Send SASE for further details.

Kid Sew™ patterns for kids aged 8 to 14 years old, with teaching kit (manual for teachers): how to hold classes, lesson plans, PR materials. MasterCard, Visa.

Lansdale Discount House
816 W. Second St.
Lansdale, PA 19446
215-855-7162

Send SASE with specific inquiry.

Fabrics: linens, cottons, blends, bridal, home decorating —full line. Notions. Sewing machines: free arm models, Baby Lock sergers. Yarns.

Lifetime Career Schools
2251 Barry Ave.
Los Angeles, CA 90064

Free booklet.

Dressmaking home study course—speed-up methods, factory shortcuts—for home sewers and professionals.

Lois Ericson
Box 5222
Salem, OR 97304

Contact your favorite fabric outlet, or send SASE for list.

Creative sewing books: Print It Yourself, Design and Sew It Yourself, Fabrics Reconstructed, Pleats, Texture.

Live Guides
10306 64th Pl. West
Mukilteo, WA 98275
206-353-0240

Free brochure.

Generic serger instructional video (Beta or VHS): covers all aspects of serger sewing on most (9) models of sergers. For sale or 10 day rental. MasterCard, Visa.

Maiden Vermont
P.O. Box 828
Middlebury, VT 05753

Brochure $2.00.

Over 60 styles of pewter buttons including flowers, folk designs, animals (teddy, rabbit, cat, others); can also be used as pins, earrings, keyrings. (Invites wholesale inquiries on letterhead.)

Marjorie Shires & Associates
2154 Yardley Dr.
Pensacola, FL 32526

Send SASE for full information.

E-Z Trace nonwoven tracing material for pattern making, copying, reinforcing much used patterns; tearproof; sold by 10 yard lot or 100 yard bolt.

Maryland Trims
P.O. Box 3508
Silver Spring, MD 20918

Catalog $2.00.

Sewing accessories and laces, button assortment, nylon and metal zipper and polyester thread assortments. Glossy embroidery floss. Others. "Up to 75% off."

Medieval Miscellanea
6530 Spring Valley Dr.
Alexandria, VA 22312

Catalog $2.00.

Medieval clothing supplies, variety of fabrics, equipment, garment patterns. Also almost 200 reproductions of jewelry from middle ages and renaissance era. Chain mail T-shirts, others. (See CLOTHING & ACCESSORIES.)

Melco Industries Inc.
1575 W. 124th Ave.
Denver, CO 80234

Send SASE for more information.

Stellar I computerized embroidery system unit, to automatically embroider designs, lettering, others.

Mini Lock Division
599 Industrial Ave.
Paramus, NJ 07652
201-967-0777

Write or call for additional information.

Mini Lock™ sewing machines, in variety of models.

Mr. Vacuum
11400 Livingston Rd.
Ft. Washington, MD 20744

Send large SASE for full details.

Sewing machine instructional manuals, parts, notions. Repair service.

Nancy's Notions
Box 683, Dept. 32
Beaver Dam, WI 53916
414-887-0391

Free catalog.

Sewing aids/notions: 15 scissors, cutters, boards, rules. Metrosene thread sampler. Shapers, bias tape makers, bodkin, third hand, weights, marking tools, tracing paper, pens/markers, measurers. Pin catchers, pins, bees-

wax. Bobbins, boxes. Create-A-Zipper. Seams Great™ finish. Elastics (and thread).

Machine presser feet, pintuck and others. Glass cross-locked beads. Charted needlework designs/kits. Hoops. Battenberg lace (yards). Applique press sheets, Stitch Witchery. Gosling drapery tapes, shade tapes. Dress form shoulder pads, Pellon, interfacings, reflective tape and material. Serger aids. Mettock threads, woolly nylon, rayon. Metallics, Sulky rayon. Rag rug items. Patterns: quilted clothes, larger women fashions (38-60). Book: *The Busy Woman's Sewing Book*, by Nancy Zieman with Robbie Fanning. *Slacks Fitting Book*.

Videos with Nancy Zieman (machine/serger titles, sew knits, leathers and suedes, lingerie, for children, for brides, glazers, tailoring, altering, 5 basic sew, 3 home decorating, machine art, monogram, accents, strip quilting, boiled wool); 3 fitting videos.

Video club: Pay one-time fee and can rent from 101 videos (sew, knit, cross-stitch, quilt, decorating, weaving, rug braiding, etc.) at low cost. Personalized shopper service. Allows discount to teachers and professionals.

National Thread & Supply Co.
695 Red Oak Rd.
Stockbridge, GA 30281

Free catalog.

Sewing equipment/items: Wiss and Gingher scissors, Sussman irons, Dritz notions, videos, lamps, others. Major credit cards.

Natural Fiber Fabric Club
521 Fifth Ave.
New York, NY 10175

Send SASE for brochure.

Natural fashion fabrics (cotton, sateen, silks, wools, others), sewing and tailoring aids; members' savings.

New Home Sewing Machine Co.
100 Hollister Rd.
Teterboro, NJ 07608
201-440-8080

Send SASE for information & nearest dealer.

My Lock sergers — electronic controlled: one needle-three thread model with rolled hem capability; two needle-three or four thread convertible, electronic speed controller. Other models.

Patty Matthews
4920 S.W. 188 Ave.
Ft. Lauderdale, FL 33332

Catalog $1.00 (refundable).

Full line of rhinestones, studs, findings.

Pfaff American Sales Corp.
610 Winters Ave.
Paramus, NJ 07653
201-262-7211

See your dealer or write for information.

Pfaff sewing machines including "Creative 1473 CD" electronic model that turns any sketch into embroidery onto fabric with "Creative Designer" unit; microchip remembers to 3,262 stitches and sews them) with machine that has 355 stitch programs — including tree cross stitch, stitch combinations; does 9 styles of buttonholes, 4 monogram alphabets. European manufactured.

Professional Sewing Supplies
P.O. Box 14272
Seattle, WA 98114
206-324-8823

Send $.25 SASE for catalog.

Sewing supplies: Chakoner (chalk markers) and refills. Magnetic holder, tailor's chalk. Cotton basting threads (non-slip) and silk. Japanese shears, snips. Thimbles— metal, leather. Iron-on interfacing, and bias and straight tapes. Waist banding. Third hand. Cutting set (tracing wheel, buttonhole cutters, awl, tweezers), needles, pins. 8 shoulder pads, underarm guards. Has quantity prices. (Also sells wholesale to businesses.)

Purchase For Less
231 Floresta PFL
Portola Valley, CA 94028

Catalog $2.00.

Fiber arts books (at reduced cost) on quilting, applique, sewing, wearable art, needlecrafts, dollmaking, others. Minimum order any four books.

Risdon Corp.
P.O. Box 5028
Spartanburg, SC 29304

See your dealer.

SHANKING AROUND. *Sewing machine feet are somewhat interchangeable if you know what shank you have. The shanks are low (or short), high (or long) for most machines, super-hi for some Kenmore machines, and slant for some Singer machines. Once you determine which ones you want, you can get almost any foot you want. Look at these feet [see illustration] to help.*

Full-size Side Views

Courtesy of Janet Stocker, publisher of Treadleart, *from Vol. 4, #6.*

From the cover of the booklet: Beyond Straight Stitching, *by Barbara Weiland O'Connell.* © *Update*

Dritz™ sewing aids and notions: Mark-B-Gone™, Trace-B-Gone™. Pins, needles, wash-pens, kits and sets. Swim bras and parts. Maternity items. Pockets, elastics, cover-buttons; others.

Rosemary's Sewing Supply
2299-M Duncan
Midland, MI 48640
517-835-5388

Send large SASE for catalog and samples.

100% cotton flannel (on bolt—by yard): prints, solid colors, juvenile prints, double napped, diaper type, large juvenile prints; quilt patches, bundles. Receiving blanket flannel. Muslin. Pellon. Threads (Dual Duty, Trusew, cone, Talon), Velcro, needles (hand, machine). Quilt batts (and baby). Elastics, pins, scissors. Buttons, tape measure, rippers, gauges, Trace-a-Pattern, sealing tape. Needle threaders. Has some quantity prices. Save 30%.

Salem Industries, Inc.
P.O. Box 43027
Atlanta, GA 30336

See your dealer or write for information.

Salem Quik Stripper™ slits quilt strips, bias tape, others.

Sarah's Sewing Supplies
7267-A Mobile Hwy.
Pensacola, FL 32506
904-944-2960

Free catalog.

Sewing notions: zippers, adjustable patterns, pins, needles, threads, aids, others.

Serger Magic
3104 W. 47th
Kennewick, WA 99337

See your dealer or send $4.99.

Serger Magic setter—write in settings, dial, set and serge (with space for favorite fabric settings). Use with any serger.

Sew Simple
P.O. Box 0206
Collierville, TN 38027

Send $5.00 and SASE for chart.

Ease chart—figures how much ease to add to body measurements in dress, shirt, jacket, etc.

Sew/Fit Company
P.O. Box 565
LaGrange, IL 60525
708-579-3222

Send SASE for list.

Sewing aids: rotary cutting mats (60 mil. thick thermopolymerstyrene with grid lines) 18" X 24" to 48" X 96" sizes "at almost half the price." Rotary cutters and blades. ("Dealer inquiries welcome.")

Sewin' in Vermont
84 Concord Ave.
St. Johnsbury, VT 05819
802-748-3803

Send SASE for list.

Sewing machines: line of Singer brand sergers and machines that may include Ultra models, Micro-computer and free arm models, others; at "discount prices."

Sewing Machine Discount Sales
20222 Paramount Blvd.
Downey, CA 90201
310-928-4029

Send SASE for information.

Singer sewing machines including school model (heavy duty) — Simplicity, White; zigzags, overlocks, etc. Threads: woolly nylon in 60 colors, cone. Coats & Clark Dual Duty II, embroidery threads for machines in 48 color spools; Spun polyester for machines in 30 colors, polyester cone threads for machines in 100 colors. "All at discount prices." MasterCard, Visa.

Sewing Supplies
75 E. Main St.
Patchogue, NY 11772

Brochure $3.00.

Home industrial machines: overlocks, blind stich, walking foot, merrow machines. Binder, hemmers, motors, hard-to-find parts, accessories.

Singer Co.
135 Raritan Center Pkwy.
Edison, NJ 08837

See your dealer or write for information.

Singer sewing machines including Ultra and Micro-computer models, free-arm types; sergers,. Manufacturer.

Singer Factory Distributors
3906 N. Harlem
Chicago, IL 60634
312-625-1515 ext.25

Send SASE for list.

Singer sewing machines, sergers, iron presses, knitting machines; "save $ on demos/closeouts/refurbished repos."

TO TURN A CORNER WITH CORD. *Stitch to within 1/8" of the corner. Change stitch length to 0 and take three stitches, ending with the needle on the inside of the corner. Pivot. Make a loop in the cord, take three stitches and return to the original stitch length. Continue stitching. Stop and tug on the cord so the loop disappears. Continue stitching.*

LEAVE A LOOP TO TURN A CORNER & PULL LATER.

CORDED SATIN STITCH EDGE

From the booklet, Beyond Straight Stitching, *by Barbara Weiland O'Connell.* © *Update Newsletters*

Speed Stitch
3113-D Broadpoint Dr.
Harbor Heights, FL 33983
813-629-3199

Catalog $3.00 (refundable).

Sewing supplies: threads—sulky rayon decorative cones and box set; 2 weights, 193 colors light, 47 colors thicker, 12 metallics. DMC machine cotton embroidery threads, pearl cotton. Basting threads, metallics, woolly nylon (serger), Metrocor poly cones. Rayon ribbon floss 28 colors, sets. Speed Stitch Method thread painting kit book. Design patterns and kits for pillows, vests, skirts, others. Nylon organdy canvas. Batting, Lowloft. Olfa cutters, rules, boards. Iron-on country patches, patterns.

Patterns—applique, quilts, quilted clothing, patchwork, handbag styles, windsocks, others. Handbag frames, clasps, snaps. Hoops. 8 markers. 5 kinds tearaway stabilizers. Pellon, velour, towel, bastiste; nylon organdy pieces. Ultrasuede and swimwear scraps. Kits/supplies/books: charted needlework, thread sketching, cutwork, quilt-a-sketch, quilting, quilts, monograms (beginner, starter) machine arts, lace-net darning, candlewicking, holiday, mini-gifts. Fabric dyes and paints, me-

dia, brushes, Marbelthix, Paint N Swirl. Machine attachments, magnifier, thread boxes, tube/hook turners. 32 videos: Sewing with Nancy titles. Design/how-to books on all above categories. Speed Stitch Instructor's Guide. Has quantity prices, large order discounts; allows discount to teachers, institutions, and professionals.

Tacony Corp.
4421 Ridgewood Ave.
St. Louis, MO 63116

See your dealer or write for information.

Baby Lock™ brand serging machines—variety of models—sews, overlocks, and trims in one operation.

The Bee Lee Company
Box 36108
Dallas, TX 75235

Free catalog.

Sewing supplies: threads, buttons, zippers, laces, trims, western trims, snap fasteners (pearl, others). Notions, interfacings.

The Button Shop
7023 Roosevelt Rd.
Berwyn, IL 60402
312-795-1234

Free catalog.

Sewing supplies: zippers (any length or standard) for jackets, jeans, trousers, neckline, and skirt types, long for coat linings, 2-way for jackets. Seam bindings, interfacings, elastics. Threads—mercerized, specialty, invisible, heavyduty, carpet, elastic, metallics; Swisse Brand poly, twist, all purpose. Extensive buttons—usuals, and military, blazer, alphabet, others. Braids, lace assortments.

Velcro, elastics, bias tapes, cable cord, rickrack, bra parts, pockets, shoulder pads. Ribbons, knit cuffs, waistbands. Beeswax. Gauges, rulers, fasteners, eyelets, buckles. Markers. Needles (all types), pins, bobbins, bulbs, foot shanks. Old treadle sewing machine shuttles and bobbins, new treadle belts; other hard to find parts. Quantity prices. (Sells wholesale to businesses.)

The Cutting Edge
P.O. Box 397
St. Peters, MO 63376
314-272-5392

Catalog $1.00 (refundable).

Serger supplies: Maxi-Lock polyester cone threads—34 colors. Candlelight metallic, woolly nylon—33 colors, J & P Coats metallics, Pearl Crown sulky rayons. Ribbon floss, synthetic ribbon. Serger thread potpourri packs. Cone stand, tree, threader, tweezers. Rubber and polyurethane elastics. Serger totes. Panasonic cord reel iron. Giraffe neck lamp. Coat-in-a-Day pattern. Serger books.

The Hands Work
P.O. Box 386
Pecos, NM 87552
505-757-6730

Catalog $2.00 (refundable).

Handcrafted buttons: porcelain, decorated; teddy bears, farm and wild animals, pets, fish, frogs, clown faces, fruits, cars, boats, geometrics, flowers, hearts; gloss, marbled, glazed colors. Free shipping on large orders.

The Perfect Notion
566 Hoyt St.
Darien, CT 06820

Catalog $1.00.

Hard-to-find sewing notions: sergers and accessories, electric and manual rotary cutters, irons and pressing aids, scissors, rulers, gauges, curves, skirt markers, bow-tie hardware, how-to books, others. MasterCard, Visa.

The Porcupine Pincushion
P.O. Box 1083
McMurray, PA 15317
412-941-4295

Catalog $1.00.

Sewing accessories, supplies, and aids: scissors (Gingher, others), ripper/threader sets, needle cases, Salem cutting mats and rotary cutters. Needles (Schmetz, denim, leather, serger, stretch types). Velcro, beeswax/holder, elastics, Wool Tone, Easy Wash, Stitch Clean, cutting and pressing grid canvas cloth. Ban-Rol wasteband interfacing; sew interfacings. Great Grid transparent tracing paper. My Double dress forms (small, medium). Ruler, French curve. 3 Rowenta irons. Thinsulate™ for outerwear. Others. Visa, MasterCard.

The Sewing Den Inc.
128 Charing Cross St.
Brantford, Ontario, Canada N3R 2J1
519-753-2718

Notions catalog $1.00. Fabric catalog $3.00.

Stretch and Sew patterns, basic sewing supplies and notions (pins, needles, snaps and other closures, zippers, others), Riccar sewing machines and sergers. Lingerie laces and elastics. Fabrics: coordinated knits—interlock, fleecerib; corduroy, challis, others; lingerie fabrics..

The Sewing Machine Man
29 Valley Rd.
Shrewsbury, PA 17361

Book: *Repair Your Own Sewing Machine*—precise, easy-to-understand, with illustrations, 34 pages; $4.50.

The Smocking Bonnet
P.O. Box 555
Cooksville, MD 21723

Catalog $3.00.

English smocking patterns, design plates, smock gathering machine, thread racks; fabrics (batiste, broadcloth, others). Threads. French handsewing items. Laces.

The Wonderful World of Hats
897 Wade Rd.
Siletz, OR 97380
503-444-2203

Catalog $6.00.

Millinery supplies: designer hat making kits: leaf/flower pillbox, leaf helmet, top and sailor hats, gaucho, Gainsborough, square brim, pillbox crowned picture. Taffeta, satin and organza flowers, velvet petals—roses, orchids, poppies; flower sprays, wreaths, clusters, dangles. Feather boas, trims, pads. Buckram frames. Brim frames Frames, ready-to-cover. Horsehair hats (untrimmed).

Fabrics: buckram, crinoline, rice net, poly netting, cotton sheet, wadding, hat linings, veiling, bridal illusion. Straw and horsehair braids and tubing. Ribbon—grosgrain, single-faced satin, velvet, picot edged taffeta. Hat bands—pleated satin, crepe; leaves, leather (men's).

Notions: pins, needles, push pins, 3" to 7¼" hat pins. Hat elastic, elastic loop. Rayon covered wire. Ribbon wires, hoop wire, boning, corset stays, pugary hooks. Glues. Hat blocks—brims, crowns, spinner. hat boxes.

Secrets Of Hat Making: Home Study Course—design, state of the art, vintage reproductions, costume, doll to adult sizes—in 3 parts, 5 information units each; covers refurbishing hats, evening/bridal, pattern making, construction, felt and straw types, classic styles, fur, leather, feather hats, more. Books: *Custom Shoe Covering*; *Altering Hat Frame Sizes*.

Things Japanese
9805 N.E. 116th St., Suite 7160
Kirkland, WA 98034

Send $3.60 for information and one spool of thread (give color).

Tire silk sewing machine threads, full color line, choice of weights, "machine twist" 50 denier filament thread.

Thread Discount Sales
5960 E. Florence
Bell Gardens, CA 90201
213-562-3438

Send large SASE for catalog.

Serger sewing machines: White Superlock 534 (2 needle, 3-4 thread convertible). Singer heavy duty Ultralock (sews 3-4 threads, open arm). Sewing Machines: Singer 500 (zig-zag, overlock, snap-on feet, twin needle, open arm). Singer Magic Press™ ironing press. Threads: rayon, machine, sergers, embroidery; overlock cone threads—over 80 colors. J&P Coats overlock threads. Woolly nylon in 78 colors, 5 variegated. Candlelight metallic yarn (washable) in 17 colors. Fine metallic threads (18 colors). May have sale prices. Free shipping on some items.

Timberline Sewing Kits
Clark St., Box 126
Pittsfield, NH 03263

Catalog $1.00.

Sewing kits: tote, garment, and cargo bags; packs, bike bag, and drawstring sacks, billfold, wallet, accessory pouch, belts. Comforter kits (4 bed sizes). Outerwear clothing kits—jackets, vests, others. May run sales. Allows discount to teachers and institutions. Manufacturer.

Trims
91 South Main St.
Wilkes-Barre, PA 18703

Send $1.00 and SASE for brochure.

Swarovski rhinestones "wholesale," and line of trims.

Treadleart
25834 Narbonne Ave.
Lomita, CA 90717

Catalog $3.00.

Sewing threads: Sulky™ rayon (35 variegated colors), DMC machine embroidery threads. Sewing machine accessories: walking foot (quilting). Fusible interfacings, stabilizers. Patterns. Handbag hardware, notions. Books. (See PUBLICATIONS.)

Viking Sewing Machine Co.
22760 Berea Rd.
Cleveland, OH 44111

Send SASE for information & nearest dealer.

Viking Husqvarna sewing machines including the 990S model electronic (computerized) model — sews Pictograms™, has built in Advisor™ that sets the machine for a variety of design applications. Other Viking models. Also in Canada: Husqvarna Sewing Machine Co., Scarborough, Ontario.

Vt. Rugs
P.O. Box 485
Johnson, VT 05656
802-635-2434

SASE and $1.00 for sample.

Denim strips—continuous with chenille edge (for totes, jackets, upholstery, rugs, etc.). 25 pound minimum.

Washington Millinery Supplies
18810 Woodfield Rd.
Gaithersburg, MD 20882
301-963-4444

Send SASE for information. Catalog available to open accounts.

Full line of millinery supplies: variety of hat materials including crinoline, heavy faille, ribbon wire, wire frames, others. Horsehair hat forms, other styles. Laces including Chantilly, Venice, Schiffli, Cluny, nylon stretch types, novelties, satins, others. Veiling—organzas, nylon sheers. Boutique trims—feathers, ribbons, pearls, beads, combs, buttons, flowers. Full line of rhinestone trims. Tiaras, headpieces. Adhesives. Steamer units. Custom dyeing service. (Also sells wholesale to businesses.)

White Sewing Machine Co.
11750 Berea Rd.
Cleveland, OH 44111

See your dealer or write for information.

White sewing machines/sergers—variety of models.

Wolf Form Company, Inc.
39 W. 19th St.
New York, NY 10011
212-255-4508

Send SASE with inquiry.

Garment model forms — all sizes in men's, women's, children's, newborn to size 52 and up. Miniature forms, leg forms, others. Custom-made forms. Manufacturer.

YLI Corporation
P.O. Box 109
Provo, UT 84603

Catalog and candlelight color chart $2.50.

Threads: woolly nylon serging threads in 78 solids and 5 variegated combinations. Candlelight metallic yarns (for serger, sewing machine, hand/machine knitting, needlepoint, weaving, others; 18 colors, 75 to 5000 yard cones.

Spinning & Weaving

❧❧❧❧❧❧❧❧❧❧❧❧❧❧❧

See also NEEDLECRAFT SUPPLIES, KNITTING & CROCHET, LACE MAKING, RUG MAKING, YARNS, and other related categories; BOOKS & BOOKSELLERS, PUBLICATIONS, and ASSOCIATIONS.

❧❧❧❧❧❧❧❧❧❧❧❧❧❧❧

Andy McMurry
Box 88
Franklin, MO 65250
816-848-3101

Send SASE for information.

Producer of Romney and Merino fleeces.

AVL Looms
601 Orange St.
Chico, CA 95928
916-893-4915

Catalog $2.00.

Weaving looms including "Baby Wolf" portable model, and "Baby Dobby" that turns the loom into a dobby loom, each of a series of wooden bars corresponds to the 8 harnesses of "Baby Wolf" (each bar equals a pick, and when a peg is placed in a hole, the harness rises.); allows weaving of complex patterns, and 2 treadles means no tieups, rids treadling errors.

Software for IBM, Macintosh, and Apple II: IBM "Generation II" weaving program to 24 harnesses. "Weave Planner" easy-to-use program, in EGA version of over 100 colors. Mac: "Design and Weave" with manual. Apple II: "Generation II"—weaves to 16 harnesses.

Ayottes' Designery
Center Sandwich, NH 03227

Send large (4 1/8" X 9½") SASE for details.

Home study course in handweaving: series of lessons, with yarn samples, weaving project needs, and cost for step-by-step progress, and achieve any level of accomplishment desired. For beginners to professional levels.

Beck's Warp 'N Weave
2815 34th
Lubbock, TX 79410
806-799-0151

Catalog and yarn samples $1.00.

Supplies/equipment/tools for spinning (including Ashford wheels), weaving (including looms), dyeing, tatting, knitting, crochet, lace making, basketry, silk and metallic embroidery, cross-stitch; yarns (cottons, wools, mill ends, others). Has quantity prices, large order (bulk) discounts on yarns.

Carol Strickler
1690 Wilson Ct.
Boulder, CO 80304

Send large SASE for details.

Software for Apple computers: "Weft-Writer" user-friendly drawdown program—disk and manual.

Castlegate Farm
555 Kingwood-Locktown Rd.
Flemington, NJ 08822
201-996-6152

Brochure and spinning sample, $2.50.

Romney fleece (spinner skirted) — by full fleece or pound, in grease or handwashed.

Cobun Creek Farm
Rt. 10, Box 15
Morgantown, WV 26505

Send SASE and $.25 for list.

Angora — carded and plucked: Coopworth and cross-bred fleece, colored and white. "Quantity discounts."

Compucrafts
P.O. Box 326
Lincoln Ctr., MA 01773
508-263-8007

Send SASE for information.

Software for Apple II computer: "The Weaver" multiharness weaving drawdown program — with color, magnification, rising and sinking sheds, interactive/automatic treading, databasing of designs, printouts. Stitch Grapher Needlecraft charting software for Apple II and IBM-PC. Quantity prices. (Sells wholesale to businesses.)

Cotton Clouds
Rt. 2
Safford, AZ 85546
602-428-7000

Catalog and over 500 samples $12.00 (includes newsletters, "notices of exclusive sales").

Cotton yarns: mercerized perles, boucles, flakes, thick-thins, others including specials, novelties. Looms, kits, tools, videos, and books. MasterCard, Visa.

Creative Designs
4370 Tuolumne Pl.
Carlsbad, CA 92008

Send large SASE for brochure. Samples, patterns $2.75.

Frame weaving looms (22" X 32") with molded teeth, accessories, instructions—simpler warping. "Quantity discounts." Designer ribbons: 63 colors. Yarns.

Creek Water Wool Works

P.O. Box 716
Salem, OR 97308
503-585-3302

48 page catalog $3.00.

Weaving looms—Ashford, Cascade, Glimakra, Louet, Schacht. Spinning wheels—Ashford, Cascade, Clemes & Clemes, Country, Craftsman, Haldane, Lendrum, Louet, Redgates, Restoration Arts, Reeves, Peacock, Schacht. Custom handcrafted spinning wheels to order (by Cascade, Fox, Joslin, and Van Eaton). Exotic fibers —full line from alpaca to quiviut.

Tools/aids: WooLee winder level, wind flyer, bobbin, others. Accessories: Fricke motorized bench carder (7" X 15"), Obadiah Tharp carding and spinning oil. Hand carders, swifts, dyes, extracts, mordants, cochineal. Books. MasterCard, Visa.

Curtis Fibers

Rt. 1, Box 15
Ritzville, WA 99169

Catalog $1.00. Fiber samples $3.00. Mill end samples $1.00.

Fibers for spinning, including hard-to-find types. Popular domestic and imported yarns. Mill end cottons.

Custom Handweaving

Box 477
Redondo Beach, CA 90277

Yarn samples $1.00 plus #10 large SASE.

Exotic yarns and spinning fibers: cashmere, camel, mohair, alpaca.

Cyrefco

P.O. Box 2559
Menlo Park, CA 94026

Catalog $3.00.

Cyrefco weaving looms — counter balance, counter march looms. "Pegasus" dobby system with complete shed change on each treadling, balanced shed—counter march action (for Cyrefco, Glimakra, and other looms).

Dorset Looms

P.O. Box 520
Stillwater, NY 12170
518-664-3668

Write or call for brochure.

Dorset Looms—crossbuck design, folding floor models. (Also sells wholesale.)

Earth Guild

33 Haywood St.
Asheville, NC 28801

Send for catalog.

Spinning and weaving: spinning wheels (Louet, Country Craftsman, Schacht), drum carder, shuttles, pickup sticks, tapestry combs, heddles, tools, templates, reeds, raddles, winders, warping boards/mills, inkle loom, card-weaving cards. Looms—Schacht (tapestry, table, floor) 4 or 8 harness, Beka rigid heddle and tapestry, Glimakra, Norwood and Cranbrook looms. Dyeing—natural dyestuffs; and Deka, Lanaset, Procion reactive, others. Full line of yarns: warp cottons, knit twist and textured weft, wools (Christopher, Harrisville, Wilde & Wooley); rug types. Spinning fibers and tools. Basketry supplies, knitting machines, netting cords/shuttles. Others. Has quantity prices; allows discount to teachers, institutions, and professionals. MasterCard, Visa. (See NEEDLECRAFT SUPPLIES and RUG MAKING.)

Eaton Yarns

P.O. Box 665
Tarrytown, NY 10591
914-631-1550

Color cards $1.50 each.

Weaving yarns from Finland — wools (Takana 7/2, Lenkki mohair, Ryijylanka 7/3, Untuvaninen 5/2, Kampavilla 32/2, Perinnelanka 12/1, Ensio 3-ply rug yarn), cotton (chenille, Nypplanka textured, Froteelanka textured), cottons in 8/3, 12/2, 20/2. Seine twines. Bias cotton strips. Linen—tow (4), line (4), and 8/3 linen warp. (Also sells wholesale.)

ECOR Company

P.O. Box 6665
Rochester, MN 55903

Send SASE for more information.

Software for IBM PC: "Pattern Analysis" program, with easy menu entry of any pattern draft. Gives minimum number (and optimum number) of harnesses and treadles required, tie-up matrix, printed output, and storage of pattern data.

Edgemont Yarn Service Inc.

P.O. Box 205
Washington, KY 41096

Samples $3.00. Free price list.

For weaving: Maysville carpet warp, fillers, yarns including mercerized pearl cotton. Rags. "Special close outs." (Also sells wholesale.) Looms.

Eileen Van Sickle

12918 Wolf Rd.
Grass Valley, CA 95949

Send $5.00 and SASE for samples.

Wool mill ends yarns, 2 and 3 ply, variety of textures and colors. Louet equipment.

Fiber Loft

Rt. 111, P.O. Box 327
Harvard, MA 01451

Catalog of samples $3.50 (with list).

Weaving/spinning equipment of: Leclerc, Schacht, Harrisville, Ashford, Louet. Natural fibers/blends (over 500 colors and textures) — alpaca wools, cottons, mohairs, rayons, of: Harrisville, Elite, Tahki, Plymouth, Crystal Palace, others. Exotic fibers (150) including silks, angora,

ribbon, cashmere, others. "Quantity discounts." (Wholesale to businesses, write to Bare Hill Studios, above.)

Fireside Fiberarts
Box 1195
Port Townsend, WA 98368
503-385-7505

Catalog $2.00.

Weaving looms: floor, tapestry, and other types; weaving accessories, yarns; spinning supplies and equipment. Basketry items. Books.

Flume Farm
18101 N. U.S. Hwy 666
Cortez, CO 81321

Send $2.00 for samples and prices.

Hand-picked Karakul and Mohair fleeces (white and colors).

Fort Crailo Yarns Co.
P.O. Box G
Newburgh, NY 12550
914-562-2698

Full sample wools $2.00; cottons $.80.

Crailo Handweaving yarns (virgin wool, fast dyes, mothproofed—28 dyed and natural colors, 4 weights for warp and weft, by half-pound cones) including Rya, Spun, Litespun, Zepher Worsted. Cotton (17 colors, 5 plys). "Direct from mill."

Fricke Enterprises
8702 State Rd. 92
Granite Falls, WA 98252
206-691-5779

Send $.52 SASE for catalog.

Wool carders — chain drive drum carders, metal and wood frames, motorized and manual model. Hand carders—curved or flat, flickers, blending boards.

Gaywool Dyes
26434 189th Ave. SE
Kent, WA 98042
206-631-7364

Send SASE for information. Dye card $1.50.

Australian spinning/weaving: dyes — for wool, mohair, silk, fur, nylon, and cashmere (chemically complete, colorfast) in 18 mixable colors; can be used for oven, microwave and cold water dyeing. Gaywool sliver—silklike wool; through 5 carding processes; wide range of colors. Covered Corriedale wool fiber. Nooramunga spinning wool (Merino B/L cross), select with chunky, long staples; in 2.5 wool bales, or bagged.

Georgia Wolterbeek
Fairmount Farm
Rindge, NH 03461

Send SASE for samples and information.

Fleece for spinning and weaving: black, brown, grays, whites; by the fleece.

Gil A & E
P.O. Box 58
Tesuque, NM 87574
505-983-8058

Catalog $1.00; SASE for price list.

Harrisville handweaving looms and accessories. "Freight free (USA except AK & HI), school discounts."

Gilmore Looms
1032 N. Broadway
Stockton, CA 95205

Free brochure.

Weaving looms—in 26", 32", 40", 46", 54" sizes, 4 and 8 harnesses: with steel rods, large eye flat steel heddles. Not sold through dealers. U.S. orders only.

Glimakra Looms 'n Yarns, Inc.
1338 Ross St.
Petaluma, CA 94954
707-762-3362

Catalog $2.50. Yarn sample, book, and 1,000 samples $15.00. (Canada: $20 U.S. funds.)

Weaving looms (from Sweden) including Viking floor jack loom (in 36" and 48" widths, 4 harnesses, 6 treadles); Countermarch, with either 1 vertical or 2 horizontal jacks; Ideal Swift Little Loom (fits into 22 sq. ft.) in widths of 24" to 40", and up to 8 harnesses and 8 treadles.

Regina Tapestry loom (and 2-harness, upright) or simpler model for gobelin style weaving. AKTIV—collapsible, moveable floor loom, with 8 harnesses and 8 treadles. Victoria—(space saver) inside width 28", with optional floor conversion. Emma — therapeutic loom (exercises arm and wrist muscles) or can be adapted to other handicaps. Susanna — rigid heddle loom; inside width 31" (or use as tapestry loom).

Weaving frames: Sara—warp right on the frame; Tina—small frame with warp around, 19" weaving width; Eva—simple, weave surface 16"-24". Belt loom. Loom accessories, aids: vertical warping mill, table warping mill, 12+ shuttles, spool frame, warping frame, umbrella swift, bobbin and ball winders, others.

Yarns: full line of wool, cottons, linens, and 50/50 cottolins—variety of textures, plys, color shades. Irish linen rug warp in 5 sizes.

VAV Magasinet Scandinavian weaving magazine with English translation; issued quarterly, it offers textile arts and weaving features; profiles of artists and weaving studios (single copy, $7.00 U.S.; $8.00 Canada in U.S. funds; Subscription $24.00 U.S., $29.00 Canada in U.S. funds). MasterCard, Visa. (See LACE MAKING.)

Grandor Industries, Ltd.
716 E. Valley Parkway, Unit 48H
Escondido, CA 92025
619-743-2345

Write for nearest store for Grandor yarns.

Grandor yarns: wool Berbers, Berber rovings; textured cottons, linens and silks for clothing; warp yarns in linen, cotton, cotton-linen; luxury mohair, wools, and blends. McMorran yarn balance. (Sells wholesale.)

Great Northern Weaving

P.O. Box 361
Augusta, MI 49012

Catalog and samples $1.00.

Rug weaving supplies: cotton rags on coils, 8/4 cotton warp, rug filler, loopers, braiding equipment, others. They pay shipping.

Hand Spun Exotic Yarn

7795 117th St.
North Delta, B.C., Canada V4C 6A7

Samples $1.00.

Musk ox quiviut from the Artic—raw and picked (by 100 gram lots). Quiviut yarns. Custom spinning service (dog hair, sheep fleece, other fibers).

Handweavers Guild of America

120 Mountain Ave.
Bloomfield, CT 06002
203-242-3577

Send SASE for list.

Publications (for members and non-members) including: Spinning wheel plans (drawings, assembly for Tyrolese type), spindle plans, suppliers directory, education directory, back issues of *Shuttle, Spindle & Dyepot* magazine, others. Beginner weaving video and manual. MasterCard, Visa. (See ASSOCIATIONS.)

Handweaving by Lois Larson

25 Montcalm Ave.
Camrose, Alberta, Canada T4V 2K9
403-672-2551

Send SASE for full information.

Software for weavers, directory of over 100 software programs available, hot to shop for hardware and software; listing of programs written in BASIC, computer requirements and sources given, and sample printouts (including color). Appendices include listings of free and almost free programs; extensive bibliography. Valuable resource for selecting weaving software by Lois Larson.

In Sheep's Clothing

24 Audubon Ave.
Providence, RI 02908

Free catalog. Samples $2.00.

Home grown angora fiber and yarn—specify preference.

J-Made Looms

P.O. Box 452
Oregon City, OR 97045
503-631-3973

Catalog $2.00.

Weaving looms: floor or table models with 4, 8, 12, and 16 harnesses, worm gear brakes, treadle lock, second and third warp beams, fly shuttle, options. Rug package, treadles, warp/back beams, sectional warp beam kits; shuttles, raddles, warping frame, heddles, reeds, others.

Jagger Spun

Water Street
P.O. Box 188
Springvale, ME 04083
207-324-4455

Complete sample collection $6.00.

Coned yarns (over 140 colors, variety of textures, blends, and weights); including wool/silk in worsted, merino, ragg, and heather.

Joyce L. Peck

Box 1051
Qualicum Beach, B.C., Canada VOR 2TO
604-752-3364

Send for details. Demo disk (drawdowns) $10.

Software for Amiga 500, 1000, 2000: "Weave-It," "Weave-It Plus" programs compatible with graphics. Up to 12 harnesses—14 treadles; plus program can calculate and print, set, warp, and weft.

Kings Valley Animal Family

39968 Ward Rd.
Kings Valley, OR 97361
503-929-2100

Send SASE for list. Samples $2.00/dozen (refundable).

Fleece: Romney, all natural colors and white.

Knots & Treadles

101 E. Pittsburgh St.
Delmont, PA 15626
412-468-4265

Send three stamps for catalog.

Video rental library—via UPS. Weaving/spinning supplies and equipment. Dyes. Sheep motifs on fabrics, ribbons, stickers, others. Books.

La Lana Wools

136 Paseo Norte
Taos, NM 87571
505-758-9631

Sample card set $15.00.

Handspun yarns (plant dyed and textured); carded blends, fleeces. Schacht equipment.

Leona Scherer

5114½ Brighton Ave.
San Diego, CA 92107

Send SASE for samples.

Handspun woolen yarns: soft, in variety of sheep-shades, by pound.

WHEEL IN TRANSIT: *When traveling with your spinning wheel, tape a spare drive cord underneath in case yours breaks. Courtesy of Susan Druding of Straw Into Gold.*

Longhorn Weavers
1203 W. 11th
Coffeyville, KS 67331
316-251-8775

Samples $2.00.

Weaving looms, spinning wheels, carders, accessories. "Discount" yarns (weaving, crochet, and knitting types), spinning fibers—variety of types.

Louet Sales
RR 4
Prescott, Ontario, Canada K7C 3P3
613-925-4502

Catalog and list of dealers $1.00.

Handweaving looms including a four harness sinking shed floor model, expandable to 8 harnesses with 10 treadles; ready to assemble. Optional 4 harness/4 treadle extension set, bench, sectional warp beams. Spinning wheels. Fibers, yarns, dyes.

Louise Heite, Importer
P.O. Box 53
Camden Wyoming, DE 19934

Spinnable sample & information packet $5.00.

Weaving kits (with finishing instructions, materials): lap robe beginner's kit—5 colors; scarf (Icelandic wool lace — 2 color combos). Icelandic yarns, pencil rovings. "Quantity discounts." MasterCard, Visa.

Macomber Looms
P.O. Box 186, Beech Ridge Rd.
York, ME 03909
207-363-2808

Write or call for catalog.

Macomber handweaving looms: Ad-A-Harness Looms™ traditional, and Ad-A-Cad/Cam Systems™; in floor models; accessories.

Marjorie K. Evans
8233 Nada Street
Downey, CA 90242
213-861-2608

Standard loom. © *Glimakra Looms 'n Yarns, Inc.*

Send SASE for further details.

Silkworm eggs—white and yellow types, by 100 lots.

Maurice Brassard et Fils Inc.
1972 Simoneau, C.P. 4
Plessisville, Quebec, Canada G6L 2Y6

Free price list; or with samples $7.95.

Weaving yarns: cottons, polyester, Orlon, linen, boucle, silk—all in several colors. Lamieux yarn (wool). Nilus Leclerc looms.

Meck's
P.O. Box 756
Cornelius, OR 97113
503-628-2696

Send SASE for details.

Wool Pickers, Wool Combs, Blockers, Skein Winders brands tools, flax processing equipment, and accessories for handspinners.

Mindsun
RD 2, Box 710
Andover, NJ 07821
201-398-9557

Free information.

Software for IBM EGA/VAG compatibles: "Mind-weave," with 136 colors, 99 thread widths, spacings and continuously variable magnification to create simple to complex fabric designs; to 32 harnesses, 64 treadles, dobby, 2000 ens, 2000 picks.

Norsk Fjord Fiber
P.O. Box 271
Lexington, GA 30648
404-743-5120

Catalog $2.00. Sample cards: Tapestry, Knitting—$3.00 each.

Fiber imports: Norwegian Spelsau and Swedish Gotland supplies for spinning, felting, knitting. Spelsau yarns. Fleece and rovings, variety of animal shades.

Northwest Looms
P.O. Box 78583
Seattle, WA 98178

Write for information.

Handweaving looms—table models including open reed and open-top heddles, jack-type table looms, up to 16 harnesses.

Norwood Looms
P.O. Box 167
Freemont, MI 49412
616-924-3901

Catalog $1.00.

Looms: Norwood and Cranbrook models. Accessories.

Oregon Romney Wools
1344 Marilyn St. SE
Salem, OR 97302
503-585-8615

Send SASE for details.

Gaywool wools, other wools, luxury fibers, angora/silk/mohair and lambswool blends. Spinning equipment and accessories. Knitting equipment.

Oriental Rug Co.
214 S. Central Ave.
Lima, OH 45802
419-225-6731

Free brochure and price list.

Rug weaving loom — floor model, weaves 36" wide, prethreaded. Accessories: beam counter, loom parts, rag cutter. Carpet warps, rug fillers, rags, looper clips, prints.

Paul Sorrick
11913 Vistawood
Spokane, WA 99218

Send SASE for details.

Software for Macintosh: "Macshuttle," creates drawdowns using a mouse. Up to 8 harnesses and treadles, 3 levels of magnification.

Pine Crest Angora Ranch
P.O. Box 3867
Prescott, AZ 86302
602-776-0505

Send SASE for prices.

Mohair (long staple, no second cuts): raw and hand scoured and carded, by pound.

Aktiv loom. © Glimarkra Looms 'n Yarns, Inc.

Polar Seas Yarn
8037 9th N.W.
Seattle, WA 98117

Complete sample set $10.00.

Textile yarns: blend of rare musk ox down and lambswool by one ounce skein, in 19 colors and natural.

R.H. Lindsay Company
16 Mather St.
P.O. Box 218
Boston, MA 02124
617-288-1155

Sample cards $3.00.

Wool: Romney/Perendale slivers in 10 natural color combinations and 21 dyed shades; 5 natural shades greasy carded. Raw fleece from Romney, Perendale, Border Leicester, Lincoln, Coopworth. Colored New Zealand fleeces; others—Australian merino, British Jacob, domestic top, White Mountain Welsh top, Australian Merino top. White and dyed clean Texas mohair. Falkland/Malvinas 56s top. Also by Tam O'Shanter Mohair and Woolen Mill. Rug and apparel wools.

Rio Grande Weaver's Supply
216 North Pueblo Rd.
Taos, NM 87571
505-758-0433

Catalog $1.00.

Rio Grande weaving loom and spinning wheel. Rio Grande yarns: hand-dyed rug, tapestry, and apparel type. Glimakra and Schacht equipment. Wool warp yarns. Natural and synthetic dyes. Fleeces (scoured, dyed, carded). Videos, books.

Robert W.H. Sinkler
Box 67
Crystal Bay, MN 55323

Send SASE for details.

Software for Macintosh Plus/SE computers: "Swift-Weave 2.01" with fabric design, analysis, 785 warp/weft ends, 32 treadles/harnesses, 3 shades (white, grey, black). Software for Macintosh II computer: "Color Swift Weave"—1000 warp/weft ends, 64 treadles/harnesses req. 2 meg RAM, choose 256 colors; with 8 viewing scales; print to ImageWriter I, II, LQ, and LaserWriters.

Robin Magaddino
2100 Swan Hwy.
Bigfork, MT 59911
406-837-4294

Samples $2.00/dozen.

Montana wool—black, white, gray fleeces with shades, textures. Medium fibers from Corriedale to soft Lincoln crosses; by pound. Assorted llama wool colors.

Scandinavian Designs
607 E. Cooper St.
Aspen, CO 81611

Dye color cards $5.00.

Prism mohair yarn dyed in five values; mohair cones (15 colors).

Scarbrough
125 Moraine
P.O. Box 1727
Estes Park, CO 80517
303-586-9332

Fiber samples $3.50. Catalog $2.50.

Equipment: Schacht, Ashford, Louet, Lendrum, Jensen, Norwood, Cranbrook, Harrisville, AVL, LeClerc, Clemes. Natural dyestuffs, Meck wool combs, accessories. Spinners sample pack. Instructional videos, books. Has major credit cards.

SPIN A NOVELTY: *Novelty yarns can be spun with roving made from fiber and colorblends. Courtesy of Anne Cary Dannenberg of Emily's Woods.*

Schacht Spindle Co., Inc.
6101 Ben Place
Boulder, CO 80301

Contact dealer; or catalog $2.00.

Spinning wheels: with two flyer whorls (for fine and medium weight yarns, with 19½" drive wheel and flyer shaft supported for precise action); with kate and bobbins. Weaving looms including floor models, table, tapestry, and table rigid heddle types. Inkle loom. Tools and accessories: winders, shuttles, beaters, heddles, spindles, umbrella swift, others.

Schoolhouse Yarns
25495 S.E. Hoffmeister Rd.
Boring, OR 97009
503-658-3470

Toika catalog $2.00. Sample cards $1.50 each.

Textile/art weaving yarns from Finland: Helmi Vuorelma —wool blanket yarn, Takana finnweave 7/2 wool, Ryijy 7/3 wool, Kampalanka 32/2 worsted, Perinnelanka 12/1 wool, tow linens (3), line linens (4), sail linen warp, cotton chenille, seine twines (3), cotton 8/3 Pilvi. Pirkanmaaan Kotityo: Poppana cotton bias strips. Toika looms and equipment.

Secret Heart Fibers
7625 Terrace Dr.
Tacoma, WA 98406
206-564-2283

Write for information.

Aussie yarn products, fine spinning fibers. Koala spinning wheels.

Shannock Tapestry Looms
10402 N.W. 11th Ave.
Vancouver, WA 98685
206-573-7264

Write for information.

Shannock tapestry looms — high tension, professional type, with roller beams and weaving accessories.

Silk City Fibers
155 Oxford St.
Paterson, NJ 07522
201-942-1100

Seven color cards and information $10.00.

Cone yarns (color coordinated, over 1000 shades) including Contessa, Avanti, Majesty, Chenille, Katrinka, Slinky, Soie Rustique. Also cottons: stonewash, lace, perle, stripe, fancy, others. And Metallique, Prima Donna, English wool, Montego. Others.

Silver Cloud Farm
1690 Butler Creek Rd.
Ashland, OR 97520
503-482-5901

Send SASE for prices.

Romney sheep, Angora goat fleeces for handspinning.

Sinkut Fibre Co.
Box 1592
Vanderhoof, B.C., Canada V0J 3A0
604-567-9383
Yarn samples $3.00. Fiber samples $3.00.

Handspun, hand-dyed yarns, and fibers in over 40 colors including: wool roving, mohair, angora, silk bricks, alpaca top, camel down, others.

© *Victorian Video Productions*

Steel Heddle
P.O. Box 546
Greenville, GA 30222
404-672-4238

Send for order information/prices.

Reeds: Steel Heddle brand, in standard and pattern reeds; "made to your specifications." (Dealer inquiries invited.) MasterCard, Visa.

Straw Into Gold
3006 San Pablo
Berkeley, CA 94702
415-548-5241

Send large SASE for list.

Ashford spinning wheels, looms. Spinning fibers: metallic, silks, blended silks, wools, mohair. Yarns. Books. Has MasterCard, Visa. (See KNITTING & CROCHET.)

Superior Graphics Software
RD 2, Box 710
Andover, NJ 07821

Send SASE for details and specifications.

Software for IBM PC or compatibles with EGA or VGA, "Mindsun" cloth design and analysis program.

Suzanne Roddy—Handweaver
1519 Memorial Dr.
Conroe, TX 77304
409-756-1719

Sample catalog $15.00 (refundable). Price list $2.00.

Weaving and spinning equipment: looms — Glimakra, Harrisville, Kyra, Louet, Tools of the Trade. Spinning wheels — Ashford, Clemes & Clemes, Haldane, Lendrum, Louet, Peacock, Tenn. Great Wheel. Loom and wheel accessories. "Discount prices." Yarns, fibers, dyes.

Talisman Clay & Fibre
1370 7th Ave.
Prince George, B.C., Canada V2L 3P1

Catalog (mailed to U.S.) $1.00.

Yarns: mohair, fine wools, tweeds, cottons, fancies, linen 35/2 to 10/6.

Texas Fibers
919 Lake Dr.
Weatherford, TX 76089

Fiber samples $2.00.

Fibers: kid mohair, fine wools, silk, alpaca, camel down. Ashford spinning wheels.

The Batik and Weaving Supplier
393 Massachusetts Ave.
Arlington, MA 02174
617-646-4453

Supplies catalog $2.00.

Complete weaving and spinning supplies including looms, spinning wheels; spinning and weaving accessories, yarns (and for knitting), fibers, dyes, and books. Has quantity prices and large order discounts. Allows discount to teachers, institutions, and professionals.

The Fiber Shop
Rt. 2, Box 290
Farmland, IN 47340
317-468-6134

Free catalog.

Spinning/weaving equipment including Charkha wheels. Gaywood dyes, knitting and crochet accessories. Fibers: wools, blends. Cottons, exotics, flax, others. Has MasterCard, Visa.

The Fold
Box 160
Chaska, MN 55318

Catalog $1.00 (credited to first order).

Spinning wheels and weaving looms: Ashford, Louet, Pipy, Schacht, Harrisville, Glimakra. Patrick Green carders. Fleece, natural fibers, and accessories. Books.

The Gleaners Yarn Barn
P.O. Box 1191
Canton, GA 30114

Sample catalog and mailing list (1 yr.) $3.00.

Mill end yarns and threads: natural, synthetic, and blends. Booklet: Mill EndLess Possibilities (guide to using mill ends), $3.00. "Low mill end prices."

The Golden Heddle
P.O. Box 761
Royal Oak, MI 48068
313-543-2294

Send SASE for current listings, details. Include a note as to your needs.

Previously-owned Loom Program: aids weavers in finding looms to meet needs, and sell looms of weavers whose needs have changed. Also has new looms.

The Mannings
1132 Green Ridge Rd.
P.O. Box 687
East Berlin, PA 17316
717-624-2223

Catalog and yarn style card $2.50.

Weaving looms by Dorset, Leclerc, Galliger. Spinning wheels. Rug yarns in variety of plys; skeined wool for dyeing; fancy yarns by Fawcett, CUM, Maypole, Lily, others. Dyes. Books. Others.

The Musk Ox Company
633 Fish Hatchery Rd.
Hamilton, MT 59840

Samples $3.00 and large SASE.

Musk ox qiviut—golden fleece of the Arctic; raw clean fiber (minimal guardhair) in 4 oz. and up lots.

The Real Ewe
5627 Richmond
Dallas, TX 75206
214-826-2316

Send SASE for prices.

Weaving looms and spinning wheels: Continental USA Schacht, Louet, Ashford; Baby Dobby by AVL. Used wheel and loom swap. Discover, MasterCard, Visa.

The River Farm
Rt. 1, Box 401
Timberville, VA 22853
703-896-9931

Catalog $1.00.

Fleece—black, brown, gray, white Corriedale (skirted, sorted). Weaving looms and spinning wheels: Schacht, Ashford, Country Craftsman, Louet. Fibers, yarns. MasterCard, Visa.

The Village Weaver
5609 Chaucer
Houston, TX 77005
713-521-0577

Catalog $2.00 (with classes information).

Full line of weaving and spinning equipment: Norwood, Schacht, Leclerc, Cranbrook, Glimakra, Harrisville, Ashford, Country Craftsman, Louet. Fibers, yarns. MasterCard, Visa.

The Weaver's Collection
1020 West Beach
Pass Christian, MS 39571

Send SASE for details.

Members receive one pound of weaving yarn a month from Yarn-of-the-Month Club.

The Weaver's Knot
121 Cleveland St.
Greenville, SC 29601
803-235-7747

Catalog $1.00.

Handweaving looms, spinning wheels; loom and wheel accessories. Dyes, books.

The Weaver's Shop & Yarn Co.
39 Courtland, Box 457
Rockford, MI 49341
616-866-9529

Catalog $3.00.

Weaving looms: Glimakra, Schacht, Leclerc, Norwood, Cranbrook, Harrisville. "Shipped free in the 48 states." Yarns, fibers. "Discounted prices."

The Weaving & Knitting Shop
1702 Walnut St.
Boulder, CO 80302

Write for loom catalog. Sample yarns $9.50.

Weaving looms: Schacht, Glimakra, Harrisville, Norwood, Cranbrook, Louet. "We will pay shipping costs (continental U.S. only)." Yarns: natural and dyed cottolin, wool/mohair, shetland, dyed carpet warp, mill ends. "Discounts up to 25% off." MasterCard, Visa.

The Weaving Studio
812 S. Summit
Iowa City, IA 52240
319-338-1789

Send SASE for ordering information.

Weaving looms, spinning supplies, yarns, fibers, books. Has token discount on large orders. Allows discount to teachers and institutions.

The Wool Room
Laurelton Rd.
Mt. Kisco, NY 10549
914-241-1910

Send $1.00 and SASE for catalog.

Weaving/spinning equipment: Schacht, Louet, Ashford ("free shipment"). Woolee Winders for Schacht, Ashford, Louet wheels. Bond knitting frames. Weaving/knitting yarns including Rowan, Crystal Palace, others; "discounted." Exotic fibers and fleece. Knitting machines and items. Basket materials. Has quantity prices. Allows discount to teachers and institutions.

The Woolery
RD #1
Genoa, NY 13071
315-497-1542

Fiberarts catalog $2.00.

Weaving looms: Glimakra, Harrisville, Leclerc, Schacht, Norwood, Cranbrook. Loom accessories. Weaving books. "Real savings." May have sales.

Treenway Crafts Ltd.
725 Caledonia Ave.
Victoria, B.C., Canada V8T 1E4
604-383-1661

Samples, price list $5.00.

Spinning wheels including Ashford. Weaving and spinning accessories. Yarns: wool, mohair, loop Merino.

Two Cotton Woods
810 Fenter, P.O. Box 686
Clint, TX 79836
915-851-1530

Sample card and price list $1.00.

Loopy mohair (from Texas), in 10 colors. Mohair fleece. (Also sells wholesale.)

Victorian Video Productions
P.O. Box 1540
Colfax, CA 95713
707-762-3362

Free catalog.

Instructional videos: (1) Introduction to Weaving, with Deborah Chandler—tools, yarns, vocabulary, projects and equipment, calculate/measure yarns; (2) Tapestry Weaving with Nancy Harvey—weaving shapes, tapestry techniques, complete 3 sample projects, finish, mount.

And others, on Beginner Four Harness, Dressing the Loom (Constance La Lena), Cut Pile Rug weaving (Orlo Duker), Card Weaving (Candice Crockett), Weave Drafting (La Lena), Rigid Heddle Weaving (Betty Davenport), Fundamentals of Hand Spinning (Rachel Brown); and advanced videos. Also has videos on lace making, basketry, needlepoint, applique, dyeing, others. Allows discount to schools, libraries.

Vreseis Limited
P.O. Box 791
Wasco, CA 93280

Contact dealer or send SASE and $3.00 for samples.

Fibers: variety of natural colored cottons (fiber lengths ranging from long to short); Pima, Acla, Sea Island hybrids. Organically grown fibers, hand picked and ginned. Mixed color and fiber sliver. "Dealer inquries welcome."

Weaver's Shed
1616 Mabry St.
Tallahassee, FL 32310

Price list and samples $1.00.

Bulky handspun (for weaving, basketry) in mostly solids. Variegated Norwegian Spelsau yarn (to 6 colors per skein); others.

Weaving Works
4717 Brooklyn Ave. N.E.
Seattle, WA 98105
206-524-1221

Catalog $1.00 (refundable).

Line of weaving looms and spinning wheels and accessories. Traditional and fashion yarns. Variety of fiber types. Dyes. Books. Also has basketry supplies, hand and machine knitting supplies.

Webs
Service Center Rd.
Northampton, MA 01060
413-584- 2225

Samples $2.00.

Yarns: mill ends—cottons, mohair, wools, chenille, silk, rug wools, alpaca, others. "Discounts." Looms, spinning wheels, carders.

Woolstons' Wool Shed
651 Main St.
Bolton, MA 01740
508-779-5081

Catalog $3.00 (cash).

Spinning and felting fibers—over 200 choices, including exotic wool blends, over 30 colors, heathers/earth tones in wool, blends, mohair blends. Over 12 textured and novelty fibers. Other exotic blends. Metallics, synthetics. Angora in rare colors, blends, and extra-long. Fine fibers (25 microns or less). "Dealer inquiries invited."

Yolo Wool Products
Rt. 3, Box 171
Woodland, CA 95695

Samples $2.00.

Spinning sliver, natural colored yarns (local and Australian). Wool batts.

Yarns—Multipurpose

❧❧❧❧❧❧❧❧❧❧❧❧❧❧❧❧❧

See also NEEDLECRAFT SUPPLIES, KNITTING & CROCHET, SPINNING & WEAVING, and other related categories; BOOKS & BOOKSELLERS, PUBLICATIONS, and ASSOCIATIONS.

❧❧❧❧❧❧❧❧❧❧❧❧❧❧❧❧❧

Broadway Yarn Co.
P.O. Box 1467
Sanford, NC 27331

Swatch cards $3.00 (refundable).

Yarns for weaving, crochet, knitting, macrame: poly/cottons, nylon, wools and blends, poly "Earthspun." Loom selvage. Others. "Wholesale prices."

Custom Knits & Mfg.
Rt. 1, Box 16
Lake Park, MN 56554
218-238-5882

Free catalog.

Nomis yarns: 3/15 and 2/15 on cones—full range of colors. Yarn trees. MasterCard, Visa.

Creative Yarns
9 Swan St.
Asheville, NC 28803
704-274-7769

Catalog $3.50.

Knitting yarns: Towan, Plymouth, Tahki, Brown Sheep, others. Handpainted needlepoint canvas, silks, Paternayan, metallics. Has MasterCard, Visa.

Davidson's Old Mill Yarns
P.O. Box 8
Eaton Rapids, MI 48827
505-388-5408

Send four SASE envelopes for samples, quarterly.

Mill end yarns: variety of types and colors.

Frederick J. Fawcett, Inc.
1338 Ross St.
Petaluma, CA 94952

Samples: linen/cotton identification $2.00. Linen embroidery fabrics $1.00. Flax fiber $1.00.

Yarns: Wools—Klippans weaving/knitting, worsted, rug yarns, dyeing wool, twist and fine yarns. Cottons—3/1 textured; 8/2, 16/2, 24/2, 30/2 warp/weft (natural, bleached, dyed). Frederick J. Fawcett cotton yarns 3/2, 5/2, 10/2 pearl (natural, bleached) 8/2, 8/4; 20/2, 30/2 mercerized. Rug lacing cord. Bockens rug warp, Viking Warps long staple cotton (10 sizes), Viking Warps—wetspun linens, dry spun, flax tow yarns (many sizes).

Bockens linen and linen tow yarns. Cottolin (Bockens, Borgs) cotton/linen blend. Supplies/equipment for spinning, weaving, knitting. Quantity discount on very large orders. MasterCard, Visa. (See NEEDLECRAFT SUPPLIES and SPINNING & WEAVING.)

Jamie Harmon
RD 2, Box 150-170
Richmond, VT 05477

Samples and brochure $3.75.

Handspun and naturally dyed wool yarn; rainbow skeins of worsted weight, others. Rainbow Ridge children's sweater kit.

Jesse's Spring
Rt. 1, Box 145
Monroe, VA 24574

Over 200 samples $10.00.

Yarns: wools (Wilde, Manos, Harrisville), Le Gran mohairs, Newport cottons, Euroflax linens. Porcelain and pewter buttons.

John Perkins Industries, Inc.
P.O. Box 8372
Greenville, SC 29604
803-277-4240

Send SASE for list.

Hand and machine yarns—single, plied, novelty, fancy, natural, colors, bleached, variegated, on cones, cakes, dyetubes. Specialty yarns, ultra fancy, house specials assortments; by pound up lots at low cost; may have 25 pound or 50 pound assortments at reduced cost.

Marr Haven
772 39th St.
Allegan, MI 49010

Send large SASE for brochure and samples.

Soft American mule spun from wool Rambouillet sheep —by skeins or cones, natural shades.

Martha Hall
462 Main St.
Yarmouth, ME 04096
207-846-9746

Catalog $2.00. Yarn sample set (230) $12.00.

Hand-dyed yarns: silks, mohair, linens, cottons, cashmere, alpaca, wools. Ribbons, totes, baskets, books.

Ogier Trading Company
410 Nevada Ave., P.O. Box 686
Moss Beach, CA 94038
415-728-9216

Color card subscription $8.00 (refundable).

Line of imported fashion and novelty yarns—variety of

weights, colors, styles.

On the Inca Trail
P.O. Box 9406
Ft. Worth, TX 76147
817-233-6321

Send SASE for order information.

Bolivian alpaca yarns in fine, sport, worsted, and bulky (spun to specification) in 25 colors and naturals.

Te Awa Wools
P.O. Box 5236
Fullerton, CA 92635

Send SASE for brochure.

New Zealand wool yarns, soft, natural, and heather colors (for knitting, crochet, weaving).

The Fiber of Eden
Rover Rt. Box 83
West Plains, MO 65775

Catalog and samples $8.00.

Yarns: angora, camel down, kid mohair, silk, wool. Hand dyeing services.

The Yarn Basket
5114 Top Seed Ct.
Charlotte, NC 28266

Sample card and prices $5.00 (refundable).

Full line of types, color shades, and plys of natural yarns for weaving and knitting.

Wilde Yarns
P.O. Box 4662
Philadelphia, PA 19127

Sample cards $6.00.

Yarns: earthy natural wools (8 colors, 3 plys), white wool (various weights, piles), Berber wools (6 rustic colors, 2 plys), dyed Berber (6 tweed colors, 2 plys). 3 ply wool (16 subtle shades), 2 ply warp/weft wool (28 colors), bulky wool yarn (10 bold colors), wool clothing yarn (undyed naturals, 18 muted colors).

Novelty yarns—wool (12 colors, coordinates with clothing yarns). Carded wool—5 natural and 9 dyed colors. ("Dealer inquiries invited.")

Yarn Barn
918 Massachusetts
Lawrence, KS 66044
913-842-4333

Catalog $1.00. 6 mailings per year $4.00.

Yarn mill end and sample club: yarns include wools, cottons, acrylics, silks, linens; yarn accessories. (Also has basketry supplies.) Books (knitting, weaving, dyeing, lace making, basketry, others). Large order discounts.

Yarn Country
P.O. Box 6500
Concord, CA 94524

Catalog $3.00. 400 samples $8.00.

Yarns: Brunswick, Reynolds, Pingouin, DMC, Patons, others—wools, blends, cottons, rayon, acrylic. Accessories. Cross stitch/canvas items. Has MasterCard, Visa.

Seasons. © Vea Prints.

Section III

Resources

General Craft Business

See also SUPPORTIVE MATERIALS & AIDS. This category is meant for those who have moved from hobby status to professional, or have become suppliers, service providers, or otherwise in business; and those who would like to be.

Ad-Lib Publications
51 No. Fifth St.
Fairfield, IA 52556

Send SASE for further information.

Books and data bases: *Directory of Book, Catalog, and Magazine Printers*, by John Kramer (1000 printers of these & other bound publications), lists are specialty detailed to aid in choices; an important reference for publishing. Other book marketing titles including *Made Easier, Forms* for direct response, and *Opportunities, 1001 Ways to Market* (authors and publishers).

Data bases: PR Flash: The National Publicity Database—valuable public relations computer directory for book marketing (and other). Book Marketing Opportunities: A Database—a computer directory as above, with reviewers, columnists, TV and radio stations, bookstore chains, mail order, directories, booksellers, wholesalers, others. Has Demo Disk, and subscriber updates.

American Council for the Arts
1285 Avenue of the Americas, 3rd Fl.
New York, NY 10019

Send SASE for further information.

Book: *Money for Artists, A Guide to Grants and Awards for Individual Artists*, researched by the Center for Arts Information, edited by Laura R. Green. It lists some 10,000 awards, fellowships, residencies, and commissions offered by about 250 organizations; sections include Multidisciplinary Arts (including sources of awards for artists), Visual Arts, and Literary and Performing Arts. Listings include profiles of the awards offered, contact person, eligibility requirements, and deadlines. Includes indexes; in hardcover or paperback.

Barbara Brabec Productions
Box 2137
Naperville, IL 60567

Send for free home business success catalog.

Books by Barabara Brabec: *Homemade Money, The Definitive Guide to Success in a Homebased Business*, 4th edition; *Creative Cash (How to Sell Your Crafts. Needlework Designs & Know-How); Crafts Marketing Success Secrets*. Publishes *National Home Business Report*. See PUBLICATIONS.

Brick House Publishing Company
3 Main St.
P.O. Box 512
Andover, MA 01810
617-475-9568

Send SASE for further information.

Books: *The New Money Workbook for Women*, by Carole Phillips, *Personal Financial Planning (New Strategies for Success with the New Tax Law), The Entrepreneurial Mind*, by Jeffry A. Timmons, *Sky Hooks and Track Shoes (Climbing the Career Ladder)*, by May Gruber; others.

HomeWork
Box 394
Simsbury, CT 06070

Send SASE for details.

This is a newsletter for home-based businesses with "A Christian Perspective." Issues provide business advice and data, an overview of possible ventures, hints, computer and marketing information, and networking.

Lifestyle Crafts
2164 Riverside Dr.
Columbus, OH 43221
614-486-7119

Write or call for sample copy.

Buyers' Resource Directory with a buyers' service card referral program; for anyone who wholesales a product line; allows readers to contact any of 15,000 shop buyers.

Mark Publishing
15 Camp Evers Lane
Scotts Valley, CA 95066
408-438-7668

Contact dealer, or send SASE for information.

Book: *You Can Make Money From Your Arts and Crafts*, by Steven and Cindy Long. Covers some businesses, marketing methods, finding markets, craft shows and fairs (and how to enter them), wholesaling, sales reps, advertising, publicity, and more.

Midmarch Arts
Box 3304, Grand Central Station
New York, NY 10163

Send SASE for further information.

Book: *Whole Arts Directory*, by Cinthya Navaretta —arts resources (shown by state in U.S., Canada): organizations, cooperative galleries, museums, focus on women and minorities; visual arts, photography, performance art, films and videos, crafts, artists' colonies, retreats, and study centers; financial aid, legal issues, and insurance; information services; federal, state, private agencies.

Northwoods Trading Company
13451 Essex Court
Eden Prairie, MN 55347

Send SASE for further information.

Directory of Wholesale Reps for Craft Professionals—lists those interested in crafts with descriptions of each company, and tips and data on presenting crafts work, to aid in making the right connection.

Oliver Press
Box 75277
St. Paul, MN 55175
612-426-9681

Send SASE for catalog.

Business resource books for quilting/others, most by Jeannie M. Spears: (1) *Pricing Your Work* (fair price with profit, wholesale vs. retail, pricing formulas, more). (2) *Slides: Photographing Your Work*. (3) *Bookkeeping: A Practical System*. (4) *Shops: Start-Up Steps* (quilt shop setting up), by Joyce Sloan. (5) *Selling Your Work Through Galleries*, by Nancy Smeltzer. (6) *Copyrights, Patents, and Ethics for Quilters*. Also publishes *The Professional Quilter* and offers back issues with a wealth of business data. (Also sells wholesale to businesses.)

Para Publishing
Box 4232
Santa Barbara, CA 93103

Send SASE for information.

Books: *The Self Publishing Manual (How to Write, Print & Sell Your Own Book)*, a reference guide to writing, publishing, marketing, promoting, and distributing books; by Dan Poynter. Other Poynter books: *Book Marketing, Book Reviews, New Releases and Book Publicity, Direct Mail for Book Publishers*, and others.

RT Marketing Institute
P.O. Box 4564
No. Hollywood, CA 91607

Send SASE for further information.

Marketing video—How to Market Your Arts and Crafts (1 hour), by Howard L. Cossman: Sell original artwork and/or reproduction rights in exchange for fees and royalties, pre-selling from a single sample, and other steps in marketing original work.

Softart
278 Court St.
Portsmouth, NH 03801
603-430-WARE

Send SASE for further information.

Software for computer: Inventory Control, handles consignment, wholesale, sample galleries and your shop, traces taxable costs and commissions due. Prints packing lists and labels. Shows instant inventory at any gallery.

Sylvia's Studio
1090 Cambridge St.
Novato, CA 94947
415-883-9426

Send SASE for catalog.

Manuals for home study: Sylvia Landman's college classes and national workshops. Correspondence courses: Running a home-teaching studio, arts and crafts business, television consultations for arts and crafts in the marketplace. (Also knitting and crochet courses, books, tools.)

The Country Press
P.O. Box 5024
Durango, CO 81302

Send large SASE for brochure.

Creative Outlets directory booklet with detailed listings of shops, shows, catalogs which buy or consign handmade items, and publications that advertise crafts for resale; associations and information sources for artists and craftspeople; $5.00 ppd.

The Francisco Enterprise
572 143rd St.
Caledonia, MI 49326
616-877-4185

Send SASE for further information.

The Craftmarket Listing™: market of crafts to best prospects—over 2,000 active craft gallery, gift shop, and boutique buyers who appreciate direct mail marketing. Includes mailing labels, sourcebook, card decks, disks, tapes sequenced in alphabetical and/or zip code order.

The Front Room Publishers
P.O. Box 1541-CSS
Clifton, NJ 07015

Free Learning Extension Catalog.

Publications (titles for crafts marketing and aspects of home-based businesses; 5½" X 8½" softcover): (1) *Directory of Craft Shops*; (2) *Directory of Wholesale Reps for Artisans*; (3) *Pattern Designer Directory*; (4) *Catalogs, Brochures, Circulars . . . Create Your Own on a Budget*; (5) *How to Market Your Handcrafts to Shops/ Galleries*; and (6) *How to Purchase Supplies Wholesale*; (7) *Creative Crafters Directory*
Also carries other books on business, craft success series, crafts markets, starting/operating a business, others. (Publishes *Craft Marketing News*.)

Ventana Press
Box 2468
Chapel Hill, NC 27515

Send SASE for information.

Books: *Looking Good in Print (A Guide to Basic Design for Desktop Publishing)* by Roger C. Parker, covers ways to produce attractive, effective newsletters, advertisements, brochures, and correspondence; amply illustrated.

The Makeover Book: 101 Design Solutions for Desktop Publishing presents a collection of before and after graphic ideas for computer users. Covers examples of newsletters, charts, graphs, reports, and other business papers, with makeover explanations shown beside originals; over 200 illustrations.

Watson-Guptill Publications
1 Astor Plaza, 1515 Broadway
New York, NY 10036

Contact a book dealer, or send SASE for information.

Book: *Graphic Design for the Electronic Age*, by Jan V. White. This book covers design for non-designers (working with desktop publishing) and also for professionals using traditional typesetting equipment. White brings basics forward, to choice of typefaces, columns, headlines, and subheadings; how to handle pictures and captions; building a publication from cover to cover; a manual by a noted designer.

Supportive Materials & Aids

❦❦❦❦❦❦❦❦❦❦❦❦❦❦❦❦❦

See also GENERAL CRAFT BUSINESS RESOURCES and PUBLICATIONS.

❦❦❦❦❦❦❦❦❦❦❦❦❦❦❦❦❦

A.I.M. Fixtures
P.O. Box 708
Franklin, NC 28734
704-369-9803

Write for brochure.

Modular display systems for artists and craftsmen—aluminum components, variety of sizes.

Action Bag Company
501 N. Edgewood Ave.
Wood Dale, IL 60191
708-766-2881

Free catalog.

Bags: Ziploc and regular plastic bags, variety of sizes, including Floss-A-Way™. Cotton drawstring bags, retail shopping bags. Shipping supplies. Manufacturer. (Also sells wholesale to dealers.)

Alpha Impressions Inc.
4161 S. Main St.
Los Angeles, CA 90037
213-234-8221

Free brochure.

Labels—woven and printed care instructions and size tabs, in stock. Custom labels: woven and printed labels and hangtags (professionally finished) to specification.

Antique Dealers Supply
Box 717
Matawan, NJ 07747
908-591-2883

Free catalog.

Show/display items: Allstate showcases, Xenon showcase lights, folding tables, Fire retardant table covers, halogen lighting, moving supplies. Booth signs, bubble wrap boxes, security aids. KD Majestic canopies.

Badge-A-Minit
348 North 30th Rd., Box 800
LaSalle, IL 61301
815-224-2090

Free color catalog.

Badge-A-Minit Starter kit: you make, with original design fronts, others.

Bates Display & Packaging Co.
1700 W. Pico Blvd.
Los Angeles, CA 90015
213-739-8855

Send SASE for prices.

Glass-topped containers with Bates Foam gem pads (snap-lid boxes)—with 4mm wide pad; in variety of sizes for jewelry, stones, others. "Elite gem case" 24 square glass-topped snap lock gem containers with foam inserts. American Express, MasterCard, Visa.

California Dream
P.O. Box 12961
La Jolla, CA 92037
619-292-8800

Send SASE for information.

Fabric labels: size, care/content, or custom made.

Charm Woven Labels
Box 30027
Portland, OR 97230

Send SASE for list.

Personalized woven labels with stock phrases: From the needles of, Custom Made by, Original, Hand Made by, Hand knit by, Made especially for you, Fashioned by, or blank (you choose). Has quantity prices.

Color Q Inc.
2710 Dryden Rd.
Dayton, OH 45439
513-294-0406

Free artist success aid packet.

Custom services—full-color fine art reproductions, limited edition prints, posters, greeting cards, post cards, brochures, reference sheets; expanded line of papers.

Dana Labels, Inc.
7778 S.W. Nimbus Ave.
Beaverton, OR 97005
503-646-7933

Brochure $1.00.

Labels custom printed: garment labels, size tabs, tags, care and content labels. Paper shipping, embossing, and cosmetic labels, pressure sensitive and others.

Dover Publications, Inc.
31 East 2nd St.
Mineola, NY 11501

Free catalog.

A Clip Art Series of copyright-free design books—black on glossy white paper, to clip and use in graphic design (printed on one side 8½" X 11"): borders on layout grids; Christmas, holiday, seasons and special occasions

cuts, ready-made borders, borders (florals, Art Nouveau and Deco, thematic).

Old-fashioned romantic, eating and drinking, children, sports, silhouettes, Gibson Girl, and others. Contemporary: teddies, performing, wedding, men's and women's heads, children, patriotic, humorous and other sports, humorous office and others cuts, nautical, silhouettes, wining/dining, travel/tourist, school and education, baby care, transportation, houses/real estate, medical/ health, other motifs.

Alphabets, quick copy art. A wide range of copyright free design books—signs and symbols, silhouettes, florals, geometrics, optical illusions, Art Nouveau, Art Deco; borders, crests, frames, illustrations including old-fashioned people, animals, products, transportation, early advertising, ethnic designs, ornaments, and lattice work, trademarks, calligraphy, others. (Also art, craft, and needlecraft books; other non-craft books.)

Eden
94 466 Kauopua St.
Mililani Town, HI 96789

Send SASE for brochure and samples.

Wide variety of bags and shapes (to fill as sachets, potpourri, others), in calico and moire taffeta drawstring types, others. Cellophane bags and little paper "tote" bags (variety of sizes, in small quantities).

Elaine Martin Inc.
P.O. Box 261
Highwood, IL 60040
708-945-9445

Free detailed brochure.

Show/display equipment: snap joint canopies (3 standard colors; slant, flat, or peak roof models, folding tables, director chairs. MasterCard, Visa.

End of the Trail Collectiques
5937 N. Greeley
Portland, OR 97217
503-283-0419

Send SASE or call for prices.

Jewelry cases—plastic, flat style; others.

Flourish Co.
5763 Wheeler Rd.
Fayetteville, AR 72703
501-444-8400

Free brochure.

White tarps—standard and custom sizes, "lowest prices." Protector™ canopy, for show-display, in variety of sizes, styles. Flame resistant fabric.

GraphComm Services
P.O. Box 220
Freeland, WA 98249

Free catalog.

Custom labels and hangtags, tagging equipment, self-inking stamps, merchandising and advertising specialties. Typesetting service. "New customer discounts."

Hawaiian Sun, Inc.
Box 5447
Louisville, KY 40205
502-458-5066

Send SASE for full details.

Zipper side panels™ to fully enclose all KD Kanopy and EZ-UP™ Instant Shelters™ — of 250 denier polyester (water resistant and fire retardant) with nylon zippers (comes with zipper front door, carry bag).

Heirloom Woven Labels
Grand Central Post Office
P.O. Box 2188
New York, NY 10163

Send SASE for list.

Woven labels—wide range of colors/styles, personalized.

Ident-Ify Label Corp.
P.O. Box 204
Brooklyn, NY 11214

Send SASE for list.

Personalized labels on white cotton, with stock phrases: Original by, Handmade by, Made especially for you by, Hand Knit by, Made with love by Mother (Grandmother), Made with tender loving care, Hand woven by, Fashioned by, and blank style (you-add). Name tapes (1 line). Has quantity prices.

J & N Imports
P.O. Box 2272
Birmingham, MI 48012
313-642-2672

Write or call for free sample.

Jewelry boxes: velvet ring, earring, and pendant types; by dozen.

John Mee Canopies
P.O. Box 11220
Birmingham, AL 35202
205-967-1885

Write or call for information.

KD Majestic canopies, 3 sizes. EZ-Up 500 canopies, 4 sizes with double truss frame and polyester top. "Package specials." And items from Show-off, Graphic Display Systems, Armstrong. Replacement tops, chairs, others. Major credit cards, layaways, leasing.

Johnson's Instant Shelters
7656 SE 123rd Lane
Belleview, FL 32620
904-245-2923

Call or write for "package specials."

Canopies: double truss model with polyester top in 3 sizes, many colors. Zippered side panels (with door), bags, stakes. MasterCard, Visa.

Kyle Murray Trailers
P.O. Box 8250
Greenwood, SC 29646
803-229-4666

Send SASE for information.

Cargo trailers—single and tandem axle models, in 4 sizes each; options: double rear doors, color choice, white spoke wheels, rubber torsion axles.

L&L Stitchery
P.O. Box 43821
Atlanta, GA 30378
404-691-2239

Free brochure.

Personalized woven labels: fabric sew-ons. Name tapes.

M.D. Enterprises Display Systems
4907 W. Hanover Ave.
Dallas, TX 75209
214-352-2802

KD Kanopy display system: panels covered in heavy fabric, knock down panels, tubular construction for lighting, easy-adjustable.

Mitchell Graphics, Inc.
2230 E. Mitchell
Petoskey, MI 49770

Write for catalog.

Full color direct order mail and postcard products—illustrations of arts and crafts.

National Display Co.
P.O. Box 6869
Toledo, OH 43612

Free brochure.

Oak and aluminum framed showcases (jewelry, etc.)—glass topped.

NewsTech
12337 Pinebrook
S. Lyon, MI 48178

Catalog and samples $2.00.

Hang tags, business cards, and self-stitch labels—variety of original designs to-be-personalized. Has quantity prices. MasterCard, Visa.

Northwest Tag & Label, Inc.
111 Foothills Rd., Suite 221
Lake Oswego, OR 97034

Brochure $1.00.

Labels on satin, nylon, polyester: care content, size tabs, in stock, and custom labels, size stickers. Hang tags, variety of types. Custom-made labels, to specification.

O'Brien Mfg.
2081 Knowles Rd.
Medford, OR 97501
503-773-2410

Free catalog.

Oak showcases (with tempered glass)—or showcase assembles without glass; for countertop or floor; variety of sizes, modular knock-down system.

Ozark Novelty
22 S. Main, P.O. Box 28
Webb City, MO 64870
417-673-5171

Send SASE with inquiry.

Jewelry showcases: aluminum framed, hinged glass lid. Has MasterCard, Visa.

Phoenix Woodworks
Rt. 3, Box 562
Greencastle, IN 46235
317-653-8592

Send SASE for additional information.

Hardwood display cases (walnut, oak, cherry) in 5 sizes (9" X 12" X 2" to 15" X 21" X 2"; dovetail case 15" X 21" X 3") in softwood or hardwood. All cases with color foam backing; lockable cases available.

Plastic Bagmart
554 Haddon Ave.
Collingswood, NJ 08108
609-858-0800

Free price list.

Plastic bags: clear, zipper lock, carryout types; shipping tapes, bubblepack bags, tissue, others. "Same day shipping." "Discount/wholesale."

Polybags Plus
Box 3043
Port Charlotte, FL 33949

Send SASE for brochure.

Polybags, zip close bags, cotton drawstring bags, floss organizers, heavy-duty piece bags selection. Others.

Saket
7249 Atoll Ave.
No. Hollywood, CA 91605

Free catalog.

Plastic bags: all sizes, small and large quantities, for crafts/hobbies, commercial and office use, industry.

Stack Storage Systems
P.O. Box 1927
Santa Rosa, CA 95402

Free brochure.

Storage systems including expandable model, wood, with strong slide-out shelves (vertical and horizontal); others. MasterCard, Visa.

Sterling Name Tape Company
P.O. Box 1056
Winsted, CT 06098
203-379-5142

Send $1.00 for custom label sample kit.

Write or call for information. Custom labels: printed with name, logo, artwork, etc.; one or more ink colors, care or content information printed on back, on durable white or colored polyester tape. Small or large quantities.

The Artist's Magazine
1507 Dana Ave.
Cincinnati, OH 45207

Reprint: "Photographing Your Paintings" (how to take professional looking slides and prints to present to gallery owners, dealers, and show juries, etc.); $1.50.

The Fabric Label Co. of KDI
9889 Hibert St., Suite E
San Diego, CA 92131

Catalog and samples $1.00.

Designer logo labels, care and content labels. Dennison tools and fasteners, hand labelers. Others.

The Plastic Bag Outlet
190 W. Passaic St.
Rochelle Park, NJ 07662

Send SASE for list.

Plastic bags: hi-density t-shirt handle bags (4 sizes), loop handle bags, tote handle bags (3 sizes), and super reinforced tote handle bags. Has MasterCard, Visa.

Trophy Glass Co.
912 Parker St.
Ft. Worth, TX 76112
817-457-3730

Send SASE for information.

Display cases (and kits)—custom sizes/finishes; all glass view, sliding glass or mirrored. Doll stands.

Yazoo Mills Inc.
P.O. Box 369
New Oxford, PA 17350
717-624-8993

Send SASE or call for information.

Mailing tubes in full line of lengths and any quantity, with end plugs for most standard sizes; by carton.

© *Action Bag Company*

Books & Booksellers

🐚🐚🐚🐚🐚🐚🐚🐚🐚🐚🐚🐚🐚🐚🐚🐚

See also specific categories of arts, crafts, needlecrafts, and hobbies; and PUBLICATIONS.

🐚🐚🐚🐚🐚🐚🐚🐚🐚🐚🐚🐚🐚🐚🐚🐚

Bette S. Feinstein
96 Roundwood Rd.
Newton, MA 02164

Lists $1.00.

Books and booklets (out of print and new: needle and fiber crafts (quilting, textiles, dressmaking, patchwork, cutwork, stampwork, ethnic and historic clothing, others). Old issues of magazines. Book search service.

Betterway Books
F&W Publications, Inc.
1507 Dana Ave.
Cincinnati, OH 45207

Send SASE for details.

Publisher of such useful and practical books as *Homemade Money*, by Barbara Brabec; *People, Common Sense, and the Small Business* by Patricia Tway, Ph.D., *Preserving Your Paper Collectibles*, by Demaris C. Smith; and *Stay Home and Mind Your Own Business*, by Jo Frohbieter-Mueller.

Dover Publications, Inc.
31 East 2nd St.
Mineola, NY 11501

Free catalog.

Craft/needlecraft books including a series of copyright-free design books: alphabets, historic ornaments, florals, people, fashions, animals, others. Art Nouveau and Art Deco designs, cut and use stencil books. Craft books on stained glass, glass working, silk screen, bookbinding, paper crafts, beading, marionette making, woodworking, carving, and toymaking, others. Coloring books. Needlecrafts: quilting, knitting, crochet, lace making; charted designs. And: textiles, collectible dolls, photography, architecture, art instruction; children's activity books.

Gossamer Publishing
P.O. Box 84963
Seattle, WA 98124

Catalog $2.00.

Over 200 books, magazines, and videos: sewing, crafts, needlecrafts, quilting, business and travel, others.

Kempton J. Smith
140 Waite Rd.
Boxborough, MA 01719

Send $1.00 & title, author, requirements, and include (if known) other data on publisher, edition, condition. $1.00 search fee is non-refundable. Worldwide book search out-of-print and hard-to-find books located.

North Light Book Club
P.O. Box 12411
Cincinnati, OH 45212

Send SASE for complete details.

Members of this club receive an introductory book at greatly reduced cost and agree to purchase at least two books within the year (at member prices). Books cover: techniques of oils, watercolors, acrylics, pastels, pen, ink; painting, drawing; painting on silk, greeting card design, picture framing, calligraphy, graphics, others. Master-Card, Visa.

Publishers Central Bureau
One Champion Ave.
Avenel, NJ 07001

Write for catalog.

Books cover a wide variety of categories including woodworking, blacksmithing, paper crafts, art techniques, art masters, watercolors, painting, calligraphy, folk art; artist's market; needlecrafts, knitting, crochet, sewing, embroidery; others. Most at reduced cost.

Storey Publishing
Schoolhouse Rd.
Pownal, VT 05261

Send SASE for list.

90 booklets including: Braiding Rugs, Refinishing Pine Furniture, Building Simple Furniture, Stencilling, Quilting, Clay Flowerpots, Caning; others. MasterCard, Visa.

The Book Detective
2607 Terrace Dr. #12
Cedar Falls, IA 50613

Send SASE for list and/or with inquiry.

Book search service for needlecraft titles, others.

The Unicorn
1338 Ross St.
Petaluma, CA 94954
707-762-3362

Catalog $1.00.

Books: extensive selection on weaving; pattern books, rag rugs, others. Titles in spinning, dyeing, color, lace making, basketry, 100+ knitting titles. Costume and fabric decorating on silk. Instructional videos on weaving, knitting, others. (See NEEDLECRAFTS.)

Publications

🐤🐤🐤🐤🐤🐤🐤🐤🐤🐤🐤🐤🐤🐤🐤

WHAT'S IN A PUBLICATION? So much that informs, inspires, and fosters ideas and quality workmanship. The descriptions in the listings below give a hint as to what is included in these publications, but are no substitute for actually seeing an issue.

Costs are shown as an aid to getting publications faster (without having to send for cost information). However, after an order is placed there will still be a time lag of some weeks before the first issue is received.

Single and subscription costs may be correct through 1992 (and maybe even 1993). Beyond that, it is important to send an SASE (stamped, self addressed envelope) for current rates.

WHERE A SINGLE COPY IS ORDERED, IT IS RECOMMENDED THAT $1.00 POSTAGE BE ADDED TO THE COST GIVEN IN THE LISTING TO ENSURE GETTING IT (OR GETTING IT IN GOOD CONDITION).

🐤🐤🐤🐤🐤🐤🐤🐤🐤🐤🐤🐤🐤🐤🐤

American Clay Exchange
Box 2674
La Mesa, CA 92044

Sample copy $1.50.

American crafted pottery highlights this biweekly newsletter that includes antiques and collectibles; on china, earthenware, dinnerware.

American Craft
72 Spring St.
New York, NY 10012

Single copy $5.00.

This is a publication of the American Craft Council—a showcase of excellence in all crafts (textiles, ceramics, needlecrafts, many others)—that is one of the member benefits. Profiles of crafts and craftspeople are given as points of education and inspiration.

American Indian Art Magazine
7314 E. Osborn Dr.
Scottsdale, AZ 85251

This is a quarterly magazine fostering native American art, with features on all aspects.

American Quilter
P.O. Box 3290
Paducah, KY 42002

This official magazine of the American Quilter's Society color-displays quilts, techniques, etc., to promote the art form and preserve the craft. Among the features: who's

who, historical notes, show listings and events, more. $15.00 per year. (See ASSOCIATIONS.)

American Woodworker
Box 139
Emmaus, PA 18099

This home woodworking project magazine presents techniques and how-to's from the masters; with detailed instructions and in-depth buyer's guides.

Art & Crafts Catalyst
P.O. Box 433
South Whitley, IN 46787

Single copy $4.50.

This is a bimonthly magazine listing arts and crafts festivals, shows, and other events throughout the U.S. (listings include professional show directors and mall shows); with details on place, time, deadlines, and fees involved. Includes classified advertising. Subscription: $17.00 per year.

Basketmaker
38165 Carolon
Westland, MI 48185

Single issue $4.00.

This is a quarterly magazine for basket weavers, designers, and collectors; with features that include illustrations of domestic, foreign, historic, and ethnic collections. Reports on workshops and other events, news, book reviews, and advertising.

Black Sheep Newsletter
25455 N.W. Dixie Mountain Rd.
Scappoose, OR 97056

Single copy $3.00.

Quarterly newsletter for growers, spinners, and textile artists interested in black sheep wool and other animal fibers. Coming events, book reviews are among the regular features. Has advertising. Subscription: $12.00 per year (U.S.), other countries $16.00 per year (U.S. funds).

Cab & Crystal
406-7 Elizabeth St.
N. Mississauga, Ontario Canada L5G 2Y8

This is a Canadian magazine for rockhounds, with news on shows, clubs; features on lapidary and minerals. Subscription (U.S.) $31.50. Canadians $24.00.

Cartoonist Profiles
Box 325
Fairfield, CT 06430

Edited by a cartoonist with a daily feature for a major syndicate for 27 years. Quarterly magazine explores how cartoonists became successful, through profile features.

Cast On
P.O. Box 1606
Knoxville, TN 37901

Send SASE for information.

This is the official publication of The Knitting Guild of America, sent to members in order to foster education and communication. A wealth of knitting projects from known designers is shown, with illustrations, diagrams, and directions. Regular features include Needles and Purls (letters), Tips and Hints, Book Reviews, and Guild Activities. Has advertising. (See ASSOCIATIONS.)

Ceramic Arts & Crafts
30595 W. 8 Mile
Livonia, MI 48152

Sample copy $1.95 (U.S.).

This monthly magazine focuses on how-to's in hobby ceramics, with projects shown in color, with materials needed list and step-by-step directions. A variety of techniques is given in each issue. News & Views, Show Listings, advertisements and Shopper Stopper classifieds are regular features. Subscription: $18.70 per year.

Ceramics Magazine
30595 W. 8 Mile Rd.
Livonia, MI 48152

Single copy $2.75.

This 10X yearly ceramics publication presents mold designs and products from known manufacturers, decorating techniques, and contributions by world famous ceramic artists; informative articles by professionals, tips and shortcuts. Patterns appear in every issue, printed on clay carbon graph paper. National show listings are given. Products are showcased through reviews and advertising. Subscription: $18.00 per year (10 issues). Outside U.S. $28.00 (U.S. funds).

Classic Toy Trains
P.O. Box 1612
Milwaukee, WI 53233

Send SASE for information.

This quarterly magazine for collectors and operators also serves to inspire model railroad crafters. Among the classics presented are Lionel, American Flyer, LGB, and others.

Color Trends
8037 9th Ave. N.W.
Seattle, WA 98117

Send SASE for information.

This magazine is devoted to color and dyes, with actual dyed fabric, yarn, and paper samples included; dye instructions, yarn painting, designer fabrics data, color innovations, more; published twice yearly.

Counted Cross-Stitch
306 East Parr Rd.
Berne, IN 46711

Single copy $2.95.

This counted cross-stitch magazine is published bimonthly, bringing readers a variety of charted design projects for variety of decorative touches on music and other boxes, towels of all types, kitchen items, pillows, baby items, decor accessories of all types. A Stitching Hotline, Product and Book Reviews, and Designer Data round out the content. Has advertising.

Country Handcrafts
Box 572
Milwaukee, WI 53201

Send SASE for information.

This magazine has a country theme throughout a wide variety of crafts and needlecrafts projects: folk art, old-time techniques upgraded for today's tools and materials. Projects include how-to's and illustrations.

Craft Marketing News
P.O. Box 1541
Clifton, NJ 07015

Send SASE with inquiry.

Bimonthly published for craftspeople, businesses, designers, and others wanting to market their talent. It offers listings of shops wanting handcrafts, and reports on business and related aspects from creating a logo to taxes, and more. Wholesale suppliers are given; personal profiles provide inspiration. Has advertising.

Craft Network Guild
Rt. 1, Box 42
Chattanooga, OK 73528

Single copy $3.50.

This publication is an enthusiastic collection of informal member profiles, patterns, suppliers, other data useful to craftspeople.

Crafter's SourceLetter
7509 7th Place, S.W.
Seattle, WA 98106

Single copy $4.00.

This newsletter reviews suppliers of art and craft materials, sources for patterns, kits, fabrics, supplies, with evaluations. Subscription: $15.00 year (4 issues). (Also has *Sewer's SourceLetter* and *Stitcher's SourceLetter*.)

Crafts
News Plaza, P.O. Box 1790
Peoria, IL 61656

Single copy $2.95, Canada $3.95.

How-to techniques and some full-sized, fold-out crafts projects are included in colorful monthly issues of this magazine. Project categories may be quilting, T-shirt and other fabric painting, soft doll making, boxes and other fabric crafting, holiday fashions and decor, country needlecrafts; more. Has advertising. Subscription: $17.95 per year.

Crafts 'N Things
P.O. Box 7519
Red Oak, IA 51566

Single copy $2.95.

This 10X yearly magazine provides a wealth of projects per issue (with pattern sheets, illustrations, directions) in a wide range of techniques that include cross-stitch and other embroidery, sewing, home decor items in many crafts, holiday and seasonal items, easy projects, trendy techniques, crochet, doll making, knitting, egg crafting, and many others (with source data) and regular columns. Subscription: $14.97 per year.

Crafts Plus
130 Spy Court
Markham, Ontario, Canada L3R 5H6

Single copy $2.50.

Published 8 times yearly, this crafts magazine provides a wide variety of crafts and needlecrafts projects including those for lace, quilting, crochet and knitting, sewing, folk art painting, country decoratives, many others, with patterns and full directions. Regular columns include Coming Events in Canada listings. Subscription: $14.95 (Canada); U.S. and other, $21.95.

Creative Crafts & Miniatures
Box 700
Newton, NJ 07860

Send SASE for information.

Crafts, needlecrafts, and miniatures are covered in this magazine, in how-to features, with patterns and illustrations. Reader's letters, product and book reviews, and store listings are regular features. Has advertising.

Crochet Patterns
P.O. Box 50036
Boulder, CO 80321

Send SASE for information.

Advanced and beginner projects are presented in this magazine; 18 projects per issue, with color photos and materials list. Quick projects and articles also included.

Crochet Today Fashions
306 E. Parr Rd.
Berne, IN 46711

Single copy $2.95.

Quarterly magazine features fashions and accessories for men, women, and children; over 15 patterns per issue, with illustrations and graphs; for baby sets, boys' and girls' vests, sweaters, skirts, dresses; women's sweaters, shells, vests, shawls, skirts, dresses; men's vests and sweaters, others. Accessory patterns include totes and purses, belts, sashes, hats, and others. Has advertising.

Crochet World
306 E. Parr Rd.
Berne, IN 46711

Single copy $2.95.

This bimonthly magazine presents illustrated project patterns for adult and children's apparel, dolls and doll clothes, toys, and home decor items (for kitchen, bath, bedroom, baby's room, others; pillows, afghans, coverlets, curtains, others); doilies, totes, potholders, others. Projects are marked for level of ability — easy to advanced. Potpourri trades/wants, and Show-It-Off are among regular features. Has advertising.

Cross Country Stitching
P.O. Box 710
Manchester, CT 06040

Send SASE for information.

This counted cross-stitch magazine is published 6 times yearly, with 20 to 25 design projects per issue—in color, with clear charts. Designs including country motifs, Scripture, others. $15.00 per year (U.S.).

Cross-Stitch & Country Crafts
3000 Walnut St., P.O. Box 52416
Boulder, CO 80302

Single copy $2.95.

Every bimonthly issue of this magazine has at least 23 original cross-stitch patterns and designs — with color photos (close-up, hands-on) as aid, with chart ratings, skein data; for heirloom and country motifs. Finish It Tonight projects and designer originals are included. Subscription: $12.97.

Darkroom Photography Magazine
9021 Melrose Ave.
Los Angeles, CA 90069

Send SASE for information.

This magazine (published 8 times yearly) presents darkroom topics for professional and amateur photographers including: manipulation, processing, printings; how to build equipment, tools and products guides, special effects, and others.

Decorative Artist's Workbook
P.O. Box 3284
Harlan, IA 51537

Sample copy $3.95 ($4.95 Canada).

Magazine dedicated to showing readers all about tole and decorative painting through color worksheets and patterns; led step-by-step by professionals — Jo Sonja Jansen and Priscilla Hauser and others. Projects may include painting of home decor items, personal accessories, clothing and other fabric items; for metal, wood, Styrofoam, papier mache, plastic, glass, others. Has advertising. Subscription: $18.00 per year; Canadian and foreign, $22.00 per year (U.S. funds).

Decorative Arts Digest
P.O. Box 7520
Red Oak IA 51566

Single copy $2.95.

Bimonthly magazine devoted to the art of tole/ decorative painting; presents how-to's from prominent artists (and a featured artist per issue), with updated techniques for all media, color illustrations for projects, over 85

exclusive patterns a year. Has advertising. Subscription: $17.95 a year.

Decorative Woodcrafts
1912 Grand Ave.
Des Moines, IA 50309

Single copy $4.95.

This Better Homes and Gardens magazine shows a variety of techniques for wood crafts (cutting, painting, woodburning, others); and product information. Tips and questions/answers complete the publication. Subscription $29.97 yearly (U.S.).

Doll Castle News
P.O. Box 247
Washington, NJ 07882

Sample copy $2.95.

Bimonthly magazine given to dolls and doll making. Each issue contains articles on dolls, dollmakers, miniatures, places of interest, and museums—with photos and illustrations; doll and miniatures listings, a paper doll section, doll clothes patterns, and needlework. Has advertising. Subscription: $16.95 per year (U.S.).

Doll Crafter
30595 W. 8 Mile
Livonia, MI 48152

Single copy $3.95.

This monthly magazine aids the reader to make or collect dolls—through features, how-to's and news. May include patterns and diagrams for crafting; and reports of shows and events. Has advertising. Subscription: $29.95 yearly, U.S.

Doll Designs
306 E. Parr Rd.
Berne, IN 46711

Single copy $2.95.

Bimonthly magazine for doll and toy craftspeople; with features in composition, cloth, softsculptured, ceramic, and other types of dolls; with technical how-to's, trends and styles of today and yesterday's toys. Doll clothing, dollhouses and furniture are also presented, as are profiles of noted doll artists. Advertising.

Doll World
306 E. Parr Rd.
Berne, IN 46711

Single copy $2.95.

Bimonthly magazine for doll lovers—doll crafters and collectors. It presents features on a variety of dolls, doll patterns, and informative articles on all eras and areas worldwide. Includes a Doll Shows listing, pattern reviews, and advertising.

Early American Life
P.O. Box 8200
Harrisburg, PA 17105

Send SASE for information.

This magazine on early America offers projects on early crafts, examples of quality craftsmanship, building, decorating, and renovating ideas; gives source data and a calendar of events.

Fiberarts, Magazine of Textiles
50 College St.
Asheville, NC 28801

Single copy $4.50.

This 5X yearly fiberarts magazine presents quilting, weaving, stitchery, knitting, soft sculpture, and others; historical design and techniques, fiber data are also included. Features, show data. Subscription: $21. yearly U.S.; Canada $23.00.

Fine Print
1610 Bush St.
San Francisco, CA 94109

Send SASE for information.

The artistry of book printing and binding is presented in this quality magazine.

FineScale Modeler
P.O. Box 1612
Milwaukee, WI 53201

Single copy $2.75; (Canada $3.25).

This bimonthly magazine covers scale modeling: aircraft, boats, cars, figures, fantasy/sci-fi, dioramas, others. Professional technical data are presented, with articles on scratch building, detailing, displaying, and more. Regular departments: Coming Events, new product and workbench reviews, Clinic—questions, answers, letters, Tips and Techniques, and advertising. Subscription: $17.95 U.S. (8 issues); Canada $20.95 (U.S. funds).

Good News Rag
Box 5222
Salem, OR 97304

This newsletter of Lois Ericson and Bets Barnard presents sewing views and previews, how-to's, personal summary and more. Subscription $8.00 yearly U.S.

Handwoven
201 E. 4th St.
Loveland, CO 80537

Single copy $4.50.

This weaving magazine is issued 5 times yearly, with photographed woven projects (complete with step-by-step instructions); in-depth articles on techniques, weaving lore, history, profiles. Projects include a whole range of functional items for the home, fashions, accessories, fabrics. Two special researched theme issues are included each year. Subscription: $21.00 per year; Canadian and other foreign $26.00 (U.S. funds, surface delivery).

Hemming Motor News
P.O. Box 100
Bennington, VT 05201

Send SASE with inquiry.

This is billed as "the world's largest collector car marketplace" with over 800 pages monthly filled with "thousands" of ads for old cars, parts, services, supplies.

Herbal Crafts Quarterly Newsletter
Rt. 13, P.O. Box 357
Mappsville, VA 23407

Send SASE for information.

Herbal crafting is the focal point for this publication. Past features included spice and sachet wreath making, flowers. Regular columns: Hints, product and book reviews, letters. Subscription $25.00 per year (U.S.).

HerbalGram
P.O. Box 201660
Austin, TX 78720

Single copy $5.00.

Quarterly journal published by the American Botanical Council and the Herb Research Foundation. It presents reviews, media covers, and herb data, along with market updates, legal reports, conference information, book reviews, a calendar of herbal and scientific events, and more. Each edition is previewed and edited by a 16 member scientific advisory board. Subscription: $25.00 per year (U.S.).

Herban Lifestyles
84 Carpenter Rd.
New Hartford, CT 06057

Single copy $3.00.

This is a bimonthly newsletter devoted to herbs. Subscription: $18.00 per year.

Home Mechanix
1515 Broadway
New York, NY 10036

Single copy $1.75.

Remodeling, renovation, and repair of home and car is what this magazine presents readers, through home projects (with detailed illustrations, diagrams, and data) and features on interior design, construction, outdoor and workshop projects; tools and tips. Subscription: $11.94 per year; Canada and other foreign $16.94 (U.S. funds).

Home Shop Machinist
2779 Aero Park Dr., Box 2820
Traverse City, MI 49685

Send SASE for information.

Metalworking and machining how-to articles are presented in this magazine.

Hooked on Crochet
206 West St.
Big Sandy, TX 75755

Send SASE with inquiry.

An assortment of patterns (illustrated, diagrammed, with directions) make up this bimonthly magazine — projects for personal and home decor: women's and children's vests, tunic, shirt, sweaters, others; tea towels and others, ensembles, afghans, pillows, others. Crochet Talk (letters) and Stitches (pictures and directions) are regular features.

HOW Magazine
P.O. Box 12575
Cincinnati, OH 45212

Sample copy $8.50.

The focal point for this bimonthly magazine is graphics —design, technique, concepts as given by contemporary art directors, production people, computer-graphics professionals, and others—with coverage of techniques, tools, problem solving; on color separations, papers, computer systems; on the business aspects of graphics, clients, copyright, and more. Meant for those new to the field or established pros; features cover skill improvement and the latest innovations.

International Sculpture
P.O. Box 19709
Washington, DC 20036

Send SASE for information.

Members of this organization receive a magazine on sculpture business, projects, exhibits, and more.

Kit Car
8490 Sunset Blvd.
Los Angeles, CA 90069

Single copy $3.50.

Specialty cars constructed from kits is what this bimonthly magazine is focused on; each issue illustrates and details a Showcase of models, from the popular Cobra to others of vintage or racing style. Technical features aid car builders in details of installation and operation. Has advertising. Subscription: $12.95 per year. Write to P.O. Box 2528, Los Angeles, CA 90078.

KiteLines
P.O. Box 466
Randallstown, MD 21133

Single copy $4.50 and $1.50 postage.

The comprehensive international journal of kiting—the only magazine of its kind; the source of news, plans, techniques, reviews of new kites and books, profiles of kiting personalities, in-depth feature articles on aspects of kite making and flying. Other departments include letters, tips and techniques, and a directory of outlets/retailers nationwide. Has advertising. Subscription: $14.00 per year U.S.; all others $18.00 (U.S. funds).

Knitting News
P.O. Box 161
St. Mary's City, MD 20686

Newsletter features patterns, news, book reviews, and more. It is issued quarterly. Subscription: $15.00 per year (includes 10% discount on books and items).

Knitting World
306 E. Parr Rd.
Berne, IN 46711

Single copy $2.95.

Packed with knitting patterns and directions, this bimonthly magazine covers knitwear for all members of the family (dresses, sweaters, vests, scarves, shawls, neckties, others), and household accessories (afghans, pillows, others). Has advertising. Subscription: $12.97 per year; Canada $17.77 (U.S. funds). Write to P.O. Box 11309, Des Moines, IA 50340.

Lapidary Journal
P.O. Box 1000
Devon, PA 19333

Single copy $3.00.

In this monthly publication of jewelry making and the lapidary arts, outstanding photography showcases gemstones' properties and technical data; articles cover expeditions, equipment, shows, workshop projects, and an events calendar. Has classifieds. Subscription $24.00 yearly (U.S.).

Leather Crafters Journal
4307 Oak Dr.
Rhinelander, WI 54501

Send SASE with inquiry.

This bimonthly publication features leather crafting for all ages and skill levels; provides how-to, step-by-step detailed articles using full sized patterns with illustrations. Sources information given for tools and supplies. Subscription $22.00 yearly.

Leisure Arts
104 Riverwood Rd.
No. Little Rock, AR 72118

Send SASE with inquiry.

A range of creative arts is represented in this bimonthly magazine — counted cross-stitch, knitting and crochet, and a variety of other crafts projects are by noted professionals. Unique projects include color illustrations, charts or diagrams, and directions. Regular departments include Letters, Your Way (tips), book reviews, and Show Your Style. Has advertising.

McCall's Cross-stitch
825 Seventh Ave.
New York, NY 10019

Single copy $2.95; Canada $3.75.

Cross-stitching charted designs/projects magazine.

McCall's Needlework & Crafts
P.O. Box 1790
Peoria, IL 61656

Single copy $2.95.

Bimonthly magazine presents the projects of professionals, diagrammed or charted and color illustrated, for easy crafting. Traditionally emphasizing needlecrafts, today's magazine keeps that focus with Basics, and sections on Knitting, Crochet, Sewing, Embroidery, and Needlepoint: fashions for family members, home accessories. A few crafts are highlighted. Subscription: $11.97; $17.97 Canadian and other foreign (U.S. funds). Write to P.O. Box 10052, Des Moines, IA 50340.

Metalsmith
5009 London Derry Dr.
Tampa, FL 33647
813-977-5326

Send SASE for information.

Quarterly magazine is published by The Society of North American Goldsmiths; offers reviews, esthetics, criticism, profiles of master metalsmiths, technical papers, surveys of galleries, and other business. (See ASSOCIATIONS.)

Mind Your Own Business at Home
P.O. Box 14850
Chicago, IL 60614

Send SASE for information.

Aspects of home-based business are presented readers of this newsletter of the National Association for the Cottage Industry.

Miniature Collector
170 Fifth Ave.
New York, NY 10010

Single copy $3.50.

This magazine gives readers a look into the world of dollhouses and other scale miniatures; with professional articles, Projects & Plans, and Showcase features. Household furnishing, houses, buildings, and architectural details are illustrated and described. Other departments include News & Views, Auction Report, Calendar of shows, and new products. Has advertising. Subscription: $14.00 U.S.; outside U.S. $19.99 (U.S. funds).

Miniatures Dealer Magazine
Clifton House
Clifton, VA 22024

Single copy $1.50.

Presented for retailers in the dollhouse and miniatures trade, this monthly magazine deals with how-to's, innovative techniques and ideas for marketing, shop and personality profiles.

Miniatures Showcase
633 Wisconsin Ave., Suite 304
Milwaukee, WI 53203

Single copy $3.25; Canada $3.75.

This is a quarterly magazine that shows artisans and miniature collections; utilizing detailed closeup photography of dollhouses, people, and accessories, and other scenes, along with descriptions and explanations. Projects—scratch building, finishing, assembling—are also shown. Has advertising. Subscription: $12.95 per year; Canada and other foreign, $16.95 (U.S. funds). Write to 1027 N. 7th St., Milwaukee, WI 53233.

Model Airplane News
251 Danbury Rd.
Wilton, CT 06897

Single copy $2.95; Canada $3.75.

Model aircraft is this monthly magazine's focus—carried through step-by-step projects (illustrated, diagrammed, and described). Products and their use are shown, and a Field and Bench Review given of aircraft with specifications. Has advertising. Subscription: $25.00 per year; foreign $35.00 (U.S. funds).

Model Builder
898 16th St.
Newport Beach, CA 92663

Single copy $2.95; Canada $3.95.

This monthly magazine features model building—construction articles, Radio Control, peanut plans, electric flight, and old timers; product reviews, and more. A featured model is illustrated, with diagrams and specifications given. R/C and other model groups are also presented. Has advertising. Subscription: $25.00 per year U.S.; outside U.S. $38.00 per year (U.S. funds).

Model Railroader
P.O. Box 1612
Milwaukee, WI 53201

Authoritative monthly magazine of scale model railroading has ideas for beginner and veteran modelers; projects are given with directions, and a variety of railroads are showcased. Has advertising. Subscription: $27.95 per year U.S.; Canada $33.95; foreign $37.95 (U.S. funds).

Modern Machine Knitting
P.O. Box 110, 264 H St.
Blaine, WA 98230

Single copy $4.50.

This monthly machine knitting magazine features illustrated project patterns, sources of supplies and more.

National Home Business Report
P.O. Box 2137
Naperville, IL 60567

Sample back issue $7.00.

This is a quarterly networking report for home business people. Readers communicate with others and read of business tips and topics, marketing, valuable resources, and business management techniques. Subscription: $24.00 per year (U.S.); Canada $28.00 per year (U.S. funds).

National Stampagraphic
19652 Sacramento Lane
Huntington Beach, CA 92646

Single copy $4.50.

This quarterly magaazine is about rubber stamps of the artistic kind; presenting the creations of stamp artists throughout, with technical features, personal profiles, and more. Regular features include a slew of stamping hints and ideas. Has advertising. Subscription: $16.00 per year (U.S.).

Needlepoint News
Box 5967
Concord, CA 94524

Single copy $2.00 plus postage.

This is a bimonthly magazine of how-to's, designs, profiles, and technical data—all related to needlepoint.

Needlepoint Plus
3300 Walnut Ave.
Boulder, CO 80323

Single copy $3.50.

This bimonthly publication is written by and for needlepointers. Newest trends and designs are presented, and it is illustrated with diagrams, charts, and photos. $21.00 yearly U.S.

Northwest Photo Network
1309 No. 77th
Seattle, WA 98103

Free copy.

Photography is the focus of this quality taboid-sized publication for commercial photographers and others; it gives information on events, techniques, and specialized topics; provides marketing and other business data, a Gallery Guide for the Northwest, marketing and promotional strategies and more. Features are punctuated with detailed, innovative photographs. Has advertising.

Nutshell News
21027 Crossroads Cir., P.O. Box 1612
Waukesha, WI 53187

Single copy $3.50.

Monthly magazine for miniatures craftspeople and enthusiasts; offers comprehensive reports on shows, profiles of craftspeople and displays of their work, how-to tips and techniques, visits to museums and private collections, and more. Miniatures projects are diagrammed, illustrated, and directed. Has advertising. Subscription: $16.00 for 6 months, $29.00 per year (U.S.); Canada and other foreign $36.00 per year (U.S. funds).

Old-Time Crochet
306 E. Parr Rd.
Berne, IN 46711

Single copy $2.95.

Quarterly magazine features patterns from cover to cover of classic, traditional apparel, accessories, home decor; may include lace edgings, doilies, applique, filet, table linens, curtains, afghans; adult and children's clothes; illustrated directions. Has advertising. Subscription: $9.95 per year (U.S.); Canada $13.00 per year (U.S. funds).

Ornament
P.O. Box 35029
Los Angeles, CA 90035

Send SASE with inquiry.

Ornament of the ancient, contemporary, and ethnic kind is the focus of this quality magazine that presents jewelry and clothing; original designs, techniques are beautifully photographed; news and features are included; galleries and shops are supported, collecting encouraged; with resources for the artist/craftsperson. Has advertising.

Outdoor & Travel Photography
1115 Broadway, 8th Floor
New York, NY 10010

Send SASE for information.

Magazine focuses on the outdoors, nature, and travel. Published quartelry, it presents topics unique to this specialty; adds a "Readers Portfolio" for submission of work and resume. Subscription: $15.00 (U.S.).

Pack-O-Fun
P.O. Box 7522
Red Oak, IA 51566

Single copy $1.95.

This crafting-fun magazine is published 6X yearly for children (and the child in us) projects from items found around the home — magazine pages, popsicle sticks, newspapers, felt, items from backyards, boxes, eatables, containers, others; and for holidays; with illustrated directions. One page of advertising. Subscription: $11.95 yearly (U.S.).

Photo Opportunity
P.O. Box 838
Montclair, NJ 07042

Sample copy $4.00.

Profiles of professionals, strategies for photography studios and other places of business; promotion of work and business and more are given in this bimonthly magazine with Sell, Publish, Exhibit in their masthead. The publication features success pointers and resources; and successful (and up-and-coming) people profiles. Has advertising.

Photographer's Forum
614 Santa Barbara St.
Santa Barbara, CA 93101

Send SASE for information.

This is a publication for photographers and those interested in photography.

Photographic Magazine
8490 Sunset Blvd.
Los Angeles, CA 90069

Single copy $2.50.

How-to magazine for photographers, published monthly to inform of techniques and special effects in darkroom, lighting, equipment, tools, and more—amply illustrated. Both camera and video products are presented and reviewed. Has advertising.

Plastic Canvas! Magazine
23 Old Pecan Blvd.
Big Sandy, TX 75755

Sample copy $2.95; Canada $3.75.

Bimonthly magazine gives stitch basics and projects for many items, each one with stitch and color charts, materials lists, and instructions. Typical patterns include wall hangings, baskets, boxes, tissue holders, organizers, jar lid/covers, banks and models, cubes, vases, and others.

Popular Photography
P.O. Box 51803
Boulder, CO 80323

Single copy $2.95.

Monthly magazine for anyone involved in photography. Techniques with cameras and equipment are covered as are the latest trends. Photography indoors and out, with sophisticated camera or not—readers find topics of information and interest. Has advertising.

Popular Woodworking
P.O. Box 5986
Concord, CA 94524

Send SASE for information.

Bimonthly magazine presents project ideas, techniques, and other data; step-by-step instructions, color photos, and technical diagrams for woodworking projects.

Potpourri From Herbal Acres
Box 428-MB
Washington Crossing, PA 18977

Send SASE for information.

Front cover to back, this is a networking publication. It is issued quarterly and devoted to things herbal—a way station for hobbyists and professionals to share "herbal delights." A real blend of experiences, ideas, tips, recipes, crafts, and what's new in the herbs.

Potpourri Party-Line
7336-CS Berry Hill
Palos Verdes, CA 90274

Send SASE for information.

Naturals/florals, potpourri, and related topics are features of this quarterly publication meant for dried floral and fragrance designers (and others who are interested). Issues may have a central theme (such as weddings) and include background information. Subscription: $15.00 per year (U.S.); Canada $18.00 (U.S. funds).

Primer
82 Colfax Rd.
Springfield, NJ 07081

Send SASE for details.

This newsletter for the decorative painting and crafts industry is published bimonthly. It addresses topics of business interest, evaluates advertising, copyrights, business promotion, accounting, marketing, and others. Subscription: $24.00 per year (U.S.).

Professional Stained Glass
Rt. 6, Box 69
Brewster, NY 10509

Single copy $3.00.

Monthly magazine presents fine examples of contemporary and other stained glass, beveled and other glass topics through color photographs, diagrams, and description. Includes Notable Works and artists. Has advertising. Subscription: $30.00 per year U.S.

Profitable Craft Merchandising
News Plaza, P.O. Box 1790
Peoria, IL 61656

Sample copy $4.00.

A 13X yearly magazine for retailers, manufacturers, publishers, importers, distributors, and designers; presents product information from a craft merchandising level, with new trends, projects, news and views; in crafts, needlecrafts, and creative sewing. Trade shows are reported and an annual directory is included with subscription. Has advertising. Subscription $30.00 per year (U.S.); outside U.S. $40.00 per year (U.S. funds).

Quick & Easy Plastic Canvas!
23 Old Pecan Blvd.
Big Sandy, TX 75755

Send SASE for information.

What *Plastic Canvas! Magazine* does for projects, this bimonthly magazine does for easy projects (with the same full color illustrations, charts, and directions) throughout each issue.

Quilt World
306 E. Parr Rd.
Berne, IN 46711

Single copy $2.95.

Bimonthly magazine presents full sized patterns throughout—motifs, diagrams, photographs for a variety of quilts from heritage to contemporary style. International news, Show Directory, and Classifieds.

Quilter's Newsletter Magazine
Box 394
Wheatridge, CO 80034

Send SASE with inquiry.

Each issue of this magazine is packed with 50-100 quilt photos, and news of quilts and quilters around the world. Also includes quiltmaking lessons, features, hints, contests, and more. Project instructions are illustrated, with full-size pattern pieces, for 5-15 quilts. Columns by noted quilters and features on them are shown. Regular departments: show calendar, quilt club and guild news, and more. Has advertising.

R/C Modeler Magazine
Box 487, 144 Sierra Madre Blvd.
Sierra Madre, CA 91024

Single copy $2.95.

This is a magazine devoted to radio control models.

Railroad Model Craftsman
Box 700
Newton, NJ 07860

Single copy $2.95.

Model railroads—actual lines, and modeling kits and scratch building prototypes are covered in this monthly magazine. Project features include photographs, diagrams, and specifications. Scenery and landscaping is covered. Kit construction hints are given. Regular departments include Test Track product reviews and Timetable—scheduled events and notices. Subscription: $25.00 per year (U.S.); Canada $31.00.

Rock & Gem
4880 Market St.
Ventura, CA 93003

Single copy $2.50.

This jewelry making/rockhound magazine is published monthly to present and review lapidary equipment; feature field trips, collecting, prospecting, and related data; identify gems and minerals through photos and descriptions. Has advertising. Subscription: $18.00 per year (U.S.).

Rubberstampmadness
408 S.W. Monroe #210
Corvallis, OR 97330

Sample copy $4.00.

A world of rubber stamping is represented in this bimonthly publication that is printed on heavy stock (with full-color covers) to properly show stamp artistry. Each issue has extensive reviews of the current catalogs of artists, news and views, mail art listings, and how-to issues with aspects of the craft—eraser carving, fabric stamping, artful stamp combinations, creative layouts, and more. Has advertising. Subscription: $18.00 per year U.S.

Rug Hooking
P.O. Box 15760
Harrisburg, PA 17105

Single copy $6.95.

This is a 5X yearly magazine devoted to all aspects of rug hooking; with pictured projects (4-5 per issue) from hooking experts to instruct and inspire. Features techniques, beginner and pro designing, preparing and dyeing wools, a wealth of creative ideas, and profiles of noted professionals—all emphasized with quality photographs. Has advertising. Subscription: $24.95 U.S.; Canada $29.95 (U.S. funds).

SAC
P.O. Box 159
Bogalusa, LA 70429

Send SASE for information.

Monthly publication gives nationwide news (and indepth reports) on upcoming arts and crafts shows in the south; listings given by state, with details as to place, times, contacts, cost, whether juried or not. Mall shows advertised. Show Listing Form and Resources appear in every issue.

Scale Ship Modeler
7950 Deering Ave.
Canoga Park, CA 91304

Send SASE for information.

Covering all aspects of model boating, this magazine has comprehensive, informative articles, with color photos of masterfully crafted replicas, building techniques, kit reviews, motor and R/C installations, showcase models, and worldwide coverage of special meets and events. Has advertising.

Sculpture
1050 Potomac St. N.W.
Washington, DC 20007

Send SASE with inquiry.

The magazine of The International Sculpture Center (a nonprofit organization devoted to the advancement of contemporary sculpture). Examples of superb quality sculpture in many forms abound through the issue — fibers, wood shapes, stone, metals, plastics, and others— shown in color. Profiles of sculptors and their work offer creative possibilities. Has advertising. Membership subscription: $40.00 in U.S., Canada, Mexico (U.S. funds).

Serger Booklet Series
2269 Chestnut, Suite 269
San Francisco, CA 94123

Send SASE for information.

This booklet series is published bimonthly and includes easily understood reports on new serger technology (including information not found elsewhere). Professionals present popular topics in depth, in concise, easy-to-follow format, basic ideas to advanced. Past booklets included: "Serging Sweaters" (how to make in an hour), and "Serging Lingerie."

Sew It Seams
P.O. Box 2698
Kirkland, WA 98083

Send SASE with inquiry.

This bimonthly magazine provides illustrated articles by professionals, with techniques, tips and shortcuts, products and notions information, and personal experience features to aid and inspire. Has advertising.

Sew News
P.O. Box 1790
Peoria, IL 61656

Single copy $2.95 (Canada $3.95).

Publication appears monthly, reports on fashions, fabrics, sewing savvy, and projects. Projects and suggestions are illustrated or diagrammed for clarity; fabric treatments, color, dyeing, and fashion coordinating are shown. Commercial and other sewing patterns are reviewed. Professional hints are given, as are resources and product data. Has advertising. Subscription: $19.94 per year (U.S.); all others $29.94 (U.S. funds).

Sewing Booklet Series
2269 Chestnut, Suite 269
San Francisco, CA 94123

Send SASE for information.

This booklet series is issued bimonthly, with in-depth reports on the latest sewing methods, written by sewing professionals. (Past booklets have included: "Guide to Today's Interfacings," "Newest Knit Know-How," and "Creative Machine Stitchery.") Ample illustrations enhance technical data throughout.

Shuttle, Spindle & Dyepot
120 Mountain Ave. B101
Bloomfield, CT 06002
Single copy $6.50.

Send SASE with inquiry.

Official magazine of the Handweaver's Guild of America. (See ASSOCIATIONS.) Issues have technical data, illustrations, and descriptions of the finest examples of weaving, spinning, and dyeing. Has advertising.

Sideline Business
Box 351
Emmaus, PA 18049

Send SASE for information.

This monthly publication guides those with at-home businesses to market craftswork and ideas.

Sign Craft Magazine
P.O. Box 06031
Ft. Myers, FL 33906

Single copy $4.95.

Recognizing sign making to be a creative, practical application of artistic skills, this bimonthly magazine abounds with photos and ideas; gives data on design, projects, available materials, business aspects, pricing, marketing, and more. A photographic display of actual signs appears throughout issues. The newest products are showcased. Has advertising. Subscription: $25.00 per year (U.S.); outside U.S. $31.00 per year (U.S. funds).

Spark!
P.O. Box 5027
Harlan, IA 51537

Send SASE with inquiry.

This is a children's magazine of creative fun, with illustrated how-to's in drawing, painting, cartoons, weaving, sculpting, and other projects. With nine issues yearly. Subscription cost: $19.95 U.S.

Spin-Off
201 E. 4th Street
Loveland, CO 80537

Single copy $3.50.

Quarterly magazine on spinning. Presented are data on aspects of spinning and fibers, projects from fleece to finished, illustrated, with directions; and historical information on wheels, accessories, sheep, handspuns, and more.

Has advertising. Subscription: $18.00 per year (U.S.); other countries $22.00 year (U.S. funds, surface delivery).

Sunshine Artists USA
1700 Sunset Dr.
Longwood, FL 32750

Monthly magazine that serves as a calendar of arts and crafts shows and events of all kinds (including mall shows) nationwide. Listings are given by state, and include dates, place, contact person, address, and phone. Sponsors, indications of past attendance, and sales rundowns are given by staff representatives for 26+ individual states. Lists Audit Rated shows by date. Another list of shows is given (without evaluation) by date. Also has advertising. Subscription: $22.50 per year (U.S.); Canada and Mexico $36.50 (U.S. funds).

Teaching For Learning
46-305 Ikiki St.
Kaneohe, HI 96744

Send SASE for information.

This quarterly newsletter is for those who teach, lecture, or write on fiber arts; these readers discover how to develop resumes and portfolios, motivate students, find teaching positions, diversify income (to lecture, consult, write) and learn business aspects: promotion of work and classes; use of slides, computers, and videos in teaching, and more. Subscription: $12.00 per year (U.S.).

Teddy Bear Review
170 5th Ave.
New York, NY 10010

Send SASE for information.

Bimonthly publication presents teddy history; project profiles, holiday topics, collections, and more. $22.95 per year U.S.

The Artist's Magazine
1507 Dana Ave.
Cincinnati, OH 45207

Sample copy $3.00.

This monthly magazine abounds with features for artists craftspeople. Profiles best known professionals and their work. A wide array of projects is covered Issues may include aspects of art shows, overcoming blocks, and more. Regular features: Strictly Business topics, painting problems solved, Artists' Markets, Showplace, and more. Has advertising. Subscription $24.00 year (U.S.).

The Carriage Trade
RR2, Lot 8 Dalrymple, Box 18
Camlachie, Ontario, Canada NON 1EO

This quarterly knitting magazine presents projects and patterns, product and book reviews, and more. Subscription: $19.95 yearly (Canada), $21.95 yearly (U.S.).

The Cloth Doll
P.O. Box 1089
Mt. Shasta, CA 96067

Send SASE with inquiry.

Quarterly magazine oriented to soft doll making, with at least three patterns per issue; and a variety of topics including needle sculpturing, sewing, ideas and inspiration, detailed techniques, and marketing data. It includes doll and toy making know-how from professionals as regular columns. Has advertising.

The Crafts Fair Guide
P.O. Box 5508
Mill Valley, CA 94942

This quarterly publication covers in detail, and reviews, over 1,000 fairs throughout the West. (From about 3,000 reporting reviewer/craftspeople, 10,000 opinions are received. The guide compiles these into a format of information.) Fairs are rated for sales and for enjoyment; invaluable for craftspeople who market through shows. Shows are listed by dates, indexed by town and state. Has advertising. Subscription: $42.50 per year (U.S.).

The Crafts Report
700 Orange St.
Wilmington, DE 19801

Single copy $3.00.

Monthly newspaper that provides details on selling opportunities, trends, marketing strategies, money management, tax data, and fairs and shows information, along with profiles of successful professionals, to inform and inspire readers. Safety and other hazards are reported, and Point of View provides a forum on particular subjects. A Crafts Available section is listed by categories from Accessories, to Wood and Other Media. Exhibitions and competitions, Workshops and Seminars are also listed; Has advertising. Subscription: $24.00 per year (U.S.).

The Creative Machine
Open Chain Publishing
P.O. Box 2634
Menlo Park, CA 94026

Single issue $3.50.

This quarterly newsletter is meant for people "who love their sewing machines and sergers the way others love their computers and cars." It presents creative ideas, news, techniques, and hints for both sewing and the machine. Subscription: $12.00 yearly (U.S.); outside U.S. $17.00.

The Cross Stitcher
P.O. Box 7521
Red Oak, IA 51566

Send SASE with inquiry.

This bimonthly magazine is devoted to cross stitching, providing a variety of pattern illustrations, features and other information. Subscription: $14.97 yearly (U.S.), Canada $21.97.

The Homeowner
3 Park Ave.
New York, NY 10016

Send SASE for information.

Home remodeling and improvement are major themes for this monthly magazine, with how-to's, technical data, professional experience profiles, and more.

The Joy of Herbs
P.O. Box 7617
Birmingham, AL 35253

Send SASE with inquiry.

Quarterly publication on herbs with news, features, product resources, and advice. Crafts projects using naturals, herbs, and spices are presented, and herb growing and cultivation detailed. Herb recipes are included as are regular features: Coming Events, Book Reviews, Suppliers Directory, and more. Has advertising.

The Professional Quilter
Box 75277
St. Paul, MN 55175

Single copy $5.00.

Presented from a professional/business standpoint, this quarterly magazine offers features on management and marketing, organizing a quilt studio, teaching, designing, issues of ethics, economics, and more with valuable input from professionals. Past features have been concerned with: making a statement with quilts, buying used computers, turning professional, sales tactics, judged show rules, and others. Has advertising. Subscription: $20.00 per year (U.S.).

The Scale Cabinetmaker
Box 2038
Christiansburg, VA 24068

Send SASE with inquiry.

This is a quarterly magazine for those who build miniatures including how-to features with illustrations and directions; other data useful to scale crafting.

The Serger Update
2269 Chestnut, Suite 269
San Francisco, CA 94123

Send SASE with inquiry.

The only total serger information publication available. Noted professionals present articles with new techniques and ideas, pattern plans and projects—from easy to advanced. Reviews of equipment and products are given, as is career and teaching information. Discount coupons included. No advertising.

The Teddy Tribune
254 W. Sidney
St. Paul, MN 55107

Send SASE for information.

Magazine published 5 times yearly. Features "news and views of the bear world" and invite readers to join The Honorary Teddy Society; also includes articles on Teddy Bear collectibles, the Bear Market and more. Has advertising.

The Woodworker's Journal
517 Litchfield Rd., Box 1629
New Milford, CT 06776

Send SASE for information.

This is a woodworking publication.

The Workbasket
4251 Pennsylvania Ave.
Kansas City, MO 64111

Single copy $1.50.

This home magazine presents features on knitting, crochet, sewing, embroidery, quilting, and other needlecrafts; and crafts (stenciling, painting, others). Projects are color illustrated, with complete directions, diagrams, and patterns. (Also cooking recipes.) Has advertising.

Threads Magazine
63 S. Main St., Box 5506
Newtown, CT 06470

Single copy $4.75.

Much that can be created with threads is presented in this quality magazine. Design, details, and techniques for executing clothing, almost all needlecrafts, and related topics—dyeing, surface decorating, others—may be represented. Color illustrations appear throughout in features and profiles. Regular departments include: technical tips, notes, and a calendar of exhibits, conferences, workshops, and competitions. Has advertising. Subscription: $24.00 per year (U.S.); other countries, $28.00 (U.S. funds).

Toy Soldier Review
127 74th St.
No. Bergen, NJ 07047

Sample copy $3.00 (U.S.).

Quarterly international magazine for toy soldier enthusiasts. Subscription $12.00 per year (U.S.).

Trains
P.O. Box 1612
Milwaukee, WI 53201

This monthly magazine is meant for the railroad hobbyist and model railroader. Issues are loaded with detailed articles about railroads and the railroad world of yesterday and today. Color photographs. Has advertising.

Treadleart
25834 Narbonne Ave.
Comita, CA 90717

Sample copy $3.00.

This bimonthly magazine is geared to sewing embellishment with projects, hints, topics — illustrated, described and diagrammed. Subscription: $18.00 per year (U.S.); foreign $20.00 per year (U.S. funds).

Treasures in Needlework
P.O. Box 54532
Boulder, CO 80322

Send SASE with inquiry.

This quarterly magazine emphasizes heirloom-quality designs for needlework in features, how-to's and through illustrations. Subscription: $19.97 U.S.

Wearable Wonders
P.O. Box 11308
Des Moines, IA 50347

Send SASE with inquiry.

This bimonthly magazine offers 15-20 complete patterns for embellishing clothes (jackets, purses, shirts, vests, tennis shoes, others)—with data on the latest products including polymers, adhesives, paints, etc., with techniques for wearable art. Subscription $14.95 yearly U.S.

Westart
Box 6868
Auburn, CA 95604

Single copy $1.00.

Semi-monthly tabloid has a readership of artists, craftspeople, and students. It features profiles and current reviews. Subscription $15.00 yearly U.S.

Where It's At
7204 Bucknell Dr.
Austin, TX 78723

Send SASE for further details.

This events guide is published monthly February though November. It covers over 600 arts and crafts shows, other events and competitions in 13 states (southern, middle country). Subscription $11.95 for 3 issues. $23.95 yearly.

Wildlife Photography
Box 691
Greenville, PA 16125

Single copy $2.00.

As the title suggests, this is a publication for those who photograph in the wild.

WKMG
P.O. Box 1527
Vashon, WA 98070

Single copy $4.75.

Bimonthly magazine is a guide to machine knitters. Technical artists assist beginners; patterns are given for a variety of machines and rated for levels of ability. Issues list seminars and special events, and give yarn and product news. Has advertising.

Women's Household Crochet
306 E. Parr Rd.
Berne, IN 46711

Single copy $2.25.

This quarterly crochet publication features projects from cover to cover for home and personal accessories including afghans, doilies, pillows, table linens, rugs; sweaters, shells, skirts, dresses (for men, women, children); soft toys. Advertising. (And publishes *Women's Circle Crochet*.) Subscription for each of these magazines: $7.95 per year (U.S.); Canada $11.15. Write to P.O. Box 11306, Des Moines, IA 50340.

Wood
P.O. Box 10215
Des Moines, IA 50306

Single copy $3.95.

Bimonthly Better Homes and Gardens magazine with projects from cover to cover with specifications, directions, diagrams, and illustrations. Has advertising. Subscription: $24.97 U.S..

Woodsmith
P.O. Box 491
Mount Morris, IL 61054

Send SASE with inquiry.

Bimonthly magazine concerns itself with woodworking —plans (drawings and a series of how-to's), techniques, and photo illustrations. Also includes data on tools, finishing, joinery, and more. Projects are complete with detailed cutting diagrams, exploded views, material and supply lists; and proceed in a step-by-step fashion to completion. No advertising.

Woodwork
P.O. Box 1529
Ross, CA 94957

Send SASE for information.

This quarterly magazine covers woodworking today, with topics for all skill levels. Presents cabinetmaking design and how-to's, profiles of professionals and their work, details on tools and equipment. Includes quality photography and diagramming throughout projects and other features on contemporary and other furnishings. Has advertising.

Workbench
4251 Pennsylvania Ave.
Kansas City, MO 64111

Single copy $2.95.

Do-it-yourself woodworking magazine covers projects for home improvement, furniture and accessories making/repair, and more, with detailed directions and photographs. Carpenter's Apprentice features and resources. Has advertising. Subscription: $12.95 per year (U.S.); Canada $20.28.

Associations

❧❧❧❧❧❧❧❧❧❧❧❧❧❧❧❧

See also GENERAL CRAFT BUSINESS RESOUR-
CES and PUBLICATIONS.

The list presented below is only a partial one. It in-
cludes those who responded to inquiry or where recent
information was found. Others may well be active (Na-
tional Standards Council of American Embroiderers,
for example, might still be reached at P.O. Box 8578,
Northfield, IL 60093) but the data below is recent at
time of publication.

❧❧❧❧❧❧❧❧❧❧❧❧❧❧❧❧

Academy of Model Aeronautics (AMA)
1810 Samuel Morse Dr.
Reston, VA 22090

Send SASE for full information.

This model aviation association provides members with
a Competition Newsletter, AMA news, and *Model Avia-
tion Magazine*; opportunity to get liability insurance for
accidents arising from the operation of model aircraft,
cars, and boats. Endorses and encourages a safety code
among members regarding the flying of model aircraft.
Members have access to the AMA Museum. Member-
ship begins every January 1; special senior citizens' rates.

American Craft Council
21 S. Eltings Corner Rd.
Highland, NY 12528

Send SASE for full information.

This association is formed to promote excellence and
education in all arts and crafts — textiles, arts, needle-
crafts, sculpture, and pottery, and many others; and their
magazine, *American Craft*, reflects this emphasis.

American Home Sewing Association, Inc.
1375 Broadway
New York, NY 10018
212-302-2150

Send SASE for full information.

This is a sewing industry association that includes pri-
mary and secondary resources — uniting all facets of in-
dustry under various membership divisions. The associa-
tion holds the largest trade show in the country, in
spring and fall. Their Statement and Object to members:
To create a greater appreciation among the public for
craft, needlework, and other related products; to edu-
cate and foster cooperation among both public and in-
dustry. A bimonthly newsletter disseminates news and
to members.

American Quilter's Society
P.O. Box 3290
Paducah, KY 42002

Send SASE for full details.

Members of this society of professional and amateur
quilters join to carry on this American tradition. They re-
ceive *American Quilter* magazine four times yearly, the
"Update" bimonthly newsletter, admission to the Annual
National Quilt Show (which awards over $40,000 in cash
prizes); receive member discounts of up to 20% on books
and other resources; and may participate in the Quilts
For Sale program service (for members who wish to show
their quilts for sale in a quarterly publication).

American Society of Gemcutters
P.O. Box 9852
Washington, DC 20016

Send SASE for information.

Members of this association receive *American Gemcutter*
magazine monthly, gemcutting evaluations and instruc-
tions with regional and national awards for excellence.
Marketing assistance includes participation in national
marketing plan to sell cut stones. Other educational and
supplemental services, design library supplments, ac-
cess to the Gemcutters National Library; others.

**Association of Traditional Hooking Artists
(ATHA)**
50 Cape Florida Dr.
Key Biscayne, FL 33149

Send SASE for full information.

This rug hooking association of guilds has a publication
issued bimonthly with news, views, tips, and techniques
on the craft.

Ceramic Arts Federation
2031 E. Via Burton/Unit A
Anaheim, CA 92806

Write for information.

Professionals in ceramics form the membership of this
international federation, among them teachers, dealers,
distributors, and manufacturers. Members receive the
CAFI newsletter.

CIMTA
6507 Coachleigh Way
Alexandria, VA 22310

Send large SASE for information.

The Cottage Industry Miniaturists Trade Association is
formed for those who operate a handcrafting miniatures
business. It sponsors a trade show for those wanting to
sell to retailers or distributors; sponsors workshops for
the show; attends other wholesale shows, other func-
tions and activities throughout the year.

Doll Makers Association
6408 Glendale St.
Metairie, LA 70003

Send SASE for full details.

This is a non-profit doll makers organization devoted to fostering the art, sharing knowledge to aid beginners; holds yearly convention. Instructors teach all aspects: mold making, French handsewing, wig making, etc.

Greeting Card Association
1350 New York Ave., NW, Suite 615
Washington, DC 20005
202-393-1778

Send SASE for further information.

This new organization caters to artists, photographers, and writers in the greeting card industry. Members receive a monthly newsletter of marketing and business trends and ideas (membership composed of large to small publishers, others). Publications: artists'/writers' market list, copyright basics, industry directory, handling publicity, How to Open and Operate a Greeting Card Store, starting a business, using sales representatives, public relations, others. Monthly magazine *CardNews*.

Handweavers Guild of America
120 Mountain Ave., B101
Bloomfield, CT 06002
203-242-3577

Write or call for further details.

This association promotes excellence in the fiber arts by uniting a diverse group of craftspeople worldwide, through educational services and a biennial convention. Members receive *Shuttle, Spindle & Dyepot* quarterly journal, slide and textile kits, videos, informational publications, library book rental, suppliers and educational directories. MasterCard, Visa. (See SPINNING & WEAVING and PUBLICATIONS.)

Intl. Guild of Miniature Artisans (IGMA)
P.O. Box 71
Bridgeport, NY 13030

Send SASE for full information.

The IGMA was founded to establish a standard of quality and promote excellence in the field of artistic miniatures; any individuals may join as general members, and after six months may apply for Guild Artisan Membership (by submitting samples of their work) and paying an initiation fee if accepted. Among the primary goals of the association is to encourage and educate new artisans. Important Guild events include exhibits and shows, with awards for excellence.

Intl. Herb Growers & Marketers Assn.
P.O. Box 281
Silver Spring, PA 17575
717-684-9756

Send SASE for membership information.

This is an association of those in the herb industry—growers and those who market herbs.

Intl. Plastic Modelers Society (IPMS)
P.O. Box 6369
Lincoln, NE 68506

Send SASE for full details.

Membership in this nonprofit association includes a subscription to a bimonthly journal (of new kits, conversions, building, IPMS news, etc.), allows purchase of IPMS products; includes regional and national events and news. (Write to: IPMS/USA, at above address.)

International Sculpture Center (ISC)
1050 Potomac St. N.W.
Washington, DC 20007
202-965-6066

Send SASE for complete information.
A subscription to *Sculpture Magazine* automatically entitles one to a membership in this nonprofit organization devoted to professional development of sculptors and an appreciation of sculpture worldwide. Among other member benefits are: free registration in Sculpture Source (a computerized slide registry linking sculptors with purchasers, non-artists get a discount on first-time use), group health insurance rates, fine arts insurance group rates, discounts with many foundries and stone suppliers; discounts on books and magazines, priority registration to ISC events, a newsletter, and use of library. (Professionals receive additional benefits.)

Maritime Ship Modelers Guild
1675 Lower Water St.
Halifax, Nova Scotia, Canada B3J 1S3

Write for further information.

This guild is dedicated to sharing expertise in ship model construction. Bimonthly meetings are held, along with monthly workshops. Club members are interested in a wide range of styles and types of model construction.

National Association for the Cottage Industry
P.O. Box 14850
Chicago, IL 60614
312-472-8116

Members receive guidance on home business and a network of "millions," an information clearing house with chapters throughout the U.S., subscription to *Cottage Connection Quarterly*, and discounts.

National Cloth Dollmakers Assn.
1601 Provincetown Dr.
San Jose, CA 95129

Send SASE for full details.

This is an association whose members love and make cloth dolls and is open to any who share that experience.

National Society of Tole & Decorative Painters
Box 808
Newton, KS 67114

Send SASE for information & local chapter.

A nonprofit organization with over 30,000 members, The National Society of Tole and Decorative Painters includes students, teachers, designers, and the business community. Started in 1970, it now has chapters in the U.S. and Canada (chapters sponsor workshops, hold meetings); members receive a monthly publication and

are entitled to attend the convention and other events.

Society of Antique Modelers (SAM)
209 Summerside Ln.
Encinitas, CA 92024

Send SASE for complete information.

Members of this flying old timers society receive six issues of *Sam Speaks*, join in model free flight and R/C flying.

Society of Craft Designers
6175 Barfield Rd. NE, Suite 220
Atlanta, GA 30328
404-252-2454

Send SASE for full information.

Members of this society are composed of designers, editors, manufacturers, and others involved in the crafts industry; they hold an annual convention and other noteworthy events for the promotion of excellence of design. The society also fosters professionalism in the marketplace, education for its members, and conducts seminars and a referral service listing. A bimonthly newsletter and other reference material are offered.

Society of Gilders
42 Maple Place
Nutley, NJ 07110

Send SASE for membership information.

Society sponsored their first gilding exhibition in fall, 1988, with lectures and exhibitors from the picture frame, furniture, gilding supply, and sign making industries; members receive a newsletter.

Surface Design Association
4111 Lincoln Blvd., Suite 426
Marina Del Rey, CA 90295

Send SASE for full information.

This is a nonprofit, educational association. Members receive a quarterly journal with surface design data, news, technical and business information.

The Federation of Leather Guilds
P.O. Box 102
Arcadia, IN 46030
317-984-5960

Send SASE for information.

This federation fosters and promotes an interest in leather craft, presents an annual show with contests among members and to award prizes for their work, and bring before the membership outstanding craftspeople in the field. Leathercraft guilds are located in these states: AZ, CA, IN, IA, IL, KS, KY, MI, MN, MO, NE, ND, OH, OK, TX, and WA; and Ontario, Canada.

The Knitting Guild of America
P.O. Box 1606
Knoxville, TN 37901
615-524-2401

Send SASE for full information.

This association of knitting teachers, designers, manufacturers, and shop owners, etc. offers members a master knitter program, correspondence courses, a national design competition, and national convention; bimonthly magazine, *Cast On*, with designs and how-to information, product and other news. Local guilds meet, and educational programs are shared.

The Knitting Guild of Canada
P.O. Box 159
St. Clements, Ontario N0B 2M0 Canada

This knitting guide connects knitters from coast to coast in Canada. It is meant for machine and hand knitters. It offers a quarterly magazine, teacher registry, and information on all aspects of knitting.

The National Quilting Association
P.O. Box 393
Elliott City, MD 21043

Send SASE for information.

This national association emphasizes education, creativity and heritage—through grants, scholarships, quilt registry, and as quilters' consumer advocate.

United Federation of Doll Clubs, Inc.
6B East St.
Parkville, MO 64152

Send SASE for information.

Clubs are helpful for doll makers as a way of sharing ideas and techniques and more. Write the above federation for the address of the nearest doll club.

Index